ART
THE WHOLE STORY

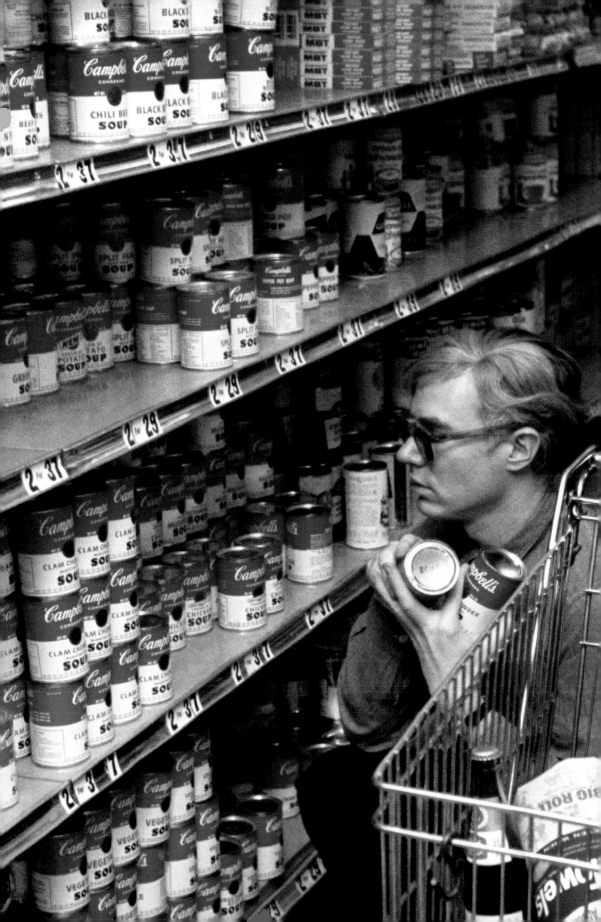

GENERAL EDITOR **STEPHEN FARTHING** FOREWORD BY **RICHARD CORK**

ART
THE WHOLE STORY

Thames & Hudson

First published in the United Kingdom in 2010 by
Thames & Hudson Ltd, 181A High Holborn,
London WC1V 7QX

Reprinted 2011, 2012, 2013, 2014, 2015, 2016

© 2010 Quintessence

This book was designed and produced by
Quintessence
The Old Brewery
6 Blundell Street
London N7 9BH

Project Editor	Fiona Plowman
Editors	Becky Gee, Carol King,
	Louise Larchbourne, Frank Ritter
Editorial Assistant	Helena Baser
Designer	Nicole Kuderer
Design Assistant	Tom Howey
Production Manager	Anna Pauletti
Editorial Director	Jane Laing
Publisher	Mark Fletcher

British Library Cataloguing-in-Publication Data
A catalogue record for this book is available from
the British Library

ISBN 978-0-500-28895-5

Printed in China

To find out about all our publications, please visit **www.thamesandhudson.com**.
There you can subscribe to our e-newsletter, browse or download our current
catalogue, and buy any titles that are in print.

CONTENTS

FOREWORD

As the new century grows older, people in ever-accelerating numbers across the world are discovering the existence of art. Museums and galleries proudly report spectacular attendance figures, not only at exhibitions of revered masters but also at shows of provocative new work by contemporary practitioners. The appetite for art of every kind is burgeoning all the time, and crowds often converge on spectacular installations with the fervour of pilgrims at great religious festivals.

Confronted by such excitement, it may seem nonsensical to view this prodigious surge of enthusiasm with gathering alarm. As a critic who has spent so much of his career encouraging readers to experience art for themselves, I would far rather feel gratified by the amount of fascination it now attracts. However, the more I watch viewers thronging to sample the latest blockbuster shows, or the permanent collections at the Prado, the Louvre and the National Gallery, the less convinced I feel that they are giving art any sustained attention. Most visitors move through exhibitions and museums with disconcerting speed. Pausing now and again in front of particular images before resuming the onward march, they do not seem prepared to scrutinize anything for a substantial time span.

On one level, their unwillingness to linger is all too understandable. Most art—unlike film, music, drama and literature—gives us the illusion that it can be taken in at a glance. We do not, apparently, need to spend the hours required to read a book, sit in a theatre, stare at a cinema screen or listen in a concert hall. Our eyes simply focus on the work displayed before us, and we take only a short while to decide whether it merits our interest. So this brevity seems very welcome. Nothing can be more irksome than realizing, after we have spent an inordinate amount of time watching an epic play, that it is irredeemably dull. Better by far, surely, to appraise art on the run and never risk wasting our energies on something meretricious. If we adopt such a policy in galleries, however, the exhibits on view there will never have a chance of involving us fully. An impatient glance is no substitute for the searching gaze. How can we hope to engage with the true subtlety of outstanding art without being prepared to stop, concentrate wholly on the work before us and, by degrees, enter into its potent imaginative world? Steady, discriminative looking is the only way to deepen our understanding of how artists can illuminate human existence. Yet it is by no means easy to engage on a profound level with the images they have produced. Our culture thrives on quick-fire visual stimuli. We are invaded at every turn by the rapid, restless rhythms of images assailing our attention. Wherever city-dwellers look—in the streets, on the Tube and through shop windows—advertising presses its urgent imperatives upon us. It batters our eyes, insisting on the most rapid response. Even if we manage to turn away from this colossal bombardment, our ever more sophisticated mobile phones will undoubtedly ring, presenting us with a far smaller yet no less intense melee of sounds, words and (increasingly) images that demand instant reactions.

However much of an adrenalin rush this relentless pressure may provide, it does nothing to prepare us for the challenge involved in the prolonged act

of looking. The pure visual charge of art is often immediate, and can arrest our eyes at once. After this initial seduction has taken place, though, we need to ensure that alternative distractions do not wrench us away. Only by remaining close to a particular work can viewers truly begin the process of entering its world and roaming around inside. But this is very hard to achieve. Scrutinizing art properly, over a considerable period of time, is a highly demanding activity and can only be learnt gradually. Once we have given the image a preliminary examination, it is tempting to conclude that nothing more will be found there. We begin to feel restless and want to move on. However, the urge to leave is worth fighting. If we stay, and allow the work to seep into our consciousness by degrees, a revelatory communion between art and onlooker may well prove possible. I have no desire to minimize the difficulties involved. Exploring an image properly involves a full-hearted commitment, and its meditative slowness remains stubbornly at odds with the frenetic pace of looking demanded by contemporary urban life. There are no formulae available, no surefire ways of arriving at the requisite sense of alert, probing observation. Each encounter with a particular work demands its own singular approach, and it would be dishonest of me to suggest otherwise. Those who argue that audio guides are the answer, providing instant commentaries on a select number of exhibits, should think again. How can you formulate an authentic response of your own when a voice, lodged intimately in the ear, is telling you precisely what to think? Such devices are bound to encourage chronic passivity in the viewer.

Yet *Art: The Whole Story* offers a refreshing corrective. Readers who consult it quietly at home can find, in these highly accessible pages, an admirable guide. Although an immense period of time is dealt with here, along with an astonishing number of different movements, the book never forgets the fundamental importance of focusing on particular images and understanding them in depth. At every turn, we are reminded about the central fascination of interpreting the richness of individual masterpieces. Reading this much-needed book can stimulate our response to an artist's vision in many rewarding ways. We must remember, however, that its words should only be absorbed either before or after encountering the exhibits waiting for us to discover them in museums and galleries. Nothing should ever be allowed to interfere with our first-hand experience of the original work, looking at it on our own with the wholehearted passion and attentiveness that great artists repay many times over. This, ultimately, is the key.

Richard Cork

ART HISTORIAN, CRITIC, EDITOR, BROADCASTER AND CURATOR
LONDON, UNITED KINGDOM

INTRODUCTION

There is no society throughout history, however low its level of material existence, that has lacked art. Depiction and decoration, like storytelling and music, are as natural to human beings as nest-building is to most birds. Yet the forms that art has taken have varied radically in different times and places under the influence of differing social and cultural circumstances.

In pre-state societies the purpose of art—cave painting, for example—is often presumed, correctly or not, to have been magical. It is imagined as expressing communal beliefs and playing a part in communal rituals. Once states with clear hierarchies of power emerged—in early Mesopotamian and Egyptian civilizations—art took its place in the service of wealth and power, embellishing palaces and glorifying the status and conquests of rulers. It also served organized religion—difficult to be clearly distinguished from secular power—in the decoration of temples, the depiction of gods and the pictorial recounting of religious myths. This is collective art, the notions of individual style or innovation absent, or certainly invisible to our eyes. Yet it is exquisitely crafted, subtle, even perfectly observed, as seen in Assyrian battle scenes or Egyptian depictions of birds and animals.

It is often, perhaps correctly, said that modern individualism takes shape among the trading and farming peoples of the Mediterranean—Greeks, Phoenicians, Etruscans, Romans. Named artists, such as Praxiteles (a. mid 4th century BC), were celebrated for their achievements. Public buildings of civic and religious importance were embellished and rulers and their triumphs glorified, but a broader class of art consumers also came into existence, exemplified by the prosperous citizens of Pompeii and Herculaneum. Various genres—landscape, portraiture, still life, animal painting, depictions of mythology—evolved to beautify their houses and record their appearance. Our perception of the art of these times is skewed by the hazards of survival—mosaics and frescoes have survived, but wooden panels mostly have not.

▼ An ancient Egyptian shown making papyrus in a mural relief at the mastaba tomb of Ti at Saqqara (2450–2325 BC). The seated figure is laying out the strips of papyrus reeds ready to be pressed and fused together to make a sheet.

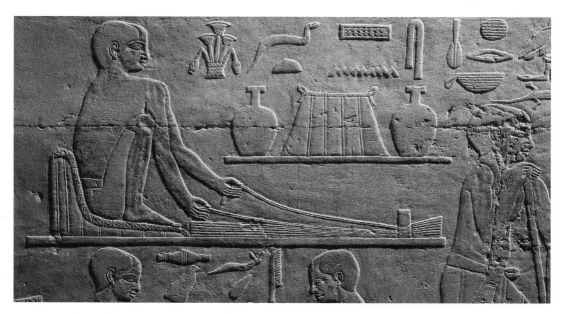

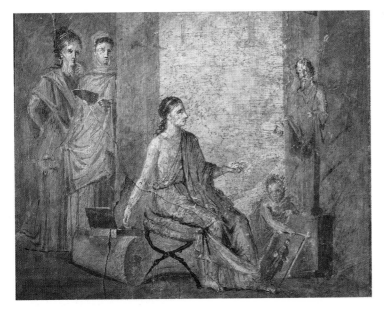

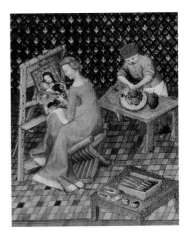

◄ Fresco showing a woman painting a statue, thought to be of the god Priapus, from the Casa del Chirugo in Pompeii (50–79 BC). A framed portrait is held by a boy at the artist's feet.

From the 4th century AD, Byzantine art evolved from Roman art transformed by the Christian religion. Art was at the service of the Church and of private religious faith. In the form of icons, images took on an inner spiritual value, with the seen standing for the unseen. However, they were also violently contested by iconoclasts, who believed the seen was supplanting the unseen. Islam, born into the same eastern Mediterranean world, tended towards similar iconoclastic beliefs, but alongside a geometrical and calligraphic art that also generated traditions of refined stylized realism. Although Islamic art itself developed out of the Roman and Byzantine styles, it was also enriched by the Sasanian art of pre-Islamic Persia. The Sassanid period saw some of the highest achievements of Persian civilization and the forms and motifs of its art travelled eastward into India, Turkestan and China.

In the 1st century BC the figure of Buddha was first carved in stone at Gandhara in present-day Pakistan, establishing the model for later Buddhist art. As Buddhism spread from the Indian subcontinent throughout Asia and the rest of the world, it exerted its own influence on the burgeoning arts of China, Japan and Korea. As the religion evolved in each host country it brought with it new forms, such as statuary and monumental sculpture. Japan's earliest art was connected with Buddhism, but from the 9th century, as the country turned away from the influence of China, the secular arts became more important and painting grew to be the strongest artistic tradition. In a society where people wrote with a brush rather than a pen, there was an intuitive understanding of the aesthetics of painting.

The backwater of Western Europe underwent a slow and intermittent transformation from the 12th to 13th centuries. The growth of trade and development of agricultural land generated new wealth, used in part to finance religious buildings, many of which were elaborately embellished with paintings and carvings. There was a discernible stylistic evolution towards three-dimensional realism, but no great gap separated Giotto (c. 1270–1337) or Simone Martini (c. 1285–1344) from Byzantine art. Beyond the Church, banking and trading cities, such as Florence, Bruges and Venice, became centres of artistic production in which minute accuracy of representation, possibly linked to developments in optics, was valued by patrons. The spirituality of a religious art was partially supplanted by themes from classical mythology, and

▲ The ancient Greek artist Timarete shown working in her studio on a portrait of the Madonna and child. Taken from Giovanni Boccaccio's *Concerning Famous Women* (1360–74).

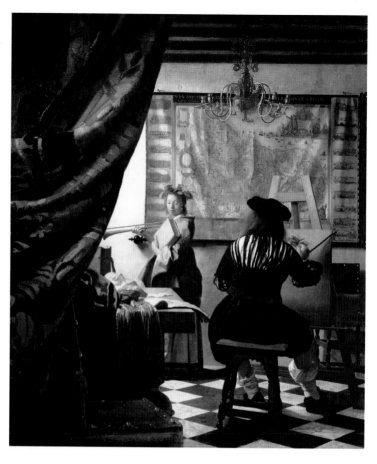

► *The Art of Painting* (1665–66) by Jan Vermeer. The Dutch painter kept this uncommissioned work in his studio as a showpiece for potential buyers. It never left his studio during his lifetime and after his death his widow refused to sell it despite her poor financial situation.

the celebration of luxury goods shown in the depiction of fine clothing and furnishings. Paintings themselves, increasingly portable items executed in oils, were luxury objects, but less valued than tapestries, for example.

Western art during what was later called the Renaissance was one of many diverse practices of painting employed across the world in the 15th and 16th centuries. It can claim no superiority of execution or sophistication compared with, say, Persian miniatures or Chinese landscapes. A lively urban popular culture in southern China gave momentum to the development of printmaking techniques for the mechanical reproduction of images, just as it did in southern Germany (and would later in Japan's 'floating world' of the Edo period). There is, however, a discernible difference in the Western tradition. Not only were innovative representational techniques such as linear perspective explored by artists, but patrons also began to expect new strategies and styles of representation. At the same time, a theory of the original genius of the artist began to emerge—tempered by the persistence of semi-artisanal status and workshop production. Individual artists achieved star status and were signed up by patrons who competed to employ the top names.

The fine proliferation of distinctive styles in the period of the Renaissance and the Reformation reflected the diversity of European culture and society. Venice's trade with the East funded works outstanding for their use of colour—the materials for these hues imported like any other merchandise. The theatricality of Baroque (as it was later termed) was the expression of the Catholic Counter-Reformation. The Protestant Netherlands required a quite different art to decorate the homes of the sober bourgeoisie or celebrate the

dignities of civic life—genre interiors, landscapes, and portraits suggesting an inner life and outer rectitude. Kings, princes and aristocrats would still pay for the celebration of their glories and depiction of their wealth. Yet there were also signs of artists finding an overtly personal significance in their art—in the late works of Rembrandt (1606–69) or in the extremist manner of Caravaggio (1571–1610).

In the 18th and 19th centuries Europe developed a consciousness of its artistic history, seen as a succession of masterpieces that were prized as jewels of culture and exhibited in galleries for the spiritual and moral edification of the public. The worship of 'great masters' of the past led contemporary painters to aspire to emulate them. The age of patronage and court painters was slow to fade—Napoleon employed his artists to celebrate imperial glory and Francisco de Goya (1746–1828) was a Spanish court painter—but increasingly artists were expected to pursue their own vision. As European society developed in the direction of maximized production, mechanization, utilitarianism and rationalism, European art developed in the direction of Romanticism—a complex cultural movement with a clear bias for nature against society and the machine, emotion against reason, and the inspired artist against the philistinism of bourgeois society.

Artists tended to regard themselves as necessarily in opposition to the materialistic modern world. Some avoided the depiction of modern subjects, taking refuge in the medieval or primitive, while others chose modern city life as a subject for ironic observation. As artists became financially dependent on producing works for sale on the market, art dealers and critics became key figures identifying talent and liaising between artist and connoisseur. A strange game commenced, in which the artist was expected to be an inspired individual devoted to the expression of his genius, yet had to produce saleable works that would probably be saleable precisely because of the artist's flaunted disdain for commerce. The notion of the avant-garde developed. This expressed a commitment to aesthetic radicalism; however, it also implied recognition of a commonplace succession by which new art presented as radical and flying in the face of established public taste soon mutated into accepted art, the beauty of which was universally acknowledged.

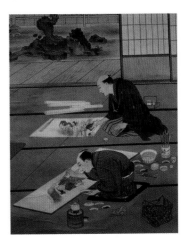

▲ Two artists at work in a studio in 19th-century Japan. They are surrounded by their equipment including paper scrolls, paints and brushes. Detail of a watercolour painting by Kawahara Keiga.

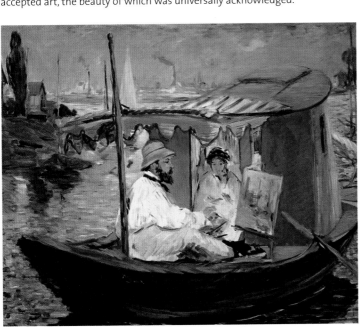

◄ *Monet in His Floating Studio* (1874) by Edouard Manet. The Impressionists took the radical step of moving the act of painting out of the studio and into the open air where they could capture the changing effects of natural light.

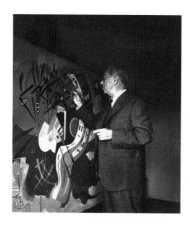

▲ Wassily Kandinsky painting in his studio in Neuilly-sur-Seine, France, in December 1936. The Russian-born artist was admired by many younger artists and he was visited in his studio regularly by Joan Miró, Alberto Magnelli, Jean Arp and Sophie Tauber.

The rapidity of social and technological change influenced the artist in myriad ways. Mass-produced paints in tubes made it possible to work in the open air instead of the studio. The first age of globalization—the rise of imperialism and international communications—brought exotic influences from Japanese prints to African masks. Artists themselves travelled. For example, Eugène Fromentin (1820–76) and William Holman Hunt (1827–1910) were among those Orientalist painters who visited North Africa and the Middle East, and their first-hand observations of the landscapes and cultures were recorded in the authentic detail of their paintings. Paul Gauguin (1848–1903), meanwhile, was lured by the exoticism of the Pacific islands, where he produced some of his finest works. The invention of photography opened a debate about the purpose of representational art, but also offered a new resource for painters. With his *Nude Descending a Staircase, No. 2* (1912), for example, Marcel Duchamp (1887–1968) acknowledged the influence of stop-motion photography. Scientific developments in the study of optics led to fresh experiments with colour, as exemplified in the techniques adopted by Claude Monet (1840–1926) and Georges Seurat (1859–91).

The opening of the 20th century found Western art in an experimental phase that broke the boundaries of any previously known artistic form. Cubism and the beginnings of abstraction were neither representational nor decorative, but forged new ways of seeing the world. Technological advances such as cinema, automobiles, electric light and aviation were influences on art, self-consciously so in the case of Futurism. Avant-garde artists formed movements with manifestos to assert programmes of artistic change. These changes preceded the cataclysm of the Great War—which incidentally reintroduced state patronage in the form of the 'war artist'. After the war a sense of cultural crisis was all-pervasive, although with varying results. Some artists sought a new objectivity or return to classicism, while others plunged into a subversive celebration of the irrational and taboo. The splendid riot of

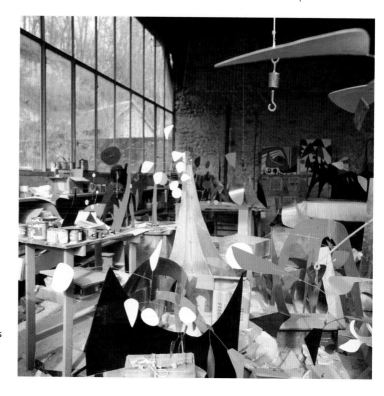

► The workshop of American sculptor Alexander Calder at Saché in the Indre valley, France. Calder is renowned for his colourful kinetic sculpture, examples of which can be seen in this photograph of his 'François 1er' studio.

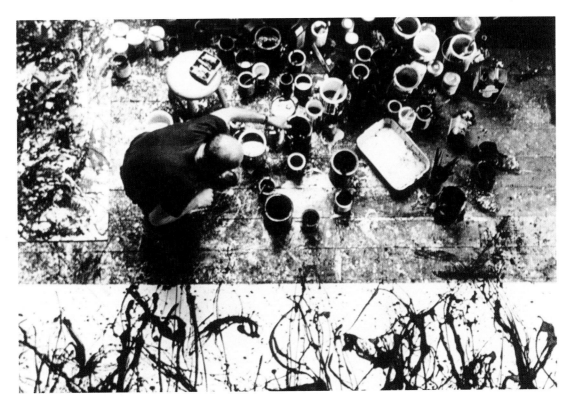

individual styles and competing movements ran headlong into the rise of European dictatorships—Soviet, Nazi, Fascist—that rejected this degenerate bourgeois art in its entirety and patronized a heroic representational art celebrating the state. This had the improbable effect of making modernist art a cherished symbol of capitalist liberal democracy, so that after World War II the CIA emerged as a source of patronage for American abstract artists. The supremacy of the United States in the world economy led with apparent inevitability to its pre-eminence as a centre of artistic production: New York, no longer Paris, was the international capital of the art world.

After 1945 some artists continued in the heroic/romantic model, expressing themselves in monumental gestural abstraction or as if tortured in expressive representational works, such as those by Francis Bacon (1909–92). The discomfort some artists felt in a commercialized society led to more radical breaks with the past. Performance artists and later Conceptual artists sought to make works that were not objects. Andy Warhol (1928–87) led another charge to demolish the 'myth' of the artist, presenting mechanically reproduced images of ready-mades as artistic works. Pop artists rejected the 'elitism' of high art. The deluge of visual imagery in the age of mass media led to an adjustment in how works of art were viewed—now they were seen as only one kind of image among many. Ironically art prices survived the assault of anti-commercialism and rose to unprecedented levels, eventually to become a vehicle for tax evasion and speculative investment. Art museums and galleries, both showcasing the art of the past and the present, gained a prominent place in the burgeoning leisure and tourism industries. Radical art forms such as the 'installation' became crowd-pullers and some artists adapted easily to the media culture of celebrity. Although circumstances seemed unpropitious, 'society continued', as John Ruskin the 19th-century English art critic so neatly put it, 'to get the art it deserved'.

▲ The Abstract Expressionist painter Jackson Pollock at work in his studio in 1950. Pollock's house-studio was in Springs in the town of East Hampton on Long Island. Pollock converted a barn into his studio, while his artist wife Lee Krasner used a bedroom to work in.

1 | PREHISTORY TO 15TH CENTURY

ANCIENT ROCK, CAVE AND LAND ART

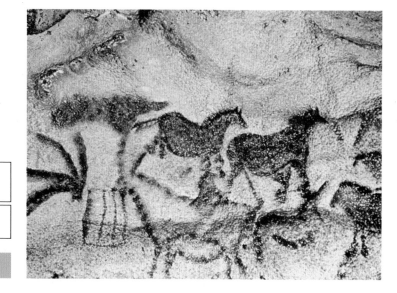

1 Altamira cave painting (*c.* 15,000 BC),
detail
Artist unknown • pigment on rock
Santillana del Mar, Cantabria, Spain

2 Ubirr rock painting (*c.* 40,000 BC), detail
Artist unknown • pigment on rock
Ubirr, Kakadu National Park, Australia

3 Lascaux cave painting (*c.* 15,000 BC)
Artist unknown • pigment on rock
Lascaux, France

The term 'rock art' is used to describe the practice, common to many ancient peoples, of painting and carving on rock, and piling up stones to form patterns on the ground. The oldest known works of art—two small sticks of engraved ochre found in Blombos Cave on the southern Cape coast of South Africa—have been dated to 77,000 years ago. These pieces are decorated with criss-cross lines scratched into the rock to form geometric patterns.

Australia is particularly rich in rock art. The island of Murujuga near the Dampier Archipelago, Western Australia, is home to the world's largest complex of petroglyphs (rock engravings), which may date back to *c.* 28,000 BC. They consist of geometric shapes alongside realistic forms depicting Aboriginal ceremonies, and animals including whales, emus, kangaroos and the now extinct Tasmanian tiger. The Ubirr site in Kakadu National Park in Australia's Northern Territory features rock paintings dating from three distinct periods, going back to *c.* 40,000 BC. Unusually, they have been repainted by successive generations of Aborigines over the centuries. The rich, oral Aboriginal tradition and belief system has made their spiritual purpose clear: most of the paintings were used in rituals performed to increase the animal population, although in some cases they are secular paintings created purely for visual pleasure. The earliest paintings at Ubirr show animals that have since become extinct and stick figures in ceremonial dress that, according to tradition, represent the spirits that taught humans to hunt and paint. The image (opposite, above) is one of the oldest at Ubirr and depicts a running hunter; its active stance places it in a style

KEY EVENTS

c. 75,000 BC	*c.* 40,000 BC	*c.* 30,000 BC	*c.* 25,000 BC	*c.* 16,000 BC	*c.* 14,000 BC
Sticks of ochre are engraved in Blombos Cave, South Africa.	The first painted images appear at the site of Ubirr in Australia's Northern Territory.	Images in red and black pigments are painted on the walls of the Chauvet Cave in France's Ardèche Valley.	Charcoal and pigments of ochre and white are used to paint images of animals in caves in Namibia's Huns mountains.	A cave in Altamira, Spain, is first painted with images. In time many portrayals of animals and stencils of human hands will be added.	The people living in and around the caves at Lascaux in France start to paint on to the caves' walls.

known as the 'Dynamic Figure' tradition. Other works, known as 'X-ray' paintings, show the skeletal structure and internal organs of humans, mammals and fish. The rock paintings of Tassili n'Ajjer in Algeria date to *c.* 8000 BC and are known for their naturalistic treatment of people and animals.

The earliest known cave paintings date back to *c.* 30,000 BC. Their meaning remains unknown, although they may have had a religious or magical purpose. The artists chose to represent the world that they saw around them and frequently depicted animals, occasionally human-like forms and, in some cases, abstract signs that may have had a spiritual meaning. The Altamira cave in Cantabria, Spain, contains some of the world's finest multi-coloured rock paintings and drawings. These images date from the Magdalenian period (16,000–10,000 BC) and depict animals, including bison in different poses, horses (opposite), a doe and possibly a wild boar, as well as symbols and hand imprints. The images are outstanding not only because they represent some of *Homo sapiens'* first artistic endeavours, but also because they are of superb artistic quality. Furthermore, the images are carefully laid out to take advantage of the contours of the cave walls, which gives them a three-dimensional quality.

Cave paintings at the Lascaux complex in Dordogne, France, have been dated to *c.* 14,000 BC. Discovered in 1940, the caves contain approximately two thousand images produced during the Palaeolithic period, most of which depict mammals, including horses, bison, stags and even a rhinoceros. Despite the limited colour palette available to the artists, the results are impressive: close attention has been paid to anatomical detail and the animals are clearly recognizable. The image (right, below) is of the head of a bison, an animal that roamed in large numbers on the European mainland.

The Laas Gaal complex of Neolithic paintings in Somalia, Africa, provides a later example of cave painting. Created from *c.* 9000 to *c.* 3000 BC, these artworks are vividly colourful and very well preserved. Local nomads knew of the paintings, but they only came to international attention, in 2002, thanks to a team of French archaeologists. The works are similar to those in Lascaux in that they depict animals, including lupine creatures and giraffes.

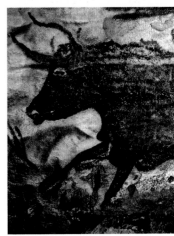

Geoglyphs represent another form of prehistoric art. These large drawings on the ground often form distinct patterns or motifs and are the precursors to 20th-century Land Art (see p.532). Peru's Nazca Lines (*c.* 200 BC–*c.* AD 600; see p.18) are regarded as the world's most outstanding geoglyphs because of their size, complexity, number and remarkable state of preservation. The motifs were mostly created by removing gravel from a desert area to form geometric shapes and images of humans, vegetation, mammals, birds and fantastical beings, connected by a series of lines. The largest drawings are up to 660 feet (200 m) in length and the geometric formations cover almost 190 square miles (500 sq km). Some experts believe they may have served a ritual, astronomical function; others suggest they are irrigation schemes or fertility symbols. **CK**

c. 11,000 BC	*c.* 10,000 BC	*c.* 8000 BC	*c.* 1000 BC	*c.* 200 BC–*c.* AD 600	*c.* AD 1000–1070
Painted images of a hunter-gatherer culture first appear on the stones of the Matobo Hills in Zimbabwe.	Argentina's Cueva de las Manos (Cave of the Hands) is decorated with stencils of human hands, created using red and black pigments.	Cave paintings in Tassili n'Ajjer, Algeria, depict a verdant Sahara region, very different from the desert the region was later to become.	The figure of a white horse, 374 feet (114 m) in length, is carved into a chalk hill in Uffington, Oxfordshire, England.	The Nazca Lines (see p.18) appear in Peru. They include images of people and animals and are made from lines in geometric forms.	The Great Serpent effigy mound—great piles of earth shaped to represent various animals—is created in Ohio. It is more than 1,300 feet (396 m) long.

Nazca Lines (Hummingbird) *c. 200 BC – c. AD 600*
ARTISTS UNKNOWN

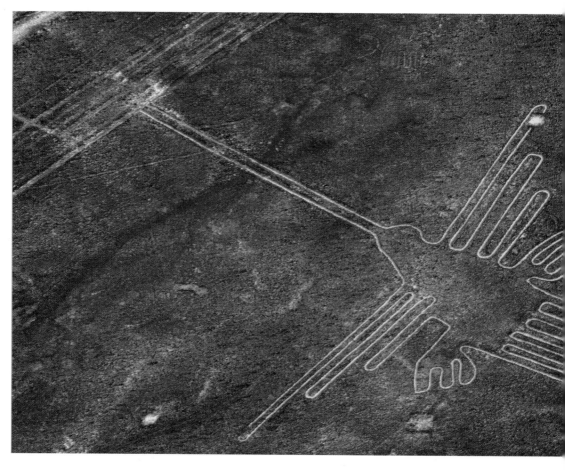

stone, gravel and soil
164 ft / 50 m long
Provinces of Nazca and Palpa,
Pampas de Jumana, Peru

The Nazca civilization flourished between 200 BC and AD 600. Although no important architecture remains, the most significant cultural characteristic of the Nazca civilization—and its greatest mystery—is the vast network of geoglyphs known as the Nazca Lines, which is situated in the desert and the Andean foothills of the Peruvian coastal plain south of Lima. These large drawings on the ground form patterns or motifs consisting of geometrical shapes, lines and figures of birds and animals, including a spider, pelican, lizard and hummingbird. The geoglyphs cover an area of more than 174 square miles (450 sq km) and the largest drawings measure up to 1,000 feet (305 m) long.

The dry, windless climate and isolation of the Nazca Plain have helped to preserve these enigmatic geoglyphs. The shallow lines were made by removing the red stone and gravel of the desert so that the whitish earth beneath was exposed, a process that required great organization and planning. The Nazca people needed a topographical measuring system employing exact measurements on a scale so large that it was impossible to see an entire geoglyph at once. It is thought that they built observation points to view the drawings from above. Birds are the most common subject of the Nazca Lines—eighteen birds have been discovered to date—but the hummingbird remains the most immediately recognizable. **RM**

 NAVIGATOR

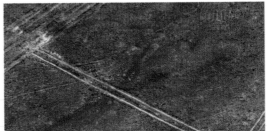

1 DISTINCTIVE LONG BILL

The hummingbird's long bill is its most distinctive feature. The tip of the bill ends at a group of parallel lines, the last of which points to the rising sun on 21 December, the date of the winter solstice. It has been suggested that geoglyphs were used as markers of an astrological calendar related to agricultural activities.

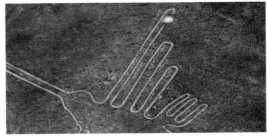

2 SIMPLIFIED WINGS

The spread wings and long tail feathers make the hummingbird easily recognizable, despite its flat, linear representation. The patterns and style of the Nazca Lines follow the Pre-Columbian tradition of simplification and abstraction of natural shapes by the removal of details and the preservation of elemental form.

NAZCA POLYCHROME POTTERY

The iconography and symbolism of the Nazca Lines are reflected in Nazca pottery and textiles. Influenced by the earlier Paracas civilization, Nazca ceramics are characterized by their polychromy—use of geometric pattern and vivid motifs of birds, animals, fish, plants and deities. Remarkably, the Nazca employed a palette of at least ten colours, a greater number than that used by any other culture in the Pre-Columbian Americas (see p.34). The colours were achieved by using slip made from mineral pigments, such as iron oxide to produce red or manganese to produce black. Nazca ceramics included bowls, beakers, dishes, vases and vessels with one or two spouts and a bridge. This vessel (c. 200–700; right) is surmounted by two birds and depicts mythological scenes. Nazca vessels sometimes depict decapitation scenes because ritual beheading was then a common practice in the Andes. Such vessels were sometimes used in households, although they were most commonly used as funereal offerings; certain shapes were allowed to be used only by high-ranking members of society. The ceramics were mostly made by coiling clay, then the mineral pigments were applied before the pieces were fired. After firing, the ceramics were polished to achieve a glossy finish.

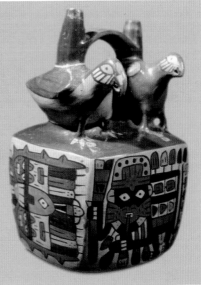

EARLY MESOPOTAMIAN ART

 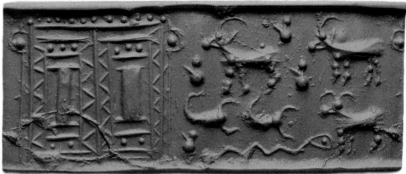

1 **Cylinder seal (3000 BC; left) and its impression on clay (right)**
Artist unknown • marble
1 3/4 x 1 5/8 in. / 4.5 x 4 cm
British Museum, London, UK

2 **'Ram in a Thicket' statuette (2600 BC)**
Artist unknown • wood, copper, other media
18 1/8 in. / 46 cm high
British Museum, London, UK

3 **Victory stele of Naram-Sin, King of Akkad (c. 2230 BC)**
Artist unknown • pink sandstone
78 3/4 x 41 3/8 in. / 200 x 105 cm high
Louvre, Paris, France

B y 4000 BC Mesopotamia—the lower valley between the Tigris and Euphrates rivers in modern-day Iraq—had been settled for centuries by the Sumerians, an industrious agricultural people who had established a thriving urban society ruled by dynastic kings based on a theocratic system of government. Over the next three millennia, the political, religious, economic, artistic and architectural traditions developed by this ancient people would lay the foundation for Western civilization.

The Sumerian civilization produced many firsts: the first city-state of Uruk, ruled by King Gilgamesh; the first organized religion based on a hierarchical structure of gods, man and ritual; the first known written language, cuneiform; the first irrigation system for cultivating crops; and the first wheeled vehicles for transporting goods and armies. Sumerians also built the first commercial trade networks, with links extending throughout Africa, Asia and Europe. In order to help them manage their vast commercial empires, the Sumerians invented the first cylinder seals, small cylinders carved with cuneiform script or figurative drawings. Cylinder seals were an important administrative tool and were either rolled over damp documents to signify certification or ownership, or pressed into wet lumps of clay that, when dry, formed a seal serving as an ancient form of lock. The Sumerian marble seal (above, left) produces an impression of animals and pots in front of a shrine or temple; seals such as this were used in trade between Mesopotamia, Syria and Egypt. Cylinder seals were fashioned from a variety of materials including shell, lapis lazuli, bronze, silver and gold. The more valuable seals were carried as identification.

At the head of the Sumerians' theocratic city-state system was the patron god, the Supreme Ruler. The king, as Executor of the Divine Will, had two functions: protector of the city-state and priest, or mediator between the gods and man. Religion was the driving force of society and Sumerian architecture and art served as functional expressions of religious beliefs and practices. Each Sumerian city was built around a monumental temple-tower structure

KEY EVENTS

c. 4000 BC	c. 3600 BC	c. 3400 BC	c. 2900 BC	c. 2700 BC	c. 2600 BC
Uruk, the world's first city, begins to flourish in Sumeria (southern Mesopotamia). The city is located to the east of the present bed of the Euphrates River.	The lost-wax technique (also known by its French name 'cire perdue') is developed in Mesopotamia and Egypt for casting objects in bronze.	Simple writing is developed in a pictographic style and is used to record tributes to the temples.	Many cities acquire defensive walls. Sumerian pictographs decline as writing is used more and more to record events and great deeds.	Gilgamesh is said to have ruled in Uruk. Legends about him are later collected in the Akkadian poem *Epic of Gilgamesh*.	The Royal Cemetery of Ur is used for sixteen royal burials. Many objects, including the Royal Standard of Ur (see p.22) are found there centuries later.

known as a ziggurat, which was composed of massive mud-brick, multi-storey platforms flanked by ramped stairways that led to the temple's shrine.

During an excavation in 1928 of one of these temple-towers, the ziggurat of Ur, the British archaeologist Sir C. Leonard Woolley made a major discovery: the burial complex of a king and a queen, identified as Pu-abi by her cylinder seal. The royal couple were buried in separate adjacent tombs with more than seventy-five attendants, along with an extraordinary funerary appointment of jewellery, religious offerings, weapons, tools, vessels, musical instruments and gaming boards for their use in the afterlife. Among the discoveries were some of the finest preserved works of Sumerian art dating from 3500 to 2400 BC. The 'Ram in a Thicket' (right) is one of a pair of funerary statuettes, so named by Woolley, that were discovered in the king's tomb. The statuettes are in fact 'he-goats' rearing on a flowering tree. Lapis lazuli forms the horns, brows and eyes; gold leaf covers the tree, face and legs; and small oblong pieces of shell and lapis lazuli comprise the tufts of fleece. A central tube suggests that the statuette originally supported something, such as a bowl. Sumerian funerary artefacts such as the Royal Standard of Ur (c. 2600–2400 BC; see p.22) provide ample evidence of a rich and resourceful culture. Although much of the iconography in Sumerian art remains obscure, as Woolley eloquently stated, '…every object found is not merely an illustration of the achievement of a particular race at a particular time, but also a new document helping to fill up the picture of those beginnings from which is derived our modern world.'

The Sumerian city-states, long established in Mesopotamia, were eventually conquered by Sargon the Great of Akkad, who ruled from 2334 to 2279 BC. Sargon established the Dynasty of Akkad and ruled from a new capital, Akkad, built on the left bank of the Euphrates. Mesopotamia was just part of Sargon's empire, which stretched from present-day Iran to the Mediterranean. The warrior king Sargon and his dynasty ruled with godlike authority.

The victory stele of Naram-Sin (right) testifies to the aggressive rule of the Akkad Dynasty. Naram-Sin (r.2254–2218 BC) was Sargon's grandson and successor, whose title was 'King of the Four Quarters', or 'Ruler of the World'. Damaged at both the top and bottom, the stele (a monument erected to commemorate an important event or person) was sculpted to celebrate the victory of King Naram-Sin over King Satuni of the Lullubi mountain peoples in present-day Iran. The stele shows the king leading his men up the steep slopes of the Lullubi domain and its composition represents a significant step forward from Sumerian sculpture, in which figures were invariably restricted to horizontal tiers. Here the sculptor shaped a dramatic triangular composition with King Naram-Sin at its apex. Below him, his victorious soldiers trample on the defeated Lullubi, while others wait in submission or are falling from the mountain. The king looks not at them but at the sky, from which signifiers of God seem to confer divine blessings upon his actions. **SA**

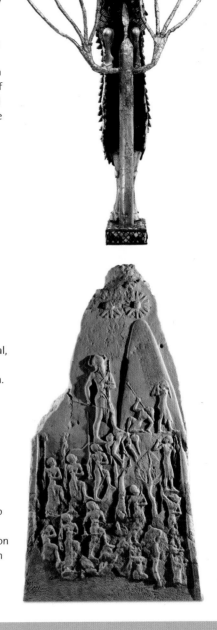

c. 2500 BC	c. 2360 BC	2270 BC	c. 2230 BC	c. 2144 BC	2000 BC
The first ziggurats, or stepped pyramids, are built. Each forms part of a temple complex and is believed to be the dwelling-place of a patron god.	The ruler Urukagina of the Mesopotamian city-state of Lagash issues humane codes of law to combat abuses by priests and the wealthy.	The city of Akkad becomes a new force in Mesopotamia. The Akkad Dynasty is to remain in power until the death of Shar-Kali-Sharri around 2100 BC.	The victory of King Naram-Sin of the Akkads over the Lullubi people is marked by a stele of highly original design (above).	Gudea is made king of Lagash. The numerous surviving statues of this king convey a powerful image of Akkad royalty.	The depletion of soil fertility causes southern Mesopotamia to go into decline; the population moves northwards.

Royal Standard of Ur *c.* 2600 – 2400 BC
ARTISTS UNKNOWN

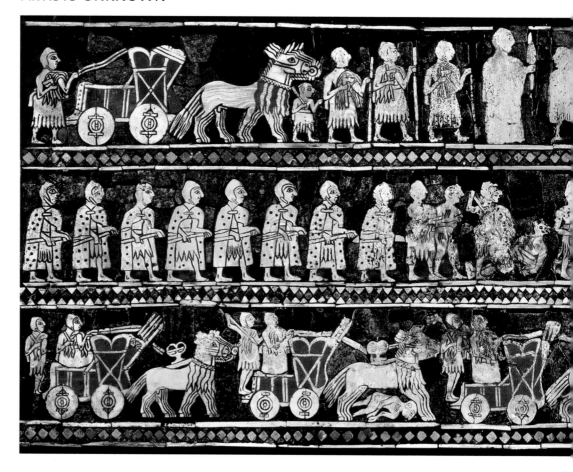

War Panel
shell, lapis lazuli and red limestone
8 ½ x 19 ½ in. / 21.5 x 49.5 cm
British Museum, London, UK

The Royal Cemetery of Ur in the south of present-day Iraq was first excavated in 1928 by the British archaeologist Sir C. Leonard Woolley. In one of the tombs Woolley discovered 'a most remarkable thing', a small trapezoidal box made of wood and inlaid with many figures in shell, red limestone and lapis lazuli. He found the box resting against the shoulder of the remains of a man whom he presumed to be a standard bearer. Woolley imagined the artefact mounted on a pole and carried heraldically into battle; the box thus became known as the Royal Standard of Ur. More recently, scholars have become convinced that the 'standard' is actually the soundbox of an ancient, stringed musical instrument.

On either side of the box are two main panels, each featuring three horizontal registers or tiers inlaid with scenes of figures and animals. When read from bottom to top, the tiered scenes present a visual narrative similar to a cartoon strip. The first panel, called the War Panel, shows the king conducting war, with the royal Sumerian army in full battle regalia brutally conquering the enemy. Infantry wielding javelins and axes slay their foe, and after the battle they bring prisoners, bound and naked, before the victorious king, who raises his spear as he decides their fate. The second panel, the Peace Panel, depicts the king and his noblemen celebrating victory at a banquet. They are seen giving thanks to the gods as men deliver spoils of war to the king. **SA**

◆ NAVIGATOR

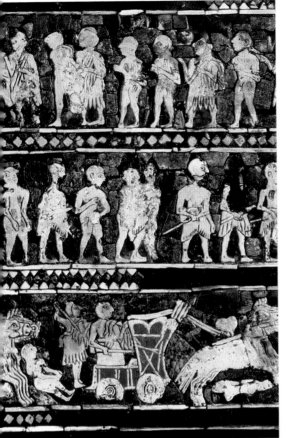

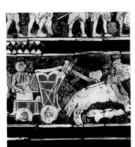

1 GREAT KING

In Sumerian art, figures are represented hierarchically—their size is altered to indicate their power or importance. Here the king is illustrated as a figure of such greatness that, even when seated, he 'bursts through' the ceiling, represented by the mosaic border, and towers over the other men.

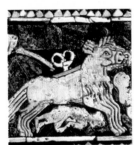

2 EFFECT OF MOVEMENT

The artist creates the effect of movement by changing the gait of the figures as they move from left to right. The onagers (wild asses), too, first walk, then trot and finally break into a gallop. Their legs appear wider and wider apart until they lift off the ground, seemingly 'flying' into battle.

3 RUTHLESS ARMY

The War Panel dramatically depicts four-wheeled chariots drawn by charging onagers trampling over bloodied enemy corpses. The panel provides one of the earliest illustrations of the Sumerian army and the artist is clearly celebrating the army's brutal and irresistible force.

VICTORY CELEBRATION

The reverse side of the Royal Standard of Ur, the Peace Panel (detail, right), depicts a scene in which the brutalities of war are forgotten. With the battle won and peace restored, the king and his nobles are seated and dressed in ritual *kaunakes*, long-fringed woollen skirts, celebrating their victory at a ceremonial banquet. Their goblets are raised in their right hands, possibly in thanks to the gods for their triumph. A musician serenades them with a lyre (not visible here). As in the War Panel, the figure of the seated king (at top left) is larger than those of his nobles, and the decoration of his *kaunake* is rendered in fine detail. Standing servants attend the king and nobles, and in the register below a parade of men bring spoils of war—a bull, a goat, fish and other plunder—to the banquet. The shell used for the figures is finely detailed in black, and slices of lapis lazuli provide the background. Touches of red limestone are added for decorative effect.

AEGEAN ART

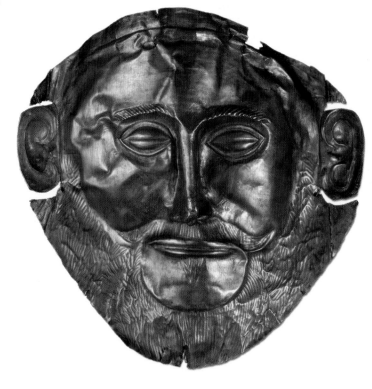

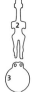

1 **Mask of Agamemnon** (*c.* 1600–1500 BC)
Artist unknown • gold
9 ⁵/₈ x 6 ³/₄ in. / 25 x 17 cm
National Archaeological Museum,
Athens, Greece

2 **Female figure** (*c.* 3200–2800 BC)
Artist unknown • marble
8 ¹/₂ in. / 21.5 cm high
Metropolitan Museum of Art,
New York, USA

3 **Marine-style flask with octopus
decoration** (*c.* 1450 BC)
Artist unknown • clay
Heraklion Archaeological Museum,
Crete, Greece

P
rior to the appearance of art on the Greek mainland, a number of
civilizations flourished in and around the Aegean Sea. The first of these
developed in the Cyclades, a group of islands south-east of mainland
Greece. From *c.* 3000 BC, a wave of settlers from Asia Minor began producing
tiny statuettes in the local marble. Distinctive in style, many of them depict
female figures in a simple, standing pose, with arms folded across the chest
(opposite, above). The few male figures carved are usually portrayed with
musical instruments or weapons. The purpose of the figurines remains a
mystery. Most have been discovered in graves, but they were not new when
they were deposited, so they evidently had some purpose for the living, too.
The carvings would once have had painted decoration, but this has worn away
over time. The spare, minimalist form of the figures has provided inspiration
for modern sculptors, just as the aesthetics of traditional African sculpture
influenced the work of early 20th-century artists such as Pablo Picasso
(1881–1973), Henri Matisse (1869–1954) and Alberto Giacometti (1901–66).

The greatest of the Aegean civilizations emerged in Crete in *c.* 3000 BC.
Minoan artists drew inspiration from Egypt, Syria and Anatolia but fused the
various styles into their own, giving it a highly original twist. They excelled at

KEY EVENTS

c. 3000 BC	*c.* 2000 BC	*c.* 1900 BC	*c.* 1750 BC	*c.* 1700 BC	*c.* 1624 BC
The early Cycladic civilization emerges in the Aegean, north of Crete. It produces distinctive, geometrical figurines.	The Minoan civilization flourishes and constructs major palace complexes on northern Crete.	The Minoan palace of Knossos is laid out in its final form.	Theran culture flourishes on the island of Santorini. It combines elements of Minoan and Egyptian culture with naturalistic frescoes.	The Linear A Minoan script emerges. It has still not been convincingly deciphered.	A volcanic eruption at Thera causes a tsunami. Trade is disrupted throughout the Aegean, which leads to the decline of the Minoan civilization.

making pottery, jewellery, frescoes and small-scale sculptures. Minoan culture was centred on the great palaces of Knossos, Malia and Phaestos, which were building complexes used for commercial, religious and ceremonial purposes rather than straightforward residences. They housed storerooms for grain and workshops for artists, as well as space for large public gatherings. The palaces were lavishly decorated with frescoes (see p.26). At Knossos, fragments remain of wall paintings depicting the spectacular processions and acrobatic displays that played an important role in Crete's ritual bull sports. The frescoes also show vivid portrayals of nature, including a cat stalking a bird, a monkey in a field of saffron and a frieze of blue dolphins.

Minoan pottery was equally varied. The most distinctive form was Kamares ware, which took its name from a cave sanctuary near Mount Ida where the first examples were discovered. Kamares vessels are extremely delicate—their clay surface is often as thin as an eggshell—and they feature an exuberant blend of geometric patterns or stylized leaves and flowers. The bold, rhythmic, curvilinear designs spread over the entire surface of each object, including any handles or spouts. A similar kind of energy can be found in more naturalistic forms of decoration. As islanders, Cretan artists were fascinated by the sea life that surrounded them and they developed a style that featured it (right, below), which they employed on pottery and metalwork. Starfish, coral, dolphins and octopuses are common motifs; the latter's fierce eyes and long, wriggling tentacles were frequently depicted.

The Minoan influence extended to the Greek mainland, where it had a major impact on the Mycenaeans, who flourished from c. 1600 to 1100 BC. The civilization owes its name to the ancient city of Mycenae, in the north-eastern Peloponnese. From here, the Mycenaeans gradually extended their power over all of southern Greece and the surrounding islands. They were more warlike than the Minoans; their palaces were heavily fortified and they left behind many weapons and martial artefacts. The ancient Greeks looked back on Mycenae as the cradle of their civilization. According to Greek myth, the city was founded by Perseus and ruled by Agamemnon, who led the Greek forces in the war against Troy. Homer described it as 'rich in gold' in the *Iliad* (c. 750 BC).

Homer's description appears to have some basis in fact. When German archaeologist Heinrich Schliemann (1822–90) excavated a circle of shaft graves (tombs consisting of a deep, narrow pit) at Mycenae in 1876, his dig yielded spectacular results. Along with a hoard of jewellery and weapons adorned with gold and silver, he unearthed a collection of burial masks that were created by hammering gold into a thin leaf over a wooden form. Details were chased on later with a sharp tool, and two holes near the ears were used to hold the mask in place with twine over the deceased's face. Schliemann hoped to link the masks with the court of Agamemnon and one of the gold-leaf masks was named the Mask of Agamemnon (opposite). However, the mask has been dated to three hundred years before Agamemnon and is likely to have covered the face of a Mycenaean ruler. **IZ**

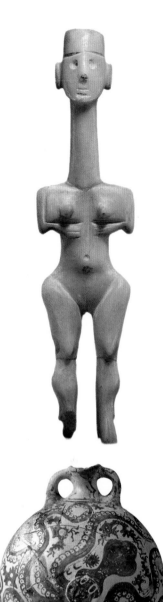

c. 1600 BC	c. 1600–1500 BC	c. 1550–1450 BC	c. 1400 BC	c. 1180 BC	c. 1100 BC
An Achaean (Mycenaean) culture evolves on the Peloponnese, with large beehive tombs and a Lion Gateway at Mycenae.	The gold Mask of Agamemnon (above, left) is made, although it probably was not made for the face of the hero of the Trojan War.	The *Toreador Fresco* (see p.26) at Knossos, showing a male acrobat apparently vaulting over the horns of a charging bull, is painted.	The Linear B Mycenaean script develops; it becomes the precursor of Greek script.	According to Homer's *Iliad*, the city of Troy is burnt to the ground.	The Mycenaean civilization declines as Greece enters a dark age.

Toreador Fresco *c.* 1550–1450 BC
ARTIST UNKNOWN

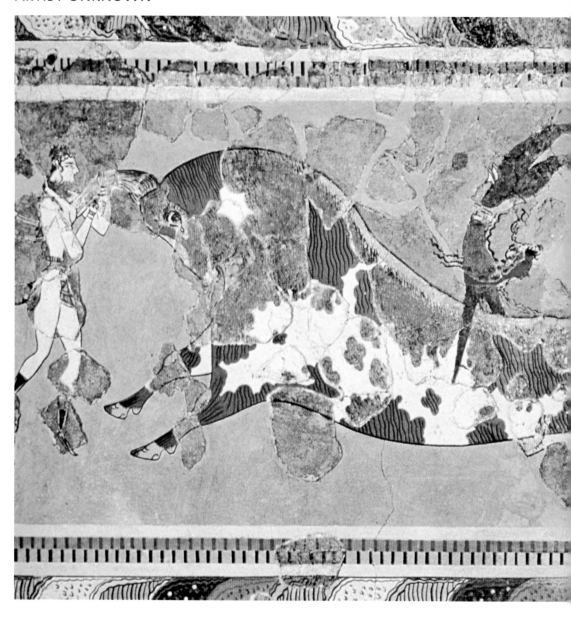

fresco on plaster
31 ⅞ x 44 ⅞ in. / 81 x 114 cm
Heraklion Archaeological Museum,
Crete, Greece

This fresco was originally located in the Court of the Stone Spout at the palace of Knossos in Crete. The palace lay at the heart of the ancient Minoan civilization, which flourished on the island. The painting portrays the bull sports, which were performed in the palace's central court, or at a temporary location near by. These athletic displays played an important role in Minoan religious rituals. The palace, along with its frescoes and numerous other artefacts, was uncovered by the British archaeologist Sir Arthur Evans during excavations started in 1899. The thin-waisted, stylized figures and the elegant, curvaceous lines are typical of Minoan art, and the colourful decorative border complements the rhythm of the scene. **IZ**

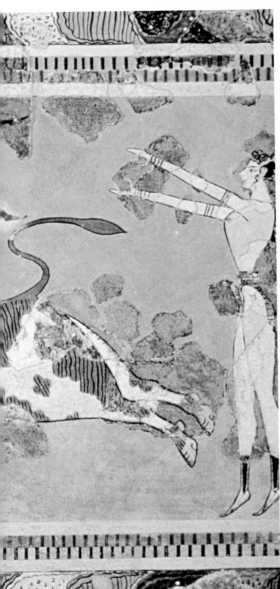

⊕ NAVIGATOR

◉ FOCAL POINTS

1 ATHLETE GRIPPING THE HORNS

The traditional interpretation of this gesture is that the athlete is grabbing the horns of the charging bull, before somersaulting over its head. Evans consulted a steer wrestler, who assured him that this would be impossible: the athlete could not have got a proper grip on the horns.

2 BULL'S LEGS

The depiction of the bull is linear and graceful, although the body is elongated. The artist has shown the bull with splayed legs to denote that the animal is galloping. The pose is intended to convey the bull's speed of movement rather than to accurately portray the manner in which bulls run.

3 ACROBAT SOMERSAULTING

This figure is normally interpreted as a male bull leaper, performing a backwards somersault over a charging bull. The acrobat has vaulted over the animal's horns and is about to land behind it. The arc of his body conveys a rapid sense of movement. Such athletes were not always portrayed in this way and sometimes are shown landing feet first on the creature's back. There has been much debate about the feasibility of this gymnastic feat.

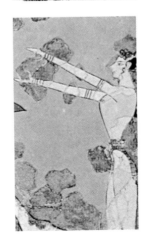

4 ASSISTANT WITH RAISED ARMS

Initial interpretations suggested that this figure is an assistant, whose arms are raised in order to catch the figure leaping over the bull's back. Other depictions of the same theme show the third figure as an acrobat, landing after a jump. In Minoan art, men were painted in red and women in white. Here, however, the white figures are wearing male attire. This has prompted the theory that they are boys undergoing some form of initiation rite.

ANCIENT EGYPTIAN ART

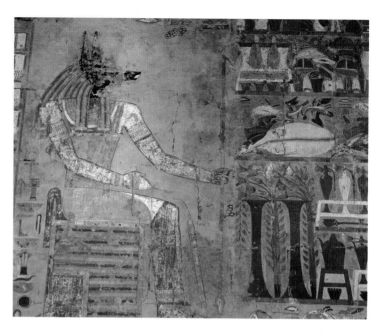

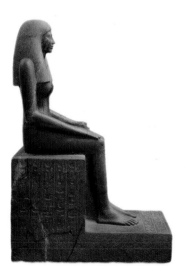

The period 2649 to 1070 BC in ancient Egypt—during which eighteen dynasties would reign—was one in which a remarkable variety of painting, sculpture, architecture, jewellery, textiles, ceramics, garden design and dresswear was produced. Egyptian artists were primarily communicators of spiritual, social and political doctrines and their work always served some cultural, dynastic or religious function. Expected to work within established systems of representation, they nevertheless exhibited highly developed levels of draughtsmanship and ingenuity. There was no distinction between 'art' and 'craft'. This division first emerged during the Early Renaissance (see p.150).

The art and architecture produced during the Old Kingdom (c. 2649–c. 2134 BC, spanning the Third to the Sixth Dynasty) established a series of artistic precedents that informed the two subsequent kingdoms. For example, during the reign of King Djoser (r. c. 2630–2611 BC), the first great ruler of the Third Dynasty, Imhotep, the king's chancellor and chief architect, created at Saqqara (the necropolis of the pharaohs) a step pyramid within the capital Memphis. (An imposing life-size statue of the king, executed in carved limestone and finished in polychromy, was discovered there in 1924. It is believed to be the world's oldest life-size statue.) Only a few years later, private pyramids or *mastabas* built for Sneferu (r. c. 2575–2551 BC), the founder of the Fourth Dynasty, mark a development from the stepped pyramidal form towards pyramids

KEY EVENTS

c. 2649 BC	c. 2630 BC	c. 2550 BC	2150–2134 BC	c. 2030 BC	c. 2061–2011 BC
The Old Kingdom, Upper and Lower Egypt, is united for the first time, under King Narmer.	The first pyramid—the step pyramid of King Djoser of the Third Dynasty—is begun at Saqqara.	The great pyramids of Giza are built for Khufu, Khephren and Menkaure. The first tomb paintings are introduced shortly afterwards.	The Old Kingdom collapses as Egypt divides into rival kingdoms.	Egypt is united once more under the Middle Kingdom. The capital moves to Thebes.	The mortuary complex of Deir el-Bahri is built for Mentuhotep II of the Eleventh Dynasty.

erected using sheer planes of stone. It was during the Fourth and Fifth Dynasties that the Egyptian Book of the Dead first came into use as a spiritual guide to the afterlife, with sections being inscribed upon the walls of tombs.

The Egyptians of the Old Kingdom were adept at sculpture. The statue *Setka as Scribe* (right) was carved out of limestone and is believed to represent Prince Setka (r.2581–2572 BC). The portrayal of the seated figure is remarkably vivid and lifelike. The sculptor evidently paid a great deal of attention to the scribe's hands, especially his right hand, which would originally have held some form of writing implement. Made from two pieces of red-veined white magnesite inlaid with a disc of rock crystal, Setka as Scribe has a learned, knowing gaze entirely befitting someone of his high rank. The tomb of Ti, discovered in 1865 by archaeologist Auguste Mariette (1821–81), is perhaps the apogee of the late period of the Old Kingdom. The highly detailed reliefs that decorate the tomb's walls provide a unique insight into everyday life in Egypt.

Between the Old and the Middle Kingdom (c. 2030–1640 BC, spanning the mid Eleventh to the Thirteenth Dynasty), art moved away from a somewhat idealized and provincial approach towards what is, by the Twelfth Dynasty, a more classical artistic sensibility. An increasingly systematic application of measurements was employed, notably in the depiction of the human form. The statue of Lady Sennuwy (opposite, below), which was stolen from the tomb of her husband Djefaihapi of Asyut and found in Nubia (Sudan), is beautifully carved and proportioned. Sennuwy sits with her left hand resting in her lap, her right hand holding a lotus blossom, a symbol of rebirth. Hieroglyphs on her chair state that she is venerated in the presence of Osiris and other gods.

The New Kingdom (c. 1550–1070 BC, spanning the Eighteenth to the Twentieth Dynasty) was marked by both political stability and economic growth. In the mortuary temple erected for the regent Hatshepsut (1508–1458 BC) on the Nile's west bank at Deir el-Bahri, a series of painted reliefs on the walls recalls her achievements. Her passage to the afterlife is also depicted, including a scene in which the jackal-headed Anubis (opposite, above), god of death and protector of the deceased, surveys offerings of food and drink placed in front of him. By this time, high-ranking officials other than the pharaoh had the means to commission finely executed murals for their tombs. It was later in the New Kingdom that the boy king Tutankhamun (r.1333–1323 BC) ruled until his premature death at the age of nineteen. This Egyptian pharaoh's tomb was found virtually intact (see p.32) when it was discovered in 1922.

The art produced during the New Kingdom, extravagant and visually sophisticated, was the most technically accomplished and wilfully ambitious of ancient Egypt, and no subsequent Egyptian civilization has surpassed it. Relics of this art that have survived over three millennia are testimony to an urbane civilization that evidently accorded art a fundamental role in securing the cultural and spiritual prosperity of its people. **CS**

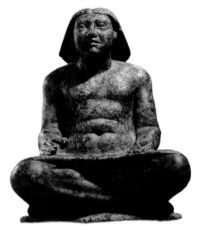

1 *Anubis, God of Death* (15th century BC)
Artist unknown • paint on limestone
Deir el-Bahri, Thebes, Egypt

2 *Setka as Scribe* (26th century BC)
Artist unknown • granite
11 ¾ × 9 × 7 ½ in. / 30 × 23 × 19 cm
Louvre, Paris, France

3 *Lady Sennuwy of Asyut* (20th century BC)
Artist unknown • granodiorite
67 ¾ × 45 ⅞ × 18 ½ in. / 172 × 116.5 × 47 cm
Museum of Fine Arts, Boston, USA

1640 BC	c. 1550 BC	c. 1550 BC	1353–1335 BC	1323 BC	1178 BC
The Thirteenth Dynasty collapses amid political unrest, marking the end of the Middle Kingdom.	Ahmose I of the Eighteenth Dynasty unites Egypt again and the New Kingdom is formed.	Construction begins of tombs for a new necropolis outside Thebes that is now known as the 'Valley of the Kings'.	Amenhotep IV (Akhenaten) attempts to turn Egypt into a monotheistic state, worshipping the sun god Aten.	Tutankhamun dies prematurely and is interred in the Valley of the Kings. His tomb and solid gold burial mask (see p.32) are rediscovered in 1922.	'Sea Peoples', whose incursions are recorded from c. 1224, are defeated by Ramses III. Egypt's power is depleted and in 1070 the New Kingdom collapses.

Inspecting the Fields for Nebamun 1350 BC
ARTISTS UNKNOWN

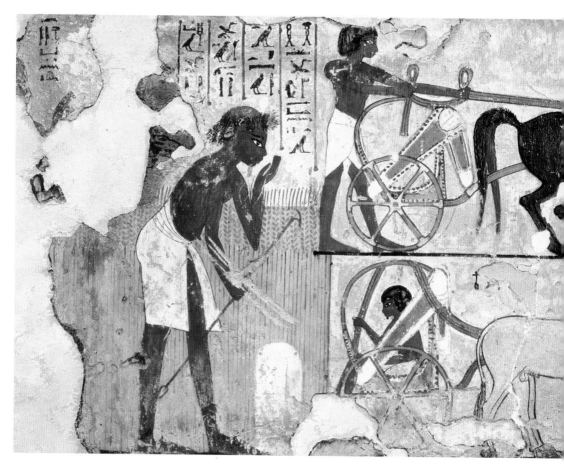

fresco
18 ¹/₈ x 42 ¹/₈ in. / 46 x 107 cm
British Museum, London, UK

This fragment of fresco was acquired by the British Museum in 1821 along with ten other fresco fragments. The frescoes originally formed part of the designs decorating the walls of the tomb-chapel (room housing a tablet or stela on which the deceased was shown seated at a table of offerings) of Nebamun, a grain accountant who worked in the temple of Amun at Karnak during the reign of Amenhotep III (c. 1390–1352 BC). Nebamun was a high-ranking official and he appears in one of the fragments inspecting the counting of geese. Elements of the tomb-chapel decoration that have not survived may have depicted him overseeing other rural activities.

In this fragment, an old farmer, on the left-hand side of the composition, stands before two officials who wait beside a sycamore fig tree with their chariots. At the behest of Nebamun the farmer is inspecting the fields and checking the boundaries and at his feet is a white boundary stone. The schematic treatment of the two officials and their chariots is typical of Egyptian art of this period, but the treatment of the older figure is unusually naturalistic, providing a striking visual counterpoint. Other fragments from the tomb include depictions of cattle being inspected, fowling in the marshes, Nebamun receiving offerings from his son, banqueting scenes and a garden with a pool, presumably Nebamun's own. One fragment shows men bringing animals as offerings, just as animals would have been left in the tomb-chapel itself as provisions for the spirit of the dead. **CS**

◆ NAVIGATOR

1 HIEROGLYPHS

The hieroglyphic text placed adjacent to the old farmer spells out the oath he is making: 'As the Great God who is in the sky endures, the boundary stone is exact!' He is referring to the white stone at his feet, which he and the officials have either placed or have been sent to check.

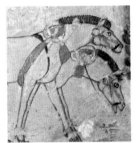

2 ONAGERS OR MULES

The fresco fragment is unusual for its representation of a pair of animals other than horses being used to pull a chariot. Some authorities have identified the animals as onagers, a species of wild ass, although they could be mules or hinnies (a cross between a horse and a donkey).

3 REALISTIC DETAILS

The farmer's baldness and his wispy grey hair are realistic details that would never have appeared in depictions of gods and pharaohs, which were always stylized as generic types. Artists were allowed to imbue their depiction of slaves, common people and animals with naturalistic details.

FRESCO TECHNIQUES

The eleven remaining fragments from the tomb of Nebamun were painted on walls that had been prepared using the *fresco secco* or dry fresco method. The walls were initially covered in an admixture of straw and mud from the banks of the Nile, after which a thin layer of white plaster was applied. The paint was not applied until after the plaster was dry. This technique contrasts with the *buon* or 'true' method of fresco, in which the artist applied pigment mixed with water to sections of plaster that were still partially wet, thus allowing the plaster to bind with the applied pigments. An example of *buon fresco* is Giotto's *Freeing of the Heretic Pietro* (1297–1300; right), in the Basilica Superiore di San Francesco in Assisi, Italy. Although the Egyptians' *fresco secco* paintings were not as durable as those produced by the Italians' *buon fresco*, the Egyptian technique allowed the artists more time to execute their designs.

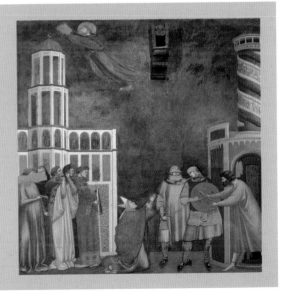

Burial Mask of Tutankhamun *c.* 1324 BC
ARTIST UNKNOWN

gold inlaid with
semi-precious stones
and coloured glass
21 ¼ x 15 ½ in. / 54 x 39.5 cm
Egyptian National Museum,
Cairo, Egypt

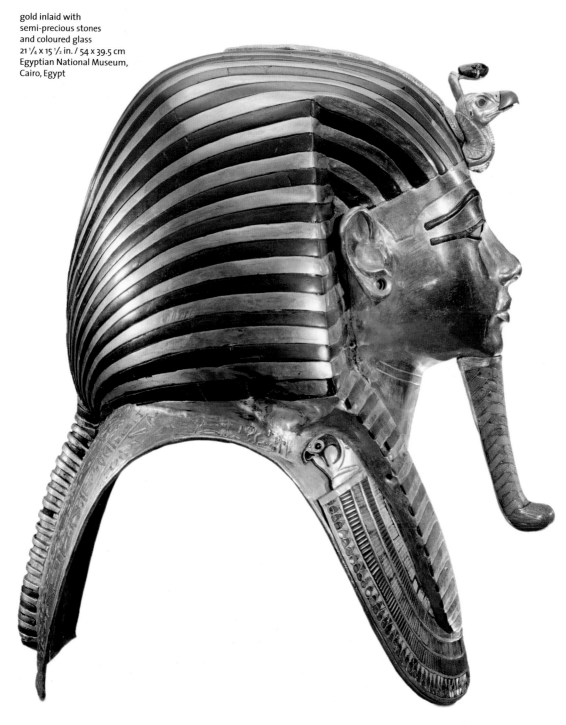

T he magnificent burial mask of Tutankhamun (r.1333–1323 BC) is probably the best-known object of Egyptian art. It combines lavish materials and superb craftsmanship to make an impression of grandeur and complexity. Although funerary masks had been in use since the Fourth Dynasty (c. 2575–2467 BC), they became far more elaborate during the New Kingdom period (c. 1550–1070 BC), when precious metals were increasingly employed. Tutankhamun's mask was hammered out of gold sheets, which were then soldered together. In more modest versions, the facial features and other details were simply painted in, but, in this instance, the artist achieved a more ostentatious effect by using a broad range of inlays, especially in the highly worked collar. The inlays include lapis lazuli, carnelian, obsidian and turquoise-coloured glass.

The burial mask played an important role in protecting the physical remains of the deceased from damage and decay. In Egyptian religious orthodoxy this preservation was deemed essential if the soul of the pharaoh was to be reborn in the afterlife. Once the body had been embalmed and the priests had recited the necessary incantations from the Book of the Dead, the mask was lowered into place, protecting the pharaoh's head. It was attached to a patterned skullcap, which in turn was glued to the body with thick resin. When the mask was discovered (see panel below), the covering was so secure that the mask could only be removed after the mummy's head was detached from its torso. **CS**

◉ FOCAL POINTS

1 NEMES

The *nemes*, traditionally worn by the pharaohs, is fashioned from gold and lapis lazuli—a material so expensive that it has been dubbed 'blue gold'. Pharaohs were regarded as the living embodiment of the sky god, hence the blue, and were also associated with the sun god, symbolized by gold.

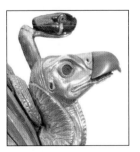

2 COBRA AND VULTURE

A traditional feature in the headdress of a pharaoh was the cobra or *uraeus*—the symbol of Wadjet, protective goddess of Lower Egypt. It rears up, ready to spit flames. Beside it, the bird's head is the emblem of the vulture goddess Nekhbet, the tutelary spirit of Upper Egypt.

3 FALCON'S HEAD ON COLLAR

To the elaborate collar, made of gold and ceramic beads, are attached golden shoulder pieces decorated with falcon heads. The latter have eyes and beaks made from obsidian. The falcon was the animal form of Horus, the sky god, and so was by association a symbol of the divine status of the pharaoh.

DISCOVERY OF THE MASK

Tutankhamun's golden mask came to light in the wake of the greatest archaeological discovery of the 20th century. In 1922 Howard Carter (1874–1939; below, figure on the left) unearthed the only major tomb that had not been ransacked by grave robbers in the Valley of the Kings, which lies on the west bank of the Nile opposite Thebes (modern-day Luxor). Carter described the moment when, with a mounting sense of wonder, he first peered into the dimly lit chamber: 'As my eyes grew accustomed to the light, details of the room emerged slowly from the mist: strange animals, statues and gold—everywhere the glint of gold.' The tomb yielded an extraordinary array of treasures,

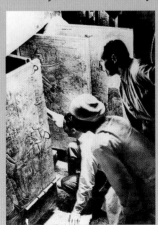

ranging from gilded shrines and thrones to chariots, lavish perfume boxes and jewellery. The scale of the discoveries was surprising given that Tutankhamun was an obscure figure who died prematurely, before he had reached the age of twenty.

EARLY PRE-COLUMBIAN ART

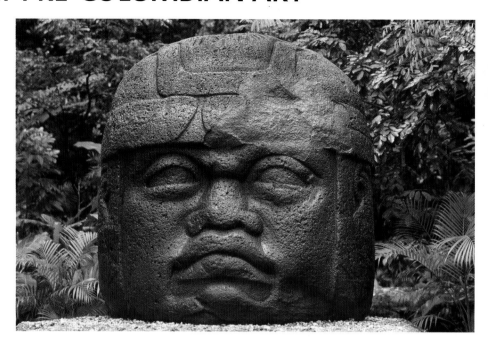

The first agricultural settlements in the Americas developed during the Archaic period (between 3500 and 1800 BC) in Mesoamerica, an area extending from central Mexico to Honduras and Nicaragua. Cave paintings and decorated objects in this region were produced by civilizations that developed during the Preclassic Era, between 1800 BC and AD 200.

The art of this period mainly took the form of decorated functional objects made of mud, stone or bone. Towards the end of the Preclassic Era, ceremonial artefacts were decorated with religious symbolism and representations of animals and vegetables. The Olmecs, who flourished from c. 1400 to 400 BC along the coast of the Gulf of Mexico, are the earliest known Mesoamerican civilization and are known for their basalt sculptures of heads (above), stone monuments and jade carvings. Seventeen colossal basalt heads, weighing several tons each, have been discovered. Each head, with a flattened nose, thick lips, and staring eyes, is crowned by a headdress reminiscent of the helmet worn during ceremonial ball games, and they may represent kings and dignitaries. The heads appear to have been placed in a line, damaged and then buried, and experts believe that they were ritually mutilated on the death of the ruler they represented. Moving the heads required enormous manpower, yet some of the heads were found 50 miles (80 km) from the nearest quarries.

KEY EVENTS

c. 2000 BC	c. 1200–c. 900 BC	c. 900 BC	c. 900 BC	c. 500 BC	c. 300 BC–c. AD 100
The earliest permanent farming communities are established in Central and South America.	The Olmec ceremonial centre of San Lorenzo in Mexico is the largest city in Mesoamerica until it is superseded by the Olmec city of La Venta.	The city of Chavín de Huántar is built in the Peruvian Andes as a religious centre by the Chavín civilization.	The Olmecs develop a hieroglyphic writing system.	The Zapotec city of Monte Albán is founded in the Valley of Oaxaca, Mexico. It is a sociopolitical and economic centre for almost 1,000 years.	The Mayan city of El Mirador in Guatemala reaches the peak of its power, housing as many as 100,000 people.

The Mayan civilization emerged around 2000 BC and reached its peak during the Classic Era, from AD 200 to 900. It extended from south-eastern Mexico to Guatemala, Belize and the western regions of Honduras and El Salvador. The Mayas traded with the inhabitants of cities such as Teotihuacan and with many of the Mesoamerican cultures, including the Zapotec and other groups in central and coastal Mexico, and further afield with non-Mesoamerican groups, such as the Taínos Caribbean island dwellers. The Mayas produced impressive art, including polychrome ceramic vases, terracotta figurines, clay and stucco models, and carvings in wood, obsidian, bone, shell, jade and stone. Most of the polychrome ceramic vessels that have survived intact have been retrieved from burial sites used by the elite. Named after an English collector, the Fenton Vase (right, below) was found in Nebaj, a Mayan site in Guatemala, and is a striking example of Mayan painted vessels created during the Late Classic Era, from AD 600 to 900. Such vessels are adorned with hieroglyphs and images portraying high-ranking members of society, as well as historical and mythological events. The Fenton Vase shows a seated lord receiving a tribute in a basket, and his name and titles are inscribed above his portrait. The four figures that appear on the vessel wear headdresses and jewellery and are likely to be Mayan dignitaries.

On the South American mainland, the Chavín civilization developed in the northern Andean highlands of Peru from c. 900 BC, remaining influential until c. 200 BC. The Chavín people are known for their skills in smelting and fashioning metals, including gold, as well as their pottery, carving and sculptures, some of which are evident at the temple in the ancient city of Chavín de Huántar. Peru was also home to the Nazca people, who flourished along the southern coast of Peru from c. 200 BC to c. AD 600. The Nazca are best known for the Nazca Lines (c. 200 BC–c. AD 600; see p.18), a network of elaborate geoglyphs found on the Peruvian coastal plain. Little remains of their culture, although examples of their polychrome pottery have survived (see p.19).

As Nazca influence declined, that of the Moche civilization rose, flourishing from c. AD 100 to c. 800. The culture was centred on the Peruvian northern coast, in valleys, including the Lambayeque, Chicama, Moche and Virú, in which numerous pyramids are found. The Moche are notable for their naturalistic ceramic pottery, much of it consisting of figures produced by means of moulds. The moulded figures are mostly yellowish-cream and red in colour and represent scenes of daily life—hunting and fishing, warfare, ceremonies and sacrifice, as well as sexual activity. The moulded pottery also takes the form of birds and animals, and head portraits with elaborate headgear. The Moche people were also masters of intricate metalwork in gold, silver and copper. Pioneers of soldering and gilding techniques, they produced sophisticated jewellery such as earrings with suspended decorated discs (opposite, below), necklaces and nose rings, often inlaid with precious stones. **RM**

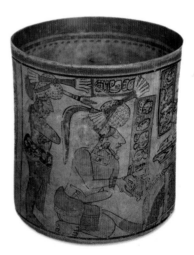

1 Colossal Head No 1 (c. 850–700 BC)
Artist unknown • basalt
114 1/8 in. / 290 cm high
Parque Museo La Venta, Villahermosa, Tabasco, Mexico

2 Fenton Vase (c. AD 600–800)
Artist unknown • ceramic
6 3/4 in. / 17 cm diameter
British Museum, London, UK

3 Ear ornament (c. 200 BC–AD 700)
Artist unknown • gold with inlaid precious stones

c. 200 BC	c. 200 BC	c. 200 BC–c. AD 800	c. AD 200	c. AD 400	c. AD 800
Building starts at Teotihuacan. The city's artists become known for pieces such as the Teotihuacan mask (c. AD 300–600; see p.36).	The Nazca culture emerges in Peru. It is famous for its polychrome pottery and the Nazca Lines (c. 200 BC–c. AD 600; see p.18).	The influence of Chavín culture in South America declines. The Moche take over in northern Peru; they are known for their naturalistic pottery.	The Temple of the Sun is completed at Teotihuacan in central Mexico.	Building begins on the Mayan city of Calakmul; it is a superpower until its rulers are overthrown by rival Mayas from Tikal in AD 695.	Mayan civilization declines as the result of warfare and economic crisis. The building of monuments and temples ceases.

Teotihuacan Mask *c.* 300 – 600
ARTIST UNKNOWN

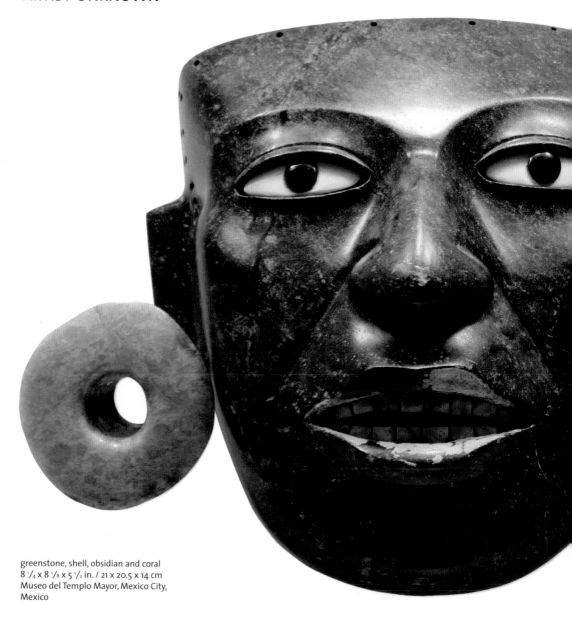

greenstone, shell, obsidian and coral
8 ¼ x 8 ⅛ x 5 ½ in. / 21 x 20.5 x 14 cm
Museo del Templo Mayor, Mexico City,
Mexico

1 OVAL EYES
The oval-shaped eyes contain
eyeballs made from shell and
obsidian irises. The eyes and
eyebrows are wide-set within
the broad, flat brow. There are
no holes in the eyes in this or
other masks of the period,
indicating that the masks
were not intended to be worn
by living people.

2 PARTED MOUTH
The half-open mouth cut into
the stone helps to create a
serene expression. Inside the
mouth are teeth decorated
with pink coral. The presence
of coral, along with shells and
other stones, in this inland
city shows the degree to
which Teotihuacan's trade
had developed.

asks such as this example represent the peak of artistic development of Teotihuacan civilization. They played a part in the funeral rituals of rulers and dignitaries and were used to cover the faces of the deceased. The masks were a symbol of transformation and transition from a human to a divine state: those buried in Teotihuacan were thought to become deified heroes and the gods always concealed their faces with masks. Masks have been found in the public and religious buildings that line the Calzada de los Muertos (Avenue of the Dead), which traverses the ancient city of Teotihuacan from north to south (see panel below). Slightly larger than human faces, the masks are made of polished stone, jade or obsidian, and are sometimes decorated with mosaics, shells, coral or turquoise. The colours of the stones relate to particular deities, and those who were decorated with masks were often also adorned with other regalia, such as earrings and necklaces made of precious and semi-precious stones.

This mask has the characteristic smooth, flat features of most masks found at Teotihuacan, which depict an idealized but anonymous facial type. The smooth features are deliberately stylized: the mask is divided into geometric, almost symmetrical planes. In part this is a result of the horizontal stone-cutting technique used in making the mask; however, it also shows a desire to convey the essence of the spirit of the deceased. **RM**

THE CITY OF TEOTIHUACAN

Teotihuacan civilization reached its peak from 292 BC to AD 900. What remains of Teotihuacan lies north-east of Mexico City and the site reveals the city to have been an important economic, political and religious centre that benefited from its access to water springs and deposits of obsidian and clay. It was home to many potters and artisans, some of whom made objects from obsidian. The trade in crafted goods contributed to the city's prosperity, and artists and craftsmen were held in high regard. The identity of the inhabitants of the city has been much debated, but some scholars believe that it was a multi-ethnic state. In its heyday, Teotihuacan had a population of around 150,000 people, making it one of the largest cities in the ancient world. It is remarkable for its monumental architecture—indicative of a high level of organization and urban planning. Along the road that forms its main axis, the Avenue of the Dead, is the huge Pyramid of the Sun (c. AD 200; below), one of the largest structures on the continent at the time.

◉ NAVIGATOR

3 RECTANGULAR EARS

The rectangular ears protruding from the side of the mask feature large ear spools made of greenstone. Ear spools were commonly worn by the elite of Teotihuacan society for decoration. Their use here reveals that the mask's owner is a high-ranking member of society.

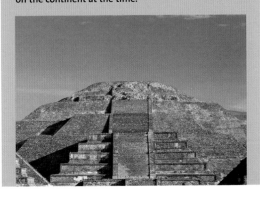

MESOPOTAMIAN AND PERSIAN ART

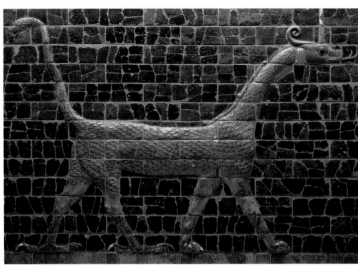

1 **Snake-dragon of Marduk, from the
Processional Way, Babylon (605 BC)**
Artist unknown • terracotta glazed
and moulded bricks
45 ¹/₂ x 65 ³/₄ in. / 115.5 x 167 cm
Detroit Institute of Arts, USA

2 **Rhyton in the shape of a seated
lion-monster, from Hamadan, Iran
(550–330 BC)**
Artist unknown • gold
8 ⁵/₈ in. / 22 cm high
National Museum of Iran, Tehran, Iran

3 *Ashurnasirpal II Killing Lions* **(detail) from
the palace of Ashurnasirpal II, Nimrud,
Iraq (9th century BC)**
Artist unknown • limestone relief
34 ⁷/₈ in. / 89 cm high
British Museum, London, UK

T he Babylonian civilization developed in southern Mesopotamia, based
around the city of Babylon, which was situated about 50 miles (80 km)
to the south of Baghdad in present-day Iraq. This civilization enjoyed two
periods of greatness. The Old Babylonian Kingdom (*c.* 1894–1595 BC) first
reached a peak during the reign of Hammurabi (1792–1750 BC), who combined
the two former kingdoms of Sumer and Akkad. Artefacts surviving from the
Old Babylonian period include sculptures of Hammurabi, whose far-sighted
code of laws is preserved on a celebrated basalt stele (upright slab).

The fortunes of the Babylonians rose for the second time in the Neo-
Babylonian period (627–539 BC), during the reign of Nebuchadnezzar II
(605–562 BC). He rebuilt the city, surrounding it with massive walls and
imposing, monumental gateways. The most impressive of these, the Ishtar
Gate, survived and is reconstructed at the Pergamon Museum in Berlin. The
gate is adorned with glazed, polychrome bricks featuring colourful reliefs of
symbolic beasts, including lions, bulls and snake-dragons. The snake-dragon
(above) was known as *mushussu* and was sacred to the Babylonian national
god, Marduk; this panel came from the Processional Way adjoining the Gate.

The Assyrians were based in northern Mesopotamia and their rise to
power began in *c.* 1900 BC. Their territories were originally centred on the city-
state of Assur, named after their national god, which is situated about 65 miles
(100 km) south of Mosul in present-day Iraq. Assyrian influence fluctuated
considerably over the centuries, but reached its climax in the Neo-Assyrian
period (883–612 BC) when a vast empire came under its sway.

KEY EVENTS

c. 1894 BC	1813 BC	1760 BC	1595 BC	*c.* 865 BC	825 BC
A dynasty of Amorites, a Semitic people, is established at Babylon, beginning the Old Babylonian Kingdom. Akkadian is the official language.	King Shamsi-Adad I unites Assur and Mari in northern Mesopotamia and builds Assyria into a power in the region.	Hammurabi rules Babylon. He takes over Assyria, Sumer and Akkad as part of a rapid expansion of the Babylonian Empire.	Babylon is sacked by King Mursilis I of the Hittites, initiating a Babylonian 'dark age' during which the Kassites come to power.	Carvings of winged guardians (*lamassi*) are installed at Neo-Assyrian King Ashurnasirpal II's palace in Nimrud (see p.40).	A limestone bas-relief sculpture, known as the Black Obelisk, is erected in Nimrud to commemorate the campaigns of King Shalmaneser III.

The Assyrians had a number of different capitals, but the major ones were Nimrud, Nineveh and Khorsabad. In each of these they constructed lavish palaces and temples that demonstrated their talent for monumental sculpture. The gateways were protected by gigantic figures, such as the *lamassu* of Nimrud (865–860 BC; see p.40). The walls were adorned with a magnificent array of carved stone reliefs, almost invariably devoted to the glorification of the king; they depicted scenes of battle, of tribute peoples bearing gifts and of sumptuous banquets. The most spectacular examples, produced for the palace of Ashurnasirpal II (r.883–859 BC) at Nimrud, include a sequence of carvings of a royal lion hunt (below). Other Assyrian sculpture was meant for more public display and carved obelisks were set up in prominent places to glorify the king.

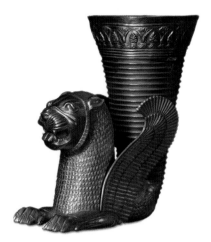

The Neo-Babylonian period (627–539 BC) was cut short by the conquests of Cyrus the Great (559–530 BC) of Persia. Power in Mesopotamia transferred to the Persians, whose capital was Persepolis, 37 miles (60 km) north-east of Shiraz in present-day Iran. Cyrus established the Achaemenid Dynasty (559–331 BC), which amassed a sizeable empire. Under the Achaemenids, Persian artists continued Mesopotamian traditions but on an even more monumental scale. At Persepolis they created a series of imposing palaces, adorned with long processions of carved reliefs, rivalling those of the Assyrians. At Susa they produced a decorative frieze composed of glazed bricks that was inspired by examples at Babylon. The Persians were also metalworkers, highly inventive in their depiction of fantastic, animal forms. A fine surviving example is the gold rhyton (drinking vessel) in the shape of a winged lion (above, right). **IZ**

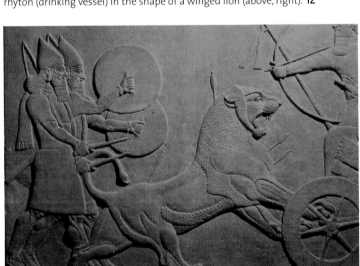

668 BC	627 BC	605 BC	559 BC	331 BC	AD 224
The Neo-Assyrian King Ashurbanipal begins to rule in Nineveh. He establishes the Library of Ashurbanipal, which partly survives today in Nineveh.	Nabopolassar rebels against the Neo-Assyrian Empire after Ashurbanipal's death and begins the Neo-Babylonian period.	Nebuchadnezzar II takes power in Babylon. He orders the construction of the Ishtar Gate in 575 BC; it is dedicated to the goddess Ishtar.	Cyrus the Great establishes the Achaemenid Dynasty in Persia. He conquers Babylon in 539 BC.	The Persian king Darius III is defeated by Alexander the Great in the Battle of Gaugamela. Alexander sacks Persepolis the following year.	The Sassanians overthrow the Parthians to achieve power in Persia. The Sassanid Empire remains in place until AD 637.

Neo-Assyrian Winged Guardian Figure 865–860 BC
ARTIST UNKNOWN

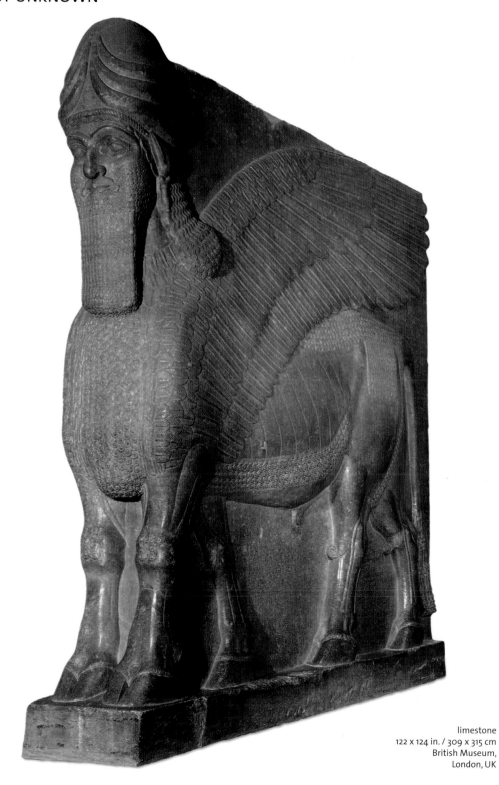

limestone
122 x 124 in. / 309 x 315 cm
British Museum,
London, UK

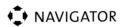
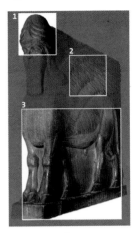

This massive sculpture is a guardian figure, also known as a *lamassu*. Guardian figures were sculpted to represent minor deities, which themselves took the form of hybrid creatures. This *lamassu* has the head of a man, the body of a bull and the wings of an eagle; respectively, these represent intelligence, strength and swiftness. Guardian figures were placed at the doors or gateways of important buildings to ward off evil spirits. This *lamassu* is one of a pair that originally flanked a doorway into the throne room of a lavish palace built by the Neo-Assyrian King Ashurnasirpal II (883–859 BC) in the Assyrian city-state of Nimrud, near Mosul in present-day Iraq. Its former companion, now in the Metropolitan Museum in New York, has the body of a lion.

The pair of sculptures was discovered at Ashurnasirpal's palace in 1846 by Sir Austen Henry Layard (1817–94), a pioneering archaeologist who later became a politician and diplomat. They are among the finest surviving examples of Neo-Assyrian 'double-aspect' reliefs; that is, they are designed to be viewed from two perspectives. The *lamassi* also exemplify the Assyrians' high level of skill at sculpting animals—it is said that scientists can usually identify the species of an Assyrian sculpture from the closely observed details. Between the legs of the carving is a lengthy inscription in cuneiform, an early type of writing. The text, known as the Standard Inscription of Ashurnasirpal II, records the titles and military achievements of the king and also appears elsewhere in the palace. **IZ**

👁 FOCAL POINTS

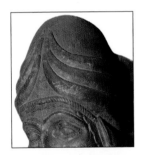

1 HORNED CAP

The horned cap on the *lamassu*'s head is a mark of its divine status. The meaning of this accessory varied over the centuries. Sometimes it referred to a specific deity, such as Anu (the supreme god) or Assur (the national god). The shape of the cap also varied, as did the number of horns.

2 EAGLE WINGS

Every detail of the *lamassu* has a special meaning. The eagle wings emphasize its speed. For Judaism and Christianity, the wings may have an added significance. Exiled Jews may have seen the figures and this may have influenced some descriptions of angels in the Old Testament.

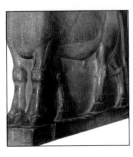

3 FIVE LEGS

The sculpture displays five legs to accommodate two different viewpoints. When approached from the front, only the two sturdy front legs are visible. When viewed from the side, however, four legs can be seen. Viewed from here, the beast appears to be striding forwards, to confront intruders.

PROTECTIVE SPIRITS

The Assyrians took particular care to protect the thresholds of rooms and buildings. The monumental *lamassi* were the most visually impressive means of warding off evil, but their power was supported by a range of other measures. When a new edifice was completed, elaborate building rites were performed and magic figurines were buried under each threshold. In addition, the *lamassi* were accompanied by smaller images of protective spirits, called genies. These were generally portrayed on glazed bricks or stone reliefs.

Several carved reliefs of genies have survived from Ashurnasirpal's palace. The most spectacular examples are griffin-demons (below), which take the form of humans with birds' heads and wings. Protective spirits were always portrayed with a bucket and fir cone, the standard symbols of purification. The cone is usually raised aloft in the right hand, while the bucket is held down in the left, corresponding to their use in rituals.

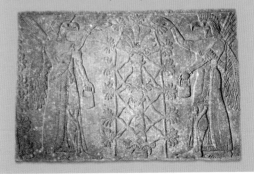

ANCIENT CHINESE ART

1 **Elephant wine vessel** (*c.* 1100 BC)
Shang Dynasty • bronze
25 ¹/₄ x 37 ³/₄ in. / 64 x 96 cm
Musée Guimet, Paris, France

2 **Funerary mask** (*c.* 1766–1045 BC)
Shang Dynasty • bronze
15 ⁷/₈ x 23 ⁷/₈ in. / 40 x 60.5 cm
Sanxingdui Museum, Sichuan, China

3 *Bianzhong* of Marquis Yi (*c.* 433 BC)
Warring States Period • bronze
Bells of varying sizes
Hubei Provincial Museum, China

Metal was first worked in China around 4,000 years ago, during the Xia Dynasty (*c.* 2100–1700 BC). Chinese artefacts surviving from before this time consist mainly of forms of pottery, already of great sophistication, and items worked from bone or stone. The development of Chinese metalworking was rapid and it was during the rule of China's first true dynasty, the Shang Dynasty (*c.* 1700–1050 BC), that bronze was widely introduced for high-status objects such as ceremonial and feasting vessels as an alternative to materials such as jade, horn, ivory, stone and lacquer.

Cast bronzes of unprecedented quality and complexity were made in northern China, at sites in the Yellow River valley of the Henan province, such as Erlitou, Anyang and Zhengzhou. Craftsmen developed a refined process

KEY EVENTS

c. 1700 BC	*c.* 1600 BC	*c.* 1200 BC	*c.* 1100 BC	*c.* 433 BC	*c.* 400 BC
Bronze working is established on a large scale at Erlitou. This, the first metalworking centre in China, paves the way for the Shang Dynasty.	Under the Shang Dynasty, a new method for casting bronze, using a variety of ceramic moulds, is invented to achieve an ornamental surface.	The collection of jade carvings of Fu Hao, general and wife of a Shang king, is buried with her after her death in battle. The objects were excavated in 1976.	Images of animals, including bears, wolves, tigers, antelopes and eagles, become increasingly common in Chinese works of art.	The magnificent tomb of Yi, Marquis of Zeng, is built in Suizhou, in the state of Hubei. Eight women are interred next to his lacquered coffin.	China, which has long been aware of the uses and value of silk, begins to develop the art of silk painting.

of piece-mould casting that enabled them to fashion vessels with elaborately decorated motifs on the surface, such as the imposing bronze wine vessel in the shape of an elephant (opposite). Vessels varied in their shape depending on whether they were to hold wine, water, grain or meat, and some bore decipherable characters, evidence of the development of writing.

Many known artefacts from the Shang Dynasty period derive from elaborate burial sites. For example, more than 4,000 objects, including bronze face masks, cowrie shells, jades and life-size bronze figures encased in gold sheet, were found at Sanxingdui in Sichuan, southern China, in 1986. Among the burial masks was the square-shaped mask with a stylized human face (right), which probably had a ritual purpose. Distinguished by prominent ears and strangely projecting eyes, the mask has lips that were originally painted red, indicated by traces of cinnabar, a mineral widely used in China to colour lacquerwork. Also interred at Sanxingdui were fragments of bronze tubes with smaller branches, probably representing trees, and bronze leaves, fruits and perching birds.

The succeeding Zhou Dynasty (1050–221 BC) lasted longer than any other dynasty in Chinese history. Its latter centuries saw years of turmoil and violence, known as the Warring States Period (475–221 BC). It was during this troubled time that the philosophical traditions of Confucianism, Daoism and Legalism emerged. The Period brought great wealth to the powerful leaders of states, as shown by the lavish burial of Marquis Yi of the state of Zeng in around 433 BC. His tomb, over 2,368 square feet (220 sq m) in size, contained ritual instruments, including a *bianzhong*—a peal of sixty-eight bronze bells (below)— jade and

c. 350 BC	c. 210 BC	c. 113 BC	c. AD 67	c. AD 105	c. AD 159
A recognizable form of Chinese script is developed. Its influence is seen in painting as well as literature.	The Terracotta Army (see p.46) is created in X'ian as a funerary monument for Emperor Qin Shi Huangdi.	Eighteen bronze lamps shaped as humans, birds and animals are created for the tomb of Emperor Liu Sheng of the Han Dynasty.	The arrival of Buddhism in China leads to new forms of art depicting the Buddha and Bodhisattvas.	The invention of paper is reported to the emperor by Cai Lun, a court official. Artists now have an important new medium on which to paint.	Weakened by family feuds and the popular campaign of the Yellow Turbans, the Han Dynasty passes governmental power to the court eunuchs.

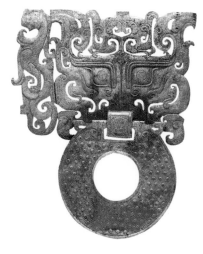

stone chimes, and wood and string instruments. The tomb also contained many objects—large pieces of furniture, musical instruments, ritual vessels and much else—that were lacquered in sumptuous red, gold and black.

The art of lacquering, invented in China, was highly advanced by the time of Marquis Yi. Lacquer was a hard, durable coating originally devised to protect wood, bamboo and other materials from water and other damage, but the process soon became equally prized as a way of decorating and enhancing the beauty of fine objects. Lacquer was a very toxic substance that was extracted from the sap of the indigenous *lac* tree and applied in many thin layers to achieve a final glossy coating. The work was hazardous, skilled, extremely time-consuming and thus expensive—a later document cites lacquer as costing ten times the price of bronze. The clear varnish was coloured with oxides of iron to achieve a deep black or a rich red, or was mixed with gold or silver powders.

The Warring States Period was brought to an end by Qin Shi Huangdi, who unified China in 221 BC. Known as 'the First Yellow Emperor', he remains a controversial figure in Chinese history. Qin directed gigantic projects, including a city-size mausoleum guarded by a life-size terracotta army (see p.46) and a national road system that many died labouring to complete. Another huge project was a predecessor of the Great Wall, built to repel marauding nomadic tribes in the north. Following the emperor's death in 210 BC, his dynasty, the Qin Dynasty, lasted only three years.

Qin Shi Huangdi was succeeded by the dynamic Han Dynasty (206 BC–AD 220), one of the golden ages of Chinese culture. It was during the Han Dynasty that the great overland Silk Route became ever more active, bringing fresh cultural influences to China and carrying China's handiworks to the West. This was the era when Chinese silks reached Rome and Roman glass beads were carried to China. Pottery was a key development in this era. Burial tombs were decorated with sculpted and painted clay figures, which were much smaller than those made in the Qin period. Such figures, known as *yong*, were placed in graves as substitutes for the living. The *yong*, which also featured musicians and performers, provide information about Chinese life at the time.

All branches of the arts thrived during the Han Dynasty and were patronized by the upper classes. For example, when the Marquis of Dai, a middle-ranking member of the aristocracy, and his wife and son were interred in *c.* 180 BC, their tombs were luxuriously furnished. Their finely lacquered coffins were covered with silk banners; the example shown opposite is painted from the bottom up with scenes of the netherworld, then of the world of man and finally of the heavenly world. Silk and lacquered objects were exclusive possessions of the nobility at the time and both technologies were advanced. The silks show that weavers could manufacture plain silk, silk gauze, damask and brocade, and embroider using a variety of complex stitches.

During the four centuries of the Han Dynasty, the wearing of jade became increasingly important. In ancient China, jade had been called *yu* and was believed to embody *yang*, or cosmic energy. As a result, jade was attributed life-giving qualities. Those living in the Han Dynasty viewed jade not only as a beautiful stone but also as a substance that was imbued with excellence, purity and virtue. Jade was a precious substance that required lengthy working using abrasives, grinders and polishers, and jade objects were both rare and expensive. The wearing of jade was a privilege of hierarchy: the king wore the *gui* jades named *zhen*, and the five classes of the nobility were assigned the stones called *huan, xin, gong, gu* and *pu*. This privilege of rank was extended to burial customs, and Han tombs contained jade shaped into many forms.

The most extraordinary jade artefacts of the Han Dynasty were entire suits of the mineral, created to encase the bodies of high-ranking personages

4 Ornamental handle with *bi* disc (100 BC)
Han Dynasty • jade
7 ⅛ x 5 ⅜ in. / 18 x 14 cm
Museum of the Western Han Tomb of the Nanyue King, Guangzhou Province, China

5 Funeral banner (*c.* 180 BC)
Han Dynasty • silk
80 ¾ x 36 ¼ in. / 205 x 92 cm (top)
Hunan Provincial Museum, China

6 Funeral suit of Princess Dou Wan (*c.* 100 BC)
Han Dynasty • jade and gold thread
67 ¾ in. / 172 cm long
National Museum of China, Beijing, China

and act as protective armour against spirits and demons in the afterlife. Two examples of these were discovered in 1968 in separate tombs dug into cliffs at Mancheng in the province of Hebei. Surrounded by more than 10,000 precious objects, the bodies of Prince Liu Shen and his wife Princess Dou Wan lay in suits of jade, each constructed from jade plaques sewn together with gold thread. The suit of Princess Dou Wan (below), which is now completely restored, required 2,156 jade plaques connected by about 24 ounces (700 g) of gold thread. The work involved in making the suits was enormous; each of the tough jade plaques was individually sawn from the rock using a simple mud saw, and each drilled at each corner with an abrasive sand drill.

The most elaborate jade suit of all, consisting of more than 4,000 plaques, was found in the tomb of Zhao Mo (r.137–122 BC), the second ruler of Nanyue, a small kingdom near present-day Guangzhou. The tomb was discovered in Guangzhou in 1983 and in grandeur it rivals tombs of the Han imperial family in North China. The tomb was lined in stone and originally painted in bright colours; it had two large chambers and two smaller ones. The large rear chamber contained the ruler's coffin, with two side sections for the bodies of attendants and servants. Vessels, musical instruments, elephant tusks and minerals for alchemy were placed in the front of the tomb. In the rear, with the bodies, were a large number of pieces of jade. Around the tomb were twelve sets of jade beads and ornaments designed to hang around the neck as pectorals or from the waist as pendants. These were both decorative and protective, as their decoration of mythical figures, animals and auspicious patterns confirms. The style of many pieces suggests that they had been imported from elsewhere in China, a demonstration of the king's wealth.

The Han Dynasty saw the continuation of a funerary tradition, established in the Neolithic period, of placing a jade disc with a central hole, known as a *bi* or *pi* disc, on or near the interred body. The *bi* disc was the highest emblem of Chinese noble status and was intended to guide a deceased spirit to heaven through the Pole Star, represented by the hole in the centre. Neolithic *bi* discs were plain in appearance, but by the time of the Han Dynasty their surface was often decorated. *Bi* discs were sometimes incorporated into the design of larger artefacts; the tomb of Zhao Mo contained furniture embellished with jade handles, each incorporating a *bi* disc in their design (opposite).

During the Han Dynasty, bronze sculpture attained new heights of artistic and technical sophistication. Tombs of the second century AD in the far north-west of China, at Kansu, contained lively sculptures of horses cast in bronze. The period also saw a growth of literature that was supported by the establishment of calligraphy as an art form, especially after the first appearance of paper in AD 105. The availability of paper also spurred interest in painting, especially for its ability to convey narrative, and this art form would come to dominate Chinese culture in the centuries to come. **RK**

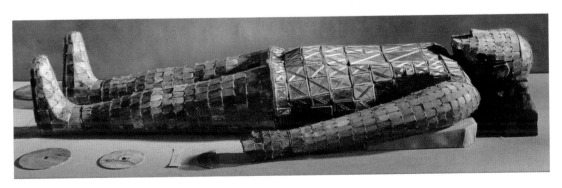

Terracotta Army *c.* 210 BC
ARTISTS UNKNOWN

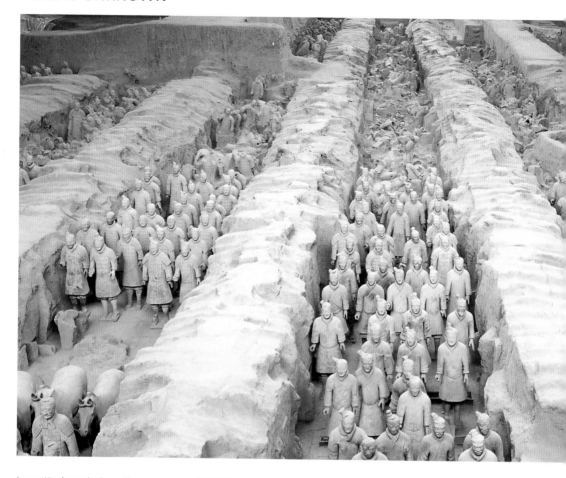

terracotta clay and coloured lacquer
172, 230 sq ft / 16,000 sq m (area)
Near Xi'an, Shaanxi Province, China

The First Emperor of China, Qin Shi Huangdi (259–210 BC), planned for himself a huge underground necropolis comprising halls and other structures surrounded by a wall with gated entrances. This compound was 'protected' by a massive army of more than 8,000 terracotta figures, interred near by in trenches within three separate pits; a fourth pit was found empty. The first and largest pit (above), holding more than 6,000 figures of infantrymen, chariots and horses, is believed to represent the First Emperor's main army. The soldiers and horses are in battle formation, standing between earthen walls; originally the floors were paved and the walls roofed over. The second pit contains about 1,400 figures of cavalry and infantry along with chariots; these represent a military guard. In the third pit, the smallest of the four with sixty-eight figures within an area of 485 square feet (45 sq m), is a command unit comprising officers and a war chariot drawn by four horses.

Traces of fire confirm the looting of the tomb by General Xiang Yu (232–202 BC) fewer than five years after the emperor's death. Archaeologists have reconstructed some of the smashed figures but others were left in pieces as they were excavated. Lined up in crouching or standing poses, the terracotta warriors vary in height, uniform and hairstyle, according to rank. The figures originally held real weapons, such as bronze spears or swords, but these were looted soon after the First Emperor was buried. **RK**

⊕ NAVIGATOR

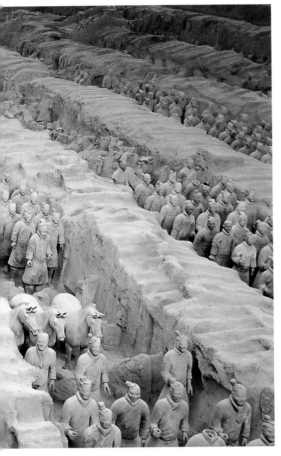

1 OFFICER

This terracotta warrior from the largest pit of the mausoleum is identifiable as an officer by its headgear—the low-ranking foot soldiers are bare-headed—and by its breastplate. The figure is 73 inches (186 cm) high, intentionally taller than the figures of lesser ranks.

2 CHARIOTEER

This figure was intended to hold the reins of a number of horses. The charioteer's armour has been adapted to include special plates attached to the ends of the forearms. These would have afforded the warrior protection from sword or club blows to the hands.

3 HORSES

The terracotta horses that stand alongside the warriors would initially have been equipped with reins and metal bits. These and many other objects have since been looted from the site, but it is possible to see from the horses' open mouths where the bits would have been placed.

MAKING THE WARRIORS

The bodies of the terracotta warriors were constructed from fired clay and mass-produced from interchangeable units or modules. The figures are slightly larger than life-size, and the officers are taller than the soldiers. Although each figure appears to be an individual, the faces and body types were modelled from a range of standardized types. The study of broken and dismantled figures has revealed that fine clay was pressed and smeared into hollow porous moulds. Pressed sections were assembled into whole figures and then finished by hand. Eight different basic face moulds were used, but because the emperor ordered that no two faces should be alike the sculptors applied individually moulded features, such as noses and ears, to alter each face before firing. After cooling, the sculptures were painted with a variety of pigments in a lacquer medium. When new the figures were brightly coloured, unlike their monotone grey today, and remnants of pigment survive in areas such as the warrior's face (right).

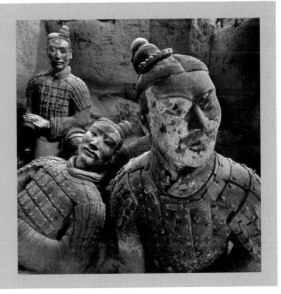

GREEK ART

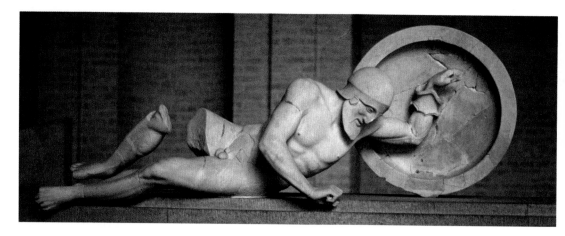

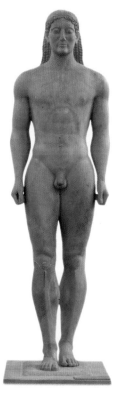

The art and architecture of Greece from 750 BC to the advent of the Romans had a fundamental effect on the evolutionary course of art and culture in the West. The Greeks created art variously to decorate temples and public buildings; to commemorate victories in battle, their famous and their dead; and as votive offerings to their gods. The idealized realism of their art was rediscovered during the Early Renaissance (see p.150) and became the standard to which most Western artists aspired until the 19th century.

In the 7th and 6th centuries BC Greece consisted of autonomous city-states. The period was marked by stability, prosperity, a rising middle-class society and the beginnings of democracy. By the mid 7th century BC, commercial exchange between Greece and trading centres in the Levant and the Nile delta had brought Near Eastern and Egyptian art to the attention of Greek artists. Egyptian architecture and monumental sculpture influenced the Greeks to move away from geometric art and adopt the styles and motifs that characterize Archaic Greek art. The development of a specific Greek artistic identity led to a flourishing of Greek arts from the coast of Asia Minor and the Aegean Islands to mainland Greece, Sicily and North Africa.

The most remarkable aspect of the new Greek art was the rapid development of sculpture, from an initially geometric and symmetrical Archaic archetype—inspired by the Egyptians—to the realism of anatomy and expression embodied by the sculpture of the Parthenon (447–432 BC) in Athens. In the Archaic period, two kinds of freestanding, large-scale sculptures predominated: the male *kouros*, a standing nude youth, and its female equivalent, the *kore*, a standing draped young woman. Among the earliest examples are two *kouroi* from Delphi, named *Kleobis and Biton* (c. 580–560 BC). These sculptures reveal Egyptian influences in their pose, linear styling and

KEY EVENTS

1100 BC	900 BC	c. 750–700 BC	c. 540 BC	c. 508 BC	490 BC
According to Greek legend, Dorian peoples invade Greece from the north; historians now think they were migrants rather than invaders.	The first city-states are founded on the Greek mainland during the Greek Dark Age.	The Homeric epics *The Iliad* and *The Odyssey* are composed.	Attic painters, such as Exekias, develop narrative scene decoration in the black-figure style of painting on pottery.	A progressive aristocrat, Cleisthenes (b. c. 570 BC), brings in a democratic constitution in Athens.	The first Persian invasion of Greece under King Darius I of Persia (c. 550–486 BC) ends when the Athenians win the Battle of Marathon.

proportions. A later *kouros* (opposite, below) from Anavyssos, Attica, wears the genre's 'archaic smile', in which the corners of the mouth are slightly upturned. The statue has an erect pose with fine modelling of the shoulders and upper torso, and the carving of the knees and thighs is more realistic. Later still, the *Kritios Boy* (c. 480 BC) represents a shift from the two-dimensional poses and archaic grin of the Archaic style to the more convincing realism of the ensuing Classical style. The stiff pose and fixed smile of earlier sculpture is replaced by a relaxed stance that shifts the body weight on to one leg and allows the other leg to bend naturalistically.

The stylistic differences between Archaic and Early Classical Greek sculpture become apparent in a comparison of two figures of fallen warriors from the Temple of Aphaia at Aegina, Greece. The earlier, Archaic warrior from the west pediment expresses the archaic grin and has his hair styled in tightly patterned beads; although the figure is carved in the round, there is a two-dimensionality in its pose. In contrast, the Early Classical warrior from the east pediment (opposite, above) shows a more convincing realism in the twist of the torso and rendering of muscle. The stoic rather than rigid grinning expression on the face marks a clear departure from the Archaic style. By the second quarter of the 5th century BC, sculptors, such as those working on the Temple of Zeus at Olympia (470–456 BC), had adopted the Severe Style, known for its simple forms, figure characterization and portrayal of emotion and motion.

In pottery, artisans had brought Corinthian silhouette painting techniques to Athens. By 550 BC this had evolved into black-figure vase painting (see p.52), in which black figures and patterns appear against the red of unglazed clay. Black-figure vases portray Greek mythological scenes as well as aspects of contemporary life, such as funerary rites, athletic events and heroic feats in warfare. Athenian, or 'Attic'—meaning the area near Athens—black-figure pottery was widely exported throughout the Mediterranean. Painters of Attic black-figure vases, such as Exekias (a.550–525 BC), expanded the boundaries of black-figure vase painting by introducing new shapes and colour-wash techniques.

The invention of the red-figure technique in c. 530 BC offered artists greater opportunities for drawing and so became dominant. In red-figure vase painting, figures and patterns appear as unglazed red clay against a glossy black background. The figures are drawn in outline and the background is painted black, allowing the figures to be drawn on with a brush rather than incised with a graver. The brush technique in red-figure vase painting allowed for greater realism than the black-figure technique and made it easier to depict the human figure. Among the greatest red-figure-vase painters of the early 5th century were the Berlin Painter (a. c. 490–c. 460 BC) and the Kleophrades Painter (a. c. 505–c. 475 BC). Both artists worked in Athens and were prolific in their output. Another was Meidias Painter (a. c. 420–c. 400), who produced the red-figure hydria (water-carrying vessel; right). The hydria is decorated with figures related

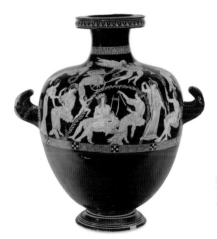

1 Fallen warrior from the east pediment of the Temple of Aphaia, Aegina, Greece (500–480 BC)
Artist unknown • marble
62 ⅝ in. / 159 cm long
Glyptothek, Staatliche Antikensammlung, Munich, Germany

2 Red-figure hydria depicting Phaon and the Daughters of Lesbos (c. 410 BC)
Meidias Painter • red-figure ceramic
18 ½ in. / 47 cm high
Museo Archeologico, Florence, Italy

3 *Kouros* from Anavysos, Attica (c. 530 BC)
Artist unknown • marble
76 ⅜ in. / 194 cm high
National Archaeological Museum, Athens, Greece

479 BC	470–456 BC	447–432 BC	404 BC	323 BC	27 BC
An alliance of Greek city-states, led by Athens and Sparta, defeats a second Persian invasion at the Battles of Plataea and Mycale.	The Temple of Zeus at Olympia is constructed. It houses the *Statue of Zeus* (c. 432 BC), one of the Seven Wonders of the World, which was later destroyed.	Pericles oversees the building of the Parthenon on the Acropolis in Athens. The temple is the peak of the development of the Doric order.	The Peloponnesian War between Athens and Sparta ends with the defeat of Athens, and Sparta becomes the leading power in Greece.	Alexander the Great dies. His empire encompassed Greece, the Middle East, Egypt and Persia, leading to the creation of Hellenistic culture.	The Roman Emperor Augustus annexes Greece to the Roman Empire as the province of Achaea.

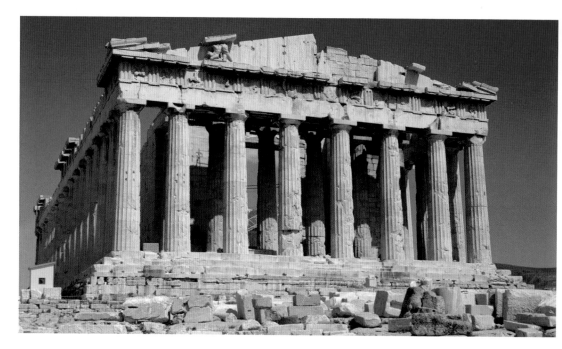

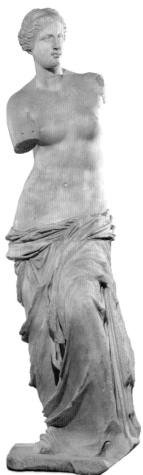

to the legend of Phaon, an old ferryman who took the goddess Aphrodite to the island of Lesbos without asking for payment. In return, she turned him into a handsome youth with whom all the women of Lesbos would fall in love.

The Persian Wars of 480 to 479 BC ravaged Athens, leaving its temples in ruins and its monuments toppled. By the middle of the 5th century BC, however, Athens was again in the ascendancy, having secured its position as the leader of a newly established Greek confederacy known as the 'Delian League'. Under the rule of Pericles (c. 495–429 BC), Greece became a wealthy imperial power, and Pericles used Athens's resources to transform the Athenian citadel. Dedicated to Athena, the city's patron goddess, the Temple of Athena Parthenos, or the Parthenon (above), is made of marble. Its sculptures and a continuous frieze (see p.56) are some of the finest examples of the High Classical style.

Greek artists of the 5th and 4th centuries BC attained a manner of representation that conveys a sense of balance and harmony. They revered mathematical proportion, rationality and order. The sculptor Polyclitus (a. c. 450–c. 420 BC) formulated a system of human proportions that achieved this Classical ideal. Myron (a. 480–440 BC) was one of the most versatile and innovative of Athenian sculptors. His work mainly survives in the form of Roman marble copies, such as the *Discus Thrower* (c. 450 BC; see p.54).

The Peloponnesian War of 431 to 404 BC between Athens and a league of allied city-states led by Sparta was an intermittent conflict. In this period artists created freestanding sculpture to be viewed entirely in the round, and there were advancements in the treatment of drapery as well as in the depiction of the female form. The Athenian sculptor Praxiteles (370–330 BC) departed from one of the most enduring conventions in Greek art by presenting Aphrodite as a nude. The slender proportions and distinctive contrapposto stance of his *Aphrodite of Cnidus* (c. 350 BC) were widely copied and became hallmarks of Classical Greek sculpture. The graceful statue of a semi-clad woman, thought to represent the goddess Aphrodite and known as the *Venus de Milo* (left), was created a century later. Its hairstyle and the delicate modelling of the flesh recall Praxiteles's works, but its spiral composition, positioning in three-dimensional space and small-breasted, elongated body are characteristic of the

innovations that took place during the Hellenistic period between the 3rd and 1st centuries BC. Parts of this statue are missing, and it is pierced by holes where jewellery would have been fixed.

During the mid 4th century BC Macedonia became a formidable power in Greek culture. The Macedonian Alexander the Great (356–323 BC) subdued the Persian empire of western Asia and Egypt, and continued his campaign into Central Asia. After Alexander's death, his successors divided up the vast empire into smaller dynastic kingdoms. This devolution of power transformed the socio-political and cultural climate of Greece and ushered in the Hellenistic age.

Hellenistic art is best characterized as Greek art that was not created by artists in the Greek homeland but by new Hellenistic dynasties, such as the Seleucids in the Near East, the Ptolemies in Egypt and the Antigonids in Macedonia. Hellenism brought a change in the purpose of art. The new patrons were Alexander's successors, each seeking to promote their own dynastic empires. Art, previously destined for temples as votive offerings to the gods or for the glorification of the Greek state, was used to embellish homes and palaces or to commemorate military victories or represent local Graeco-Egyptian gods. The subjects of portraiture widened from royalty alone to include grotesques, children and elderly people. The variety of ethnicities portrayed, including many of African origin, reflects the diversity of the Hellenistic world.

The Hellenistic period saw a departure from the Classical style. Facial expressions, once stoic and devoid of emotion, became contorted to convey physical and psychological torment. The Pergamon Altar, built in what is now Turkey and later reconstructed in Berlin, is adorned by frieze panels of gods and giants locked in combat, but its purpose is disputed. The panel (below) shows (on the left) the goddess Hecate fighting the giant Klytios, while (on the right) the goddess Artemis fights the giant Otos. The Hellenistic desire to represent psychological stress is evident in the faces of the giants, and their sculpted torsos are rendered with closely observed anatomical realism.

By the 1st century BC, Rome had become a centre for the production of Hellenistic art, attracting numerous Greek artists. The end of the Hellenistic period occurred in 31 BC, when Octavian, later the Emperor Augustus (63 BC–AD 14), defeated Marc Antony (c. 83–30 BC) in the Battle of Actium. Ptolemaic rule was ended; the Ptolemies were the last Hellenistic dynasty to fall to Rome. **JC**

4 The Parthenon (447–432 BC)
Acropolis, Athens, Greece

5 Scene from the Gigantomachy showing the battle of the Olympian gods and the Giants (c. 180 BC)
detail of east frieze, Pergamon Altar
Artist unknown • marble
90 1/2 in. / 230 cm high
Pergamon Museum, Berlin, Germany

6 *Venus de Milo* (c. 100 BC)
Artist unknown • marble
79 1/2 in. / 202 cm high
Louvre, Paris, France

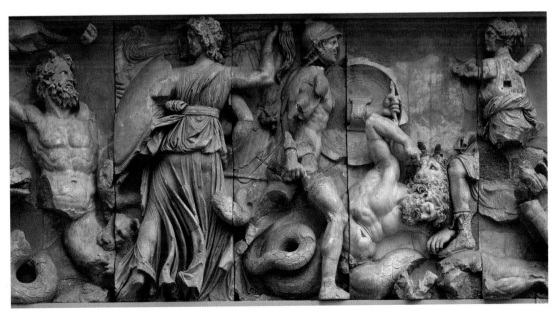

Attic Black-figure Amphora *c.* 540 – 530 BC

EXEKIAS a. 550 – 525 BC

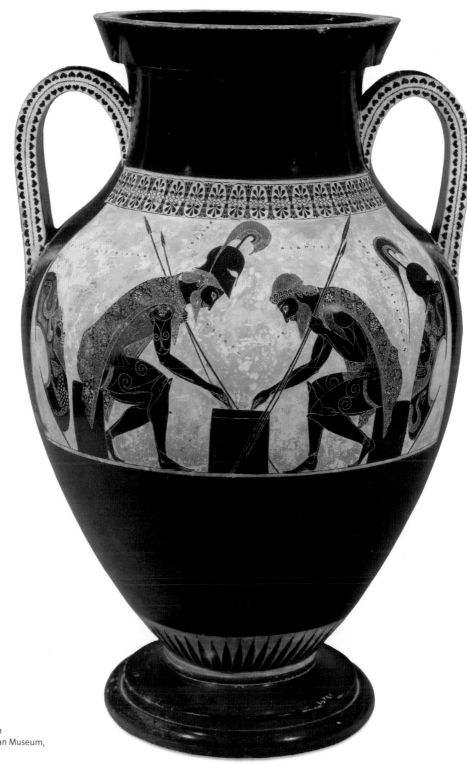

ceramic
24 in. / 61 cm high
Gregorian Etruscan Museum,
Vatican City

Exekias was an ancient Greek amphora, or vase, painter and potter who worked in Athens. He worked mainly using the black-figure painting technique, which flourished between 700 BC and 530 BC. Exekias's works are notable for their striking compositions, clean draughtsmanship and understated characterization. Eleven signed works by Exekias have survived and approximately twenty-five vessels have been attributed to him. One of his best-known works is this amphora showing the mythical Greek warriors of the Trojan War, Achilles and Ajax, playing a game of strategy. As they play to see who wins, they also await the result of a larger strategic 'game'—the outcome of the war. Exekias was an innovative painter, and the episode of Ajax and Achilles playing a game is undocumented in Greek literature. The reverse of the vase (see panel below) shows the family grouping of the 'twins' Castor and Pollux and their parents Leda and King Tyndareus. Leda was mother to Castor and Pollux but they had different fathers. The father of Pollux was Zeus, who appeared to Leda in the form of a swan, and the father of Castor was Tyndareus, Leda's husband. The brothers had a famous sibling, Helen of Troy. It has been suggested that the scene on this amphora depicts the twins leaving to rescue Helen from King Theseus, her first abductor. Other works that Exekias created also portray scenes from the Trojan War, such as Achilles slaying Penthesilea, queen of the Amazons. **JC**

FOCAL POINTS

1 ATTRIBUTION

An inscription 'Exekiasepoiesen' at the far left-hand side of the scene means 'Exekias made me'. Exekias signed the amphora twice, indicating that he was both maker and painter. Sometimes the potter and the painter were different people and one or both of them signed the work.

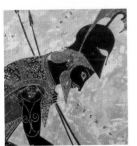

2 GAME PLAYING

Unusually Exekias depicts the heroes engaged in a game. It is thought that they are playing with dice or playing morra, which is a hand game enjoyed for entertainment or to make a decision, akin to tossing a coin. Inscriptions emerge from the figures' mouths revealing the points gained in the game.

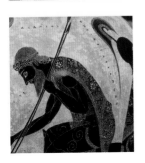

3 AJAX

There is great attention to detail in the delicately engraved armour of Ajax and Achilles. Ajax's helmet hangs against his shield behind him, although he holds on to his spear with one hand, ready for battle should it commence, while playing a game of dice with his other hand.

BLACK-FIGURE PAINTING

The black-figure technique of vase painting originated in Corinth in c. 700 BC and flourished for two centuries until it was eclipsed by the invention of the red-figure technique in c. 530 BC. Black-figure painting involves composing figures in black silhouette with a glossy black pigment and incising all linear details so that the pale clay shows through the black. Touches of red and white pigment are added before the vase is fired. It was a revolutionary method in the decoration of pottery. Prior to its invention Greece had only known the Geometric style with its limiting angular silhouette. By c. 630 BC Athenian artists were using the black-figure technique for their vases with increasing dexterity and by 530 BC Attic black-figure vases were being exported throughout Greece and the wider Mediterranean world. The works of Exekias and his contemporaries, Lydos (a. c. 560–540 BC) and Amasis (a. c. 550–510 BC), are innovative in their use of narrative scene decoration. They perfected the black-figure technique in scenes such as the one by Exekias of Ajax and Achilles playing a game and the one on the reverse of the amphora showing the 'twins' Castor and Pollux (right).

Discus Thrower (Discobolus) *c.* 450 BC
MYRON a. 480 – 440 BC

Roman marble copy of bronze original
61 in. / 155 cm high
Staatliche Antikensammlungen und
Glyptothek, Munich, Germany

The *Discus Thrower* or *Discobolus* is one of the most celebrated works in antiquity. It was a bronze made in the Greek High Classical period. The original no longer exists but there are celebrated Roman copies in marble, of which this is one, although it is a reduced version of the original. Its creator, Myron (a.480–440 BC), was born in Eleutherae on the border between Attica and Boeotia. Myron lived most of his working life in Athens and is known for his portrayal of athletes. He worked mainly in bronze, which is superior to marble in that it allows sculptors to create more dynamic poses and add realistic, fine detail. Bronze sculptures are less heavy than marble ones and easier to transport; as a result Greek sculpture spread throughout the Mediterranean.

Discus throwing was one of the events of the ancient pentathlon, in which an athlete threw a heavy disc, called a discus. Here Myron captures the athlete's state of momentary immobility. The Greek definition for this moment is 'rhythmos' and refers to an action of graceful harmony and balance. Sculptors chose to portray the discus thrower's twisted body because it satisfied a desire to depict an anatomically perfect figure and a sense of motion. Myron is widely held to be the first sculptor to represent the state of rhythmos and is credited for experimenting with dynamic poses. His zigzagging sculpture shows the athlete with his arm thrown back and his weight on his right foot, preparing to spin his body round to throw the discus, which he grasps in his hand. **JC**

FOCAL POINTS

1 FLEXED MUSCLES
Ancient discus throwers performed nude, which alllowed artists to portray the toned athlete's flexed muscles. Myron depicts the moment when the figure is poised to throw the discus with convincing realism and motion, conveying the body's taut vigour and delicate balance.

2 CALM FACE
The discus thrower has a calm expression as he turns to look towards the discus. To the modern viewer, the athlete's face seems devoid of emotion. For ancient sculptors it was important to represent the body as the aesthetic epitome of the athletic ideal, rather than focus on facial expressions.

3 MATCHED ANGULAR SHAPES
A discus thrower's physique was admired because no single set of muscles was overdeveloped. The symmetry of the athlete's proportions is emphasized by the right angle made by the thigh and calf of the left leg and that made by the torso and the outstretched right arm.

ROMAN COPIES

By the late 4th century BC, the Roman Empire had begun to expand across the Mediterranean. Impressed by Greek sculpture's naturalism and realistic detail, a growing class of affluent Romans became keen collectors. To meet the demand, Greek and Roman artists created marble and bronze copies of famous Greek statues. Moulds taken from the original sculptures were used to make plaster casts that were disseminated throughout the Roman Empire, where they were replicated in marble or bronze. As copies in marble lack the tensile strength of bronze, they required struts vor supports, sometimes carved in the form of tree trunks. Most ancient bronze statues have been lost, or were melted down for reuse to create new sculptures or weapons during times of war, so Roman copies often present the only visual evidence of Greek sculpture. Restorers sometimes made slight changes to the Roman copies, intending them as improvements. London's British Museum has a marble copy of the *Discus Thrower* that was restored in 1791 (right). It shows the athlete's head set at the wrong angle—in a downward gaze rather than looking back towards the discus.

The Parthenon Frieze *c.* 438 – 432 BC

ARTISTS UNKNOWN

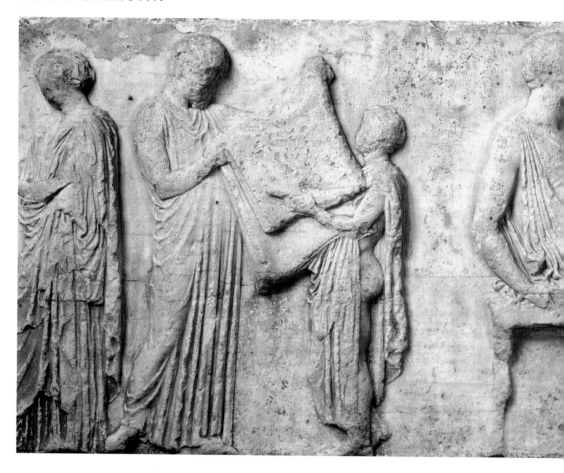

marble
39 ³/₈ in. / 100 cm high
British Museum, London, UK

The sculpted Ionic frieze of the Parthenon in Athens is one of the most intriguing creations in the pantheon of Classical Greek art. It is thought to have been created under the direction of the sculptor, painter and architect Phidias (*c.* 480–430 BC) and, after he died, by pupils from his workshop. The exceptional quality of the carving—as seen in the central portion of the east frieze (above)—epitomizes the High Classical style, and the complexity of the composition is without parallel in Graeco-Roman art. Fragments of the frieze are dispersed throughout Europe, with large sections in the British Museum in London and the Acropolis Museum in Athens. The frieze was situated high up along the exterior wall of the Parthenon's *cella*, or inner chamber, at the temple's centre.

The subject of the Parthenon frieze is unique in Greek sculpture. It is believed to represent the Panathenaic festival, the most important festival in Athens, which was staged every four years and attended by everyone, except slaves, who lived in the city and its suburbs. A procession in which a huge *peplos*, or robe, was carried culminated in a ceremony dedicated to the goddess Athena Polias (guardian of the city). The procession's religious significance is suggested in the frieze by sacrificial animals, musicians and libation bearers. The complex composition, with horsemen, charioteers and seated divinities, comprises some 378 figures and 245 animals. **JC**

✦ NAVIGATOR

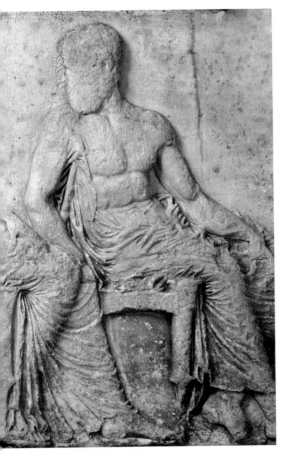

1 BEARDED MAN

The long tunic of the bearded man identifies him as a priest. He and the woman and child on either side of him are officiating at the culminating ceremony of the Panathenaic festival. The *peplos*, or sacred robe, of the goddess Athena has arrived at the Erechtheum temple on the Acropolis.

2 CHILD AND SACRED ROBE

A child wearing a ceremonial robe assists the priest in folding the *peplos* of Athena. The robe was very large and was carried on a ship with wheels, which probably symbolized the great fleet of Athens. A new robe was woven for each of the four-yearly Panathenaic festivals.

3 ATHENA POLIAS

The goddess sits on a stool with Hephaistos, smith of the gods. Because they are deities, they are much larger than the figures of the priest, woman and child. The ceremonial *peplos* was intended for draping on the Athena Parthenos, a statue 39 feet (12 m) high that stood within the Parthenon.

CAVALCADE

On the north and south sides of the frieze, serried ranks of horsemen, soldiers and charioteers match exactly the number of deaths at the Battle of Marathon (490 BC). The majority of the figures in the frieze are shown in single file without overlapping, but the horsemen (below) are depicted riding abreast and, in some instances, up to ten deep in formation. The effect is one of great vibrancy and movement, admirably displaying the sculptors' virtuosity in capturing equine anatomy, depth of perspective and the dynamism of figures moving on horseback.

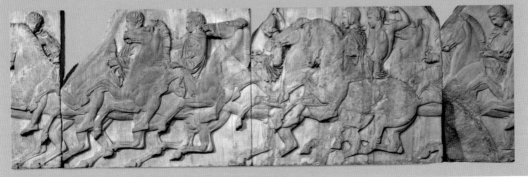

BUDDHIST ART

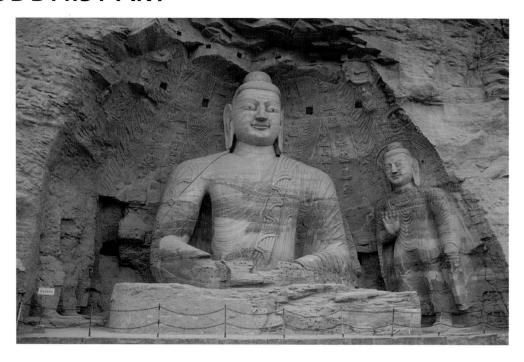

The founder of Buddhism, Shakyamuni Buddha (c. 563–483 BC), was born as Prince Siddhartha Gautama in northern India. He renounced his life of luxury and privilege and adopted an extremely ascetic life. Later he came to see that spiritual freedom is achieved by following the 'Middle Way' between extreme indulgence and self-mortification. This profound understanding led him to enlightenment, the path to Buddhahood. After his death, his cremated remains were distributed by King Ashoka of India, who ordered 84,000 stupas to be built to house relics of the Buddha.

Shakyamuni's followers formed monastic communities and over the centuries his teachings spread to every corner of Asia. The beginning of the 1st century AD saw the development in central and northern India of Mahayana Buddhism, a new school that offered the possibility of salvation to all, including women, and images of the Buddha in human form began to be made.

The region of Gandhara in present-day northern Pakistan and eastern Afghanistan was an important meeting place of artistic influences. Centuries after Alexander the Great's expedition to Gandhara in 327 BC, the influence of Greek and Roman art remained strong. Many Buddhist freestanding and relief sculptures from Gandhara reveal a fusion of Eastern and Western artistic

KEY EVENTS

c. 563 BC	c. 540 BC	528 BC	321 BC	260 BC	c. 100 BC
Prince Siddhartha Gautama, later known as Shakyamuni Buddha, is born.	The kingdom of Magadha in the Ganges valley comes to prominence under King Bimbisara.	The Buddha attains enlightenment while meditating under a Bodhi tree in Bodhgaya.	Chandragupta Maurya destroys Magadha and creates a new empire in northern India.	The Mauryan King Ashoka converts to Buddhism and introduces the faith throughout India and Ceylon (now Sri Lanka).	King Ashoka's great stupa of Sanchi, in central India, is rebuilt.

styles. Sculptures of the Buddha retain Indian iconography, such as the *ushnisa* (cranial protuberance), *ūrnā* (a tuft of hair on the forehead) and elongated ear lobes, but in their facial types and treatment of hair and robes they demonstrate distinctly Greco-Roman characteristics. The Bimaran reliquary (right) from Gandhara is a superb example of early Indian goldsmithing and is an important surviving early image of Buddha. It bears a frieze of eight pointed *caitya* arches; the Buddha (centre) is twice depicted flanked by two other deities, with praying figures filling the remaining two niches.

Mahayana Buddhism was transmitted by travelling monks and traders along the Silk Route to various small kingdoms in Central Asia, reaching China in the early centuries AD. Chinese culture was already well established by that time, based primarily upon Confucian philosophy and Daoist customs, and Buddhism adapted to accommodate local traditions. During the Northern Wei Dynasty (AD 386–535), many cave temples were created at two major centres, Yungang and Longmen in northern China. Cut directly into the cliff, the colossal Buddha in Cave 20 at Yungang (opposite) testifies to the power of the Buddhist faith that inspired its creation. The Buddha's robe is expressed in the linear, calligraphic manner that characterizes Northern Wei Buddhist art.

Buddhism was introduced to Japan in the 6th century AD from China via Korea, and by the 8th century it was firmly established as the state religion of Japan under the patronage of the emperor. The Hōryū-ji temple complex in Nara demonstrates how the Japanese adapted Chinese temple architecture. With stone foundations and tiled roofs supported by complex brackets, the temple's Kondo (Golden Hall; below) and accompanying five-storey pagoda are the oldest surviving wooden structures in the world. **MA**

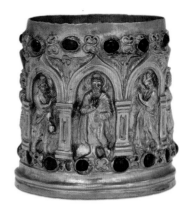

1

2

3

1 **Buddha (5th century AD)**
Artist unknown • cave sculpture
670 in. / 1700 cm high
Yungang Caves, Shanxi Province, China

2 **Bimaran reliquary (1st century AD)**
Artist unknown • gold and garnets
2 ⁵/₈ in. / 6.5 cm diameter
British Museum, London, UK

3 **Kondo (Golden Hall),**
Hōryū-ji temple (AD 711)
Architect unknown • wood
60 x 49 ft / 18.5 x 15 m
Nara, Japan

C. AD 100	C. AD 100	AD 372	C. AD 400	AD 552	AD 607
Indian Buddhist monks reach China and introduce the faith there.	The creation of Buddhist frescoes begins in the central Indian cave temple of Ajanta; the painting continues for three centuries.	Chinese Buddhists take the religion to Korea, where it is adapted to assimilate with indigenous worship of nature.	The first Japanese state, Yamato, emerges on the island of Honshū. Gigantic keyhole-shaped mounds are built for the Yamato kings.	Buddhism is introduced to Japan by monks from Korea. The monks open eight schools in Nara, capital of the Kansai region of Honshū.	The first Hōryū-ji temple is built by Prince Shōtoku at Nara. Destroyed by fire in AD 670, it was replaced by the current buildings in AD 711.

Amida Buddha 1053
JŌCHŌ d. 1057

gilded and painted wood
118 ¹/₈ in. / 300 cm high (Amida Buddha)
Byōdō-in Temple, Uji, Japan

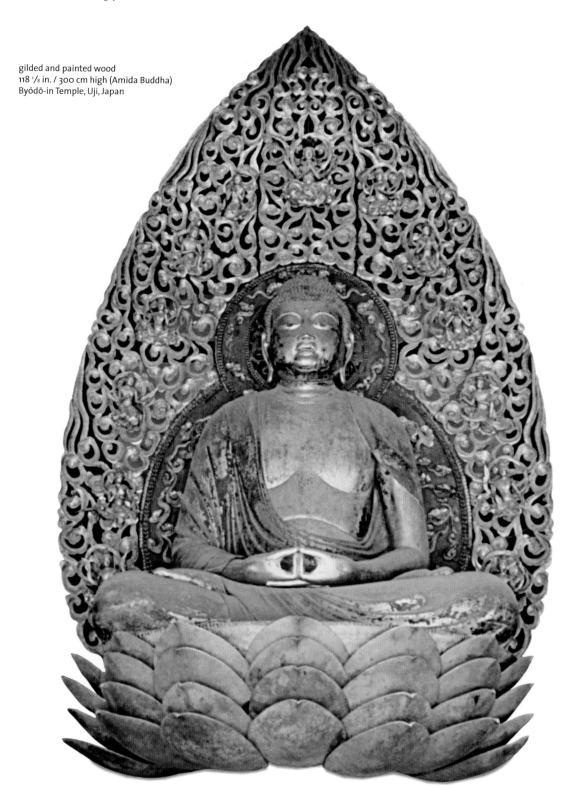

The gilded wood sculpture of the Amida Buddha, created by the sculptor Jōchō, dominates the Amida Hall, which is part of the Byōdō-in Temple at Uji, near Kyoto in Japan. In 1052 Fujiwara no Yorimichi (992–1074) converted his father's aristocratic villa into a temple complex. The Amida Hall, later known as the Phoenix Hall, was designed in the shape of a giant bird with spreading wings and a tail, and the hall's roof was surmounted by a pair of bronze phoenixes. The hall's wooden frames were originally painted in bright vermilion and the interior was sumptuously decorated with paintings. The building is intimate in scale and, seen from the far shore of the lake opposite, its reflection on the water has an ethereal beauty, evoking the Western Paradise of the Amida Buddha (Amitābha).

The monumental image of the Amida Buddha seated on a multi-layered lotus pedestal was made using the relatively new *yosegi-zukuri* technique, in which many blocks of wood were roughly carved, then joined together for final sculpting. Amida is the Buddha of Immeasurable Light and Infinite Life, a compassionate Buddha dedicated to saving anyone who recites his name repeatedly. From the 10th century, belief in Amida Buddha increased in Japan because the theory of *mappō* (Latter Days of the Law) predicted that in 1052 the world would enter a degenerate age and the only hope of salvation was through the total devotion to Amida Buddha. **MA**

◉ FOCAL POINTS

1 GOLDEN AUREOLE

Surrounding the seated Amida Buddha is a magnificent shining aureole, filled with sculpted musicians, that rises like a flame above its head. The aureole is made of wood carved to a filigree fineness before being finished in rich gold leaf. It contrasts with the smooth solidity of the Buddha.

2 BUDDHA'S FACE

The facial features of the Buddha are finely carved with a smooth finish, and gold covers the sculpture's entire face and body. The expression on the Buddha's face is serene and contemplative. The eyes are turned down to gaze upon the viewer; older statues tended to look fixedly ahead.

3 BUDDHA'S HANDS

Buddhists work to achieve rebirth at various levels, and here Amida's hands are held in the mudra (hand gesture) of rebirth in the Western Paradise at the highest possible level. Buddha's various mudras convey different messages that can be identified by referring to Buddhist iconography.

HEAVENLY BEINGS

The fifty-two small carved figures attached to the walls of the Phoenix Hall represent the host of celestials that Buddhists believe accompanied Amida Buddha when he descended from the Western Paradise to gather the souls of believers at the moment of death. He then transported the souls in lotus blossoms to the Pure Land, or celestial realm. The celestial beings are therefore part of the vision of the Pure Land represented in the hall.

Buddhist heavenly beings, known in Japan as *tennin*, consist of two groups. The first are flying maidens— divine beauties and dancers that originate in Hindu mythology and that in Sanskrit are called *apsara*. However, the beings in the Phoenix Hall, all of them portrayed on flying clouds, are bosatsu, or bodhisattva, enlightened beings that forego the Pure Land to help save others. Some of the figures are depicted playing musical instruments (right), while others dance, hold Buddhist objects or sit with their hands joined in prayer. The figures are not solid but were carved whole then split, hollowed out and rejoined in order to reduce their weight.

ROMAN ART

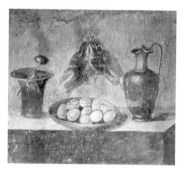

Characterizing any art as Roman is fraught with complexity for many reasons, not least the length and breadth of the ancient Roman civilization. During a period of 1,000 years, from the time of the Republic (509–27 BC) to the Empire (27 BC–AD 476), Roman territories extended from the British Isles through Western Europe, Greece, parts of North Africa and the Middle East to the Caspian Sea. Roman art was influenced by its Etruscan and Greek forerunners, so much so that, until the 18th century, little distinction was made between Greek and Roman art. This conflation was supported in part by the Roman convention of mimicking aspects of Greek art (see p.48), going as far as to make copies of Greek sculpture. However, the Romans made important and original contributions to architecture, painting, mosaics and sculpture.

The Romans are known for their innovations in both religious and secular architecture. Architects combined Etruscan and Greek elements with uniquely Roman materials and design, and showed a new concern for the utilitarian and a grandness of scale. The use of concrete, seen as economical and capable of varied shapes, and the huge unsupported barrel and groin vaults in Roman

KEY EVENTS

509 BC	c. 400 BC	264 BC	c. 200 BC	c. 60–50 BC	44 BC
The Roman city-state, ruled by kings, is replaced with a new form of government, under which it becomes known as the Republic.	Rome's ever-expanding territory brings in wider cultural influences, including red-figure vase painting from Greece and iron and textiles from Arabia.	The First Punic War breaks out; it is followed in 218 BC by the Second Punic War. The wars extend the Empire and expand Rome's naval capacity.	The enormous demand for Greek statuary in Rome leads to an influx of marble and bronze copies made from plaster casts.	Second Style, life-size figures are painted in the Villa dei Misteri, using Pompeian red (see p.64).	Julius Caesar's assassination ends a long series of civil wars. He is succeeded by Augustus, who seizes control of the Empire in 27 BC.

structures show this inventiveness. The Colosseo in Rome (opposite), an amphitheatre that housed spectacular entertainment, has become a symbol of the city. Its columns and decorative elements explicitly reference an ancient Greek style; however, the structural feats accomplished in building it so high (160 ft / 49 m) and constructing its vast oval seating area (capacity 50,000), supported by concentric corridors and covered by concrete barrel vaults, are important features of Roman design.

The most striking examples of Roman painting come from the wall paintings in the buildings of Pompeii and Herculaneum that survived the volcanic eruption of Mount Vesuvius in AD 79. In *Still Life with Eggs and Thrushes* (opposite, below) from the Villa di Giulia Felice in Pompeii, the artist used light and shade in order to make the objects appear three-dimensional. The floors of many of the homes were covered with elaborate mosaics, too.

Four Pompeian styles can be identified that show the influence of Etruscan and Greek panel and wall painting but that also focus on Roman concerns. In the First Style—also called the Masonry Style (2nd century BC)—artists used painted stucco relief that resembled coloured marble. The Second Style (80–c. 20 BC) featured architectural elements, such as ledges and columns, which were painted with shadows to create a three-dimensional effect. Landscape scenes were painted to mimic the actual scene as viewed from the window next to the painted panel. Life-size figures peopled theatrical, religious or mythological scenes, as seen in the wall paintings of the Villa dei Misteri (c. 60–50 BC; see p.64), in which the initiation rites of the cult of Dionysus, god of wine and ecstatic revelry, were painted in brilliant colour, including Pompeian red. The wall paintings in the Third Style (c. 20 BC–AD 60) emphasized two-dimensional linear fantasies and floating landscapes among ornamental aspects of design. The Fourth Style (c. AD 60–79) was an eclectic combination of the Second and Third Styles, where the solid forms of the Second Style reappeared and the wall was broken up into different spatial levels and painted with vistas of more distant scenes.

Although Roman artists copied original Greek statues, they also placed much greater emphasis on realistic details, including the lines and folds of skin, as can be seen in the marble portrait busts of prominent Roman figures. This is less apparent in full-length statues of the emperors, such as Augustus of Prima Porta (right, above), in which realistic details were often smoothed over and symbolic elements added in order to idealize the figure. The Equestrian Statue of Marcus Aurelius (AD 164–66; see p.66), with the emperor stretching out his right hand in a dignified gesture, exemplifies imperial portraiture of the period. Large public monuments were another distinctive feature of Roman sculpture: success in war or the fruits of peace were often portrayed and celebrated in triumphant altars and arches, which became effective tools of propaganda. **BD**

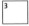

1 **Colosseo in Rome** (c. AD 70–80)
18th-century engraving
of a cross-section

2 **Augustus of Prima Porta** (20 BC)
Artist unknown • marble
The Vatican Museums and Galleries,
Vatican City

3 **Still Life with Eggs and Thrushes**, from
Villa di Giulia Felice, Pompeii (1st century AD)
Artist unknown • fresco • Museo
Archeologico Nazionale, Naples, Italy

9 BC	AD 54–68	AD 98–138	AD 260–70	AD 312	AD 476
Augustus transforms Rome into an imperial city with the help of writers Livy and Virgil and sculptures such as the grand altar Ara Pacis Augustae.	Rome reaches the height of its power under tyrannical Emperor Nero, who considers himself a patron of the arts.	Trajan and Hadrian both contribute to Rome's 'Golden Age', building aqueducts, public baths and the Pantheon (AD 126).	Funerary monuments, including steles and inscriptions, such as the Badminton Sarcophagus, are popular in the late imperial era.	Roman Emperor Constantine converts to Christianity.	The last Western emperor, Romulus Augustus, is deposed and Rome's superiority declines as political power shifts to Constantinople.

Villa dei Misteri *c. 60 – 50 BC*

ARTIST UNKNOWN

wall fresco (detail)
63 ³/₄ in. / 162 cm high
Pompeii, Italy

This magnificent scene is part of a remarkably well-preserved cycle of frescoes that was discovered near Pompeii, Italy, in the ruins of a luxurious Roman villa—the Villa dei Misteri—which sustained only minor damage during the eruption of Mount Vesuvius in AD 79. The fresco is located at the front of the villa in its most prestigious room, the *triclinium* or dining room. Its colour scheme includes blue and green, and the use of these expensive pigments suggests that the villa's owner spared no expense on materials.

The fresco panel is part of a series of tableaux depicting the 'mysteries' of an exclusively female initiation rite—probably admittance to womanhood—in which the initiate has to undergo a symbolic death and rebirth. The ritual centres on Dionysus, the Greek god of wine, agriculture and ecstasy, and a priestess is present to guide the young woman through the initiation process.

The figures are arranged, either standing or seated on different kinds of furniture, upon a green-painted narrow ledge that elevates them and helps to create the appearance of a stage. The device of the ledge identifies the fresco as being in the Roman Second Style, in which architectural features are rendered to appear three-dimensional. The life-size figures are realized in a megalographic style, that is, they are glorified to appear greater than human. By placing the figures in front of a red-painted wall amid painted columns, the artist makes them appear to inhabit the same room as the viewer. **BD**

⚙ NAVIGATOR

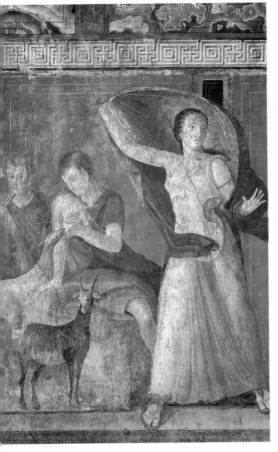

FOCAL POINTS

1 PRIESTESS

The seated woman, a priestess, wears a head covering and a wreath of myrtle. With her left hand she uncovers a tray; what it contains is unknown but could be laurel, a snake or petals. Her right hand is poised over a dish into which liquid is being poured. She may be preparing to wash her hands.

2 SILENUS, SATYR AND NYMPH

Mythological characters form part of the frieze. In the centre, Silenus, a companion and tutor to Dionysus, plays a lyre. To his left, a male satyr plays the pan pipes while a nymph suckles a goat. They signify the initiate's connection with nature; their music marks her shift to a new psychological state.

3 FRIGHTENED INITIATE

The young initiate looks to her left. She is frightened because she can see what awaits her in the next scene, which depicts the inner sanctuary where her descent to the underworld will take place. Her body is twisted towards her right and she grabs her *palla*, or wrap, as if she wants to flee her fate.

TROMPE L'ŒIL

The French term 'trompe l'œil' (trick the eye) refers to the technique of painting an image on a two-dimensional surface in such a realistic manner that it appears three-dimensional. The Roman Second Style incorporated *trompe l'œil* painting, as is evident in the painted architectural details within the frescoes in the Villa dei Misteri's Hall of Mysteries. Elsewhere in the villa, Pompeian visitors were treated to particularly spectacular *trompe l'œil* painting in which plain walls were decorated to resemble dizzying three-dimensional vistas of Corinthian columns topped by arches, the columns apparently set back in tiers to create an illusion of depth. In the example shown here (right), an arch frames a cupola, heightening the sense of distance. Roman domestic interiors were windowless and dark, and painted decoration was used to lighten living spaces and make them less claustrophobic. Backgrounds were brightly coloured and *trompe l'œil* effects were used to divide blank walls into smaller areas containing visually stimulating imagery.

Equestrian Statue of Marcus Aurelius
AD 164 – 66
ARTIST UNKNOWN

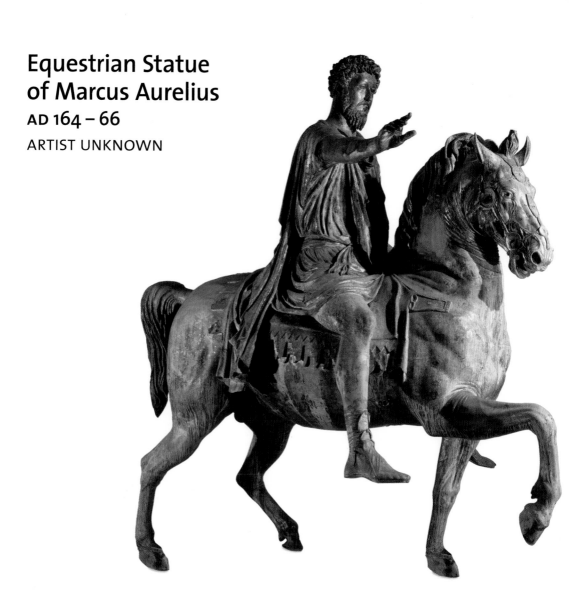

bronze
138 in. / 350 cm high
Musei Capitolini, Rome, Italy

 NAVIGATOR

The gilded bronze, more than life-size, equestrian statue of Roman Emperor Marcus Aurelius (AD 121–80) is the only complete bronze statue of its kind to survive from antiquity and one of the few to remain on public view throughout medieval times. Most statues of this type were melted down and turned into coins, reliefs or busts after Rome converted to Christianity. Such images, which seemed to deify ordinary mortals, were considered pagan, impious and unlawful. This statue escaped such a fate, however, because it was originally thought that the figure on the horse was that of the first Christian emperor, Constantine I (c. AD 272–337). It was only during the Middle Ages, when the head of the figure was compared with bust portraits of Marcus Aurelius, that the correct identification was made. Marcus Aurelius is depicted here at the height of his powers as both a victorious military leader, who had successfully led his armies to repel invading forces, and as the Stoic philosopher and author of *Meditations*, twelve books that espouse the virtues of wisdom, fortitude, moderation and justice. Originally, the statue stood in the Piazza del Campidoglio in Rome. It has now been moved to the city's Musei Capitolini to prevent it being damaged by the elements; a replica stands in its place in the piazza. **BD**

👁 FOCAL POINTS

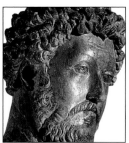

1 HEAD OF RIDER

The naturalism of the head of Marcus Aurelius is suggestive of his compassionate role as a Stoic philosopher. He was known for his concern for public welfare and for his efforts to humanize criminal laws. The fact that the emperor carries no weapons signifies that he is a man of peace.

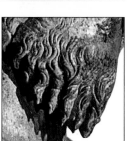

2 FACIAL HAIR

The classical style of the emperor's beard suggests strength and virility. The volume of such beards in statuary was achieved partly through the use of an early type of drill. It was only after the reign of Hadrian (AD 117–138) that Romans began to wear short beards as a sign of mature manhood.

3 RIGHT HAND

This gesture has been interpreted in a number of ways. It can be viewed as a sign of clemency for a fallen enemy; a sign of recognition and blessing of the adoring crowds; a greeting to his son, Commodus (who rode alongside him); or a sign of victory over all enemies.

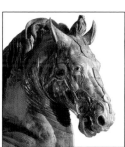

4 HORSE'S HEAD

The magnificent features of the horse give the viewer a favourable impression of the emperor's military might and importance. The horse's rounded and solid geometric forms instil in the viewer a sense of awe at the animal's commanding presence and immense strength.

5 RAISED FORELEG

Some art historians suggest that beneath the foreleg of the emperor's horse, raised in a gesture that echoes the raised right arm of its rider, was originally a figure of a cowering barbarian enemy. If this is the case, then Marcus Aurelius's hand gesture must be one of clemency for the victim.

▲ The replica statue of Marcus Aurelius on the Piazza del Campidoglio, Rome. Michelangelo's original piazza design (1538) included the star-patterned pavement, which was constructed in 1940.

THE POLITICAL POWER OF ART

Art and politics were closely linked in the ancient Roman world. Leaders were aware of the power of art to promote their political agendas publicly, as well as to celebrate their accomplishments in both war and peace. Public monuments, commemorative reliefs and motifs were replicated on utilitarian objects and coins that were dispersed throughout the Roman Empire and served as works of imperial promotion. These items were later elevated to the status of art. Often, inscriptions detailed not only family lineage but also the most recent military success or the maintenance of a lengthy period of peace and prosperity, in keeping with the Roman concern for actual events as they unfolded. In imperial times, emperors or members of their families were depicted in commanding positions, leading an army into battle or giving out food to the poor, for example. A popular subject in Roman art was that of the emperor addressing a crowd, a motif called *adlocutio*, in which the prominence of the emperor elevated his message. The coin (right) shows Emperor Hadrian (AD 117–38) coming to a halt before the troops of the British army. He raises his arms to attract attention to his address.

WEST AFRICAN ART:
THE MIDDLE AGE

1 High-relief section of a larger structure, Nok culture, Nigeria
(500 BC–AD 200)
Artist unknown • terracotta
19 ⅝ in. / 50 cm high
Musée du Quai Branly, Paris, France

2 Head of an *oni* (king) of Ife, Nigeria
(1300–1400)
Artist unknown • brass
14 ⅜ in. / 36.5 cm high
British Museum, London, UK

3 Stand for a ceremonial vessel showing a dancing girl from Igbo-Ukwu, Nigeria
(c. AD 900)
Artist unknown • bronze
National Museum, Lagos, Nigeria

The earliest sculptural tradition in sub-Saharan Africa is found in the Nok Culture (500 BC–AD 200). Its pottery sculpture is dominated by the human figure, sometimes made to almost 75 per cent of normal human size, showing clear-cut features, elaborate hairstyling and beadwork. Such sculpture has been found at many sites across a region of some 300 by 100 miles (480 by 160 km). The village of Nok, where the culture was first identified, is on the southern escarpment of the Jos Plateau in what is now Nigeria. The Nok Culture also left evidence of early iron-working south of the Sahara. The structure and dating of iron-smelting furnaces excavated at Taruga suggest Carthage as the likely source of the technology, which would have come south via early trade routes across the Sahara. It is unknown what Nok art was for, nor who the artists were, although it is believed that they were women. The example shown above is clearly part of a much larger but unknown structure.

In sub-Saharan Africa there was no 'Bronze Age'. Copper and its alloys—bronze (copper and tin) and brass (copper and zinc)—appear later than iron

KEY EVENTS

c. 500 BC	*c.* 350 BC	*c.* 300 BC	*c.* AD 600	*c.* AD 900	*c.* AD 1200
The earliest sculpture by the Nok culture—a culture in transition between the Stone and Iron Age—is created in central present-day Nigeria.	A series of settlements on raised areas within the inland Niger Delta, later to become the city of ancient Djenne, Mali, is founded.	Iron smelting furnaces at Taruga in northern Nigeria show that a fully established iron-working technology exists in the Nok culture.	The earliest farming settlements are established in the forests of Ife in south-western Nigeria.	The alloying of and casting in bronze is well established at Igbo-Ukwu, as seen in finely crafted objects found in the elaborate burial of a chief.	The earliest settlements of Edo, known to outsiders as Ubini (mistranscribed as 'Benin') are founded.

and serve decorative and sculptural purposes; often the lost-wax casting technique was used. Copper and tin were smelted in West Africa using knowledge gained from ironworking. Zinc is a difficult metal to use and its extraction did not occur in pre-industrial Africa; zinc appears in Africa only ready-made as brass, an alloy known to have been traded southwards across the Sahara. The earliest evidence for copper and bronze in sub-Saharan Africa was found east of the lower Niger at the archaeological site of Igbo-Ukwu (9th–10th century AD), where the burial chamber of a man of chiefly status was excavated. He was dressed in local bast-fibre textiles, with ornaments of beaten copper, cast bronze and imported glass beads; with the body were carved ivories and wood, and cast bronzes. Nearby, a hoard of cast bronze vessels of unknown purpose was also excavated. The cast bronzes, such as the cylindrical stand (right, below) are characterized by profuse and delicate ornament. Male and female figures are depicted, as are insects, which are otherwise almost unknown in African art. Igbo-Ukwu represents the indigenous development of alloying and casting in bronze, independently of anywhere else.

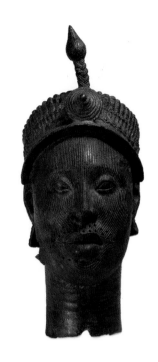

West of the lower Niger the city of Ife flourished from the 11th to the 15th century AD, its wealth deriving from a commanding position on trade routes linking the forests of the lower Niger and trans-Saharan trade via Mali. The art of Ife began with schematic stone carving by hunters; later, the development of farming was accompanied by pottery sculpture and glass bead-making. Ife sculpture is again dominated by the human figure, sometimes life size, much of which is characterized by an extraordinary naturalism. Some examples were excavated in association with semi-circular platforms within the courtyards of houses, suggesting a ritual or commemorative environment, a hypothesis reinforced by the location of some pottery sculpture in sacred groves of the forest surrounding the city. Finally, conquering heroes appear to have brought with them a casting technology of north African origin. Ife art was translated into this new medium, resulting in a series of cast brass and copper figures, and a series of life-sized heads that could have been mounted on wooden frames, the complete ensemble perhaps dressed for the purposes of commemorative celebrations. Some of these were cast showing crowns probably made of carnelian beads, such as the example in brass (right, above).

The wealth of Ife was eclipsed by the rise of other states in the region, especially Edo, also known as Benin City, to its south-east. Once the Portuguese had opened up the possibilities of navigating around Africa to India and beyond, Edo had access to the newly developing coastal trade with Europe. Portuguese traders first arrived in Benin City in 1485, to find a confident, powerful state with established artistic traditions. The Portuguese brought vast quantities of brass bracelets with them to exchange for local goods, and this encouraged the expansion of art in Benin, in particular the introduction of the commemorative plaque, cast in brass (see p.70). **JP**

C. AD 1300	AD 1324	*C.* AD 1400	AD 1472	*C.* AD 1440s–1470s	*C.* AD 1500
Brass casting is introduced into Ife.	Mansa Musa, the emperor of Mali, spends so much gold in Cairo on the way to pilgrimage in Mecca that he ruins the value of money.	Copper-alloy casting is established in Benin City.	Portuguese traders make indirect contact with Edo (Benin).	Oba Ewuare the Great (r. c. AD 1440–73) founds the present Edo political structure and brings Portuguese goods into royal ceremonial.	The *oba* (king) of Benin begins to commission plaques cast in brass (see p.70) for the royal palace in Benin City, capital of the Edo kingdom.

Benin Plaque c. 1500
ARTIST UNKNOWN

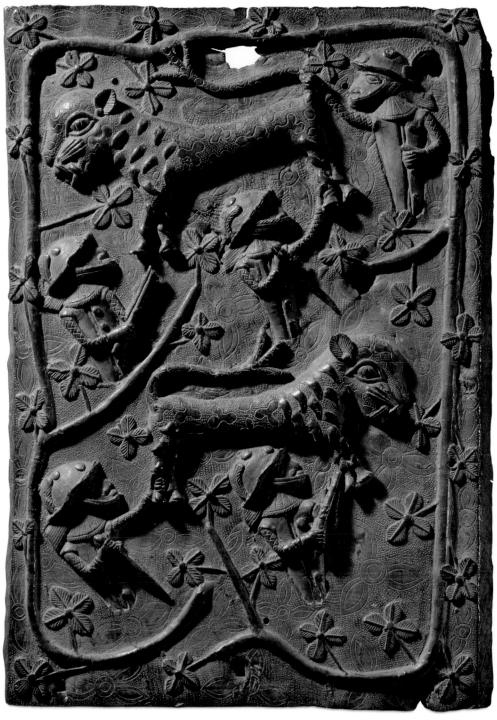

brass
21 3/4 x 15 3/8 in. / 55 x 39 cm
Ethnologisches Museum, Staatliche Museen zu Berlin,
Berlin, Germany

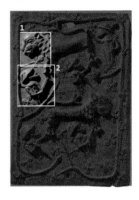

The arrival of the Portuguese in West Africa in *c.* 1460 initiated a period of cooperation with the *oba* (king) of the Edo kingdom of south-west Nigeria. The Portuguese brought with them large quantities of brass and copper bracelets, coral beads and red cloth. The technique of 'lost-wax' casting was already established in the lower Niger region and artists must have been very excited by the new supplies of brass. Although there is no direct evidence of what happened to these bracelets, there was a huge expansion in the art of brass casting and the emergence of a new form—the rectangular plaque. Between 1500 and 1700 several hundred plaques were cast, exclusively for the royal palace in Benin City. Portuguese soldiers assisted the king in his battles, and plaques depicting battles, court ceremonies, and other events often featured the Portuguese.

Dating from around 1500, this plaque is one of the earliest made. It shows a group of Portuguese soldiers in the forest seeking to capture leopards for the royal menagerie. The scene is presented as if seen from above and all the figures are twisting in movement. It is cast in low relief and the layout of imagery seems experimental, as if the artist was trying to interpret the unfamiliar two-dimensional form of a book plate within the three-dimensional tradition of Benin art. The representation of vegetation was uncommon in African art until the 20th century, and the artist may have been shown botanical plates in European books. **JP**

◉ FOCAL POINTS

1 LEOPARD

Two highly decorated and disproportionately large leopards dominate the composition. Their depiction in profile lent itself most easily to casting in shallow relief, although the sculptor achieved fine detail in elements that stand proud from the main image, such as the ear.

2 SOLDIER

All of the Portuguese soldiers are presented with their bodies facing forwards and their heads turned in profile. Their legs seem to taper, the perspective reinforcing the impression that they are being viewed from above. The soldiers are small compared to their quarry.

EVOLVING PLAQUE DESIGN

The succession of *oba*s of Benin exerted powerful control over all affairs of the Edo kingdom and between them commissioned hundreds of commemorative plaques; more than 900 survive in museums worldwide. The earliest plaques were in low relief (opposite), but the sculpted elements of later plaques are much more prominent. By the early 17th century, plaques were higher in relief. The figures become more sculptural, but without movement, and look straight out at the viewer (right). They are usually rendered in social perspective, meaning that the more important people appear larger than lesser individuals. In this example from *c.* 1600, a court priest is shown severing the head of an animal before sacrificing it to the *oba*'s royal ancestors. Five assistants hold the animal steady as he cuts its throat. The two assistants at bottom left appear to be standing under the animal they are holding, an awkward arrangement made necessary by the sculptor's desire to present the figures uniformly to the viewer; otherwise, their backs would be turned.

BYZANTINE ART

1 **Dome of Hagia Sophia, interior (532–37)**
182 ft / 55.5 m high
Istanbul, Turkey

2 **Emperor Justinian's Court (548)**
Artists unknown • mosaic
Church of San Vitale, Ravenna, Italy

In 330, Emperor Constantine I (*c.* 272–337) shifted the centre of the Roman Empire from Rome to Constantinople, on the site of the old Greek city of Byzantium. The move was to have far-reaching consequences for the world of art and architecture. Situated strategically on the Bosphorus Strait, between the Black Sea and the Sea of Marmara, Constantinople was a stage on trade routes linking Europe and the East. The city became a thriving Roman cultural and artistic centre until it was captured by Muslim Ottoman forces in 1453. Byzantine art developed over more than 1,000 years and was distinguished by a fusion of classical Greek (see p.48) and Roman art (see p.62) with an Eastern inclination towards allegory, and an increasing dominance of Christian practice.

The aesthetics of Byzantine art constantly evolved over that period, beginning with the first golden age of Early Byzantine art, which lasted from the founding of the new capital into the 700s. After the period of iconoclasm (destruction of religious icons) of 726 to 843, the Middle Period lasted from 843 to 1261, followed by a final flourishing, termed the Late Byzantine, that endured until Constantinople's fall in 1453. Classicism's realistic representation gave way to a more abstract, decorative art in which shining colour and resonant symbolism were used to create a mystical atmosphere conducive to acceptance of Orthodox dogma. In architecture, the sublime form of the dome graced the many churches constructed to accommodate the spread of Christianity throughout the Empire. Religious mosaics, frescoes, paintings, icons and carvings were designed, predominantly by anonymous artists, to decorate churches and monasteries with scenes from the life and teachings of Christ.

KEY EVENTS

330	402	532	c. 545	692	726
Roman Emperor Constantine I bases his residence in Constantinople. The city becomes capital of the Roman Empire in 359.	Ravenna succeeds Milan as the Roman capital. In 410 Rome is sacked by the Visigoths.	Emperor Justinian I (r.527–65) starts to build Hagia Sophia (above), the largest cathedral in the world until 1520. It takes only five years to complete.	Craftsmen create an ivory throne for Maximian, Archbishop of Ravenna; it is one of the finest examples of ivory carving in the Early Byzantine period.	Justinian II puts the full-face image of Christ on gold coins.	Emperor Leo III sparks a debate on the role of art in religious worship when he removes a famous icon from an imperial palace gate in Constantinople.

For the Byzantines, the emperor was God's representative on earth. The magnificent mosaic in the church of San Vitale in Ravenna (below) was commissioned by Emperor Justinian I after his army seized the Italian city from the Visigoths in 547. The emperor stands at the centre of the mosaic, his halo proclaiming his theocratic status and a golden paten, used for distributing communion breads, in his hands as he celebrates Mass with members of both the clergy and his army. Bringing together the church, state and people, the mosaic was powerful propaganda for the emperor as he attempted to win the hearts and minds of those under his dominion.

A decade later, the emperor consecrated the Hagia Sophia (opposite) in Constantinople, which had been only five years in construction. Still one of the largest cathedrals ever built, it was in size alone an awe-inspiring showpiece for Justinian's capital city. However, in architectural terms the avowed purpose of the cathedral was to inspire in the believer a sense of being closer to God. Nothing played a greater part in this than the experience of standing within the cathedral's immense space and looking up into the massive central dome. For the architects, Justinian chose two eminent Greeks, the physicist Isidore of

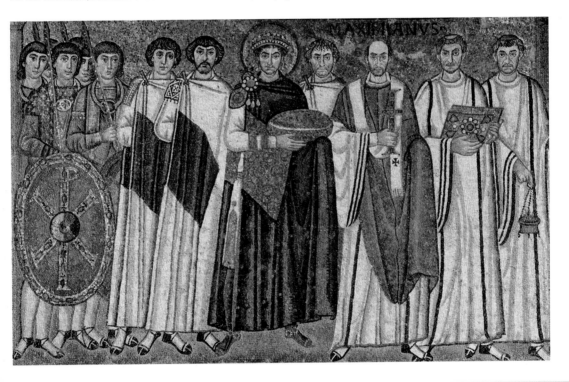

843	950s	1143	1261	1410	1453
The scourge of iconclasm ends and icons are restored to Orthodox worship. The Middle Byzantine period begins.	As the Byzantine military situation improves, patronage of art increases. New churches are built including Hosios Loukas in Stiris, Greece.	Byzantine mosaicists from Constantinople decorate churches in Norman kingdom of Sicily, notably in Palermo and Cefalù.	Emperor Michael Palaeologus regains Constantinople (sacked in 1204 by Crusaders). His reign (1259–82) sees a final golden age of Byzantine art.	Russian painter Andrei Rublev produces his famous icon *Old Testament Trinity* (see p.80).	Constantinople falls to the Ottoman Turks on 29 May after a seven-week siege. The victors rename the city Istanbul.

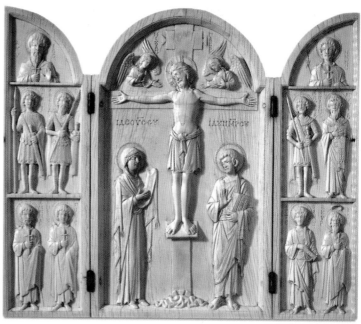

Miletus and the mathematician Anthemius of Tralles (c. 474–c. 534). The structural challenge was to support a large hemispherical dome over a square base. In the event, four massive columns were built, one at each corner of the square. On top of these were four arches. The spaces between the arches were filled with masonry to create curved triangular shapes called pendentives, which together with the tops of the arches formed a strong base for the dome. With light flooding in from forty windows at its base, the dome seemed to float above the nave. At the centre of the dome was a stern image of the all-embracing Christ Pantocrator, 'Ruler of All', master of the material and spiritual worlds. Although nearly all of the original frescoes and mosaics of the Hagia Sophia have disappeared, some fine representations of Christ Pantocrator have survived in other churches and monasteries, such as Monreale Basilica in Sicily (1180–90; see p.78). Inside the cathedral, marble pillars, rich, glittering mosaics and hangings presented a vision of heaven.

The deliberate use of colour is a vitally important characteristic of Byzantine art. In the vault mosaic of the Cappella di San Zenone in Rome there is an example of a youthful Christ making a gentle gesture of benediction. Christ's majesty is indicated with purple-red, the colour of imperial vestments (linking the figure of Christ with the emperor), and blue represents the sky and the heavens beyond. The Byzantines also selected colours for their capacity to reflect light. In Byzantine churches, light falling from windows in the upper stories was directed on to mosaics made up of glass and highly reflective golden and coloured ceramic tiles. These covered the walls and floor, capturing and diffusing the downpour of light and creating a shimmering and appropriately mystical effect. Gold mosaic tiles, in particular, were intended to illuminate the images 'from within' and were used to create certain illusions; for example, the holy figures in cupola mosaics seemed to step out of their golden background and approach the viewer .

Within the spiritual realm of Byzantine art there also existed a strong sense of order, a prized attribute essential to the survival of the Byzantine Empire. Mathematics, the theory of numbers and pure geometry were revered as the highest of the sciences, and most artists had a working knowledge of

simple geometry and measuring. The Borradaile Triptych (opposite) is a model of mathematical symmetry. Made from ivory, it shows Christ on the cross; two angels hover, one on each side of Christ's head and two archangels, Michael and Gabriel, are placed atop the side panels; the figures of the Virgin Mary and St John the Evangelist stand on either side below Christ and four pairs of saints balance the side panels of the triptych. This exact harmony was believed to reconcile and integrate tensions in Christian thought, such as those surrounding the Trinity. Symmetry and harmony calmed the troubled spirit and mathematics gave rational, intelligible form to it, just as the artwork in itself comprised a visible, tangible and accessible representation of the spirit.

Byzantine notions of beauty embraced a strong sense of hierarchy. The image of Christ, his face gradually more bearded and mature and gazing directly at the viewer, was always the central focus. Other figures stood either to his side or below him, according to their rank, illuminating the central Christian tenet of the relationship of 'the One' to the many. The two-dimensionality of these images and the lining up of figures reinforced the idea of the reassuringly fixed nature of these relationships.

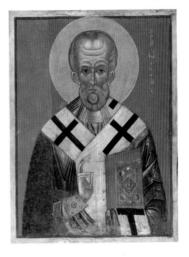

The sense of hierarchy is highly dramatized in the late 12th-century icon of *The Heavenly Ladder* (see p.76) at the Holy Monastery of St Catherine in Sinai, Egypt. The word 'icon' comes from the Greek *eikon,* meaning 'image'. In Byzantine theology the purpose of icons was to create a link between the human and the divine, enabling the viewer to communicate directly with the sacred figures depicted. Byzantine icons had their origin in *acheiropoieta,* images created 'not by human hands' but by divine agency. The term originally referred to the image of Christ's face preserved on linen, which became the prototype of all subsequent icons. These 'miraculous' icons were highly venerated in Byzantium and were used liturgically. Man-made icons, produced by artists in many parts of Eastern Europe, usually consisted of flat panels painted with an image of Christ, the Virgin or another holy person. The icon of St Nicholas (right) derives from the Novgorod School in Russia, which was active from the 12th century. This school continued the Byzantine tradition but introduced brighter colours and flatter forms. Icons were also crafted in media other than wood and paint, such as ivory, marble, metal, mosaic and textile.

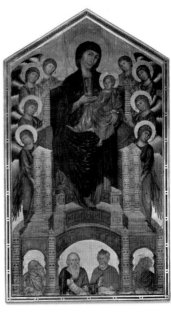

Ivory was one of the most sought-after precious materials and it was brought to the Byzantine Empire from East Africa via Egypt. It became associated with valuable objects made for religious and secular use, such as icons, pyxides (covered boxes carved with scenes from pagan mythology or Christian imagery), consular diptychs (two plaques of ivory fixed together, used to announce an individual's nomination to the rank of consul) and caskets. Such exquisitely carved pieces as the 6th-century Barberini Ivory, now in the Louvre in Paris, were luxury objects combining religious and imperial themes.

In the final period of Byzantine art, painters such as Giovanni Cimabue (*c.*1240–1302) moved away from established conventions towards a naturalism that was further expressed in the paintings of his famous pupil, Giotto (*c.*1270–1337). In Cimabue's icons, such as *Madonna and Child Enthroned* (right), the figures have gentler expressions and make more natural gestures than their predecessors. Orthodox Christianity spurred icon making in Greece and elsewhere, with Theophanes the Greek (*c.*1340–*c.*1410) and his former assistant Andrei Rublev (*c.*1360–1430) foremost in the production of icons that preserved the Byzantine tradition. After the fall of Constantinople in 1453, Russia became heir to the Byzantine civilization. Figures in Russian art became thin and elongated, and the content of images became more emotional. Russian icons are a reminder that Byzantine art was a powerful ally of Christian doctrine and practice and that its history and its legacy are inextricably tied up with the evolution of Christianity. **BD**

The Heavenly Ladder late 12th century

ARTIST UNKNOWN

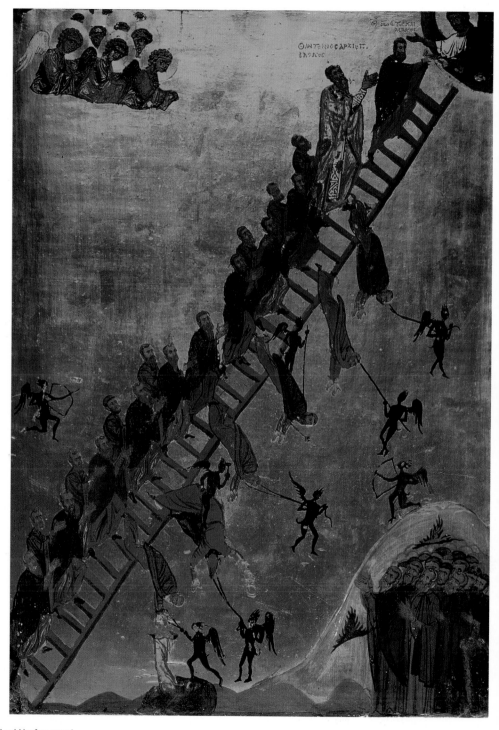

tempera and gold leaf on wood
16 ¹/₈ x 11 ¹/₂ in. / 41 x 29.5 cm
Holy Monastery of St Catherine, Sinai, Egypt

T his Byzantine artwork, which would have been used for spiritual meditation, illustrates a treatise written by John Klimakos, a Christian monk and later abbot of the Holy Monastery of St Catherine on Mount Sinai, Egypt. Titled *The Ladder of Divine Ascent* and written in the first half of the 7th century, the treatise was inspired by the story of Jacob's dream as described in the Book of Genesis, in which he saw a ladder reaching from earth to heaven, and on which angels ascended and descended. In this revered spiritual guide, John Klimakos ('klimakos' means 'of the ladder') describes in detail the thirty stages of spiritual development that lead to ultimate salvation.

The Heavenly Ladder is a dramatization of the principal metaphor of Klimakos's text and the thirty-rung ladder corresponds to the thirty stages of spiritual development that he outlined. Visually, the ladder creates a diagonal line across the centre of the icon, dividing it into two equal parts. Looking above and below the ladder as the monks ascend, led by St John, the viewer is confronted with aspects of heaven and hell, salvation and damnation, and virtue and sin. The monks aspire to reach the figure of Christ, who awaits them with a welcoming gesture at the top of the ladder, acting as a guide into heaven for those who successfully complete their ascent. Their entry to the kingdom of God is by no means guaranteed, however: en route, devils ensnare those whose faith is shaken and snatch them down to hell. **BD**

⬡ NAVIGATOR

◉ FOCAL POINTS

1 HEAVENLY ENCOURAGEMENT

In the upper left-hand corner, where the golden background is at its brightest, a group of robed, haloed angels echo the praying gesture of the monks on the ladder below. Their benevolent smiles radiate over the spectacle and they are clearly praying for the success of the climbing monks.

2 LEADERS

The figure in black at the top of the ladder is John Klimakos, the author of *The Ladder of Divine Ascent*; the figure below him is that of the bishop Antonios. Both men have successfully completed the spiritual journey and are meant to inspire those who literally and spiritually follow in their footsteps.

3 DIVINE WELCOME

Christ greets the successful members of the faithful as they approach heaven. His robe, like those of the angels, is fine and brightly coloured, contrasting with the sombre hues of the monks' earthly attire and the plain black of the devil-like figures playing havoc below him.

4 AGENTS OF LUCIFER

Nine winged and suspended demonic figures are shooting arrows at and spearing wavering monks, pulling them towards hell. This is a vivid reminder of the terrible fate awaiting those who abandon their faith or fail to achieve the virtues outlined in Klimakos's treatise.

5 AWAITING THEIR TURN

Diagonally opposite the angels, in the right-hand corner, a chorus of earthly monks watch their fellows. Their open hands suggest benediction and supplication, blessing those who are on the journey up the ladder while they prepare themselves to undertake the same process.

6 MOUTH OF HELL

Monks who submit to temptation and thus become vulnerable to the black figures are thrown into the mouth of hell. Their subsequent fate is unknown, leaving the faithful at liberty to draw on their own fears and imagine what their own punishments in hell might be.

Christ Pantocrator 1180 – 90
ARTISTS UNKNOWN

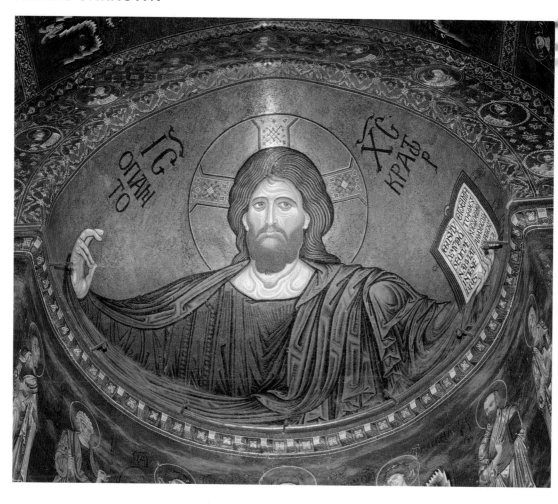

mosaic
276 x 516 in. / 700 x 1300 cm
(figure of Christ, central apse)
Monreale Basilica, Sicily, Italy

⚙ NAVIGATOR

This majestic mosaic from the Middle Byzantine period is located in the central apse above the main altar of the Orthodox Monreale Basilica in Sicily. The dominant figure is Christ Pantocrator, 'Ruler of All'. His sweeping gesture, which follows the shape of the apse, embraces the viewer by opening up the space below and is a reminder of Christ's magnanimity. Christ's standing as supreme spiritual ruler and judge of heaven and earth is asserted by the traditional Orthodox halo with its central cross, symbolizing Christ's Passion. As is typical of Byzantine church decoration, art and architecture create a harmonious, peaceful environment for reflection.

It is an indication of the spreading influence of Byzantine art and culture that the Norman King William of Sicily (1154–89), who founded the cathedral in 1174, decorated the Italian basilica with 130 mosaic scenes from the Old and New Testaments, all conforming to traditional Byzantine techniques and aesthetics. In accordance with Byzantine devotion to symmetry and hierarchy, on the apse wall directly below Christ Pantocrator is the figure of the Virgin with the Christ child on her lap; to her right is the Archangel Gabriel and to her left is the Archangel Michael; by the side of each are six apostles; flanking the window below are fourteen saints, seven on each side. **BD**

1 CHRISTOGRAM

Divided in two, to the left and right of Christ's head, is the Christogram, or monogram, 'ICXC', an acronym in Eastern Orthodox Christianity for the Greek words for 'Jesus Christ'. The bar over the 'IC' and 'XC' is a *titlo*, an old Cyrillic symbol used here to indicate that 'ICXC' is a sacred name.

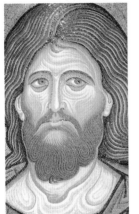

2 FACE OF AUTHORITY

The depiction of Christ with a melancholy or stern expression on his face is typical of images of Christ Pantocrator. The frontal orientation of the face is an indication of Christ's readiness to be accessible to the viewer and desire to engage him or her. However, Christ's eyes are not focused on the viewer but on the spiritual realm—the worshipper is reminded that the Almighty's constant gaze, though all-inclusive, is that of a higher, more spiritual being.

3 MESSAGE FROM CHRIST

The gospel in the left hand of Christ is open at John 8:12: 'I am the light of the world. Whoever follows me will never walk in darkness.' There are many biblical references to Christ as the origin of internal light and this is also suggested by the luminosity of the gold mosaics around him.

4 GESTURE OF BENEDICTION

The right hand of Christ is held in a typical Eastern Orthodox gesture of benediction, or blessing, one that appears in many traditional Eastern Orthodox icons of Christ Pantocrator. The position of the fingers and thumb expresses the Greek letters 'I', 'C', 'X', and 'C', forming the Christogram 'ICXC'. Apostles, saints and clergy are also seen using the gesture in Byzantine portraits, and Eastern Orthodox priests continue to use the gesture in benediction today.

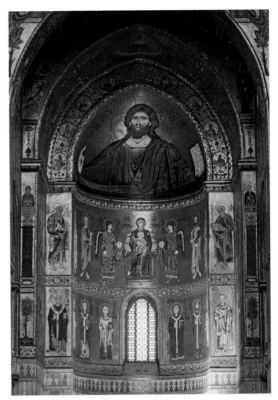

▲ Christ Pantocrator and the Virgin Mary dominate the central apse; apostles and saints cover the walls to their left and right.

BYZANTINE MOSAICS

To create Byzantine mosaics such as the *Head of St Peter* (1210; below), artists applied thousands of small, individually cut stones or pieces of glass, called tesserae, to a plaster surface on which an initial drawing of the image had been etched. In keeping with the sacred subject matter, special glass tesserae called *smalti*, manufactured in northern Italy and made from thick sheets of glass, were used alongside marble, natural stone, mother-of-pearl, precious stones and overlaid gold and silver leaf.

Old Testament Trinity 1410

ANDREI RUBLEV c. 1360 – 1430

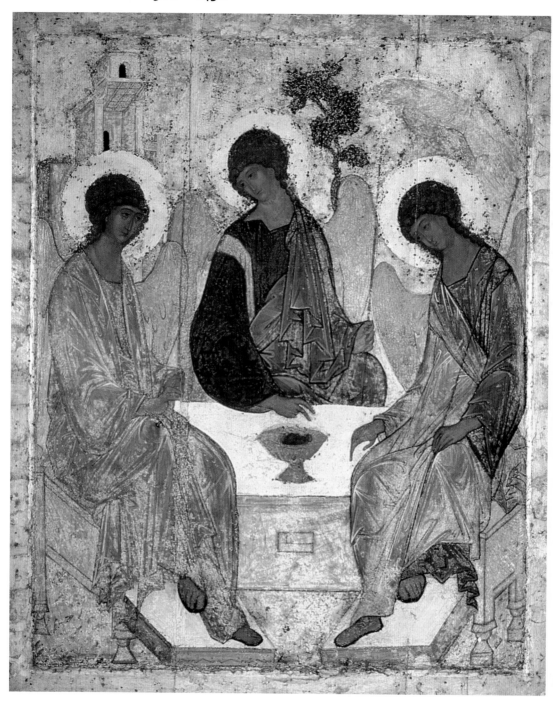

tempera on wood
56 x 45 in. / 142 x 114 cm
State Tretyakov Gallery, Moscow, Russia

This Byzantine icon, intended to stimulate spiritual contemplation in the Christian faithful, was painted by the Russian artist Andrei Rublev. It is based on the Old Testament story of the visit of three wanderers to Abraham and Sarah near the oaks of Mamre (Genesis 18: 2–15). Rublev's title suggests that he envisions the three figures, which at first appear to be angels, as symbols of the indivisible Holy Trinity; the figure of the Father is seated on the left, the Son in the middle and the Holy Spirit on the right. Visually, Rublev achieves their unity in various ways: through their peaceful and languid poses seated around the table; the similarly gentle expressions of meditation on their faces; the inclusive circularity of their gazes; and the shared intense blue of their robes, as well as the staff that each of them holds. The viewer appears welcome at their table: a place is left open in the foreground.

The welcoming atmosphere of the icon is reinforced by its typically Byzantine visual harmony and symmetry, which assist the artist in his aim to express the virtues of love and acceptance while making a theological statement on the unity of the Trinity. In keeping with Byzantine tradition, Rublev's choice of colours serves to both distinguish and unify the three figures; at the same time it creates a light that seems to emanate from within the work itself. The light gold and orange hues bathing this work give it a warmth, majesty and luminosity that account for its spiritual resonance. **BD**

◆ NAVIGATOR

👁 FOCAL POINTS

1 BIBLICAL SYMBOLS

The house pictured behind the Father symbolizes the place of eternal salvation; the tree behind the Son suggests the Tree of Life and the wood of the cross; the mountain behind the Holy Spirit evokes Mount Tabor, the mountain where the Holy Spirit appeared at Christ's Transfiguration.

2 DISGUISED OCTAGON

The composition's underlying octagonal structure, clearly established at the base by the angles of the floor, typifies Byzantine use of geometry and symmetry. Rublev disguises the underlying octagon with the curves of the haloes and wings of the three figures, as well as the folds of their robes.

3 DIVINE SACRIFICE

The table doubles as an altar. The chalice in the middle of the table holds the head of the sacrificial calf, the animal Abraham killed to feast with his visitors. It also references the Lamb of God, the symbol associated with Christ's sacrificial death, which opened the way to man's salvation.

4 CIRCLE OF GAZES

The angles of the heads and the gazes of the three figures direct the viewer's gaze in an anticlockwise circular motion around the painting. The open circle made by the three figures is welcoming to the viewer, a gesture of inclusion that is typical of Byzantine art.

⏱ ARTIST PROFILE

c. 1360–1404

Andrei Rublev's precise date of birth and birthplace are unknown. In his early years he is believed to have lived near Moscow in the Trinity Lavra of St Sergius, the spiritual centre of the Russian Orthodox Church.

1405

Rublev is first officially recorded as being one of the artists commissioned to paint frescoes and icons for the Moscow Kremlin's Cathedral of the Annunciation in 1405. A junior painter at the time, he is thought to have been trained by Theophanes the Greek (c. 1340–c. 1410).

1406–27

In 1408 Rublev, together with Daniil Cherni, painted in the Assumption Cathedral in Vladimir. From 1425 to 1427 he worked in the Cathedral of the Trinity Lavra of St Sergius, the monastery where he once lived.

1428–30

After the death of Daniil Cherni, Rublev travelled to Moscow's Andronikov Monastery, where he painted frescoes for its Saviour Cathedral. He died soon after Cherni, in 1430.

HINDU ART

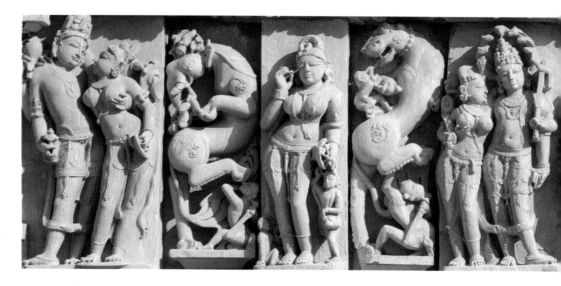

The theme of Hindu religious art is the universe, and its purpose is to link the spiritual and the material worlds. Hindus believe that their icons are imbued with a spirit that permeates the form but is in itself formless, and so they revere an icon's inner spiritual essence above its mundane outer form. Icons may be deliberately blackened with smoke or concealed by cloths even though, paradoxically, scriptures suggest that it is the beauty of form and countenance of an icon that attracts a deity to inhabit the image of itself.

The Hindu devotee acquires spiritual merit through the act of *darshan* (literally sight of, or being in the presence of, a sacred image). By contemplating an image of a god, whether it is directly visible or not, the viewer gains a share of that god's potency. Hindus also believe that there is a relationship between gift-giving and spiritual merit, and worshippers make promises of offerings to their deity or temple in the event that the god fulfils their wishes.

From the 4th to the 12th century, temple sculpture and iconography played an essential part in orthodox Hindu devotion. Hindu art has an aesthetic that involves the communication of *bhava* (mood), beauty and *rasa* (taste), and Hindu sacred imagery has a language that includes figural forms, symbols and a tendency towards multiplicity. The exterior walls of buildings, such as Kandariya Mahadeva Temple (detail, above), begun by the Chandela King Vidyadhara (r.1017–29), are covered by richly carved and sometimes erotic representations of deities and their consorts. Hindu priests, through complex rituals of consecration and daily worship, maintain the spiritual presence in their temple and its images. In addition to making art destined for temples,

Hindu artists produced a wide range of ritual objects, such as rosary beads, protective kolams or diagrams and artefacts for village and wayside shrines.

Hindu devotion centres on a close relationship with a god or goddess chosen from a range of distinctive deities. In Hinduism, Ishvar is among several names used for God, but this single, invisible, transcendental and all-powerful deity is too remote and impersonal for artistic representation. Instead, Hindus depict the Trimurti (trinity) of principal deities: Vishnu, the maintainer or preserver; Shiva, the destroyer or transformer; and Brahma, the creator. The god Vishnu, responsible for maintaining the order of the universe, is portrayed as a crowned king and holds an emblem in each of his four arms: the conch (representing primeval sound), the discus (linking Vishnu's identification with the sun and his royal power), the lotus (symbolizing the flowering of the universe) and the mace (expressing his royal authority). The sculpture *Vishnu and His Avatars* (right) is damaged and only the arms holding the discus and mace remain. Vishnu has a jewel on his chest and also a thread across his chest. Surrounding him are his avatars, or incarnations on earth. The number of Vishnu's avatars varies in Hindu scripture; the Bhagavata Purana (9th or 10th century) refers to twenty-two. Shiva, the second of the Trimurti deities, has various manifestations including Dakshinamurti (teacher), Bhiksatana (beggar), Bhairava (the most violent and destructive form) and Shiva Nataraja (dancer; see p.84). The third deity, Brahma, though less often depicted, has four heads and four arms; he carries rosary beads, a bow and a water jug.

Goddesses are loved by Hindus and often depicted in Hindu art. Each god has one or more consorts, Vishnu's being the goddesses Lakshmi and Bhudevi. More popular still are independent, more ambivalent female deities such as Shiva's consorts Kali and Durga. Kali is renowned for her lolling tongue, necklace of skulls, black body and vampire-like teeth. Despite her hideous appearance she is perceived as a great protector. In Hinduism the inner power and presence of a deity is of greater significance than a repulsive exterior.

Each Hindu deity possesses a vehicle. Vishnu's vehicle, Garuda, is half man and half eagle and is associated with the sun's movement across the sky. Depictions of such vehicles appear in both Hindu art and architecture. Konark Sun Temple, at Orissa in India, built in the 13th century by the Eastern Gangan King Narasimhadeva (1236–64), was designed in the shape of a colossal chariot with seven horses and twenty-four wheels (representing the hours of the day). Such a chariot was believed to carry the sun god, Surya, across the heavens. Each elaborately carved wheel (opposite, below) has eight spokes; each spoke represents a *prahar* (three-hour period). A wheel thus represents a single day.

Hindu sacred art attempts to envision the invisible and transcendent reality of God. It encompasses the attribution of a soul to every worldly object, a sense of the miraculous and a highly sophisticated correspondence of forms and ideas. Hinduism, and hence its art, is flexible and all-absorbing. **HE**

1 Exterior detail of Kandariya Mahadeva Temple (*c.* 1000)
Khajuraho, Madhya Pradesh, India

2 *Vishnu and His Avatars* (*c.* 10th century)
Artist unknown • red sandstone
54 ¹/₂ x 45 ⁵/₈ in. / 138.5 x 116 cm
Museum of Fine Arts, Houston, USA

3 Wheel of the chariot of the sun god Surya (13th century)
Konark Sun Temple, Orissa, India

c. 850	c. 1001	1003–10	1010–1279	1206	1343
The Tamil Dravidian Chola Dynasty emerges in southern India.	Mahmud of Ghazni (971–1030) launches the first Muslim invasion of India.	The Brihadeshvara Temple at Tanjore, built by the Chola Dynasty, initiates a new style of temple complex in southern India.	The Chola Dynasty dominates southern India. It falls in 1279 following the rise of a rival Tamil Dravidian dynasty, the Pandyans.	The Delhi Sultanate is set up by Qutb-ud-din Aybak of the Mamluk Dynasty, initiating 300 years of Turkic and Afghan rule in northern India.	The southern city of Vijayanagara is completed; it quickly builds an empire and is often in conflict with the Delhi Sultanate to the north.

Shiva Nataraja *c.* 11th century
ARTIST UNKNOWN

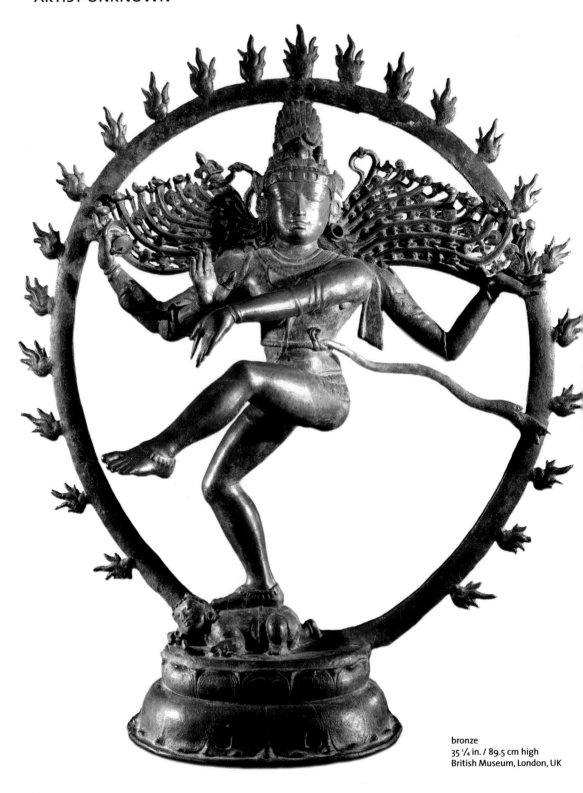

bronze
35 ¼ in. / 89.5 cm high
British Museum, London, UK

Shiva is the Hindu god of regeneration and destruction, and is therefore also the god of paradox. Of his many manifestations, Shiva Nataraja, Lord of the Dance, is the most popular among Hindus. The earliest sculptures of Shiva dancing date from the 5th century but it was under southern India's Chola Dynasty (880–1279) that this iconic representation of the Hindu god emerged, here reproduced in bronze. This icon of Shiva Nataraja is from Tamil Nadu, the dominion of the Chola Dynasty in the southernmost part of the Indian mainland. The god is performing a dance of bliss within a circle of purifying flames that symbolizes both creation and the perpetuation of the cosmos. Under his right foot he crushes Apasmara, the demon of ignorance. Typically of Shiva, who embodies many qualities and their opposites, the figure expresses contrary moods: wild ecstasy in the dance and controlled detachment—his raised right palm is calming and merciful and his left hand points to his foot as a place of refuge.

Shiva's dance in the ring of fire reminds the worshipper of the circle of life and death and its reconciliation through Shiva. In the course of his dance, Shiva reveals five elements. The lotus on which he dances represents the flowering of the earth and the universe; Shiva's sash represents the wind; the flaming disc, the fire and the sun; his hair symbolizes the flowing River Ganges and water; and the universe itself is defined by the intersection of the circle with the limbs and the sash of Shiva. **HE**

FOCAL POINTS

1 MATTED HAIR

Shiva Nataraja is crowned by flying matted hair; this commonly provides a strong design element in depictions of the dancing god. Visible in the hair is a figure of the goddess Ganga, personification of the River Ganges, falling to earth through the god's flying hair as he dances.

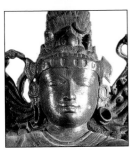

2 SHIVA

Shiva is portrayed here as beautiful; the serene expression on the god's face contrasts with the energy and dynamism of his dance. The sculptor is suggesting that, through belief in Shiva, the soul can be transported from the bondage of ignorance to salvation and eternal serenity.

3 TRAMPLED DWARF

Under Shiva's right foot lies the crushed body of a dwarf. This is Apasmara, who in Hindu mythology is the demonic personification of ignorance and illusion. Nataraja has killed him in the course of his cosmic dance. Apasmara also represents the neurological disorder epilepsy.

ICONOGRAPHY OF SHIVA

Shiva's origins are not easily determined. Some of his attributes suggest that he is an amalgam of several cult deities, including pre-Aryan fertility gods and the fierce Rudra, a minor deity who is mentioned in the Vedas, the oldest scriptures of Hinduism. The earliest examples of Shiva's iconic form come from simple relief carvings from the Gandhara region of India in the 1st century; also, a number of 2nd-century Kushana coins from the north-west of India portray a figure with multiple heads, an erect phallus and a bull mount, all characteristics of Shiva.

The earliest Vedic text, the Rig Veda, refers to phallus worshippers and Shiva has come to be symbolized by the linga, or lingam (the phallus or phallic object). Shiva's first appearance as the linga can be attributed to the 2nd or 1st century BC. The 8th-century Indian linga (right) is sculpted from schist and consists of an erect phallus with four faces of Shiva, each facing in a cardinal direction. Two of the faces represent Shiva in his most terrifying manifestation as Bhairava, associated with annihilation. The remaining two faces, in contrast, show Shiva in a pose of peaceful contemplation.

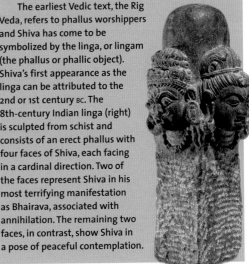

INSULAR ART

T he term 'Insular' is used to denote the art produced in the British Isles from 500 to 1000. More specifically, it is applied to the art of Scotland, Ireland and northern England. National boundaries had little relevance and it is often difficult to be precise about where and by whom an artwork was made, particularly in the case of portable objects such as manuscripts, .

The primary stylistic influence came from the Celts, a loose association of tribes who had originated in central Europe in the 6th century BC. As the Roman Empire expanded, the Celts were either absorbed into it or pushed to the western fringes of the continent. The Romans never conquered Ireland or Scotland and there the Celtic style flourished. Towards the end of the Insular period, there was also some influence from Viking and Germanic raiders who decided to settle. The chief reason for the resilience of the Celtic style was its adaptability; it was based on semi-abstract, curvilinear designs, which worked equally well in different media and on different types of object. Ironically, this meant that the same kind of pattern could be used to adorn a pagan weapon and a Christian manuscript.

The main fields of activity were metalwork, stonework and the production of manuscripts; the term 'Insular' is most commonly used in conjunction with the latter. The manuscripts were generally Gospel Books, which were an important tool for the missionaries trying to convert the local population. The finest examples, including the Book of Durrow (above), the Lindisfarne Gospels (c. 650–750; see p.88) and the Book of Kells (c. 800; see p.90), are adorned

1 **Carpet page from the Book of Durrow (c. 650–700)**
Artist unknown • vellum manuscript
9 ⅝ x 5 ¾ in. / 24.5 x 14.5 cm
Trinity College, Dublin, Ireland

2 **Ardagh Chalice (c. 700–50)**
Artist unknown • silver with silver gilding, enamel, brass and bronze
7 x 7 ⅝ in. / 18 x 19.5 cm
National Museum of Ireland, Dublin, Ireland

3 **Kirkyard Stone (c. 700–800)**
Artist unknown • stone slab
78 ¾ x 51 ⅛ in. / 200 x 130 cm
Aberlemno Churchyard, Angus, Scotland

KEY EVENTS

410	c. 450	c. 560–630	563	597	c. 625
The Romans withdraw from their erstwhile province Britannia in the face of barbarian invasions elsewhere.	Angles, Saxons and Jutes begin to invade eastern Britain and push westwards.	The *Cathach of St Columba*, a manuscript containing the Book of Psalms, is produced in Ireland.	The Irishman St Columba (521–97) sets up a monastery on Iona to bring Celtic Christianity to Scotland and northern England.	St Augustine of Canterbury (d.604), sent by the pope, arrives in southern England to convert the kingdom of Kent to Roman Christianity.	A ship containing treasure is buried at Sutton Hoo in Suffolk, England, probably as grave goods for King Rædweald of East Anglia (r. c. 600–c. 625).

with elaborate calligraphy and portraits or symbols of the four Evangelists; ornamental carpet pages precede each gospel. Their interlace decoration is thought to have an apotropaic function because of its perceived ability to trap evil, and the carpet pages are intended to protect the texts and serve as internal book covers. The most distinctive aspect of Insular manuscripts is the calligraphy. Formed from densely packed spirals and interlacing, it emulates the patterns of Celtic metalwork. Its purpose was practical: the verse and chapter divisions of the Bible had not yet been introduced, so the enlarged initials helped priests to find their way around the text. However, the sight of the dazzling designs would have impressed an illiterate congregation, emphasizing the beauty of the word of God.

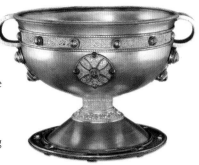

Insular metalwork was produced for both secular and Christian clients. The most famous single item is a piece of jewellery, the Tara Brooch, which was discovered in 1850 on the beach at Bettystown, County Meath. It dates from the 8th century and is a masterpiece of intricate design. The brooch is richly adorned on both sides, which is rare because craftsmen rarely bothered to work on the back of a cloak-fastener as the results would never be seen. The decoration consists of finely engraved interlacing combined with long-snouted beasts and fishtails. The brooch also features gold filigree and tiny panels of enamel or coloured glass.

Christian metalwork was also based on the style of ancient Celtic designs. The objects varied considerably. There were shrines housing the relics of native saints; decorative metal plaques, which protected the covers of manuscripts; and a broad range of liturgical vessels. The most characteristic type of shrine took the form of a small, portable box in the shape of a house or chapel with a ridged roof. Chalices and processional crosses tended to be more elaborate. The Ardagh Chalice (right, above) was part of a hoard discovered in County Limerick and is the most celebrated example. It is made of beaten silver, adorned with decorative bands of gold filigree and animal interlacing, and was used to dispense Eucharistic wine to a congregation. A girdle of ten filigree panels of animal ornament and interlace encircles the bowl between the handles, and the names of the apostles are incised below it.

Insular stonework consists mainly of monumental crosses, which were erected in the grounds of churches and monasteries. The earliest examples are simple slabs, incised with interlaced patterns or stylized figures. Later versions combine a cross with a wheel—the traditional Celtic cross—and are decorated with biblical scenes. In Scotland, the Picts also produced carved slabs, featuring interlaced crosses, animals and battle scenes, such as the Kirkyard Stone (right). Its vertical arms are inscribed with three separate knotwork designs, the horizontal arms with keywork and the centre is a spiral design. One face depicts the Battle of Nechtansmere of 685 fought between the Angles and Picts, which ended the Anglian occupation of the south of Pictland. **IZ**

c. 650–750	c. 700–800	793	c. 800	865–66	886
The Lindisfarne Gospels (see p.88) are created on the island of Lindisfarne (also known as Holy Island) in Northumbria.	The Tara Brooch is produced in Ireland, a fine example of early medieval Irish metalwork.	The Lindisfarne monastery is burnt to the ground by the Danish Vikings in their first raid on Britain.	The lavishly decorated Book of Kells is produced, probably on Iona, an island off the west coast of Scotland.	The Danish Vikings' Great Army arrives in East Anglia and marches on to conquer York, the capital of the kingdom of Northumberland.	King Alfred of Wessex (849–99) defeats the Vikings at London and agrees to recognize Danelaw, the territory occupied by the Danes in East Anglia.

Lindisfarne Gospels *c.* 650 – 750

EADFRITH (d. 721)

carpet page, folio 94 verso
vellum manuscript
13 3/8 x 9 1/2 in. / 34 x 24 cm
British Library, London, UK

◆ NAVIGATOR

The Lindisfarne Gospels, one of the finest illuminated manuscripts produced in the British Isles, takes its name from the Lindisfarne Priory on Holy Island in north-eastern England where it was created. The monastery was home to a religious community that housed the shrine of St Cuthbert (c. 634–87). A later inscription (c. 970) by a priest called Aldred (who added a translation into English) declares that 'Eadfrith, Bishop of the Lindisfarne Church, originally wrote this book, for God and for St Cuthbert....' The leather covering was fashioned by another bishop, Ethelwold (in office 721–40), and adorned with gold, silver and gems by Billfrith the Anchorite (d. c. 750). Scholars believe that the previous bishop, Eadfrith (d.721), was the artist and the scribe. The decorations follow the pattern of earlier Celtic manuscripts with initial pages (leaves with elaborate, large-scale calligraphy), carpet pages, such as the example shown here, and portraits of the Evangelists (see panel below). Each carpet page forms one half of a double spread. This example from the beginning of the Gospels faces an elaborate initial page. **IZ**

👁 FOCAL POINTS

1 SPIRAL PANEL

The design on the carpet page echoes the decoration on the facing initial page. The four panels of tightly coiled trumpet spirals, inset in pairs at the top and bottom of the page, are mirrored by the spiral roundels that adorn the initial on the opposite page.

2 SMALL CROSS

Normally, carpet pages are purely decorative and full of complex, abstract patterns. In this manuscript, however, each of the carpet pages is based around the symbolism of the Cross. This carpet page precedes St Mark's Gospel and the main cruciform pattern is reminiscent of St Cuthbert's pectoral cross, which has a circular gem at the centre. Four smaller crosses are formed from blue and yellow interlacing on each side of the central disc.

3 STEP PATTERNS

The step patterns in the central disc echo the enamelled panels in contemporary jewellery. The disc also forms the centre of the design's main cross. In addition, there is a diagonal cross, which radiates from the blue step pattern in the disc and terminates in the four panels of bird interlacing.

4 BIRD INTERLACING

Bird and animal interlacing is a common feature of Insular art. The shapes of the creatures are stylized and cannot be identified as any specific kind. Some scholars are convinced that the designs in the Lindisfarne Gospels feature birds common to the region, such as shags and cormorants.

PORTRAITS OF THE EVANGELISTS

The calligraphy and the carpet pages in the Lindisfarne Gospels have their sources in Celtic and Germanic art, but the portraits of the Evangelists stem from a different tradition. They derive from author portraits, found in Late Antique manuscripts, produced in the Mediterranean region. The apostles' robes and sandals are based on classical models and the figures are more naturalistic than the stylized depictions that featured in earlier Insular Gospels. In author portraits, the writer is often pictured with his muse, but in Christian manuscripts the latter is replaced by the Evangelists' traditional symbols portrayed with wings and haloes, floating above the disciples' heads. The image of St Luke (left) implies that the words he is writing help draw aside a curtain in men's minds, so revealing God's teachings. Each time Eadfrith painted one of the Evangelists he followed their portrait with an exquisitely coloured carpet page.

Book of Kells *c.* 800
ARTISTS UNKNOWN

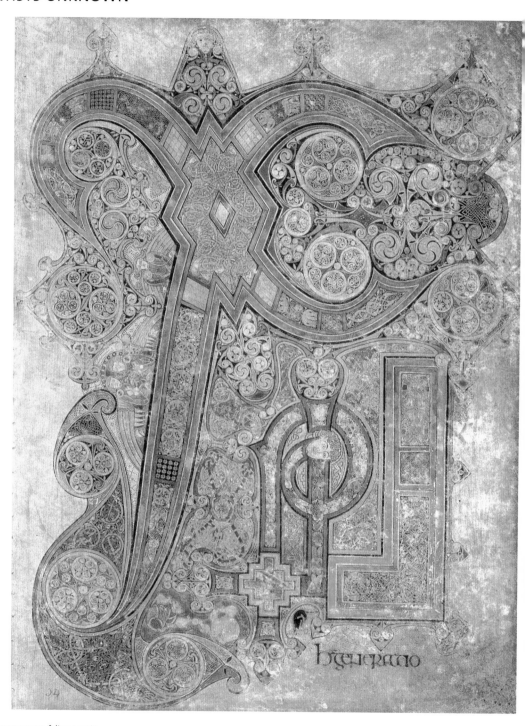

monogram page, folio 34 recto
vellum manuscript
13 x 9 3/8 in. / 33 x 25 cm
Trinity College, Dublin, Ireland

Missionaries carried miniature versions of the Gospel Books with them, often known as 'Pocket Gospels', and grander manuscripts, such as the Book of Kells and the Lindisfarne Gospels (see p.88) were placed on display. The vellum (calfskin) manuscript of the Book of Kells is 680 pages long and consists of a beautifully decorated copy of the four Gospels in Latin. The Gospels are preceded by prefaces, summaries of the Gospel stories and concordances of Gospel passages. The origins of the manuscript are mysterious. Its style dates it to *c.* 800, but the names of its creators are unknown. Most authorities believe that it was produced on the island of Iona, off the west coast of Scotland, but this cannot be known for certain. Intriguingly, the manuscript is unfinished. Many theories have been mooted for this: the project may have been too ambitious, for instance, or key contributors may have perished during a Viking raid.

The chief highlight of the Book of Kells is its intricate calligraphy. The example shown here is known as the 'monogram page' because its main image is formed from the initials 'XP', which is a shortened form of 'Chi-Rho', the name of Christ in Greek. The stylized letter 'X' (Chi) dominates the page, while the 'P' (Rho) is tucked beneath it. While being taught the meaning of the monogram, the attention of converts would be drawn to numerous interwoven symbolic and often humorous pictorial details. The page's function was to introduce the passage in St Matthew's Gospel that describes the incarnation of Jesus. **IZ**

◉ FOCAL POINTS

1 MOTHS AND CHRYSALIS

Near the top of the page, two moths appear next to a chrysalis. They are unconventional religious symbols and refer to the theme of birth and renewal, which is highlighted in this passage. The word *generatio*, which appears at the foot of the page, means 'the birth'.

2 THREE ANGELS

Three angels appear beside the monogram. The lower pair pose lengthwise, with their feet protruding from their robes. The third holds two implements, likely to be *flabella*, or liturgical fans used to drive away insects from the Eucharist and the priest. They are also symbols of honour.

3 MAN'S HEAD

Celtic craftsmen often used stylized images of human heads to adorn precious objects such as the handles of ceremonial swords and daggers, as well as the pins of elaborate brooches. It has been suggested that the head shown here was intended as a reference to Christ.

4 OTTER WITH FISH

An otter holds a fish in its mouth. The fish is an ancient Christian emblem, dating back to the 1st century. The Greek word for 'fish' is *ichthys* and its five letters form the initial letters of the sacred slogan: 'Iesous Christos theou yios soter', meaning 'Jesus Christ, Son of God, Saviour'.

5 CATS AND MICE

Two cats snag the tails of two rodents stealing a communion wafer. They, in turn, have their ears nibbled by a couple of mice. This may be one of many Eucharistic symbols scattered throughout the manuscript or simply an example of the mischievous humour common to Insular Art.

6 KNOTWORK

The Book of Kells is particularly rich in decorative knotwork, in which elements such as serpents and ribbons are interwoven into 'knots' of extraordinary complexity. Strong lenses are needed to fully appreciate the work today, but none were available for the benefit of the artists.

EARLY ISLAMIC ART

slamic art developed in the latter part of the 7th century after the death of the Prophet Muhammad in 632. Islam fostered the growth of a distinctive culture with a unique outlook in both the religious and secular arts. By the early 8th century, the Muslim world had stretched westwards as far as Spain and the kingdom of Al-Andalus, and eastwards to Samarqand and the Indus Valley. In later centuries, Islam expanded west into Turkey, where Ottoman rulers reigned until the early 20th century, and farther east, where Mughal dynasties held dominion over vast areas of the Indian subcontinent, surviving until the British formally abolished the title of 'emperor' in 1858.

The Umayyads (661–750), distant relations of the Prophet Muhammad, formed the first caliphate (or dynasty) in Damascus, Syria, and the formative years of Islamic art occurred under their rule. Religious architecture erected thanks to Umayyad patronage reflected the techniques and styles of existing artistic traditions. The mosaics of the Umayyad Mosque (Great Mosque) of Damascus (705–15), some of which survive on the upper walls of its courtyard (above), reflect the highest levels of Byzantine craftsmanship. The mosaics depict a vast landscape of plants, trees and clusters of buildings, in beautiful tones of green and gold. Even in this early period, Islamic mosaics display a

KEY EVENTS

632	661	691	715	750	836–63
The death of the Prophet Muhammad leads to a dispute over who should be his *khalifa*, or caliph, and ruler of the Islamic world.	Mu'awiya (r.661–80) becomes caliph and sets up the Umayyad Caliphate in Damascus.	The Dome of the Rock, the first major Islamic building, is completed in Jerusalem.	The Umayyad Mosque (Great Mosque) is completed in Damascus.	The Umayyads are overthrown and murdered by the Abbasids, who set up a new caliphate at Baghdad.	The Abbasid capital is temporarily moved to Samarra, north-west of Baghdad.

predilection for vegetal patterns and geometric shapes (referred to in the West as 'arabesques') rather than figural ornamentation. Mosaics at the Umayyad palace of Khirbat al-Mafjar, near Jericho in Palestine, also show the influence of Byzantine decorative motifs and Greco-Roman forms, as seen in the *Lion and Gazelles* panel (opposite, below) in the bathhouse, which depicts a lion attacking gazelles under a fruiting tree.

Under the Abbasid Caliphate (750–1258), the political centre of Islam shifted eastwards from Syria to Iraq, where Baghdad and Samarra became the cultural and commercial capitals of the Islamic world. The decorative arts produced under the Abbasid Dynasty continued with the prolific use of the 'arabesque' form in all media, from wood and metalwork to glassware and pottery. The flow of Chinese wares into the Middle East by way of the Silk Road and other trade routes created a growing demand for tableware and stimulated new developments in pottery-making.

The lustre technique, in which ceramics are glazed with copper and silver compounds to achieve a metallic finish, was invented in Iraq in the 10th century, by Islamic potters attempting to imitate Chinese porcelain. Iraq, Egypt, Syria, Iran and Spain became the main Islamic centres for the manufacture of lustre-glazed ware, and also led the way in ceramic innovation. The second major centre for the production of lustreware after Iraq was established in Cairo, which became the capital of Egypt under the Fatimid Caliphate (909–1171). Although Islam does not permit human figures to adorn artefacts that are intended for religious functions, in the secular arts the depiction of humans was commonplace. The Egyptian bowl (right, below) was first glazed and then decorated with reddish-brown lustre paint. The figure, holding a lamp or censer in his right hand, represents a priest of the Coptic (Egyptian Christian) church. The cypress tree on the right suggests a monastery garden, a common theme in Arabic poetry of the period. Stylistically, Fatimid art as a whole shows the emergence of an unmistakable 'Islamic' style without obvious links to earlier Roman, Byzantine or Iranian art.

Spanish cities such as Córdoba, Toledo and Seville were for three centuries important centres of Islamic learning and scholarship, notably in medicine, astronomy and mathematics. When the Umayyads were overthrown in Damascus in 750, a single prince, Abd ar-Rahman I, escaped to Spain. He established an independent Umayyad emirate with Córdoba as its capital and built the spectacular Mezquita (Great Mosque) in 784. In the Iberian Peninsula, as in the Islamic east, artisans decorating their rulers' palaces combined Roman and Byzantine forms with Arabic inscriptions, symmetrical patterns and leafy scrollwork. Córdoba became a centre for the production of luxury wares, the apogee of which was the production of exquisitely crafted ivories, principally caskets and

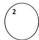
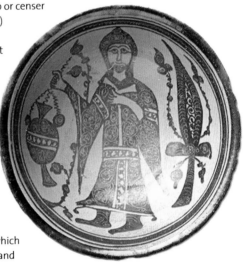

1 Interior courtyard decoration (*c.* 715)
Artist unknown • mosaic
Umayyad Mosque, Damascus, Syria

2 Egyptian bowl (1050–1100)
Artist unknown • fritware with lustre overglaze decoration
9 ¼ in. / 23.5 cm diameter
Victoria & Albert Museum, London, UK

3 *Lion and Gazelles* panel (*c.* 740)
Artist unknown • mosaic
Khirbat al-Mafjar, near Jericho, Palestine

909	912	1238–58	1260	1370	1492
The Fatimid Caliphate is established in Cairo, leading to a revival in the decorative arts.	Abd al-Rahman III (r.912–61) proclaims the Umayyad Caliphate of Córdoba in Spain.	The Alhambra is built as a palace for the Nasrids in Granada, southern Spain.	The Mongol conquest of Islamic lands is halted by the Egyptian Mamluks (1250–1517) at 'Ayn Jalut in Palestine.	Timur establishes his capital at Samarkand, Uzbekistan, and the city becomes a centre of architectural and artistic excellence.	The Christian reconquest of Spain, begun in the 11th century, is completed, ending the rule of the Nasrid Dynasty.

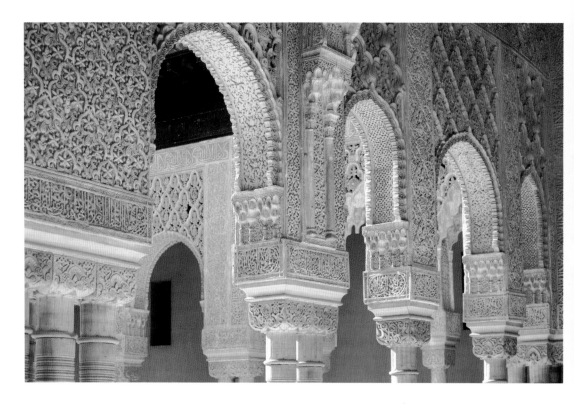

cosmetic cases with densely carved arabesque or animal forms and Arabic inscriptions, often set with gems or gold studs.

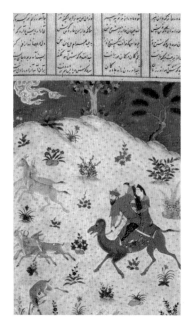

In medieval Islamic Spain, many territories had been ceded to Christian rule and there emerged a small but prosperous principality: the Nasrid Emirate of Granada. For more than two centuries the Nasrid Dynasty (1232–1492) presided over the final flowering of Islamic culture in Spain. With Christian patronage, Islamic scholarship flourished and the production of textiles and lustreware thrived. The principal monument from this period is the Alhambra (c. 1238–1358) in Granada; more a fortified royal city than a palace, it is resplendent with fountains, courtyards, baths, gardens and twenty-three towers, decorated in the Nasrid style with glazed tiles, carved and painted stuccowork (above) and carved wood. The Alhambra houses several outstanding *muqarnas* vaults, in which small, pointed niches are stacked in tiers projecting beyond those below.

The Nasrid Dynasty thrived in Spain until the end of the 15th century, but to the east, Islamic rule enjoyed no such stability. From 1219 onwards the territories of present-day Iran were devastated by repeated invasions by Mongol hordes. Commanded by Genghis Khan (c. 1162–1227), the invaders brought comprehensive economic and cultural ruin to Muslim Iran; in 1258 the Mongol assaults culminated in the sack of Baghdad, in present-day Iraq. Abbasid rule ended and the Ilkhanid Dynasty (1256–1353) came to power. A new political order arose, with the Mongol khans ruling much of Iraq, Anatolia and Iran as sub-states of their vast pan-Asiatic empire.

Despite the rival overtures of Christian emissaries from the west, the Mongol ruling classes eventually converted to Islam, a religious shift that would usher in a period of marked cultural tolerance and a distinctive evolution in Islamic artistic style. The Ilkhanid style developed in Tabriz, a city in the north-west of Iran, and is an amalgamation of three traditions: Chinese, Iranian and Islamic. Perhaps the greatest surviving Ilkhanid monument is the Mausoleum of Sultan Öljeitü (1305–13), in the Ilkhanid city of Soltaniyeh,

Iran. The mausoleum's dome, originally blue-tiled on the outside, remains the highest in Iran. Inside the dome, the gallery vaults (below) display many carved and plaster motifs painted in red, yellow, green and white. The designs have their origin in pattern books or scrolls, confirmation that developments in illuminated manuscripts were finding their way into architectural decoration.

Trade channels from east to west continued to be busy during this period, and the Chinese porcelain and silks being carried west in great quantities were highly influential in Islamic art, particularly in areas such as lustreware, tilework and painting. Indeed, Chinese motifs became inseparable from Islamic art after the 1250s. The lustreware tile (right), from a frieze at the Mongol summer royal palace of Takht-i Sulayman (c. 1270) in Iran, depicts Bahram Gur, future king of Iran, out hunting with his favourite slave girl, the harpist Azada. Bahram Gur is about to shoot a gazelle that is scratching its ear with its foot. Cobalt blue and turquoise lustre paint combine with gold to highlight the scene's principal features.

The blending of Chinese and Mongol styles is nowhere more apparent than in Islamic manuscripts, the most magnificent example of which is the Great Mongol *Shahnama* (Book of Kings). The text, completed in 1010 by the poet Abu al-Qasim Firdausi (c. 935–c. 1020), is an epic based on stories of ancient heroes and kings of pre-Islamic Iran. The illustrated book dates from 1440 to 1445. Fifty-seven of the original two hundred illustrations survive. Like the tile (right, above), the folio (opposite, below) depicts Bahram Gur out hunting with Azada. The *Shahnama* folios are notable for their dense design and spatial complexity with abundant use of colour and Chinese iconography.

A waning of Mongol power in the latter part of the 14th century saw the rise of Timur the Lame (1336–1405), or Tamburlaine as he is more commonly known, whose notorious exploits captured the imagination of Renaissance Europe. During the period of his conquests, artists and craftsmen were spared annihilation, as they had been in previous periods of upheaval, and were transported to his capital, Timurid Samarkand, in modern-day Uzbekistan. There, book illumination and miniature painting continued to flourish, and under Timur the city became one of the world's most glorious capitals. **JC**

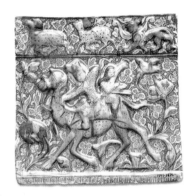

4 Interior decorative work (c. 1391)
Artist unknown • carved, painted stucco
Court of Lions, Alhambra, Granada, Spain

5 Tile from Takht-i Sulayman, Iran (1270–80)
Artist unknown • moulded fritware with colour in, and lustre over, the glaze
12 3/8 x 12 3/4 in. / 31.5 x 32.5 cm
Victoria & Albert Museum, London, UK

6 Interior gallery (1307–13)
Artist unknown • carved, painted plaster
Mausoleum of Sultan Öljeitü, Soltaniyeh, Iran

7 *Bahram Gur Hunting with Azada*,
folio from the *Shahnama*
(Book of Kings; 1440–45)
Artist unknown • ink and watercolour on vellum
6 3/4 x 4 7/8 in. / 17 x 12.5 cm
Royal Asiatic Society, London, UK

The Blue Qur'an *c.* 900
ARTIST UNKNOWN

1 KUFIC SCRIPT

Like the earliest copies of the Qur'an produced in the late 7th century, the Blue Qur'an is written in Kufic, a handsome and strikingly angular script whose name derives from the town of Kufah in southern Iraq. The monumental inscriptions of Jerusalem's Dome of the Rock are also in Kufic script.

2 GOLD AND SILVER

Each vellum folio was made of dried and stretched animal skin, dipped several times in a deep blue indigo dye. The text was first written in gold, then outlined in black ink. The punctuation marks were made in silver, although the ink has since oxidized and taken on a muted dark grey colour.

No more than three or four Qur'anic manuscripts on coloured vellum are known, and of them this copy of the Muslim holy book is the most celebrated. The Blue Qur'an is thought to have come from 10th-century Kairouan in the North African region of the Maghrib (now Tunisia). The manuscript in its entirety would once have comprised around 650 folios, but only about eighteen of them are known to have survived.

A hugely expensive undertaking, the Blue Qur'an may have been commissioned by the then newly established and fast-rising Fatimid Dynasty (909–1171) as an endowment for the Great Mosque of Sidi-Uqba at Kairouan. An entry in the mosque's inventory of manuscripts notes that in 1293 a sizeable Qur'an made of dark vellum with gold Kufic writing existed at the mosque. The Blue Qur'an is of a type unique to the Fatimids. In the late 9th century Byzantine embassies arrived in North Africa laden with luxurious gifts (including manuscripts) in an attempt to prevent renewed Fatimid campaigns against the Byzantine-held regions of Sicily. Among these gifts were Byzantine codices written in gold on parchment dyed with purple. The Blue Qur'an may have been written in emulation of these imperial purple-dyed Byzantine manuscripts. **JC**

gold and silver on indigo-dyed parchment
12 x 15 7/8 in. / 30.5 x 40.5 cm
Metropolitan Museum of Art, New York, USA

DISPLAYING THE QUR'AN

As the sacred book of Islam and the focus point within any mosque, the Qur'an is held in great respect and this status is reflected in the manner in which it is stored and displayed. The Blue Qur'an, for example, was originally contained in an ornate protective case of aloeswood decorated with copper and inlaid with gold. When a Qur'an is opened and displayed, it is customary to raise it above the floor on a stand; this is not a tall lectern at which the reader stands, in the Christian manner, but a portable frame that allows the Qur'an to be read while sitting cross-legged upon the floor in study or prayer. Like storage cases, Qur'an stands tend to be made of intricately carved wood, sometimes embellished with mother-of-pearl. The example (1360; right) was probably made in Iran; the upper section is carved four times with the name of Allah.

NAVIGATOR

CHINESE ART: TANG, SONG AND YUAN

After the fall of the Han Dynasty in 220, China entered almost four hundred years of upheaval, the Six Dynasties Period. Invading northern peoples set up kingdoms, so that life and culture in China were permeated by their influences. This period of transition continued with the Sui Dynasty (589–618), which was followed by the Tang Dynasty (618–906), recognized as the next great outward-looking period in Chinese history after the Han Dynasty. Intensified activity along the Silk Routes led to many foreign traders becoming established in the capital city, Chang'an, and Western influences were strongly felt in textiles, dress and utensils. At the same time, Chinese Buddhism was flourishing, having a marked influence on Tang sculpture and architecture until, late in the Tang Dynasty, it was banned to make way for Daoism. Poetry flourished, exemplified by the two great poets, Du Fu and Li Bai, and the spread of literature was aided by the development of woodblock printing.

An important genre of painting in the Tang Dynasty was *shan shui*, in which natural landscapes including mountains, rivers and waterfalls were depicted with pen and ink rather than paint. Wall painting, which had flourished before the Tang Dynasty, began to decline as artists increasingly turned to working on vertical or horizontal scrolls. Many *shan shui* practitioners were scholars rather than professional artists and did not wish their work to be on permanent display. Their small and elite audience of connoisseurs much preferred to enjoy the exquisite scrolls in their own select company.

1 *Spring Outing of the Tang Court* (c. 750)
Zhang Xuan • coloured ink on silk
National Palace Museum, Beijing, China

2 *Listening to the Qin* (c. 1102)
Emperor Huizong • coloured ink on silk
4 x 6 ³/₈ in. / 10.5 x 16 cm
National Palace Museum, Taipei, China

KEY EVENTS

639	672–75	c. 700	c. 750	c. 960	c. 1080
The Silk Route to the West is reopened by the Tang Emperor Hou Junji (d.643), although it is intermittently closed by Tibetan insurrections.	A statue of Vairocana, the Universal Buddha, 42 ¹/₂ feet (13 m) tall, is carved from a limestone cliff at the Fengxian Temple in Longmen, China.	Li Sixun and his son Li Chao-tao found a northern school of landscape painting, promulgating a highly decorative and meticulous style.	Artist Wang Wei becomes known as 'the poet painter' after he makes an art form of fusing painting with poetry.	Li Cheng, a follower of Jing Hao, paints a hanging scroll entitled *A Solitary Temple Amid Clearing Peaks*, noted for its depiction of animation in nature.	Critic Mi Fu famously proclaims Xsu Xsi as China's master painter, stating that one of his works is worth ten paintings by Zhang Xuan.

Zhou Fang (c. 730–800) was one of the most distinguished Tang court scroll painters. Possibly of noble birth, he was employed to paint religious subjects for the emperor, but this work is less well known than his paintings of court figures, especially of court ladies as they amuse themselves with games and pet birds and animals. Zhou's court portraiture is characterized by a strong sense of psychological truth and it also provides an accurate record of the fashions of its period. Above all, Zhou captures the poise of the portly, elegantly dressed women as they enjoy their sophisticated pastimes.

The Tang court painter Zhang Xuan (713–55) had a style very similar to that of Zhou Fang, and the works of the pair are not always readily distinguished. Zhang's *Spring Outing of the Tang Court* (opposite) depicts the Guo state queen riding with the Qin state queen and their six attendants. The eight riders are set in a well-conceived composition and a spring-like atmosphere prevails, evoked by the ladies' cheerful faces and their magnificent and beautiful clothes.

A third important Tang court artist is Han Gan (706–83). Like Zhou, he painted subjects drawn from Buddhism, but he is now best known for his paintings of imperial horses, commissioned by Emperor Xuanzong (712–56). In works such *as A Man Herding Horses* (c. 740), depicting a man on his horse, he powerfully evokes the spirit of the horse as well as its physical likeness.

After the Tang Dynasty collapsed in 906, military rulers held power in China for the Five Dynasties period (907–60). One of China's most important artists, Dong Yuan (c. 934–c. 962), was then producing figure and landscape paintings that became models of brush painting for the next nine centuries. He and his pupil Juran (a.975) founded the southern school of landscape painting, characterized by expressive brushstrokes and an impressionistic approach. In the north, the northern school of Jing Hao (a.910–50) and his pupil Guan Tong (a.907–23) focused on traditional modes of painting with their formal attention to detail and the use of colour.

When China was reunified under the Song Dynasty (960–1279), the influence of well-educated, civilian administrators was encouraged. Printing was improved by the invention in the 1040s of movable type, which aided the production and circulation of texts. Scholarship was greatly admired, from the top echelons of society downwards, and patronage of the arts burgeoned, not always for selfless reasons. Emperors and officials, ever mindful of the threat from the north, were anxious to commission works that depicted ancient precedents for their own authority. Emperors such as Huizong (r.1100–26) prided themselves on their skill at calligraphy, music and painting, and some of their work has survived. In Huizong's silk painting *Listening to the Qin* (right), the emperor plays the *guqin*, a seven-stringed musical instrument. Appreciating the music of the qin in a beautiful location was regarded as appropriately refined activity for the Song Dynasty's scholarly ruling class and interest in the qin continues to be socially significant in China today.

c. 1104	c. 1130	c. 1200	c. 1280	c. 1320	1345–68
The Imperial Painting Academy, founded in the 10th century to record events and portray nobles, flourishes under Emperor Huizong.	Mi Youren, an art expert at the imperial court, paints *Cloudy Mountains*, breaking with the traditions of the northern school of painting.	Ma Yuan, a court painter of Emperor Ninzong, establishes a 'one-corner' style of composition that leaves much of each work virtually empty.	Shufu porcelain, white with a bluish opaque glaze, is first ordered for the emperor. Some bears the inscription *shufu*, or 'central government palace'.	Zhao Mengfu, a scholar painter who eventually served the Yuan court, produces *Sheep and Goat*, a well-known demonstration of his skills with pen and ink.	After his self-imposed exile to escape taxation, Ni Zan changes his style. He now paints bare landscapes devoid of people.

Another scholarly artist of the Song Dynasty was Zhang Zeduan (1085–1145), whose *Life Along the River on the Eve of the Qing Ming Festival* (detail; above) provides a rich and accurate record of daily life in a city that is probably Kaifeng (then called Bianjing), the Song Dynasty's northern capital, and its immediate environment in the early 12th century. The work, a series of panoramic paintings on a silk handscroll, depicts the activities of the city's inhabitants at the time of the festival. Such is the work's comprehensive documentation of business and leisure pursuits, architecture, scenery, boats and period clothing that it has been dubbed 'the Chinese *Mona Lisa*'. Meanwhile, *shan shui* painting, established in the Tang Dynasty, continued in the Song Dynasty, exemplified by *Early Spring* (1072; see p.102) by Guo Xi (*c.* 1020–*c.* 1090).

During the Song Dynasty period, the balance of population, agriculture, and manufacture shifted south, and this southward swing was hastened by the capture of Kaifeng by Tartar invaders from the north in 1127. The invasion resulted in the partition of the country and the relocation of the Song Dynasty's capital to the southern city of Hangzhou (then called Lin'an). Thenceforth, the period of 960 to 1126 became known as the Northern Song Dynasty, and 1127 to 1279 the Southern Song Dynasty. An area south of the Yangtze River, known as the Jiangnan region, became a centre for culture and the arts after the move and it remains pre-eminent in the field in modern China.

3

5 4

3 *Life Along the River on the Eve of the Qing Ming Festival* (early 1100s)
Zhang Zeduan • coloured ink on silk
9 3/4 x 208 1/8 in. / 25 x 529 cm
National Palace Museum, Beijing, China

4 Trumpet-mouthed vase (early 1300s)
Yuan Dynasty • green-glazed stoneware
14 3/4 x 6 1/4 in. / 37.5 x 16 cm
Yale University Art Gallery,
New Haven, USA

5 *Autumn Colours on the Qiao and Hua Mountains* (*c.* 1295), left half
Zhao Mengfu • coloured ink on paper
National Palace Museum, Taipei, China

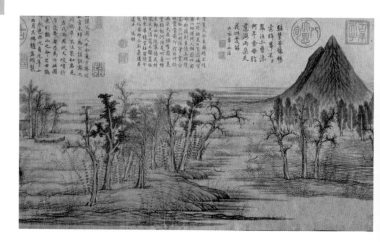

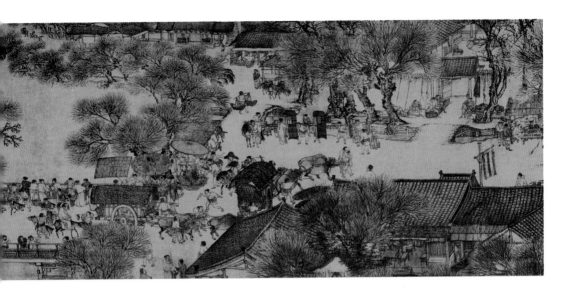

During the Song Dynasty, the learned and wealthier classes became enthusiastic collectors of works of art and antiquities. Painting and calligraphy were the most highly regarded arts, but the manufacture of lacquer, silver, gold, jade and ceramics also flourished. The court's move to the south had been preceded by the establishment in the north of imperial kilns, which were devoted to producing fine ceramics for court use. Of these the most distinguished was the Ru kiln, where ceramics were made for the exclusive use of the Northern Song emperor and aesthete Huizong (1082–1135). After the Tartar invasion of 1127, production of Ru ware ceased, although some of the official court potters may have fled with their patrons and set up kilns in the south. Northern Ru ware is extremely rare, and its subtle green and blue-grey glazes and elegant shapes make it the most avidly sought of Chinese ceramics. Fine green- and blue-glazed ceramics, such as the vase shown below right, continued to be made after the fall of the Southern Song Dynasty.

In 1279 another invading force, the Mongols (who had renamed themselves the Yuan Dynasty in 1271), led by Kublai Khan, finally overran China. Areas of Chinese culture survived and flourished, particularly in the south, but the next ninety years saw China ruled by a foreign power and connected to the wider world of the Greater Mongol Empire. The southern Chinese, who were the last to submit to the Mongols, were discriminated against under the new regime and their artists retreated from public life. Scholar-painters developed a calligraphic style focused on the expression of feeling rather than truth to subject.

One of these scholars, Zhao Mengfu (1254–1322), is known for his beautiful portraits of horses. In 1295, Zhao painted for a friend his most famous surviving hand scroll, *Autumn Colours on the Qiao and Hua Mountains* (detail; opposite), a work that was revolutionary in its innovative layering of foreground, middle-ground and background scenes to achieve a sense of depth.

Flourishing trade links were re-established during the Yuan Dynasty, both by means of the overland Silk Route and through maritime routes. Large populations of foreign merchants inhabited the coastal ports and cultural influences from the Middle East were felt in the decorative arts. At the same time, the Chinese technique of printing with movable woodblocks spread westward into Central Asia. Many new art forms appeared, in particular *zaju*, a kind of vaudeville involving comedy, dance and music. The popularity of *zaju* extended to funerary artefacts—in a tomb in Henan province, fired clay bricks with three-dimensional figurines portraying *zaju* characters lined the walls. **RK**

Early Spring 1072
GUO XI *c.* 1020 – *c.* 1090

hanging scroll, ink and light colour on silk
62 ³/₈ x 42 ¹/₂ in. / 158 x 108 cm
National Palace Museum, Taipei, China

Guo Xi painted *Early Spring*—which belongs to the Northern Song tradition of monumental landscape painting—for Emperor Shenzong (1048–85), who introduced reforms to improve conditions for ordinary people. It was probably intended to glorify Shenzong and, given its size and title, was most likely part of a set made for his palace. Chinese scroll paintings were designed to be viewed section by section, not from one static point of view as became standard in the Western artistic tradition, and Guo Xi employs multiple perspectives here, sometimes looking down on a scene, at other times on the same level. The composition of a massive mountain in the centre, flanked by lesser peaks, was an established metaphor for the structure of the imperial hierarchy with the emperor at its head. Likewise, the theme of spring—with its nurturing rains, warm breezes and sun—acted as a literary metaphor for benevolent rule. Guo Xi contrasts the majesty of the mountains with the routine activities of ordinary people, who appear minute in comparision to the grandeur of nature, a harmonious state that the painting suggests is possible only because of the emperor's wise rule.

With the conquest of North China by Jurchen tribes from Mongolia in 1126, the optimism that had helped give rise to this genre was replaced by a more subdued, introspective attitude. As a result, monumental landscape paintings, such as *Early Spring*, were replaced by smaller handscrolls that had a more limited and intimate scope. **EB**

◈ NAVIGATOR

◉ FOCAL POINTS

1 MIST
The composition is more unified than artworks created earlier in the 11th century, when distance was additive (that is, forms were placed one behind the other), but there is still no continuous ground plane. Guo Xi portrays mist between the middle and far distance to create the impression of gradual recession.

2 DETAIL OF PEAKS
The edges of the rocks in the picture were initially outlined in concentrated black ink, after which Guo Xi repeatedly retraced the outlines with layers of ink wash mixed with blue, blurring them. In this way, the artist achieved the naturalistic effect of rocks apparently emerging out of the mist.

3 FIGURES
The figures in the picture are placed in a rising hierarchy, from the mundane to the spiritual. At the bottom left, two women return home with their children. Above and to the right, fishermen haul in their catch. Midway, pilgrims cross a bridge, presumably bound for one of two Buddhist temples.

4 MOUNTAIN SPINE
Instead of using only one light source, Guo Xi sets brighter areas against dark ones. The treatment of light, and the painting's overall dynamism, reflect the Chinese view of the world as a spontaneous product of qi, or energy. Qi alters with the fluctuating (and opposite) forces of yin and yang.

⏱ ARTIST PROFILE

c. 1020–c. 1067
Born in Wenxian, northern Henan province, Guo Xi was influenced by landscape painter Li Cheng (919–c. 967).

1068–82
Guo Xi became court painter to Emperor Shenzong in 1068 and produced a series of paintings based on the seasons for halls in some of the emperor's palaces. In an essay titled 'Experiences in Painting' from 1075, an official at the court of Bianliang referred to him as the finest landscapist of his generation. Guo Xi considered his greatest achievement to be the series of landscape murals that he was commissioned to produce for a Confucian temple in Wenxian in 1082.

1083–c. 1090
Guo Xi died in c. 1090. He had recorded his thoughts on the art of landscape painting and these were later assembled as a series of essays (sometimes translated as *Lofty Ambitions in Forests and Springs*) by the artist's son, Guo Si. They were presented to Emperor Huizong in 1118 and have established Guo Xi as a great art theorist.

KOREAN ART: GORYEO DYNASTY

1 *Avatamsaka Sutra (Hwaomgyong)*, Korea,
(Goryeo period, 13–14th century)
folded book with illustrated frontispiece;
gold and silver on paper (mulberry)
8 x 17 3/16 in. / 20.4 x 43.7 cm
Cleveland Museum of Art, Ohio, USA

2 Water sprinkler (13th century)
Artist unknown · celadon ware
17 1/2 in. / 44.5 cm high
British Museum, London, UK

3 Hard pillow (Goryeo period, 918–1392)
Artist unknown · celadon ware
3 3/4 x 4 7/8 x 4 3/8 in. / 9.5 x 12.5 x 11.2 cm
British Museum, London, UK

Korea first became known to the Western world during the Goryeo Dynasty period (918–1392); the name 'Goryeo' is the origin of the country's modern name. The founder of Goryeo, Wang Geon (r.918–43), set up a new capital at Gaeseong, situated in present-day North Korea. His policy of expansion northwards resulted in conflict on the northern border. Despite successive attacks by northern tribespeople from Manchuria, cultural and economic exchange with the Song Dynasty in China flourished during the early Goryeo period, leaving deep imprints on Goryeo culture.

The 12th century was a time of peace and prosperity for the Goryeo Dynasty. It was during this period that some of the finest art objects and green ware (known as celadon ware) were produced. Classic, jade-coloured, glazed Goryeo celadons were particularly favoured in China, where they were known as 'first under the heaven'. Korean celadons were distinguished by their *sanggam* inlaid decoration. The hard pillow (opposite, below) is typical of those made for the aristocracy and for Buddhist monks; used for sleeping at night, the pillows were often interred with their owners when they died. Decorated with fine *sanggam* inlay, this example features an openwork pattern based on interlinking chains. Inlay in various materials was widely used in the Goryeo kingdom, not only on celadon ware but also on lacquer and metal. Inlay appears in some of the most exquisite Goryeo works of art. The water sprinkler (opposite, above) is decorated with an inlaid motif of stylized flowers.

While there are ample extant objects of Goryeo decorative arts, little remains of the dynasty's secular painting. However, a government bureau of

KEY EVENTS

c. 660–70	c. 700	918	993–1018	c. 1000–1200	c. 1200
The kingdom of Silla conquers those of Goguryeo and Backje, bringing the Korean peninsula under single rule.	'Pure Land' Buddhism becomes established in the kingdom of Silla.	The Goryeo Dynasty is established at Gaeseong by Wang Geon.	Korea suffers three invasions by Khitan nomads from northern China.	The first Buddhist paintings are produced, although most are later, dating from the 14th century.	Celadon production reaches a peak of artistic and technical skill.

painting was established at the beginning of the Goryeo Dynasty period. Yi Nyeong (active during the reign of Injong, 1122–46) was a famous professional painter and his works were praised by Emperor Huizong of Song China. A popular scholarly activity of the Goryeo period was to make paintings in monochrome ink of the so-called 'Four Gentlemen'—namely bamboo, orchid, plum blossom and chrysanthemum.

The military held power for nearly a century after a coup d'état in 1170, until Mongol invasions (1231–59) led to a restoration of the court's political authority. In 1259 the Goryeo court signed a peace treaty with the Mongols, soon to be officially commanded by the Yuan Dynasty. For the first time the Korean peninsula was controlled by a foreign power. Goryeo crown princes were obliged to reside in the Yuan capital until they ascended to the throne, taking Mongol princesses as Goryeo queens. The Mongolization of the Goryeo court was extensive: Mongol names were taken, the Mongol language was spoken and Mongol dress and hairstyles were adopted. This political alliance resulted in close cultural and economic ties between the Goryeo and the Yuan.

Neo-Confucianism was introduced to Korea from China by the Yuan Dynasty. The impact of Yuan ceramics on Goryeo celadons began to appear in both their shapes and designs. Yuan artists were invited to Goryeo and many exquisite sculptural and painted images in the Buddhist style were produced during this period. At the request of the Yuan Dynasty court, Goryeo scribes and painters travelled to China, bringing illuminated sutras such as the illuminated manuscript from the *Avatamsaka Sutra* (opposite). This is the frontispiece of a multi-volume sacred text and its golden brushwork depicts a temple courtyard in front of which stands a group of figures. The tallest figure, Buddha of the Future (Maitreya), addresses a kneeling pilgrim who asks him about the path to spiritual awakening. All the text of the sutra is painted in silver. Goryeo illuminated manuscripts were included alongside Buddhist paintings as items of tribute and were treasured in China for their aesthetic and religious qualities. The illuminated manuscripts were also highly praised in Muromachi Japan, where a great number of Goryeo works survive in Buddhist temples.

Buddhism was adopted as the state religion early in the Goryeo period; under the patronage of the royal court and the aristocracy, Buddhist temples increased in number and all aspects of Buddhist art flourished. The desire to promote Buddhism led to the development of printing in Korea. In the early 13th century movable metal type was invented to facilitate the distribution of texts; the oldest extant metal-printed book in the world, *Jikji*, contains the essentials of Zen Buddhism. Meanwhile, the entire Buddhist canon was carved on 81,340 woodblocks, the *Tripitaka Koreana*. Towards the end of the Goryeo Dynasty, however, Buddhism began to fail as the official state doctrine. Indeed, the corruption and the degeneration of Buddhism in the late Goryeo Dynasty period contributed to the downfall of the Goryeo Dynasty itself. **HY**

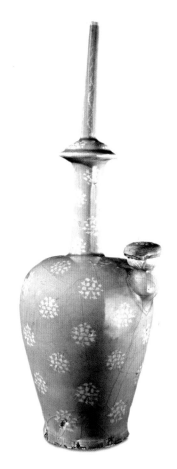

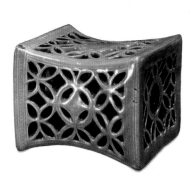

1231	1234	1236–51	1259	1362	1392
The Goryeo kingdom is invaded by the Mongols and succumbs only after a long period of resistance.	The world's first books produced using movable metal type are printed.	The *Tripitaka Koreana*, a collection of 81,340 woodblocks, is carved to produce a new printed version of Buddhist scripture.	The Goryeo kingdom becomes a vassal state of the Mongols and Mongol culture is introduced.	After a long period of indigenous resistance, the Mongols are finally driven out of Korea.	General Yi Seonggye, assisted by the Chinese, overthrows the Goryeo Dynasty and establishes the Joseon Dynasty.

Amitābha Triad 14th century
ARTIST UNKNOWN

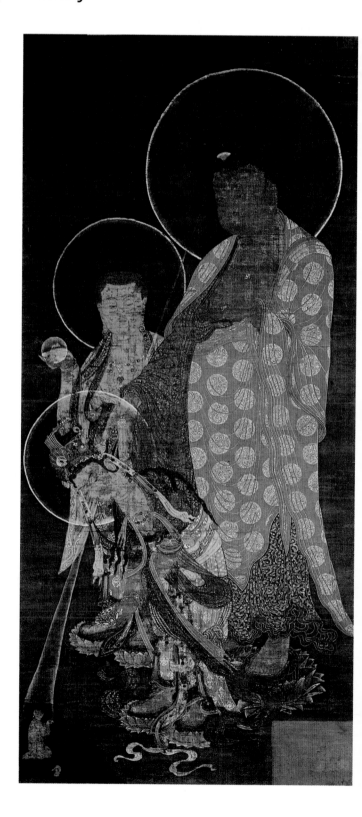

pigment, ink and gold on silk
43 ¹/₄ x 20 in. / 110 x 51 cm
Leeum, Samsung Museum
of Art, Seoul, Korea

During the Goryeo Dynasty (918–1392), the royal family and aristocrats commissioned the best-trained court painters to produce Buddhist works of this type for placing by the beds of the dying, to help them achieve salvation and rebirth in the Buddha's Western Paradise. This 14th-century example, characterized by a balanced composition, meticulous brushwork, luxuriant designs and subtle colours with abundant gold lines, reflects the aristocratic taste and refinement of the Goryeo Dynasty.

Flanked by two attendant bodhisattvas, or 'wisdom beings'—one standing, one kneeling—Amitābha Buddha stands on the right and welcomes the soul of the dying believer, represented by a tiny figure at the bottom left, kneeling with his face raised and hands joined in prayer. It was a common belief during this period that, upon faithful recitation of his name, Amitābha would allow devotees to be reborn in Sukhavati, a Pure Land or Pure Abode specifically for those seeking enlightenment. The head of each deity is surrounded by a golden nimbus, and the Amitābha trio stands on lotus-flower pedestals that symbolize their presence in Sukhavati. The intricate and luxurious designs of their robes are emphasized by a sumptuous yet delicate gold outline. On Amitābha's robe, medallions with lotus arabesques, symbolizing the universe, remain round despite the robe's folds. A beam of light emanates from a gem on the forehead of Amitābha. It is directed at the dying soul, whose attention is focused on the Buddha, reinforcing the spiritual bond between them. **HY**

👁 FOCAL POINTS

1 FACE OF MONK

Ksitigarbha (Jijang)—bodhisattva of the underworld and saviour of all beings from the torments of hell—is the only figure to look directly out at the viewer. He is represented as a monk, with a shaven head and monk's robe, and in his right hand he holds a wish-fulfilling jewel.

2 WELCOMING HAND

The Buddha of Infinite Light, Amitābha, greets the dying soul. His left hand welcomes the soul with a mudra in which the middle finger and thumb are touching. On his chest is the svastika, symbolizing Buddhist teaching, and on his right palm appears the chakra, the Wheel of Buddhist Law.

3 GOLDEN LOTUS SEAT

The bodhisattva of infinite compassion, Avalokiteshvara (Gwaneum), stoops down towards the tiny figure. He is holding the golden lotus seat that will be used to carry the soul to Amitābha's Western Paradise. In the centre of his crown is a miniature image of Amitābha, his spiritual master.

REVERSE PAINTING

Goryeo Buddhist paintings are noted for their calm atmosphere, despite the use of primary colours. In the 14th-century painting *Water-Moon Avalokiteshvara* (below), Avalokiteshvara, the bodhisattva of infinite compassion and wisdom, is depicted in his water-moon guise in a moment of quiet contemplation. The image was achieved using the technique of reverse painting. First the outlines of the image were drawn on the picture surface with black ink or red cinnabar. Colours were then applied to the back of the silk before being painted on the front. Goryeo Buddhist paintings are

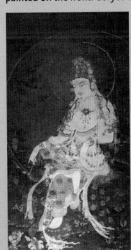

distinguished by the subtle use of colour. Here cinnabar red was used for the garment, along with malachite green, lead white and gold. The colour of the flesh was created by applying lead white and ochre to both sides of the picture surface. Gold was applied after the contours and drapery lines were completed. The technique of applying colour from the reverse obtained unusual softness and depth.

ROMANESQUE

1 *The Temptation of Christ* (*c.* 1120–40)
Artist unknown • fresco (now on canvas)
84 x 118 in. / 213.5 x 300 cm
Metropolitan Museum of Art,
New York, USA

2 *Christ Enthroned* (*c.* 1190)
Nicholas of Verdun • gold and silver gilt
detail from reliquary
Kölner Dom, Cologne, Germany

3 *The Prophet Zachariah* (*c.* 1110)
Wiligelmo • marble
detail from church portal
Duomo di Modena, Modena, Italy

A rt historians coined the term 'Romanesque' at the beginning of the
19th century to describe Western European art of the 11th and 12th
centuries. Most of the art then produced was the output of
monasteries, which were seats of learning and creativity—and very wealthy.
Embroidery, tapestry, statues, icons, frescoes and stained glass decorated
churches; there were also illuminated manuscripts and liturgical items such as
crucifixes, candlesticks and chalices, variously made of metal, enamel and ivory.

The term 'Romanesque' was suggested by the structure of the churches
themselves. They were based on the layout of the Roman basilica with its nave,
apse and aisles, although a transept was added across the nave, along with an
area to allow worshippers to walk around the sanctuary and visit small side
chapels. Churches whose architectural style is classified as Romanesque, with
sculptural facades, round-headed arches and barrel vaults, were constructed in
large numbers from Scandinavia to the Mediterranean. Their marble and stone
carvings are the prevalent surviving examples of Romanesque art, because a
great many frescoes, stained glass windows, manuscripts and embroideries
have disappeared over the centuries.

Romanesque art does not simply mimic the style of the ancient Romans.
Its influences include Coptic art from Egypt; Sassanid art from Persia (modern-
day Iran); Insular art (see p.86) from France, Switzerland, Belgium and Britain;
Barbarian art from Scandinavia and Germany; and Byzantine art (see p.72)
from Greece and Turkey. Conditions of relative peace encouraged trade and

KEY EVENTS

c. 1000	1039–65	1061	1066	1066–68	1073
The cult of the Virgin Mary becomes a popular element in Catholicism, increasing the faith's appeal to a largely illiterate following.	The Sainte-Foy abbey church at Conques, France, is built with a choir and ambulatory, in a departure from Roman architectural precedents.	The Normans, mercenaries in southern Italy since 1016, gradually take over, then invade and conquer Sicily.	William of Normandy invades England. His victory is followed by a building programme, much of it Romanesque in character.	Abbot Desiderius oversees the rebuilding of Monte Casino monastery near Naples, incorporating existing Greek mosaics.	Gregory VII (Hildebrand) becomes pope, claiming independence from secular control.

pilgrimages, and as the faithful criss-crossed Europe's pilgrim routes, so the churches, monasteries and shrines that they visited became ever more ornate.

The Church employed narrative and symbolism to convey the messages of the Bible to its largely illiterate congregations and itinerant guests. The fresco *The Temptation of Christ* (opposite) was originally located in the Ermita de San Baudelio de Berlanga, in the province of Soria, Spain, and is a typically didactic narrative. The work is one of a cycle of frescoes that adorned the church's ceiling and is notable for its bright colour and stylized figures. The large heads, eyes, hands and feet, and expressive, angular features are similar to those of Byzantine iconography. The fresco depicts the story of Christ's temptation by the Devil in the desert and includes three episodes. First the Devil tempts Christ to turn stones into bread to relieve his hunger; he then suggests that Jesus throw himself from a pinnacle to be saved by angels; finally, when the Devil fails, angels provide Christ with sustenance after his forty-day ordeal.

Another example of didactic Romanesque art is a large marble relief, the *Creation and Temptation of Adam and Eve* (c. 1110), on the west facade of the cathedral at Modena in Italy. Modena had become a place of pilgrimage because a relic of Christ's blood was housed there. Once again, the figures' linear form echoes that of Byzantine art. The work, showing Adam and Eve ashamed and wearing fig leaves, is by Wiligelmo (a. c. 1099–1120), Italy's first great sculptor. The relief is one of several portraying scenes from Genesis and is the first known large-scale frieze depicting an exclusively biblical subject. The sculptor also carved twelve reliefs of the biblical prophets, including Zachariah (right), to decorate the church portal. Their arrangement and elaborate scrollwork are similar to those of friezes decorating Roman triumphal arches.

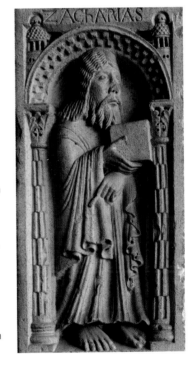

A fine example of Romanesque church furnishing is the Shrine of the Three Magi (c. 1180–1225), the largest reliquary shrine in Europe, located in the cathedral in Cologne. The cathedral was a pilgrimage centre and contains a tiered golden reliquary made to house the bones of the Three Kings. Parts of the reliquary, including the detail of Christ (right, above), were made by French goldsmith and enamellist Nicholas of Verdun (a.1181–1205). Bearing scenes from the life of Christ, including imagery of the apostles and prophets, the reliquary features seventy-four figures that form a narrative sequence within elaborate borders; enamelwork and more than a thousand jewels add rich colour.

Of the illuminated manuscripts that have survived, the English Winchester Bible (c. 1160–75) is one of the most elaborate. Written by a priest in Latin on parchment, it was created for ceremonial use. Monks worked for more than twenty years with materials including gold and lapis lazuli to create the ornately decorated initial capitals that begin each book. The inclusion of animals, plants and naturalistic scenes as decoration is typical of Romanesque art, but the drapery of the figures' clothing and other details differ slightly from Romanesque conventions and point to the Gothic style (see p.128). **CK**

1093	1094	1095	c. 1125	c. 1140	1152–90
Durham Cathedral is begun in England. A masterpiece of Romanesque architecture, it is completed within forty years.	The Basilica Cattedrale Patriarchale di San Marco in Venice is consecrated. The church's plan is an adaptation of the Roman model.	Pope Urban II calls for a Holy Crusade to wrest the Holy Places in the Near East from Muslim control.	The sculptural reliefs on the Romanesque tympanum at the abbey in Vézelay, France, are completed.	Abbot Suger begins the Basilique Saint-Denis in Paris. It is the first major structure built in the Gothic style.	Holy Roman Emperor Frederick I Barbarossa encourages a culturally diverse court art, with Romanesque, Islamic and Byzantine elements.

Bayeux Tapestry 1066–77

ARTISTS UNKNOWN

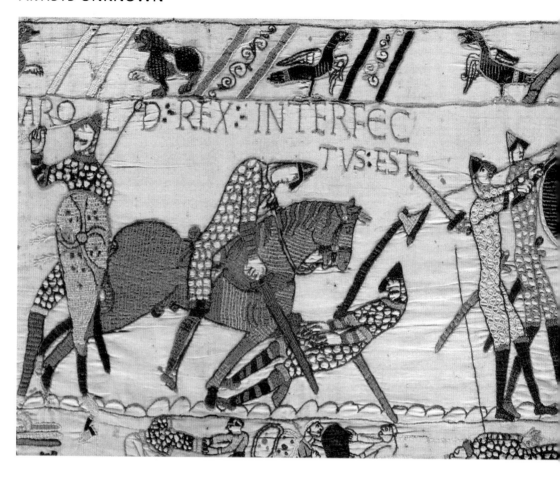

embroidery of woollen yarns on linen
20 x 2760 in. / 50 x 7000 cm
Centre Guillaume Le Conquérant,
Bayeux, France

The Bayeux Tapestry is a piece of embroidery, unique both for its vast size and the events it depicts. It gives an account of William, Duke of Normandy's victory over King Harold II of England, a triumph that led to the Norman being dubbed 'William the Conqueror'. It shows events leading up to the Battle of Hastings on 14 October 1066, from 1064 when the childless king of England, Edward I the Confessor, sent his brother-in-law Harold to Normandy, in France, to offer the English throne to William. In January 1066, Edward apparently promised the throne to Harold, and died. Harold took the crown. Within months, William had gathered his forces to invade England, where he toppled the new king at Hastings. The section of the tapestry above shows the death of Harold and the defeat of his army.

The tapestry was made from nine uneven lengths of thin, linen cloth, all of the same width. Its design, lettering, use of narrative and incorporation of animal themes are typical of north European Romanesque art. Latin is used on its panels, and it is likely that its creation was supervised by a male cleric. The colours used—brown, beige, bronze green, blue-black or dark blue, and yellow—rarely relate to nature; they indicate rather the palette of dyes available at the time. The work is believed to have been made in the south of England, possibly by nuns commissioned by Odo, Bishop of Bayeux, who was the half-brother of William the Conqueror. **CK**

◆ NAVIGATOR

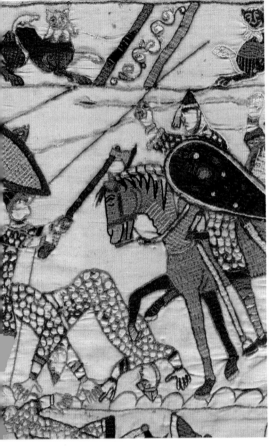

1 DEATH OF HAROLD

Harold was killed after an arrow pierced one of his eyes; he was trying to remove it when he was struck down by a Norman knight. The inscription above him reads: 'King Harold is killed'. William may have later banished Harold's assailant for an act lacking in chivalry.

2 PICTORIAL BORDERS

The borders at the top and bottom of the work act as a frame and include stylized depictions of animals as well as scenes such as fields being ploughed, indicating the season. The embroidery, which features 626 people (three are women), is a unique record of life in the 11th century.

3 VARIETY OF STITCHES

Stem stitch was used to create the outlines of the figures and couching stitch was employed to fill them in. Chain and split stitching with coloured wool and linen threads were used to create light and shadow and enhance the relief effect on lettering and objects, including arrows and spears.

NARRATIVE ART

Just like a modern comic strip or movie storyboard, the Bayeux Tapestry tells a story and is a work of narrative art. The work's episodic structure echoes that of illustrations in Anglo-Saxon biblical manuscripts. The purpose of the tapestry was to present the facts of the story, but it also acted as propaganda for William, convincing the viewer that the invasion was entirely just. The scene (right) simultaneously shows Harold being crowned king of England in January 1066 and the chain of events leading up to England's defeat at the hands of the French. Halley's Comet, at the top left, appeared four months after Harold's coronation, but in medieval times a comet was seen as a bad omen and so its presence here suggests that Harold's actions are dubious. Meanwhile, the Norman fleet assembles at the bottom of the tapestry. The symbolic inclusion of the comet and the fleet raises the dramatic tension and presages King Harold II's imminent defeat.

PRE-COLUMBIAN ART

The term 'Pre-Columbian' refers to the civilizations that flourished in the Americas before the voyages of Christopher Columbus (*c.* 1451–1506), which took place between 1492 and 1504. On the northern continent the influence of the Aztecs, or Mexica, had grown in the Valley of Mexico until their empire spanned modern highland Mexico, from the Gulf Coast to the Pacific Ocean. Mexico's Yucatán Peninsula remained under the control of the Mayas, and the Mixtecs ruled part of southern Mexico, although many Mixtecs had to pay tribute taxes to the Aztecs. In South America the Chimú, residing on the north coast of Peru, were conquered by the Incas, whose empire stretched in all directions from the Peruvian highlands into southern Peru and Ecuador, Colombia, Bolivia, northern Chile and north-west Argentina. All of these indigenous civilizations met their demise with the arrival of the Spanish.

The first contact between Spain and America's indigenous traders took place in 1518 on the island of Cozumel, off the eastern coast of the Yucatán Peninsula; the Spanish began to colonize the area a year later. On their arrival the Europeans discovered a region that lacked political unity and consisted

KEY EVENTS

1200	c. 1325	c. 1350	c. 1427	1438	c. 1441
The city-state of Cuzco is founded by the Incas in south-eastern Peru. It becomes the capital of the Inca Empire.	The Aztecs found the city of Tenochtitlán on an island in Lake Texcoco in the Valley of Mexico. It is the site of modern-day Mexico City.	The Chimú kingdom is founded along the north coast of Peru.	Itzcoatl (r. *c.* 1427–40) becomes the Aztec emperor. He forges the Triple Alliance with the cities of Texcoco and Tlacopan, and the Aztec Empire grows.	Yupanqui comes to the Inca throne as Pachacutec (r.1438–*c.* 1471), initiating a period of rapid expansion throughout the Andes.	A revolt in the Mayan city of Mayapán in Mexico leads to its being abandoned. The Yucatán Peninsula divides into competing city-states.

of a large number of distinct groups with shared cultural characteristics. The forms of late Pre-Columbian art therefore vary according to region and cultural heritage. Nevertheless, land trading routes between the indigenous groups were well developed and a commercial sea route followed the Yucatán Peninsula coastline. Analysis of goods that were carried from their place of origin has enabled archaeologists to discover which articles were traded and which artefacts and ceramic styles came to influence later art.

The Aztecs developed monumental architecture, stone sculpture and reliefs, ceramics and painting; craftsmen produced sophisticated art forms using feathers, gold and turquoise mosaic. The subjects reflect a complex set of symbols associated with religious rituals, deities and a divinatory calendar that incorporated the agricultural seasons. For example, the *Sun Stone* (opposite, above) was placed in the main temple dedicated to the sun in the Aztec capital, Tenochtitlán. It is thought to depict the face of the sun god Tonatiuh, and the concentric rings surrounding his face contain the names of the days in the Aztec month. His tongue is portrayed as a sacrificial knife and on each side of his face is a circle containing carved claws clutching a heart.

The Aztecs, Mayas and Mixtecs were hierarchical societies and believed the representation of lineage and the nobility to be very important. This is best exemplified by the various codices that have survived, such as the Mixtec codex (1200–1521; see p.116) that relates the life of Lord Eight Deer Jaguar-Claw. The concertina-like codices draw on sophisticated pictorial writing systems and were used for documentary and ceremonial purposes. In the field of ceramics, there was a marked difference between products intended for everyday purposes and those made for ceremonial use; the latter were more elaborate and decorated with painted motifs. Burning incense was regarded as a way in which man could communicate with the gods, and elaborate covers (*xantiles*) for censers (incense burners) were made in human form (right, above), with the smoke directed through the mouth of the hollow figure. The headdress of this censer cover has led experts to surmise that it is a portrayal of Macuilxochitl, or Xochipilli, the Aztec god of music, dance, feasting and sexuality.

The Incas revealed exceptional talent in architecture, stone carving, ceramics, working of precious metals and textiles (see p.114). The Chimú are best known for their shiny black pottery and their metalwork. Both civilizations are famed for their featherwork, made with colourful feathers collected from birds of the Amazonian rain forest and Andes highlands. Feathers were used as components of religious and secular items, such as wall hangings and clothing and accessories worn by the elite, including headdresses, earrings, fans and pectorals. The Chimú pectoral (opposite, below) was probably worn like a bib by a member of royalty and may have been believed to confer additional spiritual power. The pectoral's red feathers are tied in strings and are sewn on to the plain weave backing; the dark blue and turquoise feathers are glued on. **RM**

1 Detail of the Aztec *Sun Stone* (1479)
Artist unknown • basalt
140 ½ in. / 357 cm diameter
Museo Nacional de Antropología,
Mexico City, Mexico

2 Censer cover (*c.* 1200–1499)
Artist unknown • ceramic, pigment
22 ⅝ in. / 57.5 cm high
Metropolitan Museum of Art,
New York, USA

3 Chimú pectoral (*c.* 1470–1528)
Artist unknown • cotton, feathers
and shell beads
13 ¼ x 11 ½ in. / 33.5 x 29 cm
Dallas Museum of Art, USA

c. 1470	1519	c. 1520	1520	1527	1533
The Incas conquer the Chimú kingdom based at Chan Chan in Peru.	Led by Hernán Cortés (1485–1547), the Spanish begin their conquest of the Aztec Empire.	Spanish conquistadors invade the Mixtec kingdom.	The Aztec ruler Moctezuma II (r.1502–20) is killed, and the following year the Aztec capital, Tenochtitlán, falls to the Spanish.	Spanish conquistadors arrive on the Yucatán Peninsula and begin the conquest of the Mayan states; it is completed in 1546.	Inca Emperor Atahualpa (c. 1502–33) is executed by the Spanish conquistadors and the Inca Empire falls apart.

Inca Woven Tunic *c.* 1496
ARTIST UNKNOWN

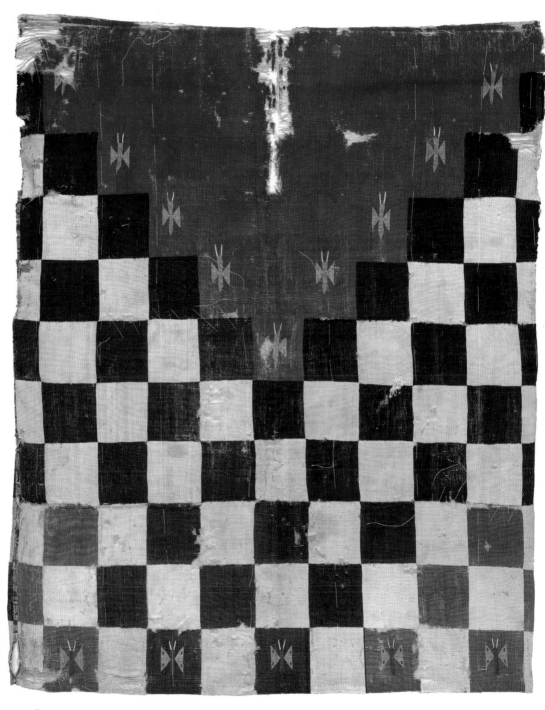

cotton, llama, alpaca
or vicuña wool
36 ¹/₄ x 28 ³/₈ in. / 92 x 72 cm
Field Museum, Chicago, USA

Textiles produced by the Incas and earlier Pre-Columbian civilizations are of great interest to Western analysts, not only because of the variety of vegetable and animal fibres used but also because of the surprising range of colours available to the weavers. Men of the Inca Empire wore a tunic or poncho consisting of a piece of cloth folded in half, with a hole in the centre for the head. The sides were sewn together with openings left for the arms. The name of this garment was an *unku*; a loincloth was worn underneath it and in cold weather the owner might also wear a cotton cape.

Inca men of high status wore an identical garment made of a fine tapestry weave, known as *cumbi*, which was double-sided—finished to the same high standard both inside and out. The garments of the king, or Inca, were the most refined of all. These were woven by the 'Chosen Women' (see panel below) using only vicuña wool. After being worn by the Inca they were destroyed to ensure that no one else ever touched them.

The *unku* shown here is believed to have been of military origin. Such tunics were not obtained directly from the weaver but received as gifts from the Inca himself. The bold design—combining a red triangle and a chequerboard pattern—had a heraldic function in that it clearly signalled the high status of the wearer to the Inca's largely illiterate subjects. Further, the highly visible presence of officials wearing such boldly patterned tunics was a reminder to the populace of the unassailability of the Inca's rule. **RM**

◉ FOCAL POINTS

1 CHEQUERBOARD DESIGN

Of the Inca tunics that have survived, the chequerboard design is the most common. The Spanish chronicler Francisco Xerez (1495–c. 1565) noted that men dressed in livery that resembled a chessboard arrived with the Inca Atahualpa (c. 1502–33) at Cajamarca, Peru in 1532.

2 INSECT MOTIF

The red yoke of the tunic is decorated with golden insects; insects in a different colour scheme embellish the chequerboard hem. The survival of chequerboard and red tunics with no ornamentation suggests that the motifs distinguished the wearer from lesser ranks.

CHOSEN WOMEN

The 15th- or 16th-century golden figure (right), wrapped in a Peruvian textile, which is fastened by a golden pin, represents one of the 'Chosen Women' of the Inca court. From the age of about ten years old, girls were selected for their beauty and taken from their homes to join the court, either at provincial centres or in the Inca capital of Cuzco. These chosen girls, or *acllyaconas*, were the only Inca females to receive an education. Their teachers, themselves Chosen Women who were called *mamaconas*, taught them about the preparation of food and drink, educated them in Inca religion and cosmology and introduced them to spinning and weaving. By the age of sixteen the girls' training was over and they were ready to enter court life. A number of the girls became courtesans of the king or were offered as wives to reinforce political alliances, but the majority became weavers, producing the finest Inca textiles. In addition to the garments made for court members, they produced a stream of artefacts for the Inca to present as gifts, or to use as a form of payment to provincial leaders. No less important was their preparation of food and drink for the many subjects carrying out obligatory work for the Inca. In this role, too, they were indispensable to the smooth running of the empire.

Mixtec Codex 1200 – 1521
ARTISTS UNKNOWN

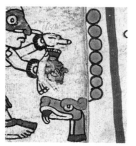

1 CIRCLES AND SERPENT HEAD

Mixtec nobles were named after the day they were born and are identified in the codex by circles and glyphs relating to their calendric names. The seven dots above the serpent glyph is the name for Lord Seven Serpent. Lord Eight Deer Jaguar-Claw's name is indicated by eight circles adjacent to a deer glyph.

2 RED LINES

The codex tells a story, the narrative sequence of which is in a boustrophedon style. This requires the reader to follow the story from right to left and back again, rather than in a linear fashion. The story's direction is indicated by a series of red horizontal or vertical lines.

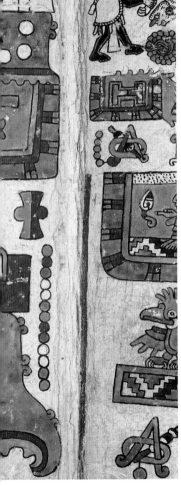

A codex is a type of book normally consisting of separate pages and some kind of binding. However, in Pre-Columbian Mesoamerica, a codex took the form of a long single sheet, made of animal skin or bark covered with lime plaster, that was folded concertina style. Many pre-conquest codices were destroyed or have perished; consequently, those that have survived have become an invaluable source of information. The codices' paintings, full of images of people, animals, objects and architecture, relate epic tales but originally they were more than just historical documents. Their screenfold format allowed them to be unfolded and stretched out for display, like murals on a wall, at council meetings and in rulers' homes. They were often exhibited at royal banquets, where they served as storyboards for poets and actors. Guests watching the play would enjoy refreshments served from pitchers and platters made of polychrome pottery decorated with scenes from the codex.

This Mixtec codex is a screenfold made of forty-seven leaves of painted deerskin. Each side tells a story painted by a scribe. The Mixtecs ruled part of southern Mexico—the area corresponding to the modern-day states of Oaxaca, Guerrero and Puebla—from 950 to 1521. One side of the manuscript relates the life of the Mixtec ruler, Lord Eight Deer Jaguar-Claw (1063–1115), including his five marriages and political and military conquests; the other side records the genealogy of his dynasty until the Spanish invasion of the Mixtec kingdom in c. 1520. Depicting the dynasty's genealogy was a way to display the basis of its right to rule. The section shown here is a folio from the reverse side, which gives an account of Lord Eight Deer Jaguar-Claw's rise to power: the towns he conquered and his meetings with people who enabled his early achievements. Historians have suggested that the codex formed part of the 'Moctezuma Treasure' that conquistador Hernán Cortés sent to Emperor Charles V (1500–58) in 1519. **CK**

facsimile, folio 50, reverse side
paint on deerskin
7 ½ x 9 ¼ in. / 19 x 23.5 cm
British Museum, London, UK

3 EIGHT DEER JAGUAR-CLAW
Lord Eight Deer Jaguar-Claw dominates the codex narrative and is depicted in profile at the top of the image clad in a jaguar headdress and sitting on a throne. According to convention the most important people in a story were shown bigger, with disproportionately large heads, to indicate their status.

4 FISH IN WATER
The Mixtecs showed particular locations in the codex using various conventions, although archaeologists have not yet identified them all. For example, rivers are shown in cross-section, in keeping with the two-dimensional planes used in the codex. The fish in water also indicates a river.

EARLY ITALIAN ART

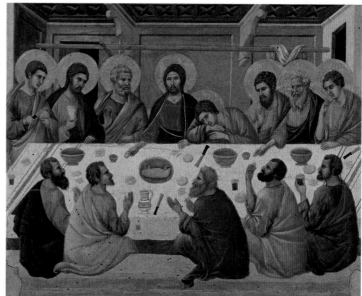

1. *The Last Supper* (c. 1398–11), detail from *Maestà*
Duccio di Buoninsegna • tempera and gold on wood
19 ⅝ x 20 ⅞ in. / 50 x 53 cm
Museo dell'Opera della Metropolitana, Siena, Italy

2. *The Art of Weaving* (c. 1334–38)
Andrea Pisano • marble relief
32 ⅝ x 27 ⅛ in. / 83 x 69 cm
Museo dell'Opera del Duomo, Florence, Italy

3. *Allegory of Good Government* (c. 1338), detail from *Allegory of Good and Bad Government*
Ambrogio Lorenzetti • fresco
Palazzo Pubblico, Siena, Italy

The art of Giovanni Cimabue (*c.* 1240–*c.* 1302) stands at a crossroads in the history of Italian painting. In works such as *Madonna and Child Enthroned* (*c.* 1280–85; see p.75), he developed an artistic language that balances the precise linear style of Byzantine painting (see p.72) with three-dimensional reality. Subsequent developments in Italian art owe much to his achievement. Certainly Cimabue was the most prestigious artist in central Italy when both Giotto di Bondone (*c.* 1270–1337) and Duccio di Buoninsegna (*c.* 1260–1318/19), founder of the Sienese school of painting, began to paint. Giotto's work marks a break with the flat, two-dimensional art of the Byzantine tradition. In the upper basilica of the Franciscan order at Assisi, Giotto used the soaring architecture of the church to frame a narrative cycle in which the illusion of real space, through which figures move with a convincing naturalism and solidity, reflects the message of St Francis's teaching. Giotto continued his experiment when he painted a fresco cycle, including the *Lamentation of the Death of Christ* (1303–05; see p.120) for the Cappella degli Scrovegni in Padua.

Giotto's contemporary Duccio is known principally for his altarpiece, the *Maestà* (above), painted for the cathedral in Siena and completed in 1311. The *Maestà* is considered a milestone in the history of Italian painting, as Duccio breaks firmly with the Byzantine tradition. Even Duccio's contemporaries recognized the importance of his achievement. To celebrate the removal of the work from the artist's workshop, a public feast was ordained and townsmen and clerics formed a solemn procession to take it to the cathedral, as church bells rang out. The gradual liberation of a three-dimensional and realistic art

KEY EVENTS

1259	1260	1285	1294	1297	1303
Sculptor Nicolò Pisano (c. 1220–84) completes the hexagonal pulpit in the baptistery of Pisa. Its architecture is Italian Gothic and its sculptures are antique.	On 4 September Siena defeats Florence at the battle of Montaperti. An era of development follows in Siena and work begins on building the cathedral.	Duccio paints the *Madonna Ruccellai* for the altar of Florence's Santa Maria Novella church.	Giotto goes to Assisi where he becomes acquainted with the works of the *marmorarii* mosaic workers, whose style influences his own.	Construction begins on Siena's Palazzo Pubblico town hall, which will house the republic's government.	Giotto is commissioned to paint the Cappella degli Scrovegni built by papal financier Enrico Scrovegni (d.1336) in expiation of the crimes of his father, a usurer.

from the static Byzantine style was aided by the introduction of narrative and action into painting. This is seen in the fourteen panels on the back of the *Maestà* that depict the Passion of Christ. The exquisite narratives reveal Duccio's talent for embracing the real world. Duccio's effect on the next generation of artists, such as Simone Martini (*c.* 1285–1344), was profound, as seen in Martini's *The Carrying of the Cross* (1335; see p.122).

Between 1337 and 1340 the government of Siena commissioned Ambrogio Lorenzetti (*c.* 1285–*c.* 1348) to adorn the council chamber in the Palazzo Pubblico with a series of frescoes containing a political programme. The images were intended to calm the turbulence of local families and corporations engaged in fomenting factionalism within the city and restore them to greater civil peace and obedience. The frescoes are known as the *Allegory of Good and Bad Government*. The *Allegory of Good Government* (below) shows an old man, dressed in the colours of the Sienese republic, assisted in his work by the cardinal and theological virtues. With a miniaturist's eye for detail, Lorenzetti depicts the effects of good government in a large cityscape, where peace and order reign and the hum and bustle of commerce and life throb within and outside the city walls. The *Allegory of Bad Government* shows a devil tyrant bringing ruin upon the city and devastation on the countryside.

During this period the influence of the Byzantine style alternated with the local classicizing tradition. Sculptors borrowed motifs from antiquity, which they combined with the new developments in realism. The sculptor and architect Andrea Pisano (*c.* 1290–*c.* 1349) is best known for the panels he created for the bronze, southern doors of Florence's Battistero di San Giovanni, completed in 1336. By 1340 Pisano had succeeded Giotto as the master of works to the cathedral in Florence. The stone-relief carvings that Pisano sculpted for the cathedral's campanile form a series portraying the practitioners of the arts and sciences. The hexagonal reliefs, such as *The Art of Weaving* (right, above), demonstrate Giotto's influence in their clear-cut design and detail. **PG**

1308	1311	1315	1322	1348–50	1348–53
Florentine poet Dante Alighieri (*c.* 1265–1321) begins to write the *Divine Comedy*.	On 9 June Duccio's *Maestà* is taken to Siena cathedral accompanied by local dignitaries bearing torches and singing canticles.	Martini paints his first authenticated work, the exquisite fresco in Siena of the enthroned Madonna and Child (*Maestà*).	Florence's wool merchants, the Calimala Guild, first decide to replace the wooden doors of the cathedral baptistery with bronze ones.	The Black Death, one of the deadliest pandemics in history, peaks in Europe; Siena suffers terribly as approximately half the population dies.	Florentine author Giovanni Boccaccio (1313–75) starts to write his collection of one hundred novellas, *The Decameron*.

Lamentation of the Death of Christ 1303 – 05

GIOTTO DI BONDONE *c.* 1270 – 1337

fresco
72 ¾ x 78 ¾ in. / 185 x 200 cm
Cappella degli Scrovegni, Padua, Italy

✦ NAVIGATOR

This panel is part of a cycle of frescoes of Christian Redemption painted by Giotto di Bondone. The frescoes are harmoniously integrated into the interior architecture of the Cappella degli Scrovegni, or Arena Chapel, in Padua. The framed panels highlight the drama of Christ's mission—Passion, Crucifixion and Resurrection—beneath the azure of the vault's ceiling.

In Giotto's scene of mourning, the Virgin Mary, Christ's disciples, Mary Magdalene and other holy women grieve over the body of the Saviour prior to his entombment. The simplified narrative allows the viewer to focus on the most intense moment of the drama. The faces of the sculpted figures are animated and natural, whereas the angels' distress is more theatrical and chaotic. The two groups of figures are united by the diagonal line of the hill; this dynamic use of space is characteristic of Giotto's best work. His considered use of light and shade imbues the scene with a heightened sense of realism that was uncommon in works of this period. Such originality helped to elevate the status of early 14th-century painting to rival that of architecture. **BD**

◉ FOCAL POINTS

1 ANGELS

The weeping angel figures at the top of the fresco look helplessly around them in every direction. Their frantic movement is in sharp contrast to the scene in the foreground; the figures look sculpted, appearing to be held in grief, and their collective gaze is fixed on the figure of Christ.

2 TREE

The leafless tree is symbolic of the withered tree of the knowledge of good and evil. It is diagonally opposite the figure of Christ and emphasizes the barrenness of the scene and the loss of sacred life. It also prefigures the longing for the renewal of life through the Resurrection.

3 COMPOSITION

Giotto's use of the diagonal rocky incline pushes the holy figures into the foreground of the fresco, thus intensifying the emotional quality of the work and bringing the viewer more closely into the drama. It also unites the distinct groups of figures with each other and with the viewer.

4 HOLY WOMEN

The figure of Mary Magdalene holding the feet of Christ brings a remarkably tactile quality to the formality of the composition, underlining Christ's humanity. This is also shown by the Virgin Mary cradling his torso, and the two women who support Christ's head and hold his hands.

5 SEATED FIGURES

The bulky rounded backs of the two seated figures in the foreground lower the centre of gravity of the work and emphasize the earthliness of the event. This serves to dramatize the ascent that is yet to come and to separate the viewer from the scene, as a privileged observer.

▲ The panel *Lamentation of the Death of Christ* is located at the bottom right of this section of the Arena Chapel frescoes.

⏱ ARTIST PROFILE

c. 1270–86

Giotto di Bondone was born in *c.* 1270 in Vespignano, Italy. He studied under Cimabue (*c.* 1240–*c.* 1302) as his apprentice.

1287–1302

He married Ricevuta di Lapo del Pela (Ciuta) in 1287 and the couple had eight children. The artist is known to have been working in Rome between 1297 and the turn of the century.

1303–13

The earliest work by Giotto, also considered his masterwork, is his fresco cycle in the Cappella degli Scrovegni, which he began in 1303. He developed an individual style by depicting holy figures in a more naturalistic manner than was usual in religious works at the time.

1314–27

Giotto spent most of his time working in Florence and Rome. His fresco in the Cappella Peruzzi, located in the Basilica of Santa Croce in Florence, shows his development of chiaroscuro and this work was later studied by Michelangelo.

1328–33

Summoned to the court of Robert of Anjou, in 1328 Giotto moved to Naples, where he worked with a group of pupils. By this time he had developed a more ornate style of painting.

1334–37

In 1334 Giotto was appointed chief architect to Florence Cathedral; he founded its campanile in the same year. Although it became known as Giotto's Tower, the bell tower was not completed to his design. Giotto spent his last years in Milan and Florence, where he continued to paint until his death in 1337. He was buried in Florence.

The Carrying of the Cross 1335

SIMONE MARTINI *C.* 1285 – 1344

tempera on wood
11 ¾ x 8 ⅛ in. /
30 x 20.5 cm
Louvre, Paris,
France

This painting, sometimes titled *The Way to Calvary*, is one of the surviving wing panels of Simone Martini's double-sided quadriptych that shows the scenes of Christ's Passion. *The Carrying of the Cross* depicts the narrative of Christ being led by soldiers out of the city of ancient Jerusalem to be crucified at Calvary. Martini shows a large crowd pouring out through the gates of the city walls, which dominate the background of the painted scene, and the figure of Christ in the centre foreground being swept along by the crowd. He is followed by the familiar figures of the Virgin Mary—who is roughly shoved aside by a soldier and supported by St John—the Angel of the Annunciation and Mary Magdalene, whose arms are raised in a grand gesture of pain and pathos. The perspective of Christ seen from above and afar allows the viewer to appreciate the scope of the drama unfolding; this is expressed in the dynamic movement of the figures in the crowd, the sheer push and pull of its mass and the wide variety of facial expressions that range from anger, pity, pain and curiosity to the sorrowful piety on the face of Christ. The chaos of the densely packed composition is balanced, however, by the rich and refined palette of reds (worn both by Mary Magdalene and Christ), gold and blues. This lyrical, elegant and life-like work demonstrates why Martini was not only the most influential painter of the Sienese School but also one of the most prominent artists of the International Gothic. **BD**

✦ NAVIGATOR

👁 FOCAL POINTS

1 MARY MAGDALENE

The gesture of Mary Magdalene raising her arms heavenward is mirrored by the spears of the soldiers. The contrast between Mary's helpless appeal for mercy and the piercing metal tips of the wooden spears dramatizes the violence and pathos of Christ's impending fate.

2 CITY WALLS

The architecture of the city walls dominates the scene, and the crowd that pours out of the city is integrated in such a way that ancient Jerusalem becomes a key element in the drama. The flow of the crowd joins the static structure of the walls with Christ and the figures in the foreground.

3 CHRIST AND VIRGIN MARY

Christ tilts his face towards the Virgin Mary. In this way Martini establishes a tender complicity between the two figures, which is rendered more pitiful by the angry men who separate them. The contrast between Christ's pain, the Virgin's sorrow and the soldiers' violence highlights the human drama unfolding.

4 WOODEN CROSS

The dark wooden cross rests not only on Christ's shoulders but also atop the crowd, suggesting that all humankind carries the full and symbolic weight of the cross. The life-like depiction of the cross coupled with its potent symbolism epitomizes the International Gothic style.

⏱ ARTIST PROFILE

c. 1299–1314

Martini studied painting from an early age and it is thought that he was an apprentice to the leading Sienese painter Duccio (a.1278–1318/19). Martini's use of decorative patterning and colour is typical of Duccio's style.

1315–34

The artist established his reputation during this period. His earliest surviving work is the fresco *Maestà* painted in 1311 for the town hall in Siena. It was followed by portrait, altarpiece and fresco commissions.

1335–41

By this time, Martini was one of the most prominent Italian painters in International Gothic. His attention to gesture and expression was much admired in France and he worked at the papal court in Avignon from 1335 onwards.

1342–44

Martini continued to paint in his later years and befriended the Italian poet Petrarch, for whom he made various paintings. His elegant style particularly influenced the work of French illuminators and Italian fresco artists.

CHINESE ART: MING DYNASTY

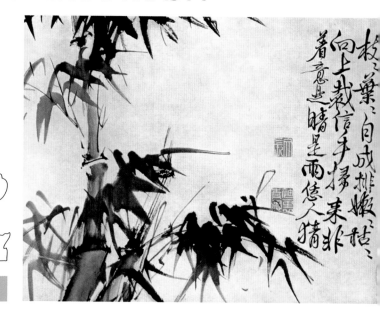

1

2

3

1 *Bamboo* (c. 1540)
Xu Wei • ink on paper
12 ⅞ in. / 32.5 cm high
Freer Gallery of Art, Smithsonian
Museum, Washington, DC, USA

2 **Covered jar with carp design** (1522–66)
Artist unknown • porcelain with blue
underglaze and enamel overglaze
18 in. / 46 cm high
Indianapolis Museum of Art, USA

3 **Roof tile from the Bao'ensi,
Nanjing** (1412–31)
Artist unknown • stone with lead glaze
Nanjing City Museum, Jiangsu, China

In 1368 a native Chinese force drove out the last troops loyal to the Mongol Yuan Dynasty (1271–1368) and established the Ming Dynasty (1368–1644). The court demonstrated its power by building palaces in many locations, including Nanjing and Beijing, and the latter became the new capital. Lavish tombs and temples were also constructed, using precious materials from all over the empire. By imperial decree, more than 100,000 workers built the Bao'ensi (Temple of Gratitude), known to Westerners as the 'Porcelain Pagoda', between 1412 and 1431. The pagoda tower was 262 feet (80 m) high and featured walls of white porcelain bricks sent from the imperial factory at Jingdezhen. There were seventy-two arched doorways of colour-glazed tiles; the roof tile (opposite, below) is typical of the exuberant style of carving and polychromatic decoration. Around 2.5 million ounces of silver were used in the building of the temple, which was razed to the ground in 1854 during the Taiping rebellion.

Ming and Qing Dynasty (1644–1911) emperors started construction of their tombs, within reach of the capital, before they died. Thirteen of the sixteen Ming emperors were interred in tombs built at a special site 30 miles (50 km) north-west of Beijing. One tomb—that of Emperor Wanli (r.1572–1620)—has been excavated. Palatial in size, the tomb held coffins for Wanli and his two empresses, surrounded by twenty-six lacquered cases containing 3,000 treasures in gold, silver, gems, porcelain, jade and silk; a phoenix headdress was encrusted with gold dragons, 150 precious gems and more than 5,000 pearls.

KEY EVENTS

1368	1403–04	1405	1420	1426	1431
General Zhu Yuanzhang unifies China and establishes the Ming Dynasty at Nanjing, proclaiming himself the Hongwu emperor.	The emperor launches five expeditions against the Mongols and campaigns in Vietnam. Elegant porcelain and textiles are produced.	The eunuch admiral Zheng He begins a series of voyages that extend Chinese influence across the Indian Ocean and across Southeast Asia.	Construction of the Forbidden City in Beijing (begun in 1406) is completed, and Beijing is declared the new capital of the Ming Dynasty.	The accession of the Xuande emperor initiates the period in which the finest and most delicate blue and white porcelain ware is made.	The Buddhist 'Porcelain Pagoda', or Bao'ensi (Temple of Gratitude), is completed in Nanjing.

By the early 15th century the empire had become prosperous and stable, allowing the growth and development of an educated elite. This favoured class travelled widely to see artworks in collections and to view beauty spots, habits that are reflected in the painting of the period. Scholars practised painting and calligraphy, collected antiques and works of art, and debated philosophical and aesthetic theory. One Ming scholar was Xu Wei (1521–93), a painter, poet and dramatist. The ink painting *Bamboo* (opposite) displays his technique of broad, dramatic slashes of ink and freely executed lines. It is this freedom of expression, in which the artist seemingly enters into an emotional rather than perfunctory confrontation with his materials, that accounts for Xu Wei's reputation as the founder of modern Chinese painting.

Although the capital city was in the north, an important centre of culture grew up further south. The Jiangnan region, to the south of the Yangtze River, was situated in a fertile agricultural area where many of the raw materials required in civilized life were cultivated, including bamboo and wood for furniture and carving, and silk for weaving. Ports along the coast received imported luxuries such as ivory, tortoiseshell and rhinoceros horn, which had long been prized in China for its reported medicinal powers and for carving; because of its scarcity, the horn was more expensive than gold. Asian rhinoceros horn was imported from India, Nepal, Malaysia, Thailand, Vietnam and Indonesia, and—in the 19th century, with the advent of steamships—also from Africa. In the late Bronze Age the hide of the animal had been used in China to make armour, while the horn was used as a drinking vessel. The horn's use in cup form continued, and Ming Dynasty rhinoceros horn cups were carved in many styles. Some imitated archaic bronze, others were carved with landscapes or in the form of plants and a few were largely undecorated save for details such as handles in the form of Buddhist or Daoist deities.

Unlike the preceding Yuan Dynasty, the Ming government tried to keep strict control of overseas travel and trade. For a short time in the early 15th century, emperors attempted to monopolize tribute trade by sending out seven expeditions under the eunuch admiral Zheng He between 1405 and 1433. These were part-diplomatic and part-trading missions that carried Chinese commodities all over East and Southeast Asia, the Middle East and Africa. From this time onwards, Chinese goods were traded around the world in ever greater quantities.

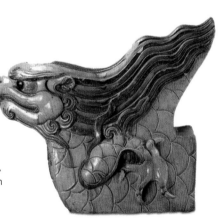

Among the many exported products was Chinese porcelain, which underwent numerous technical advances during the Ming period. The covered jar (right, above) illustrates the Ming development of adding manganese to cobalt blue to achieve a sharper line in underglaze decoration, which would otherwise blur with the glaze. The golden carp, pond vegetation and other decorations were painted on top of the glaze using multicoloured enamel paints, and the overpainting was fired at a lower temperature. **RK**

1449	1516	1577	1582	1616	1644
After a defeat in battle by Mongolian tribesmen at Tumu, the Ming Dynasty begins a major restoration and extension of the Great Wall.	Portuguese ships arrive in Macao, beginning the era of European contact with China.	Large quantities of blue and white wares and other ceramics are produced for domestic use and export at Jingdezhen, in Jiangxi province.	Italian Jesuit Father Matteo Ricci (1522–1610) arrives in Macao. In 1600 he moves to Beijing and introduces the court to Western science.	The Manchu Jin Dynasty is founded in Manchuria by Nurhachi; he begins an aggressive policy of expansion into Korea and China.	Anti-Ming rebels open the gates of Beijing to invaders from Manchuria. Chongzhen, the Ming emperor, hangs himself and the Qing Dynasty is founded.

Ming Imperial Porcelain Jar 1522 – 66
ARTIST UNKNOWN

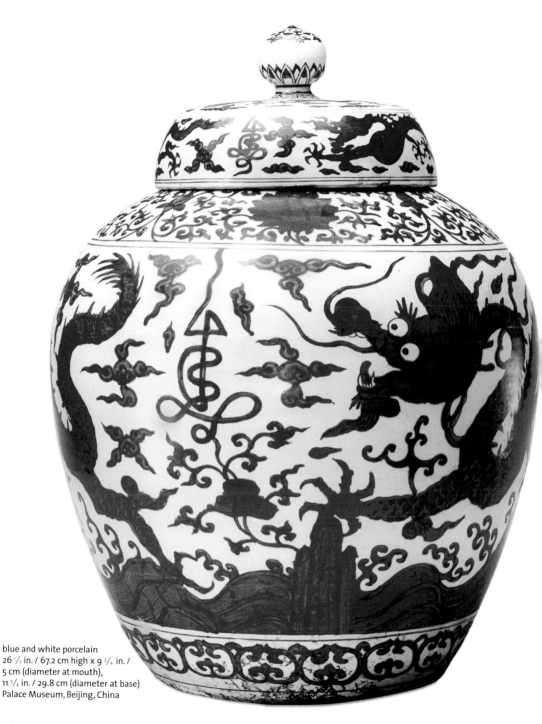

blue and white porcelain
26 ¹/₂ in. / 67.2 cm high x 9 ³/₄ in. /
5 cm (diameter at mouth),
11 ³/₄ in. / 29.8 cm (diameter at base)
Palace Museum, Beijing, China

The first porcelain in China was manufactured around AD 600, although high-fired Chinese ceramics date back 2,000 years. Chinese porcelain was always valued highly, not least by Europeans. Venetian explorer Marco Polo (c. 1254–1324) praised it as resembling translucent cowrie shell, and it was he who coined the term *porcelino*. From the 8th century, court officials requisitioned the finest ceramics from kilns around China for imperial use. In 1278, early in the Yuan Dynasty (1271–1368), a dedicated Porcelain Bureau was set up in the southern city of Jingdezhen, and in 1369, at the start of the Ming Dynasty (1368–1644), a larger Imperial Porcelain Factory was built on the same site. By the Xuande period (1426–35) huge orders from Beijing were common.

This imperial covered jar dates from the reign of the Ming Jiajing Emperor (1522–66), when much of the best porcelain was decorated with a cobalt blue pigment imported from the West known as 'Mohammedan blue' (*hui qing*), identifiable by its characteristic purple tint. Depicted twice on the jar is a dragon flying among clouds, a symbol of the emperor's supremacy and one that the Imperial Porcelain Factory was permitted to include only on wares destined for imperial use. Outside the factory in Jingdezhen, however, many private kilns operated, supplying porcelain to the populace. Large quantities exist of vessels decorated with the emperor's dragon and the empress's phoenix, both of them forbidden symbols, proof that the imperial regulations were widely disobeyed. **RK**

◉ FOCAL POINTS

1 MEDALLION

On the body of the jar, and also on its lid, are medallions in a floral design that signify longevity. The motif of the opening flower signifies the eternal recurrence of spring and is related to *shou*, a stylized Chinese character meaning longevity that often appears in Chinese art.

2 WAVE AND CLIFF

Below the flying dragon are representations of waves and cliffs, the timeless beating of the sea upon cliffs being another symbol of longevity. As visitors to the imperial court would have recognized, the jar's decoration is a reminder of the Ming Dynasty's claim to everlasting power.

3 FLYING DRAGON

Imperial dragons were given five claws because in Chinese numerology odd numbers are lucky and five is an auspicious and powerful quantity. In a metaphor for imperial power, the stylized shapes around the flying dragon represent clouds, indicating that the emperor controls heaven and earth.

PORCELAIN

The manufacture of porcelain, as illustrated by the undated Chinese blue and white plate detail, below, requires porcelain stone (*petuntse*) and porcelain clay (kaolin), which are prepared and mixed with water. The malleable material is shaped and fired in a kiln to temperatures above 2500°F (1250°C), causing it to vitrify. The resulting ceramic is white, hard bodied and durable, and when thin can transmit light. It is also lustrous and can be embellished with coloured glazes, or painted before glazing with pigments such as cobalt blue. Before the early 18th century China enjoyed a monopoly on porcelain production, which accounts for its high value as an export commodity.

INTERNATIONAL GOTHIC

1 *Annunciation* (1422–23)
Lorenzo Monaco • tempera on wood
Church of Santa Trinità, Florence, Italy

2 *Offering of the Heart* (c. 1400–10)
Artist unknown • wool and silk tapestry
97 ¼ x 82 ⅜ in. / 247 x 209 cm
Louvre, Paris, France

3 Wilton Diptych (c. 1395), interior
Artist unknown • egg tempera on oak
22 ½ x 11 ½ in. / 57 x 29 cm (each panel)
National Gallery, London, UK

4 Wilton Diptych, exterior

International Gothic emerged as a style of art in Europe at the end of the 14th century. It was characterized by strong narrative and courtly elegance, coupled with exact naturalistic detail, decorative refinement, surface realism and rich decorative colouring. The style was neglected by historians until the end of the 19th century, when Louis Courajod, a professor at the Ecole du Louvre in Paris, first pointed out its international character—international because of the similarity between stylistic trends and techniques that appeared in geographically distant European centres. Artists from France, Italy, Austria, Bohemia (now the Czech Republic) and England developed an artistic style that intensified elements of the Gothic during its last flourish, and that became a prelude to the Early Renaissance (see p.150).

The development of the International Gothic movement was influenced by the same factors that provoked a European crisis in the political, social and cultural spheres at this time. The decline of the Holy Roman Empire signalled the end of its unifying role in the Christian culture of the West, and the schism in the church prior to the death of Emperor Charles IV (1316–78), coupled with

KEY EVENTS

1380	1386	c. 1395	c. 1400	c. 1405	c. 1413
King Charles VI is crowned king of France. His reign (1380–1422) coincides with the International Gothic period.	Construction begins of Milan's cathedral in an International Gothic style that owes more to French than Italian design.	The Wilton Diptych (above, right) is created. It takes its common name from Wilton House, Wiltshire, where it was kept for many years.	Stefano di Giovanni is born. Known as Sassetta, in 1423 he paints an altarpiece telling the story of St Anthony Abbot.	Monaco completes *The Flight into Egypt*. It combines Florentine figures with an International Gothic geometrical composition.	The Duc de Berry commissions the Limbourg brothers to create the illustrated prayer book *Les Très Riches Heures du Duc de Berry* (see p.132).

the removal of the papal court to Avignon, further undermined the absolute authority of the Church. This religious crisis paved the way for a refiguring of religious themes in art, with an increased emphasis on elements of fantasy and personal piety. The movement of the papal throne to the West, along with the establishment of Charles IV's throne in Prague, helped to develop a dialogue among artists travelling between Europe's various cultural centres.

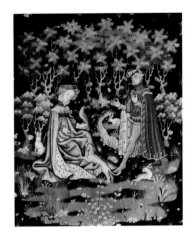

Religious figures and scenes were the period's predominant subject matter. In the *Annunciation* (opposite) by Lorenzo Monaco (*c.* 1370–1425), the painter's emotional intensity and subtlety of feeling are evident and the work displays a particularly graceful flow of line. These qualities also appear in his panels titled *The Flight into Egypt* (*c.* 1405) and *The Coronation of the Virgin* (1413). Some artists set themselves apart from their Gothic predecessors, however, by the close observation of nature and lavish craftsmanship that characterized their work. One of the period's most memorable paintings is the Wilton Diptych (below). This devotional masterpiece is an icon of Catholic heritage, yet the artist has never been identified—art historians cannot even agree on the artist's country of origin, such is the international nature of the style. The altarpiece was most likely commissioned by the English king, Richard II, whose coat of arms and white hart appear on the diptych's exterior. Hinged like a book so that it is portable for use in prayer, the interior (below, right) shows the king being presented to the Virgin Mary.

The succession of wars and the terrible cost of the Hundred Years' War between England and France, that lasted from 1337 to 1453, dramatically changed the social and political landscape of Europe and further influenced the development of its art. The tapestry *Offering of the Heart* (right, above) expresses a nostalgia that members of the old order felt for the court's feudal values, outdated chivalry, extravagance and splendour. Economic crisis and

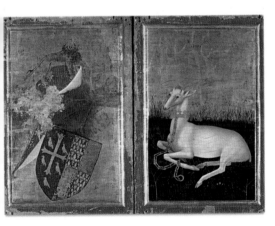

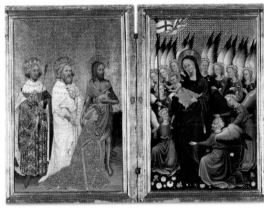

1416	c. 1417	1423	c. 1425–28	1427	c. 1440
All three Limbourg brothers die by the end of the year. It is likely that they caught the plague.	Pope Benedict XIII is deposed, bringing to an end the Avignon line of antipopes and concluding the Great Western Schism.	Da Fabriano completes his *Adoration of the Magi* (see p.131), a defining work of International Gothic painting.	Masolino da Panicale (c. 1383–c. 1435/40) and Masaccio (Tommaso di Ser Giovanni di Mone Cassai; 1401–28) paint the Cappella dei Brancacci in Florence.	Pisanello and Da Fabriano collaborate on various frescoes.	German painter Stefan Lochner (c. 1415–51) creates *Virgin and Child*, which straddles the styles of International Gothic and the Early Renaissance.

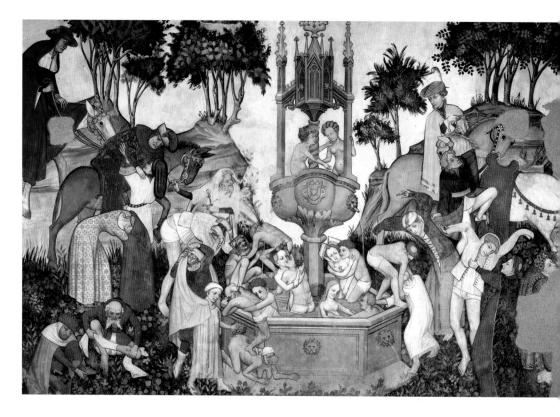

civil strife had undermined the position of the aristocracy and produced an increasingly powerful and sizeable middle class of merchants and bankers. The tapestry is therefore an indirect expression of the struggle for power between them and the merchants. The bourgeoisie, meanwhile, were gaining increasing influence and were perhaps more attracted to some of the ruling class's venal excesses than to the courtly customs that sometimes masked them.

The elegance and emotional exaggeration of the International Gothic style combined with a new kind of humanism, which found its way into the artistic depiction of figures and themes. At the Castello della Manta in Saluzzo, Italy, a student of Giacomo Jaquerio (c. 1375–1455), known only as the 'Master of Manta', painted frescoes on the walls around the baronial hall, including the scene called 'The Fountain of Youth' (detail above). It shows elderly people entering the miraculous waters to be rejuvenated, and the work is full of lively detail and strong colours. The artist was one of many painters associated with the International Gothic who were highly sensitive to the sense of movement underlying the composition. Further examples of the International Gothic aesthetic are *La Grande Pietà Ronde* (c. 1400) by Jean Malouel (c. 1360–1415), which is characterized by intense emotion and a soft, dream-like pictorial quality, and *The Road to Calvary* (1440) by Jaquerio, a crowded canvas in which the sharp angles of innumerable spears suggest shared suffering, the scene realized with a religious intensity and remarkably elegant composition.

Pisanello (c. 1394–1455) was a very competent draughtsman and many of his works feature animals. The representation of animals, vegetables, architecture and artefacts within the decorative landscape is achieved with the same attention to detail and harmony as that given to the figures. In *Madonna with the Quail* (opposite, above), the quail at the Virgin's feet, the other birds, the leafy wreath and the fruits blend into an idealized portrait of the Madonna and Child. The illumination of *Les Très Riches Heures du Duc de Berry* (c. 1413–89;

see p.132) by the Flemish Limbourg brothers (a.1402–16), completed after their deaths by Jean Colombe, is replete with animals, vegetables and wide landscapes, peopled by both aristocratic and peasant figures.

While the art of the past had represented the ideal with much recourse to imagery from the imagination, the International Gothic style produced a synthesis of the ideal—in the sense of a nostalgic looking back to the glory of the past—with a descriptive and detailed realism. The *Adoration of the Magi* (below) by Gentile da Fabriano (*c.* 1370–1427) exemplifies the fusion of these two artistic impulses and represents the peak of the artistic movement. The altarpiece was painted for the Cappella Strozzi, in the Santa Trinità church in Florence (now the sacristy) and has a strong sense of narrative that is typical of International Gothic. The artist depicts the complete story of the adoration of the Magi as told in the Bible, with a vast array of lavishly attired figures. The larger figures in the foreground, nearest to the Madonna and Child, represent the chivalrous tradition of honour and servitude, and the more animated procession of knights and huntsmen, winding its way to a turreted castle in the distant hills in the background, includes more plebeian figures. Behind the youthful king in the centre is the Florentine banker Palla Strozzi, who is included in recognition of his commission of the work.

There is a notable aura of meditation and purpose in the most important works of the International Gothic style, even within the context of its close detail and occasional extravagance. Many of the miniatures were portable so that the viewer could easily use the work of art for private contemplation. The artistic aim was always to familiarize the viewer with the myriad details of the pictorial landscape and the individual characters of the figures. While fully appreciating the realistically presented figures in all their finery and glory, the viewer was at the same time exposed to the light and space that surrounded them—an experience designed to lift and expand the spirit. **BD**

5

6

7

5 **The Fountain of Youth**
(*c.* 1420), fresco detail
Master of Manta
Castello della Manta, Saluzzo, Italy

6 *Madonna with the Quail* (1420–22)
Pisanello • oil on wood
19 ⅝ x 13 in. / 50 x 33 cm
Museo di Castelvecchio, Verona, Italy

7 *Adoration of the Magi* (1423)
Gentile da Fabriano • tempera on panel
119 ¼ x 111 in. / 303 x 282 cm
Uffizi, Florence, Italy

Les Très Riches Heures du Duc de Berry *c. 1413 – 89*

LIMBOURG BROTHERS a. 1402 – 16

gouache on parchment
5 ³/₈ x 6 ¹/₈ in.
13.5 x 15.5 cm
Musée Condé,
Chantilly, France

Considered by many to be the finest of illuminated manuscripts, *Les Très Riches Heures du Duc de Berry* is an exquisite example of a medieval Book of Hours. These devotional books included a text for each liturgical hour of the day as well as a calendar, prayers, psalms and masses for certain holy days. *Les Très Riches Heures du Duc de Berry* was commissioned by Jean, Duc de Berry (1340–1416), a French nobleman who was the brother of King Charles V of France. The duke was a great medieval connoisseur of the visual arts and a passionate book collector. He engaged the Flemish Limbourg brothers—Paul (Pol), Herman and Jean (Jannequin)—to paint the beautiful miniatures that illuminate the texts. All three artists, along with their patron, died before the Book of Hours was completed.

This work is the illustration for the month of October from the calendar, the most famous part of the Book. In the foreground peasants are shown toiling in the fields, while in the distance members of the nobility are seen walking or talking alongside the River Seine in front of the royal palace. The imposing structure of the Louvre is painted in such detail that researchers over the years have studied it to gain a better understanding of the building's original appearance. The seemingly contradictory elements of the countryside and the luxury of court life are rendered in luminous colours, applied with delicate brushwork and expensive paint. **BD**

FOCAL POINTS

1 SUN CHARIOT

The semicircular panel that tops this scene shows a charioteer carrying a brilliant sun. This image of the sun chariot, alluding to the god Phaeton, is taken from a medal showing Emperor Heraclius returning the True Cross to Jerusalem. Above this are astronomical and zodiac signs.

2 LOUVRE

The structure of the Louvre of Charles V in the background is seen from the windows of the Duc de Berry's Paris residence, the Hôtel de Nesle. It is a reminder of the power of the aristocracy at a time when its position was undermined by the economic, political and social crisis in Europe.

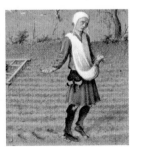

3 PEASANT IN A TUNIC

The peasant in the vivid blue tunic is sowing seeds that he carries in a white cloth pouch. The Limbourgs paid minute attention to naturalistic detail in their work; this can be seen in the accuracy of the shadow cast by the foreground figures. Such detail required extremely fine brushes and lenses.

4 PEASANT ON HORSEBACK

The peasant on horseback is drawing a harrow behind him to prepare the soil for seeding. The bird in the corner is one of a group of birds that are eating seeds. This calm, orderly scene is far removed from the harsher realities of rural life and represents the world as seen by the artists' patron.

ARTISTS PROFILES

1370s–1403

The Limbourg brothers were born in the late 1370s or early 1380s in Nijmegen, in what is now Flanders. By 1402 Jean and Paul were working in the Burgundy court illuminating a bible, possibly the Bible Moralisée.

1404–12

By 1404 all three brothers were working for Jean, Duc de Berry, an extravagant patron of the arts and keen collector of manuscripts.

c. 1413–14

The Duc de Berry assigned the brothers an ambitious project in c. 1413 and the three artists began work on *Les Très Riches Heures du Duc de Berry* in 1414. The twelve, full-page illustrations for the calendar are considered to be the most exquisite and original feature of this masterpiece.

1415–1416

The brothers died in 1416, probably as the result of the plague, leaving their Book of Hours unfinished. The French manuscript illuminator Jean Colombe (c. 1430–c. 1495) completed the work from 1485 to 1489.

KOREAN ART: JOSEON DYNASTY

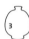

1 *Dream Journey to the Peach Blossom Land* (1447)
An Gyeon • ink and colour on silk scroll
15 ¼ x 41 ¾ in. / 38.5 x 106 cm
Tenri University Library, Nara, Japan

2 *Seodang* (late 18th century)
Gim Hongdo • colour print
11 x 9 ½ in. / 28 x 24 cm
National Museum of Korea, Seoul, Korea

3 Flask-shaped bottle (late 15th century)
Artist unknown • stoneware under
buncheong glaze
8 ¼ in. / 21 cm high
Metropolitan Museum of Art,
New York, USA

The Joseon Dynasty turned away from the Buddhism of the preceding Goryeo Dynasty and adopted Neo-Confucianism as the official Korean ideology. In order to transform Korea into a Neo-Confucian state and society, the founder of Joseon, Yi Seonggye (1335–1408), and his Neo-Confucian advisers carried out a series of anti-Buddhist measures to reduce the wealth and influence of the Buddhist monasteries and the old aristocratic families that had dominated Goryeo governmental affairs. As the new elite class, the Neo-Confucian literati came to dominate the governing bureaucracy.

The Joseon Dynasty reclaimed Korea's native traditions while supporting Ming China and its place at the centre of Confucian civilization. Joseon Korea looked back to classical Chinese sources for inspiration, and in the visual arts landscape emerged as the primary genre in painting. An Gyeon (a. c. 1440–70), one of the official painters of the Joseon court, was Korea's most prominent painter in the 15th century. He adopted classical Chinese models of the Song period but represented distinctly Joseon styles and aesthetic visions. His approach to landscape painting influenced many other Korean artists during his lifetime. In *Dream Journey to the Peach Blossom Land* (above), An Gyeon employed strongly contrasted areas of light and dark and vigorous brushwork to produce a fantastic scene based on a dream related to him by his patron, Prince Anpyeong. The idyllic Peach Blossom Land itself is seen in the right of the painting, enclosed by a ring of jagged peaks. An Gyeon not only understood Chinese painting traditions, he was also a fresh interpreter of them.

In addition to generating imaginary works of this kind, court painters were expected to produce portraits of royals and officials, as well as pictorial records of court rituals and ceremonies. Many Korean scholars and officials were themselves practitioners of the arts, with calligraphy and ink painting being the forms regarded as the most appropriate for the literati.

KEY EVENTS

1392	1400–50	1419	1446	1500–99	1636
After the last Goryeo monarch is deposed, Yi is proclaimed king of the Joseon Dynasty; the capital is on the site of modern-day Seoul.	Korean potters use Chinese techniques to produce white porcelain. King Sejong's (1397–1450) household uses it exclusively.	The new king Sejong attacks the island of Tsushima, off the south-east coast of Korea, which is used as a base by Japanese marauders.	Sejong introduces the hangeul phonetic writing system to encourage literacy. It replaces the system based on Chinese characters.	*Buncheong* (powder green) stoneware covered with white slip is made. It becomes popular in Japan after the Japanese invade Korea in 1592.	The Manchus invade Korea and force the surrender of King Injo (1595–1649). The war reinforces belief in Joseon as the true Confucian state.

The repression of Buddhism meant that art inspired by that religion declined in volume and quality, even though Buddhism remained a potent cultural force, particularly among the lower classes. Buddhist iconography found its way into Korean folk painting, or *minhwa*, which in a naive style depicts mythical figures and symbols of good luck and long life, such as deer, tigers, peonies and cranes. *Minhwa* works were produced in great numbers from the 17th century onwards to satisfy the public's desire for such images. *Minhwa* artists were people of ordinary birth who travelled around the country painting pictures to commission, often to celebrate a life event.

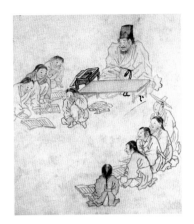

In the field of Joseon pottery, the most praised genre was white porcelain, which was seen to embody the Neo-Confucian ideals of purity and frugality. However, early in the Joseon Dynasty period there was a parallel development in *buncheong* stoneware (right, below). *Buncheong*—originally *bunjang hoecheong sagi* (grey-green ceramics decorated with powder)—is characterized by the tone of its glaze, which varies from grey and green to blue. Potters using the sgraffito (scratched away) technique first applied a white slip to the surface of the clay body, then incised a design into it. The remaining slip was scraped off to reveal the body, the piece was coated with a glaze and then it was fired. The *buncheong* style disappeared after the 16th century as Joseon potters were drawn towards Chinese porcelain.

By the late 17th century Korea's emerging identity as a nation was beginning to be mirrored in its art. The most remarkable achievement of 18th-century painting was the development of *jingyeong sansu* (true-view landscape). Instead of adopting the traditional Chinese style of idealized landscapes, artists such as Jeong Seon (1676–1759) depicted Korean scenery in paintings such as *Complete View of the Diamond Mountains* (1734; see p.136). Another important trend was the production of genre pictures with humorous portrayals of life, such as *Threshing Rice* (1780), in which Gim Hongdo (1745–*c.* 1806) depicts a lazing, pipe-smoking farmer overseeing hard-working peasants. Such works appealed to Korea's growing middle class. Gim's *Seodang*—village school—(right, above) depicts a Confucian teacher and his pupils. The painting is typical of its genre in that the artist focuses on the individuals and their expressions while leaving the background blank.

Late Joseon society adhered less rigidly to the austere Confucian virtues of the early period and enjoyed greater prosperity. The lavish use of cobalt-blue pigment became popular and the production of blue and white porcelain flourished. The growing wealth of the middle class led to a taste for luxury in the decorative arts, and lacquerware inlaid with mother-of-pearl in elaborate and exuberant designs became fashionable. Although cultural and intellectual life flourished throughout the 19th century, Korea faced internal rebellion and foreign aggression. The Joseon Dynasty was finally toppled from power in 1910 when Japan annexed Korea as part of its imperialist expansion. **HY**

c. 1644	c. 1700	c. 1700	1876	1894–95	1910
Western techniques of linear perspective and shading are first introduced in Korea by Qing Dynasty China.	The most purely Korean form of white porcelain is created, the moon jar. The large jars are round in shape and have a milky coloured glaze.	*Jingyeong*, or true-view, culture develops as uniquely Korean art forms in poetry, landscape painting and calligraphy are promoted by scholars.	The Treaty of Ganghwa is signed with Japan, opening up Korea to Japanese trade.	The First Sino-Japanese War is fought between China and Japan, primarily over control of Korea, and Chinese influence over Korea comes to an end.	The Japan-Korea Annexation Treaty marks the beginning of thirty-five years of Japanese colonial rule.

Complete View of the Diamond Mountains 1734

JEONG SEON 1676 – 1759

India ink on paper
51 ¹/₂ x 37 in. / 130.5 x 94 cm
Leeum, Samsung Museum of Art, Seoul, Korea

Designated as a Korean national treasure, *Complete View of the Diamond Mountains* marks a pivotal point in Korean art (see p.134). The dynamic circular composition is a *jingyeong sansu* (true-view landscape), a genre that emerged in the late 17th century. In a true-view landscape, the place depicted is a real location and, significantly, it is situated on Korean soil. The Diamond Mountains are on the east coast of the Korean peninsula and Jeong Seon traversed the terrain repeatedly. Joseon Korea (1392–1910) perceived Ming China (1368–1644) as the centre of Confucian civilization; the Joseon elite were educated in Chinese classics and artists painted idealized Chinese landscapes derived from Chinese models. However, this perception changed when China fell to the Manchus in 1644. From then on Joseon Korea considered itself the keeper of Confucian civilization, and the Joseon land and people became the preoccupation of many scholars. It is in this context that Jeong created this work. **IY**

◉ FOCAL POINTS

1 TITLE AND SIGNATURE

The artist produced approximately one hundred images of the mountains. On the right is the title of the work, *Geumgang Jeondo* (Complete View of the Diamond Mountains). On the left, he signed with his pen name, Gyeomjae, meaning 'humble study', and affixed his seal.

2 STEEP MOUNTAIN PEAKS

Jeong expressed his physical experience of, and emotional response to, the landscape candidly. The snow-covered, precipitous mountain peaks are deftly chiselled with swift brushwork known as Gyeomjae *sujik jun* (Gyeomjae vertical strokes) because they are the artist's own innovation. The painting depicts a total of 12,000 peaks. The highest peak, Birobong, is in the background and water flows down from it to a divided valley below.

3 VEGETATION AND ROCKS

Jeong painted over a surface repeatedly, without waiting for it to dry, using bold, top-down brushstrokes. Here, he balances the composition delicately, using plump, wet dots to give shape to the soft vegetation, whereas the rhythmic rock formations are rendered with thin, sharp lines.

4 JEONGYANG TEMPLE

Often the artist pinpointed specific sites situated in the mountains. Here, nestled in the upper edge of the verdant terrain, is Jeongyang Temple depicted in miniature. Jeong also painted a number of map-like pictures where he labelled the main features of this vast territory.

ARTIST'S INSCRIPTION

The four small characters in the middle beneath the inscription (below) show that the text was inscribed in the winter of the *gapin* year in the sexagenary cycle, dating it to 1734. The inscription reads:

> Twelve-thousand peaks of All Bones Mountain,
> Who would even try to portray their true image?
> Their layers of fragrance float beyond the East Sea,
> Their accumulated *chi* swells expansively throughout
> the world.
> Rocky peaks like lotus blossoms, emitting whiteness. Pine
> and juniper forest obscures the entrance to
> the profound.
> This careful sojourn, on foot through the Diamond
> Mountains,
> How can it be compared with the view from
> one's pillow?

2 | 15TH AND 16TH CENTURY

EARLY NETHERLANDISH ART

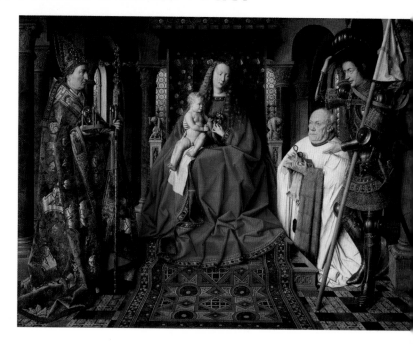

1 *Madonna and Child with Canon Joris van der Paele* (1436)
Jan van Eyck • oil on panel
48 x 61 ¾ in. / 122 x 157 cm
Groeningemuseum, Bruges, Belgium

2 Joseph, from the Mérode Altarpiece (c. 1425)
Master of Flémalle • oil on oak panel
25 ⅜ x 10 ¼ in. / 64.5 x 27 cm
Metropolitan Museum of Art,
New York, USA

The term 'Early Netherlandish art' denotes the work produced in the Low Countries, in an area roughly equivalent to modern Belgium and Luxembourg. This style, also referred to as 'Flemish', reached maturity in the 15th century, when Netherlandish painters developed a radically different style and approach to their subject matter. They rejected the courtly elegance and extravagant decoration of the International Gothic (see p.128) in favour of a new realism. Scenes of high drama were replaced with domestic interiors in which spirituality and reality sat side by side. Led by such masters as Jan van Eyck (*c.* 1390–1441), Rogier van der Weyden (*c.* 1399–1464), Hans Memling (*c.* 1430/40–94) and Hugo van der Goes (*c.* 1440–82), the Netherlandish painters left an artistic legacy that affords great insight into their world.

The key to the success of Early Netherlandish art was the region's economic prosperity. Local weavers played a significant role in the wool trade, and the northern ports helped the Netherlands become a bustling, cosmopolitan marketplace. Prior to the 1480s, Bruges was the principal port in the area. Later, as its harbour silted up, this distinction passed to Antwerp. The increase in commercial activity brought with it important new sources of patronage, and many of the major artists of this period did not originate in Flanders but were attracted from other regions—Memling, for example, came

(see p.128)

KEY EVENTS

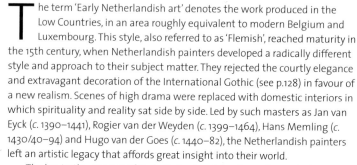

1411	1416	1425	1436	1460	1475
Sluter and Claus de Werve (*c.* 1380–1439) complete their work on the tomb of Philip the Bold, Duke of Burgundy, five years after Philip's death.	It is likely that an outbreak of the plague in France is responsible for the deaths of the Flemish-born painters the Limbourg Brothers.	Van Eyck moves to Bruges and enters the service of Philip the Good.	Van der Weyden becomes the city painter of Brussels and receives numerous international commissions.	Van der Weyden paints *Portrait of a Lady*. It is a psychological study of a young woman; her fixed downward gaze and clasped fingers suggest inner turmoil.	Van der Goes is appointed dean of the Painters' Guild in Ghent.

from Germany to work under van der Weyden. Many of those who became patrons as a result of the commercial success of Flanders also came from elsewhere. Masterpieces such as van Eyck's *The Arnolfini Marriage* (1434; see p.144) and van der Goes's Portinari Altarpiece (*c.* 1475; see p.148) were by no means isolated examples of works commissioned by Italian businessmen.

The huge advances that Netherlandish art made in the early years of the 15th century are linked directly to the Renaissance (see p.150), which had emerged in Italy and spread to most of Europe. Within a short period of time, artists became more confident about portraying both the human figure and the natural world. At the start of the century, the leading Netherlandish artist was Melchior Broederlam (*c.* 1350–*c.* 1411). His chief surviving masterpiece—the wings of an altarpiece (*c.* 1394–99) that was designed for the Chartreuse de Champmol, a monastery founded by Philip the Bold—displays a number of naturalistic touches but is still essentially Gothic in style. The scenes are set against a golden background, the landscape is stylized and the rendering of space is clumsy. By the 1430s, Netherlandish art had changed: figures were unified with their setting and a believable view of the world was presented.

The first signs of change initially came from the field of sculpture. The pioneer was Claus Sluter (*c.* 1350–1405/6), who also produced his finest work for the Chartreuse de Champmol. This commission included a series of statues of biblical prophets and the sculptures display a robust naturalism that is far removed from the stylized grace of Sluter's contemporaries. The artist's work undoubtedly influenced the style of the Master of Flémalle, one of the first great painters of the Early Netherlandish school. His identity is uncertain, although most scholars now believe that he was Robert Campin (*c.* 1375–1444), a successful artist from Tournai who probably taught van der Weyden. He executed his figures in a solid, sculptural style, which he passed on to his pupils. When he depicted Joseph (right) in one of the panels for the Mérode Altarpiece, he showed him as a modern-day carpenter, busy making mousetraps, with a view of a Flemish town outside his window.

As the Flemish region prospered, artists benefited from the growing wealth and importance of guilds and civic authorities. It is significant that van der Weyden's *Descent from the Cross* (*c.* 1435–40; see p.146)—one of the most influential paintings of the period—was commissioned by a guild, rather than a cleric or a nobleman. Many guilds were religious confraternities that came together to worship and carry out charitable activities, and they often vied with each other to commission the most impressive artworks for their association. With this in mind, it was not unusual for artists to join a confraternity. One such figure was Petrus Christus (*c.* 1410–75/6), the leading artist in Bruges after van Eyck's death. Records show that he and his wife belonged to the Confraternity of the Dry Tree, whose members included Burgundian dukes and aristocratic families. He was commissioned by the

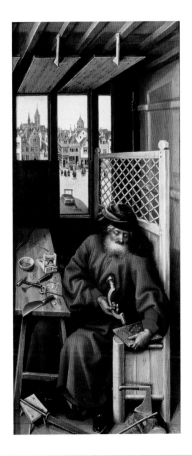

1477	1478	1482	*c.* 1500	1508	*c.* 1512–15
The Flanders region is lost in battle at the death of the Duke of Burgundy, a major patron of the arts, and taken over by the Hapsburg family.	Van der Goes leaves his successful business in Ghent to become a lay brother at the Roode Cloister near Brussels.	Maximilian I of Hapsburg becomes ruler of the Low Countries; his policies are unpopular with the Netherlandish people.	Hieronymus Bosch (*c.* 1450–1516) includes a hidden self-portrait in his triptych *The Garden of Earthly Delights* (see p.188).	Jan Gossaert (*c.* 1478–1532) visits Italy and is influenced by Italian Renaissance motifs, which he introduces into Flemish art.	David's *The Rest on the Flight to Egypt* shows the influence of the Italian Renaissance in the artist's use of colour and in the subject matter.

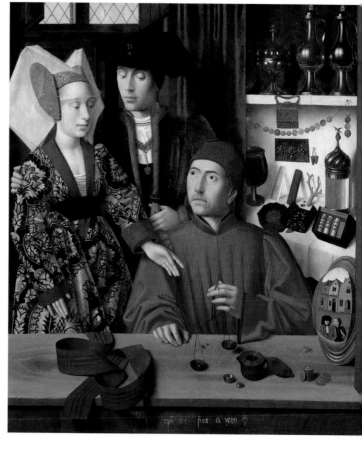

3 *A Goldsmith in His Shop* (1449)
Petrus Christus • oil on oak panel
39 ³/₈ x 33 ³/₄ in. / 100 x 86 cm
Metropolitan Museum of Art,
New York, USA

4 *Maria Portinari* (c. 1468)
Hans Memling • oil on wood
17 ³/₈ x 13 ¹/₄ in. / 44 x 33 cm
Metropolitan Museum of Art,
New York, USA

5 *The Virgin Among the Saints* (1509)
Gerard David • oil on canvas
46 ¹/₂ x 83 ¹/₂ in. / 118 x 212 cm
Musée des Beaux-Arts, Rouen, France

Goldsmiths Guild in Bruges to paint *A Goldsmith in His Shop* (above), in which a gentile couple are choosing a wedding ring. Christus demonstrates his technical skill in the naturalistic rendition of the various fabrics and uses the reflected mirror image to link the viewer to the pictorial space, a device often seen in Early Netherlandish painting.

The prosperity of Flemish towns was reflected in their willingness to commission high-quality works of art. In 1468, for example, Dieric Bouts (c. 1420–75) was appointed official painter of the city of Louvain. This brought him his grandest commission: a pair of large panels depicting the life of Emperor Otto, which were prominently displayed in the town hall. The two scenes included numerous portraits of councillors, anticipating the illustrious tradition of group portraiture that would later be established in this region. The solemn dignity of Bouts's style can be found in Memling's portrait *Maria Portinari* (opposite, above), for example, which was originally a wing panel of a devotional triptych. The artist does not concern the viewer with background distractions and focuses on the subtle expression of his sitter. In a manner typical of Netherlandish art, her eyes do not engage with the viewer. Memling introduced realism to the way he portrayed the human form and this, in particular, influenced the work of another prominent artist in Bruges, Gerard David (c. 1460–1523). In *The Virgin Among the Saints* (right), David organizes his figures in an orderly composition and renders each one in a non-idealized form. He ran a busy studio and his oeuvre is a high point in Netherlandish art.

The spread of patronage helped to improve the status of many Netherlandish artists. In the early part of the 15th century, painters either

worked for the Church or were attached to royal or aristocratic households. In this capacity, they were expected, as a matter of routine, to provide a broad range of ephemeral material—painting shields and banners or creating decorations for banquets and wedding celebrations. Van Eyck, for example, was required to gild and paint statues, while van der Goes was employed to create street decorations for the marriage of Charles the Bold, as well as processional banners for the funeral of Philip the Good and a papal jubilee. By the latter part of the century, Netherlandish artists were far more independent. Memling and van der Weyden both ran large workshops with international clienteles.

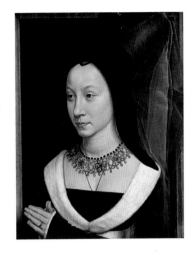

Unlike their Italian counterparts, Netherlandish artists organized their compositions intuitively, without devising a methodical system for calculating perspective or proportion. They were the first to explore the possibilities of oil painting, which van Eyck in particular raised to new heights. He used layer upon layer of translucent glaze in order to blend his tones imperceptibly and successfully depict the tiniest objects. Through this development, van Eyck and his followers were able to portray the world around them in unprecedented detail. In his *Madonna and Child with Canon Joris van der Paele* (see p.140), the artist demonstrates the full extent of his virtuosity. The canon's features have been reproduced so precisely that doctors have been able to diagnose the illness from which he was suffering; the text is slightly distorted by the lenses of the spectacles in his hand; and the Virgin and Child are reflected in the shiny helmet of Saint George, who stands by his side.

Netherlandish artists revelled in the opportunities that oil painting afforded them. They portrayed their world with genuine freshness, as if they were seeing it for the first time. They continued to do so even when they were tackling biblical themes. When Geertgen tot Sint Jans (*c.* 1465–95) showed Christ raising Lazarus from the dead, he did so against the backdrop of the Flemish countryside, with a crowd in modern dress looking on. There was nothing remotely sacrilegious about this form of deliberate anachronism. Religious sentiments in Flanders were heavily influenced by contemporary spiritual movements, which urged the faithful to construct a close, personal relationship with God. A simple piety is reflected in the work of many of the Early Netherlandish painters: from the emotional intensity of van der Weyden, who empathized closely with Christ's suffering, to the mysticism of van der Goes and the quiet contemplative air of David and Memling. **IZ**

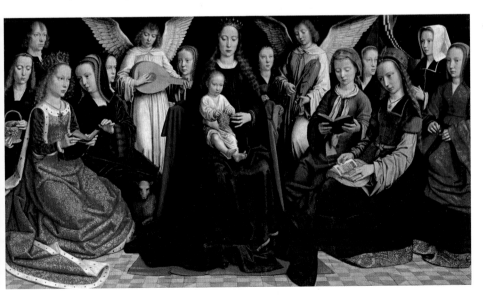

The Arnolfini Marriage 1434

JAN VAN EYCK c. 1390 – 1441

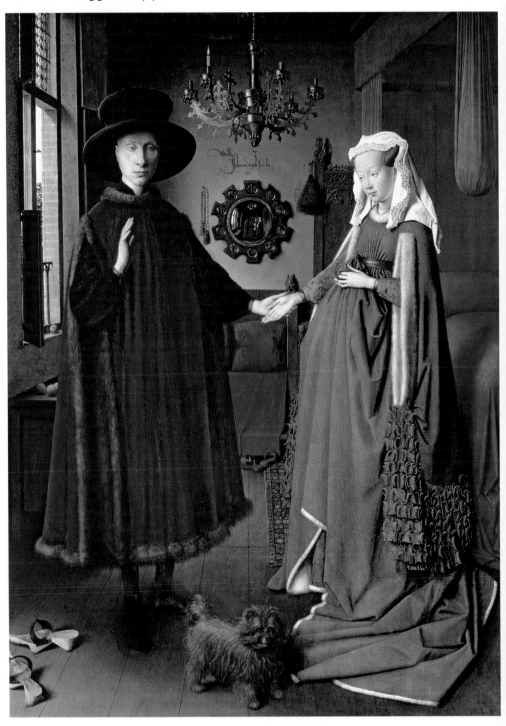

oil on oak panel
32 3/8 x 23 5/8 in. / 82 x 60 cm
National Gallery, London, UK

This painting by Jan van Eyck is thought to depict Giovanni di Nicolao Arnolfini and his wife, who were wealthy Italians living in Bruges. The painting may have been commissioned to mark their betrothal or marriage, although scholars continue to debate its precise implications. It has also been suggested that it is a memorial portrait to Arnolfini's dead wife and the painting celebrates their union. Certainly, this is no conventional wedding portrait. There is little air of celebration in the man's solemn face or the couple's formal pose, and the woman's hand seems to slip away from that of her husband. Instead, the painting is a reminder that they are partaking in a sacred act. The religious overtones are underlined by the rosary on the wall, the biblical scenes around the mirror and the discarded shoes.

Reference is made to the more earthly purposes of marriage with allusions to the woman's child-bearing role. In addition, this was a commercial union. The couple came from successful mercantile families and their wealth is openly displayed—expensive imported oranges lie on a side table, an Anatolian rug is on the floor, their furniture is opulent and their clothes are of fine quality and obviously expensive. However, the picture's artistic tour de force is the depiction of the convex mirror, which van Eyck uses as an opportunity to demonstrate his supreme skill at rendering tiny details. His signature, included as an ornate flourish, is found above the mirror. **IZ**

FOCAL POINTS

1 HAND

Infrared studies of the under-drawing show that van Eyck made several minute adjustments to the pose of the hand. The gesture is significant and may indicate the taking of the marriage oath, given the unnatural and formal way in which the couple join hands.

2 CONVEX MIRROR

The roundels decorating the mirror contain ten identifiable scenes from the Passion of Christ. The glass bears a reflection of two men, one of whom may be the artist, which gives added meaning to the signature and Latin inscription above the mirror: 'Jan van Eyck was here 1434'.

3 WOMAN

The woman appears to be pregnant, although the way she gathers up the folds of her skirt is a contemporary fashion. Nevertheless, many details on her side of the portrait relate to the child-bearing role. Behind her, a carved figurine of a dragon represents St Margaret, the patron saint of childbirth.

4 SHOES

The man's patten shoes are more than a simple domestic detail. They are a symbolic reference to the passage from the Book of Exodus: 'Put off thy shoes from thy feet, for the place whereon thou standest is holy ground'. They are placed prominently to underline the sacred nature of the event.

ARTIST PROFILE

c. 1390–1424

Little is known of van Eyck's early life, although it is thought that he was born at Maaseik, in present-day Belgium. The first record of him was in 1422, when he was based in The Hague, working at the court of John III, Duke of Bavaria-Straubing and Count of Holland and Hainaut.

1425–31

Van Eyck remained at the court of John III until John's death in 1425. Later that year, Jan entered the household of Philip III, Duke of Burgundy and worked for him in Bruges and Lille as a court artist and equerry. In the latter capacity, van Eyck undertook a number of diplomatic missions.

1432–34

Van Eyck bought a house in Bruges and entered the most fruitful phase of his career. In 1432 he completed The Ghent Altarpiece, which was groundbreaking in its naturalism, and gained lucrative commissions such as *The Arnolfini Marriage*.

1435–41

The artist continued in the duke's service and undertook numerous portrait commissions. He died in Bruges.

Descent from the Cross

c. 1435 – 40

ROGIER VAN DER WEYDEN
c. 1399 – 1464

oil on oak panel
86 5/8 x 103 1/8 in. / 220 x 262 cm
Museo del Prado, Madrid, Spain

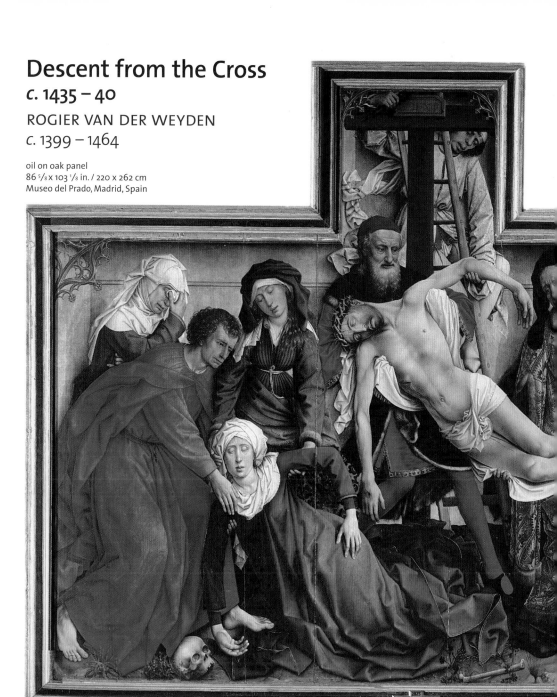

1 SPACE

The space in the centre of the painting is compressed, yet the artist manages to create a convincing illusion that is particularly effective at the top of the picture. The servant's head is partly hidden, but he extends his right arm holding the nails that he has just extracted from Christ's body.

2 CROSSBOWS

In recognition of the crossbowmen who commissioned him, van der Weyden painted two tiny crossbows in the golden tracery in the corners of the picture, adding to its sculptural quality. Christ's body is also in the shape of a crossbow after its arrow has been released.

⏱ ARTIST PROFILE

c. 1399–1431

The artist was born Rogier de le Pasture in Tournai in Belgium. His father was a knife maker and it is believed that Rogier began his artistic life as a goldsmith and then in 1427 took an apprenticeship with the Master of Flémalle that lasted five years. Rogier soon equalled his master's skill and in turn proved to be an influence on his work.

1432–36

In 1432 Rogier was received as a master in the Painters' Guild of St Luke in Tournai. By 1435 he had moved to Brussels where he adopted the Dutch translation of his name, van der Weyden. A year later he took on the lifetime post of city painter.

1437–49

Van der Weyden received prestigious civic, ecclesiastical and private commissions, including some from abroad. He painted portraits and religious subjects and also ran a large workshop. He produced work for nobles and princes including Philip III, Duke of Burgundy. When Jan van Eyck died in 1441, van der Weyden became the leading portrait painter at the duke's court.

1450–64

It is thought that he travelled to Rome in 1450 on a pilgrimage where he met Italian artists and patrons. During his stay in Italy he painted for distinguished families such as the Medici in Florence. Van der Weyden's fame increased and he soon had followers in France, Germany, Italy and Spain, who were attracted by the strong emotions, naturalistic detail and dramatic nature of his work. His influence on European painting continued until the mid 16th century.

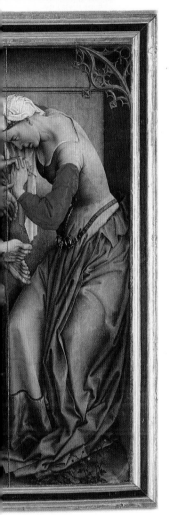

This painting is generally considered to be the finest work of Rogier van der Weyden. It was hugely influential and inspired scores of imitations by other Netherlandish artists. The altarpiece, which shows Christ's body being lowered from the cross, was commissioned by the St George's Guild of Crossbowmen at Louvain, in present-day Belgium, and was originally displayed in the guild's chapel at Notre Dame Hors-les-murs. It probably had wing panels, but these have not survived. The painting dates from the mid 1430s and it was certainly completed before 1443, when a copy was made. By 1548, the work was in the possession of Mary of Austria, the Regent of the Netherlands, and a few years later it passed to her nephew, King Philip II of Spain. The painting presents an extraordinary blend of realism and artifice. Van der Weyden crams ten imposing, almost life-size figures into a shallow, box-like shrine. Nevertheless, he uses the extremely compressed space to heighten the pain and anguish experienced by the interlocking figures in their contorted poses. They are too cramped to stretch or move, but the range of their emotions is recorded with devastating clarity. Some wring their hands, some hide their eyes and some just stare blankly, ashen-faced. Together, they convey the idea that this a dramatic moment and form an intensely emotional image of inconsolable grief at Christ's Passion. **IZ**

3 SKULL

The Crucifixion took place at Golgotha, the 'place of the skull'. Many paintings of the Crucifixion include a skull, because Adam is said to have been buried at the site. This underlines the purpose of Christ's sacrifice, redeeming the original sin committed by Adam and Eve.

4 SYMMETRY OF FIGURES

The composition centres on the echoing shapes of Christ and the Virgin Mary. Their limp bodies form S-curves, their arms are parallel and their skin has the same deathly pallor. The bowed figures of St John the Evangelist (far left) and Mary Magdalene (far right) emphasize the symmetry.

Portinari Altarpiece *c.* 1475
HUGO VAN DER GOES *c.* 1440 – 82

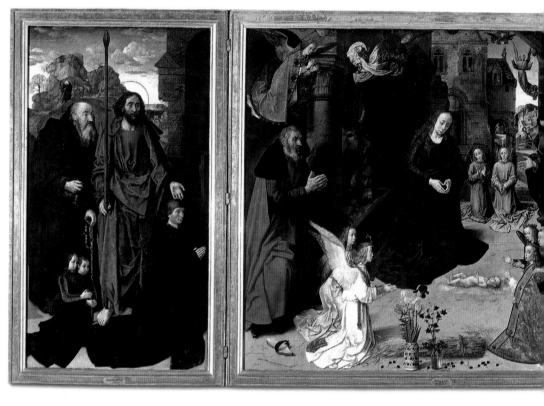

oil on wood panels
99 ⅝ x 119 ⅝ in. / 253 x 304 cm (centre panel)
99 ⅝ x 55 ½ in. / 253 x 141 cm (each side panel)
Uffizi, Florence, Italy

This altarpiece by Hugo van der Goes was commissioned by Tommaso Portinari for the church of Sant'Egidio, in the hospital of Santa Maria Nuova, Florence. It was usual to include portraits of patrons and their families in the religious paintings they commissioned, and Portinari kneels with his two sons in the left panel; his wife and a daughter kneel in the panel on the right. All bar his youngest son are accompanied by their name saints: Thomas and Anthony the Great on the left, and Margaret and Mary Magdalene on the right. Netherlandish painters often looked to the south for inspiration and this work is an example of a Netherlandish artist gaining a significant commission from an Italian source. Portinari was based in Bruges, in present-day Belgium, where he was employed as an agent for the Medici bank. He commissioned the triptych to ensure that he would not be forgotten in Florence in his absence and to demonstrate his civic loyalty.

After the altarpiece was shipped from Flanders and installed in Florence in 1483, it had considerable influence on local artists who were impressed by its meticulous naturalism. The composition of the centre panel is highly unusual. Although it resembles a traditional nativity scene, the picture is a mystic glorification of the Eucharist. The holy figures are solemn as they gaze down at Christ lying next to the symbols of his sacrifice, and the smiling, excited shepherds resemble humble churchgoers. The angels in the foreground are dressed in priestly robes, ready to celebrate mass, while, above the ox's head, a tiny devil peers out in wonder. In the left panel, Mary and Joseph make their way through rocky terrain to Bethlehem and the Magi are shown in the panel on the right. **IZ**

✿ NAVIGATOR

⏱ ARTIST PROFILE

c. 1440–68

Van der Goes was probably born in Ghent in Belgium, but there is no firm documentation about him until 1467, when he qualified as a free master at the Ghent Painters' Guild. By this stage he must have been reasonably well known because he was summoned to Bruges the following year to assist with the public decorations for the wedding of Charles the Bold.

1469–73

He produced a series of banners and other decorative ephemera for the city of Ghent, but none of these survive. His reputation continued to grow, however, as he was appointed dean of the Painters' Guild in c. 1473, a post he held until 1475.

1474–75

Van der Goes never signed his work, but his only securely documented painting, the Portinari Altarpiece, dates from this period. He left Ghent in 1475 and entered the Augustinian monastery of Rooklooster (Red Cloister) near Brussels.

1476–82

As a lay brother, he was allowed to continue painting and travelling. He also received distinguished visitors at the monastery, including the Archduke of Austria, Maximilian. His later years were clouded by depression and mental instability. In 1481, he suffered a breakdown and had to be restrained from injuring himself. He died the following year.

👁 FOCAL POINTS

1 ARCHITECTURE

Netherlandish artists often used architectural details in nativity scenes to symbolize the new religious order. The carving of the harp refers to the Old Testament's King David and Christ's ancestry. The nativity itself, by contrast, is situated in a newer building with a Gothic-style pillar.

2 SHEPHERDS

In most depictions of the nativity, the shepherds and the Magi are shown worshipping Christ together. Van der Goes gives unusual prominence to the shepherds. Their faces are portrayed with character and individuality, in sharp contrast to the idealized features of many of the other participants.

3 THE MAGI

The Magi and their retinue arrive in a procession. A courtier asks directions from a cripple while, behind him, the three kings ride side by side. They are travelling through a northern landscape. The buildings are recognizably Netherlandish and the bare trees confirm that it is winter.

4 PORTINARI'S DAUGHTER

Netherlandish artists persisted with the medieval custom of portraying their patrons on a smaller scale, to underline their difference in status from the holy figures. Portinari's daughter Margherita is accompanied by St Margaret, identified by her traditional symbol, a dragon.

5 STILL LIFES

These still-life items are symbols of the Eucharist, which is appropriate because the painting was placed above an altar. The sheaf of wheat is an emblem of the holy bread; the vine leaves and grapes on the vase refer to the wine. The red carnations represent the bloodied nails of Christ's cross.

EARLY RENAISSANCE

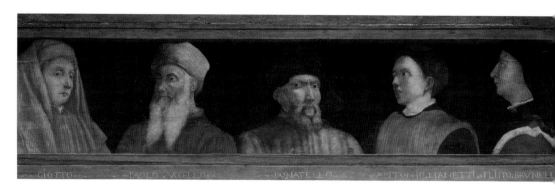

T he Renaissance marks the transition in European history from the close of the Middle Ages to the dawn of the modern world. The term 'Renaissance' means 'rebirth' and refers to a revived interest in the intellectual and artistic treasures of ancient Greece and Rome. Works by classical authors such as Plato, Aristotle, Cicero and Homer, which had fallen into obscurity in the West, were rediscovered, and a new, humanistic outlook blossomed, that prioritized humanity and human achievement. Although by no means a rejection of theological scholarship—Christian worship and symbology continued to inspire Renaissance artists—this approach was out of step with the teachings of the medieval church, which had insisted that humankind could achieve nothing without God's help.

The rediscovery of the classical world radically altered the arts of painting, sculpture and architecture in Italy. Roman history and mythology were explored for subject matter. Devotional art—flat and linear in the Middle Ages—became more naturalistic, reflecting closer observation of the human form and nature along with the development of artistic techniques such as perspective. In 15th-century Florence, many people believed themselves to be living in a new age: 'Where was the painter's art till Giotto tardily restored it?' asked Florentine historian and civil servant Matteo Palmieri in *On Civil Life* (c. 1432); 'A caricature of human delineation! Sculpture and architecture, for long years sunk to the merest travesty of art, are only today in the process of rescue from obscurity.' The city's formative role in the Renaissance is celebrated in *Five Masters of the Florentine Renaissance* (above), probably begun by Paolo Uccello (c. 1397–1475) and finished by another painter. According to the inscriptions beneath each portrait, the painting depicts, from left to right, Giotto (Giotto di Bondone; c. 1270–1337), Uccello himself, Donatello (Donata di Niccolo; c. 1386–1466), art historian and biographer Antonio Manetti (1423–97) and Filippo Brunelleschi (1377–1446). There is some debate about this, and a more accurate roll call may be (left to right): Manetti, Donatello, Uccello, Masaccio (Tommaso di Ser Giovanni di Mone Cassai; 1401–28) and Brunelleschi.

1 [blank box]

2 [blank box]

3 [blank box]

1 *Five Masters of the Florentine Renaissance*
Attrib. Paolo Uccello • tempera on wood
16 ¹/₂ x 82 ⁵/₈ in. / 42 x 210 cm
Louvre, Paris, France

2 *The Holy Trinity* (c. 1425–28)
Masaccio • fresco
267 ³/₄ x 126 in. / 680 x 320 cm
Santa Maria Novella, Florence, Italy

3 Plan, section and elevation of Santa Maria del Fiore cathedral in Florence (19th century)
Jules Adolphe Chauvet • lithograph
Private collection

KEY EVENTS

1402	1412	c. 1425	1435–36	c. 1438	c. 1450
Ghiberti is chosen to sculpt the bronze doors of the Battistero di San Giovanni in Florence. It takes more than twenty years to complete them.	The Medici family become official bankers to the Pope.	Masaccio begins painting *The Holy Trinity* for the church of Santa Maria Novella in Florence at the age of twenty-four. He dies three years later.	Brunelleschi completes work on the dome of Florence Cathedral. Alberti finishes his influential treatise *On Painting*.	Inspired by stories of Christian martyrs, Dominican monk Fra Angelico paints *The Beheading of St Cosmas and St Damian*.	Fra Filippo Lippi's *The Annunciation* includes a representation of a carved stone bearing the emblem of the Medici family.

Although no single factor can explain the unrivalled artistic flowering that Florence experienced in the early 1400s, there were key contributions by Brunelleschi in architecture, Donatello in sculpture and Masaccio in painting. Some time between 1404 and 1407, Donatello and Brunelleschi travelled to Rome together to study the ancient remains there and make excavations, a sojourn that was decisive for the development of Italian art. Clearly inspired by the antique sculpture that he had seen in Rome, Donatello went on to carve and cast the first large-scale, free-standing statues since antiquity. Like those ancient figures, his sculptures were sometimes nude. Donatello's bronze figure *David*, dating from the 1430s, was one of the earliest Renaissance independent nude statues. Brunelleschi, the first Renaissance architect, measured the dome of the Pantheon and other ancient buildings to understand the harmony of proportion in classical works and applied his engineering genius to design the huge dome for Florence's cathedral, Santa Maria del Fiore (below right). This was the city's most ambitious building project. It was begun in the 1290s and the nave and choir were completed by *c.* 1420. The great octagon at the east end of the nave had only a wooden roof until Brunelleschi began his dome, which was completed between *c.* 1419 and 1436. It is 136 feet (42 m) in diameter, and the cross on top is 370 feet (114 m) above the floor: 'A structure so immense, so steeply rising above towards the sky that it covers all Tuscans with its shadow,' noted architect, artist, antiquarian and man of letters Leon Battista Alberti (1404–72). Perhaps surprisingly, Brunelleschi's career met with an early failure: in 1401, his design for the bronze north doors of the Battistero di San Giovanni in Florence (see p.154) was rejected in favour of one by Lorenzo Ghiberti (*c.* 1380–1455), whose pupils included both Donatello and Uccello.

Brunelleschi was probably the first to demonstrate the principles of linear perspective; the underlying geometry, however, seems to have been discovered by Alberti, as outlined in his treatise *On Painting* (1435). Linear perspective is a technique whereby an artist may suggest three-dimensional depth on a flat surface. As a science, perspective is closely related to optics (the study of vision and the eye), but as a pictorial system it was only fully developed in the early 15th century, in the unique intellectual and artistic climate of Renaissance Florence. For the first time in the history of painting, there was now a mathematical system for calculating how progressively to diminish the size of figures or objects in proportion to their increasing distance.

Brunelleschi was also an important innovator in other areas and was one of the first Renaissance masters to rediscover the laws of single-point perspective. The painter Masaccio put into practice Brunelleschi's theories about how to imply depth beyond a flat surface. In the Florentine church of Santa Maria Novella, Masaccio explored the illusionistic potential of perspective by painting a chapel (above right) that seems to open up before the viewer—a *trompe l'œil* effect. The monumental image of the Trinity—God

1453	*c.* 1455	*c.* 1455–60	1469	*c.* 1470	1478
The Ottoman army takes Constantinople, and numerous artists and artisans flee Italy. Many Greek scholars arrive in the country, however.	The Gutenberg Bible, one of the earliest and most important printed books, is created by Johannes Gutenberg in Mainz, Germany.	Piero della Francesca paints his enigmatic *Flagellation of Christ*.	Lorenzo de' Medici takes the reins of power in Florence, effectively ruling as a despot. The arts flourish under him.	Uccello breaks new artistic ground with his painting *The Hunt in the Forest*, the composition of which is strongly driven by perspective.	Giuliano de' Medici, Lorenzo's brother, is murdered by the rival Pazzi family; Lorenzo survives the attack.

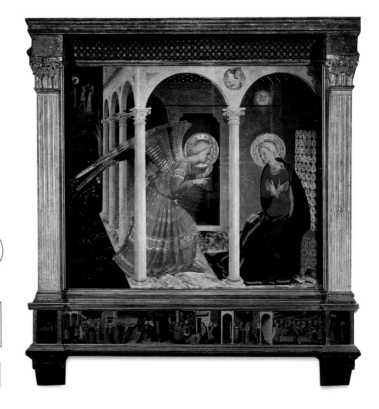

4 *The Annunciation* (1432–34)
Fra Angelico • tempera on panel
68 ⁷/₈ x 70 ⁷/₈ in. / 175 x 180 cm
Museo Diocesano, Cortona, Italy

5 *Madonna and Child with Scenes
from the Life of St Anne* (1452)
Fra Filippo Lippi • oil on panel
53 ¹/₈ in. / 135 cm diameter
Galleria Palatina, Florence, Italy

6 *Niccolò Mauruzi da Tolentino Unseats
Bernardino della Ciarda at the
Battle of San Romano* (c. 1435–55)
Paolo Uccello • tempera on panel
71 ⁵/₈ x 127 ¹/₈ in. / 182 x 323 cm
Uffizi, Florence, Italy

the father, Christ on the cross and between them a dove representing the
Holy Spirit—and the figures (the Virgin Mary and St John, standing above
two supplicant patrons) are so realistically three-dimensional that they seem
almost to be sculpted. In Florence's Cappella dei Brancacci, Masaccio painted
a series of innovative frescoes in which he used light, radiating strongly and
consistently from a single direction, to model figures with shadow and give
them a robust three-dimensionality. In the chapel's *Baptism of the Neophytes*
(c. 1427), he created some of the period's finest male nudes.

Masaccio's influence is evident in the sharply foreshortened columnated
room that acts as the setting for *The Annunciation* (above)—one of several
paintings that Fra Angelico (c. 1395–1455) produced on this theme. Although the
rigorous perspective confirms the work as an Early Renaissance piece, the floral
details and gold leaf are more typical of the earlier International Gothic (see
p.128) style. In the far distance, Fra Angelico depicts the expulsion of Adam and
Eve from the Garden of Eden; their sin will be absolved by the coming of Christ,
foreshadowed by this annunciation. The artist's use of colour was an influence
on Piero della Francesca (c. 1415–92), who worked outside Florence during his
career but knew Masaccio and Brunelleschi as well as Fra Angelico. His work
was typified by serenity, grandeur and a mathematical exactitude; indeed,
he dedicated his final years to the study of perspective and mathematics.

The confidently executed geometry in *Madonna and Child with Scenes from
the Life of St Anne* (right, above) by Fra Filippo Lippi (c. 1406–69) offers another
masterclass in Renaissance-era perspective. The right eye of the Madonna
is placed at the very centre of the work, the circular shape of which was
frequently adopted for religious paintings of the time. The rigorously applied
perspective (which operates on several different planes) is complemented by
Lippi's sensitive treatment of line, skin tones and fabric, adding a believable
naturalism to the painting. Sandro Botticelli (c. 1445–1510) was a pupil of Lippi,

but although the grace of Lippi's style is seen in Botticelli's works, such as *Primavera* (c. 1478; see p.158), the younger artist pursued a distinctive linearity of his own, developing a vigorous rhythm and flow through his use of outline.

Over a period of about fifteen years, Uccello produced three scenes of the Battle of San Romano, a day-long struggle between Florentine and Sienese forces in 1432; all were commissioned by Leonardo Bartolini Salimbeni. In *Niccolò Mauruzi da Tolentino Unseats Bernardino della Ciarda at the Battle of San Romano* (below), the artist celebrates the leader of the Florentine forces. Uccello explores the art of foreshortening and single-point linear perspective in the painting, using fallen lances to illustrate vanishing points. The effect may appear awkward, but the three paintings were originally intended to be hung high up on three different walls, which would have significantly altered the way they were to be viewed.

During this period of great artistic innovation, the Medici family came to dominate the politics and life of the city of Florence. (Lorenzo de' Medici coveted Uccello's three San Romano paintings and had them moved from their original site to his palace.) Although Florence prided itself on being a republic, in reality the city was governed by a small number of rich families. This led to many bitter and violent family feuds, although by 1478 Lorenzo had complete control of the city, and through his diplomacy and political skill gave Florence a period of relative stability until his death in 1492. His support and patronage enabled this period of intense artistic activity to continue, reaching its height in the late 15th century with the work of artists such as Leonardo da Vinci (1452–1519) and Michelangelo (Michelangelo Buonarroti; 1475–1564). By the close of the century, however, a number of factors—including the death of Lorenzo, the profligacy of the Florentine middle class and the invasion of Charles VIII of France—saw the centre of artistic patronage shift to Rome, heralding a new period in art history: the High Renaissance (see p.172). **PG**

Gates of Paradise 1425 – 52
LORENZO GHIBERTI c. 1380 – 1455

bronze and gilt bronze
200 x 113 in. / 506 x 287 cm (frame)
Museo dell'Opera del Duomo, Florence, Italy

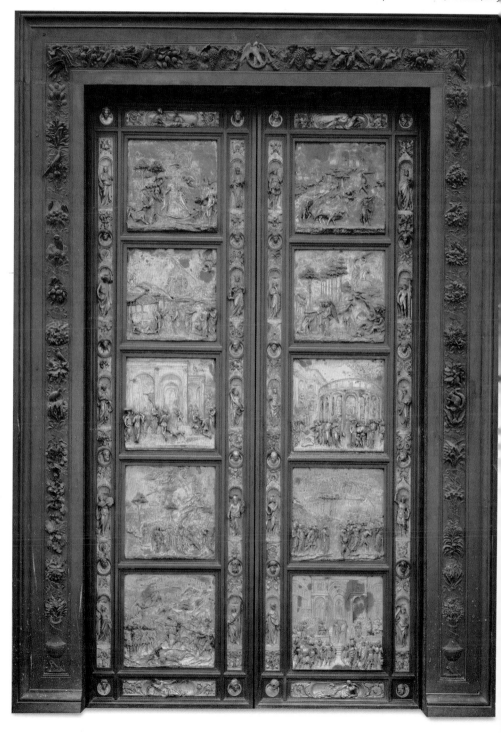

🜚 NAVIGATOR

Early in 1425, having recently completed doors for the eastern side of the Battistero di San Giovanni in Florence (see panel below), the goldsmith, sculptor and architect Lorenzo Ghiberti was commissioned by the wealthy Guild of the Calimala (wool merchants) to make a second set of doors for the baptistery's northern side. The eastern doors had been decorated with twenty-eight subjects taken from the New Testament; this time scenes from the Old Testament were to be represented. Ghiberti proposed a new design in which he reduced the number of panels to ten, thereby gaining space for additional narrative events within each panel. Groups of figures occupied subtly varying depths of relief, making the piece appear remarkably three-dimensional. Ghiberti enhanced the three-dimensional effect by utilizing Early Renaissance advances in linear perspective to create settings of landscape and architecture that seemed to recede into the background.

Although most of the reliefs were cast by 1436, the subsequent cleaning and chasing lasted for almost another decade and the final fire gilding was not complete until June 1452. During that time Ghiberti's workshop became the most important in Florence. The Calimala, delighted with the new doors, moved Ghiberti's earlier pair to the northern side and put the new pair in the key eastern portal, opposite the cathedral. The doors were named 'Gates of Paradise' because people entered through them to be baptized. In 1990 they were replaced by replicas and the originals placed in the Museo dell'Opera del Duomo. **PG**

👁 FOCAL POINTS

1 PORTRAIT OF GHIBERTI

The frames around the panels of the two doors feature portrait heads in roundels, including this one of Ghiberti himself. The roundels alternate with niches containing statuettes of Old Testament figures and sibyls. The frames' decoration is completed by floral and animal motifs.

2 LIFE OF JOSEPH

Ghiberti used high and low relief to distinguish three episodes in the life of Joseph (Genesis xxxvii–xlv). At the top right, Joseph is thrown into the pit by his brothers; in the centre, he distributes grain to a large crowd; and at the top left, he reveals his identity and forgives his brothers.

3 QUEEN OF SHEBA

The arrival of the Queen of Sheba (I Kings x) is set against a monumental portico in a composition that prefigures Raphael's *School of Athens* (1509–10). Ghiberti enhanced the sense of depth by incorporating grand architecture that he depicted using newly discovered laws of perspective.

ARTISTS IN COMPETITION

In the winter of 1401 to 1402 the Calimala announced a competition for a new pair of bronze doors for the 12th-century Battistero di San Giovanni. These would replace the doors that Andrea Pisano had made in the 1330s for the baptistery's east portal. A trial panel depicting the Sacrifice of Isaac (Genesis xxii) was commissioned. The terms of the competition were that the panel should be completed within a year and that it should conform to the quatrefoil pattern of the existing doors. The contest attracted six sculptors, including Ghiberti, Jacopo della Quercia and Filippo Brunelleschi, all of whom were assigned the Old Testament story of the sacrifice of Isaac by his father Abraham. Ghiberti ingeniously accommodated his design (below) by compacting the tragedy of love and obedience into the moment when Abraham 'stretched forth his hand and took the knife to slay his son'. After much deliberation, the Calimala contracted Ghiberti to

make a set of bronze doors depicting twenty events from the life of Christ, and also the four Evangelists and the four Doctors of the Church. Twenty years later, and at the huge cost of more than 22,000 florins, the doors were finally set in place.

Polyptych of St Anthony

1467 – 69

PIERO DELLA FRANCESCA

C. 1415 – 92

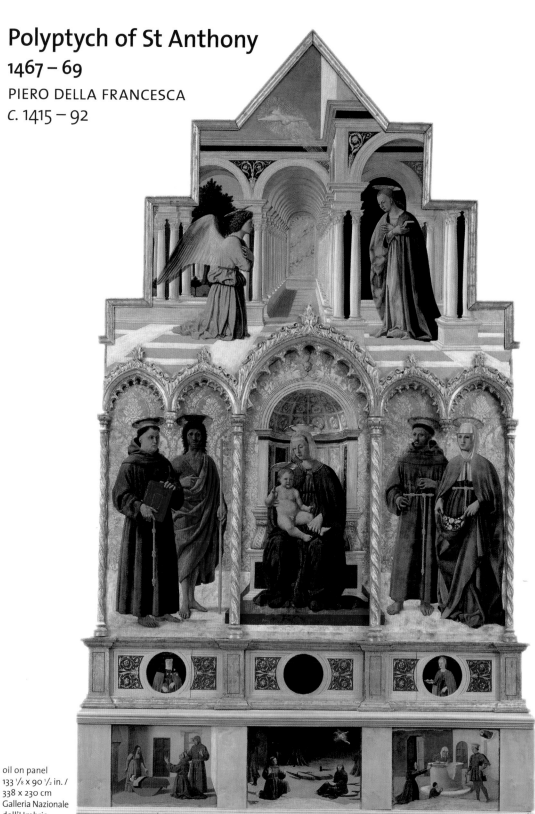

oil on panel
133 ⅛ x 90 ½ in. /
338 x 230 cm
Galleria Nazionale
dell'Umbria,
Perugia, Italy

n 1454 Piero della Francesca signed a contract to paint a monumental polyptych for the Franciscan nuns of the convent of St Anthony in Perugia, but it was more than a decade before the large altarpiece was completed. At the centre are the Madonna and Child flanked by four saints, namely (from left to right) Anthony of Padua, John the Baptist, Francis of Assisi and Elizabeth of Hungary, protectress of the Franciscan tertiaries. The predella scenes at the foot of the altarpiece depict episodes from their lives. The work is problematic because of the incongruity of the composition, in particular the Annunciation scene portrayed in the upper section. The perspective of a tunnel of Corinthian columns, each projecting a thin shadow on to the floor of the cloistered arcade, contrasts dramatically with the golden background of the saints below. It has been suggested that Piero adapted this upper panel to the centre portion of the polyptych on the order of the convent. It is also thought that the roundels and the predella contained other scenes, including an image of St John the Baptist, but they have not survived. **PG**

◉ FOCAL POINTS

1 DOVE OF THE ANNUNCIATION

The dove of the Annunciation is surrounded by a halo with rays of light that descend in a sharp diagonal towards the Virgin Mary beneath. The lines of perspective in the colonnaded portico below the dove converge on the farthest wall to create a strong sense of depth.

4 PORTRAIT OF ST ANTHONY

Although it is thought that Piero's assistants painted some areas of the central section, the portrait of St Anthony of Padua is known to be by Piero. The solid, shapely mass of the saint's tonsured head, which is reflected by his halo, is a remarkable detail, worthy of the master himself.

2 THE VIRGIN MARY

The Virgin Mary greets the Archangel Gabriel with her head bowed and her arms crossed, emphasizing her humble acceptance of the divine message of the Incarnation. Despite her stiff pose, Mary holds her prayer book in a naturalistic way, keeping a finger inside so as not to lose her place, adding to the sense of her humanity, religiosity and humility. The figure of the archangel, far from being ethereal, is solid, calm and three-dimensional.

3 ST FRANCIS AND THE STIGMATA

St Francis received the stigmata near the end of his life. The emotional impact of the event is heightened by the night-time setting. Surrounded by golden light, the figure of the crucified Christ breaks the darkness of the night sky and echoes the position of the dove shown in the Annunciation scene above.

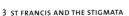

◷ ARTIST PROFILE

c. 1415–38

Piero was born in the village of Sansepolcro, in Arezzo, Italy, the son of a cobbler. He gained an apprenticeship in the Florentine workshop of painter Domenico Veneziano. In Florence Piero met other leading artists, including Filippo Brunelleschi and Fra Angelico.

1439–40

He worked as an assistant to Veneziano on a series of frescoes for the hospital of Santa Maria Nuova in Florence.

1441–52

On his return to Arezzo, Piero worked on altarpieces and frescoes. In 1451 he went to work in Rimini, and then on to Ancona, Pesaro and Bologna. Piero was called back to Arezzo in 1452 to complete a cycle of frescoes, *The Legend of the True Cross* (c. 1452–65), in the basilica of San Francesco.

1453–79

Piero went back to Sansepolcro and the following year he was commissioned to paint the *Polyptych of St Anthony*. He also worked extensively in Rome during this period but sadly none of the work Piero did there has survived.

1480–92

Piero suffered from cataracts in his later years. A talented mathematician, he devoted himself to writing theoretical works on geometry, applied mathematics and perspective, and wrote the first treatise to deal with the mathematics of perspective. He eventually went blind and died in Sansepolcro.

Primavera *c.* 1478

SANDRO BOTTICELLI *C.* 1445 – 1510

tempera on wood panel
80 x 123 ⅝ in. / 203 x 314 cm
Uffizi, Florence, Italy

The meaning of this painting by Sandro Botticelli is unclear. One school of thought sees it as a series of episodes. On the right Zephyrus, the west wind, is pursuing Chloris, a nymph, who is changed into the goddess Flora after their embrace. In the centre is Venus with a blindfolded Cupid above; she appears as the goddess of love and a representative of nature's productive powers. To the left of her are the Three Graces, and on the extreme left is the messenger god Mercury, who removes the cloud, the veil that hides truth. An alternative explanation is that the painting represents the cycle of the seasons, from February (Zephyrus) through spring and summer to September (Mercury). Both interpretations suggest an ideal that cannot be realized in the world. **PG**

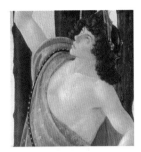 FOCAL POINTS

1 MERCURY

Botticelli's representation of the messenger god Mercury reflects his awareness of the work of Early Renaissance artists in the heroic depiction of the male physique. He may have derived Mercury's hand-on-hip stance from a contemporary statue, such as Andrea del Verrocchio's *David* (1473–75).

2 THREE GRACES

The artist's ability to convey movement is evident in the depiction of the Three Graces. Linking hands to dance in a ring they float above the lawn, hardly bending a blade of grass. Their position, with two figures facing the viewer and one with her back turned, is their typical grouping.

3 VENUS

An elegantly dressed Venus stands at the centre, set back from the other figures. All the action revolves around her. The swelling of Venus's belly suggests that she is pregnant. The myrtle plant growing behind her represents sexual desire and child-bearing within the institution of marriage.

4 ZEPHYRUS AND CHLORIS

The west wind, Zephyrus, blows on to the face of the nymph Chloris. His blue features contrast with the delicacy of her face, which shows surprise and fear. Chloris is transformed into Flora, the goddess of spring, and a string of flowers issues from her mouth at the moment of her metamorphosis.

5 FLOWERS

Botticelli's ethereal, mystical figures stand out against the rich backdrop of flowers. His naturalistic observation of spring flowers growing from a luxurious dark lawn blends with fantasy to create the impression that the figures are performing against a splendid tapestry.

NAVIGATOR

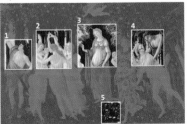

JAPANESE ART: THE INFLUENCE OF ZEN

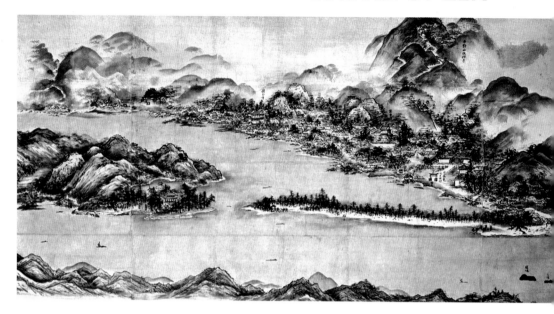

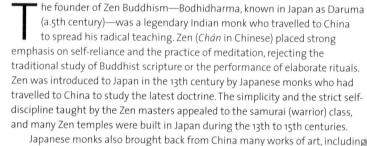

The founder of Zen Buddhism—Bodhidharma, known in Japan as Daruma (a.5th century)—was a legendary Indian monk who travelled to China to spread his radical teaching. Zen (*Chán* in Chinese) placed strong emphasis on self-reliance and the practice of meditation, rejecting the traditional study of Buddhist scripture or the performance of elaborate rituals. Zen was introduced to Japan in the 13th century by Japanese monks who had travelled to China to study the latest doctrine. The simplicity and the strict self-discipline taught by the Zen masters appealed to the samurai (warrior) class, and many Zen temples were built in Japan during the 13th to 15th centuries.

Japanese monks also brought back from China many works of art, including ink paintings and calligraphy; the monks also introduced the custom of drinking powdered tea from ceramic bowls. Trade with China's Ming Dynasty (1368–1644) was encouraged by the shogun (the hereditary military governor of Japan), and Zen monks were at the forefront of Japanese economic and cultural exchanges with their mainland neighbour. Zen temples became central to the monks' artistic and religious activities, and ink painting and calligraphy became part of their training. In secular Japan, too, Zen aesthetics were embraced by the shogun and his circle, and Zen became the most important philosophical ideal to shape Japanese culture in the following centuries. Many of the art forms still practised in Japan today, such as the tea ceremony, ink painting, Noh drama and dry landscape gardens, developed at this time under the influence of Zen Buddhism.

1 *View of Ama-no-hashidate* (c. 1501–06)
Sesshū Tōyō • hanging scroll painting,
ink and light colour on paper
35 3/8 x 70 1/8 in. / 90 x 178 cm
Kyoto National Museum, Japan

2 *Bodhidharma (Daruma)*
(late 16th century)
Artist unknown • hanging scroll painting
30 1/8 x 15 3/8 in. / 76.5 x 39 cm
British Museum, London, UK

KEY EVENTS

1336	1423	1450	1466	1495	1543
The Muromachi period begins when the Ashikaga clan take over the shogunate and establish their government in Kyoto.	Tenshō Shūbun, a Zen monk and painter, travels to Korea. His landscapes, like much art at this time, are inspired by Chinese examples.	The Zen temple Ryōan-ji is established in the Kyoto hills; it becomes the site of one of the best-known 'dry landscape' rock gardens (*kare-sansui*).	The Onin War breaks out between the shogunate and the local lords (*daimyo*); the war leads to the destruction of Kyoto in 1477.	Sesshū Tōyō paints his *Landscape in Haboku (Splashed Ink)*, evoking a mountain landscape with a minimum of rough brushstrokes.	Portuguese sailors reach Tanegashima Island and become the first Europeans to land on Japanese soil. They introduce the Japanese to firearms.

Zen rock gardens, called *kare-sansui* (dry landscape), have none of the colourful trees and plants that characterize Western gardens. The rock garden of Ryōan-ji temple in Kyoto contains only fifteen rocks of varying sizes, arranged in a rectangular plot covered with white gravel. The rocks are arranged in groups of seven, five and three, and the pattern of raked gravel creates an impression of a vast ocean dotted with small islands. Viewers are invited to interpret this pure and contemplative setting in their individual ways.

Chinese ink paintings were much admired in Japan, and a great collection was formed by the shogun. Monks in the Zen monasteries first copied the Chinese ink-painting technique, but gradually developed new subject matters and a style better suited to the Japanese. Sesshō Tōyō (1420–1506) was a monk painter who trained under the master of ink landscape painting, Tenshō Shūbun (a.1418–63), in the famous Zen Shōkoku-ji temple in Kyoto. After studying the technique of ink painting in the Chinese Song style, Sesshū travelled to China to study the works of contemporary Ming artists. On his return to Japan, he settled in Yamaguchi in western Japan and established a painting studio where he continued to paint landscapes in his highly individual style. Sesshū's *View of Ama-no-hashidate* (opposite) shows a panoramic view of the sandbar in a bay in Tango Province—one of the three most famous scenic locations in Japan. The topographic accuracy suggests that Sesshū must have travelled and observed the location at first hand. The image can be dated from the details of the temple architecture shown. This ink painting is not an imaginary 'ideal landscape' in the Chinese tradition, but a realistic depiction of a famous view.

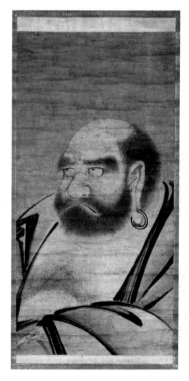

A century later, Japanese ink painting had reached a further level of technical sophistication. The image of Daruma (right) belongs to a devotional tradition in which portraits of the founder of Zen Buddhism were made in brush and ink as a route to enlightenment. The artist renders the founder's head and hair with many fine lines, contrasting this delicate technique with wide, rapidly applied brushstrokes that represent Daruma's robes. In contrast, the screens entitled *Forest of Pines* (late 16th century; see p.162) executed by Hasegawa Tōhaku (1539–1610) during the same period demonstrate an allusive, ethereal style.

In Japan tea drinking was gradually codified into an art form incorporating Zen aesthetics. The tea master Sen no Rikyū (1522–91) commissioned tile maker Chōjirō (1516–92) to create tea bowls that embodied his ideals of natural beauty. Chōjirō's bowls won the approval of the military leader Toyotomi Hideyoshi (1536–98), who bestowed upon Chōjirō the name 'Raku', which came to be stamped on his bowls. Raku tea bowls are hand-carved in clay, individually fired at a high temperature, then cooled immediately. The dark and thick glaze enhances the bright green colour of the whisked tea, and the irregular shape of the bowl gives a tactile pleasure to the user. Chōjirō's descendants continue to make Raku tea bowls to this day. **MA**

1549	1568	1582	1587	1596	1600
The Jesuit priest Francis Xavier (1506–52) arrives in Kagoshima and introduces Christianity to Japan. Eager for Western technology, some *daimyo* convert.	The *daimyo* Oda Nobunaga (1534–82) enters Kyoto and sets up a puppet Ashikaga shogun, establishing the Azuchi-Momoyama period.	After Nobunaga's assassination, Toyotomi Hideyoshi (1536–98) continues to reunite Japan; in 1587 he expels the Jesuits and takes control of Nagasaki.	Hideyoshi hosts a ten-day tea ceremony at the Kitano Shrine. The emperor attends and tea master Sen no Rikyū officiates.	Hideyoshi invades Korea for the second time (first time in 1592), but dies suddenly. Many Korean craftsmen are transported to Japan.	Tokugawa Ieyasu (1543–1616) defeats forces loyal to Hideyoshi at Sekigahara, leading to the establishment of the Tokugawa shogunate.

Forest of Pines late 16th century
HASEGAWA TŌHAKU 1539 – 1610

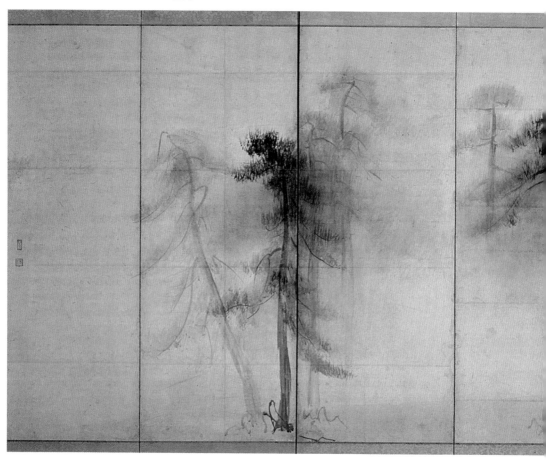

ink on paper
61½ x 136½ in. / 156 x 347 cm
Tokyo National Museum, Japan

In traditional Japanese architecture, rooms were divided by sliding door panels
called *fusuma* that were fitted into tracks on the floor and the corresponding
grooves under the beams above. Some portable room dividers were made as
folding screens called *byōbu*, which were made from a lattice of wooden frame
covered with layers of papers. They were usually made in pairs, with two, four,
six or eight hinged panels. This form of furniture became very popular during
the Momoyama period (1573–1615), when warlords built magnificent castles
and required artists to decorate the interiors. Warlords, rather than Buddhist
institutions and the imperial court, became the major patrons of art.

This, one of a pair of six-fold screens, was painted in monochrome ink by
Hasegawa Tōhaku, a painter of Buddhist imagery who studied in Kyoto under
Toshun (a.1506–42), the successor of Sesshū Tōyō. Tōhaku considered himself the
heir of Sesshū, the greatest artist of the Zen ink-painting tradition from the
previous century. Although Tōhaku studied painting by Chinese artists in
Kyoto's Zen temple of Daitoku-ji, he was a versatile artist who produced large
and dynamic screen paintings in a wide range of styles. These screens feature
the dark silhouettes of tall pine trees that loom from a dense, enveloping
morning mist. The more distant trees are only faintly visible, suggesting the
hushed, mysterious landscape of a dream. A strong Zen influence prevails, and
the empty spaces within this *byōbu*'s design invite calm contemplation. **MA**

✦ NAVIGATOR

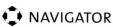

1 PINE TREE IN FOREGROUND

The pines in the foreground are painted in dark ink. Their dry brushstrokes are exceptionally energetic and verge towards abstraction when examined in detail. Monumental pine trees are a symbol of longevity in East Asian paintings. Tōhaku's trees are slender and impressionistic in style.

2 PINE TREE IN BACKGROUND

Depth of space is given by the pale tone of wet ink used for some of the trees in the background. They are positioned above the darker trees in the foreground, leading the eye into the distance. The misty atmosphere is suggestive of all that is unseen and invites the viewer to stop and reflect.

3 EMPTY SPACE

The use of empty space is an important characteristic of Zen ink painting. The empty space creates tension in the composition, stimulating the viewer's imagination. The taste for Zen's austere simplicity was shared by a cultured circle who abhorred the military leaders' extravagant displays of wealth.

PAINTING ON GOLD

During the Momoyama period there was an increase in demand from rulers and rich merchants for large and colourful paintings on a gold background. Squares of extremely thin gold foils were applied to the surface, and motifs were painted on top with colours made from a mixture of mineral pigment and glue. In 1592 Tōhaku decorated a pair of sliding door panels with a vibrant polychromatic study of nature on a rich gold background for the *daimyo* (warlord) Toyotomi Hideyoshi.

One of the most sought-after artists of this period, Kanō Eitoku (1543–90), was a prominent exponent of this painting style. In *Tartar Envoys Arriving in Ships, Their Advance Party Ashore* (late 16th century; right) he uses expanses of the background of gold-leaf paper, together with broad brushstrokes of blue-green sea, to create negative spaces that help to imply distance between the advance party on the shore in the foreground and the ships arriving in the background.

VENETIAN RENAISSANCE

Between 1300 and 1600 Venice was the greatest trading city in Europe. Although nominally a republic, like Florence, in reality Venice was an empire. The city controlled land in northern Italy, the Adriatic coast and countless islands throughout Greece as far as Cyprus. Governed by an elite and hereditary ruling class, the maritime city enjoyed a stable political climate and a thriving trade economy, leading to its nickname, 'La Serenissima' (The Most Serene). Venice's unique position on a lagoon and its close trading links with the East dramatically influenced the development of its art. The city traded in exotic and luxury goods and was filled with ceramicists, glass workers, woodworkers, lacemakers, sculptors and painters. Rich oriental patterns and design permeated the city's culture and are reflected in Venetian art.

KEY EVENTS

1424	1475–76	c. 1488–90	1494	1495	c. 1507
Florentine artist Paolo Uccello (c. 1397–1475) arrives in Venice to supervise the restoration of St Mark's, ending the city's artistic isolation.	Sicilian artist Antonella da Messina (c. 1430–79) visits Venice, bringing with him a new style of painting in oils, which local painters soon adopt.	The Lombardos begin to develop a classical style. Tullio (c. 1455–1532) decorates the Scuola Grande di San Marco facade with perspective reliefs.	Northern Renaissance artist Albrecht Dürer (1471–1528) visits Venice for the first time and is greatly influenced by the city's artistic scene.	Aldus Manutius (1449–1515) founds a groundbreaking printing press in Venice, the Aldine Press, and prints classic Greek and Latin texts.	Giorgione paints The Tempest (see p.168), arguably the first realistic representation of landscape in Western painting.

The painter Giovanni Bellini (*c.* 1430–1516) served as court artist to the Turkish Sultan Mehmet II (1432–81), painting the portrait of the conqueror of Constantinople during his stay at court in 1480. The interest in portraiture and social prestige is reflected in the large narrative scenes that Vittore Carpaccio (*c.* 1460–1525) created for the meeting halls of Venice's numerous *scuole*, or confraternities. In paintings such as *Miracle of the Relic of the True Cross* (opposite) Carpaccio places the emphasis on convincing portraits of the confraternity members and reflects their economic prosperity. He sets the miracle in the heart of Venice at the Rialto Bridge on the Grand Canal.

Although religious commissions dominated the art world, by the start of the 16th century the aspiration of Venetian artists and their patrons had changed dramatically. No longer satisfied with devotional images, they sought originality in style and subject matter. The change was first apparent in the work of Giorgione (Giorgio Barbarelli da Castelfranco; *c.* 1477–1510) and his two close followers, Titian (Tiziano Vecellio; *c.* 1485–1576) and Sebastiano del Piombo (*c.* 1485–1547). Venice had no great fresco tradition because of its damp climate. Artists painted on panel or canvas in a much freer style, making use of the new oil technique's potential to achieve vibrant chromatic effects and change ideas while painting. The large canvases procured from sailmakers in the Arsenale dockyards allowed artists to paint on a grand scale. The vast altarpiece *Assumption of the Virgin* by Titian caused a sensation when it was unveiled in 1518. The triangles formed by the red robes of the Apostles and the gesture of God above them make Mary's ascent into heaven appear physical.

Venetian sculptors, such as Tullio Lombardo (1460–1532) and his brother Antonio (*c.* 1458–1516), were more preoccupied with the Early Renaissance (see p.150) desire to recreate the classical world than were painters. But in the late 15th century Florentine sculpture was still regarded as prestigious, as shown by the commission given to Andrea del Verrocchio (*c.* 1435–88) for the equestrian monument to the mercenary soldier Bartolommeo Colleoni in 1478.

A growing interest in the art of Florence and Rome was evident in painting too, especially after 1535. From Michelangelo (Michelangelo Buonarroti; 1475–1564) and the Mannerist (see p.202) painters, Venetian artists learnt how to enliven their figure style and compositions, but they remained faithful to the quintessentially Venetian qualities of expressive brushwork and brilliant colour. While the Mannerist style became stereotyped, Titian, Tintoretto (Jacopo Comin; *c.* 1518–94) and Paolo Veronese (1528–88) retained their creative vitality, with works such as Titian's *Bacchus and Ariadne* (1520–23; see p.170). The energetic brushwork of Tintoretto's *St Ursula and the Eleven Thousand Virgins* (right) reveals why he was called 'Il Furioso' (The Furious); its dramatic use of perspectival space and lighting effects show him to be a precursor of Baroque art (see p.212). The great triumvirate of Titian, Tintoretto and Veronese produced masterpieces that were to inspire painters throughout Europe in the 17th century. **PG**

1 *Miracle of the Relic of the True Cross* (1494)
Vittore Carpaccio • oil on canvas
143 ³/₄ x 153 ¹/₈ in. / 365 x 389 cm
Galleria dell' Accademia, Venice, Italy

2 *St Ursula and the Eleven Thousand Virgins*
(*c.* 1555)
Tintoretto • oil on canvas
129 ⁷/₈ x 70 ¹/₈ in. / 330 x 178 cm
San Lazzaro dei Mendicanti, Venice, Italy

1508	1508	1516	1527	1538	1562–66
Pope Julius II (1443–1513) forms the League of Cambrai in collaboration with several European rulers in an attempt to reduce Venice's power.	Giorgione works on frescoes for the front of the Fondaco dei Tedeschi (German warehouse) in Venice; Titian paints frescoes on its south side.	Bellini dies and Titian becomes the official painter to the Venetian Republic.	Florentine architect and sculptor Jacopo Sansovino (*c.* 1486–1570) settles in Venice and introduces a new style based on central Italian models.	Titian paints *The Venus of Urbino* based on Giorgione's *Sleeping Venus* (*c.* 1510).	Tintoretto paints *The Transportation of the Body of St Mark*, one of three scenes depicting Venice's patron saint, for the Scuola Grande di San Marco.

Pietà *c.* 1505

GIOVANNI BELLINI *C.* 1430 – 1516

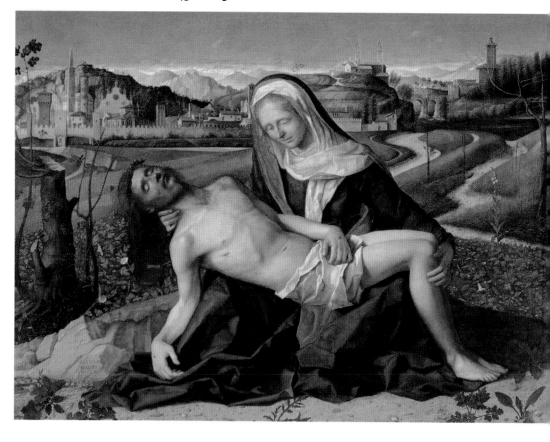

oil on panel
25 ⅝ x 35 ⅜ in. / 65 x 90 cm
Gallerie dell'Accademia, Venice, Italy

A 'Pietà' is a depiction of the Virgin Mary grieving over the body of Christ. The theme was extremely popular in northern European art and the Madonna was usually depicted in agonized and contorted grief lamenting over the gaping wounds of her dead son. Giovanni Bellini's earlier *Pietà* (*c.* 1468–70) depicted the subject of the mourning mother but with a standing Mary. The formal problem Bellini faced when he painted this later version was how to accommodate a full-grown man in the lap of a seated woman and create a convincing composition. The Madonna is seated on the ground in order to emphasize her desolation and humility. Bellini painted this piece when he was in his seventies, illustrating that he constantly reinvented his artistic language throughout his long career.

Bellini's image was created for personal and private devotion and anaesthetizes the horror of the Crucifixion. Only small holes in the hands, feet and Christ's side represent the physical brutality of the Passion. Instead the image concentrates upon the intense sorrow of the mother grieving over her dead son. Mary is saying goodbye to Christ, cradling him in her lap before his burial. Despite the small scale of the painting, the isolated figures appear monumental against the breadth of the landscape behind them. They are separated in the foreground by a hedge of flowers depicted in painstaking detail. The hedge forms an arc between the figures and the town and emphasizes their timeless separation from all earthly events, enabling the devout to concentrate their compassion and prayers upon mother and son. **PG**

✦ NAVIGATOR

👁 FOCAL POINTS

1 CITYSCAPE

The arc of flowers gives way to a flat plain with a walled town and hills rising in the distance. The cityscape is composed of recognizable buildings from Venetian towns, including the cathedral and tower at Vicenza and the bell tower of Sant'Apollinare Nuovo in Ravenna.

2 MADONNA

The apex is filled with the sad and exhausted expression of the Madonna as she gazes down at her son. The Virgin Mary cradling her dead son recalls the images of the Madonna with the infant Christ asleep on her lap; here, however, Bellini enhances the pathos of the scene by ageing the Madonna's features. Her voluminous skirts envelop her dead son and form the base of an equilateral triangle that fills most of the lower portion of the painting.

3 SAPLING

The plants in the painting and the thick dark hedge behind the Madonna are realized with minute precision. The plants were chosen for their symbolism or association with healing: the bitter herb dandelion represents Christian grief and Christ's Passion, the white strawberry flowers are the symbol of perfect righteousness, violets are for humility and the thistles to the left of Christ's head represent spiritual and bodily pain.

4 OAK TREE

The lopped tree represents the Tree of Life, which grew in the Garden of Eden. According to contemporary Christian tradition, it was cut down to provide wood for the cross of the Crucifixion. The tree bears a single leafy branch representing hope of the Resurrection.

🕐 ARTIST PROFILE

c. 1430–52

Giovanni Bellini was born in Venice to a leading dynasty of painters. His father, Jacopo Bellini, was a main protagonist in the revival of Venetian art and taught Giovanni and his brother Gentile how to paint in his busy workshop.

c. 1453–74

One of Giovanni's sisters, Nicolosia, married one of their father's trainees, Andrea Mantegna. For several years the classicism of the Paduan Mantegna exerted considerable influence on Giovanni, as seen in early works such as *The Agony in the Garden* (c. 1465). The artist also studied some of Donatello's works in Padua, which further contributed to Giovanni's artistic maturity.

1475–76

Sicilian artist Antonello da Messina visited Venice. He introduced the Flemish concern for detail and the spatial interests of central Italy to the city, which influenced Giovanni's work.

1477–1516

Giovanni's workshop became the centre of Venetian art, the milieu in which a generation of painters was formed. His prestige spread beyond the Venetian Republic; when Albrecht Dürer visited Venice in 1506, he wrote that Giovanni 'is very old and yet he is the best painter of all'.

MICHELANGELO'S *PIETÀ*

In his *Pietà* (1499; below), Michelangelo dispenses with the cruelly realistic depictions of the battered body of Christ seen in northern European art in favour of an idealized vision that balances classical beauty with naturalism. Giorgio Vasari wrote in his *Lives of the Most Excellent Italian Painters, Sculptors and Architects* (1550) that Michelangelo's *Pietà* 'displays the utmost limits of sculpture.... It is a miracle that a once shapeless stone should assume a form that nature with difficulty produces in flesh'. He portrays Mary as a young woman because she is ageless: her youth is an expression of her incorruptible purity. She sits with bowed head holding the body of her son, which fits almost completely into the contours of her abundant robes. Mary is depicted as the Queen of Heaven. She accepts the will of God and gestures with her left hand to present her dead son to the world. Here Michelangelo combines the themes of death and youth with grief and beauty.

The Tempest *c.* 1507
GIORGIONE *c.* 1477 – 1510

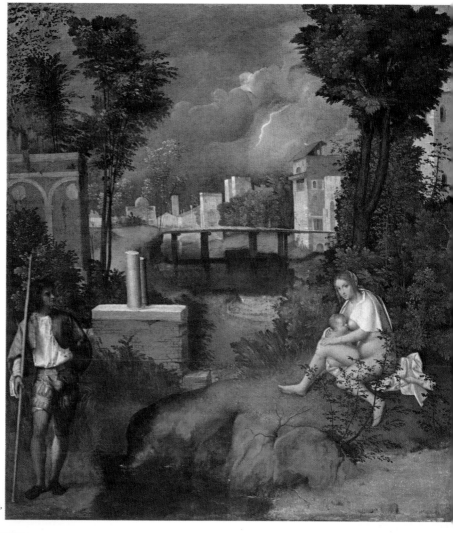

oil on canvas
32 ¼ x 28 ¾ in. /
82 x 73 cm
Galleria dell'Accademia,
Venice, Italy

✪ NAVIGATOR

Five hundred years after its completion, *The Tempest* continues to defy interpretation. It was commissioned from Giorgione (Giorgio Barbarelli da Castelfranco) by Gabriele Vendramin. Venetian art connoisseur Marcantonio Michiel saw it in Vendramin's house in 1530 and described it as 'a small, stormy landscape with a gypsy girl and a soldier'. Later it was listed in the collection of the Vendramin family as *Mercury and Isis*. In this context, the figures might represent the nymph Io breast-feeding her son and the god Mercury near by, but the painting probably had no literary origin. The viewer's eye is led past the figures, following the river deep into the picture to meet the thundery sky; the tense atmosphere of the piece is perhaps its true subject.

X-rays have revealed that the figure of the man has been painted over that of a nude woman dabbling her feet in the water, suggesting that Giorgione changed his mind about the content of the picture. Paintings with a 'hidden meaning' that is clear only to a small circle of the initiated were particularly admired by the young nobles for whom Giorgione often worked. **PG**

👁 FOCAL POINTS

1 APPROACHING STORM

Giorgione has captured the moment when a flash of lightning rips open the rain clouds. The painting has a calm, almost static quality, implying the humid atmosphere of an imminent storm. The strange blue-green landscape and golden light convey an aura of melancholy and menace.

2 SYMBOLISM

Art historian Edgar Wind saw the nude gypsy figure as an allegory of the theological virtue of 'Caritas', or charity, and the man —perhaps a soldier—as a symbol of martial valour, or strength. United, they can overcome fickle Fortune, symbolized by the impending storm.

3 SOLDIER

The isolated figure of the man leaning on his spear with his jerkin unbuttoned and his face obscured by shadow adds to the mystery of the painting. By substituting this clothed man for the female nude that originally stood here, Giorgione adds a psychological tension to the painting.

4 BROKEN COLUMNS

The broken columns between the man and the gypsy may stand for broken hopes and dreams, perhaps mirroring the transition between the sunlit foreground and the intimidating background, where the gathering storm threatens. They may also represent death.

5 LUMINOSITY

In *The Tempest*, Giorgione incorporates techniques new to the age. He mixes oil paint and egg-based tempera, creating a glazed transparency that gives a new luminosity to his art. Leonardo's influence is evident in the use of *sfumato*—softened outlines, obscuring the transition between colours.

🕒 ARTIST PROFILE

c. 1477–88

Very little is known about Giorgione. He was born in Castelfranco and moved to Venice in c. 1488, entering the workshop of Giovanni Bellini.

1489–1505

His early commissions included a portrait of the Doge Agostino Barbarigo in 1500, the year he is said to have met Leonardo da Vinci in Venice, and an altarpiece in his home town (1504). The following year, Giorgione received his first major public commission: along with a group of artists including Titian, he was asked to paint frescoes for the Fondaco dei Tedeschi (German warehouse) in Venice, which was completed in 1508.

1506–10

Only a handful of works can be confidently attributed to Giorgione, partly because of his tendency to leave works unfinished. They include *The Tempest*, *Laura* (1506) and *Sleeping Venus* (c. 1510). Giorgione probably succumbed to the plague that swept through Venice in the autumn of 1510, but his reputation as an innovator, both stylistically and in terms of artistic practice, has survived. He was the first painter to produce works for private collectors, as opposed to public or non-secular commissions. He was also a pioneer in prioritizing the mood of a painting over its subject matter, as in *The Tempest*.

LE DÉJEUNER SUR L'HERBE

Giorgione's *The Tempest* is said to have influenced Edouard Manet's *Le Déjeuner sur l'herbe* (1862–63; below). Certainly there are compositional similarities. Giorgione juxtaposes a fully clothed male and a semi-naked female, and the painting has an air of unease because the relationship between the two is unclear—there is a sense that something is about to happen. The female gazes directly at the viewer, a device also used by Manet, except that here one of the males is also alert to the viewer, and both man and woman seem to challenge the viewer to find anything amiss in the scene. Both Giorgione and Manet give their protagonists a bucolic backdrop, but while Giorgione suggests drama with storm clouds and lightning, no comment is implied by Manet's sunlit location.

Bacchus and Ariadne 1520 – 23

TITIAN c.1485 – 1576

oil on canvas
69 ¹/₂ x 75 ¹/₄ in. / 176.5 x 191 cm
National Gallery, London, UK

⬡ NAVIGATOR

Inspired by the story of two lovers from the authors Ovid and Catullus, this early masterpiece by Titian (Tiziano Vecellio) is one of a series produced for Alfonso D'Este, the Duke of Ferrara. Titian was the foremost painter of the Venetian Renaissance; after the death of his master Giovanni Bellini in 1516, he dominated Venetian art for the next sixty years and became the most famous artist in Europe. Alfonso D'Este commissioned *Bacchus and Ariadne* for his palace at Ferrara in northern Italy. This work shows the moment when Bacchus, the god of wine, meets Ariadne, daughter of the King of Crete. Having helped her lover, Theseus, to escape from the Minotaur's labyrinth, Ariadne has been abandoned on the island of Naxos. Enter Bacchus in a chariot drawn by two cheetahs, with his motley crew of drunken followers. Bacchus is shown in mid-leap as his eyes lock with those of his future bride. Initially frightened by Bacchus's appearance, Ariadne's face shows a mixture of fear and interest as she meets his gaze. Although her face is turned to Bacchus, her body is turned away from him. Demonstrating a mastery of colour, movement and imagery, Titian brings flesh to life on the canvas in an unprecedented way. **FP**

FOCAL POINTS

1 THESEUS'S SHIP

To the left of Ariadne, Theseus's ship can just be seen sailing away on the horizon. Ariadne helped Theseus escape from the Minotaur's labyrinth by giving him a ball of red thread so that he could find his way out. According to some accounts, Theseus abandoned her on Naxos while she slept.

2 BACCHUS

Bacchus is locked in an erotic gaze with Ariadne. As the Greek god of wine (Dionysus in Roman mythology), Bacchus wears a laurel of vine leaves. His athletic pose echoes the discus thrower in Greek sculpture. His pink cloak, used to hide his nudity, echoes Ariadne's vermilion sash.

3 SNAKE-WRESTLING FIGURE

This imposing figure, shown wrestling with a snake, refers to the classical statue *Laocoön and his Sons*, which had been rediscovered in Rome in 1506. Laocoön warned the Trojans in vain not to accept the Greeks' gift of a wooden horse. He was later strangled by sea serpents sent by the goddess Minerva.

4 BABY SATYR

Half-human, half-goat, the baby satyr is the only figure looking out of the canvas, 'inviting' the viewer into the frame. He has with him a disembodied calf's head, a symbol that makes reference to the grisly Bacchic ritual in which revellers dismembered a live calf and ate it raw.

5 VASE

On top of a courtesan's yellow robe lies a bronze vase. It gleams in the sunshine, drawing the eye towards it, and bears the Latin inscription 'TICIANVS F(ECIT)', meaning 'Titian made this'. Titian was one of the first artists to sign his work.

⏱ ARTIST PROFILE

1499–1510
Titian entered the workshop of Gentile (c. 1430–1507) and Giovanni Bellini at an early age. He went on to work with Giorgione, then the leading Venetian painter, and they became friends. They collaborated on a fresco of the Fondaco dei Tedeschi (German warehouse) in Venice.

1511–16
After the early death of Giorgione in 1510, Titian received his first commissions for a series of frescoes in the Scuola del Santo at Padua. With the death of Giovanni Bellini in 1516, Titian stood unrivalled in the Venetian School.

1517–30
Titian undertook more complex subjects. The Pesaro altarpiece at Santa Maria Gloriosa dei Frari strengthened his reputation. Equally inventive in portraiture, allegories, devotional and mythological work, he commanded an international clientele.

1531–50
During this period, Titian took high-profile portrait commissions, including that of the Holy Roman Emperor Charles V. His painting style became more tranquil and reflective.

1551–76
Titian worked mainly for Philip II of Spain as a portrait painter. During this time, his painting was characterized by a more refined and subtle quality.

THE COST OF COLOUR

The blue that shines out from *Bacchus and Ariadne* and is especially vibrant in Ariadne's robe (below) has lost none of its radiance over time. Titian was famed as the most original colorist of his age and he made extensive use of ultramarine. It was made from lapis lazuli, a form of limestone containing the mineral lazurite. The best grades still come from Badakshan in Afghanistan; cave paintings there suggest that lapis lazuli was used as a pigment as early as the 6th and 7th centuries. During the Renaissance, ultramarine was more expensive than gold. Its use was written into contracts and patrons often bought the pigment separately. Titian's wealthy clientele ensured that he could afford the best grades. Extracting the colour was complex and labour-intensive; it took 2.2 pounds (1 kg) of the mineral to produce 1 ounce (30 g) of the pigment. Ultramarine's use declined with the development of oil painting as it had to be mixed with white to achieve the intensity produced with egg tempera. A cheap synthetic version was invented in 1828.

HIGH RENAISSANCE

Florence was indisputably the centre of the European artistic Renaissance for most of the 15th century, but by that century's end the city-state was in turmoil. The ruling Medici family had been put to flight in 1494 by the invasion of Charles VIII of France, and after some disquieting political events the Dominican friar Girolamo Savonarola had been condemned and burnt at the stake in 1498. The papal court, meanwhile, had long returned from Avignon to Rome, which in 1420 Pope Martin V had found 'so dilapidated and deserted that it bore hardly any resemblance to a city'. The return of the papacy brought with it a new wave of confidence and wealth, stimulating patronage as the popes set about restoring the ancient city's fabric to make it once again a suitable centre of Christendom. Florence continued to be productive into the 16th century, but during the period now termed the 'High Renaissance' most important artistic developments took place in Rome.

The papal capital had two formidable cultural assets: its Christian heritage and its classical Roman past. Both made Rome a magnet for artists and scholars from all over Italy and Europe. The papal grand plan for the revitalization of Rome centred on a reorganization of the area around the Vatican and St Peter's. Pope Sixtus IV ordered the construction of a new

KEY EVENTS

1478	c. 1490	1492	1498	1499	1503
Giuliano de' Medici is assassinated. His brother Lorenzo de' Medici (Il Magnifico) becomes sole ruler of Florence.	Michelangelo begins working for the Medici family while attending the Neo-Platonic humanist academy that they founded.	Lorenzo de' Medici dies. Allegedly the entire population of Florence attends his funeral. It is the end of Florence's 'Laurentian Age'.	Savonarola is burnt in the centre of Florence after organizing the 'bonfires of the vanities' ('immoral' books and artworks) in the previous year.	A French invasion causes Bramante to leave Milan and move to Rome, where the powerful Cardinal Riario becomes his first patron.	Julius II becomes pope and establishes stability in Rome by reconciling its warring families. He also helps restore the Medici to power in Florence.

chapel in the Vatican palace for ceremonial occasions and its decoration was entrusted to a team of artists from Florence and central Italy. The side walls of this new building, the Sistine Chapel, were painted with a series of frescoes depicting the lives of Moses and Christ, emphasizing both the new papal authority and the line of apostolic descent from St Peter. Both are prominent in the fresco *Christ Gives St Peter the Keys of Heaven* (opposite, above) by Pietro Perugino (*c.* 1450–1523), in which the first pope accepts Christ's charge to guard the gates of heaven and hell. Summoned by Sixtus IV, Perugino was one of the earliest Italian practitioners of oil painting. The chapel was decorated and ready for consecration by the feast of the Assumption, 15 August 1483.

Many artists and architects travelled to the Eternal City to put into effect the many artistic projects promoted by a series of papal patrons; they included Donato Bramante (*c.* 1444–1514), Michelangelo (Michelangelo Buonarroti; 1475–1564), Raphael (Raffaello Sanzio da Urbino; 1483–1520), Pintoricchio (Bernardino di Betto; *c.* 1454–1513) and Luca Signorelli (*c.* 1440–1523). New streets and whole new quarters grew up in the city, new churches were built and decorated, and the project for the Basilica Papale di San Pietro began to get under way. Much of the work consisted of painting frescoes for the great new buildings of the Vatican, but there were other commissions, too. Pintoricchio, from Perugia, painted *Portrait of a Boy* (above right) while in Rome, before assisting Perugino with the frescoes of the Sistine Chapel in 1481 and 1482. The portrait of the unknown boy has much of Perugino's freshness, delicate modelling and colouring, and the background with its distant and faintly coloured hills and finely drawn trees is also in Perugino's style.

The artists of the High Renaissance shared the humanistic philosophy that placed man and human achievement at the centre of all things. Their outlook is exemplified by the drawings and anatomical studies of Leonardo da Vinci (1452–1519), notably his drawing *Proportions of the Human Figure (after Vetruvius)*, commonly referred to as *Vitruvian Man* (opposite, below). The drawing depicts a male figure in two superimposed positions with his arms and legs apart and simultaneously contained within a circle and a square.

The idea of man as the measure of all things extended to all the plastic arts. In 1502 Bramante built an oratory on the exact site where the martyrdom of Peter the Apostle was believed to have taken place. His circular Tempietto (little temple) of San Pietro (1502) is distinguished by a truly classical formal vocabulary. Its proportions are balanced and oriented entirely to the human scale, and the clarity of the design fully achieves the ideals of the Early Renaissance architects Filippo Brunelleschi (1377–1446) and Leon Battista Alberti (1404–72). In 1503 Pope Julius II commissioned Bramante to produce plans for a new and bigger St Peter's. Bramante proposed a central plan that combined two geometric figures, the Greek cross and the square, in a harmony as orderly as that of Leonardo's circle and square.

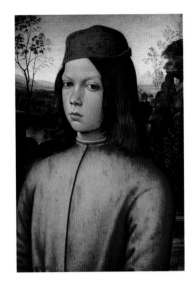

1 *Christ Gives St Peter the Keys of Heaven* (1481–82)
Pietro Perugino • fresco
131 7/8 x 216 1/2 in. / 335 x 550 cm
Sistine Chapel, Vatican City

2 *Portrait of a Boy* (*c.* 1480)
Pintoricchio • tempera on wood panel
20 x 13 in. / 51 x 33 cm
Staatliche Kunstsammlungen
Dresden, Germany

3 *Vitruvian Man* (*c.* 1509)
Leonardo da Vinci • pen and ink on paper
13 5/8 x 9 5/8 in. / 34.5 x 24.5 cm
Galleria dell' Accademia, Venice, Italy

1503	1504	1508	1512	1512	1516
Leonardo da Vinci begins the *Mona Lisa* (see p.176), also known as *La Gioconda* or *La Joconde*.	Michelangelo's monumental sculpture *David* is greeted with rapturous applause when it is revealed to the people of Florence for the first time.	Pope Julius II summons Raphael to Rome and immediately sets him to work on frescoes for what will become the pope's private library.	Michelangelo finishes painting the ceiling of the Sistine Chapel (see p.178) after four years' work. The commission contains more than 300 figures.	Raphael completes *The Triumph of Galatea* (see p.180), a fresco for the fabulously wealthy Farnese family in their Villa Farnesina, Rome.	The king of France asks Leonardo to leave Italy and come and work for him. The artist does so and dies in France three years later.

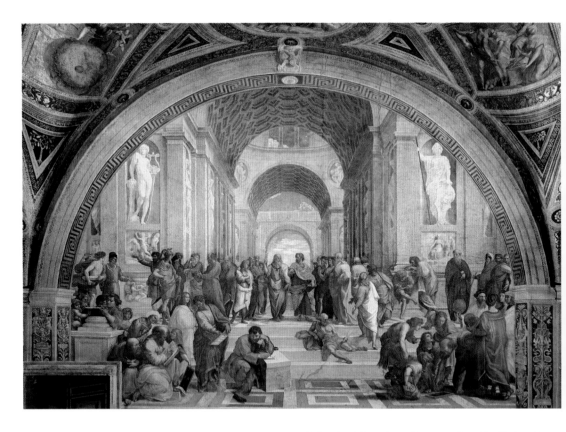

4 *The School of Athens* (1510–11)
Raphael • fresco
197 x 303 in. / 500 cm x 770 cm
Stanza della Segnatura, Apostolic Palace,
Vatican City

5 *Moses* (1513–15; reworked 1542)
Michelangelo • marble
92 ¹/₂ in. / 235 cm high
Tomb of Pope Julius II, Church of
San Pietro in Vincoli, Rome, Italy

6 *Madonna of the Harpies* (1515–17), detail
Andrea del Sarto • tempera on wood
81 ¹/₂ x 70 in. / 207 x 178 cm
Uffizi, Florence, Italy

In 1506 a massive, 8-foot-high (2.5 m) marble statue from the first century AD was found near the Basilica di Santa Maria Maggiore in Rome. It was a copy of a famous bronze of the Hellenistic period (323–31 BC) representing Apollo's priest Laocoön and his sons being killed by two huge serpents, as famously described in Virgil's epic poem, the *Aeneid*. Its discovery caused a sensation. The statue was moved to the Vatican palace where it was carefully analyzed and copied by many artists, including Michelangelo who used the powerful torso of the writhing priest as a model for many of his figures in the Sistine Chapel.

As patrons became more knowledgeable about the ancient city, they requested classical mythologies and ornamentation in their commissions. Artists responded imaginatively to these demands and faithfully reproduced and reworked classical motifs on pilasters and along friezes when commissioned to decorate chapels and palace vaults. Their decorative schemes were based upon descriptions of ancient mural painting from the classical authors and also archaeological remains, the most important of which was the great imperial palace of Nero, the Domus Aurea (Golden House), which was rediscovered in the late 1480s. Evidence was emerging of an artistic style that had up to then been found only in fragmentary form. Complete walls and ceilings covered with painting in the Third Pompeian Style (20 BC–AD 60) had survived destruction. Artists visiting underground caverns now had a rich repertoire of antique motifs from which they could draw inspiration—not only individual decorative motifs but, more importantly, entire rooms that had miraculously been preserved and which could be imaginatively recreated above ground.

One of the first artists to exploit this new repertoire of decorative motifs and respond imaginatively to the classical remains on a grand scale was Raphael. In 1506 he was summoned to Rome by Pope Julius II (1443–1513) to decorate the Vatican Stanze, a suite of apartments on the second floor of the

postolic Palace. The decoration was carried out by Raphael and his assistants between 1508 and 1524. One of the first rooms to be decorated was Julius's private library or study. The iconographical scheme of the decoration, undoubtedly established by a theologian 'ad praescriptum Iulii pontificis'—according to Julius's orders—took two and a half years to complete. In *The School of Athens* (opposite), ancient philosophers, mathematicians, astronomers and scientists converse beneath an imposing basilica, apparently based upon Bramante's early designs for the new St Peter's (which were themselves inspired by the ruined basilica of Maxentius in the Roman Forum). In the centre are Plato and Aristotle, clearly identified by the titles of their books: Plato points upwards to the world of ideas, while Aristotle extends his open hand between heaven and earth. Leonardo da Vinci, wearing a long white beard, was the model for Plato, and Michelangelo, seated on a step in the foreground with his arm resting on a block of marble, represents the mathematician Heraclitus. On the far right is Raphael himself looking out of the picture.

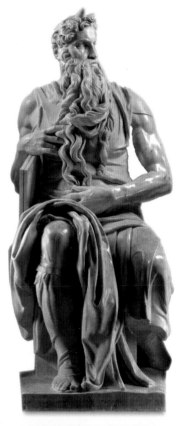

Pope Julius II died on 20 February 1513. In his will he left 10,000 ducats to continue work on the tomb that he had planned for himself in St Peter's. Michelangelo's sculptural work on the project had been interrupted by the commission to paint the ceiling of the Sistine Chapel (1508–12; see p.178), and by 1516 the only figure to have reached completion was the monumental figure *Moses* (right). The Old Testament prophet is shown seated, with the Tablets of the Law under his forearm. He is depicted at the moment when he is horrified to see his people worshipping the Golden Calf (as described in Exodus xxxii); he is filled with anger and his left leg is drawn back as if he is about to rise up in all his majesty and pour vituperation upon them. The sculpture may have been intended as an allegory of the fiery and militant pope. Michelangelo's *Moses* has since become one of the world's best-known sculptures, but the commission for Julius's tomb plagued the artist for the rest of his life.

Pope Julius II was succeeded by Giovanni de' Medici (1475–1521), who took the papal name Leo X. The new pope was short-sighted, overweight and sickly, but also an aesthete and a great patron of the arts. He is familiar because of the magnificent portrait of him painted by Raphael. Without idealizing his sitter, Raphael caught his gravitas and humanity in *Portrait of Pope Leo X with Cardinals Luigi de' Rossi and Giulio de' Medici* (c. 1518). Pope Leo X's admiration of Raphael was unbounded and he overloaded him with commissions and appointments. Raphael responded by organizing a highly efficient workshop of skilled and specialized artists who assisted him in a wide variety of work, including the privately commissioned fresco *The Triumph of Galatea* (1512; see p.180) in the Villa Farnesina, Rome. When Raphael died unexpectedly at the age of thirty-seven, his studio disbanded and his pupils helped to spread the ideals of Renaissance Rome throughout Italy and Europe.

One artist who responded to the artistic developments in Rome was the Florentine Andrea del Sarto (Andrea d' Agnolo; 1486–1530). His work is a synthesis of ideas derived from his contemporaries. He combines the compositional harmony of Raphael, the monumentality of Michelangelo and the subtle delicacy of Leonardo's *sfumato* (a deliberate lack of contrast between light and dark areas) to achieve a rare elegance and stateliness. In *Madonna of the Harpies* (right) the figures are consciously posed as ideal human beings and the effect is serene, grave and monumental.

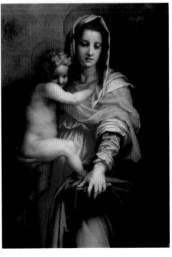

Works such as Michelangelo's Sistine Chapel ceiling and Leonardo's *Mona Lisa* (1503–06; see p.176) offered an exalted vision of God and humanity, but the Renaissance dream was about to be shattered. On 5 May 1527 Spanish, German and Italian troops under the banner of the Holy Roman Emperor Charles V swept into Rome. The atrocities committed by these troops at the Sack of Rome brought Italy's greatest artistic period to a sudden and catastrophic end. **PG**

Mona Lisa 1503 – 06

LEONARDO DA VINCI 1452 – 1519

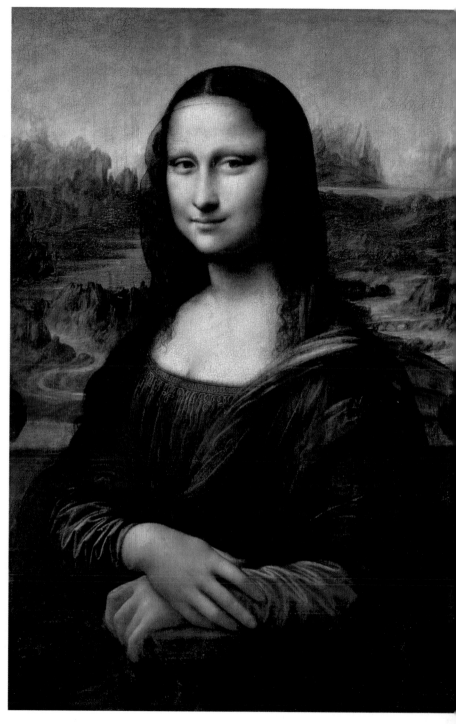

oil on poplar
30 ³/₈ x 20 ⁷/₈ in. / 77 x 53 cm
Louvre, Paris, France

t is the most famous painting in the world and yet very little is known of the woman with the enigmatic smile. As with all the works of Leonardo da Vinci, it is not signed or dated. The title *Mona Lisa*, or *La Gioconda*, derives from an account by 16th-century art historian Giorgio Vasari: 'For Francesco del Giocondo, Leonardo undertook to execute the portrait of his wife, Mona Lisa.' Leonardo used musicians and jesters to keep his sitter amused: 'As a result, there was a smile so pleasing that it seemed divine rather than human.' The subject its upright and sideways in an armchair, but her torso and head turn slightly in a subtle piral. The pyramidal design is adapted from images of the seated Madonna, but Leonardo has modified the formula to create a sense of distance between sitter and viewer, emphasized by the armrest, which acts as a dividing element.

The handling of the background in the painting reflects Leonardo's theory of 'aerial' or 'atmospheric') perspective. Light of all wavelengths is dispersed by phenomena such as rain, mist and dust as it passes through them, but light of shorter wavelengths (such as blue) is scattered more than light of longer wavelengths (such as red). This scattering causes distant objects, including the sky, to have a blueish tinge and appear to recede. In the *Mona Lisa*, Leonardo's representation of blue light scattering from distant objects gives depth to the background, as there is no clearly defined vanishing point to give a sense of recession or suggest the relative size of the objects in the rocky landscape. **IZ**

👁 FOCAL POINTS

1 LANDSCAPE

The vast landscape behind the sitter gives tremendous depth to the painting. On closer inspection, however, the background is imbalanced. The horizon to the right of the face is broken by the rocks, giving the impression that one part of the landscape is higher than the other.

2 EYEBROWS AND EYELASHES

The sitter has neither eyebrows nor eyelashes, although high-resolution scans reveal that the portrait once had both. Perhaps the pigment Leonardo used for these features has faded, or they were removed by accident during a clean. The lack of eyebrows adds to the slightly abstract quality of the face.

3 *SFUMATO*

The portrait shows the use of *sfumato*, the smooth, almost imperceptible transition between areas of colour in the painting. It is another feature of 'atmospheric' perspective and creates the impression of distance. The term derives from the Italian word for 'smoke'.

4 CROSSED HANDS

Leonardo was a skilled painter of hands. Here, the crossed hands of the sitter lie serenely in her lap, a sign of decorum at the time. A 1461 handbook for young ladies says: 'Whether you are standing still or walking, your right hand must always rest upon your left, in front of you, on the level of your girdle.'

🕐 ARTIST PROFILE

1452–98

When Leonardo was about fifteen, his father apprenticed him in the workshop of Andrea del Verrocchio. Leonardo entered the service of Ludovico Sforza, the Duke of Milan, in 1482, abandoning his first commission in Florence, *The Adoration of the Magi*. He spent seventeen years in Milan and his work from this period features designs for a tank, war vehicles and submarines, as well as his first anatomical studies.

1499–1515

After the invasion of the French and Ludovico Sforza's fall from power in 1499, Leonardo was left to search for a new patron. Over the next sixteen years, he travelled throughout Italy and worked for a number of employers, including the Pope.

1516–19

In 1516, Leonardo was offered the title of Premier Painter and Engineer and Architect of the King by Francis I of France. Although debilitated by a paralysis of the hand, Leonardo was still able to draw and teach. He died on 2 May 1519 in Cloux, France. Legend has it that King Francis was at his side when he died, cradling Leonardo's head on his arm.

Sistine Chapel Ceiling 1508–12
MICHELANGELO 1475–1564

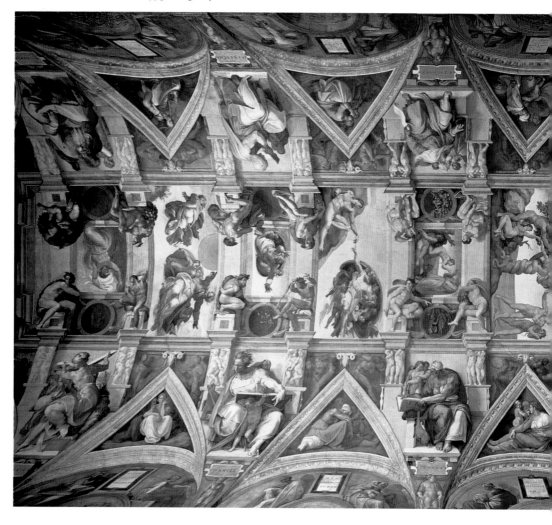

fresco
45 x 128 ft / 13.75 x 39 m
Apostolic Palace, Vatican City

✦ NAVIGATOR

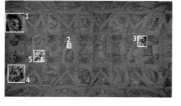

In May 1508 Michelangelo Buonarroti—who considered himself more a sculptor than a painter—reluctantly accepted the commission from Pope Julius II della Rovere to decorate the ceiling of the Sistine Chapel. The artist rejected the Vatican's ideas regarding subject matter and undertook to replace the existing decoration of a simple, starry sky with an elaborate architectural frame in which God's Creation and the Fall of Man were re-enacted. Painted piers stretch across the ceiling, creating nine panels in which major scenes from the Book of Genesis are depicted. A rhythmic division of the ceiling into large horizontal pictures and smaller flanking scenes framed by *ignudi* (nude youths) gives prominence to four major scenes that develop chronologically: *Separation of Light from Darkness, Creation of Adam, Original Sin and Banishment from the Garden of Eden* and *The Flood*. The triangular lunettes at the sides of these scenes contain images of prophets and sibyls and scenes from the Old Testament. The gigantic undertaking, which features more than 300 figures, was completed in only four years and was unveiled on All Saints' Day in 1512. **PG**

1 JEREMIAH

The monumental figure of the Old Testament prophet Jeremiah, possibly a self-portrait of Michelangelo, is quite still. He appears a man of profound thought. The author of the Book of Lamentations rests his head on his hand and grips it in a gesture of bitter grief.

2 ADAM IS CREATED

Creation of Adam, located near the centre of the ceiling, is the chapel's most famous fresco. According to the Catholic faith, man is made in God's image. Michelangelo depicts the dramatic moment just before the Creator's finger touches Adam's finger and a soul is breathed into him.

3 *IGNUDI*

Flanking the smaller panels in the centre of the ceiling are *ignudi*. The pairs of figures, perhaps wingless angels, display Michelangelo's command of anatomy and are based upon his study of ancient sculpture. Their garlands support scenes from the Old Testament.

4 LIBYAN SIBYL

Between the spandrels and the pendentives are the figures of five sibyls from classical antiquity. These were ancient prophetesses whose words were interpreted to foretell the incarnation and the coming of Christ. The Libyan sibyl is one of the most refined figures on the Sistine ceiling.

5 GOD CREATES PLANETS

In the fresco *Separation of Light from Darkness*, God is surrounded by angels and his billowing garments as he hurtles through space, arms outflung, to give form to the sun and the moon. God appears again in the same fresco, creating the planets and dividing the waters.

⏲ ARTIST PROFILE

1488–95

Michelangelo was apprenticed in Florence to Domenico Ghirlandaio, who taught him the art of fresco painting. He studied sculpture under Bertoldo di Giovanni.

1496–1515

Michelangelo travelled to Rome, where he carved the *Bacchus* and the *Pietà*. He returned to Florence and worked on *David*, completed in 1504. He was then summoned to Rome to create a tomb for Pope Julius II that was to contain forty life-size figures; the project was not realized because in 1508 Michelangelo began work on the Sistine Chapel ceiling.

1516–64

Michelangelo was commissioned by Pope Leo X to create his mausoleum. In 1534 he returned to the Sistine Chapel to paint the *Last Judgment* on the altar wall. He later designed the dome for the Basilica Papale di San Pietro in Vatican City.

The Triumph of Galatea 1512

RAPHAEL 1483 – 1520

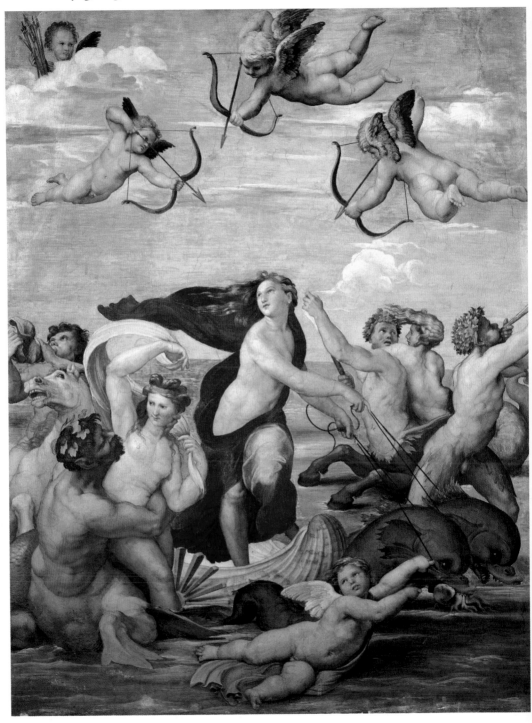

fresco
116 x 88 in. / 295 x 224 cm
Villa Farnesina, Rome, Italy

n a letter to the humanist Baldassare Castiglione, Raphael (Raffaello Sanzio da Urbino) wrote: 'In order to paint a beautiful woman, one must see many of them...but seeing how rare...fair women are, I myself turn to an ideal which I am able to create in my imagination.' Raphael's idea of perfect beauty, derived from Plato, was expressed in the features of almost every woman he portrayed. In this painting, he slightly modified an earlier portrayal of St Catherine of Alexandria for the face of the sea nymph Galatea.

Galatea speeds away from her admirer Polyphemus, the one-eyed Cyclops, in a fantastic shell chariot drawn by dolphins. According to Philostratus's version of the story, Galatea spurns the advances of Polyphemus and hurries away to her lover Acis. The subject was chosen by Raphael's patron, Agostino Chigi, who was hoping to marry Margherita Gonzaga, natural daughter of the Marquis of Mantua, but whose suit was being rejected. Chigi's selection is likely to have been influenced by earlier versions of the myth in which the Cyclops's courting of Galatea ended happily for him. **PG**

◉ FOCAL POINTS

1 SHEATHED ARROWS

Galatea ignores the cupids firing arrows at her and gazes instead towards the cupid whose arrows remain in their sheath. This cupid represents Platonic love and by gazing at him Galatea demonstrates her rejection of Cyclops's wooing and her preference for spiritual rather than physical love.

2 UNEVEN COLOUR

Raphael painted *The Triumph of Galatea* on successive days and changes in the weather caused slight variations between each day's painting. Here, the cupid's bow marks a noticeable change in the shade of blue from one day's painting to the next. Raphael tried to conceal each join in the work by means of a dividing marker. The top right corner, bounded by two flying cupids, is also relatively dark, and the sky below the left cupid is darker than the sky above Galatea.

3 DOLPHINS

Raphael's image of dolphins probably illustrates a detail in La Giostra, a popular version of the Galatea myth written by the humanist and poet Angelo Poliziano: 'Two shapely dolphins pull a chariot: on it sits Galatea and wields the reins; as they swim, they breathe in unison.'

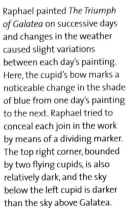

4 MOUNTED MESSENGER

The detail of Triton, messenger of the sea, on his sea horse reveals Raphael's interest in the archaeology of Rome. It is probable that the artist copied Triton's rearing and neighing animal from an antique statue—its colour and pose closely resemble those of a marble sculpture.

⏱ ARTIST PROFILE

1483–1507

Raphael was the son of Giovanni Santi, painter at the court of Urbino. On the death of his father in 1494, Raphael was apprenticed to Pietro Perugino, before going to Florence to study the works of Michelangelo and Leonardo da Vinci.

1508–13

The artist was summoned to Rome in 1508 by Pope Julius II to decorate his apartments in the Vatican palace. Work began in the Stanza della Segnatura (1509–12) and continued in the Stanza di Eliodoro (1512–14). Julius II died in 1513.

1514–15

The new pope, Leo X de' Medici, commissioned Raphael to decorate in fresco the Stanza dell'Incendio, which he and his assistants began in late 1514. Raphael was also appointed director of architectural works in the Vatican in 1514. When, in 1515, the artist was also appointed custodian of Roman antiquities, he threw himself into the job with great enthusiasm. Paintings of this period feature ornamental motifs derived from the ceilings and wall paintings of recently discovered classical buildings.

1516–20

In addition to papal commissions, Raphael was much sought after by cardinals and priests to decorate their mansions. To assist in the work, the artist organized a studio, eventually employing about fifty assistants, some of whom, such as Giulio Romano, became important artists in their own right.

NORTHERN RENAISSANCE

T
he Italian Renaissance, the intellectual and cultural revolution that transformed the state of the arts in the 15th and early 16th century, rapidly spread throughout the countries of northern Europe. Some aspects of it were more appealing than others to northern European artists. In Italy the Renaissance was a rebirth, specifically a rediscovery of the learning and cultures of ancient Greece and Rome. These cultures had less relevance to northern Europeans, for whom representations of classical mythology were much rarer than they were in Mediterranean countries. The Northern Renaissance was inspired by religious reform, which brought with it a new interest in portraying the human figure and the visible world realistically.

Italian artists devised precise mathematical systems to assist them in their portrayal of human proportions, perspective and space. Northern European artists were impressed with the results, and Albrecht Dürer (1471–1528) devoted

KEY EVENTS

1494	1494–98	1505	1509	1514	1516
Dürer makes his first trip to Italy to study its art. When he returns to Germany he disseminates the techniques he learnt, especially via his prints.	The army of King Charles VIII of France (1470–98) invades Italy and the First Italian War begins. Some Italian artists leave Italy and head north for safety.	Cranach the Elder is appointed court artist to Frederick III, Elector of Saxony (1463–1525), a position he held for life.	Dutch humanist Desiderius Erasmus (c. 1466–1536) writes *The Praise of Folly*, which satirizes human folly. It is a catalyst for the Reformation.	Dürer completes his enigmatic engraving *Melencolia I*.	Sir Thomas More (1478–1535) writes *Utopia*, which draws on classical concepts to describe a fantasy island that is home to a perfect society.

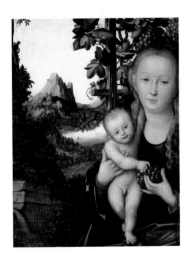

a great deal of time and effort to writing two treatises on geometry, *The Art of Measurement* (1525) and *On Human Proportion* (1528). Long before this, however, northern European artists had achieved considerable success in producing naturalistic depictions of the human form. The results can be seen in the sculpture of Claus Sluter (*c*. 1350–1405/6) and Hans Multscher (*c*. 1400–67), as well as the paintings of Netherlandish (see p.140) artists Jan van Eyck (*c*. 1390–1441) and Rogier van der Weyden (*c*. 1399–1464). Northern European painters worked instinctively, rather than from mathematical formulae, and they were assisted by new advances in the technique of oil painting, pioneered by van Eyck. These innovations enabled artists to create images that were far more detailed and realistic than if they had been working in tempera. The effects were immediately obvious in fields such as portraiture. Northern artists pioneered the three-quarter view, which enabled them to present a more rounded image of their sitters, at a time when Italian painters still favoured the profile, a two-dimensional form of portraiture.

Northern Renaissance artists aimed to achieve the same kind of realism in all their depictions of the physical world, from interiors and landscapes to still lifes and studies of human physiognomy. They gained particular renown for their skill in portraying microscopic details, such as the texture of fur or metal, or minute reflections in a mirror. Critics argued that artists became obsessed with details, rather than treating their subject as a whole as the most gifted Italians did. It is debatable whether such paintings can truthfully be described as realistic, because the artists used everyday, domestic objects as symbols.

In landscape painting familiar landmarks began to appear with increasing regularity, although some were transplanted into different settings. The notion of producing accurate, topographical records gained momentum during the Renaissance, but landscape was slow to develop as an independent genre of painting. Northern patrons had long enjoyed seeing miniature landscapes in the background of their devotional pictures, but the idea of purchasing a landscape by itself was unknown. The work of Joachim Patinir (*c*. 1480–1524) marked a change of approach. He concentrated mainly on religious painting, but the nominal subject was very often a pretext for producing a sweeping, panoramic landscape as in *Landscape with St Jerome* (opposite). Patinir deliberately chose themes that called for this expansive type of background and then tucked his figures away in a small corner. He sometimes collaborated with other artists such as Quentin Massys (*c*. 1466–1530) or Joos van Cleve (*c*. 1480–*c*. 1540), who provided the figures while Patinir worked on the setting.

The landscapes themselves are far from realistic. Patinir employed a dual form of perspective: the general scene is viewed from a height, so the horizon is high and the viewer can see a long way into the landscape. At the same time, figures, trees and buildings are portrayed frontally, as if on the same level as the viewer. Patinir also added strange rock formations, possibly inspired by the

1 *Landscape with St Jerome* (1516–17)
Joachim Patinir • oil on panel
29 1/8 x 35 7/8 in. / 74 x 91 cm
Museo del Prado, Madrid, Spain

2 *Madonna and Child* (*c*. 1525)
Lucas Cranach the Elder • oil on panel
22 7/8 x 18 1/8 in. / 58 x 46 cm
Pushkin Museum, Moscow, Russia

1517	1524–25	1526–28	c. 1551–53	1555	1566
The Protestant Reformation begins when Luther affixes his *Ninety-five Theses* to the doors of a church at Wittenberg in Germany.	The Peasants' War, a popular revolt, arises in Switzerland, Germany and Austria, with class structures in flux and the burghers' power on the increase.	The Catholic Church stops patronizing the arts in Northern Europe because of religious unrest. Holbein the Younger goes to work in England.	Bruegel the Elder travels to Italy via France. He produces many drawings and paintings of landscapes he sees on his journey.	The Peace of Augsburg is ratified in Germany; it declares that the individual ruler will decide the religion of each German state.	A movement of iconoclasm among restive Calvinists in the Netherlands leads to the Dutch Revolt.

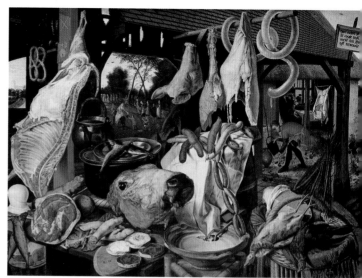

3 *Flight into Egypt (The Meat Market)* (1551)
Pieter Aertsen • oil on canvas
48 3/8 x 68 7/8 in. / 123 x 175 cm
Bonnefantenmuseum, Maastricht, Netherlands

4 *Hunters in the Snow (January)* (1565)
Pieter Bruegel the Elder • oil on wood
46 1/8 x 63 1/8 in. / 117 x 162 cm
Kunsthistorisches Museum, Vienna, Austria

5 *The Annunciation, from the Isenheim Altarpiece (c. 1512–16)*
Mathis Grünewald • oil on wood
105 7/8 x 55 1/2 in. / 269 x 141 cm
Musée d' Unterlinden, Colmar, France

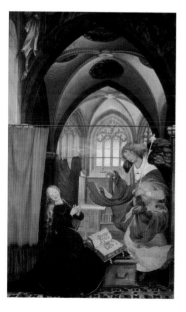

Meuse valley where he grew up; these gave the impression of an exotic, distant land. The overall effect is unsettling, but Patinir's contemporaries admired it. Dürer visited Patinir in 1520 and praised him as a 'good landscape painter', the first time the term is thought to have been used in Western art.

Pieter Bruegel the Elder (*c*. 1525–69) provided much of the impetus in the development of the landscape genre. The scenes that he portrayed in his series of paintings of the months or seasons surpassed anything that Patinir had created. In particular, the bold diagonal of the snowy ridge that leads the viewer's eye down into the valley of his *Hunters in the Snow (January)* (right), was a compositional masterstroke. Even so, rather than being pure landscapes, the paintings were effectively enlarged versions of tableaux, titled 'Labours of the Months', that appeared in medieval Books of Hours and depicted the rural activities that commonly took place during the year.

The Northern Renaissance was shaped by two other significant factors: the spread of printing and the Protestant Reformation. Printing was a German invention, attributed to Johannes Gutenberg (*c*. 1398–1468) and pioneered in a number of German cities. The development of printed images proved a boon for artists, who could sell their own prints at markets and fairs and, in the process, build up their reputations. The lucrative nature of the business can be deduced by the fact that when Dürer published his *Apocalypse with Pictures* (1498), a set of fifteen prints including *Four Horsemen of the Apocalypse* (1498; see p.186), it was so successful that it furnished him with an income for the rest of his life. Conversely, any artist who failed to ensure that prints of his work were readily available ran the risk of hindering his career. The prime example is Mathis Grünewald (*c*. 1475/80–1528). His Isenheim Altarpiece (left) was one of the masterpieces of the age but it attracted little attention because the artist produced no prints of it. This was crucial, because the painting was situated in a plague hospital that no patrons or painters felt inclined to visit.

The earliest prints were woodcuts, but by the 16th century copper engraving was becoming more common. The harder metal surface had several advantages. It was easier to work, enabling a skilled artist to achieve more subtle nuances of light and texture. It was also more durable, which meant that more copies could be made. As the son of a goldsmith, Dürer was used to working in metal and it was in this medium that he produced his most complex prints, often described as his master engravings.

The bitter divisions of the Reformation had a far greater impact in northern Europe than they did in Italy. Some artists were affected personally. Grünewald lost his principal patron because of his Protestant sympathies, while Hans Holbein the Younger (c. 1497–1543) moved to England to look for work, following religious disturbances in Basle. In Holbein's case this proved advantageous and he was soon in demand for his skills in portraiture; in 1532 he was commissioned to paint *The Ambassadors* (1533; see p.190). By contrast, Lucas Cranach the Elder (1472–1553) benefited from his close links with the Protestant leader Martin Luther (1483–1546). The two men were good friends and Cranach effectively became the official painter of the reform movement, producing several portraits of Luther and designing woodcuts to illustrate his translation of the New Testament. He continued to produce religious paintings such as *Madonna and Child* (see p.183), attempting to reinterpret traditional Roman Catholic subjects to reflect Lutheran concerns; in this work the Madonna has a Germanic appearance.

The market for altarpieces and pictures of saints in northern Europe declined because of religious changes. Moral or religious themes were treated in a more low-key fashion. Artists such as Hieronymus Bosch (c. 1450–1516) and Bruegel preferred to focus on human folly in works such as Bosch's *The Garden of Earthly Delights* (c. 1500–05; see p.188) and Bruegel's mythological *Landscape with the Fall of Icarus* (c. 1558; see p.192). Others, such as Pieter Aertsen (c. 1508–75), took care to disguise religious subjects. Aertsen began as an ecclesiastical artist but, after several of his altarpieces were destroyed by iconoclasts, he started hiding his subjects behind still lifes or genre scenes. His *Flight into Egypt (The Meat Market)* (opposite, above) was all but concealed behind a closely observed meat stall. This oblique approach typified the Mannerist (see p.202) style, which superseded that of the Renaissance. **IZ**

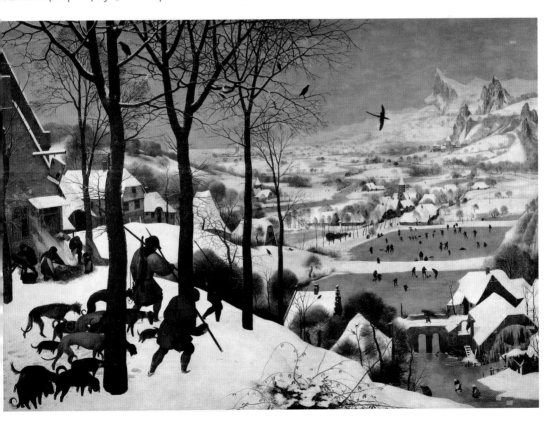

Four Horsemen of the Apocalypse 1498

ALBRECHT DÜRER 1471 – 1528

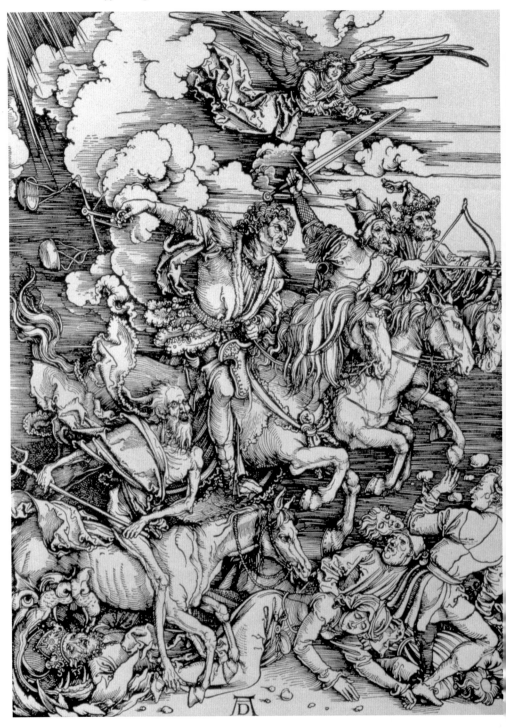

woodcut
15 ¹/₂ x 11 ¹/₈ in. / 39.5 x 28 cm
British Museum, London, UK

T his is the fourth woodcut in Albrecht Dürer's set of fifteen prints illustrating the apocalypse of the New Testament Book of Revelation. It was his first major series of illustrations and, when it was published in 1498, it proved a huge success. Dürer's innovative technique includes the use of cross-hatched and parallel lines to create light and dark tones and volume, and the diagonal figuration of the riders adds dynamism. The prints helped to forge the artist's international reputation and transform book illustration. Their success provided him with a new form of income that lasted for the rest of his life. Dürer's choice of subject was very shrewd. In the years leading up to 1500, many people believed that the end of the world was drawing near, so images of the apocalypse were very topical. In the Bible, the four horsemen appear after the breaking of the first four seals of the Holy Book held by the Lamb of God (Revelation VI: 1–8). The identities of the riders have varied in different depictions of the scene: in Dürer's version the first rider with a bow represents pestilence; the second rider has a raised sword and represents war; the third, with the empty scales, represents famine; and the fourth rider represents death, seen sweeping people into the jaws of hell. The ultimate source of the theme probably stems from the prophecy of Zechariah in the Old Testament (Zechariah VI: 1–7), which refers to the four chariots, each with different coloured horses that are defined as 'the four spirits of the heavens'. **IZ**

⬡ NAVIGATOR

◉ FOCAL POINTS

1 ANGEL'S GESTURE
Flying above the horsemen is an angel, whose gesture seems to imply a blessing. Galloping below, the rider with the bow is the most controversial in the work. Some interpret him as a destructive figure, while others believe he is Christ. In some versions of the scene, an angel holds out a crown above him.

2 MOUTH OF HELL
From the Middle Ages, hell was frequently portrayed as the gaping maw of a terrible monster representing Leviathan. Here hell devours a man wearing a bishop's mitre and an imperial crown to emphasize that death triumphs over all humanity, rich or poor.

3 FACE AND TRIDENT
Death is normally portrayed with a scythe, but tridents or forks often feature in depictions of hell, and the two symbols are associated in this picture. No artist before Dürer had conveyed the sheer scale of the destruction caused by the four horsemen, whose mounts travel at great speed.

4 FAMINE'S SCALES
Famine's scales flail behind him as the quartet gallops furiously forward. Dürer's treatment of the four horsemen has an energy that earlier versions of the subject lack. The billowing dust cloud that the riders leave behind and the tight horizontal lines reinforce the riders' speed.

⏱ ARTIST PROFILE

1471–91
Dürer was born in Nuremberg, Germany, the son of a goldsmith, and began to learn the family trade. His artistic talent was evident so he trained as a painter and a printmaker in the workshop of the artist Michael Wolgemut (c. 1435–1519).

1492–1504
He travelled and worked for publishers in Switzerland and France. He returned home in 1494 before going to Italy, where he was impressed by the work of the Early Renaissance (see p.150) painter Andrea Mantegna (c. 1431–1506). On his return, Dürer set up his own workshop to concentrate on printmaking.

1505–19
The artist made his second trip to Italy. He stayed there for two years and returned to painting. Dürer went on to produce his finest engravings and in 1515 was granted an annual allowance by the Holy Roman Emperor Maximilian I (1459–1519).

1520–28
Dürer secured the continuation of his imperial pension from Maximilian's successor, Charles V (1500–58), and wrote his books on measurement and human proportion.

The Garden of Earthly Delights c. 1500 – 05

HIERONYMUS BOSCH c. 1450 – 1516

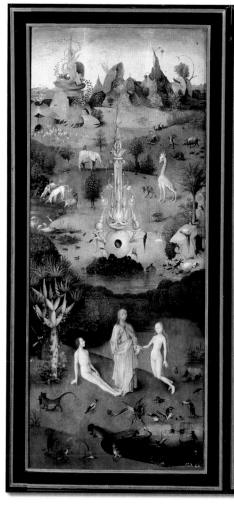
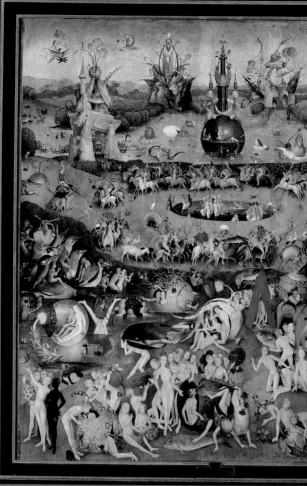

oil on panel
86 ⁵/₈ x 76 ³/₄ in. / 220 x 195 cm
(centre panel)
86 ⁵/₈ x 38 ¼ in. / 220 x 97 cm
(each side panel)
Museo del Prado, Madrid, Spain

⬡ NAVIGATOR

Hieronymus Bosch's most complex painting was too unconventional to serve as an altarpiece in a church. The triptych shows three scenes: Paradise on the left, hell on the right and a garden of worldly pleasures in between. When the wing panels are closed, the outer panel displays a grisaille (a monochrome painting executed in shades of grey and brown) depiction of God and the Creation of the world.

The left-hand panel shows God having created Eve. The landscape continues into the central panel, which suggests a natural progression from one sin to many. This main panel depicts humankind engaged in a range of 'earthly delights'. Many of its details are innocent; others are erotic, but it is clear in this painting that carnal activities are deemed sinful and lead to the torments of hell. In hell, the damned are confronted by their sins. In the foreground, personifications of the Seven Deadly Sins suffer too. Pride stares at her reflection in a demon's rump; Gluttony is forced to vomit into a pit. The fruit in the central panel has swollen to outlandish proportions compared with that in Eden. This disparity in scale was one reason the Surrealists (see p.426) found Bosch's work intriguing. IZ

⊙ FOCAL POINTS

1 ADAM AND EVE

In the panel on the left, God has made the first woman out of one of Adam's ribs, taken while he slept. God presents his creation to Adam, who has just woken up. They are in the Garden of Eden, but the pool before them is full of dark, slithering creatures, hinting at a less promising future.

2 FOUNTAIN OF FLESH

The focal point of the central panel is the Fountain of Flesh, where naked women seduce male riders who circle around them. It is the sinful counterpart to the Fountain of Life in the Garden of Eden. The lovers who have found partners indulge in a range of carnal activities in the foreground.

3 TREE MAN

This detail in the right panel is thought to represent a hellish counterpart to the Tree of Life in Paradise. The body is a hollow egg, supported on tree stumps, and art historians believe that the face is a self-portrait of the artist. Bosch produced a separate drawing of this haunting image.

4 TORTURED INDIVIDUALS

In the right-hand panel, in hell, the damned are tormented by surreal reminders of the very activities that led them there. Various musicians are tortured on gigantic versions of their instruments. Similarly, a hunter is impaled by a hare, while another is devoured by his own hounds.

5 LOVERS AND FRUIT

The plucking and eating of fruit is a metaphor for the sex act, and the peelings, which the lovers find so fascinating, are a byword for worthlessness. Indeed, most of the 'earthly delights' in the central panel are follies or sins that Bosch's contemporaries would have recognized from moral sayings.

① ARTIST PROFILE

1474–85

Nothing was recorded of Bosch until 1474 when his name appeared in the municipal records of 's-Hertogenbosch. In 1481, he married Aleyt Goyaerts van den Meervenne, whose wealth gave him the freedom to pursue his artistic course.

1486–1503

From 1486, Bosch was a member of the Brotherhood of Our Lady, a local religious organization. Over the years, Bosch gained a number of commissions from the Brotherhood, ranging from altarpieces to designs for stained glass windows. It also brought him into contact with important patrons.

1504–16

By the early 1500s, Bosch had a considerable reputation. Isabella of Spain owned examples of his work and, in 1504, he won a prestigious commission from the Duke of Burgundy, Philip the Fair. Bosch's death is recorded in the Brotherhood's records.

The Ambassadors 1533
HANS HOLBEIN THE YOUNGER c. 1497 – 1543

oil on oak panel
81 1/2 x 82 1/2 in. / 207 x 209.5 cm
National Gallery, London, UK

✦ NAVIGATOR

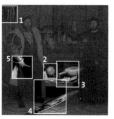

This spectacular double portrait by Hans Holbein the Younger is his most complex and enigmatic work. It depicts two distinguished diplomats. On the left is Jean de Dinteville (1504–55), the French ambassador in London. He commissioned the painting to hang in his château near Troyes in France. His companion is Georges de Selve (1508–41), the Bishop of Lavaur, a diplomat to the papacy. De Selve visited his friend in London in the spring of 1533 and, ostensibly, the picture was commissioned to mark the occasion, but the underlying meaning of the painting is unclear. The two men are portrayed with scientific and musical instruments, which testify to their learning and culture. Yet the distorted skull in the foreground is a reminder of death. In addition, many of the instruments have settings that relate to Good Friday in 1533, suggesting that the picture had a deeper religious purpose. **IZ**

FOCAL POINTS

1 CRUCIFIX

The tiny crucifix at the top left corner is almost hidden behind the rich brocade curtains. It is a reminder that Christ's sacrifice should not be forgotten, in spite of the worldly riches on display. The panel was painted 1,500 years after the Crucifixion, possibly to celebrate this anniversary.

2 TERRESTRIAL GLOBE

The painting contains several personal references to its patron. The terrestrial globe, on the shelf beneath Dinteville's left arm, represents science and exploration. It bears the name of his family home, the château of Polisy in France, where the picture was destined to hang in the grand salon.

3 LUTE AND HYMNAL

The panel was produced during the Reformation and references its religious strife. The lute is a pun on the name of Martin Luther, the architect of the Reformation; it has a broken string, signifying discord. The Protestant hymnal is open at a page that displays two of Luther's hymns.

4 DISTORTED SKULL

The purpose of the skull is unknown. It is a traditional emblem of death and was often included in *vanitas*, or vanity pictures to underline the transitory nature of worldly possessions and achievements. It was also Dinteville's personal emblem and he is wearing a skull badge in his cap.

5 DAGGER

The portrait records the ages of its subjects. The jewelled dagger in Dinteville's right hand carries an inscription that confirms his age. There is a corresponding reference to de Selve's age; 'Aetatis suae 25' meaning 'in his 25th year' is inscribed on the book beneath his right elbow.

ARTIST PROFILE

c. 1497–1516

Holbein was born in Augsburg, Germany, into a family of distinguished artists. He trained with his father, Hans Holbein the Elder, and then moved with his brother Ambrosius to Basle, Switzerland, where he designed illustrations and gained his first portrait commissions.

1517–26

Holbein was based in Basle but also carried out work in Lucerne with his father. He may have visited Italy during this period. He painted the portraits of leading humanists, most notably Desiderius Erasmus, and completed a series of altarpieces. The Reformation provoked unrest, limiting his opportunities, so he sought work in England.

1527–32

Through the recommendation of Erasmus, Holbein gained portrait commissions from Renaissance humanist Sir Thomas More and his circle. He remained in London for two years before returning to Basle, where he executed a group of murals for the town hall. When the religious situation worsened, he decided to return to England, where he settled.

1533–43

In London, Holbein painted a series of portraits of German merchants, before becoming court painter to King Henry VIII in 1536. He died in London, possibly from the plague.

ANAMORPHIC PAINTING

An unusual feature of *The Ambassadors* is the large, distorted skull in the foreground. It exemplifies perspectival anamorphic painting in which distorted images assume their normal shape only when viewed from an unusual angle. The paintings were largely inspired by the woodcuts of German artist Erhard Schön (1491–1542), and in Germany they were often referred to as *vexierbilder* (puzzle pictures). Another style of anamorphic painting—particularly popular in the 17th century—is mirror, or catoptric, anamorphosis, as exemplified by *Anamorphosis* (below) by Jean-François Niceron (1613–46). In such paintings images that appear distorted on a flat plane appear normal when viewed in a cyclindrical mirror set on top of the painting in the centre.

Landscape with the Fall of Icarus *c.* 1558

PIETER BRUEGEL THE ELDER *c.* 1525 – 69

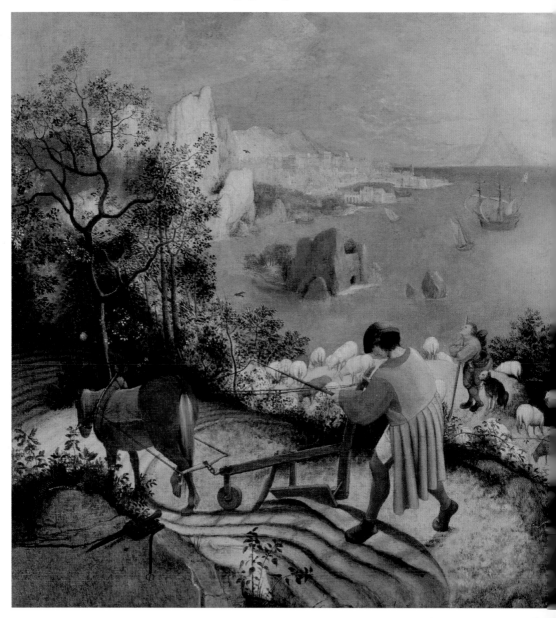

oil on canvas (transferred from panel)
29 x 44 ⅛ in. / 73.5 x 112 cm
Musées Royaux des Beaux-Arts,
Brussels, Belgium

In Greek legend, Daedalus and his son Icarus were imprisoned on the island of Crete. Daedalus was an inventor and used his skill to make two pairs of wings so he could escape with Icarus. He warned his son not to fly too high, but Icarus ignored the advice. As he soared upwards, the sun melted the wax that held his wings together. Icarus plummeted into the sea and drowned. This theme had been portrayed since antiquity, but Pieter Bruegel the Elder shifted the emphasis from the boy's personal tragedy to the reactions of the people around him. Instead of depicting Icarus in the sky, falling, Bruegel shows him already in the water, with Daedalus nowhere to be seen. **IZ**

◉ FOCAL POINTS

1 MOUNTAINOUS LANDSCAPE

Bruegel was greatly influenced by a journey he took through the Alps and was determined to work mountains into every landscape that he painted. One early commentator remarked: 'He swallowed all the mountains and rocks and spat them out again . . . on his canvases and panels.'

2 SHIP

Bruegel displays his skill at drawing detailed images of ships. The presence of the ship highlights the fact that Icarus is being largely ignored. The ship is sailing away from the boy and, although it is very close to him, there are no signs that anyone on board noticed Icarus fall out of the sky.

3 ICARUS

The only parts of Icarus that are visible are his legs, as they disappear into the sea. His death causes barely a ripple, however, as nobody seems to care about his plight. In the same way, viewers might easily miss this narrative detail if it were not for the title of the painting.

4 SHEPHERD

The shepherd is unaware of Icarus's plight as he gazes at something outside the picture frame. Neither the shepherd nor his dog are paying attention to their charges. The sheep are wandering dangerously close to the water's edge and may end up sharing Icarus's fate.

5 CORPSE IN THE FIELD

Ahead of the ploughman, but barely visible, is a corpse lying in the bushes at the end of the field. Its presence is associated with the popular proverb: 'No plough stops because a man dies'. Indeed, none of the everyday activities in the scene has been interrupted by the demise of Icarus.

✵ NAVIGATOR

ISLAMIC ART

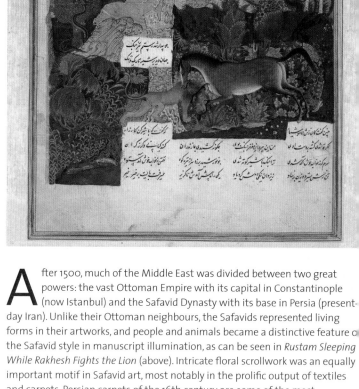

1 *Rustam Sleeping While Rakhesh Fights the Lion* (1514)
Artist unknown • illuminated manuscript
16 ⅛ x 11 ½ in. / 41 x 29 cm
British Museum, London, UK

2 Iznik fritware dish (late 16th century)
Artist unknown • fritware
14 ¾ in. / 37.5 cm diameter
Metropolitan Museum of Art, New York, USA

3 *Portrait of Shah Jahan as a Prince* (1616–17)
Nadir al-Zaman • gouache on parchment
15 ¼ x 10 ½ in. / 38.5 x 26.5 cm
Victoria & Albert Museum, London, UK

After 1500, much of the Middle East was divided between two great powers: the vast Ottoman Empire with its capital in Constantinople (now Istanbul) and the Safavid Dynasty with its base in Persia (present-day Iran). Unlike their Ottoman neighbours, the Safavids represented living forms in their artworks, and people and animals became a distinctive feature of the Safavid style in manuscript illumination, as can be seen in *Rustam Sleeping While Rakhesh Fights the Lion* (above). Intricate floral scrollwork was an equally important motif in Safavid art, most notably in the prolific output of textiles and carpets. Persian carpets of the 16th century are some of the most

KEY EVENTS

1501	1534	1539–40	1550s	1557	1616
Shah Ismail I founds the Safavid Dynasty, capturing territory in the Azerbaijani region and later much of Persia.	Shah Ismail I's son, Shah Tahmasp, signs the 'edict of repentance', which bans music, dancing, alcohol and hashish.	The Safavids transform the production of carpets into an industry and produce one of their finest examples, the Ardabil carpet (see p.196).	Ahmad Karahisari (1468–1556), famed calligrapher for Süleyman the Magnificent, creates some of his most famous manuscripts.	Ottoman architect Mimar Sinan (1489–1588) creates the multiple-domed Süleymaniye Mosque in Constantinople.	Ottoman tile making reaches its peak with the interior splendour of Sultan Ahmet mosque (also called the Blue Mosque) in Constantinople.

sumptuous ever produced. Reigning supreme is the Ardabil carpet (1539–40; see p.196), which is signed 'Maqsud of Kashan, 946'. Known for its grand proportions, fine workmanship and arresting use of colour, the carpet was one of two companion textiles that were created for the shrine dedicated to Shaykh Safi al-Din Ardabili, a Safavid place of pilgrimage.

During the 16th century, the Ottoman style evolved from a unique artistic heritage combining the Eastern traditions of Central Asia and the Timurid style with those of Byzantium, Venice and the Balkans. Ottoman public art luxuriates in a rich variety of ornamental designs rather than representations of humans or animals. Ceramic designs were influenced by Chinese porcelain, and plant- and flower-based patterns were the most common decorative motifs employed, particularly in much-prized Iznik fritware (right). Calligraphic and linear geometric designs were mostly restricted to architectural decoration. By the 19th century, Iznik wares were being collected in the West and were a source of inspiration for a number of 19th- and 20th-century artistic styles, most notably the Arts and Crafts Movement.

In religious architecture, the classical Ottoman style was re-created in Islamic communities throughout the world, its apotheosis being reached in the building of Istanbul's Süleymaniye Mosque in 1557, an appropriate answer to the Byzantine splendour of the nearby Christian church, Hagia Sophia. This classical style of architecture gradually gave way to Ottoman Baroque, an elaborate style of ornate shapes, undulating curves and abundant decoration that owed much to the influence of European architectural and artistic styles such as Rococo (see p.250) and Baroque (see p.212).

The Mughal Dynasty became the dominant power in India in 1556 and the character of Islamic art under the Mughals was heavily influenced by the Hindu artistic tradition (see p.82). The dominating religions before the Mughals were Hinduism and Jainism, and their artisans excelled in sculpture, carving, moulding and masonry. Elements of Hindu craftsmanship appear, based on the Islamic arabesque, in the form of garlands and in the intricately carved, stone-fretted screens that are featured in Mughal interior decoration. The Mughal style in painting bloomed under the patronage of Emperor Akbar (r.1556–1605). During his reign, Akbar's court painters continued to paint literary themes in the Persian tradition but introduced an increasing naturalism.

The reign of Shah Jahan (r.1628–58) inculcated a preference for royal portraiture and genre scenes; the more formal Safavid manner was imbued with a new vibrancy in colour, feathery brushwork and acute attention to detail. The influence of such European realism is unsurprising, given the presence of a Portuguese trading colony on the west coast of India from the early 16th century. The *Portrait of Shah Jahan as a Prince* (right) represents the culmination of a dramatic change in court portraiture. Gone are the simple fabrics and plain background; this portrait presents a picture of wealth and imperial splendour. Mughal painting declined as successive emperors tended towards asceticism in their artistic outlook, which inevitably led to a more austere and less dynamic style of art. **JC**

1620s	1628	1653	1680s	1700s	c. 1720
Ateliers first set up by Emperor Akbar commission painters to decorate literary works such as the *Razmnama* with gilded illustrations.	Shah Jahan begins his reign as Mughal emperor, during which he revives the Persian influences in Islamic art and architecture.	The Taj Mahal, Shah Jahan's tribute to his late wife, is completed. It is considered to be the finest example of Mughal architecture.	Glass cut, scratched and engraved with honeycomb or geometric patterns and Roman-style cameo glass become popular.	Geometric or vegetal patterns and abstract arabesque motifs begin to be recognized in the West as symbols of Orientalism (see p.286).	In Constantinople, the miniaturist and official court painter Levni (d.1732) publishes a book of his portraits of sultans and their families and scenes of Ottoman court life.

Ardabil Carpet 1539 – 40
MAQSUD OF KASHAN (dates unknown)

wool and silk
414 x 210 in. / 1050 x 530 cm
Victoria & Albert Museum,
London, UK

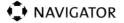

NAVIGATOR

As one of the earliest examples of a Persian carpet, and among the very few with a signature, the 16th-century Ardabil carpet is an important work of art in a medium that boasts a rich and complex lineage in the story of Islamic art. This carpet is one of a pair that was sold to the Victoria & Albert Museum in London, at the end of the 19th century. Both carpets were in such poor condition that only one could be fully restored, using materials from the other. The Ardabil carpets were completed between 1539 and 1540 at the court of Shah Tahmasp, who had them woven for the shrine of his ancestor, Shaykh Safi al-Din Ardabili. The carpets lay side by side in the funerary mosque for more than 300 years.

The Ardabil carpet is one of the largest carpets in the world and is regarded as a masterpiece of Safavid religious art owing to the subtlety and complexity of the pattern, the depth and richness of the colours, and the monumental scale of the invention. At the centre is the shamseh motif in the form of a starburst medallion surrounded by oval cartouches. The objects depicted in the carpet, such as the pair of pendant lamps, are shown as flat, two-dimensional shapes. This design uses perspective to make the most of the flat surface of the carpet and is characteristic of Islamic art. The carpet uses an impressive ten colours, ranging from turquoise, midnight blue, deep blue, green and light green to cream, yellow, salmon, plum and black. **JC**

1 INSCRIPTION

At one end, the carpet bears the legend: 'Except for thy heaven there is no refuge for me in this world; other than here there is no place for my head. Work of the slave of the court, Maqsud of Kashan, 946.' This ode by Hafiz is a reference to the Muslim act of worship in prayer.

2 PENDANT LAMP

The pendant lamp motifs that hang at either side of the central starburst motif are not equal in size, but when the carpet is viewed from the end with the smaller lamp, they appear the same size. Such use of perspective in Safavid art is extremely rare.

3 SHAMSEH MOTIF

The starburst medallion design emanates from the middle of the carpet. The shamseh is a common feature of Islamic manuscript painting, textiles and architectural decoration, indicating that there was a strong collaboration between the various artisans' studios at the shah's court.

4 ARABESQUE

The use of abundant arabesque and curvilinear motifs, such as scrolls, swirling leaves, stems and flowers, is a typical feature of book painting and Qur'ans. The influence of book illumination extends to all areas of Safavid art, but is most notable in carpet design.

AFRICAN ART: EARLY MODERN PERIOD

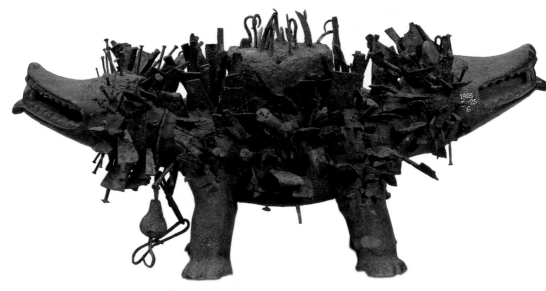

The Portuguese went to West Africa looking for direct access to African gold and Indian pepper. The coastal communities they encountered were little different in material terms from those at home, except in maritime technology and firearms. They admired the work of local artists. In Sierra Leone, Benin City and Kongo they commissioned work from highly skilled ivory sculptors, including elaborately carved vessels, salt and pepper pots, horns, trumpets, spoons and forks. The salt cellar (opposite, above), ornamented with men, dogs and serpents was carved in the early 16th century, after tobacco had been introduced from the Americas.

In 1482, the Portuguese built a castle at Elmina (the mine) in what is now the modern state of Ghana, as a base for their trade; but to obtain the gold available in this part of West Africa they had to import slaves from Benin and the Niger Delta. This is how the transatlantic slave trade began; although slavery was still commonplace throughout much of Europe. The Portuguese were followed by the Dutch, the English, the Swedes and the Danes, all in competition for this newfound wealth. Access to European trade encouraged warfare between local states. In the early 1700s the Asante confederacy came into existence led by Osei Tutu, the Asantehene (Asante ruler) at Kumasi, and according to legend a Golden Stool, the embodiment of the Asante nation, was conjured down from the sky. (It has never left Kumasi.) Asante controlled the forested region from the coastal hinterland of Elmina to the savanna, a wealthy, confident, expanding empire based on conquest and trade, its visual

1 **Double-headed dog (late 19th century)**
Artist unknown • wood, iron, magical medicine
11 x 25 ¼ in. / 28 x 64 cm
British Museum, London, UK

2 **Salt cellar, Sapi-Portuguese (c. 1490–1530)**
Artist unknown • ivory
9 ½ in. / 24.5 cm high
Museum für Völkerkunde, Vienna, Austria

3 ***Adwinasa* man's cloth (late 19th century)**
Artist unknown • silk with cotton weft
116 ½ x 78 in. / 296 x 198 cm
British Museum, London, UK

KEY EVENTS

1460	1482	1485	c. 1490–1530	1553	c. 1625
Portuguese sailors and traders land in Sierra Leone.	The Portuguese build a castle at Elmina as a base for the gold trade. Later it is captured from them by the Dutch.	The Kongo king and nobility are converted to Catholic Christianity.	The Sapi—ancestors of the Bullom and other peoples in coastal Sierra Leone—carve ivory to sell to the Portuguese.	Two Kongo ivory horns are listed in the inventory of Cosimo de' Medici in Florence.	Shyaam aMbul aNgoong, the greatest cultural innovator and magical doctor in Kuba history, becomes king of the Bushoong, the leading Kuba group.

arts developing in support of the state and its nobility. Gold was beaten and cast for use in regalia, vessels were made of beaten or cast brass and weights were cast in brass for use in weighing gold. Much of this art was figurative and referred to proverbs that interpreted ideas about tradition and authority. The success of the Asante empire also promoted the demand for patterned textiles. In the 1730s a Danish envoy to the Asante court had observed that local textile artists unravelled imported silk and woollen cloths in order to reweave the yarn with local hand-spun cotton. The man's wraparound garment (right, below) shows the high point Asante textile art reached in the 19th century with a distinctive patterning known as *adwinasa*, 'fullness of ornament'.

In 1483, further around the coast, well beyond Benin City, the Portuguese encountered the kingdom of Kongo. The king and his court were converted to Catholic Christianity, which led to the development of a literate intellectual class, with African bishops and ambassadors to European courts. Exported Kongo carved ivories and textiles woven from raffia were sufficiently highly prized in Europe to appear in Catholic iconographical painting of the early 16th century. In 1665, European slave dealers finally brought about the disappearance of Christianity and the destruction of the kingdom. The moral and social panic induced by slavery may have been responsible for the flourishing (and perhaps the inception) of the best-known Kongo form, the *nkisi* (plural *minkisi*), in which a sculpted wooden figure is covered by iron blades and nails. The figure is usually human, sometimes about to throw a spear, although sometimes the figure takes the form of a double-headed dog (opposite), whose two heads enable it to view both this world and that of the dead. The *nkisi* sculpture is a receptacle for magical preparations (medicines) used for healing affliction or catching thieves and witches. A nail or blade will be identified with a supplicant and inserted into the body of the figure to release and direct the energy compounded within the magical preparation. Christianity returned during the 19th century, along with new forms of education and the appearance of Western medicine, but the healing and protection provided by *minkisi* remain active and popular.

By the beginning of the 17th century, at the southern margin of savanna and forest, the 'Kuba' hero, Shyaam aMbul aNgoong had established the dominance of the Bushoong, the ruling group within the region (Kuba is a term of alien origin for people otherwise without a collective name but who acknowledge Bushoong authority). He introduced the cut-pile embroidery of raffia cloth, already established in Kongo and elsewhere, together with the *minkisi*-type artefacts that secretly sanction royal authority. Shyaam is also said to have initiated the carving of the portrait statues that commemorate individual Bushoong kings (see p.200), as well as masquerades to dramatize kingship and the origins of matrilineal succession. **JP**

1665	1701	1730s	1792	1835	1897
The destruction of the Kongo kingdom is brought about by the expansion of the transatlantic slave trade.	Kumasi king Osei Tutu wins the battle of Denkyira. The Golden Stool is conjured from the sky and falls in Tutu's lap; he becomes the first Asante king.	A Danish envoy notes the unravelling of imported silk textiles in order to reweave the yarn into Asante patterns.	Freetown, Sierra Leone, is founded as a home for liberated African slaves initially settled in Nova Scotia, Canada.	Muslim slaves riot in Salvador, Bahia. This leads to the repatriation of freed slaves to West Africa, particularly to Lagos.	British forces destroy Benin City and several thousand artworks are stolen. They are now scattered across the museums of the world.

African Masks 1500 – early 20th century
ARTISTS UNKNOWN

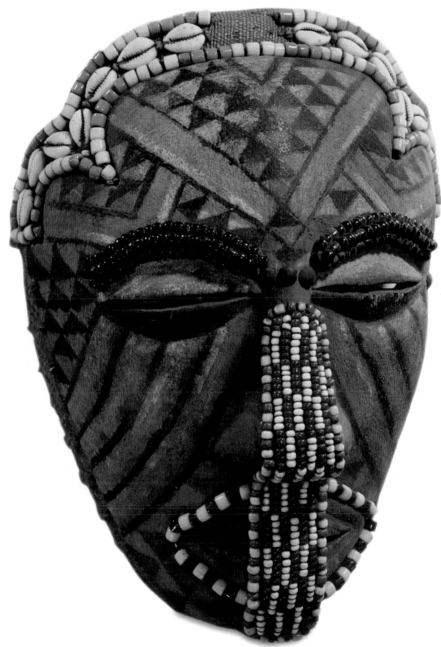

Ngady Mwaash aMbooy mask
wood, painted textile, glass beads, cowrie shells
Ghana National Museum,
Accra, Ghana

Masquerades continue to be popular in the cultural life of many parts of West and Central Africa. In the Kuba kingdom, in the present-day Democratic Republic of the Congo, the wife of King Shyaam aMbul aNgoong introduced the *mukyeeng* mask (right, above); emblematic of royal authority, it makes use of the image of the elephant (the projections from the head are the trunk and tusks). A similar mask, the *Mwaash aMbooy*, was also created by Shyaam's wife to show his power over the *ngesh*, the spirits of the forests, while the *Ngady Mwaash aMbooy* (left) is, literally, the 'woman of the *Mwaash aMbooy*'. This refers to Shyaam's wife and to the incestuous relationship between Woot, the mythic hero from whom all men are descended, and his sister, which is the origin of matrilineal inheritance (in which a man is succeeded by his sister's son). These masks embody royal authority and magical power. Yet performance, as in all masquerade whatever its overt purposes, while reiterating cultural themes does not present a narrative history. Elsewhere in sub-Saharan Africa masked performers entertain, initiate boys into manhood, heal, enable the deceased to revisit their descendants, lead warriors into battle, judge cases and execute witches. The masks served to distance the performers from their daily roles in small-scale societies where everyone knew everyone else: their purpose is dramatic but not theatrical. Sometimes masks are nothing more than the disguise that promotes its entertainment value. Yet in some traditions the mask itself is a repository of energy, capable of healing. Sometimes the identity of the wearer was kept hidden, especially when the re-embodiment of the dead was intended. **JP**

MUKYEENG MASK, CONGO

This early 20th-century mask, portraying the elephant as emblematic of royal authority, comes from the Kuba kingdom of the Democratic Republic of the Congo. It has cowrie shells and glass beads on a raffia base.

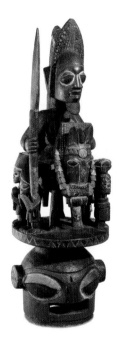

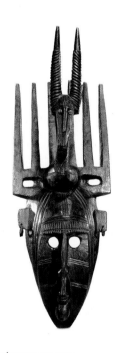

JAGUN-JAGUN MASK, NIGERIA

Probably carved *c*. 1900 by Bamgbose of Osi-Ilorin, Opin-Yoruba. The mask was worn as a test of youthful strength in the funerary rites of a wealthy man.

N'TOMO MASK, MALI

Worn by those who turned uncircumcised Bamana boys into adult men. The figure at the front is Ci Wara, the mythic antelope-man who brought agricultural skills to the region.

NDOP PORTRAITS

The richness of the Kuba court at Nsheng, the capital founded by Shyaam, dazzled the first European visitors in the late 19th century with its art, regalia and masked performances. Shyaam, the son of a slave, had travelled westwards and brought back goods of transatlantic origin, such as maize, cassava and tobacco, as well as things of more local origin, including oil palm, raffia textiles and the mancala game. Shyaam is also said to have initiated the carving of portrait statues from life, *ndop*, revered as the king's double; whenever the king was away, the *ndop* could be rubbed with oil to conjure up his presence. The *ndop* with a mancala board at the front of it (right) identifies it with Shyaam and is emblematic of his status as the creator of the features that made Kuba civilization so distinctive. In reality, however, on the basis of a study of the *ndop* known to have been made before the 20th century, it may well be that this is a tradition only of 18th-century origin. Nsheng is located in the savanna south of the tropical forests of central Africa, and now in the Democratic Republic of Congo.

MANNERISM

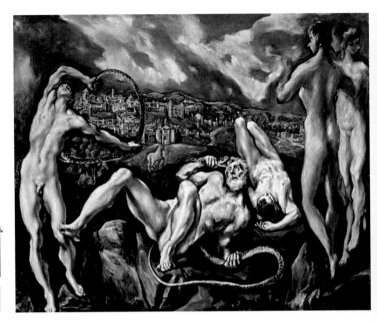

1 *Laocoön* (c. 1610–14)
El Greco • oil on canvas
54 x 67 ¾ in. / 137 x 172 cm
National Gallery of Art,
Washington, DC, USA

2 *Rape of a Sabine* (1581–82)
Giambologna • marble
161 ⅜ in. / 410 cm high
Loggia dei Lanzi, Florence, Italy

3 *Madonna of the Long Neck* (c. 1535)
Parmigianino • oil on canvas
85 x 52 in. / 216 x 132 cm
Uffizi, Florence, Italy

The term 'Mannerism' derives from the Italian word for style: *maniera*. This may seem surprising, as Mannerist works are often commonly described as 'unnatural', 'artificial' or 'odd'. The last has been used in the sense that the work differs from prevailing Renaissance values, since Mannerism was in some senses a reaction to the relative naturalism of the High Renaissance.

Mannerist art often involves exaggeration or strangeness of some kind, most notably harsh coloration, as in the acidic hues of *Laocoön* (above) by Cretan-born El Greco (Doménikos Theotokópoulos; c. 1541–1614), who eventually settled in Spain but worked for some time in Italy. This powerful work shows the priest Laocoön being punished by the gods, seen at the right of the painting, for attempting to warn his fellow Trojans of the threat posed by the Trojan Horse, which concealed an attacking force of Greek soldiers. Sent by the gods, serpents from the sea are seen killing Laocoön and his two sons. The eerie white light in the work suggests that the scene is lit by a flash of lightning, a dramatic effect that is reinforced by the white in the ominous distant clouds. There is a dreamlike quality to the painting too: the rocks in the foreground seem as formless and insubstantial as the clouds on the horizon; at the left-hand side of the canvas, the two almost seem to merge. This composition, like many Mannerist works, is highly inventive and complex; to modern eyes it may be mysterious.

KEY EVENTS

c. 1510	c. 1520–25	1525	1530	1540	1565–68
The style later known as Mannerism first starts to appear in the works of artists based in Florence and Rome.	Flemish artist Joos van Cleve (1480–1540) finishes *The Last Judgment*, a masterpiece of northern Mannerist art.	Pontormo (Jacopo Carucci; 1494–1556) begins his altarpiece *The Deposition from the Cross* (see p.204).	King Francis I of France founds the Fontainebleau School; it will become the first centre of Mannerism.	Agnolo Bronzino (1503–72) begins his masterpiece *An Allegory of Cupid with Venus* (see p.206).	Giorgio Vasari works on the renovation of the church of Santa Maria Novella in Florence, producing a Mannerist altar painting.

Some commentators have suggested that El Greco's distorted style and freely flowing rhythms were signs of insanity. Works such as *Laocoön, The Burial of the Count of Orgaz* (1586–88; see p.208) and the *Assumption of the Virgin* (1577–79) seem less 'odd' when the spiritual fervour that leaps out of every brushstroke is recognized. This divine element is picked up in the much later Romantic idea of reflecting God's grand design in art. Indeed, the painter William Blake produced forms similar to some of El Greco's. Another key characteristic of Mannerism is the deliberate elongation of bodies and proportions, as seen in the three standing figures in El Greco's *Laocoön* and also in the *Madonna of the Long Neck* (right, below) by Parmigianino (Francesco Mazzola; 1503–40). This quality is evident in the Madonna's extended neck, her slender fingers and overall body length—she dwarfs the angels crowded to the left of the painting. This 'stretching' of proportion is also evident in the treatment of the leg to the left and the limbs of the baby Jesus.

The degree of distortion in Mannerist works varies from artist to artist. For example, the elongated, contorted poses of *Rape of a Sabine* (right, above) by leading Flanders-born Mannerist sculptor Giambologna (Jean Boulogne; 1529–1608) are more elegantly harmonious than those depicted in the work of El Greco or Parmigianino. Produced without a patron, the project provided Giambologna with the opportunity to explore how to incorporate several figures in a single, relatively complicated composition. The sculptor involved subtle elongation in his solution to the complex spatial problems posed by the three intertwining bodies.

Like later artistic movements, such as Romanticism (see p.266) and Impressionism (see p.316), Mannerism was a movement with core ideas that bound together an otherwise disparate group of artists. German, French and Dutch Mannerists often applied these ideas, each in their own way: from the *Triumph of Wisdom* (c.1591) by Bartholomeus Spranger (1546–1611), which brought Northern European realism to the mix, to the Italianate portrait *Pierre Quthe* (1562) by François Clouet (c.1510–72). To this we can add the decorative stucco work and painting of Italians Francesco Primaticcio (1504–70) and Rosso Fiorentino (1494–1540) at the French royal palace of Fontainebleau; a model for French Mannerism, the work that the two artists produced for the palace was part elegant restraint, part controversial inelegance. Arcimboldo (c.1527–93), the Mannerist Hapsburg court artist and later inspiration to the Surrealists, created strangely arresting and symbolic portraits of human heads, each one a cleverly arranged assembly of fruits and vegetables. In these bizarre images, Arcimboldo took the strangeness of Mannerism to new heights.

These diverse works show that Mannerism's main quality was less a single, coherent style than a new self-consciousness about style itself as a distinct and personal entity. By extension, this new emphasis on each artist's 'inner design' remained important in much Baroque work (see p.212). **AK**

1576	1581	1588	c.1588	1609	1620
Greek Mannerist painter El Greco moves from Italy to Spain.	Flemish artist Spranger becomes court painter to Rudolf II in Prague. He helps to spread Mannerism in northern Europe.	Philip II of Spain launches the Spanish Armada in an attempt to challenge the Protestant rule of Elizabeth I, but is defeated.	El Greco paints *A Prelate*. The identity of the sitter is established in 1988 as Francisco de Pisa, a professor of scripture at Toledo University.	Philip II begins the expulsion from Spain of the moriscos (former Muslims converted to Christianity). The process ends in 1614.	Mannerist artist Scarsellino (Ippolito Scarsella; c.1550–1620) dies. Known within the School of Ferrara, he studied the Mannerist Parmigianino.

The Deposition from the Cross 1525 – 28
PONTORMO 1494 – 1556

oil on wood
123 1/4 x 75 5/8 in.
313 x 192 cm
Cappella Barbadori,
Chiesa di Santa Felicità,
Florence, Italy

Also known as the *Lamentation, The Deposition from the Cross* was painted as a dramatic altarpiece for Filippo Brunelleschi's Cappella Barbadori in the Chiesa di Santa Felicità, Florence. Depicting the crucified Christ after he was taken down from the cross, the altarpiece is regarded as the finest work by Pontormo and is a masterpiece of Mannerism, partly because it is a daring departure from Renaissance norms. Pontormo took a familiar Christian theme and gave it an unsettling treatment; no cross is visible, Christ is placed some distance off-centre and there is little attempt to represent three-dimensional space or conventional scale. The picture plane is flattened and a confused maelstrom of bodies twists this way and that—to the extent that in places it is difficult to distinguish which limb belongs to whom.

The Virgin Mary is collapsing in grief and reaches out for support. The outer figures float and bend inwards, their attitudes contributing energy to a spiralling composition that leads the viewer's gaze in an anticlockwise direction around the crowded mass of bodies, eventually coming to rest on Christ's limp figure. Partly in compensation for the poor light in the chapel, Pontormo realized the composition in almost garish colours, and the scene has the agitated emotion typical of much Mannerist art. The natural world has been stripped back to the edges of the frame and seems drained of colour, unlike the mourners' garments in vibrant pinks and blues. **AK**

FOCAL POINTS

1 CHRIST

Christ's figure has a sculptural quality and shows Pontormo's strong sense of line. The body has a twisted pose common in Mannerism. Christ has been symbolically displaced from the heart of the work, which has no central focus—in the same way that, to a believer, life has no meaning or order without Christ.

2 VIRGIN MARY

Pontormo shows the swooning figure of the Virgin Mary much larger than the other figures in the canvas. With her grief-stricken face and her long, extended arms, Mary's presence makes a powerful impact on the viewer—not only as the divine Madonna, but also as a bereft mother.

3 RIGHT-HAND WOMAN

The glowing pink and yellow clothing of the young woman on the right attracts the eye to her moving figure as she rushes to the Virgin Mary to offer support. The vibrant colours of her dress add a decorative beauty to the work and mirror the skin tones of the crouching man.

4 MAN IN FOREGROUND

This vivid foreground figure balances precariously on the balls of his feet—an unrealistic, if not impossible pose for someone supporting a corpse. His beseeching expression addresses the viewer directly and is an invitation to share his sorrow and the intensity of the experience.

ARTIST PROFILE

1512–18

Jacopo Carucci took the name 'Pontormo' from his birthplace in Tuscany. He studied with Leonardo da Vinci (1452–1519) and Piero di Cosimo (1462–1521) before entering the workshop of Andrea del Sarto (1486–1530) in 1512. By the time he painted *Joseph in Egypt* (1518), he had developed a Mannerist style.

1519–25

Pontormo painted a fresco of *Vertumnus and Pomona* (1520–21) for the Medici villa at Poggio a Caiano near Florence. In 1522, he moved to the Carthusian monastery at nearby Certosa del Galluzzo and painted frescoes showing the Passion and Resurrection of Christ (1522–25).

1526–45

The artist collaborated with his pupil and adopted son, Bronzino, from the 1520s, and with Michelangelo (1475–1564) in the 1530s.

1546–56

Later work was influenced by the prints of Albrecht Dürer (1471–1528). The unfinished fresco for the choir of Florence's Basilica di San Lorenzo occupied Pontormo until his death.

An Allegory of Cupid with Venus 1540 – 50

AGNOLO BRONZINO 1503 – 72

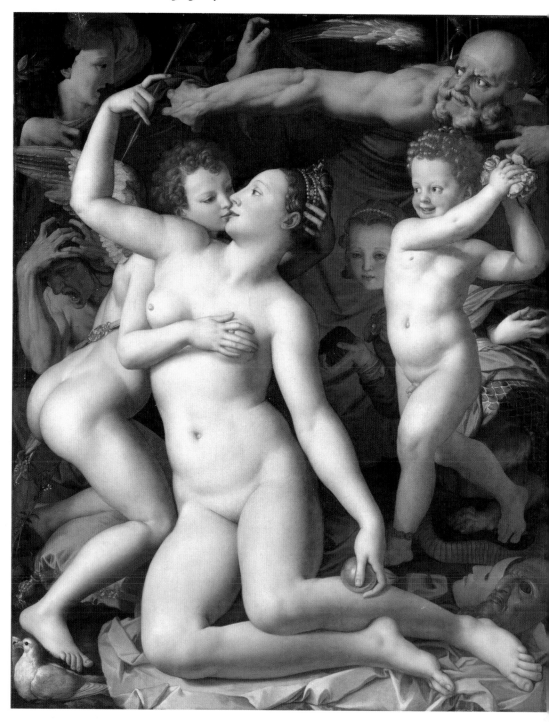

oil on wood
57 5/8 x 46 in. / 146.5 x 117 cm
National Gallery, London, UK

Florentine artist Agnolo Bronzino specialized in sophisticated allegorical narrative. He made careful figure studies from life and used them as reference for the nude figures in *An Allegory of Cupid with Venus* to create a scene of cool eroticism. The composition of the painting is tight and complex. The elderly man top right, an hourglass positioned above him, is the personification of Time. Other figures on the right represent playful pleasure; those on the left qualities such as Oblivion, Jealousy and Despair. The interweaving figures, facing in different directions to add movement, and the elongated hands and feet of the central figures are typical of Mannerist works.

Bronzino was an intellectual and poet as well as a painter. This work was influenced by the love poetry of Italian poet Petrarch, as seen in the intimately tender facial expressions of Venus and Cupid, but the relationship between the two central figures also has a bawdy tone. Bronzino excelled in the depiction of surfaces, and Venus's flesh in particular gleams with a smoothly polished, alabaster-like finish. Her limbs are consummately modelled and well defined with clear outlines, reminiscent of classical sculpture. The work was commissioned as a gift for Francis I of France and its symbolism—the precise meaning of which is unclear—would have provided stimulating palace conversation. A mixture of stylish eroticism with what appears to be an improving allegory, the painting lacks the emotional intensity of the work of Bronzino's master, Pontormo. **AK**

FOCAL POINTS

1 OBLIVION

The figure of Oblivion, with a horrified expression and mask-like face, appears to be attempting to draw a veil over the incestuous love of Venus and her son, Cupid. Oblivion appears to be thwarted by the powerful arm of the figure of Time, who knows that all human affairs are fleeting.

2 INCESTUOUS KISS

There can be no mistaking the erotic nature of the kiss of Venus and Cupid as her tongue appears to come into play. Cupid is identified by his wings and arrow, and Venus by her apple, so viewers could not evade the truth of the painting. Some owners even had the tongue detail painted out.

3 FRAUD

Crouching behind the happy boy is the allegorical figure of Fraud, a creature whose grotesque body is belied by a beguiling face. With one hand Fraud offers Venus a honey cake, but the other hides the sting in her tail. Her presence warns of the self-deception that erotic love can foster.

4 MISCHIEVOUS BOY

Grasping rose petals in his hands, the mischievous boy is stepping on a thorn, highlighting the treacherous nature of erotic love. He is often interpreted as Pleasure, but also as Folly or Jest. His arm position, poised to scatter the petals, adds a touch of Mannerist movement.

5 MASKS

The masks, another reminder of false appearances, look up towards Venus, and the sight line flows along Venus's left arm, across her body, along her arched right arm and then right along Time's arm. Within this framework, the eye darts about viewing the various characters, most looking towards Venus.

6 HOWLING WOMAN

This distraught figure is one of the few elements to spoil the superficially light, playful mood. Head bowed, she tears at her hair with claw-like hands, every sinew strained. The figure personifies Despair or Jealousy and is sometimes associated with madness arising from syphilis.

The Burial of the Count of Orgaz 1586 – 88

EL GRECO *c.* 1541 – 1614

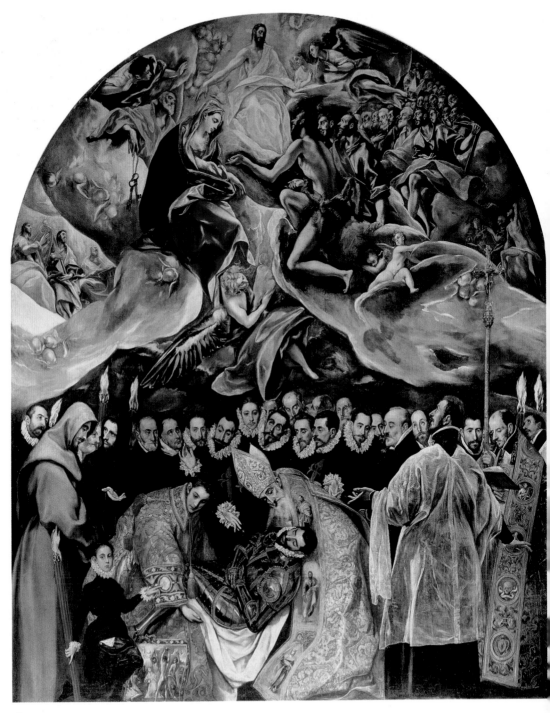

oil on canvas
181 1/8 x 141 3/4 in. / 460 x 360 cm
Church of Santo Tomé, Toledo, Spain

NAVIGATOR

B y 1586, El Greco (Doménikos Theotokópoulos) had settled in the thriving Spanish city of Toledo. *The Burial of the Count of Orgaz* illustrates a popular local legend and was commissioned by the artist's parish priest, Andrés Nuñez, for the church of Santo Tomé to honour one of its greatest benefactors, the 14th-century Spanish count Gonzalo Ruíz de Toledo. The count was a pious philanthropist who left money for improvements to the church of Santo Tomé. According to the legend, St Stephen (shown to the left of the count's body) and St Augustine (shown to his right) appeared at the count's burial and personally laid him to rest.

During his early training, El Greco studied the icons of Byzantine art, and in this work he employed two different styles. In the lower, earthbound half of the picture he painted more naturalistic, sculptural figures together with portraits of contemporary Toledan dignitaries, many of whom are unidentified (Nuñez is the figure on the far right of the line of dignitaries). It was customary for eminent locals to assist at the burial of nobles. In the upper half of the painting, El Greco adopted a Mannerist style, using exaggerated coloration, unconventional spatial arrangements and distorted forms to suggest a divine dimension as the count's soul soars to heaven. The picture is an expression of the fervour common to many artists of the Counter-Reformation, when a restating of Catholic ideals had become all-important in the face of advancing Protestantism. **AK**

FOCAL POINTS

1 JUXTAPOSITION OF COLOUR
Placing the cherry reds, rich blues and acid yellows of the Virgin Mary and St Peter's clothes next to strangely greyish whites makes the celestial part of the painting appear to reverberate. This adds to the impression that the viewer and the subjects are witnessing a vision.

2 SOUL AS INFANT
El Greco characterizes the count's soul as a newborn infant. He surrounds it with billowing folds to give a sense of upward movement and spirituality. The perspective is unusual: the space collapses inwards and draws the eye upwards to suggest that the soul is soaring to heaven.

3 SELF-PORTRAIT
El Greco portrayed himself just above the head of St Stephen. He looks out of the canvas, signifying that this is a personal work for him. The scene took place in the 1300s, yet he paints the dignitaries in 16th-century dress, making the story more potent for contemporary viewers.

4 ARTIST'S SON
The boy at the front is the artist's son, Jorge Manuel. He gestures towards the burial, acting as a link between the viewer's real world and the painting's imaginary one. A handkerchief in his pocket is inscribed with El Greco's signature and '1578', the year of the boy's birth.

ARTIST PROFILE

1541–66
The artist was born Doménikos Theotokópoulos in Crete (then part of the Venetian Republic). 'El Greco' was his soubriquet as he signed his paintings in Greek. He trained as an icon painter and a Byzantine influence is noticeable in his work.

c. 1567–76
He moved to Venice, where he stayed for three years as an apprentice in a studio before going to Rome, where he opened his own workshop. He adopted a Mannerist style, using twisted figures and unusual perspective.

1577–78
El Greco left for Spain, living first in Madrid and then Toledo, which was an important religious centre. He received many commissions for religious institutions.

1579–1614
El Greco failed to find favour with King Philip II. He chose to remain in Toledo for the rest of his life and set up a workshop. Far from the artistic centres of Italy, he continued to explore and intensify his Mannerism, using complex poses of intertwining figures and compressed space.

3 | 17TH AND 18TH CENTURY

BAROQUE

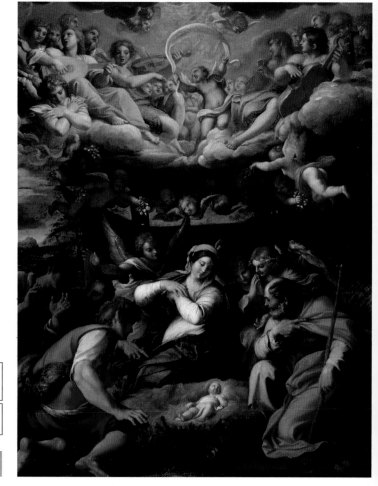

1 *Adoration of the Shepherds* (1611–12)
Annibale Carracci • oil on canvas
41 x 32 ⅝ in. / 104 x 83 cm
Musée des Beaux-Arts, Orléans, France

2 *The Ecstasy of St Theresa* (1645–52)
Gianlorenzo Bernini • marble
137 ¾ in. / 350 cm high
Santa Maria della Vittoria, Rome, Italy

3 *The Ecstasy of St Theresa*, detail

The 17th century was a time of great change throughout Europe. Politically, it was a period of autocratic leaders who were all too keen to flaunt their great wealth: jewel-encrusted chalices, solid gold-thread tapestries and elaborate architectural curls and swirls are all characteristic of their extravagance. At the same time, the works of Newton and Galileo produced historic innovations in the sciences, and the philosophy of Descartes changed man's sense of his place in the world. However, the biggest upheaval was in the field of religion, where the Protestant Reformation called into question the leadership of the popes in Rome. Western Christianity had been split into two and the Catholic Church set about regaining its authority by combating the Protestant faith, reforming itself and conveying its new ideas by means of art.

KEY EVENTS

1610–11	1623–24	c. 1637	1641	1653	1661
Rubens paints his triptych *The Raising of the Cross* (see p.218) after returning to Flanders from Italy. It shows a bold use of colour and chiaroscuro.	Bernini sculpts *David*, a statue praised for its unusual and realistic facial expression and taut musculature.	Poussin paints *The Abduction of the Sabine Women* and provokes a debate on the virtues of Classicism and the Baroque.	Andrea Sacchi (c. 1600–61) combines music and art by depicting the castrato Marcantonio Pasqualini crowned with a laurel wreath by Apollo.	Artemisia Gentileschi dies. She was the most famed female painter of the Baroque movement.	Mattia Preti (1613–99) takes the Baroque style to St John's Co-Cathedral, Valletta, Malta, where he paints scenes from the life of St John the Baptist.

The strategies for this Counter-Reformation were laid out during the Council of Trent (1545–63), which emphasized the propagation of religious ideals via the medium of pictures, and demanded greater accuracy in the depiction of biblical narratives and the use of images to arouse new religious fervour.

The term 'Baroque' was initially a derogatory one, introduced by critics of a later generation wishing to discredit the art that had preceded them. The word 'baroque' means 'misshapen', and refers to the typically flowing, quasi-endless forms associated with the style. It is used to designate the art, architecture and music that followed the Late Renaissance and preceded the Rococo (see p.250) period. Seen as a reaction to the mannered style in vogue at the end of the 16th century, in which classical idealism had given way to placid beauty, the Baroque is particularly associated with art that was commissioned by the Catholic Church. It is characterized by heavy ornamentation, complex but systematized design and a luxuriant deployment of colour, light and shade.

Rome is the city most associated with the Baroque. It became the international centre of artistic production, artistic debate and, owing to the presence of the papacy, of artistic commissions. Artists from across Europe came to study the art of classical antiquity and of the High Renaissance (see p.172), especially the works of Michelangelo (Michelangelo Buonarroti; 1475–1564) and Raphael (Raffaello Sanzio da Urbino; 1483–1520). From this city, Baroque ideals and visual characteristics were spread across Europe as artists returned home. The work of two Italian masters, Michelangelo Merisi da Caravaggio (1571–1610) and Annibale Carracci (c. 1560–1609), had the greatest impact at the start of the period. Although neither artist was born in Rome, both produced work in the city. In his native Bologna, Annibale Carracci, along with his brother Agostino (1557–1602) and his cousin Ludovico (1555–1619), started an art academy that promoted a commitment to truth, encouraging drawing from life and the study of classical antiquity. His work is typified by well-defined and solid figures, by the clear communication of the subject and a powerful emotional energy. Carracci's style is full of movement, activity and colour. In *Adoration of the Shepherds* (opposite), Carracci demonstrates his knowledge of classical sculpture and his ability to create monumental and exuberant designs while at the same time appealing to viewers' emotions, portraying beauty and avoiding detail. Carracci's influence is seen in the works of Guercino (Giovanni Francesco Barbieri; 1591–1666), where movement is conveyed through the lines of the subjects' flowing drapery. Guercino was a prolific artist and his work is also a testimony to the commercial opportunities of his time—he retired a rich man after completing 106 altarpieces and almost 150 other paintings.

Caravaggio desired to depict the world faithfully, in truthful images. His naturalism is characterized not by beauty but by a frankness that often resulted in the depiction of a gritty reality. The most influential aspect of his work is his use of dramatic light and shade, as seen in *The Conversion of St Paul* (see p.216), painted between 1600 and 1601. His style was copied throughout Europe, creating schools of followers whose work is defined as 'Caravaggesque'.

1672	1682	1691–94	1701	1715	1723–25
Giovanni Pietro Bellori's *The Lives of the Modern Painters, Sculptors and Architects* is published.	Renowned landscape painter Lorrain completes *Ascanius and the Stag* in the year of his death.	Master of ceiling decoration Andrea Pozzo (1642–1709) paints *The Entrance of St Ignatius into Paradise* in Sant' Ignazio, Rome.	The outstanding Baroque court painter Hyacinthe Rigaud (1659–1743) is commissioned to paint French king, Louis XIV.	Building begins on Vienna's magnificent Karlskirche. It is designed by Austrian architect Johann Fischer von Erlach (1656–1723).	The Spanish Steps are built in Rome. It is the longest staircase in Europe and an urban monument in the Baroque style.

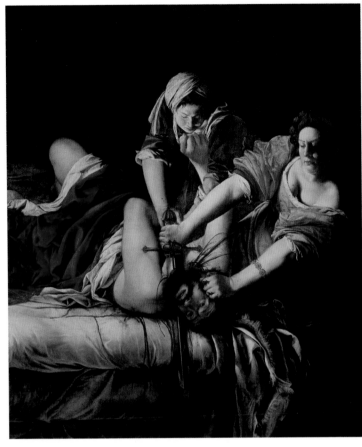

4 *Judith Beheading Holofernes* (1620)
 Artemisia Gentileschi • oil on canvas
 78 ³/₈ x 64 in. / 199 x 162.5 cm
 Uffizi, Florence, Italy

5 *Immaculate Conception of the Venerable
 Ones* (c. 1678)
 Bartolomé Esteban Murillo • oil on canvas
 107 ⁷/₈ x 50 in. / 274 x 127 cm
 Museo del Prado, Madrid, Spain

6 *The Martyrdom of St Philip* (1639)
 José de Ribera • oil on canvas
 92 x 92 in. / 234 x 234 cm
 Museo del Prado, Madrid, Spain

In particular, the artist developed the technique of chiaroscuro, first introduced by Leonardo da Vinci a century earlier, which spread across Europe and can be found in the works of the Spaniard José de Ribera (1591–1652), including the dramatically lit *The Martyrdom of St Philip* (opposite, below). Similar to Caravaggio in style is the work of Artemisia Gentileschi (1593–1653), who was the greatest female artist of the 17th century. She used dramatic lighting and demonstrated a rebellious spirit in her painting *Judith Beheading Holofernes* (above), which is a horrifying and surprisingly explicit rendition of the Old Testament story.

The works that best display the stylistic characteristics of Baroque art are the sculptures and architectural projects of Gianlorenzo Bernini (1598–1680). He dominated the artistic scene in Rome with his exuberant, dynamic, theatrical and organic works. His most renowned sculpture, *The Ecstasy of St Theresa* (see p.213) in the altar of the Cappella Cornaro, Rome, is remarkable for its sense of movement and for its appeal to the piety of its viewers. Made of marble, bronze, glass and fresco and combining architectural elements and sculpture, the figure of St Theresa is collapsed in near-erotic rapture. Such works can be contrasted with those of Nicolas Poussin (1594–1665) and Claude Lorrain (1604/5–82), both of whom painted in Rome during the Baroque period. Both artists were repelled by Baroque excess and developed more constrained, classical styles.

The most influential Flemish artist of the Baroque period was Sir Peter Paul Rubens (1577–1640). Having absorbed the art of Italy during years of travel, he settled in the city of Antwerp, where he created numerous religious images,

ortraits, historical paintings and altarpieces. His work, such as *The Raising f the Cross* (see p.218) of 1610–11, is characterized by visible brushwork and painterly freedom that he learnt from Titian. Rubens's influence is visible n the dynamic composition, plasticity of form and vibrant colouring seen n the works of other Flemish artists, including Jacob Jordaens (1593–1678), rans Snyders (1579–1657) and Jan Brueghel the Elder (1568–1625). Son of the enowned artist Pieter Bruegel the Elder (*c.* 1525–69), Jan Brueghel was a close riend of Rubens and the two even collaborated on paintings. In *The Garden f Eden* (1615), Brueghel painted the lush, velvet landscape, the countless nimals and the flowers, while Rubens added his typically full-bodied, sensual gures. Rubens's most famous pupil was Anthony van Dyck (1599–1641), whose xpressive use of paint produced some of the most lively portraits of the aroque period. His *Equestrian Portrait of Charles I* (1637–38) shows his skill as painter of portraits who not only accurately recorded a person's features, but lso emphasized the dignity and importance of the sitter.

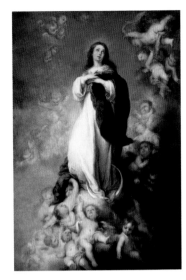

In Spain, portrayal of the royal family and court, which also had the unction of royal propaganda, was the responsibility of court painter Diego 'elázquez (1599–1660). The complex and captivating *Las Meninas* (see p.220), vhich the artist painted in 1656, represents the high point of Velázquez's areer. While Velázquez was confined mostly to his role in court as a portraitist, osé de Ribera and Bartolomé Esteban Murillo (1617–82) provided a profoundly Catholic Spain with devotional altarpieces and inspirational images. Murillo's echnical tour de force, *Immaculate Conception of the Venerable Ones* (above ight), in which Mary gazes heavenward in a dramatic, spiralling composition painted with energetic brushstrokes, was an awe-inspiring vision of the glory hat awaited the faithful. Such an image rejects the classical values of balanced orms, visible boundaries and pure lines. It typifies Baroque art in its complicated composition, emphasis on light and colour, interest in conveying movement and direct appeal to the senses. **AB**

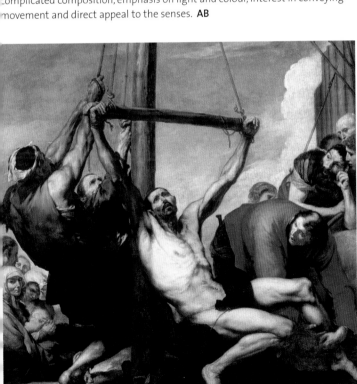

The Conversion of St Paul 1600–01

CARAVAGGIO 1571–1610

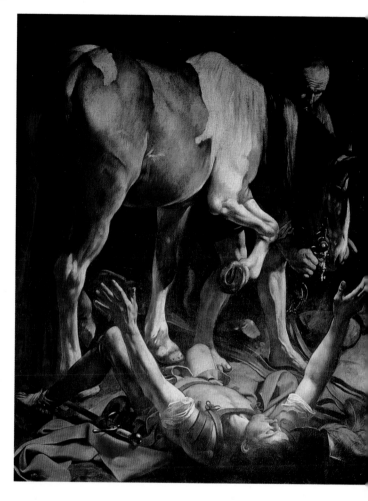

oil on canvas
90 ½ x 69 in. / 230 x 175 cm
Cappella Cerasi, Santa Maria del Popolo,
Rome, Italy

◉ NAVIGATOR

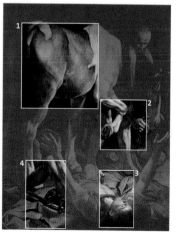

Painted at the height of Caravaggio's career, this painting recounts the moment of Saul's conversion to Christianity, when he is thrown off his horse by a shaft of celestial light while journeying on the road to Damascus. Tiberio Cerasi, treasurer to Pope Clement VII, commissioned the work for the chapel of the church of Santa Maria del Popolo, Rome, where it still hangs today. Like much of Caravaggio's work, it was controversial when it first appeared because the realistic portrayal of its religious subject was deemed overly coarse and inappropriate. Renowned for his bold compositions, flair for suspense and high level of realism, Caravaggio was a master of the dramatic use of lighting whose technique had an impact on the work of other painters. In *The Conversion of St Paul*, his use of chiaroscuro—literally, 'light-dark' in Italian—accentuates his depictions of volume and forms by means of highlights and shadows. The use of strong lighting also brings structure to the composition and helps to convey the narrative. Caravaggio reinvents the biblical storytelling by placing the focus on the human, rather than the divine, element of this tumultuous event. For example, the groom seems more concerned with the welfare of the startled horse than with the supernormal transformation that is unfolding before him. **AB**

⊚ FOCAL POINTS

1 HORSE

Most of this painting is taken up by the backside of a horse. Beautifully delineated by strong lighting that helps define the form of the muscular beast, the abrupt composition is explained by the location of the painting. It hangs in the entrance of the Cappella Cerasi and is viewed from an angle.

2 HOOF AND GROOM'S HAND

The drama of the scene is intensified by the use of suspense: the horse's hoof at the centre of the composition is held in mid-air, as if about to strike St Paul, and is spotlit for added effect. Also caught in the light is the groom's hand, gripping the reins firmly to avoid an accident.

3 ST PAUL'S FACE

Having just fallen from his horse, St Paul, the principal figure, is lying in a dramatic pose at the very foreground of the composition, with his arms outstretched in the air in a shock reflex. Christ has just appeared before him and he has been blinded by a heavenly light. This is the moment at which Saul is converted to Christianity. The divine nature of the event is evoked by St Paul's closed, blinded eyes and expressive gesture, and the golden light.

4 CLOAK AND SWORD

The cloak and sword signify Paul's life up until then, in which as Saul, a Roman soldier, he persecuted Christians. Now a divine voice says, 'Saul, Saul, why do you persecute me?' and he subsequently becomes known as St Paul, the founder of the Christian Church. The cloak also echoes the wrappings of the baby Jesus, iconic in Christianity, and, together with the nearby animal, Paul's helpless position and outstretched arms, emphasizes that this is a spiritual rebirth.

⏲ ARTIST PROFILE

1584–90

In 1584, at the age of thirteen, Michelangelo Merisi da Caravaggio moved to Milan to take up an apprenticeship with Simone Peterzano (c. 1540–96). He developed a naturalistic style that broke with the conventions of Mannerism (see p.202).

1591–99

Caravaggio moved to Rome, where he lived in poverty until he was taken on by Cardinal del Monte. The artist's early work was intimate in nature but developed his reputation for dramatic lighting, stark realism and imaginative composition.

1600–05

By 1600, Caravaggio was established as the most influential painter in Rome. His career shifted into the public domain when he was commissioned to paint major works for several Roman churches between 1601 and 1605. Some of these were rejected because of their striking everyday realism, which was deemed disrespectful by the Church.

1606–10

In the last few years of his life, Caravaggio became notorious for his violent activities. He murdered a man in 1606 and spent the rest of his life on the run in Naples, Sicily and Malta. During this time he continued to receive significant commissions and his work became increasingly harsh and powerful, as seen in *Beheading of St John the Baptist* (1608).

LIGHT OUT OF DARKNESS

In *The Supper at Emmaus* (1601; below), which depicts Jesus blessing the supper of the disciples after his Resurrection, Caravaggio achieves dramatic effect with chiaroscuro. The evening meal offers a natural pretext for presenting a room in darkness, from which the characters emerge by virtue of varied and specifically directed lighting. Judging by the shadow above Christ's head and the seat of the man on the left, one source of light appears to be low, a fire or lantern. However, this source is complemented by light from a higher place that turns the tablecloth stark white and picks out the cap, faces, hands and sleeves, subtly suggesting the divine nature of the event because of the common identification of God as a brilliant light from above.

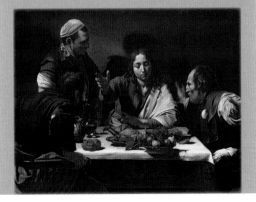

The Raising of the Cross 1610 – 11

SIR PETER PAUL RUBENS 1577 – 1640

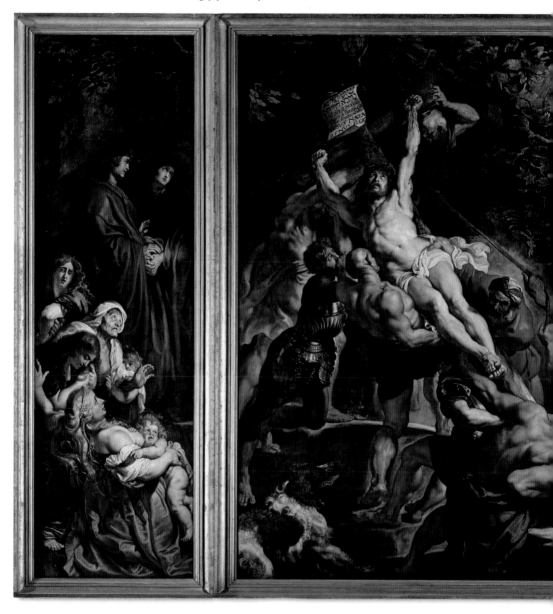

oil on canvas
182 x 134 in. / 462 x 341 cm
Onze-Lieve-Vrouwekathedraal,
Antwerp, Belgium

This altarpiece was commissioned from Sir Peter Paul Rubens for the high altar of the St Walburga church in Antwerp. The triptych is designed to arouse religious fervour and Christ's heroic demeanour is intensified by the use of light and shade. All three panels form one narrative and the vital activity takes place in the central column of light. The diagonal line of the cross creates a dynamic composition, which is emphasized by the taut ropes being pulled in parallel. While the Virgin Mary (left) contains her sadness, other women express their horror by throwing their arms in the air; their shock is accentuated by the twisting forms of their limbs and flowing hair. Two thieves (right) are also being crucified. One is forcibly held back while the other is nailed to the cross. **AB**

1589–1607

Rubens served his apprenticeship under Tobias Verhaecht (1561–1631), Adam van Noort (1562–1641) and Otto van Veen (1556–1629). He first travelled to Italy in 1600, where he was influenced by the work of Titian, Raphael and Leonardo da Vinci.

1608–14

Rubens was appointed court painter to Archduke Albert in 1609. He quickly established his reputation as the foremost painter in northern Europe and was lauded for the vitality of his triptychs in the cathedral in Antwerp.

1615–29

The demand for Rubens's work was remarkable and he ran an organized studio of pupils and assistants. His work included religious and historical paintings, portraits and self-portraits, as well as tapestry design. After the death of Archduke Albert in 1621, Rubens became an adviser to the Infanta Isabella.

1630–40

Rubens married his second wife in 1630 and she inspired many of his later paintings. He died from gout in 1640.

👁 FOCAL POINTS

1 CHRIST'S FACE AND TORSO

The figure of Christ is the focal point of the triptych. While earlier depictions of the Crucifixion had emphasized Christ's physical suffering, here he is portrayed as a heroic figure whose body does not reveal his agony. His muscular torso is reminiscent of classical sculptures of gods.

2 STRAINING MUSCLES

The bulging muscles of the man pulling the rope and of the other figures who are straining to raise up the cross add movement to the painting. The realistic depiction of the taut bare flesh strongly suggests the physical effort that is needed to accomplish the task.

3 BRUTAL SOLDIERS

The Roman soldiers crucify the two thieves in the background. One soldier's baton and extended arm cut across the panel in a diagonal, directing the viewer's gaze back to Christ. The powerful horses dominate the foreground and their staring eyes and flaring nostrils convey fear.

✿ NAVIGATOR

Las Meninas 1656

DIEGO VELÁZQUEZ 1599 – 1660

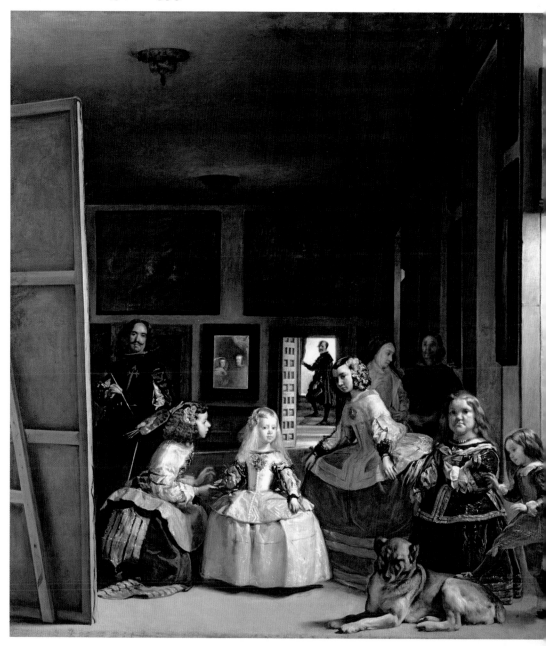

126 x 108 ½ in. / 320 x 276 cm
Museo del Prado,
Madrid, Spain

Set in the Alcázar Palace, Seville, *Las Meninas* (The Maids of Honour) depicts an intriguing scene in which artist Diego Velázquez paints himself at work. He is painting a portrait of King Philip IV and his queen, Mariana, who are—by implication—in the same place as the viewer and are reflected in the mirror on the back wall. Framed in the doorway to the rear is the queen's chamberlain, Don José Nieto Velázquez. At the centre of the canvas is the Infanta Margarita Teresa, a maid of honour on each side. Velázquez evokes an air of vulnerability in his portrayal of the young princess; her pose is artificial compared with the playfulness of the court dwarf at the far right of the painting, who himself resembles a child and is teasing the king's dog with his foot. In typical Baroque style, the artist creates a convincing illusion of space with his rendition of light and shade. Velázquez directs light from the window specifically on to the face and dress of the Infanta. Viewed close up, his brushstrokes are visible and it becomes clear that the artist has added texture and luminosity by the addition or subtraction of layers of paint. **AB**

◉ FOCAL POINTS

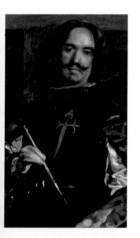

1 VELÁZQUEZ

The artist's face is realistically described in a confident self-portrait. On Velázquez's chest is a red cross indicating his membership of the knightly Order of Santiago. This honour was not granted to him until 1659. Close examination reveals that the cross was added after the painting was completed. Some believe that King Philip IV painted the cross as Velázquez lay dying, but it is more probable that the artist added the cross himself after he was made a knight.

2 KING AND QUEEN IN MIRROR

At the back of the room hangs a large mirror in which the king and queen are reflected. The royal couple, the subject of many Velázquez portraits, are small and in the background yet still demand the viewer's consideration. The mirror functions as a symbol of the purpose of art: to reflect reality.

3 MAID OF HONOUR

The maid of honour to the Infanta's right is Isabel de Velasco. Looking towards the king and queen, and the viewer, she appears to curtsy. To the Infanta's left is María Agustina Sarmiento, who respectfully kneels to offer her mistress some refreshment on a silver tray.

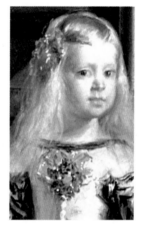

4 INFANTA MARGARITA

Highlighted by the strongest source of light in the painting, the five-year-old princess stands at the centre of the canvas. She stares out directly at the viewer with an expression that suggests complete awareness of her exalted position. She is wearing a white silk dress that is rendered by countless visible strokes of fluid paint. Dabs of pure white paint help to depict the reflection of light from the luxurious fabric and the princess's golden hair.

◷ ARTIST PROFILE

1611–18

Diego Velázquez grew up in Seville and went to study with Francisco Pacheco (1564–1644) at the age of twelve. He was advised to 'go to nature for everything' and developed a style of lifelike painting. He married Pacheco's daughter in 1618.

1619–28

Velázquez established his reputation for realism with his masterpiece *Adoration of the Magi* (1619). In 1623, he became court painter to King Philip IV. In his royal portraits, his palette became lighter and his brushstrokes more fluid.

1629–50

The artist befriended Rubens, visited Italy and enjoyed his most productive artistic period. His repertoire extended to equestrian studies and a series of portraits of court buffoons and dwarves.

1651–60

Velázquez settled in Spain. His style focused on the overall effect of his painting rather than on realistic detail. He often painted with both short- and long-handled brushes so that he could occasionally stand back from the canvas as he worked. He died in 1660 and his wife died only a few days later.

DUTCH GOLDEN AGE

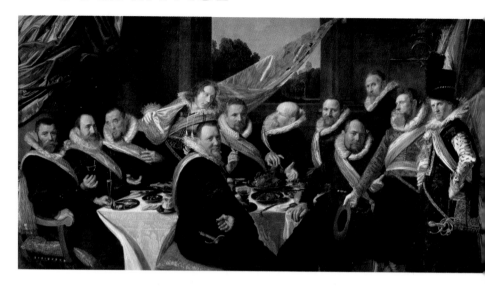

1 *A Banquet of the Officers of the St George Militia Company* (1616)
Frans Hals • oil on canvas
68 ⅞ x 127 ½ in. / 175 x 324 cm
Frans Hals Museum, Haarlem, Netherlands

2 *Gallant Conversation* (1654–55)
Gerard Terborch • oil on canvas
28 x 29 in. / 71 x 73 cm
Rijksmuseum, Amsterdam, Netherlands

3 *Courtyard of a House in Delft* (1658)
Pieter de Hooch • oil on canvas
28 ⅞ x 23 ⅝ in. / 73.5 x 60 cm
National Gallery, London, UK

After eighty years of war, the Treaty of Munster (1648) gave the Dutch Republic its independence and, in a mostly Protestant nation, art took a different direction. The Republic of the Seven United Provinces had previously been part of an area now covering the northern European countries of the Netherlands, Belgium and Luxembourg, which had been governed by the Hapsburg kings of Spain. In order to seek independence from its Catholic rulers, the Netherlands created a state governed by elected citizens, soldiers and merchants who would build the wealthiest nation of 17th-century Europe. The financial success of the young republic relied on its maritime power and foreign trade. With its renewed prosperity and the creation of a mercantile bourgeoisie, the republic created demands for new art, resulting in a golden age of Dutch painting.

During the 17th century, more than five million paintings were produced in the Netherlands. They were commissioned by an emerging, prosperous middle class that replaced the patronage of the church and nobility. These new patrons had different tastes, which led to the use of fresh subject matter and the creation of new means of production. The subjects of still life, portraiture, landscape and domestic interiors gained significance at the expense of the traditional images of devotional scenes and biblical and historical narratives.

Although many distinct artistic centres developed in leading towns, their proximity to one another meant that ideas, styles and indeed artists flowed easily from one city to the next. It is difficult to outline specific schools or discernible styles according to location. Instead, artists of the Dutch Golden Age can be grouped according to their choice of subjects because art production

KEY EVENTS

1614	1616	1624	1629	1631	1630s
Adriaen van de Venne (1589–1662) paints *Fishing for Souls*, an allegory of the fight in his country between Catholicism and Protestantism.	Hals establishes himself as one of the most important Dutch painters of the era.	Rembrandt moves to Amsterdam for the first time, where he studies briefly under Pieter Lastman.	De Hooch, the son of a stone mason, is born in Rotterdam. (He died in 1684.)	Arent Arentsz (1585/6–1631), better known by the nickname Cabel, dies in Amsterdam.	Judith Leyster (1609–60) establishes herself as one of the few female influential Dutch painters.

aw increased specialization by type during this period. What united artistic production in this era was a desire to look at the surroundings and immediate world for inspiration and to aspire to a high degree of realism in painting.

With the accession to power of a new ruling elite came a new form of portraiture, and the most celebrated and influential portraitist of the period was Frans Hals (c. 1582–1666), who settled in the city of Haarlem but was born in the southern city of Antwerp. Previous generations of portrait painters were indebted to the works of Jan van Eyck (c. 1390–1441), producing images of faces and torsoes set against an austere monochrome background. The works of Hals are outstanding for their lifelike qualities, impromptu poses and energetic brushwork. In his *Marriage Portrait of Isaac Massa and Beatrix van der Laen* (1622) both sitters appear to have turned and smiled at the viewer on impulse, conveying an impression of immediacy and intimacy. Hals often applied the paint wet on wet, a method that was ahead of its time and greatly admired by 19th-century painters. His work differs in tone and function from the many group portraits of Dutch citizens typically commissioned by guilds and civic guards for their meeting halls. Hals's first major work was *A Banquet of the Officers of the St George Militia Company* (opposite). This life-size study was a masterpiece of dynamic portraiture and quite unlike anything in the artist's previous work. Hals broke with convention and placed his sitters in an asymmetric arrangement with a variety of poses and expressions. The result was a group portrait of rich characterization and great vivacity.

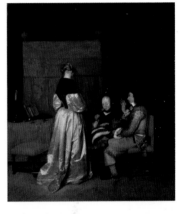

The style of portrait painter Jan de Bray (c. 1627–97) was influenced by Hals but his brushwork and handling of his subject matter was much smoother. In *The Regents of the Children's Orphanage in Haarlem* (1663), de Bray's scene is well organized and the sitters are looking directly at the viewer, with their heads almost at the same level. Some of the most famous of these group paintings were produced by Rembrandt Harmensz. van Rijn (1606–69) and include his celebrated portrait of a militia company, *The Night Watch* (1642; see p.226).

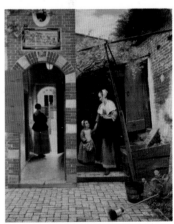

Despite the loss of a market for religious narratives, more ordinary tales are found in a new category, known as genre painting. The term has been used since the 19th century to denote scenes set in alehouses, kitchens, courtyards and brothels, for example, in which the daily lives of ordinary people are represented. These scenes are exemplified in the work of Johannes Vermeer (1632–75), Pieter de Hooch (1629–84) and Gerard Terborch (1617–81). The latter's *Gallant Conversation* (right, above), previously known as *Paternal Admonition*, was for a long time thought to show a father lecturing his daughter. Study of a later, renovated version of the work revealed that the man on the right holds a coin in his fingers. This detail, along with the prominence of the bed, led to the revised view that the man is a client and the young woman a prostitute. The painting showcases Terborch's unrivalled expertise in the portrayal of fabrics. De Hooch's *Courtyard of a House in Delft* (right) highlights

c. 1635	1645	1648	1656	c. 1662–64	1665
Flower painter Jan Davidsz. de Heem (1606–83/4) moves to Antwerp and joins the Guild of St Luke.	Carel Fabritius (1622–54), a former apprentice to Rembrandt, paints his evocative *Self-portrait*, which echoes his old master's work.	The independence of the United Provinces is officially recognized in the Peace of Westphalia.	Rembrandt is declared bankrupt; all his possessions and paintings are sold.	Vermeer's *The Music Lesson* exhibits a new understanding of perspective.	Adriaen van Ostade (1610–85) paints *The Physician in His Study*.

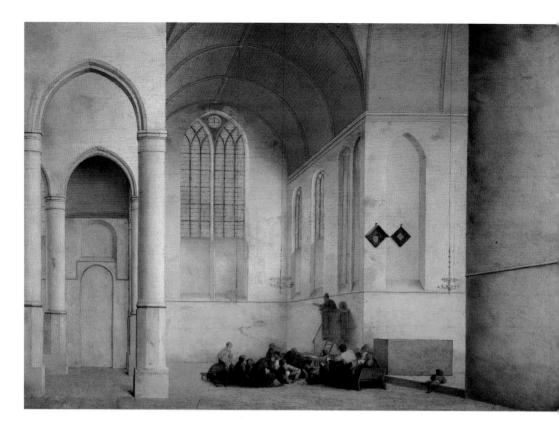

his careful observation of architecture. De Hooch often depicted courtyard settings, as they allowed him to explore the effects of perspective; the scene from the courtyard in Delft cleverly provides a view through the passageway and into the street beyond. Like Vermeer, de Hooch delighted in minute detail, seen in the contrasting patterns of colour and texture in the different brickwork. The human figures in de Hooch's works, however, are less compelling than those portrayed in Vermeer's domestic scenes, such as *The Kitchen Maid* (c. 1658; see p.228).

Rembrandt is best remembered for his self-portraits, yet along with his inventiveness as a portrait painter he was one of the few artists in the Dutch Republic to produce historical narratives. He often depicted scenes from the Old Testament and these works are painted on a more intimate scale and use effective chiaroscuro lighting to add to the sense of drama. Although images of biblical stories were in great demand across Catholic Europe, particularly in Italy where the Baroque (see p.212) movement was at its peak, they were not needed by a Protestant nation that had rejected the use of images in churches. In Europe, the Thirty Years War of 1618 to 1648 saw the decline of the Holy Roman Empire and led to Catholic churches being stripped of their decoration and reduced to plain interiors. Nowhere is this more visible than in the accurate depictions of church interiors produced by Pieter Saenredam (1597–1665). He specialized in 'portraits' of churches and invented a new subject matter of precise architectural representations. He worked methodically, producing many preparatory sketches and using the science of perspective, and made meticulous images of buildings. The starkness of newly whitewashed walls is depicted in the *Interior of the Church of St Odulphus at Assendelft* (above) and the painting took sixteen years to complete from the first sketch to the finished work.

Still life was another genre that emerged during the Dutch Golden Age and many of the seemingly straightforward compositions convey complex messages. For the first time luxurious objects, flowers, foods and kitchenware became the subject matter of paintings. Arranged on tabletops, often painted life size and set against plain backgrounds, the objects were chosen for their symbolic meanings as well as their textures and surfaces. A still-life category known as 'vanitas' featured objects such as hourglasses, skulls and candles—symbols to remind the viewer that while life may be full of riches, death is inevitable.

Willem Claesz. Heda (c. 1594–1680) was one of the most renowned still-life painters of the 17th century. He often chose objects in muted colours that belonged to everyday life, such as plates, jugs, fish and bread. In works such as *Still Life with a Gilt Cup* (below), Heda placed cut bread, a plate of oysters, a pewter tankard and a green römer glass together with great skill and taste. A spiral of cut lemon peel to the right of the frame provides a strong colour contrast to the otherwise subdued palette. Heda showed great mastery in the way he depicted tin, silver and glass and the manner in which light reflects on these smooth, polished surfaces. Another popular still-life category was that of flower painting, exemplified by the works of Ambrosius Bosschaert (1573–1621). In *Still Life with Flowers* (above right), the vibrant blooms point to the fleeting nature of beauty, and their large size and glamour emphasize that it is only through the power of art that these petals have not withered.

The most distinctive feature of Dutch art is its images of the flat plains of Holland, as seen in the many panoramic views of the countryside with huge expanses of sky. The country was very aware of the fragility of territory, as much of its land had been reclaimed from the sea and lay below sea level. The landscapes produced by Jan van Goyen (1596–1656) and Jacob van Ruisdael (c. 1628–82; see p.230), among others, are characterized by low horizons, subtle lighting and a spontaneity of vision. The same can be said of the work of Salomon van Ruysdael (c. 1600–70), who specialized in seascapes. While the ships responsible for the trade and wealth of the Dutch Republic are painted with meticulous draughtsmanship, the sea and sky reflect the effects of atmosphere and light. There is much evidence that landscape artists of the period studied and made drawings out of doors. Whether or not the views painted are of a specific location, all achieve a sense of realism that characterizes art of the Dutch Golden Age. **AB**

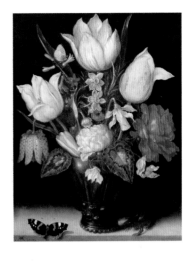

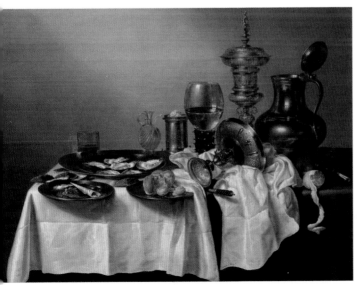

4 *Interior of the Church of St Odulphus at Assendelft* (1649)
Pieter Saenredam • oil on panel
19 ³/₄ x 29 ⁷/₈ in. / 50 x 76 cm
Rijksmuseum, Amsterdam, Netherlands

5 *Still Life with Flowers* (1607)
Ambrosius Bosschaert • oil on copper
9 ⁵/₈ x 7 ¹/₂ in. / 25 x 19 cm
Private collection

6 *Still Life with a Gilt Cup* (1635)
Willem Claesz. Heda • oil on canvas
34 ⁵/₈ x 44 ¹/₂ in. / 88 x 113 cm
Rijksmuseum, Amsterdam, Netherlands

The Night Watch 1642
REMBRANDT HARMENSZ. VAN RIJN 1606 – 69

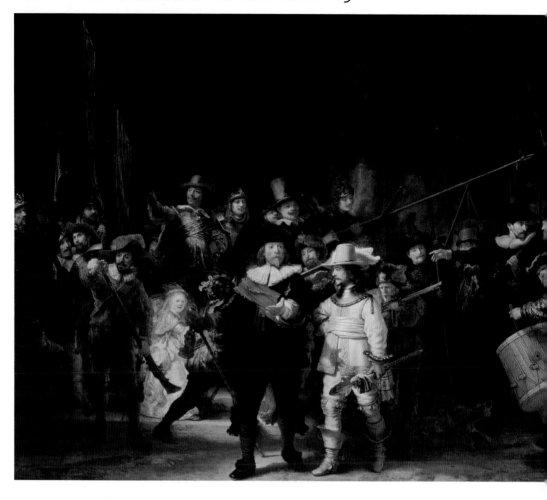

oil on canvas
149 ¹/₂ x 178 ¹/₂ in. / 379.5 x 453.5 cm
Rijksmuseum, Amsterdam, Netherlands

🔆 NAVIGATOR

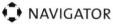
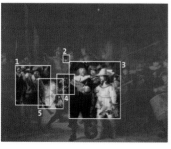

In 1642, at the height of his fame, Rembrandt Harmensz. van Rijn was given the prestigious commission to paint a large group portrait of a civic guard. Although commonly known as *The Night Watch*, the painting's original title is *The Company of Captain Frans Banning Cocq and Lieutenant Willem van Ruytenburch*. Surrounded by darkness and to the sound of a beating drum, this group of militiamen prepares to march out beneath its raised standard. In the centre of the composition, dressed in black with a red sash and holding a baton, is Captain Frans Banning Cocq (1600–55), who leads the way with an outstretched arm. He is closely followed by his lieutenant, dressed in resplendent yellow and gold. Group portraits of civilian militias were common in the 17th-century Dutch Republic. What is extraordinary and unique about Rembrandt's painting is that instead of placing members of the guard in a neat row and giving each person equal space and prominence, he creates an action-filled scene akin to a historical narrative, in which the guardsmen prepare to form rank. The guardsmen each paid a fee to be included in the painting and each is named on a shield in the background. Rembrandt dramatizes the scene with the use of dark areas punctuated by highlights on each face, helmet and weapon. **AB**

👁 FOCAL POINTS

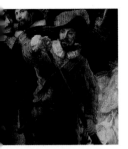

1 MAN LOADING GUN

The militias in the Dutch Republic were known by the weapons they carried. The men in this particular militia were known as the *kloveniers*, or arquebusiers, after the long-barrelled firearm that they carried: the *klover*, or arquebus. Here a guard dressed in red is loading the weapon.

2 REMBRANDT SELF-PORTRAIT

Rembrandt signed the painting in the bottom left-hand corner and also included a self-portrait behind a pikeman at the back of the composition. The artist is recognizable by his prominent nose and is wearing his trademark beret; he appears to be peering into the scene as if peeking through a keyhole.

3 LIEUTENANT

Van Ruytenburch can be identified as a lieutenant because he carries a partisan (weapon with a flat iron blade) at his side and is taking orders from his captain. Crosses from the Amsterdam coat of arms decorate his lapels and reveal that the militiamen are Amsterdam arquebusiers.

4 OAK LEAVES ON HELMET

The crouching militiaman who has just fired his weapon behind Captain Frans Banning Cocq wears a helmet bearing an emblem of an oak leaf. The oak leaf was a traditional symbol for the arquebusiers and is one of many pictorial references to the guild and to Amsterdam in the painting.

5 GIRL IN GOLD

To the left of the captain is the unexpected image of a young girl dressed in gold. She is the company's mascot and on her belt is a dead bird. The militia corps had a chicken's claw on its coat of arms and the clearly painted claws of the dead bird reference this symbol.

🕐 ARTIST PROFILE

1606–30

Rembrandt was born in Leiden to a mill owner. He attended Leiden University but never graduated. He was apprenticed to local painter Jacob van Swanenburgh (1571–1638) for three years before completing his training in 1624 with Pieter Lastman (c. 1583–1633) in Amsterdam.

1631–38

Having received critical acclaim and encouragement from art dealer Hendrick van Uylenburgh (c. 1587–1661), Rembrandt moved to Amsterdam. In 1632 he was commissioned to paint *The Anatomy Lesson of Dr Nicolaes Tulp* (1632). In 1634 he married van Uylenburgh's niece, Saskia (1612–42). The couple had four children, but only one survived infancy.

1639–55

He bought a large house, which he also used as a studio, and built up a collection of art and curiosities. Rembrandt regularly used his family as models and painted numerous self-portraits. His wife died in 1642. Later he found a companion in his maid, Hendrickje Stoffels (1626–63) with whom he had a daughter.

1656–69

Rembrandt's lavish spending, fall in production and refusal to compromise his artistic principles meant he got into debt. He was declared bankrupt and forced to sell his townhouse. The artist was buried in a pauper's grave.

REMBRANDT'S VISUAL DIARY

Rembrandt painted himself throughout his career in many different guises. Eighty-six self-portraits survive, providing a visual diary of the artist from youth to old age. The arresting self-portrait below was painted in 1640, when he was thirty-four years old and at the height of his success. Rembrandt deliberately chose to paint himself like an Old Master, and the assured three-quarter pose composition is similar to the dignified pose used by Titian (c. 1485–1576) in his portrait *A Man with a Quilted Sleeve* (c. 1510) and by Raphael (1483–1520) in *Portrait of Baldassare Castiglione* (c. 1514–15), both of which Rembrandt had studied. Rembrandt's elegant costume also references Albrecht Dürer's (1471–1528) self-portrait painted in 1498, which shows the artist dressed in gentlemanly attire.

Rembrandt's achievements encouraged him to produce self-portraits, which were collected by connoisseurs and helped to further establish his reputation.

The Kitchen Maid *c.* 1658
JOHANNES VERMEER 1632 – 75

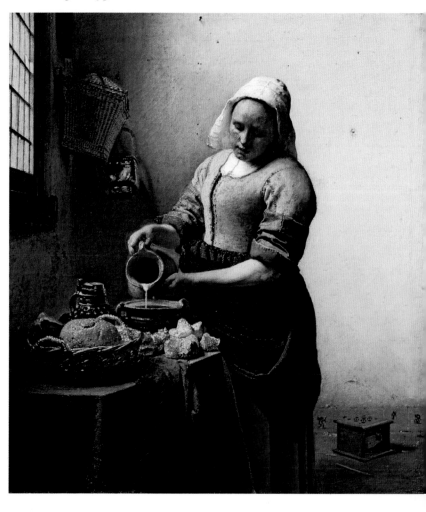

oil on canvas
18 x 16 in. / 45.5 x 41 cm
Rijksmuseum, Amsterdam,
Netherlands

◆ NAVIGATOR

In a stark 17th-century interior, a sturdy young woman focuses her attention on the task of pouring milk from a jug into a bowl. Her concentration adds to the tranquillity of the scene in which the only suggested noise is the trickle of poured milk. All these factors make the atmosphere deeply intimate and time seem to stand still. Johannes Vermeer brings dramatic impact to a humble domestic moment. He was a master of daily observation and paid meticulous attention to detail, as evidenced by the nail in the wall and the stains on the whitewash. His treatment of light and shadow shows great skill; the light falling on the maid highlights her pale forearms and guides the viewer's gaze to the stream of milk. The yellow and blue of the maid's bodice and apron shine in the light and are echoed in the blue cloth and objects laid out on the table. Although *The Kitchen Maid* is not a portrait, the viewer is left in no doubt that it must have been painted from direct observation and that the carefully depicted features of the woman belonged to a real person (the Vermeer family's servant Tanneke Everpoel may have posed for the picture). The realism, however, should not overshadow Vermeer's skilful composition, designed to make the scene aesthetically and emotionally satisfying. **AB**

⊙ FOCAL POINTS

1 THE LIGHT

The window is the one source of light in the room. Vermeer's inclusion of a broken pane of glass shows his attention to detail; the way the light enters through the opening displays a subtle use of light. The light from the window picks out the brass bucket, which gleams against the shadowy wall.

2 NAIL IN THE WALL

At the very top of the image, above the maid's head, a nail has been hammered into the wall. This realistic detail in fact points to a painting or map that Vermeer had initially hung on the wall but that he later painted over so as not to distract from the figure of the maid.

3 DELFT TILES

Vermeer was born in Delft, a city famed for its pottery. One of the tiles edging the bottom of the wall depicts Cupid the god of love, which, with the foot warmer, were emblems of feminine lasciviousness. Its inclusion is perhaps meant to emphasize the temperance of the present subject.

4 BREAD

Vermeer is recorded as having paid painstaking attention to detail. Seen from afar, the crust of bread in the basket on the table looks convincing and realistic; on closer inspection the viewer can clearly see that it is in fact made up of countless dots of paint.

5 TABLE TOP

While the maid is seen from below, the tabletop is painted from a slightly raised viewpoint and has been tilted forwards to allow the viewer a clear view of all the objects on display. Such subtle discrepancy in the perspective allows Vermeer to have control of his subject and of his audience's vision.

⊙ ARTIST PROFILE

1632–54

Little is known about Vermeer's early life. In 1652, after his father's death, Vermeer took over his painting dealership. He married Catherina Bolnes in April 1653 and converted to Catholicism. Later that year he joined the Guild of St Luke, a trade association for painters.

1655–57

His first known paintings, *Christ in the House of Martha and Mary* (c. 1654–56) and *Diana and Her Companions* (c. 1653–56), were created. *The Procuress* (1656) is one of Vermeer's first signed works; the picture of the man holding a glass of wine is thought to be a self-portrait. In 1657 he painted his first genre piece, *The Maid Asleep*, and wealthy Delft citizen Pieter van Ruijven became his patron.

1658–67

In this mature period he painted his much-loved *The Little Street* (c. 1658) and his only landscape *A View of Delft* (c. 1660–61). He also produced detailed and harmonious domestic interiors.

1668–75

From the late 1660s Vermeer's work became more stylized. A contemporary described him in his diary as a 'celebrated painter'; in 1670 he became headman of the guild again. The outbreak of the Franco-Dutch war in 1672 saw his earnings slump. On his death, he left his widow massively in debt.

DELFTWARE

Just visible in the bottom right corner of *The Kitchen Maid* is a row of Delft tiles. Vermeer was working during the main period of production of the popular, glazed, blue and white pottery known as Delftware. Master potters who were producing Delftware would have belonged to the same artists' guild as Vermeer. Until the late 16th century, only the wealthy could afford to buy ceramics. After the fall of Antwerp in 1585, many Flemish potters settled around Delft. When the import of Chinese porcelain threatened the Dutch trade, potters started to imitate the porcelain and created Delftware. Unlike porcelain, Delftware is made from a clay mixture that is covered with a tin glaze after it has come out of the kiln. It ranged from everyday household items to fancier pieces that were displayed in the homes of the prosperous. Although tiles were often used on the walls to keep out damp, eye-catching tile tableaux were also used

as decoration. Biblical and mythological subjects were common, as were local scenes of Delft (left) and the Dutch countryside. Oriental landscapes also featured because of the popularity of Chinese porcelain.

A Landscape with a Ruined Castle and a Church 1665

JACOB VAN RUISDAEL *c.* 1628 – 82

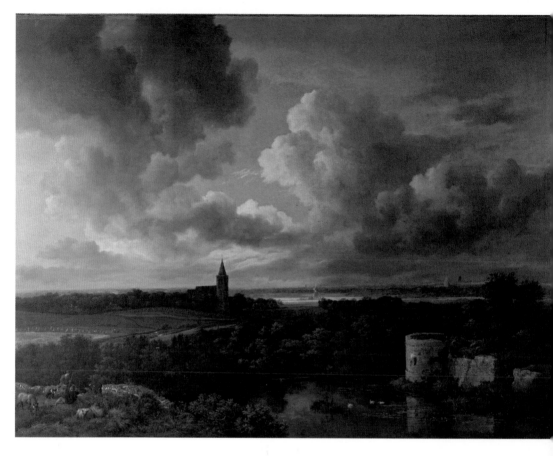

oil on canvas
42 ⁷/₈ x 57 ¹/₂ in. / 109 x 146 cm
National Gallery, London, UK

I n the new Protestant Dutch Republic, where the Church no longer
commissioned religious images, secular patrons particularly prized landscape
paintings of the Netherlands. This open landscape by Jacob van Ruisdael
could well be renamed a skyscape because a large part of the canvas is filled
with sky and billowing clouds. Outdoor images of this kind, first created in the
17th-century Netherlands, constituted a new type of picture. While images of
natural scenery had existed for a long time, they had always served as the
backdrop to historical, mythical or biblical narratives. Here the landscape is the
central subject. It is tempting to assume that the scenery it depicts, flat and
seemingly endless, is a topographical representation of an actual place. In fact,
the painting reflects no exact location, instead being a generalized view of
Gooiland, an area in the centre of the Netherlands.

While the scenery of this painting is incontestably Ruisdael's work, the
shepherds and animals, seen in the bottom left corner, were painted by Adriaen
van de Velde (1636–72), a figure and animal specialist. This collaboration
between artists of different specialisms was common practice in Dutch painting.
Ruisdael worked with Philips Wouwerman (1619–68) and Jan Lingelbach
(1622–74) in the same way. The painting is typical of his work in middle life, the
area of sunlit meadow contrasting with dramatically stormy skies to suggest a
divine presence in a way that was quite different from the religious imagery of
the old order, because it appears wholly natural at the same time. **AB**

✦ NAVIGATOR

FOCAL POINTS

1 SKY

The billowing clouds are painted as if seen from below and their volume is beautifully rendered by the use of highlights and shadows. Close inspection reveals that only a few swift and visible strokes describe these weightless forms. The visible brushmarks add a sense of movement to the sky and convince the viewer that a brisk wind animates the scene. The changing nature of the weather is implied by this motion and a break in the clouds.

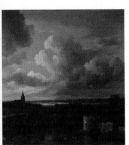

2 LOW HORIZON

The horizon has been placed low, at a third of the height of the composition, implying a low viewpoint. It is broken only by church spires and the sails of a windmill, giving a sense of infinity. This use of a low horizon encourages the painting's viewer to feel immersed in the scene.

3 SKY REFLECTED IN WATER

A secondary image is recorded in this landscape: in the middle foreground the sky and castles are perfectly reflected in a tranquil stretch of water. Two hundred years previously, the architect and writer Leon Battista Alberti (1404–72) had said that painting was 'the act of embracing by means of art the surface of the pool'. Ruisdael takes that observation literally, employing immense technical skill to create a perfect reflection of the half-imaginary landscape.

4 HUMAN FIGURES

Two seated figures rest in the bottom left of the painting. Dwarfed by the landscape around them, they illustrate man's place within God's creation in an echo of earlier religious works. The presence of two shepherds tending a flock also brings a suggestion of classical Arcadia.

ARTIST PROFILE

c. 1628–44

Born Jacob de Goyer in Haarlem, the capital city of North Holland, the artist received his early training in painting from his father, Isaak de Goyer, an art dealer and frame maker who later took the name van Ruysdael, and his uncle, Salomon van Ruysdael, a specialist in townscapes and riverscapes. Jacob also changed his name, but spelt it van Ruisdael.

1645–55

The artist produced his first reliably dated works in 1645. During this period he focused on studying nature and reproducing it in simply constructed works. He travelled for several years in the eastern Netherlands and western Germany to practise his techniques and gain first-hand experience of wild, wooded and hilly landscapes.

1656–60

In 1656 Ruisdael settled in Amsterdam, his home for most of the rest of his life. He earned the freedom of the city of Amsterdam in 1659. His work continued to be focused on dramatically lit landscapes of hills, forests and waterfalls. In 1660 he wrote a testimonial for a pupil, Meindert Hobbema (1638–1709), the only evidence that he took pupils.

1661–82

Ruisdael moved back to Haarlem at the end of his prosperous career. He was buried in the city's cathedral.

LANDSCAPE: ART OF THE NORTH

Paintings that represented vast vistas and inviting panoramas, such as *Landscape with the Flight into Egypt* (1563; below) by Pieter Bruegel the Elder (c. 1525–69), were much praised in northern Europe in the 16th and 17th centuries. Landscape painting as a genre was also encouraged and promoted by the Protestants, who believed that artists should record God's creations. However, this act of copying as opposed to inventing was scorned by some, and famously ridiculed by Michelangelo, who is purported to have exclaimed, 'In Flanders they paint with a view to external exactness. . . . They paint stuffs and masonry, the green grass of the fields, the shadow of trees, and rivers and bridges, which they call landscapes, with many figures on this side and many figures on that. All this, though it pleases some persons, is done without reason or art. . . .'

RAJPUT PAINTING

1 *Asavari Ragini*, folio from the Chawand *ragamala* (c. 1605)
Nasir-ud-din • gouache on paper
7 ⅞ x 7 ½ in. / 20 x 19 cm
Victoria & Albert Museum, London, UK

2 *The Boar-faced Goddess, Varahi*, folio from the *Tantric Devi* series (1660–70)
Kripal of Nurpur • watercolour, gold, silver and beetle-wing cases on paper
8 ⅜ x 8 ½ in. / 21 x 21.5 cm
San Diego Museum of Art, USA

3 *Radha and Krishna Walking in a Grove* (1820–25)
Artist unknown • gouache on paper
11 x 7 ¾ in. / 28 x 20 cm
Victoria & Albert Museum, London, UK

Rajput paintings celebrate the courtly culture and colourful pageantry of India's romantic past. They speak to us of the Hindu world view and of the *bhakti*, or devotional movement, of medieval Hindu India. Commissioned by the many Rajput Hindu rulers of kingdoms in northern, central and the western Himalayan regions, from the 16th to the 19th centuries, these jewel-like paintings were small enough to be held in the palm of the hand and admired, and treasured in the same way as jewellery. Rajput paintings from the Himalayan hill region are known as Pahari paintings (meaning 'of the mountains'), paintings from the states of Mewar, Marwar, Bikaner, Jaipur, Bundi, Kota and Kishangarh are called Rajasthani paintings, while those from Malwa and Bundelkhand are central Indian.

From the mid 16th until the early 18th century, the wealth and power of the Mughal Dynasty ensured that its Islamic art influenced the art and architecture of much of the northern Indian subcontinent. Although Rajput painting embraced some Mughal influences in both content and style—in particular the art of portraiture that previously had had no place in the

KEY EVENTS

1567–68	1605	1615	1623	1636	1658
Mughal Emperor Akbar destroys the Mewar capital at Chittor, but Rana Udai Singh escapes and founds a new capital in Udaipur.	An early example of Mewar painting comes from Chawand. This lively style continues until subdued by Mughal influences from 1680.	The last Rajput state succumbs to Mughal rule when Rana Amar Singh of Mewar signs a treaty with Prince Khurram (later Shah Jahan).	Early *ragamala* paintings are made in the Marwar school of Rajput painting in Pali.	Early Malwa painting includes the *Rasikapriya* (a poem analyzing the love sentiment) series; it is a conservative work with flat compositions and dark backgrounds.	The Kota school of Rajput painting starts to use vibrant colours and bold lines in its style of portraiture.

world of Hindu gods and goddesses—the ethos of Rajput art was distinct and indicative of the indigenous culture of India. An essential element of Rajput paintings was the Indian aesthetic theory of *rasa* (meaning sentiment or emotion), which emphasized the artists' and viewers' role in the artistic experience. The artist chose to convey one or other of nine emotional states, and the depictions were interpreted and appreciated by the viewer, known as a *rasika*, or connoisseur. Love is the most popular emotion depicted in Rajput painting and it is expressed in both romantic and divine form.

The folio of *Asavari Ragini* (opposite) is from the Rajasthani state of Mewar, which developed its painting sensibilities from the manner of early Rajput painting—derived from linear 'Western Indian' Jain manuscript illuminations and various sultanate painting techniques. The folio portrays the sentiment of *sringara rasa*, or erotic love: a tribal girl is pining for her beloved and sings melancholy songs of love. The folio belongs to a *ragamala* (garland of melodies) series of paintings and is intended to represent visually verses aspiring to capture the essence of a *raga* (melody).

Some Rajasthani and central Indian states, such as Mewar and Malwa, continued to produce paintings through the 17th and 18th centuries in the simple, robust, earthy style exemplified by *Asavari Ragini*, with scarcely any influence from the art of their Mughal overlords, which by then had developed a more refined and naturalistic look. Other Rajput kingdoms, such as Marwar, Jaipur, Bikaner and Kishangarh, adopted elements of their styles from Mughal ateliers in Delhi or elsewhere, either by introducing Mughal artists into their studios or by emulating Mughal paintings. Rajput art was also influenced by the art of distant regions of India; for example, *Krishna Lifts Mount Govardhan* (c. 1690; see p.234) incorporates elements of Golconda painting imported from the southern province of Deccan.

Early Pahari paintings from Rajputs in the foothills of the western Himalayas were in a dynamic style epitomized by *The Boar-faced Goddess, Varahi* (right, above) from the small hill state of Basohli. This painting depicts Varahi, the female consort of Varaha (Vishnu in his incarnation as a boar), majestically seated on a magnificent tiger with her many hands holding emblems of her attributes. The bold, brightly coloured work is highlighted by tiny, luminous beetle-wing cases stuck on the paper to suggest shining jewels.

Later Pahari paintings were much influenced in style by the courtly art of Mughal India under the ruler Muhammad Shah (r.1719–48). The hill states of Guler and Kangra developed a refined, technically assured style in which tall, handsome men and graceful, lithe women played their part in the ever popular narrative of Krishna and Radha, or in the *Rasamanjari*, a poem about the moods and nuances of love: unrequited love—with a lover pining for a beloved—or fulfilled romantic love, for example. *Radha and Krishna Walking in a Grove* (right) is typical of Kangra art, in that nature is depicted as a lush, verdant paradise—albeit in a naturalistic manner—so that artistic depth and perspective play an important part. The beautifully outlined figures inhabit a charming world of fantasy and illusion, meant to depict a vision of heaven. **RA**

Krishna Lifts Mount Govardhan *c.* 1690
USTAD SAHIBDIN *c.* 1601 – 1700

1 KRISHNA

The *Bhagavata Purana* proclaims Krishna, the eighth incarnation of Vishnu, as a supreme deity and narrates his time on earth. Here the blue-bodied Krishna is bejewelled and crowned, showing that, despite his living on earth as a simple cowherd, he is a king among kings.

2 INDRA

Krishna lifts up the mountain to shelter his followers from Indra, the Vedic god of thunder who is shown riding on his white elephant mount, Airavata. Indra is depicted amid the dark, swirling thunder clouds that threaten to submerge the villagers in his attempt to chastise them.

This painting from the desert kingdom of Bikaner in Rajasthan, northern India, illustrates one of the god Krishna's miraculous feats, as narrated in the *Bhagavata Purana*, a 10th-century religious text. The myth tells the tale of Indra, the Vedic god of thunder, who sends forth a deluge to punish village folk living in the region of Vraja for worshipping Mount Govardhan instead of him. Krishna, a simple cowherd, lifts the mountain with his finger for seven days and nights to protect the villagers and cattle from drowning.

The illustrated *Bhagavata Purana* manuscript to which this painting belongs was commissioned by Raja Anup Singh (1669–98) of Bikaner, a Sanskrit scholar, prodigious warrior and politician, art patron and one of Bikaner's greatest kings. Anup Singh, who spent most of his later years in the southern province of the Deccan, first campaigning for the Mughal Emperor Aurangzeb (1658–1707) and then in government, introduced a distinct Deccani flavour to Bikaner painting and sent home a number of Deccani paintings for artists in his studio to emulate. It was not unusual in a Mughal or Rajput painting studio to copy or trace details from a painting produced by a master artist, and it is possible that details in *Krishna Lifts Mount Govardhan* were copied from a Deccani painting.

During the latter part of Anup Singh's reign, a new style was introduced by artists such as Ustad Sahibdin, the master painter of *Krishna Lifts Mount Govardhan*, who was a court painter to the rulers of Bikaner. Pronounced influences from Golconda painting in the Deccan are visible in the use of the colour lilac, the delicate and refined line, an inclination towards a more stylized and less realistic aesthetic and an aspiration towards a magical, ethereal quality in painting. Golconda paintings were prized and renowned for their refined and enchanting sensibilities. *Krishna Lifts Mount Govardhan* exemplifies the late 17th-century Bikaneri style under Ustad Sahibdin, featuring thin, attenuated, doll-like figures and delicate lines combined with naturalistic details such as the cow shown giving birth. **RA**

watercolour on paper
11 x 7 ⅞ in. / 28.5 x 20 cm
British Museum, London, UK

3 ADORING WOMEN

Village maidens or *gopis* wave banners, fly whisks and gaze in adoration at Krishna, signifying that he is the supreme lord. The maidens symbolize the singular devotion of a soul for the Hindu god and are used in later Krishna *bhakti* poetry as a metaphor of longing for the divine.

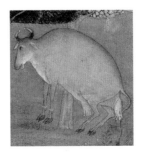

4 COW GIVING BIRTH

Details such as the cow shown giving birth to a calf, the other cows and the lilac rock-like formation that symbolizes Mount Govardhan are identical to and were probably copied from a Deccani painting from Golconda titled *Animals and Ascetics in a Landscape*. Such copying was not unusual.

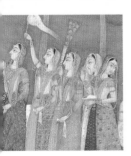

JAPANESE ART: EDO PERIOD

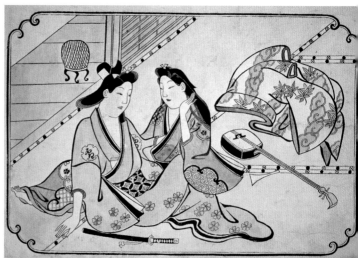

1 *A Young Man Dallying with a Courtesan* (c. 1680)
Hishikawa Moronobu • hand-coloured woodblock print
10 ¼ x 14 ½ in. / 26 x 37 cm
Takahashi Collection, Japan

2 *The Actor Fujimura Handayu as a Keisei* (c. 1700)
Torii Kiyomasu • woodblock print
13 x 6 ¼ in. / 33 x 16 cm
Brooklyn Museum of Art, New York, USA

3 *Salt Maidens on the Tago-no-ura Beach with Mount Fuji Behind* (c. 1767)
Suzuki Harunobu • colour woodblock print
11 x 8 in. / 28 x 20.5 cm
Private collection

The 250 years of peace maintained by the Tokugawa shoguns of Japan during the Edo period, from 1603 to 1867, encouraged popular culture to flourish, and with it the art of *ukiyo* (floating world). *Ukiyo* echoes the Buddhist teaching that all is illusion, and during the Edo period the term came to denote the pursuit of fleeting pleasure. In the strictly stratified society of Edo Japan, merchants were consigned to the lowest class, but the rise of prosperous urban centres meant they had the financial freedom to enjoy leisurely activities. Spending time with courtesans or watching kabuki classical dance dramas were popular pastimes that inspired artists to produce appealing images for an urban clientele. Woodblock printing made it possible to reproduce large numbers of images cheaply and initiated the mass circulation of *ukiyo-e* (pictures of the floating world). Art was no longer a prerogative of the elite and was enjoyed by the populace.

Woodblock printing was used to mass-produce Buddhist texts and votive images from the 8th century onwards, but it was not until the early 16th century that secular printed books were produced. Early woodblock-printed books were illustrated with black and white pictures, which were sometimes hand coloured. In the early 17th century, printed versions of Japanese classical literature began to be produced in the Saga area of Kyoto. Named after the area of Kyoto where they were produced, *Saga-bon*, or Saga books, are essentially luxury books characterized by graceful calligraphic text printed with movable type and printed black and white illustrations in traditional style. Their publication marked the beginning of a remarkable proliferation of printed

KEY EVENTS

1603	1603	1617	1633–39	1682	1689
Tokugawa Ieyasu (1543–1616) is appointed shogun, founding the Tokugawa dynasty of shoguns in Edo.	The first performance of kabuki, by Izumo no Okuni (b. c. 1572), takes place; it is originally performed by women but by the 1670s it is performed only by men.	Yoshiwara is established as Edo's only licensed theatre and brothel district. Many *ukiyo-e* prints depict this area.	A series of isolationist edicts are issued: Westerners are expelled, external trade is limited and Catholicism is declared illegal.	Ihara Saikaku (1642–93) writes the novel *The Life of an Amorous Man*; it ushers in the populist *ukiyo-zoshi* style.	The Zen master and poet Matsuo Bashō (1644–94) writes the first great haiku, a seventeen-syllable poem recording a journey to Honshu.

ooks in Japan because they were soon followed by cheaper books on the ubjects of popular legends and fairy tales with naive illustrations. By the 8th century, there were more than 1,500 publishing houses in Japan, feeding he public's insatiable appetite for books with a range of content from fiction, oetry and classics to travel guides.

Early illustrations were created by anonymous artists, but in the 1670s, Hishikawa Moronobu (c. 1618–94) achieved such fame as a popular illustrator hat he started to sign his works. Moreover, he made the most significant contribution to the popularity of *ukiyo-e* by publishing his images as single heets, independent from the text. Moronobu's *A Young Man Dallying with a Courtesan* (opposite) is an early example of the *shunga* (spring pictures) genre of risqué erotic pictures that constituted a substantial part of many *ukiyo-e* artists' oeuvre. Single-sheet prints quickly became fashionable and images began to be judged for their artistic value. Publishers followed the trend and commissioned artists to design eye-catching prints featuring actors and beauties. Torii Kiyomasu (a.1697–1722) specialized in *yakusha-e* (pictures of actors), animated images of popular kabuki actors who commanded celebrity status in Edo society, and the prints were often used to publicize performances. His portrait *The Actor Fujimura Handayu as a Keisei* (right, above) shows the actor wearing a wildly decorated robe scattered with calligraphy. Its gracious, free-flowing lines and tapered brushwork are typical of Kiyomasu's oeuvre.

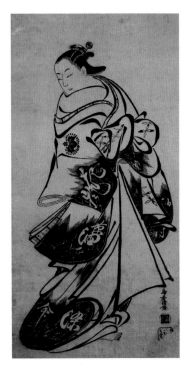

To make the prints more attractive as merchandise, early works were hand coloured with a few colours. In the 1740s the first type of polychrome print, *benizuri-e* (red-printed pictures), began to appear, with areas in rose-pink and green made from vegetable dye added to black outline. The desire to make full-colour prints resulted in the invention in 1765 of *nishiki-e* (brocade pictures) by Suzuki Harunobu (c. 1725–70), an effect that was achieved by superimposing several blocks. The prints' lavish colours were likened to those of *nishiki*, or silk, brocades. At the same time, the skills of block carvers and printers became highly sophisticated, and it became possible to reproduce faithfully the fine detail of the fluid and delicate lines in artists' original drawings. Harunobu's brightly coloured prints depicting elegant young girls, such as *Salt Maidens on the Tago-no-ura Beach with Mount Fuji Behind* (right), were an immediate commercial success. Harunobu expertly juxtaposed colours on striped and check costumes in this image. His themes were often inspired by classical poetry, but the figures were always placed in the contemporary settings with great attention to fashionable hairstyles and costumes. He dominated the world of *ukiyo-e* by publishing hundreds of his delicate and lyrical images until his death in 1770. Kitagawa Utamaro (c. 1753–1806) advanced the depiction of women one step further with more realistic portraits, including *Coquettish Type* (1792–93; see p.238). His work ushered in the golden age of *ukiyo-e* prints in Japanese art of the first half of the 19th century (see p.290). **MA**

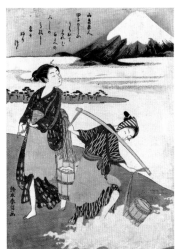

1697	1716–36	1720	1740s	1765	1787
Kiyomasu produces images of popular kabuki actors, such as *The Actor Ichikawa Danjuro I in the Role of Takenuki Goro.*	The Kyoho economic reforms are introduced and the ban on Western books ends.	A limited number of Chinese and Dutch books are allowed into Japan, especially those concerned with science and medicine.	*Benizuri-e* prints appear. Okumura Masanobu (1686–1764) and Torii Kiyomitsu (c. 1735–85) are among the leading proponents of the technique.	Harunobu develops full-colour *nishiki-e* prints by superimposing several woodblocks to form a single image.	The Kansei Reform begins, reversing many liberal tendencies of previous decades. By 1790 censor seals are required on single-sheet prints.

Coquettish Type 1792–93
KITAGAWA UTAMARO *c.* 1753–1806

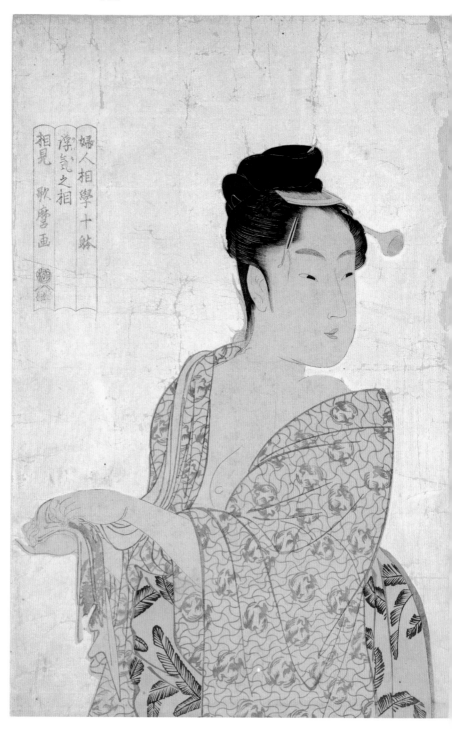

婦人相學十躰
浮気之相
相見
歌麿画

colour woodblock print with mica
14 3/4 x 9 5/8 in. / 37.5 x 24.5 cm
Tokyo National Museum, Japan

Kitagawa Utamaro is synonymous with *bijin-ga*, the popular genre of *ukiyo-e* (pictures of the floating world), which focuses on images of beautiful women. Utamaro portrayed women of all ages and social classes in a realistic style. The artist's most successful collaboration with his publisher Tsutaya Juzaburo (1750–97) was a series of *okubi-e* (large head pictures). These deployed a new format of portrait depicting the upper half of a woman's body and paying special attention to facial characteristics. Utamaro's keen observation of women, often in private moments, captured personality and mood as well as physical appearance. *Coquettish Type* comes from the series titled *Ten Studies in Female Physiognomy*. It shows a dishevelled woman having just emerged from her bath. The Japanese title of the study identifies her as *uwaki*, a word that suggests fickleness and flirtatiousness. Her coquettish pose, slightly open mouth and the disarray of her clothing and hairpins underline the suggestion of flirtatiousness. **MA**

FOCAL POINTS

1 CARTOUCHE WITH SEALS

The inscriptions in the cartouche include the title of the series, *Ten Studies in Female Physiognomy*, on the right, and Utamaro's signature on the left. From 1790, the ruling shogunate declared that all *ukiyo-e* had to be inspected and stamped with a seal, and below the artist's name is a circular seal indicating official approval. Beneath is another seal in the shape of an ivy leaf under Mount Fuji. It is the logo of publisher Tsutaya, whose name means 'Ivy Shop'.

2 MICA BACKGROUND

Publishers looked constantly for new techniques to help boost sales. The print's background is embellished with mica dust to create a white metallic sheen that shines and sparkles. Utamaro was one of the first artists to use the expensive material for an entire background.

3 HAIR STYLE

The expertise of the block engraver and printer is as important as that of the artist, and their skill is visible in the fine details of the woman's hairstyle. Utamaro implies that she is fancy-free and shows her hair in disarray with pins, combs and strands of hair sticking out.

4 KOSODE

Utamaro pays great attention to textile patterns, using subtle colour combinations to create a decorative effect. He was particularly adept at using the patterns of fabrics to suggest the sensuous contours of the female form. Here Utamaro uses the folds of the garment to emphasize her coquettishness; the woman's *kosode* (a loose, straight-seamed garment that was the precursor to the modern kimono) also falls off her shoulder, revealing her breast.

ARTIST PROFILE

c. 1753–81

Utamaro was born Kitagawa Ichitaro, but later changed his name according to the custom at that time. The date and place of his birth are unknown, although it is thought he was born in Yoshiwara, the pleasure quarter of Edo (now Tokyo).

1782–91

He was commissioned by the publisher Tsutaya to illustrate luxury editions of *kyoka* (crazy-verse poems). His *Gifts from the Ebb Tide* (1789) became the representative work of the genre.

1792–93

The publication of *Great Love Themes of Classical Poetry* and *Ten Studies in Female Physiognomy* confirmed Utamaro's reputation as a master of *bijin-ga*.

1794–1803

Juzaburo died in 1797 and the loss of his patron left Utamaro without a strong direction and his work declined in quality.

1804–06

Utamaro was arrested for publishing a series of prints relating to a banned biography of a 16th-century military ruler. He was imprisoned briefly and died two years later.

CHINESE ART: QING DYNASTY

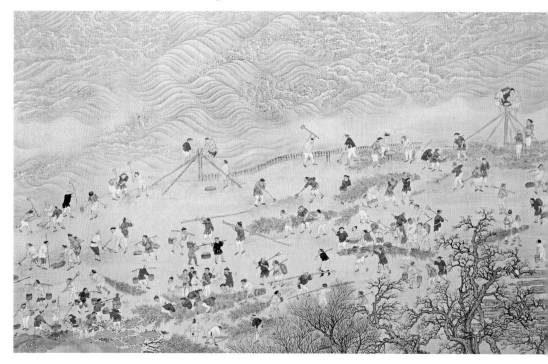

By the early 17th century a confederation of tribes occupying land in Manchuria had become powerful. In 1644, unified by strong leaders, they swept down through the Great Wall, captured Beijing and declared themselves the new rulers of China. The dynasty they founded, the Qing, was to control China until the end of the dynastic era in 1911.

Qing Dynasty emperors brought with them their own Manchu traditions and language but were quick to adopt Chinese culture. During the 18th century they encouraged religious and diplomatic alliances with Tibet and Mongolia, resulting in the construction of many Buddhist temples of the Tibetan school, especially in Beijing. These were filled with exotic images of deities and elaborate sets of ritual implements. A typical artefact is the statue (opposite) of Lobsang Palden Yeshe (1738–80), the Sixth Panchen Lama, whose meeting with the Qianlong Emperor in 1780 (shortly before the Lama's death) was celebrated with the lavish redecoration of temples and creation of new statuary. The statue is decorated with gilded cloisonné enamel, using the ancient technique in which *cloisons*, or compartments, are created by laying metal strips on the object's surface and filling them with coloured enamel paste before firing in a kiln.

KEY EVENTS

1644	1645	1661–1722	1683	1683	1715
The Manchus take Beijing and set up the Qing Dynasty with the six-year-old Shunzhi as the first emperor (r. 1644–61) and Dorgon as regent.	The Manchus force Chinese men to shave their foreheads and wear their hair in a long queue (plait) as a demonstration of their loyalty.	The Kangxi Emperor's reign is seen as a golden age of Qing cultural and economic achievement. Relations improve between the Chinese and Manchus.	The 600-year-old imperial kilns at Jingdezhen, Jiangxi province, are rebuilt and the production of high-quality porcelain is resumed.	Taiwan, which had been under the control of Zheng Chengqong (Koxinga) and Ming refugees, is taken by the Qing Dynasty.	Italian Jesuit painter Giuseppe Castiglione (1688–1766) arrives in Beijing. His art offers a unique blend of European and Chinese technique and themes

Many artists and craftsmen were paid by the court to produce artefacts
for palace use, such as lacquered imperial thrones (see p.242). The Imperial
Household Department controlled workshops both within the Forbidden
City and outside it. Some of the artisans were on permanent duty, such as
those in the imperial glass factory established in 1696 under the direction
of the Bavarian Jesuit Kilian Stumpf. Other workers using materials such as
ivory, jade and precious metals were summoned to the capital for a specific
period of service. Among the crafts pursued in the Beijing workshops was
the curious south Chinese practice of growing gourds inside moulds. The
gourd would take on whatever elaborate form of mould had been designed
for it, and would then be customized with a lining of gold, silver or lacquer
for use as a vessel.

Another workshop in the palace produced paintings for the court. Some
were the work of foreign Jesuits attached to the Forbidden City who employed
techniques novel to Chinese pictorial art, such as vanishing-point perspective.
Other palace paintings were made by Chinese artists, including sets to record
important state events. For example, early in his reign the Kangxi Emperor
(1661–1722) undertook a series of six trips to the southern cultural heartland
of Jiangnan, a region of sustained opposition to the Manchu conquest. The
six southern tours were intended to show the people their new ruler, who
bestowed patronage and gifts on a favoured few. These politically motivated
outings were recorded in a series of paintings including *Emperor Kangxi
Inspecting the Dams of the Yellow River* (opposite) by a team of artists, led by
Wang Hui (1632–1717), that included Yang Jin (1644–1728) and Gu Fang (a. c. 1700).
The appointment of Wang Hui—the epitome of the class of 'scholar painters'
praised by the Ming Emperor Dong Qichang—marked a new combination of
the native 'amateur' tradition and the professional painter at court.

The artist Bada Shanren (1626–1705) embodied opposition to the Manchus
and held a senior rank within the hierarchy of amateurs. A relation of the Ming
imperial family, he retreated to a Buddhist monastery to escape the Qing
conquest. In the 1670s he returned to secular life and practised a unique style
of painting in which bold, enigmatic images and subtly defiant calligraphy were
used to express concerns of the fallen Ming Dynasty's still-faithful subjects.
Outside the circles of imperial and scholarly life, theatre, music, prints, books
and the decorative arts were well patronized. In the case of jade carving,
supplies of nephrite rock were augmented in the 18th century by the
importation of jadeite from Burma. Jadeite is typically a bright emerald green,
which sometimes occurs mixed with white in the same stone. By the 19th
century, jade carvers at Guangzhou (Canton) worked almost entirely with
imported green jadeite, while those in Beijing, Suzhou and Shanghai confined
themselves chiefly to white. Jadeite continues to be the most highly valued
stone for jewellery today, particularly in the south and in Hong Kong. **RK**

1 *Emperor Kangxi Inspecting the Dams
of the Yellow River* (c. 1689)
 Wang Hui, Yang Jin, Gu Fang
 ink and colour on silk scroll
 26 3/4 x 61 3/8 in. / 68 x 156 cm
 Musée Guimet, Paris, France

2 Statue of the Sixth Panchen Lama (c. 1780)
 Artist unknown • gilded cloisonné enamel
 26 in. / 66 cm high
 The Field Museum, Chicago, USA

1793	1840	1851–66	1894	1900	1911
The Qianlong Emperor (1735–95) receives diplomatic mission led by Lord Macartney, but declines to enter into trading relations with Britain.	The Opium War begins after the Daoguang Emperor (r. 1821–50) attempts to stop opium trafficking by the British East India Company.	The violent Taiping Rebellion among the peasantry is led by Christian convert Hong Xiuquan, who claims to be the brother of Jesus.	The First Sino-Japanese War leads to China's defeat and its loss of Taiwan and Korea.	An army from Japan, the United States and European countries enters Beijing to quell the Boxer Rebellion against the West's presence in China.	A nationalist force led by revolutionary Sun Yat-sen (1866–1925) expels Pu Yi, the Qing child emperor, and ends the rule of the Qing Dynasty.

Qing Dynasty Imperial Throne 1775 – 80
ARTIST UNKNOWN

carved polychrome lacquer on wood base
47 x 49 $^5/_8$ x 36 in. / 119.5 x 126 x 91.5 cm
Victoria & Albert Museum, London, UK

The Chinese imperial workshops supplied luxury items in many media to be used either by the court or as gifts for the emperor to bestow as marks of his favour. One of the most renowned palace workshops was the 'Orchard Factory', situated north-west of the Forbidden Palace in Beijing and first established in the 15th century to manufacture the finest carved lacquer artefacts. Lacquer derives from the sap of a tree, *Toxicodendron vernicifluum*, that grows in the warm southern regions of China, Korea and Japan. Coloured pigments such as cinnabar (red mercuric sulphide) or lamp black were added to colour the lacquer, and it was then applied in thin layers to a wooden or silk substratum; the protective lacquer was then polished to give an attractive sheen. By the Qing Dynasty period imperial carved lacquer was produced not only in Beijing but also in southern cities, such as Yangzhou, Suzhou and Nanjing, that specialized in the work.

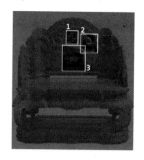

The Qing emperors did not use a single throne but had several that were distributed among many palaces throughout China. This elaborate carved lacquer throne came from one of the 'Travelling Palaces' in the Southern Park, a large area 6 miles (10 km) to the south of Beijing that was used by the Qing emperors for troop reviews and hunting. Lacquer was applied to the throne for several months in order to achieve a thickness deep enough to carve in high relief and reveal varicoloured layers. The skill of both the lacquerers and the carvers is evident in the intricate decorative carving that covers the throne. **RK**

◉ FOCAL POINTS

1 IMPERIAL DRAGON

The decoration of this throne marks it out as an imperial object. The dragon depicted facing forward in the centre was permitted only for imperial use. Elsewhere, five-clawed dragons among clouds symbolize the emperor, and dragons pursuing flaming pearls denote infinite wisdom.

2 *BAOXIANG* FLOWERS

Raised bands of decoration bear the design of a composite flower called *baoxiang* that combines features of the peony, lotus, chrysanthemum, pomegranate and other flowers. *Baoxiang* flowers represent nobility and beauty, and appear on decorative imperial objects in all media.

3 TRIBUTE BEARERS

This panel depicts foreign tribute bearers bringing treasures from afar to demonstrate their allegiance to the emperor of China. The elephant bearing a vase on its back is not only a deliberately exotic motif but also forms a rebus, or visual pun, meaning 'auguries of great peace'.

IMPERIAL CLOCKS

Not all the artefacts produced by the 18th-century imperial workshops in Beijing and elsewhere in China had their origins in traditional Chinese manufacture. Clockmaking in China began in the Ming Dynasty period, when European clocks were first copied by the imperial workshops. In 1732 the third Qing emperor, Yongzheng (r.1722–35), set up the Qing Palace Clockmaking Factory, which specialized in chiming and musical clocks. Yongzheng's successor, Qianlong (r.1735–96), was a passionate protector of the cultural heritage of China but he also collected European clocks, which he caused to be duplicated by the imperial workshops. The example below, made in China in 1790 from brass and wood, is an astronomical clock that, in addition to telling the time, incorporates circles of engraved brass on the dial that give the positions of the celestial bodies relative to Earth. Imperial clockmaking laid the foundations of a new industry in Suzhou, on the Yangtze River in Jiangsu Province. By the end of the Qing Dynasty period, in 1911, the designs of Suzhou clocks had become much more Chinese than European in character.

INDIGENOUS ART OF OCEANIA

The term 'Oceanic art' refers to the works created by the indigenous people of the Pacific Islands, commonly separated into regions known as Melanesia, Polynesia and Micronesia. The art history of Oceania begins, at the latest, 3,000 years ago, with prehistoric ceramics from the Lapita tradition from New Caledonia, the Santa Cruz Islands and the Fiji Islands. Before the 19th century a small number of artefacts were collected by visiting Europeans, who regarded these objects as ethnographical documents or curios. Their artistic value became evident in Europe at the turn of the 20th century. At their places of origin, however, skilful techniques of body ornamentation, tattooing, dance and other performance, and architecture were often more important to the local audiences or producers than the objects. Artworks continued to be created, and collected by Europeans, throughout the 19th century in a rapidly changing environment in which creativity increased and individual master artists gained prominence.

Across Oceania there are several key groups of artistic interest. During the 18th and 19th centuries in Polynesia, carvings were characterized by ornate features and supernatural subject matter, and painted and unpainted bark cloth was used in great quantity. The Te Hau-ki-Turanga meeting house (above), originally constructed in Orakaiapu Pa, Manutuke, Aotearoa (New Zealand), was built by Raharuhi Rukupo as a memorial to his brother and is the oldest dated meeting house that still survives as an ensemble. It is said to embody the spirit

KEY EVENTS

1600 BC	500 BC	AD 300	1000	1100	1200
The Lapita culture develops in the Bismarck Archipelago; it spreads to New Caledonia, Fiji and Tonga by 1000 BC.	Polynesian culture develops in Fiji, Tonga and Samoa, expanding to Tahiti by 200 BC.	Polynesians from Tahiti settle Rapa Nui (Easter Island) and reach Hawaii in about AD 400.	Polynesians from Tahiti settle in Aotearoa (New Zealand).	The first *moai*, or massive stone heads, commemorating ancestors are erected in Rapa Nui.	Work begins on Nan Madol, a city built on a group of artificial islands on the Micronesian island of Pohnpei. It flourishes into the 19th century.

that drove Rukupo to complete the building and is one of the finest examples of carving from the Turanga school; the elaborate figures that line the walls are ancestors. The Maori tribes of Aotearoa also carved small weapons and jewellery from nephrite. The precious stone was much treasured and items such as *hei-tiki* pendants were handed down through generations as valuable heirlooms. Sculptures in wood, bone or stone from the Marquesas Islands can be identified by the distinctive use of the *tiki* (figure) motif. In Hawaii god figures (right, below) were made from wood, sometimes with feathered heads and feathered capes. There are also the huge figures of Rapa Nui (Easter Island) carved from stone and their delicately carved counterparts of small dimensions made from wood.

Within the Melanesian arc, five large art areas can be identified: Coastal and Lowland New Guinea, with such centres as the Papuan Gulf, the Sepik River and the Lake Sentani area; the Bismarck Archipelago with the Admiralty Islands, New Ireland and New Britain; the Solomon Islands; Vanuatu (formerly the New Hebrides); and New Caledonia, with the adjacent Loyalty Islands. Artistic skills were employed to produce objects in daily use, such as cups and containers, as well as to craft others made for ritual and ceremonial use, such as standing figures announcing ancestral prestige. Sculptures were made in a vast array of materials, techniques and shapes and local artists had diverse approaches to questions of form, function and meaning. Elaborate mask costumes may be considered as semi-soft sculptures in which plant fibres, including painted bark cloth, served to cover a stiffened support, while bird feathers, coloured leaves and shells added attraction and vibrancy. Masks vary between human-like personalities and imaginative creations, impersonating non-human spirits. The most spectacular types are from the Middle Sepik River area of New Guinea. Flute masks (opposite, below), made by over-modelling a firm support, were used in ceremonial houses; they added faces to sacred flutes, which were not to be seen or touched by the uninitiated, including women and children.

In wooden sculptures the motif of the human figure is often combined with that of local animals such as the cassowary, crocodile, hornbill, cockatoo, snake, flying fox or pig, or even with plants such as a palm tree or a banana. Figuration, though, rarely strives for a likeness; it rather tends to create a vision of a spirit being. Numerous carving types belong to locally distinct styles and show a broad spectrum of artists' renderings of spirit beings or mighty ancestors for ceremonial occasions. By inserting shells as eyes or by over-modelling with clay or by painting, such sculptural forms are often enhanced. Not only do they attract the eye, but they also have their own gaze.

From Micronesia, only a few types of works became widely known, such as the *tino aitu* figures collected on Nukuoro Atoll (in the Caroline Islands). There are carvings from the ceremonial houses (*bai*) on the islands of Palau (Belau), and wooden masks from Mortlock Island (part of Chuuk). A few outstanding textiles rival their counterparts from Island Southeast Asia. **ChK**

1 **Flute mask from the Lower Sepik River region, Papua New Guinea (19th century)**
Artist unknown • plant fibre, shell, human hair, cassowary feathers and bone
18 ³⁄₄ x 5 ¹⁄₈ x 5 ¹⁄₈ in. / 47.5 x 13 x 13 cm
Musée du Quai Branly, Paris, France

2 **Te Hau-ki-Turanga meeting house (1842)**
Raharuhi Rukupo (Ngati Kaipoho tribe)
wood and reed
Museum of New Zealand Te Papa
Tongarewa, Wellington, New Zealand

3 **Ki'i 'aumakua figure (early 18th century)**
Artist unknown • wood, hair and bark
16 ¹⁄₈ in. / 41 cm high
British Museum, London, UK

Reliquary Figure
18th century
ARTIST(S) UNKNOWN

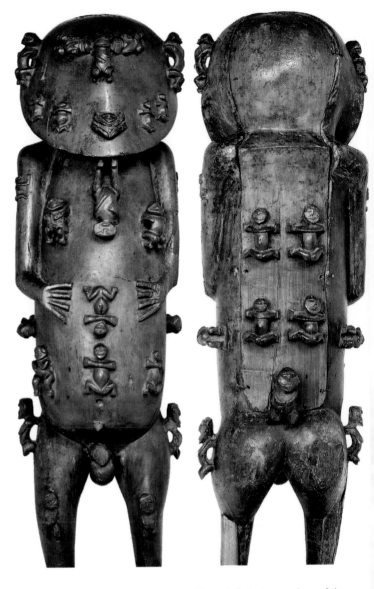

hardwood
46 in. / 117 cm high
British Museum, London, UK

⚙ NAVIGATOR

This sculpture was given, among other artefacts, to members of the London Missionary Society (LMS) in 1821 by a group of Christian converts from the island of Rurutu in the Austral Islands in the south-eastern Pacific Ocean. No information about the original function of this sculpture survives but missionary sources refer to the figure as Aa (best transcribed with a glottal stop as A'a), the national god of Rurutu and the 'ancestor by whom the island was peopled'. This identification cannot be verified, but the head, body and detachable panel are carefully hollowed to fit a skull and long bones, so it is probable that the figure is a reliquary for the remains of a revered ancestor. Although bone relics were not present when the sculpture was handed over to the LMS, reliquaries are known from elsewhere in Polynesia, including Hawaii and New Zealand.

Originally the figure would have been wrapped in decorated bark cloth and would have undergone periodic rites of reconsecration involving unwrapping and rewrapping. In the 20th century the sculpture was much admired, even idolized, by artists such as Pablo Picasso and Henry Moore. **PSH**

⊙ FOCAL POINTS

1 HEAD

The features of the face are composed of small figures carved in high relief. Polynesian artists were highly skilled but the naturalistic representation of the human figure was not a primary concern; instead their task appears to have been to evoke embodiments of divine ancestors.

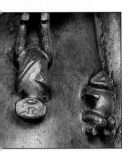

2 CARVED FIGURES

The significance of the small figures carved on the sculpture is not known. They are of two types: sixteen are upright with arms to abdomen and fourteen are splayed with arms and legs outstretched. The former may be male and the latter female; they may refer to descendants of the founding ancestor.

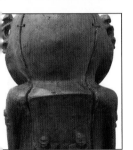

3 DETACHABLE PANEL

The detachable panel follows the contours of the back, neck and cranium and is carefully hollowed at the back of the head. The entire sculpture was made with adzes, chisels and burins of stone, shell and shark teeth, and the deep excavations would have been a laborious process.

4 SMALL FIGURES ON THE BACK

Fifteen figures are carved with arched backs that serve as lugs. They were probably used for the attachment of ritual bindings, possibly feathered cords that would have played a key role in the periodic refurbishment of the relics and reliquary. They do not fix the panel; six pairs of holes serve this purpose.

5 DAMAGED GENITALS

The figure has been emasculated, almost certainly by the LMS. The triangular-shaped break below the navel indicates that the penis was erect and may have taken the form of a figure. The entire sculpture's phallic form expresses the generative potency of the divine ancestor.

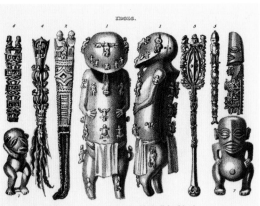

▲ An engraving of important religious items acquired by the London Missionary Society from Polynesia, including two views of the Rurutu reliquary with a modest loincloth. Published by LMS missionary William Ellis in 1829.

POLYNESIAN SCULPTORS AND ICONOCLASM

The makers of images and other ritual paraphernalia in pre-Christian Polynesia were experts in transforming raw materials into cultural objects. They also built large, double-hulled canoes that enabled them to conduct long voyages of exploration and settlement. Their skill is all the more remarkable because, until the arrival of European voyagers in the second half of the 18th century, the Polynesians did not have metal tools; instead they worked predominantly with stone-bladed adzes (below). The wood carvers of Rurutu were well known not only in the Austral Islands but also in neighbouring places such as Tahiti. Complete images, including the reliquary from Rurutu, originally combined men's wood-carving skills with wrappings made of painted bark cloth, which were the product of women's skilled labour. Image-making for religious purposes ceased in the first half of the 19th century once local Polynesian populations converted to Christianity. As proof of their conversion, many images were destroyed or offered to the missionaries, who either destroyed them or preserved them as trophies for missionary museums. Few images survived this iconoclasm and those that did were usually stripped of their wrappings—a known method of deconsecration.

Malagan Carving

c. 1900

ARTIST UNKNOWN

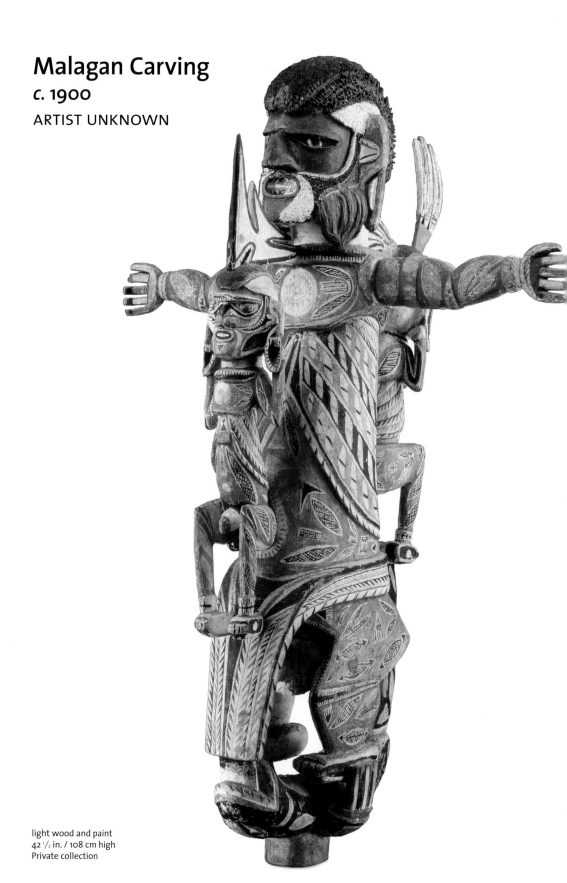

light wood and paint
42 ½ in. / 108 cm high
Private collection

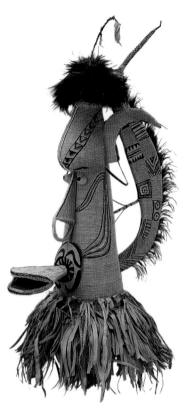

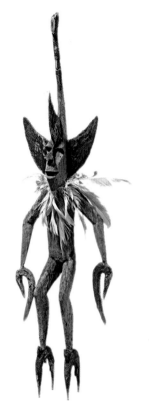

SULKA MASK

On the body of this mask from New Britain strips of pith are mounted, painted and decorated with pandanus leaves and feathers. Sulka masks are used to embody the presence of ancestors and are revealed only briefly to overwhelm the audience. Once used, the masks are destroyed.

SEA SPIRIT

In this figure, created before 1865, an artist from San Cristobal Island (Makira) combined the traits of fish and humans in one body. Sea spirits are often malignant towards human beings. This spirit, however, gave proof of his benevolence by herding bonito fish towards fishermen.

TREE FERN FIGURE

In northern Vanuatu, elongated figures are carved from the densely packed aerial roots of tree ferns. They announce an individual's status in the social hierarchy. Status was increased by giving pigs with rounded tusks to people of high rank, or by sacrificing the pigs to ancestors.

M alagan art (pronounced 'málánggan') from northern New Ireland, part of the Bismarck Archipelago, is a highlight of Melanesian art. The term 'malagan' refers not only to complex ceremonies that were held to commemorate deceased members of local matrilineal clans but also to the carvings that were made for these occasions according to clan-owned concepts. Malagan carvings were commissioned (an exception in Melanesia) from respected artists and traditionally they were destroyed at the conclusion of the ceremony. For each carving, the artist tries to combine specific motifs relating to the origins of life, achievement and death. By recreating in an idealized form the social network of the remembered person, each image helps to free the living community from the impact of an individual death.

Created around 1900, this work figures in André Breton's original version of *L'Art magique* (1957). Such carvings were cut in a light wood, often to be combined with a separate lower figure. Arms or additional figures were often inserted or added—another malagan peculiarity—with mortise-and-tenon joints used to attach the protruding forms. This created an outward-oriented and dynamic sculpture (see opposite). At the core of this piece, a central upright body with a bony thorax evokes calm control over life forces. The painting of the body is executed with intricate lines and strong colours and induces the idea of transparent skin. The surface designs represent fish and birds. **ChK**

KANAK DOOR JAMB

This door jamb from New Caledonia symbolizes the head and wrapped body of a former chief. Preserving the presence of a mighty ancestor, it impresses visitors.

ROCOCO

1 *Shepherd Piping to a Shepherdess* (c. 1747–50)
François Boucher • oil on canvas
37 x 55 ⅞ in. / 94 x 142 cm
Wallace Collection, London, UK

2 *Cupid* (1758)
Etienne-Maurice Falconet • porcelain
12 in. / 30.5 cm high
Victoria & Albert Museum, London, UK

3 *Young Woman with a Macaw* (c. 1760)
Giambattista Tiepolo • oil on canvas
27 ½ x 20 ½ in. / 70 x 52 cm
Ashmolean Museum, Oxford, UK

The light-hearted, decorative style of Rococo flourished throughout Europe for much of the 18th century. It emerged in France at the turn of the century and remained popular until the 1770s, when it gradually gave way to Neoclassicism (see p. 260). At its peak, Rococo achieved an irresistible blend of elegance, charm, wit and playful eroticism.

The term 'Rococo' was originally meant as a mocking jibe. It is said to have been coined by a student of Jacques-Louis David (1748–1825) in the 1790s, when the reputation of the style was at its lowest ebb. The word itself was a humorous fusion of *rocaille*, a fancy style of rock decoration used in fountains, and *barocco*, the Italian source word for Baroque (see p.212). For contemporaries, these origins suggested that the style was a trivial or comical debasement of the latter, but the term has since lost any pejorative overtones.

The Rococo style was a development from and a reaction to the Baroque. Its artists worked for the same kind of patrons and treated similar themes; however, they stripped away the excessive pomp and grandeur associated with Baroque art. In France Rococo was shaped by three artists, Jean-Antoine Watteau (1684–1721), François Boucher (1703–70) and Jean-Honoré Fragonard (1732–1806), whereas in Italy the movement was mainly associated with the frescoes of Giambattista Tiepolo (1696–1770). In Germany, Austria and Britain, the Rococo spirit found its greatest expression in architecture and the decorative arts.

KEY EVENTS

1712	1715	1728	1742	1744	1745
Watteau becomes a member of the Royal Academy in Paris.	The death of King Louis XIV (1638–1715) leads to a new, more frivolous style of French art culminating in the peak of the Rococo movement.	Boucher leaves his native France to study in Italy, where he is particularly influenced by the art he encounters in Venice.	German Philip Mercier (1689–1760) returns to his home in London after travelling in Italy and France. He sells pictures acquired on his trip, introducing Rococo to Britain.	Jean-Baptiste Pigalle (1714–85) sculpts *Mercury Attaching His Wings* for his admission to the French Royal Academy.	King Louis XV (1710–74) meets Madame de Pompadour, who soon becomes his lover and one of Rococo's most important patrons.

The painters used a number of recurrent themes and Rococo artists were particularly fond of theatrical effects. The figures in their pictures were often shown in some form of fancy dress and there was an air of fantasy about the proceedings. In the case of Watteau, the inspiration for his paintings of *fêtes galantes* (idyllic outdoor amusements of the idle rich), such as *Pilgrimage to Cythera* (1717; see p. 252), came from contemporary plays and the improvised antics of the Italian Comedy. However, the artist was careful to conceal his sources, so that his costumed lovers genuinely appeared to be playing their flirtatious games in some enchanted setting.

In a similar vein, Tiepolo's compositions have often been compared with productions of grand opera. In his frescoes at Udine in Italy a curtain is drawn back to reveal certain scenes, creating the impression that the spectator is watching a performance on a stage. Tiepolo liked portraying his figures in exotic attire. His *Young Woman with a Macaw* (below right) is a portrait for Elizabeth Petrovna, Empress of Russia. It was probably intended as a fancy picture and the model may have been one of the artist's daughters. The parrot symbolizes the exotic and luxurious, as well as the subject's moral laxity.

In France, Boucher achieved success with another type of charade: pastoral scenes such as *Shepherd Piping to a Shepherdess* (opposite) in which the countryside is transformed into a rural idyll where shepherds can ignore their work and frolic with their lovers in sunlit meadows. Boucher often drew his inspiration from the pantomimes of Charles-Simon Favart. The romantic alliance of Boucher's shepherds was symptomatic of the Rococo obsession with love. After the weighty allegories and histories of the Baroque, this interest proved a welcome relief for the aristocratic patrons of the period. The amorous subject matter took many forms. Tiepolo translated it into high drama and frequently returned to the story of *Antony and Cleopatra* (1745). For Watteau and Fragonard, it was often an elaborate game, as is evident in Fragonard's *The Swing* (1767; see p.254) in which the theme of infidelity is portrayed as a harmless incident, with no moral or emotional consequences.

The lack of serious content was one of the chief criticisms levelled against Rococo art, inevitably so given that the work was decorative in style. Watteau and Boucher worked in various media, and Boucher held posts at the Gobelins tapestry factory and the Sèvres porcelain works. His designs needed to be relatively simple so that they could readily be adapted for paintings, book illustrations, tapestries, theatrical backdrops, decorative screens and porcelain figures or snuffboxes. Rococo sculpture often found its expression in delicate porcelain pieces used to decorate interiors, rather than in marble. The porcelain figure *Cupid* (right, above) by Etienne-Maurice Falconet (1716–91) reflects the Rococo preoccupation with romantic, and often illicit, love. Modelled in 1758, in soft-paste biscuit porcelain, the figure was based on Falconet's sculpture of the subject in marble, exhibited a year earlier. **IZ**

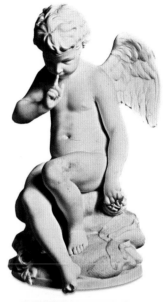

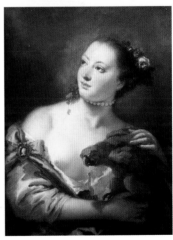

1751	1752	1753	1765	1782	1789
Boucher paints the scandalously erotic *Mademoiselle O'Murphy*, a nude of a fourteen-year-old girl who later becomes Louis XV's mistress.	Fragonard is awarded the Prix de Rome.	In *Analysis of Beauty* English artist William Hogarth (1697–1764) argues that the undulating lines and S-curves of Rococo are the basis of beauty.	Louis XV appoints Boucher as First Painter of the King.	English painter Thomas Gainsborough (1727–88) exhibits a truly Rococo portrait, of the popular Italian ballet dancer Giovanna Baccelli.	The start of the French Revolution marks the end of the aristocracy and hence, art patrons. Rococo is unfavourably associated with the *ancien régime*.

Pilgrimage to Cythera 1717

JEAN-ANTOINE WATTEAU 1684 – 1721

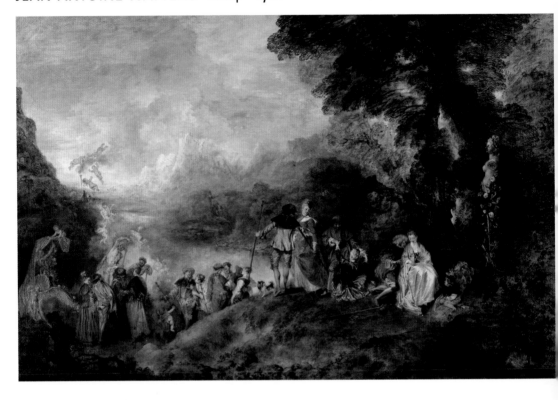

oil on canvas
50 ³/₄ x 76 ³/₈ in. / 129 x 194 cm
Louvre, Paris, France

Jean-Antoine Watteau's most famous painting is the definitive example of a *fête galante*, as well as a major landmark in the development of the Rococo style. A *fête galante* painting depicts a romantic idyll, in which costumed figures amuse themselves in an attractive outdoor setting. They flirt, listen to music and saunter amorously around beautiful parklands. The idea had its origins in symbolic, medieval depictions of the mythical garden of love. This theme was modified over the centuries, most notably by Sir Peter Paul Rubens (1577–1640), but Watteau made the subject his own. He removed the symbolic element from his *fête galante* pieces, replacing it with an air of theatrical fantasy. He also drew inspiration from plays, generally avoiding specific references, in order to give his pictures a timeless and universal appeal.

Pilgrimage to Cythera depicts a group of elegant young people who have voyaged to an island associated with Aphrodite, the goddess of love. They are shown after visiting Cythera's shrine and are ready to begin their return journey. One hypothesis is that the idea for the painting came from a comedy, *The Three Cousins* (1700) by French dramatist Florent Dancourt. The play features a scene in which village youths, dressed as pilgrims, travel to a temple of love on Cythera. The painting was Watteau's reception piece for the Royal Academy of Painting and Sculpture in Paris, and he eventually delivered it in 1717. It was usual for the Academy to choose the subject matter for such pieces, but Watteau was allowed to select his own. The painting's qualities were admired at the time, but the work fell out of favour after the French Revolution in 1789 because it epitomized the indolent lifestyle of the old aristocracy. Neoclassicist (see p.260) painter Jacques-Louis David and his pupils are even said to have thrown bread pellets at it. **IZ**

✦ NAVIGATOR

FOCAL POINTS

1 WOMAN GAZING

The woman in the centre of the painting is giving a wistful, backward glance. She appears reluctant to leave the magical isle and gazes back ruefully, apparently all too aware of the fleeting nature of love. Scholars have debated whether the couples are embarking for Cythera or returning from it, and most prefer the latter argument. The couples have paired off, and the autumnal colouring and approaching sunset suggest that their outing is drawing to a close.

2 STATUE OF APHRODITE

Cythera is the Greek island of Kythira in the Peloponnese. It is associated with the goddess Aphrodite. According to one legend, she was born on the foaming surface of the sea and then drifted ashore on a scallop shell, landing on the island. The title of the painting is thus synonymous with 'Pilgrimage to the Island of Love'. The statue is dedicated to Aphrodite and is adorned with her attributes: the garlands of roses and the quiver of arrows used by her son Eros.

3 SEATED COUPLE

The painting is an essay on the stages of love. Some of the couples appear bashful; others are confident. The pair most in love are closest to the statue of Aphrodite. They are so enamoured that they fail to notice their companions leave, even though a costumed cherub tugs at the lady's skirt.

4 PILGRIMS

Watteau portrays the lovers as pilgrims engaged on a quest for love. Many of the men carry a staff and wear the plain, broad-brimmed hat associated with pilgrims. The pairs of lovers are absorbed in each other's company as the pilgrims guide their maidens towards the ship.

ARTIST PROFILE

1684–1701

Watteau was born in the French town of Valenciennes. He became an apprentice in the workshop of a local painter.

1702–09

The artist went to Paris and was employed by painter, engraver and theatrical designer Claude Gillot (1673–1722) before entering the workshop of the decorative artist Claude Audran III (1658–1734), who was then the curator of the Luxembourg Palace. Watteau benefited enormously from studying its numerous artworks. When he failed to win the Prix de Rome, he retreated briefly to Valenciennes.

1710–18

Watteau returned to Paris, where he established his reputation. In 1712, he was granted associate membership of the Royal Academy, although it took him five years to deliver his reception piece *Pilgrimage to Cythera*. He honed the style of his *fêtes galantes* and won the support of a rich financier and art collector Pierre Crozat, who became his patron.

1719–21

Illness clouded his later years and in 1719 Watteau travelled to London to seek medical help. He returned to Paris a year later and executed one of his late masterpieces, *Gersaint's Shopsign*. It displays a dramatic shift in style, but it was all too late: Watteau died of tuberculosis at Nogent-sur-Marne in France.

REPEATED SUCCESS

Such was the success of *Pilgrimage to Cythera* that Watteau painted a second version (below) a year later, at the request of his friend Jean de Julienne, director of the prestigious Manufacture des Gobelins tapestry factory. The second version currently hangs in the Charlottenburg Palace in Berlin. There are numerous differences between the two versions, all of which serve to heighten the atmosphere of amorous frivolity. Watteau included additional putti in the later painting, some in areas where previously there were none. He made the ship more prominent, giving it diaphanous pink sails that help to establish a warmer palette than in the original painting. The statue of Aphrodite, an obscure detail in the original, is highlighted and has become animated, interacting with cherubs that play at her feet.

The Swing 1767
JEAN-HONORÉ FRAGONARD 1732 – 1806

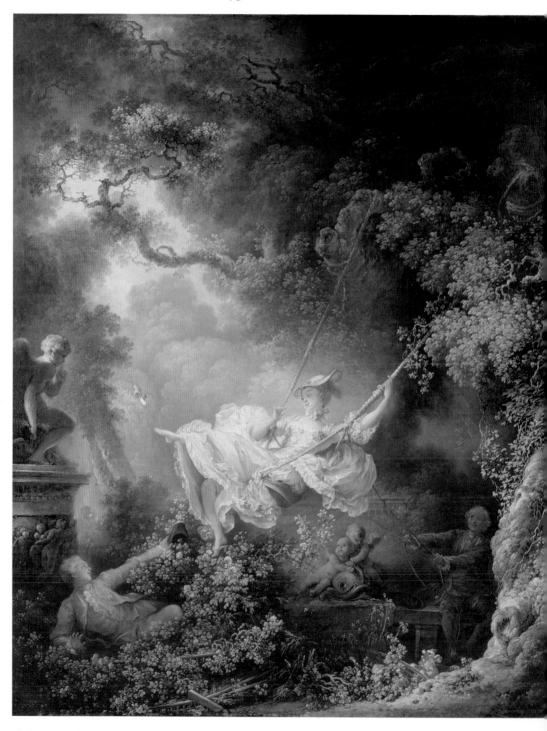

oil on canvas
31 7/8 x 25 1/4 in. / 81 x 64 cm
Wallace Collection, London, UK

This delightful scene was painted early in the career of Jean-Honoré Fragonard when he had recently become a member of the Academy and his work was garnering high praise at the Salon. An unidentified courtier approached him discreetly with a proposal for a commission. The young man wanted a portrait of himself with his mistress. He was to be shown as her secret lover, concealed in dense shrubbery, while a bishop pushed the lady on her swing. Fragonard baulked at the anti-clerical element, fearing that it might jeopardize his career, and persuaded his patron to replace the bishop with a cuckolded husband.

At first glance, this amorous encounter appears to be taking place in a wild, forest glade. However, the garden implements, the statuary and the architectural details behind the woman make it clear that the intended setting is a lavish, private estate. The lush surroundings are reminiscent of the gardens of the Villa d'Este at Tivoli in Italy, where the artist spent the summer of 1760. This type of erotic picture was designed for private display and such works fell out of favour after the French Revolution in 1789. Its first known owner, Ménage de Pressigny, was guillotined in 1794 and the painting was confiscated by the authorities. Even as late as 1859, the Louvre declined the offer of the painting and it was eventually purchased by an English collector. The work was not exhibited publicly until 1860. **IZ**

👁 FOCAL POINTS

1 STATUE OF CUPID
Fragonard liked to use statues as witty accessories and arrange them to participate in the action. The cupid is a traditional symbol of love and highly appropriate for an amorous scene. Here it acts as a silent accomplice, raising a finger to its lips to underline the secrecy of the lovers' meeting.

2 WOMAN'S SHOE
Rococo artists revelled in eroticism. The dainty pink shoe that flies through the air epitomizes the flirtatious mood of the picture. In earlier morality paintings, a missing slipper was used to suggest a woman's loss of virginity. Also the girl kicks up her skirts to give her lover a glimpse of her thighs.

3 WOMAN SWINGING
Paintings of young women on swings were popular during the Rococo era. The swing represents inconstancy and is an ideal vehicle to portray marital infidelity. The husband appears to control it with two long ropes, but in reality he would never have been able to propel the impractical swing successfully.

4 SMALL DOG
Almost hidden at the foot of the picture is an animated little dog, watching the proceedings. Its presence is ironic because dogs were often included in double portraits as symbols of marital fidelity. It jumps up and yaps, as if to raise the alarm about the illicit relationship, but none of the participants take notice.

🕓 ARTIST PROFILE

1732–51
Fragonard was born in Grasse in Provence, France. His family moved to Paris where he trained as a lawyer's clerk before finding his true vocation. He studied art under Jean-Baptiste Chardin and François Boucher, whose warm, sensual approach had a lasting impact on his style.

1752–60
Fragonard won the Prix de Rome and continued his studies in Italy. He spent the summer of 1760 sketching in Tivoli.

1761–79
The artist returned to Paris and became a member of the Academy in 1765, winning prestigious commissions. After 1767 he ceased to exhibit at the Salon and dealt directly with private patrons. *The Swing* set the benchmark for his style and he was frequently employed by Madame du Barry, one of King Louis XV's mistresses.

1780–1806
With the emergence of Neoclassicism (see p.260), Fragonard's art fell out of fashion. Jacques-Louis David found him a post at the Louvre, but Fragonard died in obscurity.

GRAND TOUR ARTISTS

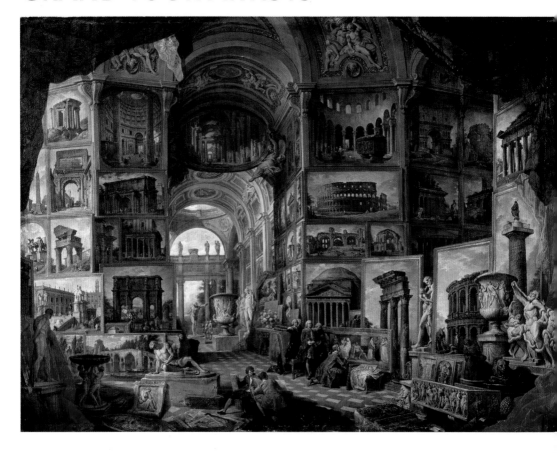

The term 'Grand Tour' was first mentioned in print in Richard Lassels's *The Voyage of Italy* (1670) and refers to the European trip taken by young, mainly British aristocrats as part of their classical education. It was a custom that influenced many artists and writers of the period. Although many of these wealthy travellers would have attended university before their journey, the reputation of English universities had declined and there were few facilities for the study of modern languages. In 1776, after his own Grand Tour, Scottish economist and philosopher Adam Smith declared that it was the poor state of the universities that had led to the Grand Tour becoming a key part of an upper-class education.

Usually accompanied by a tutor known as a 'bear-leader', these early tourists followed prescribed routes. One route made its first stop in Paris, where the Englishmen adopted a Parisian style of dress and took lessons in fencing,

1718	1726	1735	1748	1757	1768
Thomas Coke returns to England after a six-year Grand Tour; he commissions a Palladian-style mansion at his family estate in Holkham, Norfolk.	The 3rd Duke of Beaufort commissions a Florentine workshop to make the 'Badminton Cabinet'. It takes thirty craftsmen five years to create it.	Canaletto paints *Venice: A Regatta on the Grand Canal*, epitomizing the English perception of the city.	An archaeological dig begins at the ancient site of the buried town of Pompeii; it proves an important inspiration for many great artists and architects.	Panini paints *Ancient Rome* and *Modern Rome* for the French collector, Count de Stainville, ambassador to Rome.	The Royal Academy is founded in London. Its president, Sir Joshua Reynolds, aims to rival European academies th so impressed him on th Grand Tour.

ancing, riding and French conversation. They were encouraged to seek out the
ne art collections of the Louvre and the Tuileries, visit the impressive libraries
nd Notre-Dame de Paris, and admire the gardens of the Palais Royal and the
alais du Luxembourg. They purchased works of art to ship home, thus fuelling
ne spread of Neoclassical art (see p.260) that was so fashionable at the time.

The Grand Tour made a stop in Turin and sometimes Milan, before heading
or Florence and the most famous gallery in the world during the 18th century:
ne Tribuna in the Uffizi. Designed by Bernardo Buontalenti (c. 1536–1608) in the
te 1580s, the octagonal room was filled with important antiquities and High
enaissance (see p.172) and Bolognese paintings from the Medici collection.
fter Florence, the tourists visited Padua and Bologna en route to Venice, an
nportant stop on the Grand Tour. The rich William Beckford greatly admired
ne Venetian architecture during his visit in 1782 and declared, 'I have no terms
o describe the variety of pillars, of pediments, of mouldings, and cornices,
ome Grecian, others Saracenical, that adorn these edifices, of which the
encil of Canaletti conveys so perfect an idea as to render all verbal description
uperfluous.' He was referring to the artist Giovanni Antonio Canal (1697–1768),
ommonly known as Canaletto, whose *View of Venice with St Mark's* (c. 1735; see
.258) was one of many paintings he made of the important Venetian landmark.

Along with Canaletto, Giovanni Paolo Panini (1691–1765) was a well-known
edutisti, or painter of large, detailed paintings of cities or landscapes. Many of
is works found their way to England, including the large group housed at Woburn
bbey and those bought by King George III for the Royal Collection. Panini
ocused on scenes of Rome and was the first painter to make a special feature
f ruins. His *Interior of an Imaginary Picture Gallery with Views of Ancient Rome*
opposite) depicts a host of venerable Roman sights, many of which would be on
 tourist's itinerary; two young artists sit in the foreground, making copies from
ne works on display. A companion piece showed scenes from modern Rome.

After visiting various churches designed by the architect Andrea Palladio
508–80), such as his domed masterpiece Il Redentore (1576–91), the aristocrats
ontinued south. The climax of the Grand Tour was Rome, where the tourists
xplored the city's classical remains with an antiquary or *cicerone*. Key sites to visit
ncluded the Musei Vaticani, the Colosseo and the Musei Capitolini; equally
nportant was a sitting with a portrait painter. Tourists could commission a
esident British painter, such as Sir Joshua Reynolds (1723–92), who was in Rome
om 1750 to 1752, or a popular Italian artist, such as Pompeo Batoni (1708–87),
/ho painted *Colonel the Hon. William Gordon of Fyvie* (right).

Before heading home, the tourists often made a trip to Naples, Mount
'esuvius and the archaeological excavations of Herculaneum and Pompeii,
/hich began in the 1730s. Items uncovered in these digs had a huge impact
n British taste in pottery and furniture, as seen in the 'Etruscan' pottery of
osiah Wedgwood and Sons and items of furniture by Thomas Sheraton. **ReM**

1 *Interior of an Imaginary Picture Gallery
with Views of Ancient Rome* (1756–57)
Giovanni Paulo Panini • oil on canvas
73 ¹/₄ x 89 ³/₈ in. / 186 x 227 cm
Private collection

2 *Colonel the Hon. William Gordon
of Fyvie* (1766)
Pompeo Batoni • oil on canvas
101 ¹/₂ x 73 ¹/₄ in. / 258 x 186 cm
Fyvie Castle, Scotland, UK

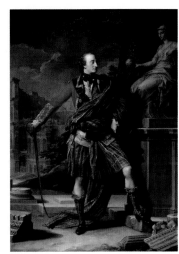

1770s	1787	1792	c. 1800	1810	1824
lount Vesuvius erupts peatedly. Joseph Vright of Derby 734–97) was not in aly during an ruption, yet his aintings of one ecome famous.	Batoni dies; he owned the most prestigious portraiture studio in Rome and built up a lucrative business painting wealthy Grand Tourists.	Robert Adam (1728–92) is buried in Westminster Abbey. He brought the designs of ancient Greece and Rome to numerous British homes.	Giovanni Domenico Tiepolo (1727–1804) continues his drawings of Punchinello, who is a popular character outside Italy, thanks to the Grand Tour.	Johann Zoffany (1733–1810) dies. In the 1770s, he had travelled to Italy and was commissioned to paint Grand Tour scenes for Queen Charlotte.	Art collector Sir William Holburne embarks on a Grand Tour. His art collection is left to the public and becomes the Holburne Museum of Art in Bath, England.

View of Venice with St Mark's *c. 1735*
CANALETTO 1697 – 1768

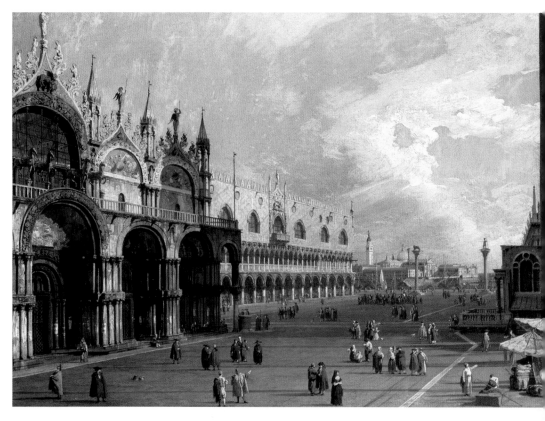

oil on canvas
18 ¹/₈ x 24 ³/₄ in. / 46 x 63 cm
Huntington Art Collection,
San Marino, California, USA

NAVIGATOR

This painting by Giovanni Antonio Canal, also known as Canaletto, exemplifies the artist's strong sense for topographical detail and his talent for composition. Canaletto painted Piazza San Marco many times from different perspectives, along with numerous other accurate but subjective *vedute*, or views, of Venice. Originally in the collection of the Prince of Liechtenstein, Vienna and Vaduz, this sweeping vista of the Basilica di San Marco and the Palazzo Ducale is currently displayed in California alongside *View of Venice with the Salute*, its pendant, or companion piece, of the same date.

Piazza San Marco is the official centre of Venice and has long been a popular meeting place and location for many of the city's festivals and offices of state. The square's architectural content dominates the left side of the painting: the basilica, Venice's Byzantine cathedral, is the building in the foreground and beyond it is the palace, residence of the various doges, with its distinctive white and pale rose-coloured marble. Across the lagoon in the far distance lies the island of San Giorgio Maggiore with its church, which was designed by Andrea Palladio.

The delicate delineation of the architecture and evocative use of the Venetian light lend a light touch to Canaletto's view of the square. Scattered groups of figures help to convey the idea that Venice was a thriving commercial centre. By choosing a view of the square that contained its most significant buildings, the artist ensured that the painting would appeal to the wealthy tourists who were arriving in Venice in droves, cramming crates with paintings and sculptures to take home as souvenirs of their visits. **ReM**

FOCAL POINTS

1 GOLDEN CHURCH

Known as the Chiesa d'Oro (Golden Church) for its opulent Byzantine decoration, the Basilica di San Marco has an exterior boasting five round-arched portals. Canaletto painted the gilded mosaic above the central arch with a combination of bright painterly strokes that contrast with the precise rendering of the architectural structure. Above the arch are the four horses of St Mark, looted from the Hippodrome of Constantinople in 1204.

2 ST MARK'S COLUMN

The painting's powerful perspective draws the viewer's eye towards St Mark's column in the distance. The column is capped by a lion, the saint's evangelistic symbol. To its right is a second column, surmounted by a statue of San Theodore of Amasea, 'Santodaro' to the Venetians. The eye wanders past the columns to focus on the island of San Giorgio Maggiore in the lagoon beyond, a reminder of Venice's watery location and its maritime history.

3 LONG SHADOWS

Canaletto is famed for his use of light. Here, he conveys that it is late afternoon by painting long shadows that stretch across the square. Canaletto's ability to give his paintings a strong sense of place partly explains the attraction of his work for aristocrats as mementos of their Grand Tour.

4 GROUPS OF PEOPLE

The colourful figures peopling Piazza San Marco are not painted in great detail, but they add vibrancy to the scene. Some figures head towards the entrance of the basilica and others simply stand and talk. A man in the central foreground wearing a black hat gazes back towards the viewer.

ARTIST PROFILE

1697–1718

Canaletto was born in Venice, where he trained under his father, a theatrical scene painter.

1719–20

He went to Rome for a year with his father to execute scenery for two operas. While he was there he began to draw and paint architectural views and when he returned to Venice he registered with the Venetian artists' guild.

1721–45

He adopted the diminutive Canaletto (the little canal) by the mid 1720s to distinguish his work from his father's. His earliest datable works are four views of Venice from c. 1725, which are unusual because they were painted on site. Canaletto found that painting small, formulaic, topographical views was lucrative and his scenes of festive life in Venice proved popular with British tourists.

1746–55

Prompted by his success with the Grand Tourists, Canaletto made England his base during this period, quickly finding patrons among the leading members of London society.

1756–68

When he returned to Italy in 1756, Canaletto broadened his subject matter to include views of Rome. His style became grander and increasingly linear to meet his patrons' tastes.

CANALETTO IN ENGLAND

The Austrian War of Succession (1740–48) dissuaded British tourists from travelling to Italy, and in May 1746 the lack of business prompted Canaletto to follow his patrons to England. A number of aristocratic patrons commissioned Canaletto to paint views of London and their estates. Charles Lennox, Duke of Richmond, welcomed him to Richmond House and commissioned him to paint views of St Paul's Cathedral and the new Westminster Bridge. Another patron, Sir Hugh Percy, later the Duke of Northumberland, was one of the main financial backers of the bridge, which prompted him to buy *London, Seen Through an Arch of Westminster Bridge* (1746–47; below). Other commissions included views of the Badminton countryside for Charles Somerset, Duke of Beaufort, such as *Badminton House, Gloucestershire*.

NEOCLASSICISM

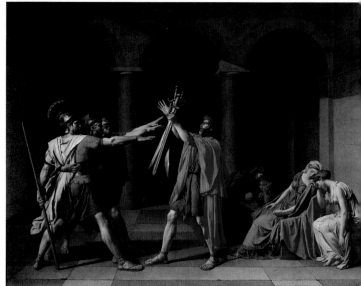

1 *The Oath of the Horatii* (1784)
Jacques-Louis David • oil on canvas
130 x 167 ¼ in. / 330 x 425 cm
Louvre, Paris, France

2 *The Apotheosis of Virgil* (c. 1776)
John Flaxman • jasperware
16 ⅛ in. / 41 cm diameter
Harris Museum, Preston, UK

3 *Napoleon I on the Imperial Throne* (1806)
Jean-Auguste-Dominique Ingres • oil on
canvas • 102 x 63 ¾ in. / 259 x 162 cm
Musée de l'Armée, Paris, France

Neoclassicism was a dominant style in Western art from the late 18th century until around 1830. In its most basic form, the movement aimed to revive the spirit of the great civilizations of ancient Greece and Rome and developed as a reaction against the hedonism and frivolity of the Rococo movement (see p.250). Its initial momentum came not from artists but from *philosophes* (philosophers)—the spokesmen for the Enlightenment in France. Led by men such as Denis Diderot and Voltaire, the *philosophes* railed against the moral laxity of the Rococo style and, by association, the regime that had spawned it. In its place, they demanded art that was rational, moral and high-minded. A revival of the culture of the classical world fitted this bill perfectly.

The seeds for the revival were sown in Rome. Its theoretical basis was provided by Johann Winckelmann, a German scholar who worked for Cardinal Alessandro Albani, a wealthy collector of antiquities. In his books, Winckelmann proclaimed the superiority of Greek art, while also urging painters to 'dip their brush in intellect'. These ideas were embraced by Anton Mengs (1728–79), who was also based in Rome. He produced a ceiling fresco on the subject of Parnassus (1760–61) for Albani's new villa. Although it appears insipid to modern eyes, this painting was hugely influential in promoting Neoclassicism, largely because it was on the most popular route followed by travellers undertaking the Grand Tour (see p.256), and was thus seen by many visitors. Over the course of its development

KEY EVENTS

1748	1740s and 50s	1768	1774	1775	1787
The buried city of Pompeii is discovered, renewing interest in classical antiquity. Later excavations uncover a series of wall paintings.	Giovanni Piranesi (1720–78) establishes his reputation with a series of dramatic *vedute* (views) of Rome. It is completed in 1774.	Angelica Kauffman (1741–1807) is awarded a founding membership of the Royal Academy for her contribution to Neoclassical painting and interior design.	David wins the Prix de Rome and begins his studies at the French Academy in Rome.	Josiah Wedgwood (1730–95) perfects jasperware and employs Flaxman to create a large portion of the designs.	David exhibits his painting *The Death of Socrates* (see p.262) at the Paris Salon; it is critically acclaimed and compared with works by Michelangelo.

across Europe, Neoclassicism took on different characteristics and meaning. In the hands of Jacques-Louis David (1748–1825), it was a grand, heroic movement that was associated with the French Revolution; in the creations of Robert Adam (1728–92) and James Wyatt (1746–1813), it became a fashionable, decorative form of interior design; and later, in the time of Jean-Auguste-Dominique Ingres (1780–1867), it was a mainstay of the art establishment: the voice of authority pitted against the young upstarts of the Romantic movement (see p.266).

The main inspiration for Neoclassicists came from literary and historical sources. One of the chief criticisms of the *philosophes* was that the Rococo vision of the classical world revolved around erotic fantasies of naked goddesses. By contrast, David's paintings focused on heroic figures from the history of Greece or the Roman Republic. His most influential works highlighted the courage and sacrifice of men such as Socrates, Brutus and the Horatii. *The Oath of the Horatii* (opposite) is regarded as the first masterpiece of Neoclassicism. It depicts the Horatii brothers swearing to defeat their enemy (the Curiatii family) or else die for their country. David organized his composition in a frieze-like manner that emphasizes the geometric shapes of the warriors' poses and the Roman architecture. The muted colours and curved lines of the grief-stricken relatives provide a corner of relief from the overall severity of tone. The stern, moral lessons of David's canvases caught the mood of rebellion in France. However, as the revolutionary government disintegrated, giving way to the rise of Napoleon, the spirit of Neoclassicism changed. Artists began to emphasize the splendour of Rome's Empire, rather than the moral fibre of its Republic.

By this stage, Neoclassicism was popular in other branches of the arts. In sculpture, the leading figures were Antonio Canova (1757–1822), Bertel Thorvaldsen (1768/70–1844) and John Flaxman (1755–1826). Canova epitomized the spectacular aspect of the style in his colossal, nude statue of Napoleon (1802–06) and his dramatic version of Hercules and Lichas (1796). Flaxman, by contrast, was notable for his clarity and restraint. Along with his sculptures, he became renowned for the linear perfection of his illustrations and the classic simplicity of the reliefs that he designed for Wedgwood pottery (right, above). Neoclassicism also dominated the decorative arts. In Britain, Adam and Wyatt transformed the interior design of the country house, while in France Pierre Fontaine (1762–1853) and Charles Percier (1764–1838) pioneered the Empire style, which echoed the grandiose pretensions of Napoleon's rule.

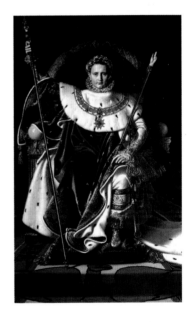

In painting, the Neoclassical tradition was continued by David's pupils, notably Antoine-Jean Gros (1771–1835) and Ingres. With both of these artists, however, the old style was tempered by Romantic traits. Ingres's superlative draughtsmanship and smooth, enamel-like finish, as seen in his portrait *Napoleon I on the Imperial Throne* (right), placed him firmly in the Neoclassical camp, whereas his taste for exotic, Orientalist (see p.286) subjects linked him to the new Romantic movement. **IZ**

1789	1803	1804	1814	1824	1833
The French Revolution begins and David is forced into exile.	Thorvaldsen secures his reputation in Rome with his sculpture *Jason with the Golden Fleece*. It is influenced by the sculptures of ancient Greece.	Napoleon Bonaparte (1769–1821) is proclaimed Emperor of France. The event inspires numerous artworks by Neoclassical artists.	Ingres paints his sensuous nude *La Grande Odalisque* (see p.264). It is exhibited at the Salon in 1819 and receives mixed reviews.	Ingres leaves Italy and returns to France, sparking an artistic rivalry with Eugène Delacroix, a proponent of Romanticism (see p.266).	Horatio Greenough (1805–52) begins his marble sculpture of George Washington. It is the first state commission awarded to a US sculptor.

The Death of Socrates 1787

JACQUES-LOUIS DAVID 1748 – 1825

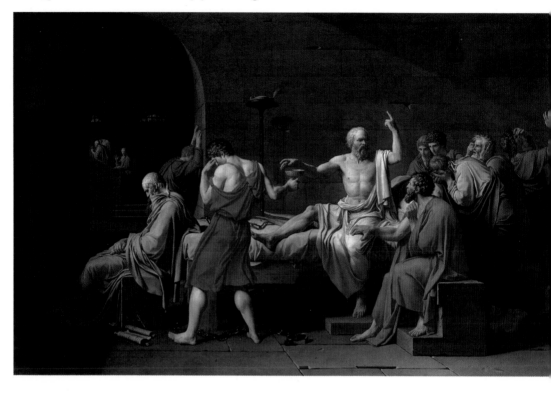

oil on canvas
51 x 77 ¼ in. / 130 x 196 cm
Metropolitan Museum of Art,
New York, USA

Jacques-Louis David painted *The Death of Socrates* for a private patron and the heroic subject matter and classical forms are typical of Neoclassicism. The scene shows Socrates in prison, visited by his disciples, just before the poison is administered. David's patron chose the subject for this commission but it is clear that the blend of courage and self-sacrifice appealed to the artist Socrates's energetic gesture and pose is in direct contrast to the swooning figures who surround him. David highlights their movement with accents of light and shade and bathes his central figure in divine light.

The Greek philosopher Socrates (469–399 BC) was one of the greatest figures of the ancient world. His stern, moral outlook was hugely influential, although his controversial views often brought him into conflict with the authorities. In 399 BC, he was tried and condemned for corrupting the minds of Athenian youth. Socrates could have avoided his fate by recanting his beliefs and going into exile, but he refused to compromise his ideals and chose death instead. David based his painting on the account of these events in *Phaedo*, one of Plato's dialogues, and also consulted a scholar, Father Adry. Although David drew on these various sources for the composition, he also added his own interpretation and set the scene in a Roman-style chamber. He reduced the number of disciples listed in Plato's account and featured one or two others who were not present at the death, such as Plato. Plato was ill at the time and did not attend his master's deathbed. If he had been present, he would have looked considerably younger than the figure seated calmly at the foot of the bed, because he was in his twenties when Socrates died. *The Death of Socrates* was well received when it was exhibited at the Salon and Sir Joshua Reynolds (1723–92) described it as 'the greatest effort of art since the Sistine Chapel'. **IZ**

◆ NAVIGATOR

⊙ FOCAL POINTS

1 FIGURE IN PASSAGEWAY

The figure leaning against the wall is Apollodorus. According to Plato, Socrates sent Apollodorus away because he was so distraught at the impending death of Socrates. David includes him in the shadows of this powerful image and depicts him in a pose of all-consuming grief.

2 MAN HOLDING THE BOWL

All the figures in the chamber are friends or disciples of Socrates apart from this young man. He has been sent to oversee the execution but is so distressed that he cannot bear to witness the proceedings. His anguish underlines the heroism of Socrates and the cruel injustice of the sentence.

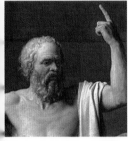

3 SOCRATES'S RAISED ARM

Socrates spent his final hours debating the immortality of the soul. He raises a finger aloft, indicating that there is a higher sphere of existence than the mortal domain. His relaxed attitude to death is emphasized by the casual way that he reaches for the bowl of hemlock without looking at it.

4 SEATED MAN

This is Crito, one of Socrates's closest disciples. When the sentence was announced, he tried to persuade his master to flee. The Metropolitan Museum of Art owns a preparatory study for this figure. Executed in black and white chalk, it is one of six surviving studies for the disciples.

5 PLATO

Only one of Socrates's disciples reacts to the imminent tragedy in the same dignified manner as the master. Plato sits motionless at the end of the bed, facing away from the drama of the scene. His head is bowed, lost in thought, as he contemplates the fate of Socrates.

⏱ ARTIST PROFILE

1748–79

Born in Paris, David trained under Joseph-Marie Vien (1716–1809). After several attempts, he finally won the Prix de Rome in 1774. He went with Vien to Italy, where his studies of antique art helped him to develop a rigorous, Neoclassical style.

1780–88

On his return to Paris, David rapidly achieved success at the Salon. He took on pupils and was received into the Academy. As the French Revolution approached, his stirring scenes of heroism and sacrifice caught the mood of the times. David moved to Rome in order to paint *The Oath of the Horatii*, the most powerful of these ancient fables.

1789–1802

When the Revolution broke out, David was in his prime. He became a deputy of the National Convention and helped abolish the Academy. He was also a personal friend of the revolutionary leaders and was eventually forced into exile during the dark days of the Terror.

1803–25

After the Revolution, David was engaged by Napoleon. He was named *premier peintre* (first painter) and won major commissions from the new regime, but Bonaparte's defeat coincided with David's final fall from grace. In 1816, he fled to Brussels, where he remained in exile for the rest of his life.

REVOLUTIONARY FERVOUR

Political idealism rarely produces great art but the work of David is a notable exception. During the 1780s, he managed to condense the principles of Neoclassicism into a series of stark and powerful canvases that added fuel to the incendiary, political mood of the times. After the revolution, David became fully engaged with the new regime. He joined the new government and voted for the death of the king. David's political duties limited his artistic activity. Although he planned a number of works in honour of the revolution, only one came to fruition. This was *The Death of Marat* (1793; below), the painter's

moving tribute to Jean-Paul Marat who was assassinated. Marat actively promoted the violent purges following the overthrow of the monarchy. Here David portrays Marat with the dignity and tenderness of a martyred saint.

La Grande Odalisque 1814

JEAN-AUGUSTE-DOMINIQUE INGRES 1780 – 1867

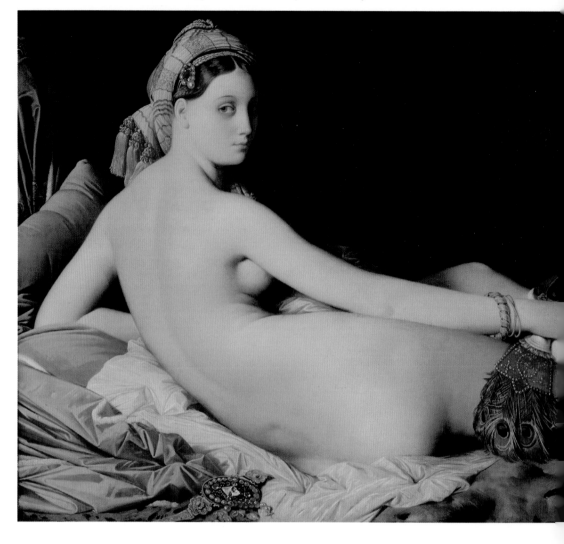

oil on canvas
35 7/8 x 63 3/4 in. / 91 x 162 cm
Louvre, Paris, France

◆ NAVIGATOR

This painting was commissioned by Queen Caroline of Naples, Napoleon's sister. It was originally intended to form a pair with another nude by Jean-Auguste-Dominique Ingres, but Bonaparte's regime crumbled, Caroline fled the country and the second nude, a sleeping figure, was destroyed. Ingres was committed to the Neoclassical style: the mood of his painting is cool and he pays particular attention to line over colour. *La Grande Odalisque* was painted in Rome, during a period when the artist was enjoying a far higher reputation in Italy than in France. In 1819, when the painting was exhibited at the Paris Salon, it received a mixed reception, partly because of the distortions of the female figure that suggest the influence of Mannerism (see p.202). Although the pose of the *odalisque*, or concubine, echoes that of the portrait of *Madame Récamier* (1800) by Jacques-Louis David, Ingres portrayed his model as a woman of the harem, embracing the taste for Orientalist (see p.286) subject matter that was popular with Romantic artists (see p.266). Despite this affinity, Ingres remained opposed to Romantic ideals until his death. **IZ**

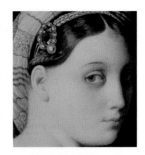

1 IMPERIOUS GAZE

In spite of her nudity, the odalisque appears remote and inaccessible. She turns her body away from the viewer and there is no spark of warmth in her imperious gaze. This effect is underlined by the indistinct background and the cool, silvery tones of the fabrics and accessories.

2 AWKWARD POSE

La Grande Odalisque is full of elegant contradictions. The figure seems the epitome of pampered indolence and effortless sensuality, but on closer inspection her pose is stiff and awkward. The position of the left leg is highly improbable and would be difficult to hold for any length of time.

3 INCENSE BURNER

Ingres may have been prepared to exaggerate the curves of his model, to heighten her visual appeal, but he made use of pure illusionism to evoke the other senses. The thin trails of smoke from the incense burner, rendered precisely, conjure up a heady, perfumed mood, while the textures of the opulent materials have a believably tactile appearance. The Neoclassicist Ingres often displayed an appetite for the exotic that was more typical of the Romantic painters.

4 CURVE OF BACK

When this painting was exhibited at the Salon of 1819, most of the criticism focused on the figure's oddly elongated spine. Some commentators remarked, more specifically, that the woman had three extra vertebrae. Ingres was well aware of this, but had no compunction about distorting the anatomy of his model in order to create a more pleasing and sensual line. This aspect of his style would later influence the work of Pablo Picasso.

🕐 ARTIST PROFILE

1780–1805

Ingres studied at the Academy in Toulouse, then in David's studio in Paris. In 1801, he won the Prix de Rome scholarship.

1806–24

Ingres took up his scholarship at the French Academy in Rome. He won commissions from the Bonapartes, but his paintings were poorly received in Paris and he remained in Italy until 1824.

1825–40

His return to France coincided with success at the Salon and Ingres was hailed as the leader of the classical school. He left Paris in 1834 to become director of Rome's French Academy.

1841–67

He returned to Paris, cementing his role as champion of official art. His work was showcased at the Universal Exhibition of 1855.

ROMANTICISM

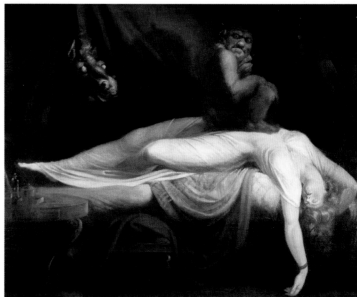

1 *The Nightmare* (1781)
Henry Fuseli • oil on canvas
40 x 50 in. / 101.5 x 127 cm
Detroit Institute of Arts, USA

2 *Wanderer Above the Sea of Fog* (1818)
Caspar David Friedrich • oil on canvas
37 ³/₈ x 29 ¹/₂ in. / 95 x 75 cm
Kunsthalle Hamburg, Germany

3 *The Raft of the Medusa* (1819)
Théodore Géricault • oil on canvas
193 ¹/₄ x 281 ⁷/₈ in. / 491 x 716 cm
Louvre, Paris, France

Romanticism galvanized Western art, literature and music in the late 18th to mid 19th centuries and continues to shape modern ideas about creativity and the artist. The movement emerged when a combination of particular philosophical, political, social and artistic movements and conditions brought imaginative individualism and unconstrained creativity to the fore. Its impact swept across Europe, where it was embraced most passionately in France, Germany, Switzerland and Britain. The movement was also hugely influential on North American art, especially landscape painting.

The Romantic mode was partly formed by the German philosophers Immanuel Kant, Karl Schlegel and Georg Hegel, who focused on the artist's 'inner' world as the proper content of the Romantic sphere. This idea of the inner world, specifically its visionary, dreamlike core, fuelled early Romantic works such as the macabre painting *The Nightmare* (above) by Swiss artist Henry Fuseli (1741–1825). It depicts a woman lying defenceless on her bed, trapped within her nightmare vision, while a demon incubus squats on top of her looking defiantly out at the viewer.

The Romantic theme of the artist as a tortured genius communing with sublime nature is powerfully expressed in *Wanderer Above the Sea of Fog* (opposite, above) by Caspar David Friedrich (1774–1840), a painting that evokes the lone heroes of Romantic poetry, such as Shelley's Prometheus. Here, the

KEY EVENTS

1779	1782	1789	1793	1799	1809
The world's first iron bridge is constructed at Coalbrookdale in England, heralding the Industrial Revolution and the arrival of profound social change.	Fuseli exhibits his first version of *The Nightmare* at the Royal Academy in London, and the painting rapidly becomes famous.	The French Revolution begins. Romantic writers flourish in the new order, as exemplified by the works of François-René de Chateaubriand.	David (1748–1825) paints *The Death of Marat* about the murder of his friend. The painting becomes an emblem of the French Revolution.	A military coup brings Napoleon to power in France. Napoleon as a national hero becomes the subject of numerous admiring Romantic paintings.	Blake holds his one-man show 'Poetical and Historical Inventions'. It attracts very few visitors and receives only one review.

olated artist is experiencing the world as no one has experienced it before. ïiedrich's wanderer is symbolically at the very edge of existence. He stands n the mountain top, confronted by a physical, and emotional, choice—he ɔuld end his life by hurling himself into the unknown or he could return to ie world below a changed man.

Romanticism arose partly in reaction against the rational thought f the 18th-century Enlightenment. The French Revolution of 1789, sparked y the example of the American Revolution (1775–83), marked the start of a ɪng period of war-torn years across Europe, illustrated by major Romantic ʲorks such as *The Third of May, 1808* (1814; see p.270) by Francisco de Goya 746–1828) and *Liberty Leading the People* (1830; see p.272) by Eugène ʲelacroix (1798–1863). During the Enlightenment, thinkers had sought to ɪtionalize the world and move away from the domination of superstitions ɪnd religious ideals towards a more ordered world created by intelligent ɪinking. When bloody chaos persisted and a better world failed to materialize, disillusionment set in that helped to feed Romanticism.

The Romantic artistic movement placed emphasis on heightened ɪmotions, on the turbulence of human psychology and on the awe-inspiring ɔower of nature—a force so much greater and more powerful than humankind. ɪ *The Raft of the Medusa* (below), by French Romanticist Théodore Géricault 791–1824), a classical pyramidal composition is combined with an expressive ɪnd horrifying depiction of a real-life shipwreck, one that had occurred just ɪhree years before the artist finished the painting. Géricault used various ʲiends as models, including Delacroix for the figure with a red headscarf in

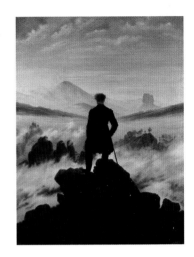

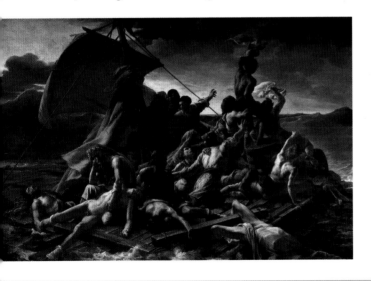

4 *Snow Storm—Steam-Boat
 off a Harbour's Mouth* (1842)
 J. M. W. Turner • oil on canvas
 48 ⁵/₈ x 60 ³/₈ in. / 123.5 x 153.5 cm
 Tate Britain, London, UK

5 *View of the Round-Top in the Catskill
 Mountains* (1827)
 Thomas Cole • oil on canvas
 39 ³/₄ x 54 ¹/₂ in. / 101 x 138.5 cm
 Museum of Fine Arts, Boston, USA

6 *The Valley Farm* (1835)
 John Constable • oil on canvas
 70 ⁷/₈ x 61 ⁷/₈ in. / 180 x 157 cm
 Tate Britain, London, UK

the foreground. The captain of the *Medusa* was an incompetent sailor who had
secured the post solely through his familial connections with the government.
When the painting was unveiled at the Paris Salon in 1819, it caused a scandal.
Not only did it portray a well-known and unsettling story of passengers forced
to turn to cannibalism in order to survive, and the descent into madness
that many of them suffered, but it was also a direct criticism of the present
government. The figure of the *Argus*, the ship that rescued the survivors, can
be seen in the far distance and Géricault hints that it might not have arrived
in time. Like Fuseli's *The Nightmare*, the painting provoked an instinctive and
powerful visceral response in its viewers.

The Industrial Revolution in Europe was another factor in the upsurge
of Romanticism because it ushered in a period of social disruption and
feelings of helplessness against 'unnatural' mechanized forces. This anxiety
was central to Romanticism and led to a reassertion of humanity's special
relationship with an unspoilt, uncivilized nature, as expounded by the
French theorist Jean-Jacques Rousseau. Many artists envisioned this version
of nature as boundless and terrifying. In this respect they were influenced
by 18th-century 'sublime' art, exemplified by the precipitous mountain or
volcano scenes that were so popular with Grand Tour artists (see p.256) such
as William Pars (1742–82) and Joseph Wright of Derby (1734–97).

Romantic art therefore addressed the search for the sublime—the rush
of heightened emotions and the powerful forces and feelings that nature
could evoke. Some Romantic artists, such as William Blake (1757–1827), looked
for this inspiration in religion, but many others held spiritual rather than
conventionally religious views. The dramatic vortex of *Snow Storm—Steam-
Boat off a Harbour's Mouth* (above) by J. M. W. Turner (1775–1851) features raw,
elemental nature and freely expressive execution; the boat at the heart of the
storm can be seen to symbolize man's battle with forces greater than himself.

Other artists, including the Englishman John Constable (1776–1837),
expanded Turner's vision of the natural world by exposing the boundless
and terrifying forces of nature. In *The Valley Farm* (left), however, Constable
offers a more personal interpretation of a Romantic theme. The artist grew
up in Suffolk and the area became one of his chief sources of inspiration; his
father's mill in Flatford and its surrounding land inspired a large number of his
landscapes. *The Valley Farm* shows a house alongside the River Stour in Flatford

is the home of Willy Lott, a farmer who was born there and who lived in the house for more than eighty years. Constable painted the house numerous times; for him the farm was a symbol of security and of nature unscarred by human greed or development. It was a bucolic pastoral scene that invoked within him a feeling of serenity, which he intended to convey to his viewers. He used richly expressive, loose brushstrokes to evoke the animating hand of nature in the clouds, the trees and the flowing river water.

It is difficult today, when looking at works by Constable, to appreciate how controversial they were when painted. The English artistic establishment disliked Constable's landscapes, suggesting that he should paint in a more conventional style and return to the Old Masters in order to see how landscape paintings should look. The artist was praised for his portraiture, which he performed out of financial necessity and deeply resented, but his landscapes were considered discordant and unappealing. It was not until *The Hay Wain* (1821), also featuring Willy Lott's farm, was exhibited in France in 1824 that Constable's Romantic work began to be appreciated. The artist received far greater approbation in France than in England during his lifetime.

American Thomas Cole (1801–48) also painted homages to his homeland. He was a vital force behind the Hudson River School, a group of landscape painters influenced by the Romantic aesthetic who sought to capture the sublime relationship between man and wilderness in the Hudson River Valley. Cole's *View of the Round-Top in the Catskill Mountains* (below) gives the viewer a sense of actually being there, breathing in the mountain air and feeling awe at the vastness of nature. The wind-blasted mountainscape is bleak and forbidding, but Cole illuminates it with the first moments of dawn, when the rising sun transforms the river far below into molten pale gold. **AK/LH**

The Third of May, 1808 1814

FRANCISCO DE GOYA 1746 – 1828

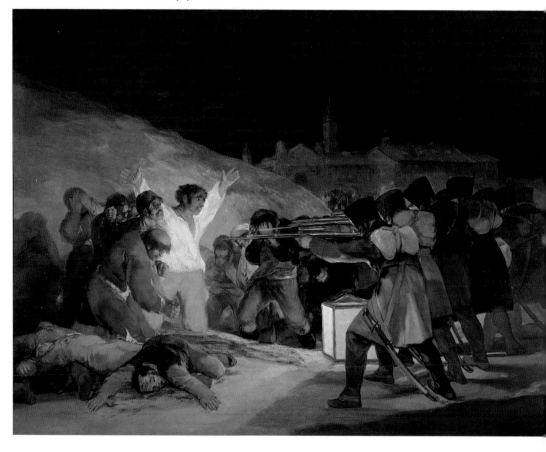

oil on canvas
105 x 136 in. / 268 x 347 cm
Museo del Prado
Madrid, Spain

✪ NAVIGATOR

Francisco de Goya's shocking image depicts a real historical event—a French firing squad executing ordinary people in Madrid as punishment for the actions of Spanish rebels, who had revolted against the French occupation. The revolt had taken place the day before, on 2 May 1808. Goya was court painter to Spanish royalty before the French takeover and kept this role under the Bonapartes. *The Third of May, 1808* was painted a year after the French occupation ended. The artist wrings a Baroque–Romantic expressiveness and drama from the situation, with the painting's shadowed backdrop providing a forbidding foil for the illuminated scene of horror.

The painter used contrasts to tremendous effect in this scene and the two groups of figures face each other at very close range. On the right, an anonymous, neatly dressed line of French imperial soldiers, whose faces the viewer cannot see, prepare to fire. They are all bent forward in unison, their guns in a terrible line of death. The rigidity of the soldiers suggests their automaton-like presence and their lack of emotion regarding what they are about to do. On the left of the canvas, the bedraggled victims are caught in a horrific procession—some already dead, some in position in front of the guns, others inexorably moving forward to die in their turn. Each is depicted in a way that invites the viewer's compassionate identification. The centrally placed, white-shirted man, with his pleading, rictus stare, holds his arms up as if crucified, inviting the viewer to identify him with Jesus Christ. **AK**

1 STIGMATA

The right hand of the kneeling man about to be executed clearly bears a stigma-like mark, highlighting his role as a martyr and reinforcing the comparison with Christ. This is emphasized by the way the man opens up his chest, in a pose of crucifixion, ready to take the bullets.

2 TROUSERS OF MAN GRIPPING HIS HEAD IN ANGUISH

Goya's bold, expressive brushwork is notable on the clothing of the Spaniards, including the white shirt of the central figure and the colour-spotted trousers of his companion, who holds his head in his hands. In contrast, the clothing of the firing squad is painted in a more even, cool manner. In true Romantic spirit, the artist is drawing attention to his sympathy for the plight of the Spaniards.

3 RED BLOOD

Extensive rivulets of red blood staining the ground by the already fallen victims provide an extreme contrast with the rest of the picture, which is painted in subdued, neutral tones. The other exceptions to this are the bright white shirt and yellow trousers of the man about to die; these are illuminated by the single bright lamp pointed directly at the victim, which focuses the viewer's attention on the tragedy of his imminent demise.

4 PRAYING HANDS

This friar's hands have been painted with great passion. They are clenched in prayer, their tension suggesting his terror and fervour as he prepares to die while praying for those who have died. The contortions of anguish in his face are shown in closely observed and convincing detail.

1760–85

At the age of fourteen Goya became apprentice to José Luzán (1710–85) in Saragossa and was later commissioned to paint decorative frescoes for the local cathedral. During this period he was denied entrance to the Royal Academy of Fine Art.

1786–91

The young Goya had his first success as a genre painter in Madrid and was commissioned to paint King Charles III. He was appointed court painter to Charles III and later Charles IV.

1792–97

Goya contracted a cholera-like disease that would forever alter his perspective and leave him permanently deaf.

1798–1818

Nude Maja (1800) and *Clothed Maja* (1803) outraged Spanish society, which considered them profane. *The Disasters of War* series (1810–14) recalls the horrors of the Napoleonic invasion.

1819–23

The artist began the *Black Paintings*, a series of murals later transferred to canvas. They are epitomized by dark scenes of violence that were never meant to be displayed publicly.

1824–28

Goya began a self-imposed exile in Bordeaux, France. His final paintings were executed in a style that anticipated Impressionism (see p.316).

SUBVERSION OF A COURT PAINTER

Goya seldom spoke of his political allegiances, yet his paintings are revealing. *The Third of May, 1808* makes explicit his opinion of the French occupation, yet he had been the official painter to the occupiers. The same subversion can be seen in *The Family of Charles IV* (1800; below). Although Goya was court painter to Charles IV, he makes the queen the central figure, instead of the king, and highlights her two illegitimate children, the result of her infidelity. Perhaps this was a deliberate jibe at the king's impotence at court, his decisions often thwarted by the queen, who had greater political power owing to her affair with the prime minister.

Liberty Leading the People 1830
EUGÈNE DELACROIX 1798 – 1863

oil on canvas
102 ¹/₄ x 128 in. / 260 x 325 cm
Louvre, Paris, France

♦ NAVIGATOR

O ne of the most famous symbols of insurrection in the history of art is *Liberty Leading the People* by Eugène Delacroix. Its subject is the Parisian uprising of July 1830 that replaced the Bourbon king Charles X with Louis-Philippe, Duke of Orléans, and the painting caused a sensation at the 183⁻ Salon. Delacroix depicts a key moment: the final breaching of the barricades by the republican rebels on 28 July. The drama of the piece is increased by the upwardly thrusting pyramidal frame at its heart, picked out by the red, white and blue in Liberty's *tricolore* (at the apex of the 'pyramid') and on the figures below. This structure echoes that used by Théodore Géricault in *The Raft of the Medusa* (1819), for which Delacroix had posed as one of the figures.

Delacroix cleverly balances modernity and allegory in this work. 'I have undertaken a modern subject, a barricade,' the artist declared later, 'and if I have not fought for my country, at least I will paint for her.' In vividly contemporary dress, the firearm-waving street urchin (right), top-hatted bourgeois (possibly Delacroix, who was present at the revolt), factory workers, soldiers and students anchor the painting as a historical event, as does the distant view of Notre-Dame de Paris. Liberty's drapery and monumental figure refer to classical tradition and Grand Manner history painting. As a grittily modern retelling of classical ideals, however (Liberty sports un-classical underarm hair), the painting shocked some contemporary viewers. **AK**

FOCAL POINTS

1 FLAG

By placing the red of the *tricolore* against a patch of blue sky, Delacroix makes the vibrant hue sing out. The juxtaposition of contrasting colours red and blue is highly striking. The colours of the flag are repeated in the clothes of the blue-shirted worker at Liberty's feet. Delacroix was an expert technician, adept at placing certain tones next to each other, or echoing colours in different places, in order to amplify a mood or message.

2 EXPRESSIVE SKY

Delacroix's treatment of the sky catches something of the chaos of urban warfare, a luminous layering of the natural sky with hazy smoke and the glow of the fires of battle. Delacroix's technique combines the expressiveness of Romanticism with a close attention to realistic detail, conveying emotion while remaining true to a historical time and place. His brushwork would later become much looser, with more impasto and thick layering.

3 LIBERTY'S FOOT

The placement of Liberty's front foot as she steps over the barricades encapsulates a momentous stage in the battle. The billowing hem of her garment also adds to the sense of movement in the composition, establishing this event as a historic tipping point.

4 SHADOWS

The richly shadowed areas show Delacroix's mastery of chiaroscuro. He was influenced in this by the work of Antoine-Jean Gros (1771–1835) and Géricault. Strong contrasts with the glowing highlights, combined with bold colours, add drama and serve to pick out each principal figure.

ARTIST PROFILE

1806–15

Delacroix studied at Paris's Lycée Impérial from 1806 to 1815, during which time he won prizes for drawing and the classics.

1816–27

Géricault and Delacroix studied together in the Paris studio of Pierre Guérin in 1815. The next year, Delacroix entered the Ecole des Beaux-Arts. In 1822, the Salon accepted his *Barque of Dante* (1822) inspired by Géricault's *The Raft of the Medusa*. A series of brilliant but controversial paintings, including *Massacre at Chios* (1824) and *Death of Sardanapalus* (1827), saw him become the leading French Romantic artist.

1828–56

In 1832, Delacroix joined a diplomatic mission to North Africa and Spain, producing more than one hundred artworks of exotic scenes, which would inform many of his later works. Six years later, his *Medea about to Kill Her Children* (1838) was a major talking point at the Salon. Now much sought after, he accepted numerous commissions to decorate public buildings.

1857–63

Having been denied admission to the Institut de France—partly at the behest of his rival Jean-Auguste-Dominique Ingres, the master of Neoclassicism (see p.260)—Delacroix was finally accepted in 1857. Five years later, he co-founded the Société Nationale des Beaux-Arts.

POLITICS AND PATRONAGE

In Delacroix's France, where affiliations changed rapidly, politics and patronage were complex, intertwined affairs. Louis-Philippe I bought *Liberty Leading the People* to commemorate his accession but recognized its inflammatory potential and hid the picture away from public view for many years. Delacroix (*Self-portrait*; 1837; below) was awarded the Légion d'honneur for the painting in 1831, but had also been a favoured artist of the ousted ruler, Charles X. Delacroix had friends in both camps and remained vague about his loyalties. Despite his nonconformist style and the confrontational themes in many of his works, Delacroix enjoyed the patronage of the state during his career. Apart from the *Death*

of Sardanapalus (1827), all his early historical paintings were bought for the Musée du Luxembourg. In 1824, he received his first government commission and from the 1830s onwards he created murals and paintings for many of the city's public buildings.

4 | 19TH CENTURY

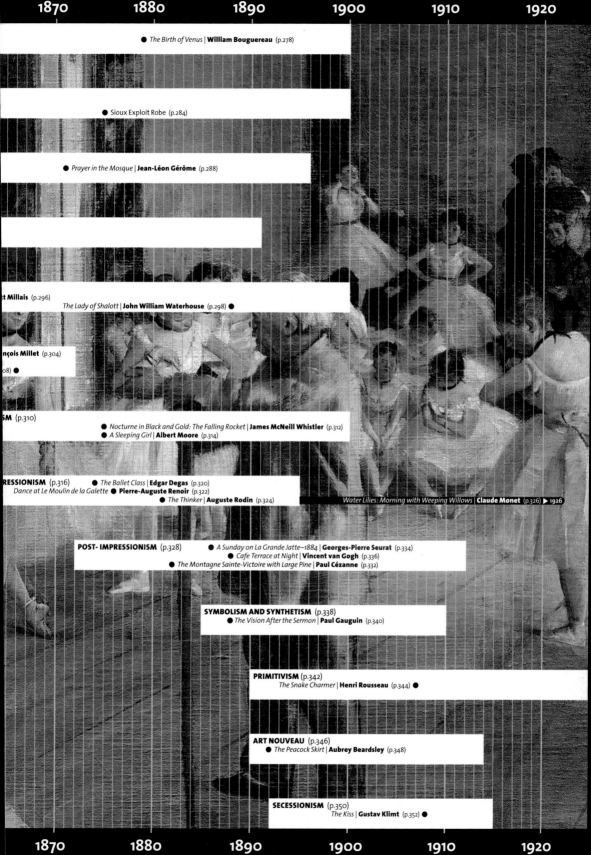

FRENCH ACADEMIC ART

W hen the Académie Royale de Peinture et de Sculpture amalgamated with two other academies to become the Académie des Beaux-Arts in 1816, it established itself as the most illustrious art institution in Europe, on which all the others modelled themselves. For two centuries the European art world had been controlled by academies—institutions that encouraged, appraised and represented the arts. First established in Italy during the 16th century, art academies had flourished across Europe, replacing the medieval guild-apprentice system and becoming the most reliable path for professional artists through training, competitions and exhibitions.

For a place at an art academy, hopeful young artists took an entrance exam and, once accepted, studied for several years. Academies existed to elevate artists above craftsmen, who were seen as manual labourers, and they emphasized the intellectual element of producing art. To train as an artist in an academy, a student would spend years copying works by past artists in order to assimilate their methods. Every drawing had to be approved by masters before a student was allowed to advance to the next level. Initially students drew from prints, then from plaster casts of classical statues, finally progressing to drawing from life. Once proficient in drawing, they learnt to paint, but there was a strict hierarchy of acceptable subjects. History painting, which included biblical and classical subjects, had the highest status, next were portraits and landscapes

KEY EVENTS

c. 1800	1816	1824	1834	1835	1841
French art, especially Academic art, is most strongly influenced by Jacques-Louis David (1748–1825), whose studio is attended by a vast number of pupils.	The French Royal Academy merges with two other academies to become the Académie des Beaux-Arts.	Eugène Delacroix (1798–1863) shows Massacre at Chios at the Paris Salon. Its free approach challenges established traditions of Academic art.	The Martyrdom of St Symphorien by Jean-Auguste-Dominique Ingres (1780–1867) is badly received, infuriating the artist.	Ingres, determined never to exhibit to the public again, gladly leaves Paris to become director of the French Academy in Rome.	Ingres returns to Paris after his Antiochus and Stratonice is well received at the Palais Royale. Its reception is an endorsement of his Neoclassical style.

276 19TH CENTURY

nd last were still lifes and genre paintings. Throughout the 19th century, Neoclassicism (see p.260), which emphasized linear purity, and Romanticism (see p.266), which focused on the expressive use of colour, were the Academy-approved styles that artists were encouraged to draw upon in their work. Successful students were awarded the prestigious title 'Academician', which was an artist's greatest professional accolade.

Students' progress was measured by competitions. In Paris, the most famous was the Prix de Rome, the winner of which was awarded up to five years of study in Rome. Another competition was the Paris Salon—the official art exhibition of the Académie des Beaux-Arts. It was held annually or biennially, and only paintings and sculptures in the conventional styles of Academic art were accepted by the official Salon jury. Thousands of works were displayed, with Salon judges dictating the placement of the work at the exhibitions and thereby determining how visible they were to private collectors.

Leading Academic artists included William Bouguereau (1825–1905), Jean-Léon Gérôme (1824–1904), Alexandre Cabanel (1823–89) and Thomas Couture (1815–79), all of whom successfully combined the theories of Neoclassicism (stating that art should be modelled on accepted classics of form and composition, not to repeat them but to synthesize their qualities in new works) and Romanticism (stating that art should be subjective, individual, imaginative and expressive of the artist's emotion). Bouguereau's *The Birth of Venus* (1879; see p.278) exemplifies the highly finished painting technique, characterized by imperceptible brushstrokes and smooth colours, that was typical of Academic art. Sentimental subject matter was demanded by the Academy, and Academic artists chose religious and classical subjects and presented idealized interpretations of those subjects in meticulous detail. Cabanel's *Phèdre* (opposite) depicts the moment in Greek myth at which Phaedra has declared her love to Hippolyte, her husband's son from a previous marriage. Gérôme drew on Greek myth for his *Pygmalion and Galatea* (right), which depicts the sculpture of Galatea being brought to life by the goddess Venus, fulfilling Pygmalion's wish for a wife as beautiful as his sculpture. The composition is dramatic and charged with feeling, yet the central figure is realized with a Neoclassicist's respect for the form of ancient sculpture.

Industrialization and the European revolutions of 1848 transformed social conditions and artists began to reconsider the authority of Academic art. Among the first rebels were the French Realists (see p.300) and the British Pre-Raphaelites (see p.294), who objected to the conservatism and inflexible structure of the academies, as well as their control of patronage. Claiming that the polished finish of Academic paintings showed insincerity and a perfunctory approach, rebel artists held alternative, unofficial exhibitions to show their unconventional work. Later the Impressionists (see p.316) rejected the principles of Academic art, stating that all subjects are equally acceptable and that the truthful depiction of the sensation of light is art's true goal. **SH**

1 *Phèdre* (1880)
Alexandre Cabanel • oil on canvas
76 3/8 x 112 5/8 in. / 194 x 286 cm
Musée Fabre, Montpellier, France

2 *Pygmalion and Galatea* (c. 1890)
Jean-Léon Gérôme • oil on canvas
35 x 27 in. / 89 x 68.5 cm
Metropolitan Museum of Art,
New York, USA

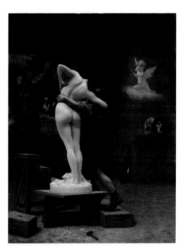

1848	1849	1855	1863	1863	1881
The French Revolution causes the Paris Salon to become more liberal and fewer works are rejected. There is political upheaval throughout Europe.	Gustave Courbet (1819–77) paints *The Burial at Ornans* in a Realist style that challenges the idealism of the Academic tradition.	French Academic art gains worldwide recognition through being exhibited at the Exposition Universelle in Paris.	The Académie des Beaux-Arts is renamed Ecole des Beaux-Arts; it is the basic model art school until the Bauhaus (see p.414) in the 20th century.	The Salon jury rejects some 3,000 works, more than half of the submissions for this year. The Salon des Refusés is established in protest.	The French government withdraws sponsorship of the Paris Salon. A group of artists founds the Société des Artistes Français (Society of French Artists).

The Birth of Venus 1879
WILLIAM BOUGUEREAU 1825 – 1905

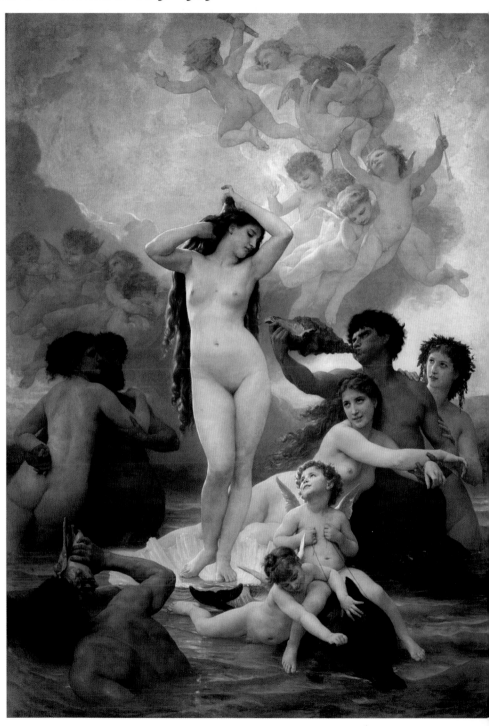

oil on canvas
118 ⅛ x 84 ⅝ in. / 300 x 215 cm
Musée d'Orsay, Paris, France

This classical representation of the Roman goddess of love and beauty is based on many earlier iconic works. William Bouguereau, the archetypal French Academic artist, deliberately paid homage to the painting of the same name by Sandro Botticelli (1445–1510), to *Triumph of Galatea* (1512; see p.180) by Raphael and to *Venus Anadyomène* (1848) by Jean-Auguste-Dominique Ingres. With her perfect, porcelain-like flesh and flowing hair, Venus is born out of the waves and emerges on her shell, surrounded by admiring tritons, sea nymphs and putti. Along with many of his contemporaries, Bouguereau used the pretext of painting a goddess in order to paint a sensuous, idealized nude. His use of rich colour, careful finish, the precision of the execution and the physical perfection of the subject made this work extremely successful when it was first shown. His refined technique represents the pinnacle of achievement in the French Academic tradition, for which he was both admired by traditionalists and reviled by the avant-garde during his lifetime. **SH**

👁 FOCAL POINTS

1 VENUS'S LEGS

Venus's pose is asymmetrical and in this regard Bouguereau consciously follows Botticelli. But unlike Botticelli's goddess, this Venus does not adopt a 'pudica' pose, whereby her hands hide her pubic area and breasts. Bouguereau's Venus is far more erotic and the artist revels in revealing the shapely body of a beautiful woman. His smooth, glazed brushstrokes were admired by supporters of Academic art and he was renowned for his ability to depict skin realistically.

2 VENUS'S FACE AND ARMS

Unashamed of her nakedness, Venus raises her arms in a languid stretch and lowers her gaze in modesty at her beauty. When Bouguereau painted this work, Ingres was revered as the most accomplished painter of nudes; Bouguereau's choice of pose, with raised arms, echoes that of Ingres's Venus.

3 PUTTI IN THE SKY

The plump little putti admiring the goddess are intended to remind viewers of the two in Raphael's *Sistine Madonna* (c. 1512–14). As in most of Bouguereau's works, the background is painted sketchily in order to make the central theme appear more prominent.

4 NYMPHS AND ZEPHYR

In Roman myth, the zephyrs blew Venus in a shell from the ocean to Paphos in Cyprus, and represent spiritual passions. To acknowledge Botticelli's Venus, Bouguereau paints the intertwining zephyrs and nymphs in a naturalistic way—they are mythical beings in credible earthly poses.

5 PUTTI WITH DOLPHIN

Two putti are shown riding on a dolphin, a traditional symbol of protection. French Academic artists included putti, which are almost always depicted as winged male babies, to show their reverence for Italian Renaissance art. Putti appear with dolphins in several Renaissance sculptures.

🕐 ARTIST PROFILE

1825–45
Bouguereau was born in La Rochelle, France. He received his first drawing lessons from Louis Sage between 1838 and 1841. In 1842 his family moved to Bordeaux where he enrolled at the Ecole Municipale de Dessin et de Peinture. In 1844 he won first prize there for a painted figure of St Roch.

1846–74
Bouguereau gained entry to Paris's Ecole des Beaux-Arts in 1846 and won the Prix de Rome in 1850. He started to exhibit genre paintings and mythological themes at the Paris Salon.

1875–1905
He began teaching at the Académie Julian, an alternative to the Ecole des Beaux-Arts. In 1881 he was elected the first president of painting of the Société des Artistes Français.

INDIGENOUS ART OF NORTH AMERICA

T he term 'art', in the Western sense, was first applied to indigenous material culture from North America at the turn of the 19th century. Although the word refers to the aesthetic aspects of the artefacts, none of the art was made for aesthetic reasons alone. Made using local resources and designed to be used in daily life, clothing, sculpture, pottery and other visual expressions developed from rich and complex systems of knowledge. Interconnections between cosmology, spirituality, power and politics are just some of the meanings embodied in the North American art produced in the thousands of years prior to European contact. Diversity in terms of environment, language and social organization led to distinct regional artistic traditions that illustrated the ways in which communities expressed their engagement with the world around them. At the same time, indigenous peoples were linked through extensive trade networks that spanned the continent, providing conduits for new materials and ideas, which were incorporated into long-standing cultural traditions. This process continued throughout the often devastating impact of European colonization.

The introduction of corn from Mesoamerica contributed to the settlement and development of enormous chiefdoms in the Southeast by the end of the

KEY EVENTS

600 BC–AD 1150	1000	1000–1400	c. 1390	1492	1500–1800
Mimbres pottery flourishes. The style is characterized by geometric designs and figurative images of animals and people.	The Thule people and their technologies move east and their influence spreads across the Arctic.	Mississippian cultural practices thrive throughout the Southeast.	The League of the Haudenosaunee (People of the Longhouse) is founded.	The arrival of Christopher Columbus (c. 1451–1506) marks the beginning of sustained contact with Europeans.	Following their migration from northern climes, Navajo tribes obtain weaving techniques from Pueblo people.

st millennium. The largest of these was Cahokia, located east of present-
y St Louis, Missouri. Copper repoussé plates illustrating a supernatural
eity known as 'Birdman' (right) are attributed to Cahokia but found in burial
ounds in other regions too. This widespread archaeological evidence attests
Cahokia's political, spiritual and artistic influence. Cahokia's centralized
overnment survived for nearly 500 years until the inhabitants dispersed
ound 1400, some 150 years prior to the spread of European diseases that
ecimated indigenous populations across North America.

In the far north, the Arctic was populated by successive waves of nomadic
eople: the Paleo-Arctic, Dorset and finally Thule, the ancestors of present-
ay Inuit people. Arctic and sub-Arctic aesthetic expression can be seen in
arments of clothing that were designed, sewn and embellished by women,
ot only to physically protect the wearer from the harsh climate but also
 spiritually connect the hunter with the game he sought. Small carvings,
ich as an ivory polar bear from the Dorset era found in the Igloolik area
outh of Baffin Bay, were made by men to ensure successful hunting or to
ommemorate the power of a formidable foe. The small size emphasizes
e portability required by a nomadic lifestyle.

On the Northwest Coast, the Chilkat weaving technique was used
 make robes, tunics and aprons. Chilkat textiles were usually woven
om mountain goat wool and cedar bark and Tlingit people acquired the
echnique through intermarriage with the more southerly Tsimshian in
e late 18th century. The Chilkat robe makes clear the balance between
egional specificities and values that are shared more widely; robes of this
pe embodied the balance between men and women, which had great
gnificance for many indigenous groups across North America. In this example
 a ceremonial Chilkat blanket (opposite, above), a man painted the formline
esign on a board and a woman wove it. The completed robe would have
een a visual manifestation of social hierarchy because such robes were worn
nly by the highest ranked individuals; when paired with oratory, the robes
onveyed the power of the wearer and confirmed ownership of ancestral
nd and histories.

Pottery making has been an integral component of indigenous
ommunities in the Southwest for thousands of years. Until the early 20th
entury, when tourist demand for pots outstripped supply, pottery making was
he domain of Puebloan women. Like their Anasazi ancestors, Hopi, Zuni and
ther Pueblo women gathered clay from sacred places, developed and refined
echniques for shaping and firing their pots, and drew on their dreams and
he artistic precedents of their foremothers for embellishing their pottery.
he geometric and figurative designs found on Southwest pottery (opposite,
elow) exhibit both regional and individual diversity and visualize the cultural
raditions that shape the Puebloan worldview. **MS**

1 **Chilkat-style blanket (19th century)**
Artist unknown • wool and cedar bark
31 x 71 in. / 78 3/4 x 180 3/8 cm
The Newark Museum, USA

2 **Repoussé plate (c. 1000)**
Artist unknown • copper
Smithsonian National Museum of
Natural History, Washington, DC, USA

3 **Zuni Pueblo water jar (c. 1880)**
Artist unknown • earthenware
11 x 13 in. / 28 x 33 cm
Museum of Fine Arts, Boston, USA

1680	1700–1800	1741	c. 1820	1830s–1870s	1880s
ueblo communities work together for welve years to drive he Spanish out of ew Mexico, emporarily ending ntense missionization.	Agreements between the Iroquois people and Europeans are recognized through the exchange of wampum belts.	Vitus Bering (1681–1741) travels to Alaska and the Northwest Coast and establishes the first Russian settlements in Southwest Alaska.	Haida artists begin carving argillite to provide souvenirs for European traders.	Indigenous peoples across North America are forcibly displaced to reservations in order to accommodate American expansion.	Significant cultural practices are outlawed, including the Sun Dance ceremony, although they continue to be practised in secret.

Star House Pole 19th century
ARTIST UNKNOWN

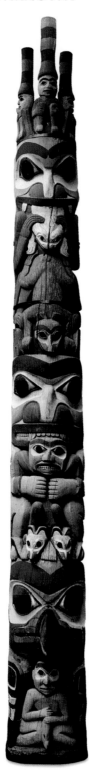

⬡ NAVIGATOR

red cedar tree
447 ¼ in. / 1136 cm high
Pitt Rivers Museum,
Oxford, UK

Haida monumental art is produced by the Native American inhabitants of Haida Gwaii (Queen Charlotte Islands) of British Columbia, Canada. The Star House Pole is a house frontal pole commissioned by Anetlas (c. 1816–93), then chief of the K'ouwas eagle clan, for a potlatch (legal ceremony) held to adopt a young girl. Historically, this type of pole would have served as the entrance to a house, by way of a circular door carved through its bottom figure. All the figures on the pole relate to the history, crests, societal status and privileges of Anetlas and his wife, and the story behind each figure is provided by an oral history. The figures are viewed from bottom to top because, contrary to popular belief, the bottom figure on a Haida pole is usually the most significant.

The artist carved the Star House Pole from a red cedar tree, or ts'uu, that was approximately 600 years old. He would have spent a great deal of time searching for the right tree—ancient, tall, straight grain and tight rings—before felling and halving it, hollowing out its back and transporting it back to the village. There he would have carved the pole, using iron tools, as dictated by the crests and stories associated with Anetlas and his family. The painting on this pole follows classical Haida style. Black paint enhances the primary design elements, such as the raven's beak; red is used for secondary elements, such as lips and nostrils; and blue-green is used to highlight areas such as the eye sockets. The original paint was made from natural pigments that were ground and mixed with fish eggs—black from charcoal, red from red ochre and blue-green from a rare coppery clay.

The Star House Pole stood in front of Anetlas's home in Old Massett until it was sold and shipped to England in 1901. On Haida Gwaii, such poles are still being carved and raised by clans today. **NC**

1 THREE WATCHMEN

The watchmen's hats boast *skil*, or potlatch rings, which record the number of potlatches held by the pole's owner. The central watchman, representing Anetlas, had nine rings originally. Today only four remain; the rest are thought to have been cut off to fit the pole into a container for its journey to England.

2 BEAR WITH FROG IN MOUTH

This bear holds a frog in its mouth and a bear cub is stretched out below. Like the bear, the frog is a very common symbol on poles. Frogs can be easily identified by their toothless mouths and crouched position; frequently they face down towards the ground.

3 GRIZZLY BEAR

The grizzly bear, or *xuuds*, bares sharp teeth while holding a human captive. The absence of a labret in the lower lip indicates that the figure is a man. Early documentation recorded that this section of the pole imparts a story about a bear-husband killing a hunter who stole his wife. Contemporary Haida believe it to be about a young girl who is kidnapped by bears and brought back to their village. She marries and gives birth to children who are half-bear, half-human.

4 RAVEN

The massive raven at the bottom of the pole probably represents a crest owned by Anetlas, whose clan has the rights to the raven as one of its crests. The absence of a lower lip labret in the human figure between the raven's wings indicates a male. He is holding what contemporary Haida believe to be a type of marine mammal. Although the base of this pole now sits on a platform, the pole extended at least 8 feet (2.4 m) into the ground in its original location.

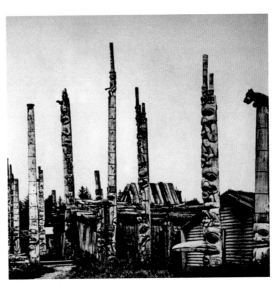

▲ A photograph taken in the 1880s of the Star House Pole in its original location in Old Masset (second from right). A Haida dwelling could have four or even five poles associated with it.

HAIDA ARGILLITE CARVING

Argillite carved objects became popular in the early 19th century when they were used by the Haida people to trade with Europeans. Numerous carvings were made solely for trading, rather than aesthetic or cultural purposes, and consequently the imagery of the early works in particular is a mixture of Haida and European styles. The Haida carving (below) features three humans, one wearing a hat of frogs, on an eagle. Argillite is mined at the Slatechuck quarry near Skidegate on the east side of Graham Island in Haida Gwaii. The exact location of the quarry is a well-kept secret because this variety of 'black slate' is found nowhere else in the world and the Haida people have exclusive rights over its use. In its natural state, argillite is green-black or grey-black in colour, but carvers rub it with oils and polish to give it a jet-black, glossy finish.

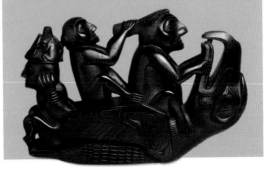

Sioux Exploit Robe early 19th century
ARTIST UNKNOWN

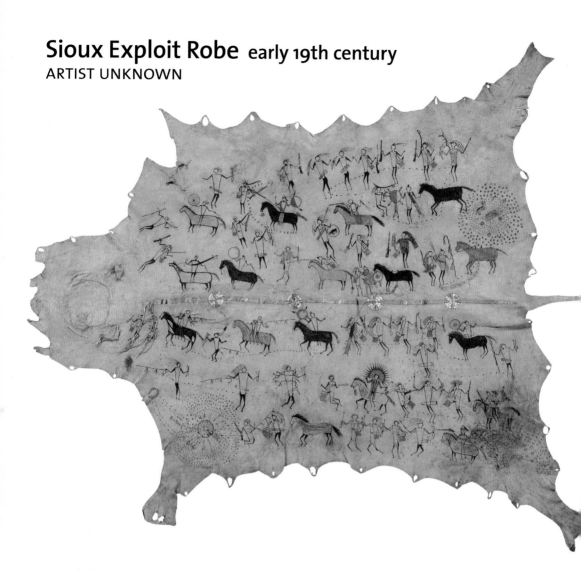

paint on buffalo hide
97 1/4 × 43 3/4 in. / 247 × 111 cm
Musée du Quai Branly, Paris, France

Exploit robes such as this Sioux example were an important visual record of the lives of male members of the native populations that inhabited the Great Plains of North America. They were worn wrapped around the body, with the skin of the head of the animal hanging on the left side of the wearer. Each robe illustrated the events from the life of the warrior who painted and wore it; the narrative can be read from right to left, beginning in the upper right corner. Encounters with enemies were of prime importance because a successful outcome would have been the principal way in which a young man would gain honour. Each scene on the exploit robe, connected through dashed lines, serves as a mnemonic device for recording enemy coups, battles won and horses stolen. The concentric circles of marks that appear on this hide relate to significant battles involving the wearer. The narrative celebrates the warrior's exploits, but also connects him to the spiritual world that provided him with the protection and power that enabled his success. It cannot be fully understood without the oral narrative that accompanied it. Many ceremonies centred around the buffalo and the buffalo hunt, and the meat and hide were used to feed, clothe and house people. As the buffalo herds were decimated in the 1880s and the Plains Indians were forced on to reservations, painters turned to other media to record the important histories of their tribes. **MS**

⚙ NAVIGATOR

FOCAL POINTS

1 HORSES

The inclusion of horses on the robe indicates their value within Plains cultural practices. Introduced by the Spanish in the 17th century, horses quickly became symbols of power and wealth, and contributed to the social and cultural transformation of Plains lifestyles. Alongside the introduction of guns, the use of horses facilitated territorial expansion and warfare; hunting buffalo also became much more efficient on horseback.

2 HUMAN FIGURES

Human figures are depicted in pictographic style; each person is frontally situated and simply outlined. Few figures have facial features yet their tribe can be identified by the specific hairstyles of different Plains groups. The torsos are tapered and movement is indicated through outstretched arms and bent legs. Increased access to Western artistic conventions in the second half of the 19th century led to more detailed and naturalistic representations.

3 WAR BONNET

A man on horseback wears a headdress or war bonnet. It is made from golden eagle feathers and was worn only by accomplished warriors. The individual feathers, known as honour feathers, were awarded for daring and heroic acts; they were notched and decorated to designate each brave deed.

4 HOLES ON EDGES

The women of the tribe prepared the hides. The holes along the edges indicate where stakes were used to stretch the skin for drying and painting. The hide was often cut in half for tanning, which was a long process that included soaking the skin in the brains of the animal to soften it.

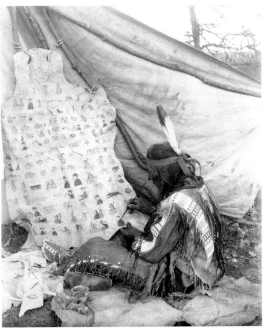

▲ Sam Kills Two, a Sicangu Lakota man, paints a winter count on to a suspended hide—Rosebud Reservation, South Dakota, c. 1910. Each image represents a significant moment in every year from the late 18th century to the early 20th century.

STAR QUILT

At the lower centre of the robe (opposite) is a Plains warrior wearing an elaborate war bonnet. The representation of the war bonnet on the robe relates to a geometric motif known as the feather design, which embellished hide robes worn by men. Composed of concentric circles of long, narrow triangles, this design emulates the feathers of the war bonnet as seen from behind. The importance of the design continues to the present day in the form of star quilts (example below) made by women. Quilting was introduced in the late 19th century and quickly became incorporated into cultural practices. Although the media have changed from hide to cloth, quilts continue to foreground important symbols of honour as they are used and worn in secular and ceremonial contexts.

ORIENTALISM

1 *The Turkish Bath* (1862)
Jean-Auguste-Dominique Ingres
canvas on wood panel
42 ¹/₂ x 43 ¹/₄ in. / 108 x 110 cm
Louvre, Paris, France

2 *The Bab-El-Gharbi Road, Laghouat* (1859)
Eugène Fromentin • oil on canvas
56 x 40 ¹/₂ in. / 142 x 103 cm
Musée de la Chartreuse, Douai, France

3 *The Scapegoat* (1854)
William Holman Hunt • oil on canvas
34 ¹/₄ x 55 ¹/₈ in. / 87 x 140 cm
Lady Lever Art Gallery, Liverpool, UK

The term 'Orientalism' is used to denote works of art produced in Europe in the 19th century that appeared to depict accurate images of the Near and Middle East. With the new availability of steam power and railways, many artists were able to travel to countries such as Turkey, Morocco, Egypt and the Arabian peninsula. Orientalism is characterized by a sense of accuracy in its imagery. A realist style imparts an impression of topographic or ethnographic truth to Orientalist works, regardless of whether or not they are in fact accurate portrayals. Indeed, some of the paintings were based on preconceived ideas about the Orient and feature obvious prejudices in the narratives that they tell. The paintings described as Orientalist share not so much a similarity of style as a unity of subject matter. They include images of life, landscapes and buildings and the popular motifs of fantastical harems, sultans and slave markets. By the end of the 19th century, the popularity of Orientalism as an art movement had declined, although Orientalist images and themes remained influential into the 20th century and inspired the travels and works of Pierre-Auguste Renoir (1841–1919), Henri Matisse (1869–1954) and Paul Klee (1879–1940).

The interest in making images of the 'Orient'—a term derived from the Latin meaning 'rising'—was in part prompted by the invasion of Egypt in

KEY EVENTS

1819	1832	1838	1842	1854–61	1860
Ingres exhibits at the Paris Salon. The exhibition is poorly received.	Delacroix travels to North Africa, where he fills several sketchbooks with drawings.	William Allan (1782–1850) exhibits *The Slave Market, Constantinople,* with the Blue Mosque as a striking element of the background.	Captain Colin Mackenzie, a veteran of the recent war in Afghanistan, wears an Afghan costume as he sits for his portrait by James Sant (1820–1916).	Holman Hunt paints *A Street Scene in Cairo: The Lantern Maker's Courtship,* inspired by his travels around North Africa and the Middle East.	Henriette Browne (1829–1901) is one of the first female artists to paint harem scenes.

98 by Napoleon Bonaparte (1769–1821), and it was predominantly French
nd British artists who worked within the Orientalist tradition. *The Turkish
ath* (opposite) by Jean-Auguste-Dominique Ingres (1780–1867) is a crowded
omposition, filled with voluptuous, alluring and flawless female nudes. The
rcular shape of the painting gives the impression that the women are being
ewed through a peephole and that the scene exists for the pleasure of the
nlooker. Although Ingres's work includes exotic motifs, he never travelled to
e East. His images of inviting, sensuous flesh differ in tone from the works
f Antoine-Jean Gros (1771–1835) and Pierre-Narcisse Guérin (1774–1833), who
roduced large historical scenes. Gros's paintings are grand epics, concerned
ith fulfilling the demands of imperialism; although they feature Islamic
rchitecture and dress and North African light and terrain, they are designed
o justify Napoleon's campaigns in Egypt.

Artists such as Eugène Fromentin (1820–76) and William Holman Hunt
827–1910) travelled to the Near and Middle East and depicted both real
nd imagined scenes. They produced paintings of landscapes, monuments
nd contemporary scenes that they exhibited as objective and documentary:
Fromentin's street scene *The Bab-El-Gharbi Road, Laghouat* (right, above)
oldiers seek respite from the sun. North African and Arabian landscapes
ere also used as settings in which to portray historical and biblical scenes.
olman Hunt made three visits to the Middle East to portray his paintings in
n authentic setting with accurate local detail. *The Scapegoat* (below) depicts
ne of the two sacrificial goats used in the rituals of the Day of Atonement, as
escribed in the Book of Leviticus. Hunt made the painting near the Dead Sea
nd went to great lengths to find a rare white goat to study. The red ribbon
ymbolizes Christ's crown of thorns. **AB**

1865	1871	1877	1882	1888	1896
awrence lma-Tadema 836–1912) cements is reputation with aintings inspired by he history and culture f Egypt.	Jean-Léon Gérôme (1824–1904) paints *Prayer in the Mosque* (see p.288), a reverent depiction of a non-Christian religion painted by a European.	Construction begins on Lord Leighton's Arab Hall, decorated with tiles bought on travels throughout North Africa and the Middle East.	Russian Jews begin to establish early Zionist settlements, which lead to the founding of the modern Zionist movement.	William Blake Richmond (1842–1921) paints *The Libyan Desert, Sunset*. It pays homage to the Romantics (see p.266) and the Impressionists (see p.316).	*Der Judenstaat* (The State of the Jews) by Theodor Herzl is published. It encourages Jews to migrate to the 'Land of Israel'.

Prayer in the Mosque 1871

JEAN-LÉON GÉRÔME 1824 – 1904

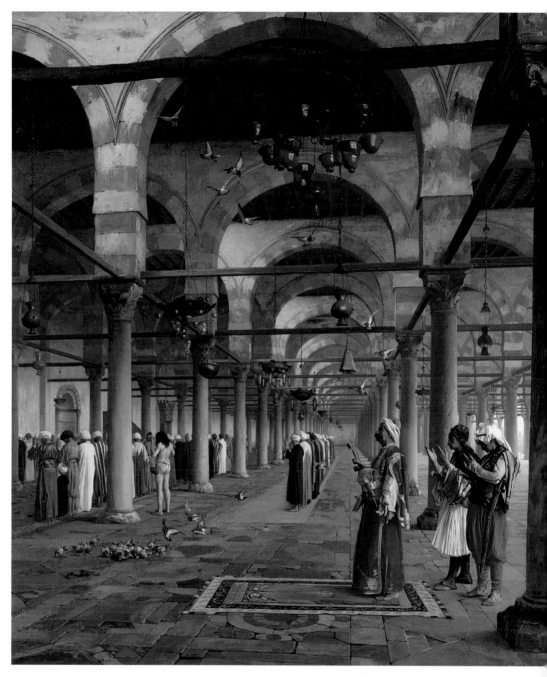

oil on canvas
35 x 29 ½ in. / 89 x 75 cm
Metropolitan Museum of Art,
New York, USA

ean-Léon Gérôme was discouraged from painting by his family, but he nonetheless trained as an artist in the studios of Paul Delaroche (1797–1856) and then of Charles Gleyre (1806–74). He travelled to Italy and visited Pompeii, and this led him to specialize rly on in scenes of ancient Greek and Roman daily life or history. From 1853 he regularly avelled to Turkey, Egypt and Asia Minor and established a reputation for his paintings of e Near and Middle East. Throughout his career, Gérôme focused his interest on personal ther than overtly political themes, from the piety of Muslim worshippers to the exotic nsuality of the bathhouse and the dark undercurrents of slave auctions.

Although it is unlikely that Gérôme witnessed the particular scene of worship in this ainting, he has represented a typical event in such detail, evidence of close observation, at a sense of authenticity prevails. *Prayer in the Mosque* depicts the mosque of Amr in airo, which had fallen into disuse by the time Gérôme came to see it in 1868 on his urney to Egypt. The seemingly infinitely repeated columns create a rhythm that precipitates e eye towards the empty back wall, and the upright pillars are echoed visually by the neatly igned worshippers. It is likely that the painting, like many other of the artist's Orientalist orks, is based on various sketches and photographs produced at different times during his avels. He used this realistic style to create all his imaginary scenes and the precise handling f his brush and smooth finish of his paintings produce a quasi-photographic surface. **AB**

FOCAL POINTS

1 MOSQUE INTERIOR
Gérôme represents the mosque as faithfully as possible. The prayer niche, or mihrab, on the left wall indicates the direction of Mecca, towards which all figures are turned to pray. From the ceiling hang different lanterns, and a dramatic perspective defines the space.

2 HOLY MAN
One figure who stands out from the worshippers is a Muslim holy man. Unlike most of the others, he is standing directly on the tiled floor. Isolated, he looks vulnerable, dressed in only a loincloth. His head is uncovered to reveal his long hair and on his left arm hangs a begging bowl.

3 WEALTHY MAN
In contrast with the holy man's simplicity, a figure in bright red and gold clothing stands out in the foreground. He is a notable personage who displays his higher social status by having two attendants. Instead of worshipping on one of the communal carpets, he stands on a personal prayer mat.

4 PIGEONS ON FLOOR
The solemn, religious atmosphere of the mosque is disturbed only by pigeons that have flown in from the courtyard visible on the far right. The worshippers, their minds on their prayers, accept the pigeons' presence in the mosque and ignore their flapping wings and cooing.

ARTIST PROFILE

1840–45
After attending the Paris studios of Paul Delaroche and Charles Gleyre, Gérôme studied at the Ecole des Beaux-Arts.

1846–52
Gérôme failed to win the Prix de Rome in 1846 but produced numerous successful works on Greco-Roman themes. His *Anacreon, Bacchus and Cupid* (1848) won him a second-class medal at the Paris Salon. In 1848 he co-founded the Néo-Grec group with Jean-Louis Hamon (1821–74) and Henri Pierre Picou (1824–95); all three had been pupils of Gleyre.

1853–63
A journey with actor Edmond Got to Constantinople in 1853 was the first of many trips to the Near East. Gérôme's first visit to Egypt in 1856 inspired many Orientalist paintings of Arabs in religious and historical settings. In 1863 he married Marie Goupil, daughter of the publisher Adolphe Goupil.

1864–1904
Gérôme became a sculptor in later life. He was elected a member of the Institut de France in 1865 and an honorary member of the British Royal Academy in 1869.

JAPANESE ART

1 *Fifty-three Stations of the Tokaido Highway: Early Departure from the Daimyo's* (c. 1834)
Utagawa Hiroshige • woodblock print
10 x 14 5/8 in. / 25.5 x 37.5 cm
Brooklyn Museum of Art, New York, USA

2 *Tour of the Waterfalls of Various Provinces: Amida Waterfall on Kisokaido Road* (1830)
Katsushika Hokusai • woodblock print
14 x 10 in. / 35.5 x 25.5 cm
Weatherspoon Art Museum, Greensboro, USA

3 Cover of *Le Japon Artistique* (1888)

The art of *ukiyo-e* (pictures of the floating world) flourished with a new vigour in the first half of the 19th century when several series of landscape prints by Katsushika Hokusai (1760–1849) and Utagawa Hiroshige (1797–1858) were published in quick succession. Hokusai's *Tour of the Waterfalls of Various Provinces: Amida Waterfall on Kisokaido Road* (top, right) is a typical example. The scene shows the round hollow of the waterfall, reminiscent of the head of the Amida, the Buddha of Boundless Light. The dominant use of blue characterizes the landscape prints by both Hokusai and Hiroshige. The so-called Prussian blue made from synthetic aniline dye was imported from the West in the early 19th century, and soon replaced the fugitive (less permanent) traditional colour made from plants.

Hokusai's *Thirty-six Views of Mount Fuji* (c. 1829–33) was a monumental work that established landscape as a popular genre. It was inspirational for his younger contemporary Hiroshige who designed *Fifty-three Stations of the Tokaido Highway: Early Departure from the Daimyo's* (above), which shows the fifty-three post stations along the coastal path of the Eastern Sea Road where travellers could break their journey for rest and refreshment. Hiroshige's scene depict various travellers, including the grandest, the *daimyo*, the feudal lords who journeyed to Edo from their provincial estates to attend the shogun's court. Hiroshige continued the theme of topographical prints with other series, such as *One Hundred Famous Views of Edo* (1856–58), which provide a valuable record of 19th-century Japan. Images of the countryside in different

KEY EVENTS

1811	1826–33	1854	1863	1867	c. 1868
The Tokugawa shogunate permits the translation of foreign-language books for the first time.	Katsushika Hokusai publishes his influential series of landscape prints, *Thirty-six Views of Mount Fuji*.	Japan opens up its sea ports to traders from the West for the first time in two hundred years. Europe consequently becomes fascinated with Japan.	Anglo-Italian photographer Felix Beato (1832–1909) arrives in Japan. His photographs inspire European artists.	The Exposition Universelle (World Fair) in Paris includes a Japanese pavilion for the first time.	A revolution in Japan sees the restoration of the Meiji emperor to power and impulse to bring Japan into greater accord with the West.

easons captured the imagination of the city-dwellers in Edo and encouraged appreciation of the beauty of nature as well as a yearning to travel. Hiroshige's lyrical and romantic views of rural Japan offered a comfort and an escape from the realities of Edo society, which was becoming chaotic and decadent.

Japan faced radical political and social changes in the mid 19th century when the authority of the Tokugawa shogunate began to crumble. The pressure from Britain and the United States forced Japan to open up to the outside world after a long period of seclusion. In 1868 a coalition of samurai leaders deposed the shogun and established a new government in Edo, now renamed Tokyo. The second half of the 19th century was marked by rapid westernization carried out under the slogan 'Bunmei kaika' (Civilization and Enlightenment).

The enthusiasm for large-scale expositions was initiated by the Great Exhibition in London in 1851 and many international expositions followed in Europe and the United States in the second half of the 19th century. The Japanese government was keen to participate in the international arena, hoping to increase exports and to boost the economy of the newly formed government. In Britain, the International Exhibition held in London in 1862 provided a large display of Japanese art ranging from *ukiyo-e* prints, bronzes, ceramics, lacquered and enamelled works, and textiles. Victorian artists began to collect Japanese objects, and Japanese elements featured prominently in the Aesthetic movement (see p.310). Christopher Dresser (1834–1904), a designer and an entrepreneur, travelled to Japan and supplied goods to the newly opened Liberty store in Regent Street and Tiffany & Co in New York.

Japanese art and crafts were received enthusiastically in France, aided by the influence of art critic Edmond de Goncourt (1822–96) who spearheaded the fashion for all things Japanese, precipitating the rise of Japonisme. Tadamasa Hayashi, a Japanese art dealer in Paris, is known to have sold more than 150,000 *ukiyo-e* prints between 1890 and 1901. The artists of the Impressionist (see p.316) and Post-Impressionist (see p.328) movements were captivated by the dynamic visual effects in *ukiyo-e* prints. Some of the unique characteristics in *ukiyo-e*, such as exaggerated foreshortening, asymmetry in composition, areas of flat colour and the cropping of figures, were taken up by the young artists working in Impressionist and Post-Impressionist circles.

Siegfried 'Samuel' Bing (1838–1905), a German art dealer working in Paris, also contributed to the spread of Japonisme. From 1888, he published a monthly illustrated journal *Le Japon Artistique* (right), which played a key role in disseminating Japanese aesthetics to a European audience. He was keen to point out the importance of natural motifs in Japanese art. His store in Paris, Maison de l'Art Nouveau, opened in 1895. It initiated the Art Nouveau movement (see p.346) and inspired the most representative French artist of the movement, Emile Gallé (1846–1904), to design sinuous glass vessels with floral and insect motifs. **MA**

1872	1876	1878	1885	1890	1891
James McNeill Whistler (1834–1903) sketches *Japanese Woman Painting a Fan*, characterized by a quasi-Asian subtlety and delicacy.	Claude Monet (1840–1926) exhibits *La Japonaise (Camille Monet in Japanese Costume)* at the second Impressionist Exhibition in Paris.	Hayashi (1853–1906) arrives in Paris to attend the World Fair. After it is over he starts an antiquarian business.	Gilbert and Sullivan's operetta *The Mikado*, inspired by Japanese culture, premieres at the Savoy Theatre in London.	Vincent van Gogh (1853–90) writes to his family about his painting *Blossoming Almond Tree* and how it was inspired by Japanese art.	Mary Stevenson Cassatt (1844–1926) shows a series of Japanese-style etchings in Paris, after seeing an exhibition of *ukiyo-e* prints.

Under the Wave, off Kanagawa *c.* 1829 – 33
KATSUSHIKA HOKUSAI 1760 – 1849

woodblock print
10 ¹/₄ x 14 ⁷/₈ in. / 26 x 38 cm
British Museum, London, UK

One of the best-known images of Japanese art in the West, *Under the Wave, off Kanagawa* was designed by Katsushika Hokusai as part of his series *Thirty-six Views of Mount Fuji*. Landscape was a new subject matter for *ukiyo-e* woodblock prints in the early 19th-century Edo period and Hokusai's series was well received. Landscapes were used only as backdrops for human activities in the *ukiyo-e* prints of the 18th century; in Hokusai's image, nature assumes centre stage. The tiny figures in the boats, precariously bobbing on the raging sea, seem about to be engulfed by the huge wave. The ominous sky behind the snow-covered Mount Fuji adds a threat of more bad weather. The work suggests the frailty of human existence compared to nature's power. **MA**

1 HOKUSAI'S SIGNATURE

Hokusai's signature appears on the left of the title cartouche. It reads: 'Hokusai aratame Iitsu hitsu' (by the brush of Iitsu, formerly Hokusai). Hokusai is known to have used up to thirty different names during his long career. He signed many of his works 'Gakyojin Hokusai' (Hokusai, mad on drawing).

2 CLAW-LIKE WAVES

The crest of the wave is frozen at its height, before it overwhelms the boats. The claw-like peaks of water froth as if they are alive and emphasize the overpowering force of nature. The impending crash introduces tension to the foreground in contrast to the serenity of Mount Fuji behind.

3 ATMOSPHERIC SKY

The subtle gradation in the sky creates a brooding atmospheric effect around Mount Fuji. It is known as the bokashi technique and is achieved by partially wiping the colour off the block before printing. The technique was one of many that changed 19th-century woodblock printing.

🕐 ARTIST PROFILE

1778–1803

At the age of eighteen, Hokusai was accepted into Shunsho's studio and was given his first professional name: Shunro. He established himself as a skilful *ukiyo-e* artist, specializing in genre scenes and images of graceful women.

1804–20

Hokusai began to focus on landscapes and images of daily life in Japan. He worked in collaboration with author Takizawa Bakin and illustrated many popular novels and fantasy books. He also published his first *Hokusai Manga* (1814–78).

1821–33

During the 1820s, Hokusai was at the peak of his career and published his most celebrated series of prints, *Thirty-six Views of Mount Fuji*, which was an immediate success. It was so popular that Hokusai added ten more prints to the series.

1834–49

Hokusai designed black and white illustrations for another notable landscape series, *One Hundred Views of Mount Fuji*, in 1834. He continued to produce important work in later life; despite this success, he lived and died in near poverty.

✧ NAVIGATOR

PRE-RAPHAELITE ART

1 *Ophelia* (1851–52)
John Everett Millais • oil on canvas
30 x 44 in. / 76 x 112 cm
Tate Britain, London, UK

2 *The Last of England* (1852–55)
Ford Madox Brown • oil on canvas
32 ¹/₂ x 29 ¹/₂ in. / 82.5 x 75 cm
Birmingham Museum and Art Gallery,
UK

3 *The Day Dream* (1880)
Dante Gabriel Rossetti • oil on canvas
62 ¹/₂ x 36 ¹/₂ in. / 159 x 93 cm
Victoria & Albert Museum, London, UK

In 1848, seven students at London's Royal Academy formed a secret society called The Pre-Raphaelite Brotherhood. The dictates of the Academy's first president, Sir Joshua Reynolds (1723–92), were still in force and the students wanted to move away from sombre colour palettes, fixed subject matter and rigid conventions. The three founding members of the Brotherhood were John Everett Millais (1829–96), Dante Gabriel Rossetti (1828–82) and William Holman Hunt (1827–1910); they were joined by Thomas Woolner (1825–92), Frederic George Stephens (1828–1907), James Collinson (1825–81) and William Michael Rossetti (1829–1919). They admired early Italianate art and were nostalgic for the medieval period, believing medieval art to be freer and more experimental than in their own era. They marked their art with the initials 'PRB'.

Of the seven members of the Brotherhood, only six were artists. William Rossetti was an aspiring writer, with a full-time day job at the tax office in London. One of the aims of the Brotherhood was the melding of art and literature and they produced a monthly magazine, *The Germ*, sub-titled 'Thoughts towards Nature in Poetry, Literature and Art'. Very few copies were sold and only four issues were published. Although a financial failure, the journal was critically acclaimed and in later years it became hugely influential.

The Pre-Raphaelite (or 'before Raphael') artists painted with painstaking fidelity to nature, often choosing medieval romance as their subject matter. Although the French Impressionists (see p.316) are usually credited with beginning the practice of *plein-air* painting, the Pre-Raphaelites were painting out of doors several decades earlier. Millais painted *Ophelia* (above) as an

KEY EVENTS

1848	1849	1851	1852	1853	1854
The first meeting of the Pre-Raphaelite Brotherhood (PRB), a secret artistic society, takes place at Millais's family home on Gower Street, London.	The first painting to be inscribed with the letters 'PRB' is exhibited in the Free Exhibition at Hyde Park Corner.	John Ruskin writes a letter in defence of Pre-Raphaelitism to *The Times*. Holman Hunt and Millais paint in the open air for the first time.	Woolner emigrates to Australia, inspiring Madox Brown's *The Last of England* (above right). Collinson enters the Jesuit community at Stonyhurst, England.	The PRB comes to an end. Burne-Jones and Morris meet at Exeter College, Oxford. The Millais brothers travel to Scotland with Ruskin.	Holman Hunt travels to the Middle East. Woolner returns to England. Collinson leaves the Jesuit community and returns to art.

illustration of her drowning in Shakespeare's *Hamlet*. While the figure of Ophelia herself was painted in the studio, Millais spent many days by a riverbank painting the vegetation and incorporating flowers mentioned in the play. Like his colleagues, Millais primed the canvas with white paint, then layered colours on top of it before it was fully dry. This 'wet white ground' gave the Pre-Raphaelite paintings a luminosity of colour that echoed Early Renaissance art (see p.150). Millais's earlier work *Christ in the House of His Parents* (1849–50; see p.296) attracted harsh criticism at the Royal Academy's Summer Exhibition of 1850. Novelist Charles Dickens (1812–70) condemned the painting as being too brutally realistic. He also accused the Brotherhood of bringing 'distasteful' subjects into art, such as prostitution, ugly poverty and unartistic death. For some time any painting associated with Pre-Raphaelitism, even if the artist was not a member of the group, was deeply unfashionable.

The Pre-Raphaelite Brotherhood lasted only five years yet it led to one of the most influential British artistic movements. Among the group's associates were G. F. Watts (1817–1904) and Ford Madox Brown (1821–93). Brown's *The Last of England* (above right), depicting a couple leaving England for a new life in Australia, was painted out of doors; it owes its intense emotion and its faithful reproduction of the light on a dull day at sea to Pre-Raphaelite ideals. Madox Brown remained true to Pre-Raphaelitism for many years, but Watts went through many revolutions of style, including a period as a pillar of the Symbolist movement (see p.338).

By the late 1850s, Pre-Raphaelite art was admired and widely emulated. A 'second generation' of Pre-Raphaelite artists emerged, the most successful of whom were William Morris (1834–96), who went on to found the Arts and Crafts movement, and Edward Burne-Jones (1833–98). Burne-Jones's early work was most influenced by the fantasy of works by Rossetti, such as *The Maids of Elfen-Mere* (1854); in Rossetti's later painting *The Day Dream* (right), Morris's wife, née Jane Burden, appears as a temptress, her body clothed in sensuous satin shining against a stylized background. Burne-Jones also revelled in depicting women as love objects in medieval costume, often, as in his *Briar Rose* series (c. 1870–90), in meticulously reproduced natural settings.

Several women other than Jane Burden were associated with the movement. Lizzie Siddal (1829–62) was not only a model, muse and Dante Rossetti's wife, but also a fledgling artist. Maria Spartali-Stillman (1844–1927) was one of Burne-Jones's pupils, as well as being much in demand as a model. Her cousin, Maria Zambaco (1843–1914), was a sculptor and the inspiration behind many of Burne-Jones's most mesmerizing paintings. Other Pre-Raphaelite artists included Arthur Hughes (1832–1915), whose inspiration to paint came from reading an issue of *The Germ*; Valentine Prinsep (1838–1904), a star pupil of G. F. Watts; and John William Waterhouse (1849–1917), who took Pre-Raphaelitism into the next century. **LH**

1857	1858	1861	1880	1888	1890
Madox Brown organizes an exhibition of Pre-Raphaelite work. The Manchester Art Treasures exhibition also includes work by the Pre-Raphaelites.	Morris publishes his first book of poetry. Madox Brown founds the Hogarth Club —a society to exhibit Pre-Raphaelite art.	Morris founds Morris, Marshall, Faulkner & Co. The company's goods prove very popular at the 1862 International Exhibition in London.	Prinsep exhibits *The Delhi Durbar of 1877* for the first time. The work is later installed in Buckingham Palace.	John Waterhouse paints *The Lady of Shalott* (see p.298). Its realistic style and medieval subject matter recall early Pre-Raphaelitism.	Burne-Jones exhibits a series of paintings entitled *The Legend of Briar Rose*. They depict scenes from a poem by Morris.

Christ in the House of His Parents 1849 – 50

JOHN EVERETT MILLAIS 1829 – 96

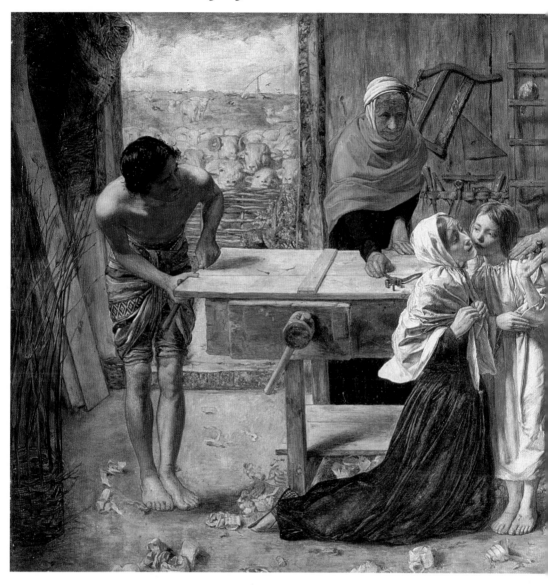

oil on canvas
34 x 55 ⅛ in. / 86.5 x 140 cm
Private collection

This painting, also called *The Carpenter's Shop*, depicts Joseph, Mary, Jesus, St Anne and her son, who was later known as John the Baptist, and an unnamed second man, presumed to be Joseph's apprentice. This simple scene is set in Joseph's carpentry workshop and is full of religious imagery prefiguring Christ's crucifixion. Jesus has cut his hand on a nail sticking out of the wooden bench and holds his palm up for examination. His mother kneels in front of him and raises her cheek to be kissed; her face is sorrowful as though prescient of what is to come. Joseph reaches out to inspect the wound and St Anne is about to remove the nail. John brings a bowl of water to wash the blood away. Criticized when it first appeared for being blasphemous, this painting has since become recognized as one of Millais's greatest works and a masterpiece of early Pre-Raphaelitism. **LH**

◉ FOCAL POINTS

1 FLOCK OF SHEEP

Seen through the open doorway, a flock of sheep reminds the viewer of Jesus's title 'Lamb of God', referring to his sacrifice to atone for human sin. The animals' interest in the scene also calls to mind Christ the Shepherd and his flock of faithful Christian followers.

2 CARPENTER'S WORKSHOP

Millais found a carpenter's workshop in Oxford Street, London, and spent hours there sketching the scene, from the tools on the back wall to the planks of wood in the corner and the curls of wood shavings on the floor. In his preliminary sketch, the tools on the wall formed the sign of the cross.

3 WORKING MAN

Joseph's bare skin offended prudish Victorian convention, and contemporary viewers were furious that Millais had made the Holy Family appear as ordinary people. A few decades later Millais would have been praised as a master of realism, but in 1850 he was accused of blasphemy.

4 JOHN

John is dressed in an animal skin, a reference to his later asceticism. The bowl of water he carries to wash the cut is a link to his baptism of Jesus in later life, as well as to Jesus later washing away his followers' sins. His attitude is humble, as though he knows Jesus's true nature.

5 WOUNDED HAND

The painting is filled with Christian symbolism. Jesus's hand is bleeding, as if marked with the stigmata; the nail he has cut it on prefigures the nails with which he will be fixed to the cross. His hand shows the cut but also suggests a sign of benediction, familiar from images of the adult Jesus.

⬍ NAVIGATOR

The Lady of Shalott 1888

JOHN WILLIAM WATERHOUSE 1849 – 1917

oil on canvas
60 ¹/₄ x 78 ³/₄ in. / 153 x 200 cm
Tate Britain, London, UK

NAVIGATOR

This painting was inspired by a poem, 'The Lady of Shalott' (1842) by Alfred Lord Tennyson (1809–92), which was itself based on Arthurian legend. When John William Waterhouse sought to express the poem on canvas he focused on the lines, 'And down the river's dim expanse / Like some bold seer in a trance . . . / With a glassy countenance / Did she look to Camelot.' The lady in the legend has spent years imprisoned in a tower on a river island with weaving as her sole pursuit. She understands that she must never look out of the window or a curse will fall upon her; instead, she watches the world outside by its reflection in a mirror. When a knight, Sir Lancelot, rides past singing, she falls instantly in love. She abandons her loom and rushes to the window, but then the mirror cracks and she knows she has been cursed. She leaves the tower, climbs into a boat and slowly floats down the river to Camelot and her death. Waterhouse chose to depict this departing moment— the point of no return as she prepares to leave her home. The theme of a woman abandoning a celibate life for one of doomed passion was extremely popular in Victorian literature, art and melodrama, but the lady's story has resonances beyond romance. Tennyson was addressing the issue of personal isolation and the necessity of participating more fully in society, and his theme was taken up many times by Pre-Raphaelite artists, notably William Holman Hunt and Dante Gabriel Rossetti. Waterhouse himself was to paint two more scenes from the poem. **LH**

FOCAL POINTS

1 LADY'S FACE

The model's expression and the way her head is raised upwards recall the appearance of Lizzie Siddal in Dante Gabriel Rossetti's painting *Beata Beatrix* (1864–70). Rossetti depicted Beatrice, loved by Dante, at the moment of her death; Waterhouse's lady knows death is imminent.

2 CANDLES AND CRUCIFIX

Of the three candles in the prow of the boat, two have been extinguished by the wind, an indication that the lady is almost at the end of her journey and her life. The crucifix lying before her is a reminder of sacrificial death and suggests that the lady will find her way to heaven.

3 FLOATING LEAVES

The leaves on the water represent not just the autumn of life but the Victorian notion of the 'fallen woman', a woman who has succumbed to sexual temptation. This detail is a reminder of Millais's *Ophelia* (1851–52), which has a similar theme and also contains rich symbolism from nature.

4 EMBROIDERY

Draped over the boat is the embroidery that the lady has been making. In the circles are scenes that she has seen in the mirror during her imprisonment, including Sir Lancelot on his charger. They show a life denied to her— and one that she is now determined to discover.

5 CHAIN

The chain held loosely in the lady's right hand has kept the boat moored to the island, but it also has a metaphorical meaning. It represents her fears of the unnamed curse that has bound her to her loom and her tower. By letting go of the chain (and her fears), she is setting herself free.

ARTIST PROFILE

1871–85

Waterhouse enrolled with the Royal Academy Schools in 1871. Three years later, one of his paintings was accepted for the Academy's Summer Exhibition. In 1885 the artist was elected an Associate of the Royal Academy after his exhibition of *St Eulalia* (1885; below). It focuses, like many of his subsequent paintings, on the tragic fate of a young woman—in this case, martyrdom for refusing to honour pagan gods.

1886–89

The artist attended a mid-career exhibition of John Everett Millais in 1886 and became more aware of the Pre-Raphaelite movement. His masterpiece of 1888, *The Lady of Shalott*, combines a Pre-Raphaelite sensibility with the French naturalistic style of Jules Bastien-Lepage.

1890–1913

Waterhouse abandoned classical subjects in favour of myths and magic in classical antiquity. English woods and coastal waters become the setting for fairy-tale encounters, as in *The Naiad* (1893) and *Hylas and the Nymphs* (1896). His paintings featuring nude young women, hugely popular in his time, tend now to be criticized as voyeuristic.

1914–17

The artist returned to narratives in historical settings. His sources were Shakespeare—he paints Miranda in *The Tempest*—and medieval ballads and romances.

SUCCESSIVE INFLUENCES

John William Waterhouse was an artistic chameleon. His style changed several times throughout his long career. Much of his early work was indebted to the paintings of John Everett Millais and Dante Gabriel Rossetti. This inspiration did not go unnoticed; writer and critic George Bernard Shaw commented acidly: 'Giving reminders of other artists is quite a specialty with Mr Waterhouse.' The influence of Sir Lawrence Alma-Tadema on Waterhouse's work became apparent in his Roman-inspired subjects, such as *St Eulalia* (1885; below). It was this painting, created three years before *The Lady of Shalott*, that earned

Waterhouse his place in the Royal Academy. He became a popular tutor at the Academy's art school and many of his students also adopted the French naturalistic style, especially after Waterhouse completed *The Lady of Shalott*—just as earlier on he had emulated the styles of his own heroes.

REALISM

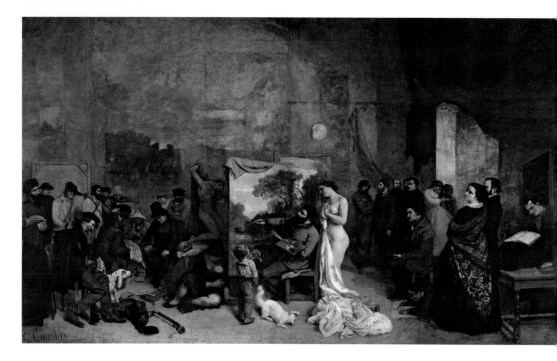

Realism marked a formal and stylistic shift away from the idealized, dramatic nature scenes and history paintings of early 19th-century Academic art (see p.276). It was part of a wider movement in the arts that began in France in the wake of the February Revolution of 1848. Rapid population growth, successive failed crops and rapid industrialization had caused deprivation and hardship for the poor in both rural and urban areas. This led to considerable unrest and culminated in the Revolution, after which the provisional government granted universal male suffrage and accorded citizens the 'right to work'. The poor now had a political voice. Realist painters responded to the social and political changes by rebelling against the art establishment and eschewing Romanticism (see p.266), choosing to depict ordinary people and events in a naturalistic, almost photographic, painting style based on close observation. They often painted such scenes on large-scale canvases to deliberately elevate their significance to that of major historic events.

Gustave Courbet (1819–77) is considered to be the leader of the Realist movement and his painting *The Artist's Studio: A Real Allegory Summing Up Seven Years of My Artistic and Moral Life* (above) declares his political and artistic agenda. In it he combines the prestigious style and scale of

KEY EVENTS

1830–32	1848	1848	1850	1856–57	1857
Writer and pioneer of literary realism Honoré de Balzac (1799–1850) publishes six novelettes titled *Scenes from Private Life*.	The Salon accepts ten of Courbet's paintings. He develops a friendship with the influential art critic Champfleury, who becomes his champion.	Marx and Engel's radical pamphlet, *The Communist Manifesto*, is published in London by a group of German political refugees.	Courbet's sympathetic portrayal of two peasant workers, *The Stonebreakers* (1849; destroyed in 1945), sparks outrage when it is shown at the Salon.	As the theoretician of the Realist movement, Champfleury edits the periodical *Realism*.	Millet's *The Gleaners* is shown at the Salon. It is regarded as politically subversive in its portrayal of the hardships of rural poverty.

history painting with the realistic subject matter of his studio, thereby ridiculing the idealized stance of Academic art. On the left of the painting are representatives from all walks of life—both rich and poor—including a priest, merchant, hunter and beggar. On the right Courbet depicts his friends, including his patron Alfred Bruyas (1821–77), the philosopher and anarchist Pierre-Joseph Proudhon (1809–65), the critic and novelist Champfleury (1821–89) and poet Charles Baudelaire (1821–67). The artist is shown in the centre with a naked female muse, a cat and a child. Courbet's critique of Academic art did not find favour with the art establishment. The jury at the Paris Salon of 1855 accepted more than ten of Courbet's paintings, but refused to exhibit *The Artist's Studio*. This prompted the artist to organize a solo show at the Paris 'L'Exposition Universelle' in 1855. He built his own pavilion and called it 'Le Réalisme'. The exercise did not result in significant sales but it brought Courbet to the attention of a younger generation of Parisian artists. After this exhibition, Courbet moved away from his early Romantic style and painted Realist landscapes, seascapes and still lifes, before moving on to more erotic subject matter. This included nudes such as *Sleep* (1866; see p.308) and *The Origin of the World* (1866), a frank study of female genitalia that was denied public exhibition until late in the next century.

The scrutiny of urban and social ills found its liveliest expression in the political caricatures and cartoons of Honoré Daumier (1808–79), whose lithographs were published in satirical political journals. Daumier also produced some 300 paintings, including *The Laundress* (right). This is the largest of three painted versions of the composition, one of which was exhibited at the Paris Salon in 1861. It is based on Daumier's observations from his studio, which overlooked the River Seine. He shows a washerwoman with her daughter arriving back on land from the laundry boats moored on the river; he gives them a statuesque nobility and grace to rival any Venus. The painting exemplifies the sympathy expressed by Realist artists for those whose lives consist of unrelenting toil. The pair are plainly exhausted, and the daughter, holding a beater, seems doomed to the same fate as her mother.

The countryside became an important subject for Realist painters, who depicted bleak landscapes in the same way that previous artists had portrayed major historical and mythic events. The Barbizon school of artists spearheaded the move towards painting rural scenes. Inspired by the rural scene paintings of English artist John Constable (1776–1837), the school was formed by a group of artists led by Jean-Baptiste-Camille Corot (1796–1875), Théodore Rousseau (1812–67), Jean-François Millet (1814–75) and Charles-François Daubigny (1817–78). They settled in the village of Barbizon near the forest of Fontainebleau and painted nature for itself rather than as a backdrop to mythical scenes. Millet explored the idea of depicting figures in his landscapes, including peasant labourers in works such as *The Gleaners* (1857; see p.304).

1 *The Artist's Studio: A Real Allegory Summing Up Seven Years of My Artistic and Moral Life* (1854–55)
Gustave Courbet • oil on canvas
142 ⅛ x 235 ⅜ in. / 361 x 598 cm
Musée d'Orsay, Paris, France

2 *The Laundress* (c. 1863)
Honoré Daumier • oil on wood
19 ¼ x 13 in. / 49 x 33 cm
Musée d'Orsay, Paris, France

1865	1867	1867	1871	1871	1872
Manet's *Olympia* is considered shocking because of its erotic nature when it is displayed at the Salon.	Courbet and Manet organize personal shows at the Place de l'Alma in Paris near the site of the Exhibition Universelle.	The first volume of Marx's *Das Kapital* (Capital) is published. It examines the significance of introducing machinery into the workforce.	The French Army is defeated in January after the Siege of Paris, bringing an end to the Franco-Prussian War.	The Paris Commune is formed in March. Courbet is elected to its council as president of the Fédération des artistes.	The Salon rejects paintings that Courbet created while being imprisoned for his participation in the Commune.

Rousseau preferred to paint landscapes *en plein-air*. Although he also included figures in his paintings, they were always dwarfed by the landscape, highlighting the power of nature and relative powerlessness of man. His melancholy paintings were refused so often by the Paris Salon over the course of twenty years that he was dubbed *le grand refusé* by the art critic Thoré. The Barbizon group's influence is apparent in Corot's landscapes, such as *Mantes, View of the Cathedral and Town through the Trees* (*c.* 1865–70), in which he depicts nature realistically with subtle rendering of foliage and the effects of light. However, Corot's adoption of a pearly-coloured palette and interest in light and shadow distinguish him from other Barbizon school members and mark him as a precursor of the Impressionists (see p.316). Although his earlier work depicts nature exactly, with a draughtsman's eye for outline and definition, the artist increasingly adopted an Impressionistic style in which the qualities of the landscapes were suggested rather than overtly stated.

Edouard Manet (1832–83), like Courbet before him, wished to free himself from the constraints of Academic art. His work bridges the gap between Realism and Impressionism, as much in his choice of subject matter as in his painting technique. Manet defied both the art establishment and public opinion by painting everyday scenes featuring beggars and denizens of cafes and taverns. His works, like the later works of Courbet, frequently caused controversy: *Olympia* (1863; see p.306), in which a nude model clearly identified as a worldly Parisian courtesan adopts the pose of Titian's *Venus of Urbino* (1538), was deemed scandalous. Although Manet was influenced by Courbet, he was never part of his inner circle, and Manet's theatrical sense of composition and use of black line distinguishes his works from those of the older artist.

Courbet's rejection of idealization and his close attention to portraying accurately what the eye sees had a strong influence on younger painters such as Henri Fantin-Latour (1836–1904), who studied at Courbet's studio in 1861. Fantin-Latour became known for his portraits and still lifes, particularly those of flowers, such as *Roses in a Champagne Flute* (opposite, above). While it may

em that painting flowers could never be an act of rebellion, Fantin-Latour
as aware that a still life with fruit or flowers was judged to be the lowest
enre of painting by the Académie des Beaux-Arts. He eschewed religious,
erary and historical scenes and instead produced images intended to appeal
urely to the eye. Fresh, vital and remarkable in his dextrous use of paint,
ntin-Latour produced works that defied the strictures of Academic art.

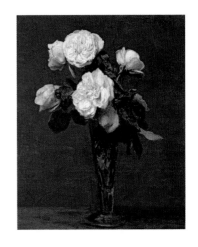

The Realist movement was not confined to France. By the middle of the
th century, political revolts had broken out in Austria, Germany and Italy
s a result of an increasing social awareness and a belief in democracy and
dividual freedom. Socialism, as propagated by German philosophers Karl
arx (1818–83) and Friedrich Engels (1820–95), was centred on the ideal of
cial equality and a fair distribution of wealth. This ideology became the
ison d'être of much Realist art. In 1870 a group of Realist artists formed the
ociety for Travelling Art Exhibitions in Russia, a collective that staged shows
an effort to bring art to the people. Group members became known as 'The
anderers' or 'The Itinerants'. Among them was Nikolai Kasatkin (1859–1930),
ho is known for his genre paintings of workers and miners in the Donets
asin in the Ukraine, an example of which is *Poor People Gathering Coal at an
xhausted Mine* (opposite). The standing woman looking directly at the viewer
lls attention to the hopeless existence and daily struggles of the poor.

The 19th century was a time of rapid technological progress and
dustrialization. Although the output of Adolph Menzel (1815–1905) varied in
oth style and content throughout his career, he is recognized as Germany's
remost Realist painter for grand-scale works that examine working-class life
nd conditions. For *The Iron-Rolling Mill* (below), Menzel did more than
o preparatory sketches at the Chorzów (then called Königshütte) steelworks
southern Poland, which was part of Prussia at that time. The painting's
rovocative modernity made it an instant sensation and it quickly became
nown as *Moderne Zyklopen* (Modern Cyclops), a title that elevated the harsh
ality of an industrial worker's life to the status of mythology. **ED**

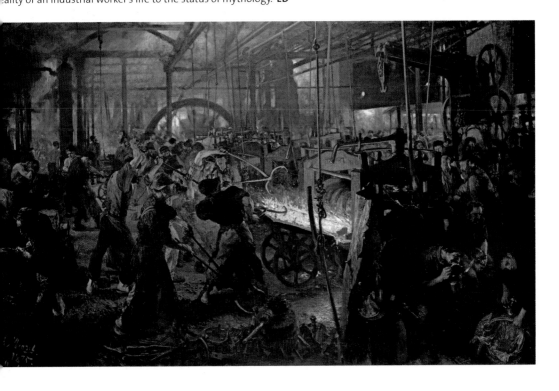

The Gleaners 1857
JEAN-FRANÇOIS MILLET 1814 – 75

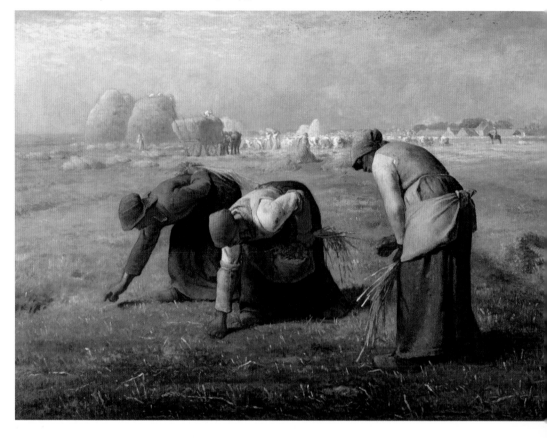

oil on canvas
33 x 43 ¼ in. / 83.5 x 110 cm
Musée d'Orsay, Paris, France

✦ NAVIGATOR

Jean-François Millet is closely associated with the Barbizon school of artists who settled in a small village on the outskirts of Paris. The artists shared the aim of developing a more naturalistic style of landscape painting and Millet became known for his Realist peasant scenes in particular. These rural scenes were controversial at the time because they were produced on a scale previously reserved for classical or historical works. In *The Gleaners,* Millet has imbued the three peasant women with a strong sense of dignity. They are depicted carrying out back-breaking work as two of them gather the remains of the crops after harvesting and the third binds together her feeble sheath. The women's fixed expressions and thick, heavy features accentuate the laborious nature of their work. They are set against a harmonious background scene of farmers reaping an abundant harvest in a golden corn field; Millet uses the contrast of light and shade to emphasize the class divide.

Millet was keen to explore the relationship between the peasant class and the land but he did not seek to create overtly political works. He saw his work in personal terms and *The Gleaners* is an expression of his melancholic nature. When the painting was exhibited in the Paris Salon in 1857, critics were divided in their opinions of the subject matter, according to their own political beliefs. Republicans praised the work for its dignified, realistic portrayal of the rural working classes, whereas conservatives were wary of its progressive nature and regarded it as subversive. Millet's work profoundly affected Vincent van Gogh, who shared his compassion for farm workers and labourers. **ED**

1 LANDSCAPE

Millet excelled at landscape painting and was noted for his naturalistic depiction of countryside scenes. In *The Gleaners* he paints an idyllic pastoral landscape bathed in the warm light of sunset. It provides a stark contrast to the gruelling toil of the three gleaners.

2 LANDLORD

The landlord is the isolated figure on horseback in the background who is overseeing the farmers harvesting the crops. Millet depicts the landowner as a blurry, inactive figure in the distance, which serves to highlight the plight of the gleaners labouring in the foreground.

3 GLEANING

The term 'gleaning' refers to the activity of picking up leftover crops from farmers' fields after the harvest. The three women are depicted in the three phases of gleaning: searching for scraps, picking them up and tying them in a sheath. Gleaning was one of the main occupations of French peasants at the time and Millet spent ten years researching the theme. He directs the viewer's attention to the work of the peasants and away from the landowner's harvest.

4 BLUE AND RED HATS

The strong colours of the peasants' hats stand out against the soft, golden landscape and their hues are brightened by the light of the setting sun. The patches of vivid colour draw the eye to the women bent double and accentuate their close attention to the land. The red and blue hats and the white sleeves call to mind the colours of the French flag—an important symbol in the political upheaval in France during the 19th century.

1814–36

Jean-François Millet was born in the village of Gruchy in Normandy into a wealthy farming family. He began his artistic studies while still a teenager and was a pupil of portrait painter Paul Dumouchel.

1837–44

Millet moved to Paris in 1837 and spent two years studying at the Ecole des Beaux-Arts with Paul Delaroche. He painted mostly portraits and small pastoral scenes and had his first picture accepted by the Salon in 1848. He married his first wife, Pauline-Virginie Ono, in 1841 but she died a few years later.

1845–59

In the mid 1840s Millet met several artists in Paris who later joined him at the Barbizon school. They included Constant Troyon (1810–65) and Narcisse Diaz (1807–76). In 1849 he settled in Barbizon and began a productive period of painting landscapes and peasants at work. His trio of peasant pictures, *The Sower* (1850), *The Gleaners* and *The Angelus* (1857–59), marks a turning point in his career, although the paintings were not well received universally at the time.

1860–75

During the 1860s Millet built up an international clientele yet still remained financially insecure until shortly before he died. His later works were pure landscape and less controversial.

BARBIZON SCHOOL

Jean-François Millet was a founder member of the Barbizon school of artists, who painted in a Realist style and produced predominantly landscape scenes. The group of artists settled in the village of Barbizon, close to Fontainebleau, and were inspired by their immediate surroundings, exemplified in Théodore Rousseau's 19th-century painting *Pond at the Edge of a Wood* (below). They strove for greater naturalism in their work and achieved it by using simple subject matter and maintaining a meticulous eye for detail. The artists made a conscious shift towards realism in the midst of the Romantic movement (see p.266), which was dominant at the time. Other important Realist artists from the Barbizon school include Théodore Rousseau and Charles-François Daubigny.

Olympia 1863
EDOUARD MANET 1832 – 83

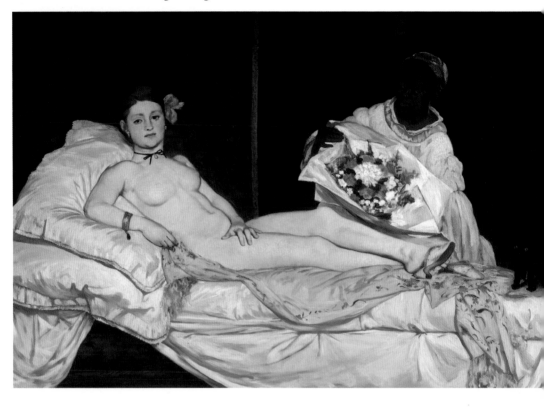

oil on canvas
51 ⅛ x 74 ¾ in. / 130 x 190 cm
Musée d'Orsay, Paris, France

Edouard Manet's *Olympia* created a great deal of controversy in 19th-century Napoleonic France. Its blatant depiction of a French courtesan in repose was a far cry from the artist's society scene *Music in the Tuileries*, painted one year previously. Although *Olympia* can be placed within a wider context of female nudes and its pose recalls Titian's *Venus of Urbino* (1538), this painting caused a scandal because of its deliberate lack of allegory and its allusion to nakedness rather than classical nudity. In 19th-century art, nudes were perfectly respectable as long as the subject was depicted as a classical nymph or goddess-like figure. In *Olympia* the nude figure is a common woman named Victorine Meurent (1844–1927), who was Manet's model and companion. She is portrayed in a contemporary setting, adorned with a pink orchid in her hair, jewellery and footwear, which all draw attention to her contrived nakedness and status as a courtesan. The single slipper symbolizes a loss of innocence and the orchid is a conventional symbol of sexuality.

In this work Manet promotes the Realist idea that art can depict everyday life in a straightforward manner. The naked flesh is not painted in the smooth, idealized style of classical nudes; in fact, the harsh lighting adds an element of brutality to the scene. The painting was first exhibited in the Paris Salon of 186 and modern viewers considered it vulgar and entirely unsuitable for exhibition within the coveted space of the Salon. The naked figure stares out of the canvas in a confrontational manner and there is a notable lack of modesty. The fully clothed, black female maid was another point of contention and she continues to be discussed in post-colonial scholarship as the central figure of this painting. **ED**

✦ NAVIGATOR

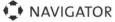

1 NAKED FEMALE

The nude figure is a trope in canonical high art and was considered the highest example of artistic achievement. Manet's *Olympia* was not considered in this way, however, because of her status as 'naked' rather than nude. The adornments on her body—especially her jewellery—establish her as a courtesan and therefore she is placed on a baser level than the allegorical figures who were painted into many history paintings of the Romantic era.

2 OLYMPIA'S MAID

The black female maid is a portrait of a woman named Laura, who is used here as a professional model. She has become iconic retrospectively with regard to issues of black female subjectivity in the art historical canon. She stands, fully clothed, holding a bouquet of flowers most likely from her mistress's client. Olympia is oblivious of her maid's presence, and the emotional distance between the two women is emphasized by their physical separation.

3 BLACK CAT

The black cat is a symbol of superstition and indicates the 'taboo' nature of what is being depicted. It is especially resonant in its placement next to Laura, as it draws attention to the stereotypes of black femininity and sexuality circulating during the time this painting was exhibited.

4 FLOWER BOUQUET

The bouquet of flowers is a classic symbol of female sexuality and draws attention to this scenario as a highly sexualized one. The pattern of the flowers is picked up in the drapery on Olympia's divan spread, which further emphasizes her status as a common courtesan.

1832–45

Edouard Manet was born into an upper-middle-class family in Paris. His father was a judge and disapproved of his son's choice of career, but Manet was often taken by his uncle to visit the Louvre and in 1845 he began his first drawing course.

1846–60

The artist practised his technique by copying Old Masters in the Louvre. During the 1850s, he travelled in Europe and visited museums in Austria, Germany, the Netherlands and Italy. He studied with the artist Thomas Couture (1815–79) between 1850 and 1856, and then opened his own studio.

1861–69

In the Salon of 1861 Manet exhibited *Spanish Singer* (1860) to great critical acclaim. However, this reputation did not last and by 1863 Manet had caused a scandal with the overt sexuality of *Le Déjeuner sur l'herbe*, which was rejected by the Salon. *Olympia* was similarly controversial and Manet became known (reluctantly) as the leader of the avant-garde.

1870–83

Encouraged by his friend Berthe Morisot (1841–95), Manet worked in the open air and painted scenes of Paris, including *The Cafe Concert* (1878). His later work was influenced by the Impressionists as seen in *Berthe Morisot* (1872). Manet suffered considerable ill health in his forties and died aged fifty-one.

PORTRAYAL OF VENUS

Olympia is inspired by a long-standing tradition of nude Venuses, exemplified in works such as *Venus and the Lute Player* (c. 1565–70; below) by Titian. It was acceptable to depict Venus without clothes because she was portrayed as an allegorical or mythical figure. Classical nudes were common in the Italian Renaissance and the art public of the 19th century would have been familiar with this tradition. Realist painters, however, depicted a different, non-idealized style of female nude. Manet received extremely harsh criticism when *Olympia* was exhibited in 1865 and Gustave Courbet's erotic scenes were banned from exhibition for much of the 19th century for their highly sexualized content.

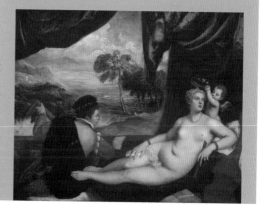

Sleep 1866
GUSTAVE COURBET 1819 – 77

oil on canvas
53 ¹/₈ x 78 ³/₄ in. / 135 x 200 cm
Musée des Beaux-Arts, Paris, France

This erotic painting of two women entwined in an amorous embrace was commissioned by the Turkish diplomat and collector Khalil-Bey. It was never intended for public display, a factor that provided Gustave Courbet with greater freedom in undertaking his subject. The sense of expression, movement and presence that the artist gives to the figures shows his commitment to paint what he saw before him. Courbet had difficulty getting his work exhibited at the Paris Salon because it broke with artistic and social convention. He painted another controversial work in the same year, *The Origin of the World*, which explicitly showed female genitalia. **ED**

NAVIGATOR

⊙ FOCAL POINTS

1 JOANNA HIFFERNAN

The model for this figure was Joanna Hiffernan, a recurring muse in Courbet's work. An Irish-American, her fair skin and long red hair made her an ideal model. Courbet shocked his contemporaries by eroticizing the nude and transgressing from its classical treatment.

2 FLOWER VASE

As with Edouard Manet's painting *Olympia* (1863; see p.306), this work includes a bouquet of flowers in the composition. Although it is located as a decorative feature in the corner of the painting, the enamelled vase of flowers also symbolizes female sexuality, a theme that is central to the work. Here the flowers are 'contained' in a womb-shaped vase, which contrasts with the suggested sexual abandon of the sleeping naked women.

3 JEWELLERY

The jewellery that is skewed across the lovers' bedside table, as well as the adornments on the bed itself, indicates a lavish decadence that pervades the painting. The rich colour scheme of blue drapery, pink sheets and white pearls marks this scene as one of luxury and indulgence.

4 GLASS PIECE

A central concern for Realist painters was to convey the reality of their surroundings and focus on visualizing what the eye saw. The coloured glass ornament on the bedside table typifies this preoccupation and Realist painters often visualized the transparency of glass. Details of such objects are not key to the composition, but the artist's observation of them is acute. Courbet was influenced by the still lifes and domestic interior scenes of 17th-century Dutch art.

AESTHETICISM

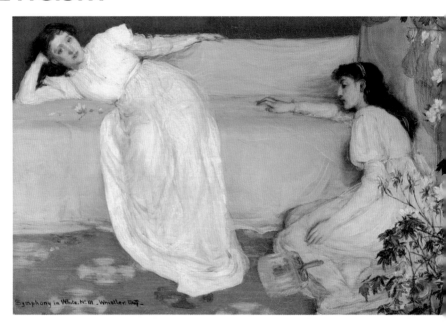

1 *Symphony in White, No. III* (1865–67)
James McNeill Whistler · oil on canvas
20 ½ x 30 ⅛ in. / 52 x 76.5 cm
The Baker Institute of Fine Arts,
Birmingham, UK

2 *Blossoms* (1881)
Albert Moore · oil on canvas
67 ¼ x 28 in. / 171 x 71 cm
Russell-Cotes Gallery, Bournemouth, UK

nitially influenced by the work of Pre-Raphaelite (see p.294) artists such as Dante Gabriel Rossetti (1828–82), a strong English–French artistic movement emerged in the mid to late 19th century that prioritized mood, appearance and pleasure over narrative, meaning and purpose. One French commentator noted: 'Everyone began to worship the beautiful. . . . The female Aesthete wore her hair cropped and her dress was of sombre tint and 15th-century design. The male Aesthete, on the contrary, let his locks grow long'. Such observations, along with lampoons in *Punch* and in Gilbert and Sullivan's opera *Patience* (1881), created bad press for pure Aestheticism. In reality, the movement embraced a complex web of ideas bound by one vital concept: the importance of the artistic object itself, separate from social, political, religious or moral rationales. Such a dramatic opposition to the traditional Victorian values of social inclusion and communal improvement helped prepare the ground for Modernism.

The phrase 'art for art's sake', popularized (though not originated) by French poet and art critic Théophile Gautier (1811–72) and now welded to Aestheticism, came to suggest empty self-indulgence and affectation but was originally intended to highlight the value of craftsmanship. Aesthetic artists used subtle but complex colour blending to encourage the viewer to contemplate a painting purely as an object of decorative art. Detachment from its subject matter was desirable for the viewer to fully appreciate the artistic value of the work.

KEY EVENTS

1864	1868	1871	1872	1876–77	1877
Lord Leighton (1830–96) begins to build Leighton House in London, a groundbreaking example of Aesthetic architecture.	Moore exhibits *The Quartet: A Painter's Tribute to the Art of Music*, melding the two Aesthetic worlds of art and music.	Whistler paints *Arrangement in Grey and Black: The Artist's Mother*. It is the first of his paintings to use the word 'arrangement' in the title.	Beardsley is born; he will become a key figure of the Aesthetic movement.	Whistler designs the Peacock Room in London. Its green-blue walls, copper and gold leaf and Oriental air are defiantly Aesthetic.	Sir Coutts and Lady Blanche Lindsay open the Grosvenor Gallery in London, displaying works by Aesthetic artists shunned by the Royal Academy.

Anglophile American painter James McNeill Whistler (1834–1903) and Irish-born writer and wit Oscar Wilde (1854–1900) were two of the most outspoken and dandyish proponents of Aestheticism. For Wilde, purposeless beauty was all: art could not be immoral and 'life imitates art'. Whistler's tranquil *Symphony in White, No. III* (opposite) conjures up a languid mood of calm and contemplation that is distinctly Aesthetic in tone. 'The absence of energy, a certain languor in the attitudes, and the sagging curves of the compositional lines lend the weariness of modernity to the effect,' observed *The New York Times*.

In Whistler's *Nocturne* series (1860s–70s) of paintings of the River Thames he moves further away from traditional narrative and representation towards an emphasis on colour, mood and shape. *Nocturne in Black and Gold: The Falling Rocket* (c. 1875; see p.312) attracted the wrath of critic John Ruskin (1819–1900), who thought that art should be true to life and have a moral purpose. Whistler's 'Ten O'Clock' lecture of 1885, delivered in London, Oxford and Cambridge, reveals the extent of his Aesthetic creed. In it he scorns contemporary fashions for medievalism in art and home crafts and describes the true artist as a god-like being divorced from ordinary life and with unique abilities to uncover beauty and improve on nature.

Aestheticism's other major painter, Albert Moore (1841–93), was initially influenced by Pre-Raphaelitism but soon moved towards an Aesthetic-style appeal to beauty and the senses. Moore and Whistler were mutual admirers and, like many contemporary Aesthetes, they saw music as the perfect art form. Here form and content were one and traditional subject matter was obliterated—hence the musical titles of some of their paintings. Moore's *The Quartet: A Painter's Tribute to the Art of Music* (1868) drapes modern musicians in classical dress. Conceived in the manner of a frieze, it reveals the artist's love of ancient sculpture for the beauty of its forms alone. This, together with the decorative influence of the Japanese print demonstrated in pictures such as *A Sleeping Girl* (c. 1875; see p.314) and *Blossoms* (right), shows Moore embracing the flat picture plane and asserting the importance of form, colour and composition. The work of Sir Edward Burne-Jones (1833–98) also highlights a shift towards an Aesthetic stress on the image itself rather than on recognizable subject matter.

By the turn of the century, Aestheticism was in decline but its ideals had strongly influenced William Morris (1834–1896) and the Arts and Crafts Movement, both in Europe and the United States. In his early career Morris embraced the Aesthetic desire to produce beautiful objects that transcended the shoddy goods introduced by mass production and mechanization. Morris's emphasis on flowing, asymmetric patterns drawn from plant forms helped to shape the freely drawn and swirling plant shapes of Art Nouveau (see p.346), along with the flowing arabesques of Englishman Aubrey Beardsley (1872–98), himself an arch-Aesthete. **AK**

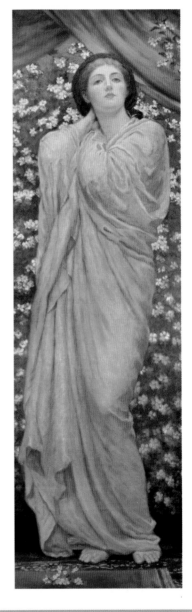

1878	1881	1885	1889	1890	1895
The Whistler v. Ruskin trial comes to court. Ruskin had publicly criticized Whistler's free approach and Whistler sued him for libel.	Gilbert and Sullivan's operetta *Patience* parodies the Aesthetic movement.	Whistler delivers his 'Ten O'Clock' lecture, explaining his Aesthetic creed.	The Exposition Universelle Internationale is held in Paris.	Whistler publishes *The Gentle Art of Making Enemies*, which draws partly on the experience of his libel suit against Ruskin.	Wilde is found guilty of gross indecency and sentenced to two years' hard labour.

Nocturne in Black and Gold: The Falling Rocket *c.* 187

JAMES MCNEILL WHISTLER 1834 – 1903

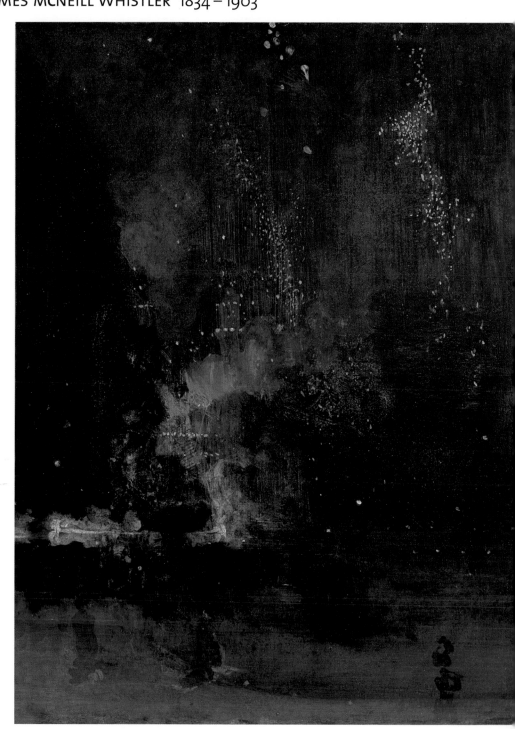

oil on canvas
23 $^7/_8$ x 18 $^1/_4$ in. / 60.5 x 46.5 cm
Detroit Institute of Arts, USA

This is one of art history's most controversial works and was the subject of a high-profile courtroom battle between James McNeill Whistler and leading art critic John Ruskin. In 1877 Ruskin famously reviewed the picture as 'flinging a pot of paint in the public's face'. Whistler sued. In court the artist stressed that the painting was not an unfinished descriptive view but a fully realized 'artistic arrangement' that 'represents' its subject. Whistler was exonerated but awarded an insulting one farthing's damages and no costs, a serious setback to his career. From the 1860s, Whistler made paintings of London's River Thames at night, naming them 'Nocturnes' in homage to the musical form. This view from his waterside home reveals a fireworks display in Cremorne pleasure gardens. A tree masses darkly on the left while beyond it lies the platform from which rockets are set off. Whistler's idiosyncratic *Nocturne* series—in which judiciously arranged blocks of harmonious tone and points of colour triumph over narrative—is widely seen as his greatest achievement and a vivid expression of Aestheticism. **AK**

◉ FOCAL POINTS

1 DESCENDING SPARKS

The shower of falling sparks looks like a constellation of coloured stars in the night sky. Whistler was often a fast worker, but he was also a very careful one—the points of colour representing the sparks have obviously been positioned with great thought. Whistler's expressive brushwork and coloration convey the movement and thrill of that fleeting moment when a rocket explodes in the sky and sparks shower down.

2 FOREGROUND FIGURES

Three spectators in the foreground watch the fireworks soar into the sky. Their ethereal execution lends the picture a compelling, vision-like quality and cleverly captures the look of people outside in the dark, illuminated briefly by an unnatural, sulphurous light.

3 BOLD PAINTWORK

During the 1870s, Whistler's handling of paint became noticeably bolder. This area of the painting shows very clearly the careful grading and blending of closely related, harmonious tones at which Whistler excelled. This style was central to his personal definition of Aestheticism.

4 FIREWORK PLATFORM

In the centre of the composition is what appears to be a launching platform for the fireworks. It is obscured by a swirl of thick smoke rising into the sky and by the darkness of the night, yet the intense brightness of the lights visible around it creates a sense of excitement and mystery. These slashes, vapors and points of bold light are reminiscent of some of the seascapes painted by J. M. W. Turner, another admirer of the River Thames.

🕐 ARTIST PROFILE

1855–58

Having trained as a US Navy cartographer, Whistler moved from the United States to Paris in 1855, attending Charles Gleyre's (1806–74) studio and studying Diego Velázquez (1599–1660) and Rembrandt (1606–69), Japanese prints and Eastern arts.

1859–77

Whistler moved to London, exhibiting his first major oil painting, *At the Piano*, to acclaim at the Royal Academy in 1860. Well-dressed, exuberant and witty, he was friendly with Dante Gabriel Rossetti and Oscar Wilde.

1878–80

Despite successfully defending himself in court against Ruskin's criticisms of *Nocturne in Black and Gold: The Falling Rocket*, Whistler was bankrupted by the costs of the case and the building costs of his home, The White House.

1881–1903

Whistler took his mother's maiden name of McNeill on her death in 1881. In 1888 he married Beatrix Godwin, the widow of architect E. W. Godwin, designer of The White House.

A Sleeping Girl *c.* 1875

ALBERT MOORE 1841 – 93

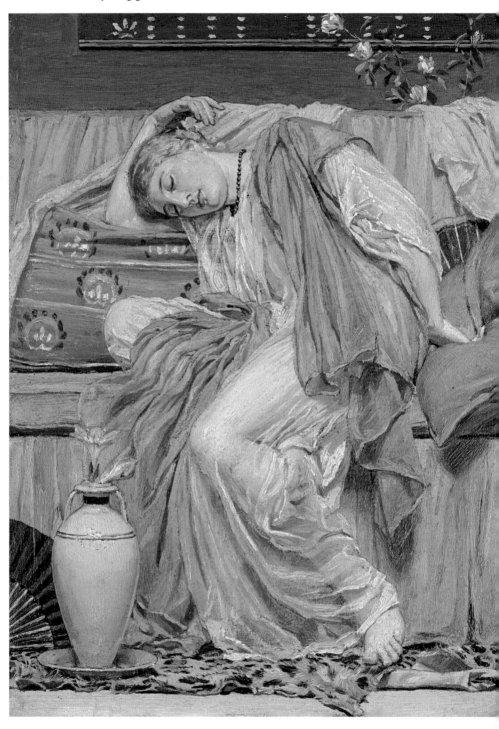

oil on canvas
12 ¹⁄₈ x 8 ⁷⁄₈ in. / 31 x 22.5 cm
Tate Britain, London, UK

The mature paintings of Albert Moore typically feature languid girls and women in classical-style dress. In *A Sleeping Girl* the delicately rendered folds of the dress reveal Moore's fascination with classical sculpture, an interest inspired by a visit to Rome in 1862 to 1863 and long hours spent in London's British Museum studying the Elgin Marbles. Between the mid 1870s and mid 1880s, he produced several small paintings of such girls in interior settings. They may have acted as preliminary studies for his larger paintings, such as this one. This painting replaces narrative with an Aesthetic experience of colour, line and pattern—the girl has been arranged as another object, albeit the principal one, in a relatively two-dimensional ensemble of still-life objects. However, the careful construction and beautifully balanced tones—with Moore using a lighter, brighter palette than fellow Aesthete James McNeill Whistler—make it an obsessive search for perfect formal beauty rather than an exercise in decoration. Moore painstakingly built up the paint on his canvases in thin layers, resulting in a glowing delicacy.

The picture features many of the elements favoured by Moore and the Aesthetes: the classical drapery, the Far Eastern vase and fan, the exotic animal-skin rug, the unusually patterned bohemian cushion and the motif of a bloom behind the ear. The work was not exhibited during Moore's lifetime but a painting in a similar vein—*Pansies* (c. 1875)—was shown and the eminent art critic John Ruskin described it as 'consummately artistic'. **AK**

✿ NAVIGATOR

◉ FOCAL POINTS

1 HEAD AS DESIGN FEATURE

The way in which the girl's head is encircled by a perfectly shaped and positioned arm, along with the elegant, reversed S-shape of her body, helps turn her into a design element. This transforms the image from a narrative into a painting to be admired for its aesthetic beauty alone.

2 REALISTIC BLOSSOMS

Depicted with convincing realism, the precisely rendered blossoms make the work more than just a decorative panel. They allow the artist to introduce notes of brighter colours to enliven the painting and draw attention to the serene, cooler, colour harmonies that he creates.

3 CLASSICAL DRAPERY

Moore's shimmering, translucent drapery—light, gauzy folds that sparkle as they catch the light—was effected after making numerous studies of nudes, clothed figures and drapery. The delicate glow is the result of painting in layers, finishing with a grey wash topped with light colours.

4 PICTORIAL HARMONY

The colour of the flowers in the vase echoes that of the bloom tucked behind the girl's ear, her rosy cheek, the fabric edging on the right of the frame, and the spray of blossoms top right, and unifies the composition. The vase is part oriental, porcelain artefact (note the fan), part classical urn.

⏱ ARTIST PROFILE

1841–59

Moore was born in York, England. His father was an artist and encouraged his love of art. In 1858 he went to the Royal Academy school but left after a few months to form a sketching society with other young artists. He initially produced landscapes in the Pre-Raphaelite (see p.294) style.

1860–65

After a trip to Rome, Moore developed a lifelong interest in classical sculpture. By the mid 1860s he had started to paint pictures of harmonious, classically draped girls that allowed him to concentrate on the movement, colour and texture of the fabric, for which he became best known.

1866–74

Like many of his contemporaries, Moore was influenced by Japanese art. He began to paint pictures that were decorative, subtly coloured and almost devoid of subject.

1875–93

He produced many images of sleeping girls that represent the epitome of the Aesthetic life and its idea of beauty as something that is artistically created.

AGE OF IMPRESSIONISM

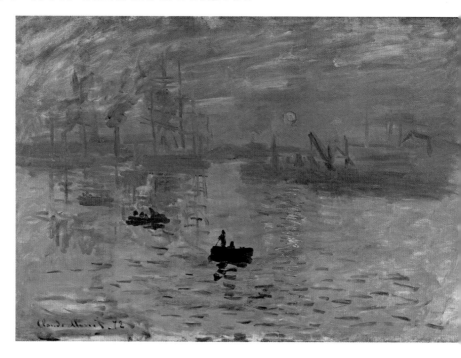

T he term 'Impressionist' was originally intended as an insult. Critic Louis
Leroy (1812–85) seized on the title of a seascape by Claude Monet
(1840–1926), *Impression, Sunrise* (above), and wrote: 'Impression...a
wallpaper pattern in its most embryonic state is more finished than this seascape'.
Leroy titled his scathing article 'Exhibition of the Impressionists'. The name stuck.

Monet was one of a group of artists working in France during the second
half of the 19th century who reacted against the historical themes and highly
polished finish of French Academic art (see p.276). They set out to create
images of modern life as they saw it, capturing the impression of a passing
moment and the fleeting effects of light. Impressionist paintings were greeted
with derision when they were first exhibited in Paris in the 1870s because they
looked unfinished to the 19th-century eye. Instead of creating a smooth surface
where individual brushstrokes were blended to be invisible, the Impressionists
applied paint in bold, bright colours and in broken brushwork. Their subject
matter was as pioneering as their technique. They ventured out of their studios
to observe the world around them and painted what they saw: landscapes
around Paris, ballerinas adjusting their pumps and laundresses at work, for
example. Such scenes were deemed radical and even improper at the time.

KEY EVENTS

1859	1863	1870–71	1872	1874	1876
Pissarro and Monet attend the Académie Suisse in Paris.	Napoleon III (1808–73) pioneers the Salon des Refusés for artists rejected by the Paris Salon. Among the exhibits is Manet's *Le Déjeuner sur l'herbe*.	The Franco-Prussian War causes a number of artists to flee Paris. Several Impressionists move to London for safety. Bazille is killed in the conflict.	Monet paints *Impression, Sunrise*, the painting that gives the Impressionist movement its name.	A group of artists whose work had been rejected by the Paris Salon mount an exhibition in Paris; among them are some of the Impressionists.	Sisley paints *The Flood at Port-Marly*. He paints the scene seven times, concentrating on depicting the changing reflections in the water.

Among the Impressionists' inspirations were Japanese woodblock prints, first seen in France in the 1850s. They showed scenes from everyday life using bold, flat colours and simple designs, with dynamic, often off-centre compositions. Sometimes they featured looming foreground figures that were cropped by the edge of the picture. Photography also had an impact on the Impressionists. Edgar Degas's (1834–1917) pictures of ballet dancers (see p.320) were inspired by the freeze-frame photographs of Eadweard Muybridge (1830–1904), which revealed how animals and humans move. Photographers used hand-held cameras to take photographs showing blurred moving figures. The pictures featured random compositions, sometimes with empty foregrounds and odd crops, and Impressionist artists carefully composed their work to suggest such spontaneity.

Impressionism emerged from the coming together of a group of like-minded artists who met in the teaching studios and cafes of Paris in the 1860s. The oldest member of the group, Camille Pissarro (1830–1903), first met Monet at the Académie Suisse in 1859. When Monet joined the studio of Charles Gleyre (1806–74) in 1862, he became friends with his fellow students who became known as the Impressionists: Pierre-Auguste Renoir (1841–1919), Alfred Sisley (1839–99) and Frédéric Bazille (1841–70). The gifted Bazille was killed in the Franco-Prussian War before he could make a name for himself. Bazille's spacious studio in the Batignolles suburb of Paris, which he shared with Renoir, is captured in *Bazille's Studio* (below). It was a meeting place for Impressionist artists who were said to be from the 'Batignolles School' at the time. Edouard

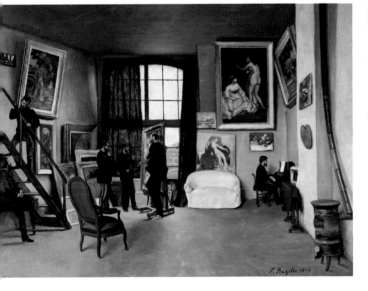

1 *Impression, Sunrise* (1872)
Claude Monet • oil on canvas
18 7/8 x 24 3/4 in. / 48 x 63 cm
Musée Marmottan, Paris, France

2 *Bazille's Studio* (1870)
Frédéric Bazille, Edouard Manet
oil on canvas
38 5/8 x 50 5/8 in. / 98 x 128.5 cm
Musée d'Orsay, Paris, France

1876	1877	1881	1886	1894	1902
Renoir paints *Dance at the Moulin de la Galette* (see p.322).	Degas invites Cassatt to exhibit with the Impressionists. She is the only American and one of only three women to join them.	The sixth Impressionist exhibition causes discontent among the group and some artists refuse to participate owing to its emphasis on realism.	Emile Zola's (1840–1902) novel *The Work* criticizes the Impressionist movement.	The Dreyfus Affair splits the Impressionist movement as it exposes Renoir and Degas as anti-Semites; many fellow Impressionists are Dreyfusards.	Rodin makes a full-size relief of *The Thinker* (see p.324). Its energetically textured surface echoes the broken brushwork of Impressionist painting.

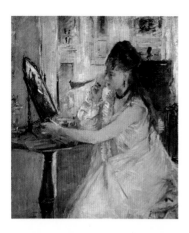

Manet (1832–83) is shown looking at a canvas on an easel and it is thought that the man behind him smoking a pipe is Monet and the man sitting on a table by the stairs is Renoir. Bazille includes some of the works rejected by the Paris Salon in his painting, in an implicit criticism of the Academy and to affirm his own ideas regarding art.

Monet invited his friends to join him on painting trips to the forest of Fontainebleau, south of Paris. The young artists were inspired by the Realist (see p.300) ethos of Gustave Courbet (1819–77) and by the *plein-air* (open-air) landscapes of the Barbizon school painters Théodore Rousseau (1812–67), Charles-François Daubigny (1817–78) and Jean-Baptiste-Camille Corot (1796–1875). But while the earlier generation of artists made landscape studies in the open air, all apart from Daubigny worked them up into finished paintings in the studio. Monet, Sisley, Renoir and Bazille put great store on completing their works on the spot.

When they were not painting, the future Impressionists would meet regularly at the Cafe Guerbois, a popular haunt with many progressive artists and writers. Manet often held court there, expounding his avant-garde ideas about art. Around this time Degas also came under the influence of Manet. Degas had trained at the Ecole des Beaux-Arts and studied antique and Renaissance art in Italy, but under Manet's influence he turned his sights on themes of modern life. Manet also drew his elegant model, protégée and sister-in-law, Berthe Morisot (1841–95), into the group.

Despite their common concerns, the Impressionists did not all adhere consistently to Impressionist principles. Monet is seen as the quintessential Impressionist because of his modern subject matter and his lifelong commitment to capturing the visual impression created by transient light effects. Sisley's subject matter was more circumscribed and he mostly painted landscapes. Degas was aloof from the group, despite exhibiting in seven of the eight Impressionist shows; he was committed to drawing and painting indoors, working up his compositions in the studio. Much of Pissarro's work features rural, rather than urban, scenes. *The Red Roofs, Corner of a Village, Winter* (opposite) depicts the countryside near his home at Pontoise. His modernity lies in his approach to colour, light and composition. The orange-brown colour of the roofs is echoed by that of the plants and fields, and his thick impasto brushwork catches the light. Successive parallel planes stretch across the canvas as he creates a sense of depth by the diminishing size of his subjects.

As respectable women, Morisot and American artist Mary Stevenson Cassatt (1844–1926) were excluded from painting many of the scenes of contemporary modern life that feature in works by their male counterparts. Unlike the male Impressionists, they could not sit and paint in the boulevards, cafes and parks. In consequence, pictures by the female members of the Impressionist circle mostly feature women in domestic settings, such as the boudoir shown in Morisot's *Young Woman Powdering Her Face* (above left), or in respectable public settings, such as a box in the theatre as seen in Cassatt's *In the Loge* (below left). Cassatt depicts a fashionable lady dressed for an afternoon performance at the Français, a theatre in Paris.

Manet came to be seen as the father figure of the Impressionists, inspiring them to paint modern life, but he refused to exhibit with them and continued to seek recognition at the Paris Salon, France's official annual art exhibition. At this time in France, success as an artist meant success at the Salon. Its selection committee chose to display highly finished, Academic paintings, with historical, religious or mythological themes. Since this was not the type of art that the future Impressionists wanted to paint, most of their paintings were rejected. In 1874, in response to the repeated rejections, the artists decided to take

matters into their own hands and organize a show for themselves. They gave themselves a name that suggested no particular group style. Thirty artists, including the core group of Monet, Renoir, Sisley, Pissarro, Degas and Morisot, exhibited under the name 'Société Anonyme des artistes, peintres, sculpteurs, graveurs' (Anonymous Society of Artists, Painters, Sculptors, Engravers). Between 1874 and 1886, there were eight Impressionist exhibitions. This was the period during which Impressionism was at its height and when the group was at its most coherent. Even then, however, it was not a unified or exclusive school and only Pissarro exhibited at all eight shows. Numerous other artists, from Monet's old mentor Eugène Boudin (1824–98) to Degas's protégée Mary Cassatt, were invited to exhibit with the Impressionists. At the eighth show in 1886, one room in particular spelled the end of the original Impressionist circle: it was here that Georges-Pierre Seurat (1859–91) and Paul Signac (1863–1935) exhibited works including *A Sunday on La Grande Jatte–1884* (1884–86; see p.334). These artists used a more systematic approach to representing colour and light, which became known as Neo-Impressionism.

Although Impressionism was essentially a new way of painting, Degas and Renoir both made sculptures, and contemporary sculptors such as Medardo Rosso (1858–1928) and Auguste Rodin (1840–1917) shared the spirit of Impressionism, rejecting the precision and idealism of Academic sculpture in favour of vibrant textured surfaces that echoed Impressionist brushwork.

The initial Impressionist circle broke up in the late 1880s, but Impressionism had a huge and lasting influence. By the end of the 19th century, artists around the world were painting contemporary subjects with bold, freely handled brushwork, and subsequent art movements can be seen as both a development of Impressionism and a reaction against its limitations. In many ways, Impressionism represents the beginning of modern art. **JW**

3 *Young Woman Powdering Her Face* (1877)
Berthe Morisot • oil on canvas
18 1/8 x 15 3/8 in. / 46 x 39 cm
Musée d'Orsay, Paris, France

4 *The Red Roofs, Corner of a Village, Winter* (1877)
Camille Pissarro • oil on canvas
21 1/2 x 25 7/8 in. / 54.5 x 65.5 cm
Musée d'Orsay, Paris, France

5 *In the Loge* (1878)
Mary Stevenson Cassatt • oil on canvas
32 x 26 in. / 81 x 66 cm
Museum of Fine Arts, Boston, USA

The Ballet Class 1871 – 74
EDGAR DEGAS 1834 – 1917

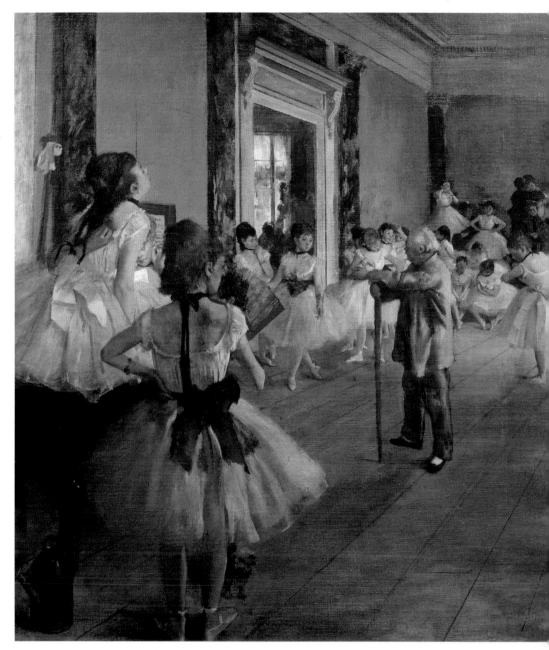

oil on canvas
33 ¹/₂ x 29 ¹/₂ in. / 85 x 75 cm
Musée d'Orsay, Paris, France

Edgar Degas once wrote: 'They call me the painter of dancers.' Indeed, more than half of his oils and pastels depict teenage ballet dancers in the *corps de ballet* at the Paris Opéra—sometimes on stage, but more often as they rehearsed or rested behind the scenes. From the 1870s onwards, he drew and painted them obsessively. *The Ballet Class* is characteristically intimate and informal—showing details such as the young dancer scratching her back—yet impersonal. 'For me,' wrote Degas, 'the dancer has been the pretext for painting beautiful fabrics and rendering movement.' In the striking, off-centre composition, ballerinas and their mothers cluster around teacher Jules Perrot. The asymmetrical design, unusual viewpoint and cut-off figures betray the influence of snapshot photography and the designs of the Japanese *ukiyo-e* prints that Degas collected. Converging lines created by the floorboards direct the eye upwards and inwards to create a dramatic sense of space. Despite its appearance of spontaneity, of a moment observed, this is a carefully invented image, which Degas altered significantly as he worked. **JW**

◈ NAVIGATOR

◉ FOCAL POINTS

1 INFORMAL DETAILS

One of the young dancers can be seen twiddling with her earring, although her face is half-hidden by the hunched shoulder of the girl sitting on the piano scratching her back. These informal details add a touch of humour as well as a sense of documentary realism to the painting.

2 PILASTERS

Degas copied these marble pilasters from another painting of a similar scene. He often drew at the old Paris Opéra until it burnt down in 1873. Rather than paint at the new Opéra, he based his settings on drawings of the old site. His works were inventions, not on-the-spot observations.

3 MONSIEUR JULES PERROT

The image of Monsieur Perrot is based on a drawing that Degas made of the choreographer in 1875. Perrot was one of the most gifted dancers of his generation and a celebrated choreographer. He had actually retired from teaching about ten years before Degas began the painting, and the picture seems partly to be in homage to the great man. X-rays have revealed that Degas had originally shown an unidentified dance teacher, seen from behind.

4 A CHANGE OF FOCUS

Originally, the foreground dancer was the principal figure in the piece and faced outwards. Degas turned her to look into the painting, drawing the eye to the new focus: Jules Perrot. The red details form part of a series of red accents that run through the painting, helping to articulate the sense of space.

◷ ARTIST PROFILE

1834–58

After studying law, in April 1855 Hilaire-Germain-Edgar Degas entered the Ecole des Beaux-Arts, where he trained with Louis Lamothe (1822–69), a pupil of Jean-Auguste-Dominique Ingres (1780–1867) and under whom he developed a style informed by exquisite draughtsmanship. He also spent three years in Italy, studying the Old Masters.

1859–73

Degas returned to Paris and shifted artistic direction, possibly influenced by Manet. He eschewed historical settings in favour of more modern subjects, such as cafes, the ballet and the racecourse. He served in the Franco-Prussian War, and during this time his eyesight began to deteriorate.

1874–85

Degas's work appeared in the first Impressionist exhibition in 1874. Family debts forced him to concentrate on his art to earn money and he went on to create some of his most enduring work, often featuring working-class Parisians or performers, such as *L'Absinthe* (1876), *Miss La La at the Cirque Fernando* (1879), and numerous images of ballerinas, including *Star of the Ballet* (c. 1876) and the sculpture *Little Dancer of Fourteen Years* (c. 1881).

1886–1917

As his sight failed, Degas worked increasingly with pastel and sculpture, producing many powerful works with female subjects, such as *The Tub* (1885–86) and *Dancers at the Bar* (1888). He also experimented with photography.

Dance at Le Moulin de la Galette 1876
PIERRE-AUGUSTE RENOIR 1841 – 1919

oil on canvas
51 ⁵/₈ x 68 ⁷/₈ in. / 131 x 175 cm
Musée d'Orsay, Paris, France

⬢ NAVIGATOR

Pierre-Auguste Renoir used vibrantly coloured brushstrokes in this complex work to convey the lively atmosphere of a moving crowd. Shown at the third Impressionist exhibition of 1877, the painting garnered both praise and criticism. One reviewer noted that it 'caught perfectly the raucous and rather bohemian atmosphere of this open-air dance hall'; another commentator thought that the figures appeared to be 'dancing on a surface that looks like purplish clouds.' A masterpiece of early Impressionism, it depicts young people enjoying a Sunday afternoon dance in the dappled sunlight of the garden of the Moulin de la Galette—an old windmill in Montmartre, Paris, lately converted into a cafe and dance hall.

Renoir's friend and biographer Georges Rivière claimed that the entire work was painted on the spot, but its large scale and the existence of various sketches suggest that Renoir completed it in the studio after making sketches in the open air. The artist rented a studio nearby so that he could attend the dances and paint the scene. Rather than use professional models, Renoir persuaded his artist and writer friends and several local working girls to pose for him. Rivière is shown seated at the table on the right wearing a straw boater. Renoir's girlfriend Marguérite Legrand, known as Margot, is seen on the left in a pink dress dancing with a partner. Perhaps because of the painting's mixed reception, Renoir began to distance himself from the Impressionist group after the exhibition and instead focused on showing his work at the Paris Salon. **JW**

FOCAL POINTS

1 GAS LAMPS

The Sunday dances at the Moulin de la Galette took place from 3 p.m. until 11 p.m., and as evening fell the gas lamps were lit. Renoir features the distinctive white lamps, yet their artificial light was not his main interest. Instead he focuses on capturing the effects of the daylight as it filters through the trees.

2 FLIRTATIOUS ATMOSPHERE

Renoir captures the flirtatious atmosphere of the dance. A man in a straw boater rests his hand on a tree trunk, leaning forward, as if trying to gain the attention of the girl with her back against the tree. Almost hidden between them, a seated girl gazes towards a man in the foreground.

3 CROPPED FIGURE

In the bottom left corner of the painting a young woman sits on a bench talking to a little girl, whose inclusion adds an air of innocence to the scene. The woman's face is cropped by the edge of the canvas. The crop reflects the influence of snapshot photography and adds to the sense of immediacy and informality. Renoir deliberately creates the impression that this scene is not posed and that it continues beyond the borders of the picture frame.

4 DANCER'S DRESS

Renoir's distinctive feathery brushstrokes capture the effect of sunlight and shadows falling on the pink-coloured dress of the female dancer Legrand, her rakish-looking partner and the ground on which they dance. The mottled patches of pale, pearly pinks and mauve-blues are the 'purplish clouds' to which a contemporary reviewer referred. Renoir's soft, broken brushwork blurs edges and breaks up forms yet unifies the composition.

ARTIST PROFILE

1841–60

Renoir was born in Limoges in south-west France, where he worked in a porcelain factory painting designs on china.

c. 1861–68

He moved to Paris and joined the studio of the fashionable Swiss Academic (see p.276) painter Charles Gleyre (1806–74), where he was influenced by the work of Realist (see p.300) painter Gustave Courbet. In Paris Renoir met other painters, including Claude Monet and Alfred Sisley; all three later became Impressionists. Renoir first exhibited at the Paris Salon in 1864.

1869–80

He and Monet worked together sketching on the River Seine, and Renoir began to use lighter colours. In 1874 six of Renoir's paintings were hung in the first Impressionist exhibition.

1881–90

After visiting Italy and being impressed by the work of Raphael (1483–1520), Renoir's style changed to become linear and classical as he adopted a formal technique.

1891–1919

Renoir developed rheumatoid arthritis. In 1892 he went to Spain and was inspired by the work of Diego Velázquez (1599–1660). In 1907 he moved to Provence because of its warmer climate and in later life he turned to sculpture.

PAINTED PORCELAIN

When he was thirteen years old, Renoir accepted a position as an apprentice porcelain painter. He worked as a porcelain painter for five years until the factory was automated, and such was his skill that he was nicknamed 'Mr Rubens'. There he developed a love of decorative art, in particular French decorative art of the 18th century, and developed his skill as a colorist using clear, bright colours. The 18th-century Sèvres porcelain piece below, designed by Rococo (see p.250) artist François Boucher (1703–70), exemplifies the vibrant effect of pure colours on a white base that inspired Renoir. Having painted on white porcelain, Renoir was aware (as were other Impressionists) that canvas primed with white or cream makes colours appear lighter and brighter. In *Dance at Le Moulin de la Galette*, Renoir shows great skill in the way he ties the large, complex composition together by interweaving a palette of dark blues with paler blues, pearly pinks, creams and buttery yellows.

The Thinker 1880 – 81
AUGUSTE RODIN 1840 – 1917

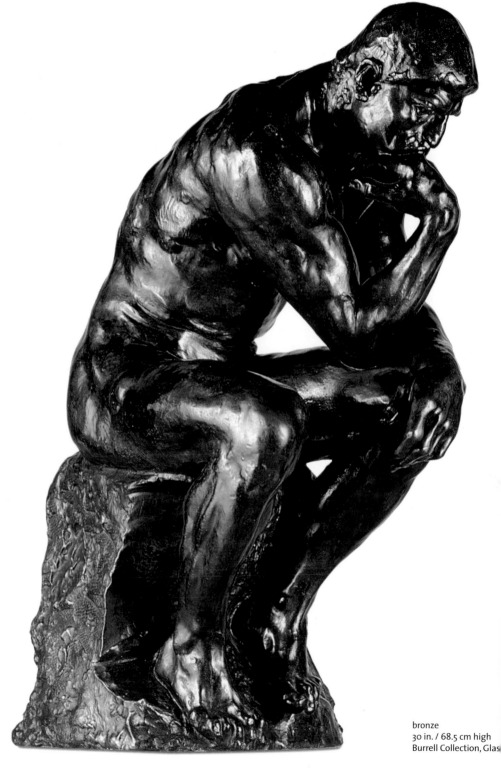

bronze
30 in. / 68.5 cm high
Burrell Collection, Glas

This sculpture was originally designed as part of an elaborate commission titled *The Gates of Hell* for a museum of decorative arts in Paris. It comprised various statues representing characters from Dante's *Divine Comedy* and this figure was to be positioned on the lintel, contemplating the fate of the tormented figures sculpted in relief below, but the museum was never built. Exhibited in 1888 as an independent work titled *The Poet*, *The Thinker* may have been intended to represent the poet Dante, but Auguste Rodin dispensed with anecdotal details, such as Dante's distinctive costume, and sculpted a nude figure, transcending the particular to create a timeless, universal image. Every element of *The Thinker* is illustrative of concentrated thought. As Rodin noted, 'He thinks not only with his brain, with his knotted brow, his distended nostrils and compressed lips, but with every muscle of his arms, back and legs, with his clenched fist and gripping toes.' This masterpiece shows the extraordinary expressive power with which Rodin imbued the naked human body and one of the many bronze casts is set above his grave. **IZ**

◉ FOCAL POINTS

1 BOWED HEAD

The figure is lost in thought as he rests his chin on his hand. His bent head and fingers suggest that he is turning in on himself—in a pose that expresses intense concentration. His massive features are rough and unpolished beneath the exaggerated ridge of his heavily modelled brow.

2 CONTRAPPOSTO

The figure's bent right arm rests on his left thigh and his relaxed left hand is draped over his left knee. This turning, contrapposto pose is reminiscent of sculptures and paintings by Michelangelo and makes the sculpture interesting from all angles. It also accentuates the skin tones, muscles and veins of the figure. Rodin placed great emphasis on the emotive power of the outline, which he created by 'rotating my clay and my model in turn'.

3 GRIPPING TOES

The toes gripping the roughly hewn rock express intensity and concentration: the outward, physical expression of internal, mental struggle. The tension extends through the strained calf muscles gouged into the surface, which add a sense of vibrancy and movement, despite the seated pose.

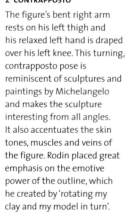

4 MUSCULAR BACK

The fall of light emphasizes the rippling musculature of *The Thinker*'s back. The pocketed surface texture creates dramatic contrasts of light and shade, echoing the broken brushwork of Impressionist painting. The viewer gains much by walking around the sculpture, experiencing it from all angles.

⏱ ARTIST PROFILE

1840–70

As a teenager, Rodin joined the government school for art and design. Despite being awarded prizes for drawing and modelling, he was rejected three times by the prestigious Ecole des Beaux-Arts. He turned his attention to making a living as an ornamental stonemason.

1871–79

Rodin moved to Belgium to find work and held his first exhibition as an independent sculptor in Brussels. In 1875 he travelled to Italy, where he was inspired by the work of Michelangelo. Rodin's first major work, *The Age of Bronze* (c. 1876), caused a furore when it was exhibited in Brussels and at the Paris Salon: it was so lifelike that he was (wrongly) accused of casting from a live model.

1880–99

In 1880, Rodin received his commission for *The Gates of Hell*. As he worked on this and other projects, his reputation—and studio—continued to grow. The radical nature of works such as *The Burghers of Calais* (commissioned 1884) and the magnificent *Monument to Balzac* (commissioned 1891) brought notoriety as well as success.

1900–17

Despite controversies surrounding his work, Rodin was seen as the world's greatest living sculptor and an entire pavilion was devoted to him at the Paris World Fair in 1900. He married his lifelong partner Rose Beuret only months before he died.

Water Lilies: Morning with Weeping Willows 1915 – 2

CLAUDE MONET 1840 – 1926

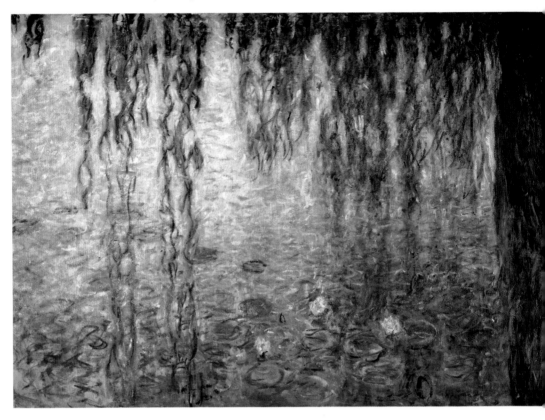

left panel
oil on canvas
78 ³/₄ x 167 ³/₈ in. / 200 x 425 cm panel
Musée de l'Orangerie, Paris, France

✿ **NAVIGATOR**

W ater lilies were the focus of Claude Monet's art for more than twenty-five years. In 1890 he bought the house and surrounding land that he and his family had been renting at Giverny in the French department of Eure. The family developed the land into a garden, including an extensive water-lily pond, and Monet had a huge studio built in the garden in which to work. In addition to individual water-lily paintings (he went on to produce around 250), the artist also envisaged painting a vast decorative scheme that would surround the viewer. With the encouragement of a distinguished friend, the French Prime Minister Georges Clemenceau, he created what has been called 'The Sistine Chapel of Impressionism': a series of magnificent murals depicting aspects of the water-lily pond at Giverny.

In 1927, the year after Monet's death, these eight water-lily murals were installed in two oval rooms in the Orangerie, a building in the Tuileries garden in Paris. This panel occupies the left-hand position of one mural, a three-panel work that is nearly 42 feet (13 m) long. The huge, dream-like canvas, worked on over a period of years in the artist's studio, is a synthesis of observation and memory that may seem far removed from the small, sketchy paintings that Monet executed rapidly in the open air during his early years as an Impressionist. Yet the painter's early preoccupations remain water, reflections and what he called the *enveloppe*—the atmospheric 'envelope' of light that bathes every scene. As he said of his water-lily pond, 'The essence of the motif is the mirror of water whose appearance alters at every moment.' **JW**

FOCAL POINTS

1 REFLECTIONS

Capturing the water's reflections of a cloudy but bright morning sky, Monet uses extraordinarily free, criss-crossing brushstrokes to build up a pale, encrusted veil of iridescent colours. Monet omits both horizon and sky, creating an ambiguous sense of untethered space.

2 TRAILING LEAVES

The weeping willow leaves touching the water's surface form a continuous feathery trail, and the leaves are indistinguishable from their reflections. Tendrils of green paint, flecked with dark pinks and blues, run vertically down the canvas and are chaotically interwoven with the white, pinks and blues of the pond's surface. The fringe of leaves stretches from the top edge to the bottom edge of the canvas, creating a two-dimensional, frieze-like effect.

3 WILLOW TRUNK

At some point Monet decided to reduce the width of this trunk. Although it is painted with textured brown, blue, ochre and deep pink paint, its edges have been roughly overpainted with the paler colours of the water and vegetation behind it. In the full canvas, the dark trunks of this and another willow tree run from top to bottom, creating a framing device for the composition. The pale, reflective surface of the water seems to float behind them.

4 LILY BLOSSOMS

The clusters of white, pale pink and yellow water-lily blooms that punctuate the surface of the canvas are picked out in heavy impasto. The elliptical shapes of the lily pads are suggested by calligraphic, sweeping flicks of red, blue and green paint; these, in contrast to the lilies, are applied thinly.

ARTIST PROFILE

1851–57

Claude Monet initially earned a living by selling charcoal caricatures in his home city of Le Havre. He was taught to use oil paints by Eugène Boudin; both were inspired to work outdoors by the Dutch painter Johan Jongkind (1819–91).

1858–72

In Paris Monet studied at Charles Gleyre's studio where he met Pierre-August Renoir, Frédéric Bazille and Alfred Sisley. Their experiments in quickly capturing the effects of light while painting outdoors, or *en plein-air*, led to the development of Impressionism. Monet married Camille Doncieux, a model, in 1870. His painting *Impression, Sunrise* (1872) spurred critic Louis Leroy to name the movement.

1873–80

Camille died in 1879 and Monet's two sons were cared for by Suzanne Hoschedé with her own children in Paris, until they all joined him in rural Eure in 1880.

1881–1926

Monet's works began to sell for high prices and in 1890 he bought the property and estate in Giverny. Among his later paintings were several series, such as his studies of the cathedral in Rouen, in which he observed the effects of changing light.

POST-IMPRESSIONISM

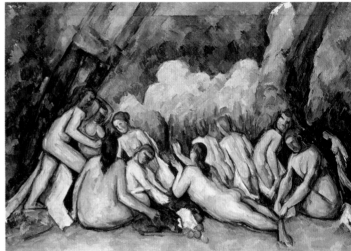

1 *Bathers* (c. 1894–1905)
Paul Cézanne • oil on canvas
50 1/8 x 77 1/4 in. / 127 x 196 cm
National Gallery, London, UK

2 *Self-portrait* (1889)
Vincent van Gogh • oil on canvas
25 5/8 x 21 1/2 in. / 65 x 54.5 cm
Musée d'Orsay, Paris, France

3 *Tropical Landscape, Martinique* (1887)
Paul Gauguin • oil on canvas
35 3/8 x 45 1/4 in. / 90 x 115 cm
Staatsgalerie Moderner Kunst,
Munich, Germany

The term 'Post-Impressionism' is assigned to the work of a number of pioneering artists who followed in the wake of the Impressionists (see p.316). They did not form a cohesive group or movement, nor did they share a common aim or style. Most had either been through an Impressionist phase or had been affected by some aspect of the style before moving on to explore new artistic territory. In practice, the term 'Post-Impressionism' is mainly used to describe the work of four artists: Paul Cézanne (1839–1906), Georges-Pierre Seurat (1859–91), Vincent van Gogh (1853–90) and Paul Gauguin (1848–1903). All these artists responded in individual ways to Impressionism: Cézanne focused on pictorial structure; Seurat was interested in the scientific nature of colour; Van Gogh's expressive brushstrokes reflected his emotional intensity; and Gauguin experimented with the symbolic use of colour and line.

The term 'Post-Impressionist' was coined by English art critic and painter Roger Fry (1866–1934). From 1906 to 1910 he was curator of paintings at the Metropolitan Museum of Art. In 1910, he organized an exhibition of modern French art in London titled 'Manet and the Post-Impressionists'. The show was put together hurriedly and attracted mostly unfavourable reviews, but it created a sensation because it introduced the English public to contemporary European art. The majority of the pictures were by Cézanne, Gauguin and Van Gogh. The exhibition's title was the only one that all the organizers could agree on; they toyed with the terms 'Expressionist' and 'Synthetist', but 'Post-Impressionist' stuck and, two years later, Fry staged a second Post-Impressionist exhibition that was more focused and better received.

KEY EVENTS

1872	1879	1884	1886	1889	1891
Cézanne moves near to Pissarro's home in Pontoise. Pissarro encourages Cézanne to focus on landscape painting.	American amateur painter and physicist Ogden Rood (1831–1902) writes an influential book on colour theory titled *Modern Chromatics*.	Influenced by new optical and colour theories, Seurat begins work on *A Sunday on La Grande Jatte—1884* (see p.334).	Van Gogh leaves Antwerp and moves to Paris, where he meets Gauguin, Seurat and Pissarro, among others.	Van Gogh paints *Starry Night*. During the course of the year, he creates more than 150 canvases.	Seurat dies of meningitis at the age of thirty-one; according to Signac, Seurat 'killed himself by overwork'.

Impressionism had revolutionized French art; it had shown new ways of capturing the physical world on canvas, but many artists felt that they had reached a dead end. It no longer seemed enough to paint shadows and reflections. Post-Impressionist artists generally moved away from the naturalism of Impressionism; they used vivid colours, thickly applied paint, real-life subject matter and expressive brushstrokes that emphasized geometric forms. This approach lies at the heart of Cézanne's work. Cézanne wanted to strip away surface details and probe deeper, analyzing the essential geometry of nature. While most Impressionists employed tiny touches of paint, Cézanne opted for larger patches of colour. As his confidence grew, these planes of colour became larger and more abstract. The results can be seen in his later landscapes, such as *The Montagne Sainte-Victoire with Large Pine* (c. 1882; see p.332), and figure paintings, such as *Bathers* (opposite). This radical approach to composition influenced the Cubists (see p.388).

Gauguin began painting as a hobby. With the encouragement of Camille Pissarro (1830–1903), he developed an Impressionist style and contributed to the last five Impressionist exhibitions. When the movement started to disintegrate, he came under the influence of the Symbolists (see p.338), who adopted pure colours and a rhythmic, linear style to express ideas or emotions. Before departing to spend the latter part of his career in Tahiti, Gauguin visited Martinique, in the Caribbean. He stayed there for five months in 1887, and painted *Tropical Landscape, Martinique* (below), one of a number of canvases

1893	1895	1899	1903	1906	1912
Gauguin paints *The Moon and the Earth* based on a Polynesian legend.	Cézanne has a one-man show in Paris; it inspires many younger artists.	Signac publishes *From Eugène Delacroix to Neo-Impressionism*, glorifying the Post-Impressionists.	Paris's Salon d'Automne holds an exhibition of Gauguin's paintings. His work influences young avant-garde artists.	Cézanne dies in Aix-en-Provence, France, having attained almost mythic status in the eyes of succeeding generations of artists.	Fry organizes a second Post-Impressionist exhibition in London. It includes several Cubist works, and has British and Russian sections.

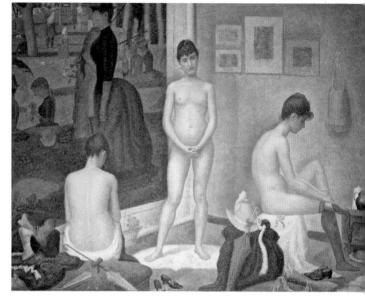

4 *Models* (1886–88)
Georges-Pierre Seurat • oil on canvas
78 ³/₄ x 98 ³/₈ in. / 200 x 250 cm
The Barnes Foundation, Merion,
Pennsylvania, USA

5 *Portrait of Alice Sethe* (1888)
Théo van Rysselberghe • oil on canvas
76 ³/₄ x 38 ⁵/₈ in. / 195 x 98 cm
Musée départemental Maurice Denis,
Saint-Germain-en-Laye, France

6 *At the Moulin Rouge: The Dance* (1890)
Henri de Toulouse-Lautrec • oil on canvas
45 ¹/₂ x 59 in. / 116 x 150 cm
Philadelphia Museum of Art, USA

7 *Women at the Well* (1892)
Paul Signac • oil on canvas
76 ³/₄ x 51 ⁵/₈ in. / 195 x 131 cm
Musée d'Orsay, Paris, France

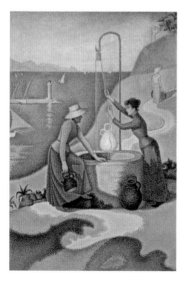

inspired by the island's exotic vegetation and scenery. The Martinique paintings
demonstrate the artist's adoption of flat, warmer colours and his move toward
Cloisonnism, a style of painting in which dark or bold lines enclose areas of
bright colour. Gauguin went on to explore this new style more fully at the
artists' colony at Pont-Aven, Brittany, to which he made several visits along with
a number of other artists. His work from this time proved an inspiration to a
young group of painters, known as the Nabis, who were led by Paul Sérusier
(1864–1927).

Gauguin had an ill-fated sojourn with Van Gogh at Arles in the South
of France, where the latter lived in poverty and depression yet created many
of his most celebrated works. The pair had met in Paris, where both had felt
constrained by the limitations of the Impressionist style. A quarrel between the
two artists in Arles led to Van Gogh's breakdown, during which he mutilated his
left ear. Despite his troubled state of mind, Van Gogh managed to combine the
simplified, decorative forms that he found in Japanese prints and Symbolism to
great effect. The intensity of Van Gogh's personality is evident in his *Self-portrait*
(see p.329). The artist produced more than forty-three self-portraits throughout
a ten-year period. He wrote in a letter to his sister that he was looking for
'a deeper likeness than that obtained by a photographer.' This self-portrait
from 1889 features his characteristic swirling and thick, impasto brushstrokes,
which emphasize the steady gaze of the subject. The dominant blue and green
colours of the canvas contrast strongly with the artist's red hair and beard.

Like Cézanne, Seurat focused on a specific aspect of Impressionism, but
moved it on to a different level. His key area of interest was optics. Seurat
admired the vibrant colour harmonies that the Impressionists had achieved
but was dissatisfied with their methods. For the most part, they had combined
their colours intuitively, whereas Seurat was determined to devise a more
rational, scientific programme for his art. He read widely on the subject,
basing his 'Divisionist' technique on ideas that he found in *Grammaire des
Arts du Dessin* (Grammar of Painting and Engraving, 1867). He concluded
that his colours would be more vivid and intense if he placed tiny touches of
complementary tones side by side rather than mixing them on his palette.

Seurat described the theory of separating his colours as 'Divisionism', but
a number of other terms soon came into use. Critic Felix Fénéon (1861–1944)

alled the technique 'Pointillism' and coined the word 'Neo-Impressionism' to escribe the movement formed by Seurat. The Neo-Impressionists brought a nore scientific approach to colour and light through Divisionist and Pointillist echniques. Seurat may have felt that he was refining the Impressionists' echnique, but he had no intention of putting it to the same use. His paintings o not convey flickering reflections or fleeting light effects. Instead, Seurat's igures are static, sculptural and have a timeless quality. Although *A Sunday n La Grande Jatte—1884* (1884–86; see p.334) created controversy when it vas shown at the last Impressionist exhibition of 1886, it was widely seen and cted as a manifesto for the artist's theories, attracting numerous converts to he style. His painting *Models* (left) was the second that Seurat produced in he Pointillist style. This monumental work features nude models disrobing in eurat's studio, perhaps having just posed for *A Sunday on La Grande Jatte*, a ortion of which can be seen on the canvas leaning against the studio wall.

The most important of Seurat's disciples was Paul Signac (1863–1935). The air met in 1884 and immediately became friends. Signac spread the gospel of Divisionism with considerable zeal and, after Seurat's death in 1891, became the eading spokesman for the group. In 1892, he left Paris for St Tropez where he nade several paintings of the harbour. His *Women at the Well* (opposite, below) vas developed from one of his first sketches. Signac decided to isolate the wo characters and devote a painting to them. He synthesized elements in the urrounding landscape in order to create a new one. In France, the other leading Neo-Impressionists were Henri Edmond Cross (1856–1910) and Pissarro, while in Belgium the style was taken up by Théo van Rysselberghe (1862–1926) and Henri van de Velde (1863–1957). Van Rysselberghe adopted Divisionist techniques in he field of portraiture in works such as *Portrait of Alice Sethe* (right, above).

One of the most colourful Post-Impressionist artists was Henri de Toulouse-Lautrec (1864–1901). Most of his work, including *At the Moulin Rouge: The Dance* (below), centres on the bohemian cafes, brothels and nightclubs of Montmartre, a seedy world that he portrayed truthfully but with sympathy, humour and insight. The man dancing nimbly to the left of the painting is a skilled dancer who performed under the name Valentin le Désossé (Valentin the Boneless'). An outstanding draughtsman, Toulouse-Lautrec was innovative n his use of fast brushstrokes, emphasis on outlines and contours, and ability to capture the spontaneity of people in their work environment. **IZ**

The Montagne Sainte-Victoire with Large Pine *c.* 188:

PAUL CÉZANNE 1839 – 1906

oil on canvas
26 ¹/₄ x 36 ³/₈ in. / 67 x 92.5 cm
The Courtauld Gallery, London, UK

Situated just east of Aix-en-Provence, Mont Sainte-Victoire was Paul Cézanne's favourite subject for painting. He produced more than sixty representations of the mountain, using it for his radical experiments in landscape painting and continually reinventing his painting technique. While the Impressionists (see p.316) had focused on the transient effects of light and weather on a landscape, Cézanne attempted to analyze the underlying geometry of the rocks and vegetation—to 'treat nature by the cylinder, the sphere, the cone'. It was his lifelong goal to reproduce his subjects exactly as he saw them; a tree, for example, might appear as a cylinder represented by only a few simplified colour planes. Cézanne studied Mont Sainte-Victoire from many angles, using blocks of colour to achieve a spatial effect known as 'flat depth' to depict its topography more effectively.

Cézanne painted this particular canvas from a spot on his brother-in-law's property, where it was his practice to work on two different pictures of the same view at the same time. When Cézanne showed this work for the first time at a local society of amateur painters, the Société des Amis des Arts at Aix, in 1895, it was met with incomprehension. The only person who admired it was the son of a childhood friend of Cézanne's, a young poet and writer, Joachim Gasquet. The artist was so grateful for his appreciation that he signed the painting, something that he did rarely, and gave it to Gasquet. Two years after Cézanne's death in 1906, Gasquet sold the painting for the then astounding sum of 12,000 francs; by that point Cézanne had been rediscovered by contemporary, young, avant-garde artists. **IZ**

✦ NAVIGATOR

◉ FOCAL POINTS

1 SKY BETWEEN BRANCHES

Cézanne was concerned with the overall effect of his picture, rather than individual details. In between the branches of the tree, there are patches of grey and green that may be clouds or leaves. They help to produce the desired effect of making the upper part of the canvas shimmer with movement.

2 MOUNTAIN

Unusually, Cézanne began his paintings by locating the main elements with simple charcoal marks and then adding patches of colour. He built up his forms by carefully orchestrating the tones of the patches. The craggy surface of the mountain, for example, is conveyed purely by colour.

3 BRANCHES OVER HOLLOW

Cézanne reshaped nature to suit his design. The tree is a frame for the main motif: the mountain. The graceful curve of the trunk complements the gentle, diagonal slope of the landscape in the foreground. Similarly, the boughs on the right follow the line of the hollow in the distant terrain.

4 VIADUCT

The artist includes the Pont de l'Arc, the principal, man-made landmark in the Arc Valley. Increasingly, Cézanne omitted such identifiable features as he lost interest in portraying specific details, preferring to use them only as a vehicle to explore the interplay between colour and form.

5 SIMPLIFIED LANDSCAPE

Cézanne sought to reduce the landscape before him to its essential structure, which he expressed in line and geometric shapes. Curves were increasingly presented as multiple flat planes. The effect was new and was taken to even greater abstraction in the work of the Cubists (see p.388).

🕐 ARTIST PROFILE

1839–60

Cézanne was born in Aix-en-Provence, in the South of France. His father was a hat manufacturer and part-owner of a bank and, under his influence, Cézanne began studying law. In 1861 he switched to art and attended the Académie Suisse in Paris, where he met Camille Pissarro.

1861–72

Cézanne returned to Paris. He exhibited at the Salon des Refusés and socialized with Impressionist artists, but did not enjoy commercial success. His early work is full of morbid, often violent fantasies. This changed after he met bookseller Marie-Hortense Fiquet in 1869. He feared his father's reaction, however, so their relationship was kept secret.

1873–86

Cézanne worked at Pontoise with Pissarro, who helped him to develop his mature style. Cézanne participated in two of the Impressionist exhibitions, but increasingly preferred to work in isolation at Aix. He married Fiquet in 1886, shortly before the death of his father.

1887–1906

Thanks to his inheritance, Cézanne was wealthy enough to pursue his artistic experiments intensively. He began to achieve recognition in 1895 after exhibiting in a solo show organized by the art dealer Ambroise Vollard.

CAMILLE PISSARRO

Cézanne's temperament was never suited to conventional academic study, although he did attend the Académie Suisse, where there was no formal instruction. The key influence on his mature style came from the Impressionist painter Camille Pissarro, a fellow student at the Académie. In 1872 Cézanne moved near to Pissarro's home in Pontoise in France. Pissarro steered Cézanne away from the melodramatic inventions of his youth and encouraged him to focus on landscape painting, such as his own *Entering the Voisins Village* (1872; below). Crucially, Pissarro persuaded him to try painting outdoors, forming the basis of the working method that Cézanne used for the rest of his career.

A Sunday on La Grande Jatte–1884 1884 – 86
GEORGES-PIERRE SEURAT 1859 – 91

1 WOMAN FISHING

The image of the female angler is odd because she is dressed in her Sunday finery and has no other fishing apparatus with her. It has been suggested that it is an allusion to a prostitute, based on a pun that was in common usage at the time: *pêcher* means 'to fish' and *pécher* 'to sin'.

2 WOMAN AND CHILD

The eye is drawn to the woman and child, strolling in the middle distance. They face the painter directly and seem to walk in a dreamscape, surrounded by figures that appear frozen into immobility. As if to distinguish the pair from their fellows, most of the latter are depicted in profile.

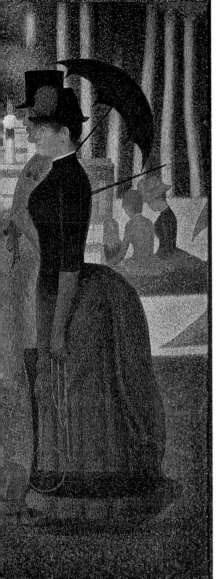

❖ NAVIGATOR

Georges-Pierre Seurat's gigantic masterpiece created a stir when it was shown at the final Impressionist exhibition in 1886. Some viewers were baffled by it, but most recognized it as a revolutionary work that went far beyond the bounds of the original movement. In its subject matter—the depiction of a slice of modern city life—the painting was true to the spirit of Impressionism. La Grande Jatte is a tiny island in the River Seine, where Parisians of all classes went to relax on their day off. Seurat's canvas portrays a cross-section of society, with soldiers, boatmen and a wet nurse mixing with the well-dressed upper classes. In its execution, the painting could hardly be more innovative. The treatment of light and colour was extremely complex, heralding the Pointillist style that Seurat was to develop. In addition, the composition had none of the spontaneity that the Impressionists admired. Seurat produced more than fifty preparatory studies as he carefully worked out the structure of the piece. They ranged from oil sketches of the landscape background to sensitive crayon drawings of individual figures.

The figures appear anonymous and psychologically isolated, as if part of a classical or ancient Egyptian frieze. Their lack of individuality is deliberate. Seurat wanted to advance Impressionism and create an image that would have the gravitas and timelessness of a large-scale history painting. This does not mean that the work lacks its own wry humour: he paints his figures dressed in the latest fashions but in classical poses, in an ironic dig at the foppery of contemporary finery. Seurat aimed to weave together the disparate figures in a harmonious, decorative manner. The result is a work that immediately became notorious when it was shown and helped establish a new direction for painting. **IZ**

oil on canvas
81 ¾ x 121 ¼ in. / 207.5 x 308 cm
Art Institute of Chicago, USA

3 USE OF SHADOWS
Seurat creates depth and perspective through his unnatural use of shadows. The large area of very dark shadow in the foreground draws the eye inwards and contrasts with the rest of the scene, which is bathed in sunlight. Farther back, dark parallel bands mark out the middle distance.

4 SEATED MAN WITH TOP HAT
There are discrepancies of scale within the composition. For example, this seated man appears too small in relation to his two neighbours and to the woman in the centre with the parasol. Seurat worked in a tiny studio and could not stand back far enough to gauge the overall effect of the picture.

Cafe Terrace at Night 1888

VINCENT VAN GOGH 1853 – 90

oil on canvas
31 7/8 x 24 3/4 in. / 81 x 65.5 cm
Rijksmuseum Kröller-Müller,
Otterlo, Netherlands

incident van Gogh painted this vibrant night scene at the Place du Forum in Arles, Provence, in September 1888. He had settled in the city earlier in the year and was eagerly awaiting the arrival of Paul Gauguin. In the meantime he was working intensively, experimenting with new techniques that he had learnt from the Impressionists (see p.316) and combining them with far richer colours and a vigorously worked paint surface. Van Gogh mentioned in a letter that the idea for this picture came to him after reading a description of a cafe at night in a novel by Guy de Maupassant. He made a detailed pen and ink drawing of the subject, but wanted 'to paint the night right on the spot…it is the only way to get rid of the conventional night scenes, with their poor, yellow whitish light'. In line with Impressionist thinking, he was anxious to convey the darkness naturally, without using any black paint. After completing the picture, he wrote jubilantly to his brother: 'There you have it—a night painting without having used the colour black, only beautiful blue, violet and green.' **IZ**

◈ NAVIGATOR

◉ FOCAL POINTS

1 SKY

Van Gogh applied his paint in very thick layers, without smoothing over the surface. His brushstrokes are generally visible to the naked eye and are particularly evident in the patchwork formation of the sky. Sometimes he modelled his forms in layers of impasto, rather than drawing them.

2 HORSE AND PASSERS-BY

Van Gogh has depicted the reflected yellow glare from the gaslight on the horse and passers-by. Whereas the Impressionists would have done this to capture the fleeting moment, Van Gogh has exaggerated the process, using it more for decorative and expressive effect.

3 GUTTER

The artist employs a dizzying form of perspective to draw the viewer's eye into the composition. The lower half of the painting is full of converging lines; in the centre is the line of the gutter, pointing towards the waiter. The gutter is flanked by strong diagonals: the pavement on its left, and the outer row of tables and the pavement on its right. Above, the awning and the roofs form secondary diagonals, leading down into the heart of the picture.

4 AWNING

Van Gogh challenged himself to portray two contrasting light sources: the glaring, artificial light from the cafe and the more subtle lighting from the stars. He was particularly absorbed by the underside of the awning, which is entirely built up from different tones of yellow.

◷ ARTIST PROFILE

1853–81

Van Gogh was born in the Dutch village of Groot-Zundert, the son of a preacher. He embarked on several different careers before he found his true vocation: he worked for a firm of international art dealers, was employed as a teacher in England and served as a lay preacher in a Belgian mining district.

1882–85

Van Gogh moved to the Netherlands, where he had informal art lessons from Anton Mauve (1838–88) which were paid for by his brother Theo, who provided him with unstinting support throughout his life. In 1885 he produced his first genuine masterpiece, *The Potato Eaters*.

1886–88

Van Gogh moved to Paris and there he met the Impressionists and their circle. He experimented with their techniques and began to exhibit work at avant-garde shows. In 1888 he moved to Arles in the South of France for its sunlight, and the colours of his work intensified. Gauguin came to join him, but Van Gogh's mental health deteriorated and he attacked his friend. Gauguin fled and the distraught Van Gogh cut off part of his ear.

1889–90

Hospitalized at Saint-Rémy, Van Gogh continued to work feverishly, producing some of his finest paintings. In 1890 he moved to Auvers-sur-Oise, near Paris, to be close to his brother. His work was gaining recognition, but nervous exhaustion had worn out the artist. He died in July after shooting himself.

SYMBOLISM AND SYNTHETISM

1 *The Buckwheat Harvest* (1888)
Emile Bernard • oil on canvas
28 ³/₈ x 36 ¹/₄ in. / 72 x 92 cm
Josefowitz Collection, Lausanne,
Switzerland

2 *Green Death* (c. 1905)
Odilon Redon • oil on canvas
21 ⁵/₈ x 18 ¹/₄ in. / 55 x 46 cm
Museum of Modern Art, New York, USA

3 *Le Grand-Lemps* (c. 1892)
Pierre Bonnard • oil on canvas
13 ³/₄ x 9 ¹/₂ in. / 35 x 24 cm
Private collection

ymbolism emerged in the 1880s as a reaction against the 19th century's
preoccupation with materialism and technological change. The term was
coined by the French poet and critic Jean Moréas in an article he wrote
for *Le Figaro* called 'Le Symbolisme' in 1886. Symbolist poets expressed personal
deep feelings, Moréas wrote, 'to clothe the idea in sensuous form'. The term
was soon applied to any imaginative and intuitive style of painting that
avoided objectivity and naturalism. Symbolist painters developed the idea that
had been propagated by Eugène Delacroix (1798–1863) earlier in the century
that colour could be expressive as well as descriptive. Many artists explored
similar ideas with line and shape. Symbolist painters rejected naturalism and
realism in favour of reviving Romanticism's (see p.266) emphasis on the
imagination. They eschewed the tangible, external world in favour of looking
within and making feelings and ideas the starting points of art.

Symbolism related more to an artistic approach than to a particular style.
One of the major groups of artists using this approach was briefly based in
Pont-Aven in Brittany. It included Paul Gauguin (1848–1903), Emile Bernard
(1868–1941) and Paul Sérusier (1864–1927). The artists were attracted by the mix
of folklore and devout Christianity they encountered in the inhabitants of this
remote, rural area. They experimented with images of dreams and memories
using flat, simplified forms in unnatural colours and rhythmic patterns, the
results of which can be seen in Bernard's *The Buckwheat Harvest* (above). The

KEY EVENTS

1884	1886	1888	1889	1890	1891
Pierre Puvis de Chavannes (1824–98) begins work on a series of Symbolist murals for the Musée des Beaux-Arts in Lyons, France.	Poet Jean Moréas unfolds the Symbolist manifesto in an article about poets Stéphane Mallarmé and Paul Verlaine in the French newspaper *Le Figaro*.	Sérusier paints *The Talisman*, a landscape using bold, flat forms separated by dark contours; it acts as a catalyst for his friends to form the Nabis.	A small exhibition of Synthetist works is held at the Café Volpini in Paris, during the Exposition Universelle. None of the works are sold.	Vuillard paints his groundbreaking work *Octagonal Self-portrait*. The painting shows a visionary use of bold colour that predates Fauvism (see p.370).	French critic Albert Aurier writes an article on Gauguin in which he defines the aesthetic of Symbolism. Poet Arthur Rimbaud dies in Marseille.

nnaturally red grass in the painting gives it a quality of otherworldliness. auguin, meanwhile, believed art to be an abstraction, created by the synthesis f perceived nature and the artist's experiences. His style of plain, unblended plours and simplified forms outlined in black, as exemplified in his *Vision fter the Sermon* (1888; see p.340), was extremely influential. He emphasized nat an emotional response to art was more important than an intellectual ne and that artists should paint from their imaginations rather than from bservation. He advised his followers to 'paint by heart' because emotion more meaningful than natural forms. This theory of synthesizing subject natter with emotions was termed 'Synthetism' and both Bernard and Gauguin laimed to have developed it. As a branch of Symbolism, Synthetism was at its eight between 1888 and 1894, although some artists continued working in ne style into the 20th century.

Whereas the Synthetists explored feelings through humble subjects, motions such as melancholy, despair and hopelessness became central nemes for other Symbolist artists. Dreams, nightmares, religion and death vere portrayed using intense, spiritual imagery. Some Symbolists worked n intricate detail, whereas others worked in an almost raw and childlike implicity. Many artists painted in broad areas of flat colour and others used uminescent hues and delicate brushstrokes. Odilon Redon (1840–1916) painted ream-like images with fragmented imaginative elements and illusions about ne subconscious mind, which anticipated many Surrealist (see p.426) ideas. *reen Death* (right) represents a macabre vision or fantasy involving a haunted-oking green figure rising out of a serpent-like creature.

Another Symbolist group was the Nabis, active from 1888 to 1900. Among ne group were Maurice Denis (1870–1943), Pierre Bonnard (1867–1947), douard Vuillard (1868–1940), Félix Vallotton (1865–1925) and Paul Sérusier. The roup's name came from the Hebrew word for 'prophet' and it referred to the rtists' enthusiasm for Gauguin's expressive Synthetist style and the fervour vith which they endorsed it. Sérusier, who met Gauguin at Pont-Aven in 1888, vas the motivation behind the group. The style of the Nabis was characterized y flat patches of colour, bold contours and simplified drawing. The artists lso experimented with painting on different supports, including cardboard nd velvet. As well as painting, they produced posters, prints, textiles and book llustrations and they created set designs for Symbolist theatre productions. Much of their work was influenced by contemporary Japanese prints and Art Jouveau (see p.346) designs. Whereas many of the Nabis were concerned vith mystical Christian themes, Bonnard and Vuillard often portrayed ntimate domestic scenes. Unlike the Impressionists (see p.316), who sought to ccurately reflect the colours of the natural world, Bonnard often exaggerated nd distorted colour in order to express a sense of mood, as seen in *Le Grand-emps* (right), one of his typical, densely packed landscapes. **SH**

The Vision After the Sermon 1888
PAUL GAUGUIN 1848 – 1903

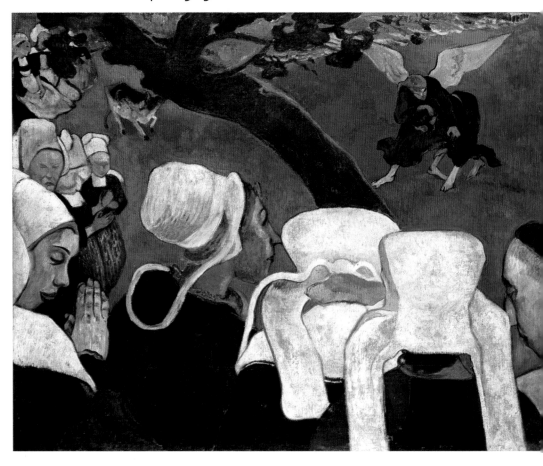

oil on canvas
28 ³/₈ x 35 ⁷/₈ in. / 72 x 91 cm
National Gallery of Scotland,
Edinburgh, UK

◆ **NAVIGATOR**

Usually regarded as Gauguin's first masterpiece, *The Vision After the Sermon* is a symbolic and spiritual work. The Breton women, shown in the painting in their distinctive ceremonial headdresses, have just heard the priest read a sermon based on the story in Genesis (32:22–32) about Jacob's night spent wrestling with a mysterious angel. This dramatic composition with its daring colours set it apart from most work of the 1880s, when an adherence to naturalism was expected. After the eighth Impressionist exhibition in 1886, Gauguin decided to find his own expressive style. Believing that materialism had corrupted Paris, he stayed in the unspoilt village of Pont-Aven in Brittany. There he and other like-minded artists developed Synthetism. This new style of art had affinities with Symbolism and focused on simplifying forms and applying paint in unmodelled areas of bright colour. While working on this painting, Gauguin wrote to Vincent van Gogh: 'The landscape and the fight only exist in the imagination of the people praying after the sermon.' A diagonally placed tree separates the different subjects of the work. The sombre tones of the women's dress signifies their belonging to the concrete, earthly world; this contrasts with the vivid colours depicting the subject of the vision. Gauguin's use of colour marks his move away from Impressionism (see p.316). His portrayal of the figures also reflects the unsophisticated wooden saints, rough walls and gargoyles he saw in the Pont-Aven church. **SH**

⊙ FOCAL POINTS

1 KNEELING WOMEN

The stark black and white shapes of the Breton women against the red background symbolized Gauguin's break with Impressionism. He hoped his depiction of simple pious people in the country would reintroduce a materialistic urban society to the mystery of their inner spiritual lives.

2 TREE AND COW

The real and imagined worlds (secular and spiritual) of the figures and the vision are separated by a diagonally placed tree trunk. The far side of the trunk is tinged with a thin line of orange reflecting the radiance of the vision. The cow signifies the simplicity of rural life in Pont-Aven.

3 JACOB AND THE ANGEL

Gauguin's technique of using flat areas of darkly outlined colour was influenced by Japanese art; it also resembles stained glass windows. His choice of ultramarine blue for the angel's robe, bottle green for Jacob's and chrome yellow for the angel's wings was surreal and highly unusual.

4 THREE FIGURES AT THE EDGE

In cropping the figures at the canvas edges, rejecting traditional perspective and abandoning any indication of a particular source of light, Gauguin broke with convention. The distortion of the bonnets and the cropping of the priest's head echo the style of the Japanese prints he collected.

5 PROFILE OF PRAYING WOMAN

The praying woman's face is barely modelled; few details or tones have been added and the black outlines make the image appear even flatter. Bold white highlights echo the headdresses of the women and the single stroke of vermilion forming the lower lip picks up the background colour.

⊙ ARTIST PROFILE

1872–79

Gauguin began a successful career as a stockbroker in Paris and married Mette Sophie Gad in 1873. The couple had five children over the next ten years. After meeting Pissarro in 1874, he started to paint landscapes under his influence and began to spend much of his time with the Impressionists.

1880–82

Gauguin exhibited with the Impressionists at three of their independent exhibitions in Paris.

1883–87

After a financial slump, Gauguin resigned from the stock market to devote himself to art. In 1886, after exhibiting at the final Impressionist exhibition, he left his family in Copenhagen and moved to Pont-Aven, Brittany, France. He spent the next year there and produced many Synthetist works.

1888–90

Gauguin stayed with Van Gogh in Arles, southern France. The two artists quarrelled and Gauguin returned to Paris in 1890.

1891–1903

Gauguin moved to Tahiti and painted vivid, primitive works. He attempted suicide in 1897 and settled with a Tahitian girl on the Marquesas Islands in 1901. Sentenced to imprisonment for libel in 1903, he died before starting his sentence.

JAPANESE PRINTS

In the late 1850s, treaties between Japan and Western countries opened up trade and introduced Japanese culture to Europe. The French expression 'Le Japonisme' was used from 1872 to describe the influence of Japanese art on Western art. After meeting Van Gogh in 1886, Gauguin's enthusiasm for Japanese art was aroused and he began collecting prints and drawings by Katsushika Hokusai (1760–1849) and Ando Hiroshige (1797–1858). These works inspired him and he based many of his compositions on their understated, asymmetrical arrangements and flat areas of bright colour. Gauguin often incorporated images of his prints into his paintings, as in *Flowers with a Japanese Print* (1889; below).

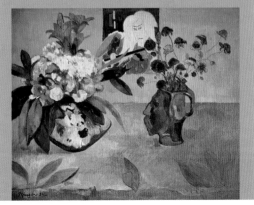

PRIMITIVISM

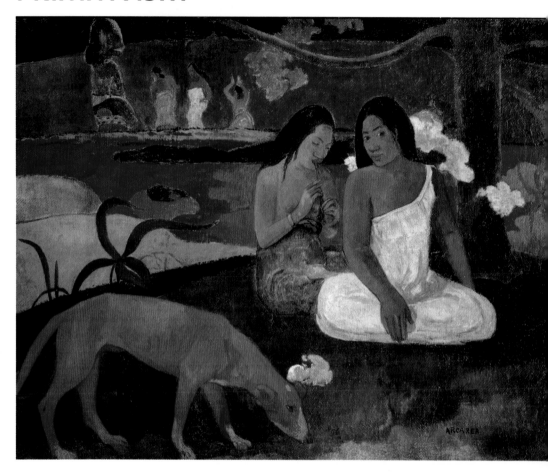

By the end of the 19th century, European imperial control of South Americ
Africa, Asia and Australasia had expanded and colonial conquests in Asia
Africa and Oceania in particular meant that artefacts were sent home to
be exhibited or sold as curiosities. Ethnological museums were opened in man
European cities and numerous artists travelled to places such as North Africa
and the Middle East. This coincided with a desire among young avant-garde
artists to repudiate accepted traditions of art and find better ways of working.
Disillusioned with much of modern life, some artists began exploring tribal ar
in museums or looking to non-Western cultures, such as the African or Oceani
They believed that the art of these ancient cultures was more moral, instinctiv

KEY EVENTS

1891	1893	1903	1904	1905	1906
Gauguin leaves Europe and settles in Tahiti where he explores native art. Rousseau shows his first jungle painting at the Salon des Indépendants.	Rousseau, whose work has been shown regularly at the Salon des Indépendants since 1886, retires from his job as a toll collector to devote himself to art.	Paris's Salon d'Automne holds an exhibition of Gauguin's work. It influences the avant-garde artists and Picasso in particular.	Kirchner studies ethnic art at the Museum of Ethnology in Dresden. A year later Gauguin's paintings are shown at the Weimar Museum, inspiring young artists.	Rousseau shows his *The Hungry Lion Throws Itself on the Antelope* at the Salon d'Automne alongside works by Matisse and the Fauves (see p.370).	Matisse buys an African statue in a junk shop in Paris; late he shows it to Picasso who stays up half the night drawing it.

nd sincere than Academic art (see p.276) where technical skill and classical ideas were revered. By discarding Western sophistication and looking to other ultures, it was believed that art could be reinvigorated.

Rather than a distinct movement, Primitivism was a trend whose ideas nformed much of 20th-century art. The meaning of the term was soon xtended to refer to the art of children or untrained artists, so that it referred artly to what became known as Naive art. This simple, uncomplicated style of art, as seen in *The Snake Charmer* (1907; see p.344) by Henri Rousseau (1844– 910), was initially reviled by the establishment but was regarded as innovative nd inspiring by younger avant-garde artists.

Pablo Picasso (1881–1973), Paul Gauguin (1848–1903), Emil Nolde (1867–1956), Henri Matisse (1869–1954), Constantin Brâncuși (1876–1957), Ernst Ludwig Kirchner (1880–1938) and Amedeo Modigliani (1884–1920) were some of the rtists who responded to tribal art's distortions of form, bold patterns and ontrasting colours that released them from the tradition of representation. They experimented with its simple shapes and outlines, symbolic codes, distortion nd pattern. They excluded details, realism, linear perspective and natural olours and created abstract works in a way that had been impossible up to hen. They also celebrated sensuality and the concept of the unconsciousness.

One of the first artists to inspire others with the notions of Primitivism vas Gauguin. Disenchanted with France, he moved to Tahiti and concentrated on producing art that was without artifice or technical complexity. His nterest in folk art intensified and he studied the methods of local craftsmen. n rejecting Western civilization, he tried to make his own art more primitive, exotic, instinctive and closer to what he saw as the natural and moral purity of the indigenous people around him. This resulted in paintings such as *Arearea*, also known as *Jokes* (opposite), which simplifies volume in its use of lat planes of colour, and evokes an atmosphere of exoticism with its 'primitive' ntensity of colour and mix of dream and reality. When Gauguin's work was hown in Germany in 1905 and 1910, it had a profound effect on the German Expressionists (see p.378), who were attracted by ethnographic art's simplified, exaggerated forms.

The appeal of Primitivism was not confined to painting. Musicians and culptors also embraced it. Inspired by Romanian folk art and masks, Brâncuși ransformed sculpture by abandoning modelling in favour of direct carving to produce increasingly abstract works. He produced several versions of his bust of a young Hungarian woman, *Mlle. Pogany* (right). He simplifies his subject's eatures to geometric shapes, producing a streamlined egg shape.

Primitivism's extensive interpretations and universal appeal meant that t remained an enduring trend in 20th-century art. After World War II and the demise of colonialism, the tribal art aesthetic had been so fully absorbed into rtistic practice that the idea of Primitivism became mainstream. **SH**

1 *Arearea* (1892)
Paul Gauguin • oil on canvas
28 ³/₄ x 37 in. / 73 x 94 cm
Musée d'Orsay, Paris, France

2 *Mlle. Pogany version I* (1913)
Constantin Brâncuși • bronze with black patina on limestone base
17 ¹/₄ x 8 ¹/₂ x 12 ¹/₂ in. / 44 x 21.5 x 31.5 cm
Museum of Modern Art, New York, USA

1907	1910	1912	1913	1923	1938
icasso visits the frican collections t the Trocadéro in aris, throws a banquet or Rousseau and aints *Les Demoiselles* ''Avignon (see p.392).	The Galerie Arnold in Dresden holds an exhibition of Gauguin's work. Kirchner designs the poster for the show based on a Gauguin painting.	Modigliani carves *Woman's Head* in limestone; its facial features and abstract, elongated head are inspired by African sculpture.	Nolde travels to Papua New Guinea (then German New Guinea) and is inspired to create a number of works reminiscent of wooden tribal carvings.	Brâncuși carves *Bird in Space*, aiming to depict a bird in flight. Its elongated shape represents a bird's movement rather than its physical attributes.	Kirchner commits suicide after the anti-Modernist Nazi regime seizes 639 of his works and condemns them as 'degenerate art'.

The Snake Charmer 1907

HENRI ROUSSEAU 1844 – 1910

oil on canvas
66 x 75 in. / 169 x 189.5 cm
Musée d'Orsay, Paris, France

◈ NAVIGATOR

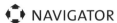
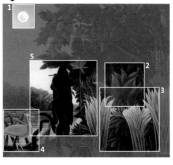

Commissioned by the mother of painter Robert Delaunay (1885–1941), *The Snake Charmer* was painted by the self-taught artist Henri Rousseau after he was accepted by the avant-garde. In a moonlit jungle, a mysterious figure plays her flute, summoning serpents from the vegetation. Every element from the lush tropical greenery to the moon and flamingo, appears to be made up of pieces of appliquéed fabric, giving a sense of a two-dimensional composition. Two Academic artists (see p.276), Félix Auguste Clément (1826–88) and Jean-Léon Gérôme (1824–1904), advised Rousseau to let nature be his only teacher. He followed this advice throughout his life. The two Academics also helped Rousseau to obtain an official permit to draw copies of artworks in the Louvre. Rousseau's best-known paintings depict jungle scenes, but he never left France. Instead, he often took his sketchbook to the Jardin des Plantes in Paris, where he drew for hours. This painting, with its strange plants and animals from exotic lands, has a sensual, dream-like quality. Its naivety, rhythmic use of pattern and bright colour palette are typical of Primitivism, and Rousseau's unschooled technique was influential on a younger generation of artists. **SH**

FOCAL POINTS

1 APPARENT SIMPLICITY

Although Rousseau's work was thought to represent untutored simplicity, he planned his paintings in great detail, choosing patterns and colours very deliberately. At the top of the canvas, a silvery moon hangs in the dusky sky and illuminates the edges of everything beneath it.

2 LAYERED TECHNIQUE

Rousseau's painting technique is unusual. Rather than using a limited palette and mixing colours he painted in layers, starting with the sky and adding on a few leaves at a time, waiting until they were dry before painting more. He uses many different greens to show depth and space.

3 LACK OF LINEAR PERSPECTIVE

Rousseau probably transferred his sketches on to the canvas using a copying device and then modified the plants to appear more exotic. The intertwining patterns of jewel-bright leaves and flowers create a sense of harmony and depth, although there is no traditional linear perspective.

4 DREAM-LIKE QUALITY

The flamingo is rendered in the only pastel colour scheme used in the picture. Like the snakes, the bird is transfixed by the woman's music and calmly gazes at her from the bulrushes. The horizontal ripples on the water enhance the dream-like stillness of the painting.

5 USE OF ALLEGORY

The snake charmer is shapely but obscure; only her eyes and knee-length, undulating hair are seen clearly. A snake coils around her neck and two dance at her feet. She has been compared to Eve in the Garden of Eden, but she charms the wildness of nature and is unafraid of the serpent.

ARTIST PROFILE

1844–83

Rousseau was born in Laval, France. He joined the army but never saw combat; when he left in 1868 he entered the Paris municipal toll-collecting service as a second-class clerk. This led to his nickname 'Le Douanier' Rousseau.

1884–92

He obtained a permit to sketch in national museums. He sent two paintings to the Salon des Champs-Elysées in 1885 but his work was rejected by the Paris Salon. From 1886 he exhibited annually at the Salon des Indépendants where he showed his first jungle painting, *Tiger in a Tropical Storm (Surprised!)*, in 1891—it was ridiculed for its childish amateurism.

1893–1908

The Hungry Lion Throws Itself on the Antelope was shown at the 1905 Fauves (see p.370) exhibition. Rousseau started to receive critical recognition and mixed with avant-garde artists including Robert Delaunay and Pablo Picasso.

1909–10

Rousseau's paintings were acquired by the influential art dealers Ambroise Vollard and Joseph Brummer in 1909 and he had his first solo show in a furniture shop. He died in Paris a year later; the same year an exhibition of his work took place at Alfred Stieglitz's (1864–1946) 291 gallery in New York. Rousseau was given a retrospective at the Salon des Indépendants in 1911.

ROUSSEAU AND NAIVE ART

Naive art appears uncomplicated and the term is applied to the work of any artist who lacks formal training. However, the childish appearance of Naive art is often deceptive. Rousseau is the best-known Naive artist and many tried to emulate his use of bright colours, disregard for perspective, layers of flat shapes and patterns, and careful attention to detail. As an untrained art establishment outsider, he was initially ridiculed for his childish style, for example in *Self-portrait* (1890; below). Acceptance of his work came with the emergence of Primitivism in the early 20th century, when young avant-garde artists looked to non-Western cultures and began to appreciate the innocence of Naive art. The first to

recognize Rousseau's talent was French writer Alfred Jarry (1873–1907), who introduced Rousseau to the bohemian circle in Paris in 1893. Picasso later became a buyer of Rousseau's work, and in 1908 he hosted a banquet at his Montmartre studio in honour of the artist.

ART NOUVEAU

1 *Fatality* (1893)
Jan Toorop • chalk and pencil on paper
23 ⅝ x 29 ½ in. / 60 x 75 cm
Rijksmuseum Kröller-Müller,
Otterlo, Netherlands

2 *The Precious Stones: Amethyst* (1900)
Alphonse Mucha • colour lithograph
24 ⅜ x 9 ⅞ in. / 62 x 25 cm
Chrudim Regional Museum, Chrudim,
Czech Republic

3 Grasshoppers vase (1913)
René Lalique • blue opalescent glass
11 in. / 28 cm high
Private collection

A rt Nouveau was a versatile, decorative style that gained huge popularity throughout Europe and the United States. It affected every branch of the arts from painting and architecture to graphic art and design. The chief characteristic of the style was the use of sinuous, linear patterns. Stylized natural forms, such as leaves or tendrils, predominated, but stylized human forms were also occasionally employed, as were relatively abstract motifs such as the whiplash curve and the arabesque. Designers avoided symbolic or expressive content in their work, focusing instead on its decorative appearance. By divesting their subjects of emotional or narrative content, they helped pave the way for the development of abstract art.

Art Nouveau evolved from an eclectic variety of sources. It owed something to the bold simplifications of Japanese prints, which had proved such an inspiration to the Impressionists (see p.316). It was also influenced by the Arts and Crafts Movement in Britain and, in particular, by the rhythmic, floral patterns in the wallpaper designs of William Morris. In addition there were echoes of the stylizations employed by such artists as Paul Gauguin (1848–1903), Vincent van Gogh (1853–90) and Edvard Munch (1863–1944). Dutch painter Jan Toorop (1858–1928) began his career as an adherent of Symbolism (see p.338), and in his early works, such as *Fatality* (above), he used unpredictable, curvy lines and symbols to depict a world beyond reality. Gradually he abandoned cryptic meaning in favour of purely decorative works in the Art Nouveau style.

KEY EVENTS

c. 1890	1892–93	1894	1894	1895	1895
Japanese prints, already embraced by Aestheticism (see p.310), attract artists for their intertwining organic forms and strong colours.	Belgian architect Victor Horta (1861–1947) designs the first Art Nouveau-inspired building, the Tassel House in Brussels, with curvilinear ironwork.	Oscar Wilde publishes his play *Salome* for the first time in England, with illustrations by Beardsley that include *The Peacock Skirt* (see p.348).	The magazine *Pan* notes 'sudden violent curves occasioned by the crack of a whip' in a work, and 'whiplash curves' become part of the style's lexicon.	Bing opens La Maison de l'Art Nouveau in Paris and the shop and gallery become a major meeting point for Art Nouveau artists.	Mucha introduces his distinctive style to Paris with a poster advertising the play *Gismonda* by Victorien Sardou.

The Art Nouveau movement emerged initially in France. The name came from La Maison de l'Art Nouveau, a shop in Paris opened in 1895 by a German art dealer, Siegfried Bing (1838–1905). Bing mainly dealt in Eastern artworks but he also showed the work of modern European designers. He had a particular interest in glassware and after meeting the American Louis Comfort Tiffany (1848–1933) in 1898 Bing became the exclusive European distributor of the designer's goods. Bing also sold work by the two other giants of Art Nouveau glass: Emile Gallé (1846–1904) and René Lalique (1860–1945). The latter's work, which frequently features realistic or stylized representations of plants and insects, such as the opalescent glass vase with a grasshopper motif (right, below), also included jewellery pieces in plant and insect forms.

The French capital was also at the forefront of developments in a relatively new art form: the poster. Two of its leading exponents, Alphonse Mucha (1860–1939) and Jules Chéret (1836–1932), were pioneers of the new style. They both became known for their colourful images of attractive young women, for example Mucha's *Amethyst* (right), one of his *Precious Stones* series that also included *Ruby*, *Topaz* and *Emerald*. Women in Art Nouveau were loosely based on the femmes fatales popularized by the Symbolists, but their long tresses were no longer intended as weapons to ensnare the unwary; they were simply decorative. In Paris the influence of Art Nouveau was also evident in architectural features, such as the wrought-iron entrances that Hector Guimard (1867–1942) designed for the city's new Métro stations.

A German variant of Art Nouveau was generally known as 'Jugendstil', after an influential magazine, *Die Jugend* (Youth), published in Munich from 1896 to 1914. *Die Jugend* was an important showcase for the new style and one of its principal illustrators was the Hamburg artist Otto Eckmann (1865–1902). In common with other Art Nouveau contributors, he created designs for a wide variety of furniture, ceramics and wallpaper. In Austria, the style was called 'Sezessionstil', because of its close links with the Vienna Secession (see p.350), while in Italy it was known as 'Stile Liberty', a reference to the Liberty department store in London. Founded in 1875 by Sir Arthur Lasenby Liberty (1843–1917), the Liberty shop promoted the work of Art Nouveau designers.

In Britain the linear stylizations of Art Nouveau are closely associated with the graphic work of Aubrey Beardsley (1872–98), such as *The Peacock Skirt* (see p.348). In Glasgow the dominant figure was Charles Rennie Mackintosh (1868–1928). He benefited from a revival of interest in Celtic decoration (spearheaded by Liberty) and was also influenced by the creation of The Studio in 1893, which exhibited illustrations of the work of Beardsley and Toorop. Mackintosh became best known for his fastidious, all-encompassing approach to interior design. For two of his most celebrated commissions—the tea rooms in Willow Street and Ingram Street in Glasgow—he designed every detail, from the external facade and murals to the furniture, cutlery and menus. **IZ**

L'AMÉTHYSTE

1896	1897	1899	1900	1909	1914
Eckmann begins to produce graphic work for the magazine *Jugend*, the main disseminator of the German variant of Art Nouveau style.	Lalique is awarded the Croix de la Legion d'Honneur for the jewellery he exhibited at the Exhibition Universelle in Brussels.	Guimard designs his first Art Nouveau entrances for stations of the Paris Métro. Constructed from iron and glass, the last is built in 1905.	At the Exposition Universelle in Paris, Lalique causes a sensation with his jewellery and *objets d'art* made from bronze, ivory and glass.	Mackintosh completes his new building for the Glasgow School of Art. It is Britain's first original example of Art Nouveau architecture.	At the start of World War I, Art Nouveau is seen as a luxurious, expensive style. It gives way to the simpler and more streamlined look of Modernism.

The Peacock Skirt 1892

AUBREY BEARDSLEY 1872 – 98

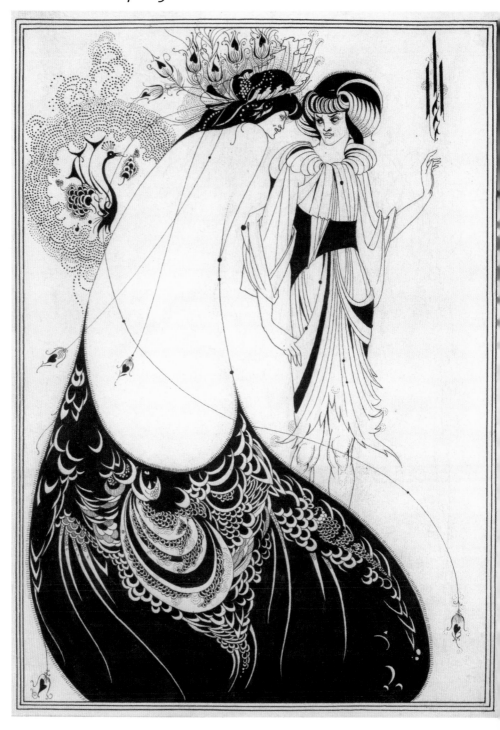

black ink and graphite on paper
9 x 6 ⁵/₈ in. / 23 x 17 cm
Harvard Art Museum/Fogg Museum, Cambridge, Massachusetts, USA

Aubrey Beardsley produced *The Peacock Skirt* as one of a set of illustrations for the play *Salome* by Oscar Wilde. The dramatist's original text was in French, and after reading it Beardsley produced a powerful drawing of Salome holding the head of John the Baptist. Wilde saw the drawing and realized immediately that in Beardsley he had found the ideal illustrator for the English edition of his book.

The commission was fraught with problems, however, because the publisher found many of the drawings too pornographic and demanded changes. Beardsley responded by producing some of his most dazzling designs, although many had limited relevance to the text. Often, as in *The Peacock Skirt*, he was diverted by the decorative possibilities of Salome's extravagant attire. He expresses his fascination with women's fashion by representing Salome using simple, sweeping lines and providing meticulous detail only for her headgear and lower dress. The publication of the book caused a scandal and Beardsley gained a notoriety that he did not entirely welcome. **IZ**

◈ NAVIGATOR

◉ FOCAL POINTS

1 NARRABOTH

Androgynous figures were common in *fin de siècle* art, and they can be found in abundance in *Salome*. Effeminate in face (but with masculine knees), this figure is Narraboth, the young captain of Salome's guard. Salome browbeats him into letting her meet John the Baptist.

2 MONOGRAM

Beardsley was impressed by the butterfly that James McNeill Whistler used in place of a conventional signature. His own emblem was intended to suggest candles, which played a significant role in his art. He liked to perpetuate the myth that he worked only at night, lit by two favourite candlesticks.

3 PEACOCK FEATHER

A defining feature of Art Nouveau is the transformation of natural forms. The initial source of inspiration was often provided by plants or other living creatures, but artists depicted these in a decorative and highly stylized manner. In Salome's headdress, for example, some of the peacock feathers appear to take on a life of their own. Here, a lengthy strand does not move naturally but forms a graceful arabesque that complements the curve of Salome's dress.

4 PEACOCK SKIRT

The semi-abstract designs on Salome's skirt, loosely based on peacock feathers, exemplify Beardsley's decorative flair. He had been hugely impressed in 1891 by Whistler's celebrated Peacock Room, in which blue and gold peacocks, painted in a glittering, Oriental style, covered entire walls.

5 PEACOCK IN BACKGROUND

The peacock behind Salome refers to a passage in the play. After Salome dances for him, Herod offers her his collection of peacocks in place of John the Baptist's head. Beardsley depicts the bird entirely with curving lines, and its decorative medallion serves to heighten the image's sense of mystery.

◷ ARTIST PROFILE

1889–91

Beardsley began working as an insurance clerk, but dreamt of a career in art. He showed his drawings to Sir Edward Burne-Jones (1833–98), who offered encouragement.

1892–95

He received his first major commission, to illustrate an edition of Sir Thomas Malory's *Le Morte d'Arthur*. Recognition followed swiftly and Beardsley became art editor of *The Yellow Book*, a quarterly literary periodical. He was later sacked from *The Yellow Book* because of his association with Oscar Wilde.

1896–98

Beardsley helped to launch a new periodical, *The Savoy*, and produced Rococo-style (see p.250) illustrations for Alexander Pope's *The Rape of the Lock*. He converted to Catholicism in 1897 and moved to France, where he died from tuberculosis.

SECESSIONISM

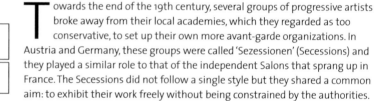

1 **Exterior detail of the Secession Building, Vienna, Austria (1898)**
Joseph Maria Olbrich

2 **Poster for the thirty-third exhibition of the Viennese Secession (1909)**
Otto Friedrich · colour lithograph

3 **Salome (1906)**
Franz von Stuck · oil on canvas
45 1/2 x 24 5/8 in. / 115.5 x 62.5 cm
Lenbachhaus/Kunstbau, Munich, Germany

Towards the end of the 19th century, several groups of progressive artists broke away from their local academies, which they regarded as too conservative, to set up their own more avant-garde organizations. In Austria and Germany, these groups were called 'Sezessionen' (Secessions) and they played a similar role to that of the independent Salons that sprang up in France. The Secessions did not follow a single style but they shared a common aim: to exhibit their work freely without being constrained by the authorities.

The trend began in Munich in 1892, where the newly formed Secession built a private gallery to house its exhibitions and soon outshone the official cit organization. The Munich group was never as radical as the other Secessions and its leading figure, Franz von Stuck (1863–1928), became a professor at the Munich Academy, where his pupils included Paul Klee (1879–1940) and Wassily Kandinsky (1866–1944). Von Stuck was a Symbolist (see p.338) artist whose evocative painting were often dark and erotic. In *Salome* (opposite), he portrays the central figure a a sensual *femme fatale* and encircles the decapitated head of John the Baptist with a blue halo, drawing attention to the grotesque lower corner of the scene.

The most influential of the Secessions was formed in Vienna in 1897. Gustav Klimt (1862–1918) was elected as its first president and remained the dominant painter within the Secession until his departure in 1905. From the outset, the members of the Vienna Secession had a far broader range of interests than their German counterparts. The group produced its own periodical, the *Ver*

acrum (Sacred Spring), to publicize its ideas, and its members included architects and decorative artists as well as painters. Architect Joseph Maria Olbrich (1867–1908) designed the spectacular building (opposite), where the association held its exhibitions. Dubbed 'the Golden Cabbage' on account of its glittering dome, it had the Secessionists' motto inscribed above the door: 'To each age its art, to art its freedom'.

The Viennese Secessionists did not promote any specific style of art, although they were closely associated with Art Nouveau (see p.346). The group's main aim was to shake the Viennese art world out of its provincial torpor by acquainting it with the latest artistic currents from other parts of Europe. They devoted a generous amount of space at their shows to the work of foreign artists and designers. At the eighth exhibition (1900), for example, an entire room was set aside for the furniture and artworks of Charles Rennie Mackintosh, whereas the sixteenth exhibition (1903) focused on the paintings of the French Impressionists (see p.316) and Post-Impressionists (see p.328). The Secession also purchased works by artists such as Auguste Rodin (1840–1917) and Vincent van Gogh (1853–90) to donate to a modern gallery in Vienna. Despite this international outlook, it was the work of Klimt that created a great and lasting impact. He provoked a storm of protest when he exhibited *Philosophy* and *Medicine* (c. 1900)—two of his controversial paintings commissioned for the city's university—because they were deemed overtly sexual. Feelings ran equally high in 1902 when his *Beethoven Frieze* was put on show. Klimt had intended it to be an ephemeral work that was to be destroyed after the exhibition. However, while some critics denounced it as 'painted pornography', others campaigned to have it preserved. The more sensual imagery and decorative gold leaf of *The Kiss* (1907–08; see p.352) also failed to impress the critics, although this painting has since become iconic.

The Berlin Secession was formed by 1899. Its most prominent figure was Max Liebermann (1847–1935), who later became one of the foremost German Impressionists. He was appointed as the Secession's first president and remained at the helm until 1911. Under his leadership, the group provided a successful alternative to academic forums and helped Berlin overtake Munich as the most important artistic centre in Germany. For all its liberalism, the Berlin group was still wary of the avant-garde. In 1910, the work of a number of Expressionist (see p.378) painters was rejected from the twentieth exhibition of the Berlin Secession. Emil Nolde (1867–1956) wrote a bitter letter of recrimination to the president and was expelled from the group. Other artists soon followed and together they formed the Neue Sezession (New Secession) in 1910 under the leadership of Georg Tappert (1880–1957) and Max Pechstein (1881–1955). The association flourished briefly and provided an important rallying point for Expressionist artists including Ernst Ludwig Kirchner (1880–1938), Erich Heckel (1883–1970) and Karl Schmidt-Rottluff (1884–1976). **IZ**

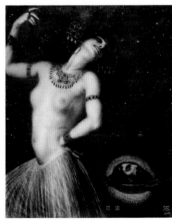

1905	1908	1910	1912	1912	1915
After a series of disagreements, Klimt leaves the Viennese Secessionists and is joined by his splinter group, the Klimtgruppe.	Klimt's *The Kiss* is exhibited for the first time and is condemned for its blatant eroticism.	The work of nearly thirty Expressionist (see p.378) artists is rejected by the Berlin Secession. The rejected artists form a 'New Secession'.	Egon Schiele (1890–1918) is jailed briefly and is forced to leave Krumau when it is discovered that he is using young girls as nude models.	Pechstein is expelled from the artistic movement Die Brücke for having exhibited with the Sezession and the Neue Sezession.	Lovis Corinth (1858–1925) becomes the new president of the Berlin Secession and retains the position for ten years.

The Kiss 1907 – 08
GUSTAV KLIMT 1862 – 1918

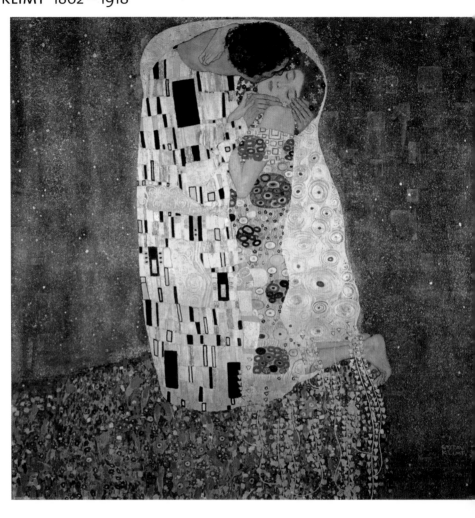

oil on canvas
71 x 71 in. / 180 x 180 cm
Osterreichische Galerie Belvedere,
Vienna, Austria

✦ NAVIGATOR

With his painting *The Kiss*, Gustav Klimt produced the definitive version of a theme that had absorbed him for years: the human embrace. In 1902 he had included in his *Beethoven Frieze* a naked couple embracing to illustrate a section titled 'A Kiss for the Whole World', and in 1904 he had incorporated 'A Kiss' in his design for a section, titled 'Fulfilment', of a series of murals painted in the dining room of the Palais Stoclet in Brussels.

The Kiss is the culminating work in Klimt's so-called 'golden' phase and the abstract decorative motifs, made up of both geometric and floral patterns, dominate the design. The painting was produced at a critical time in the artist's career. He had resigned with several colleagues from the Viennese Secession and together they mounted a new exhibition titled the 'Kunstschau' (Art Show) in 1908, where *The Kiss* was displayed in public for the first time. The 'Kunstschau' attracted fierce criticism and was a financial disaster, but the quality of Klimt's masterpiece was recognized. Before the exhibition was over, the Austrian government had bought the painting for the nation. **IZ**

FOCAL POINTS

1 HEADS OF THE LOVERS

In all of Klimt's versions of the human embrace, the man's face is obscured and the main emphasis is on the woman. Her eyes are closed, presumably in rapture, but the picture also has a more morbid undertone. The woman's skin has a deathly pallor, and the painful, horizontal tilt of the head is clearly designed to evoke comparison with contemporary paintings of severed heads. The theme of decapitation was extremely common in Symbolist art (see p.338).

2 WOMAN'S FEET

Klimt's painting is full of intriguing ambiguities. At first glance it appears that the man dominates physically, but the girl's protruding feet make it clear that she is kneeling, while he appears to be standing. If she were standing, she would tower over her partner.

3 GOLDEN STREAMERS

The streamers cascading below the figure of the woman, and covering the right-hand section of the bank of flowers, may be linked with her apparel, but it is more likely that they were designed to hint at stylized tresses of hair. In Symbolist art, *femmes fatales* were often portrayed with extremely long hair, which they could use to ensnare their victims. Significantly, in the *Beethoven Frieze*, the feet of Klimt's lovers are bound together with coils of hair.

4 FLORAL BANK

The bank of flowers provides the only hint of reality in the setting for the lovers' embrace. Klimt loved flowers and let the garden of his studio run wild so that he could witness nature in its rawest state. He also enjoyed painting flowers, although these never adorned conventional landscapes.

ARTIST PROFILE

1876–92

At the age of fourteen, Klimt began his training at the Vienna School of Applied Arts. While still a student, he formed a partnership with his brother Ernst (1864–92) and Franz Matsch (1861–1942). They won commissions to decorate public buildings.

1893–1904

The business was a notable success, culminating in a commission for a set of murals at Vienna University. However, Klimt was increasingly drawn to avant-garde art. In 1897 he co-founded the Secession, an exhibiting body designed to promote avant-garde trends. Klimt's new style horrified the authorities and eventually he abandoned the university project.

1905–11

After a series of disagreements within the Secession movement, Klimt resigned. Now at the height of his powers, he executed some of his finest works and was honoured with an exhibition at the 1910 Venice Biennale. He also produced his most spectacular decorative scheme, at the Palais Stoclet in Brussels.

1912–18

Klimt was more isolated in his final years. He concentrated mainly on his portraits of beautiful women, which had always been in high demand. He also produced landscapes and erotic allegories. Klimt suffered a stroke and died from pneumonia a few months before the end of World War I.

GOLD AND MOSAIC

Klimt's extensive knowledge of the applied arts had a significant effect on his painting. His father was a goldsmith and Klimt's familiarity with this field served him well. In *The Kiss* he used a coating of gold dust to create his shimmering background and applied shiny gold leaf to the figures' costumes. Klimt's taste for opulent, golden colour was also formed by his interest in mosaics. He had studied mosaics, but his fascination with the subject grew after a visit to Ravenna in Italy in 1903, where he was overwhelmed by the glittering mosaics, such as the Byzantine (see p.72) example below. Klimt adapted the technique for use in his work and it proved a major influence on his mature style. In *The Kiss*, the effect is most evident in the golden cocoon that separates the lovers from the outside world. Its fragmentary patterns and richly encrusted surface drew their inspiration from mosaics.

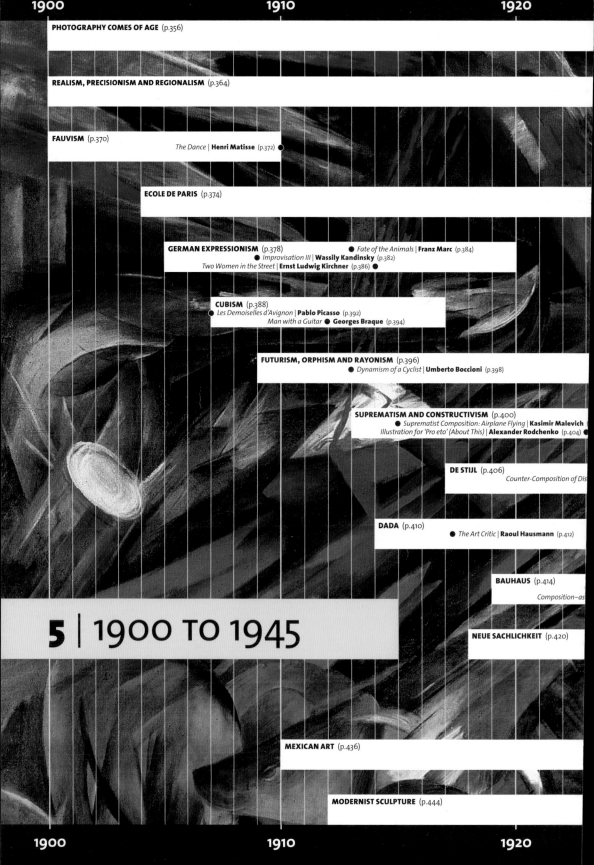

5 | 1900 TO 1945

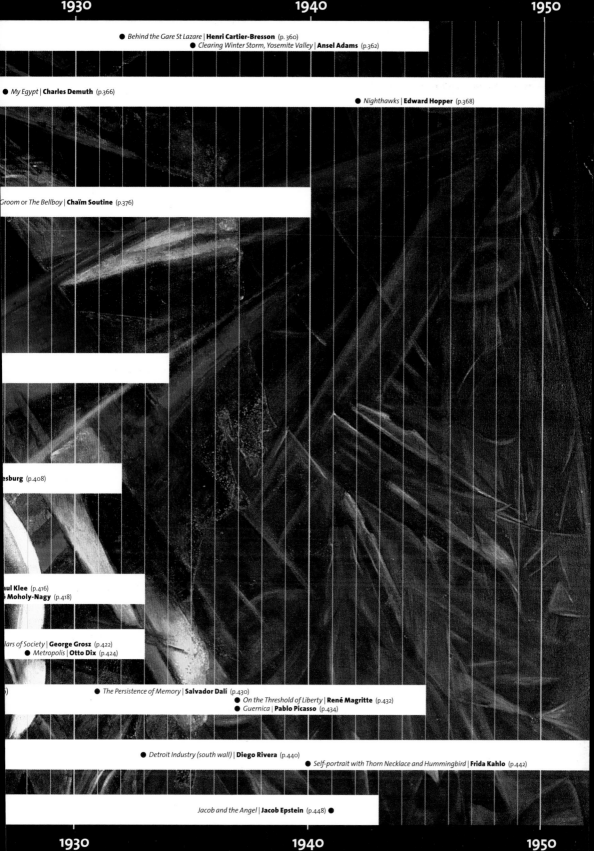

PHOTOGRAPHY COMES OF AGE

1 **The Steerage** (1907)
Alfred Stieglitz • photogravure on vellum
13 1/4 x 10 1/2 in. / 33.5 x 26.5 cm
Whitney Museum of American Art,
New York, USA

2 **The Flatiron Building, New York** (1905)
Edward Steichen • platinum print
18 3/4 x 15 1/8 in. / 48 x 38 cm
Museum of Photographic Arts,
San Diego, USA

3 **Cabbage Leaf** (1931)
Edward Weston • gelatin silver print
7 1/2 x 9 1/2 in. / 19 x 24 cm
Museum of Modern Art, New York, USA

P hotography was first accepted as an art form at the start of the 20th
century. The term 'Pictorialism' emerged to describe photographs that
emulated paintings in style, manipulated by the use of soft focus and
sepia tones, for example. American and European photographers formed
societies to exhibit their work and promote photography as an art form that
depicted truth and employed naturalism. One such society was New York's
Camera Club, and pioneering photographer Alfred Stieglitz (1864–1946) had
held his first solo show at its premises in 1899. Stieglitz was dissatisfied,
however, because at that time art shows were judged by painters rather than
by photographers, so he decided to stage a show that would be appraised only

KEY EVENTS

1900	1902	1908	1916	1920	1922
Photography becomes available to everyone with the introduction of the first Kodak Brownie, a simple cardboard box camera.	Stieglitz sets up the first photographic magazine with a purely visual focus, *Camera Work*.	Father of fashion photography, Frenchman Baron de Meyer (1868–1949) has his Impressionistic fashion shots published in *Camera Work*.	Strand takes an iconic series of street images, such as *Blind*, which combines social documentation with the simplified forms of Modernism.	Albert Renger-Patzsch (1897–1966) and August Sander (1876–1964) adopt the Neue Sachlichkeit (New Objectivity; see p.420) ethos in photography.	Harry Burton (1879–1940) visits Egypt to document in photographs Howard Carter's excavation of Tutankhamun's tomb.

photographers. He founded a group called the Photo-Secession, which put
on a show at New York's National Arts Club in 1902 to great critical acclaim.
Three years later, he set up the Little Galleries of the Photo-Secession, with
fellow photographer Edward Steichen (1879–1973). It became known as '291',
after its address on Fifth Avenue. In a groundbreaking move, they displayed
photographs alongside Modernist paintings and sculptures. Stieglitz promoted
Steichen's work and the pair became close friends.

Steichen was a pioneer, too. He hand-processed his study of New York's
Flatiron building (right, above) using layers of pigment suspended in a light-
sensitive solution of gum arabic and potassium bichromate. This technique
created a colour image before colour photography was invented, and gave
the image a distinct painterly quality. Taken at twilight, the photograph
resembles a Whistler painting in the way that it captures the misty light
and mood of its riverside setting. Its composition is reminiscent of a
Japanese woodcut.

Stieglitz broke artistic boundaries with his photograph *The Steerage*
(opposite), which shows passengers in the upper- and lower-class sections
of a steamer that is about to set sail from New York to Germany. The
combination of its urban content, which illustrates the divide between rich
and poor, and its angular shapes marks the shift from the naturalism of
Pictorialism towards Cubism (see p.388).

After World War I, artists embraced the prevailing mood, which celebrated
mechanization and speed. Modernism was evident in the work of
photographers in Europe, the United States and Japan as they began to create
sharper images, often in close-up, notable for their precision and clean lines.
In the United States a protégé of Stieglitz, Paul Strand (1890–1976), produced
photographs of urban areas and landscapes with an abstract feel that
emphasized form and movement. He was a member of New York's Photo
League, which sought to use photography as a way of promoting social reform
in the 1930s. Other Photo League members included Edward Weston (1886–
1958) and Ansel Adams (1902–84). In 1932 they founded Group f/64:
a small group of photographers whose collective purpose was to challenge
the dominance of Pictorialism. The group advocated straight photography,
which aimed to depict an image as realistically as possible without the use
of manipulation. Its work with depth of field transformed landscape
photography and heralded a shift away from Pictorialism's soft focus towards
photographs showing exquisite detail and fine organic forms, as seen in
Weston's *Cabbage Leaf* (right).

Photography as social comment was innovative in the 1930s, but taking
photographs of everyday life was not. The emergence of lightweight cameras
in the 1930s meant that photographers could be more spontaneous and led
French photographer Henri Cartier-Bresson (1908–2004) to famously capture

1931	1935	c. 1935	1938	1944	1945
Photojournalist Willi Ruge (1882–1961) risks his life to take *Der Fotograf* (The Photographer) during a daring parachute jump over Berlin.	The Works Progress Administration in the United States employs artists. As part of this scheme, Lange's work documents the migrant experience.	Adams captures Yosemite Valley in the aftermath of a storm in his photograph *Clearing Winter Storm, Yosemite Valley* (see p.362).	Walker Evans (1903–75) hides his 35mm camera and surreptitiously photographs passengers on the New York subway.	Capa covers the D-Day Landings. His photograph of a GI landing on Omaha Beach becomes one of the most important shots in history.	Adams, Lange and Imogen Cunningham (1883–1976) teach the first fine art photography course at the California School of Fine Arts.

the moment with shots such as *Behind the Gare St Lazare* (1932; see p.360). Fellow photojournalist Gyula Halasz, known as Brassaï, (1899–1984) also caught the mood of the Parisian streets with images such as *Morris Column* (left, below). It suggests the isolation of nocturnal urban life with a solitary figure set against a backdrop of misty half-light. Many of Brassaï's images were taken as he walked the streets of Montparnasse at night, photographing its prostitutes, artists and criminals. When he published his work in *Paris de nuit* (Paris After Dark) in 1933, its subject matter caused an outrage similar to that provoked by Henri de Toulouse-Lautrec's 19th-century paintings of Parisian 'low life'.

Street photography, as this style was known, pushed the boundaries of documentary photography. Austrian Usher Fellig, known as Weegee, (1899–1968) extended the camera lens into the grisliest of scenes as he recorded New York's hoodlums, drunks, brawls, car crashes, fires and murders at night. He monitored police and fire department radio dispatches and arrived at crime scenes to take pictures such as *Gunman Killed by Off-Duty Cop at 344 Broome St* (1942). The image of Andrew Izzo shot dead while attempting a hold up is starkly violent and looks like a scene from a film noir.

Brassaï was a major influence on British photographer Bill Brandt (1904–83). He was commissioned by the War Office to take photographs of Britain during the Depression and the Blitz and the results transformed British photography. His book *The English at Home* (1936) depicted the stark contrast between the leisured lives of the aristocracy and the daily drudgery of the working class. Later in his career Brandt focused on landscapes, portrait and nudes, experimenting with lighting and contrast in his photographs. His series of nudes, published in *Perspective of Nudes* (1961), is printed in his signature high-contrast style, devoid of mid tones and detail. Brandt's studies of the industrial north, such as *East Durham Coal-searchers* (1937) show how h documentary style combined an acute social conscience in terms of subject matter with a Modernist aesthetic form. Brandt was a photojournalist when the genre was nascent. It had been lightweight camera technology that had given rise to the genre, but the arrival of photo-led magazines such as *Picture Post* in Britain in 1938 and the revamp of *Life* in the United States in 1936 mean that the new breed of photographers had somewhere to publish photographs outside mainstream newspapers.

During the Great Depression, artists of all kinds were drawn to social issues, and photographers were no exception. The Photo League provided low-cost darkroom facilities and technical instruction and many of its members became well known, including Dorothea Lange (1895–1965). Her poignant pictures of homeless and unemployed people, such as *White Angel Bread Line* (1932), humanized the economic crisis. She was employed by the Farm Security Administration in an initiative that ran from 1935 to 1944 to document the plight of farmers and migratory workers in rural areas. *Poor Migrant Mother and Children* (below) was taken in Nipomo, California and shows a destitute pea picker with two of her children. Lange's photographic style, with its focus on individuals suffering under the strain of poverty, defined the era and influenced successive generations of documentary photographers.

Fashion magazines such as American *Vogue* and *Harper's Bazaar* continued to increase in popularity from the 1930s. Richard Avedon (1923–2004) was one of the first fashion photographers, and he revolutionized the industry by infusing his pictures with emotion and movement. Cross-pollination between fashion photography and art was frequent. British photographer Sir Cecil Beaton (1904–80) is as revered for his innovative portraiture as his graceful fashion shots. His close-up compositions and use of classical statuary, glittering cloth and fragments of paper owed much to the Surrealist (see p.426) works of artists such as Salvador Dalí (1904–89) and Man Ray (1890–1976).

World War II saw some photojournalists metamorphose into combat photographers. Hungarian Robert Capa (1913–54) cut his teeth as a war photographer during the Spanish Civil War and made his name with *The Falling Soldier: Loyalist Militiaman at the Moment of Death* (opposite, above). It shows a soldier falling backwards after being shot and is said to depict the moment of his death. Famous as it is, the image is also controversial: it has been suggested that it was staged and that the militiaman was shot while posing for the photograph. Capa's other legacy is Magnum Photos, the agency that he co-founded in 1947. It pioneered the idea that photographers should choose their own subject matter, rather than be assigned stories by picture editors. Capa died, camera in hand, when he stepped on a landmine in 1954 while covering the First Indochina War. Magnum continues to chronicle world events and its living archive houses more than one million images. **CK**

4 *The Falling Soldier: Loyalist Militiaman at the Moment of Death* (1936)
Robert Capa • gelatin silver print
7 1/8 x 9 3/8 in. / 18 x 24 cm
Museum of Modern Art, New York, USA

5 *Poor Migrant Mother and Children* (1936)
Dorothea Lange • photograph
4 x 5 in. / 10 x 12.5 cm
Library of Congress, Washington, DC, USA

6 *Morris Column* (1934)
Brassaï • gelatin silver print
15 3/8 x 11 5/8 in. / 39 x 29.5 cm
Musée National d'Art Moderne, Centre Pompidou, Paris, France

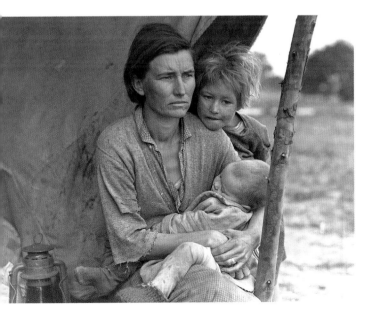

Behind the Gare St Lazare 1932
HENRI CARTIER-BRESSON 1908 – 2004

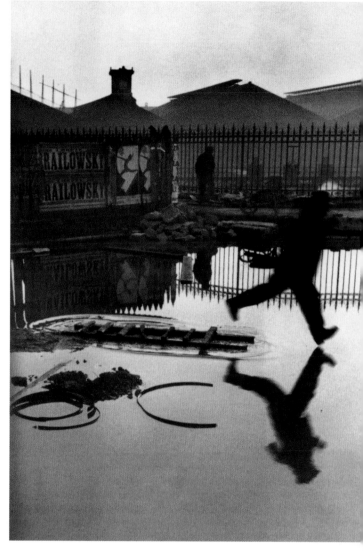

gelatin silver print
various dimensions
Private collections

◉ NAVIGATOR

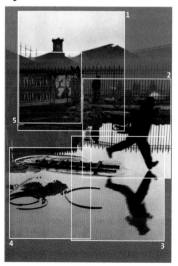

Henri Cartier-Bresson is revered as a photographer for capturing 'the decisive moment', as exemplified in *Behind the Gare St Lazare*. A pioneer of street photography, Cartier-Bresson snapped the young man jumping across a puddle behind the station and caught him in mid-air. The image has a pleasing symmetry with the key figure and the railings reflected in the water. The poster advertising acrobats on the left of the image mirrors the movement of the jumping man, while the ladder and metal rings in the foreground recall those used in circus acts.

The picture is not technically perfect, but the apparent spontaneity of the image and its compositional beauty, compared with the posed studio shots of contemporary photography, was revolutionary. Cartier-Bresson said of the photo: 'I put my lens through a gap [in the fence] just at the moment that the man jumped.' **CK**

FOCAL POINTS

1 BACK STREET

The background of the photograph features an ugly structure in a back street but Cartier-Bresson imbues it with the happy quality of an idyllic pastoral scene. The street photographer favoured scenes of daily life and his ability to see beauty in the margins of large cities was unprecedented.

2 SNAPSHOT

The image resembles a casual snapshot of a man. What is significant is that Cartier-Bresson took this photograph before the concept of a snapshot existed. Using a lightweight Leica camera, he could take pictures on an ad hoc basis and favoured the spontaneity of the moment.

3 REFLECTIONS

The leaping man's image is reflected in the puddle, as are the railings. Cartier-Bresson had a love of symmetry and balance, and was able to see patterns in everyday scenes. He created images with an almost organic quality, although he found them in a mechanized world.

4 GEOMETRIC SHAPES

Cartier-Bresson was influenced by the angular forms of Surrealism (see p.426) and the geometric shapes of Cubism (see p.388). He noticed the triangles of the rooftops and the sweeping arcs of the construction materials on the ground; he used the sense of rhythm they give to the image.

5 POSTERS

The figure of the acrobat repeated on the pair of posters behind the railings mirrors that of the man leaping. With the initial letter 'B' obscured by the railings, the adjacent poster advertises a performer named 'Railowsky', whose name puns (in French and English) with 'railway'.

ARTIST PROFILE

1927–31

Cartier-Bresson studied under André Lhote (1885–1962) in Paris and then moved to Cambridge to study painting and literature.

1932–36

He acquired his first Leica camera in 1932; the lightweight model enabled him to take photographs while travelling and he only ever used this type of camera. He supplemented his income by working as an assistant to film director Jean Renoir.

1937–46

Cartier-Bresson covered the coronation of King George VI in London and famously photographed the crowd rather than the procession. He joined the French army in 1940 and spent time as a prisoner of war and working for the French Resistance.

1947–65

In 1947, he set up the Magnum photo agency with Robert Capa, David Seymour (1911–56) and George Rodger (1908–95). They aimed to assert the rights of the photographer to the integrity of the images they shot. Cartier-Bresson's photo book *Images à la sauvette* (The Decisive Moment) was published in 1952, with a front cover by Henri Matisse (1869–1954).

1966–2004

He left Magnum in 1966 and devoted himself to drawing and painting. The Fondation Henri Cartier-Bresson opened in Paris in 2003, showcasing his and other photographers' work.

CAPTURING THE MOMENT

A photograph taken by Martin Munkácsi (1896–1963) inspired Cartier-Bresson's philosophy of capturing the moment. Hungarian-born Munkácsi made a living taking photographs for German newspapers and became known for innovative action shots that changed the face of sports photography with their clever composition. When Hitler came to power, Munkácsi emigrated to the United States and found a job with *Harper's Bazaar*, where he soon made his name as a fashion photographer. The photograph that had such a profound effect on Cartier-Bresson was *Three Boys at Lake Tanganyika* (c. 1929; below). It was taken by Munkácsi on an assignment in Liberia

for the *Berliner Illustrirte Zeitung* and shows three boys running into the waters of Lake Tanganyika. Cartier-Bresson was captivated by the image's spontaneous quality. 'It is the only photo that influenced me,' he said many years later.

Clearing Winter Storm, Yosemite Valley *c.* 1935
ANSEL ADAMS 1902 – 84

silver gelatin print
15 ¹/₈ x 18 ⁷/₈ in. / 38.5 x 48 cm
Private collection

⚙ NAVIGATOR

American Ansel Adams was a commercial photographer who became famous for his landscapes of the American West, and in particular nature reserves, such as Yosemite Valley in California's Sierra Nevada. *Clearing Winter Storm* was taken during his most experimental and creative period and is one of his most popular photographs. It shows the valley just after a snowstorm has departed, leaving behind a fresh fall of snow. Adams's mastery of technique enabled him to obtain the maximum number of tones from a black and white film, imposing order on the apparent chaos of the storm by ridding the image of distracting elements and intensifying what he saw as important. This technique was completely innovative.

In this photograph Adams invites the viewer to marvel at the beauty and power of nature. At the same time his deployment of abstract shapes shows that he was influenced by Modernism. He uses photography as a modern medium and celebrates it for its own unique qualities rather than as a development from realistic painting and fine art. *Clearing Winter Storm* demonstrates that the medium of photography can convey the emotional experience of the photographer. Adams returned to Yosemite Valley many times throughout his life to photograph its creeks, waterfalls, granite cliffs, forests and meadows. **CK**

⊙ FOCAL POINTS

1 SHADES OF GREY

Adams controls the grey-scale tones in the negatives by using a light meter to obtain silver densities that correspond to his 'previsualization' of the scene. The outcome is an image with a vast number of shades of grey, black and white, as seen in the departing storm clouds.

2 SHARP FOCUS

Adams uses a small aperture to create the maximum depth of field and to ensure that a large percentage of the image is in focus. This produces a crisp image where fine details are clear to the viewer. For this image he used a short exposure time to avoid showing any movement in the clouds.

3 WILDERNESS LANDSCAPE

Adams depicts the landscape in an almost primal state: devoid of people and free from all traces of modern living. The image celebrates nature and the photographer's passion for preserving the American wilderness. He was a keen conservationist and in 1934 lobbied the US Congress to stop mining and logging in King's River Canyon near Yosemite Valley. Adams's landscape photographs helped to popularize photography of the American outdoors.

4 U-SHAPE

Adams captures a U-shape at the centre of the image, which leads the viewer's eye back to the snow-covered crags. He gives as much space to the swirling clouds as he does to the dogtooth patterns of the densely packed forest in the foreground, thus creating a balanced vista. The tonal quality of the distant landscape adds an otherworldly dimension to the scene. Adams includes 'unrealistic' elements to create an image that viewers will find uplifting.

⏱ ARTIST PROFILE

1916–26

On a family trip to Yosemite National Park, California, Adams took pictures with his first camera, a Kodak Box Brownie. He developed an interest in photography but pursued a career as a concert pianist.

1927–39

He took his first acknowledged photograph *Monolith, The Face of Half Dome* in 1927 and devoted himself to photography after meeting New York photographer Paul Strand in 1930. During the 1930s, he co-founded Group f/64 (1932), opened his own gallery in San Francisco (1933) and became editor of the popular photography magazine *US Camera* (1939).

1940–52

Adams worked on his technique and in 1941 developed the zone system—a technique to control exposure and development on negatives and paper. He taught at both the Art Center School of Los Angeles and the California School of Fine Arts. In 1946 he received a Guggenheim Fellowship to photograph national parks and published the *Illustrated Guide to Yosemite Valley*.

1953–84

Adams collaborated with Dorothea Lange for a *Life* magazine photo essay in 1953. He became less creative as he took on more commercial assignments and was awarded the Presidential Medal of Freedom in 1980. He died of heart failure in 1984.

GROUP F/64

Adams co-founded Group f/64 in 1932 with seven San Francisco-based photographers, including Willard van Dyke (1906–86) and Imogen Cunningham, whose *Succulent* (1920s; below) was exhibited at their first show. The group was named after the f/64 aperture on the lens of a large-format camera; the smallest aperture, it gives the maximum depth of field. Group f/64 promoted 'pure' photography—clean, sharp images—in contrast to the 'artistic', soft-focus style popular from the early 1900s; their prints were on glossy paper because a matt finish could distort the outlines of their subjects. Group f/64 celebrated the potential of their medium mainly with photographs of American landscapes, rural life and organic forms.

REALISM, PRECISIONISM AND REGIONALISM

1 *American Gothic* (1930)
Grant Wood • oil on canvas
30 ¾ x 25 ¾ in. / 78 x 65 cm
Art Institute of Chicago, USA
© Figge Art Museum, successors to the
Estate of Nan Wood Graham/Licensed
by VAGA, New York, NY

2 *Upper Deck* (1929)
Charles Sheeler • oil on canvas
28 ¾ x 21 ¾ in. / 73 x 55 cm
Harvard Art Museum/Fogg Museum,
Cambridge, USA

3 *Brooklyn Bridge* (1949)
Georgia O'Keeffe • oil on masonite
48 x 35 ⅞ in. / 122 x 91 cm
Brooklyn Museum, New York, USA

The terms 'Realism', 'Precisionism' and 'Regionalism' represent different aspects of a general trend by certain American artists working from the turn of the 20th century to distance themselves from the influence of European Modernism. The trend began with the Ashcan School—a group of painters who chose to depict everyday scenes in working-class areas of New York as their subjects. Among the Ashcan School artists was Robert Henri (1865–1929), who later taught Edward Hopper (1882–1967).

Hopper's work has come to typify the American Realism movement. His paintings convey the sense that the events depicted on canvas are taking place

KEY EVENTS

1908	1913	1927	1930	1932	1933
The only group exhibition by The Eight—central figures in the Ashcan School of realist artists—is put on at the Macbeth Gallery, New York.	The Armory Show in New York polarizes devotees of abstract and realist art, and indirectly facilitates the development of American Realism.	Demuth paints *My Egypt* (see p.366) as part of a series of paintings depicting industrial buildings.	Wood exhibits *American Gothic* at the Art Institute of Chicago. The work focuses attention on the qualities of people in the rural Midwest.	Wood begins an artists' colony in Stone City, Iowa. Despite earning an excellent critical reputation, it collapses within two years due to a lack of funds.	The government-sponsored Public Works of Art Project begins as part of President Franklin D. Roosevelt's New Deal in the United States.

n front of the viewer in the here and now, as seen in his diner scene *Nighthawks* 1942; see p.368). His restless couples, glimpsed through apartment windows, r individuals sitting on the edges of their beds in contemplation, have an mbivalence that invites the viewer to add a context and interpret their situation.

The Precisionist movement surfaced in about 1915 and was at its peak uring the 1920s. Precisionist works are characterized by their urban and ndustrial subject matter and their geometric forms and well-defined lines ave been likened to elements of Cubism (see p.388). Charles Sheeler (1883– 965) described his own work as Precisionist and his paintings were informed y his experience as a photographer of modern architecture. His *Upper Deck* right, above) is a portrait of the USS *Majestic*. The ship is new and spotless, and he precise line and the subtle shift in tones of white give this work a brightly t, other-worldly quality. Other Precisionist works by artists such as Sheeler nd Charles Demuth (1883–1935) implied that 'honest' American industrial uildings possessed a form of spirituality.

For the Regionalist group of artists working in the Midwest, even these ubtle Modernist tendencies were un-American. The three most prominent egionalists were Grant Wood (1891–1942), Thomas Hart Benton (1889–1975) and ohn Steuart Curry (1897–1946). These artists presented a somewhat idealized iew of rural life in an America still caught in the Great Depression, and their nward-looking stance reflected the nationalist and isolationist policies of their ountry between the two world wars. Wood's *American Gothic* (opposite) honours hose who settled the land, portraying an old-style couple, indefatigable, holding firmly not only to their pitchfork but also to their spirit of Puritan ndeavour. The viewer is left to interpret whether the two homesteaders— layed by the artist's sister and local dentist—are stoical or merely cantankerous.

In 1933 the US government introduced a programme of patronage to aid unemployed artists. Regionalist artists were among those sponsored by the state o decorate the walls of American civic buildings. In 1932 Ben Shahn (1898–1969) vorked as an assistant to the Mexican muralist Diego Rivera (1886–1957) on his rescoes (which were later destroyed) for New York's Rockefeller Center. Shahn's rban scenes and portraiture have been described as 'Social Realist', because of heir sympathetic portrayal of ordinary working people.

Georgia O'Keeffe (1887–1986) fused realism with abstract representation to reate a highly individual strand of modern American art. She took inspiration rom harsh landscapes—those of New Mexico and the Southwest in articular—and native flowers, but she also painted urban scenes in the style of the Precisionists. In *Brooklyn Bridge* (right), O'Keeffe focused on the formal elements of the bridge to give the functional structure a spiritual dimension; he tall arches are reminiscent of those in Gothic cathedrals and this effect is heightened by the intersecting, diagonal suspension cables, whose outlines and subtly changing colours resemble stained glass windows or folded wings. **LM**

My Egypt 1927
CHARLES DEMUTH 1883 – 1935

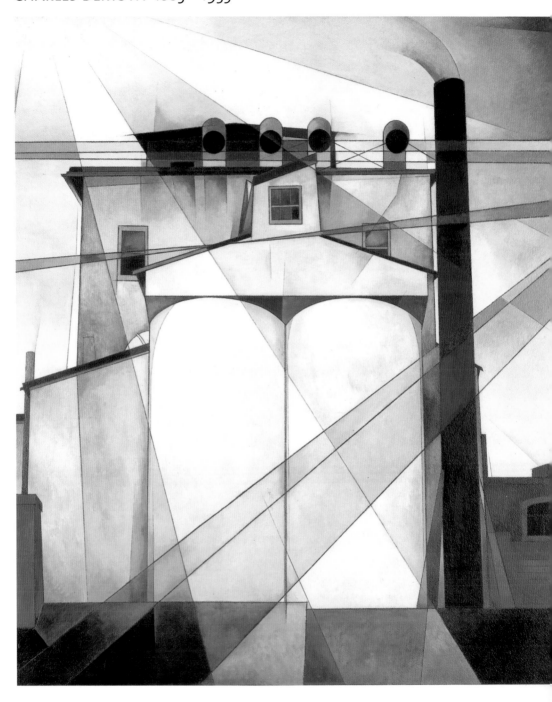

oil on canvas
35 ³/₄ x 30 in. / 91 x 76 cm
Whitney Museum of American Art,
New York, USA

NAVIGATOR

Charles Demuth spent much of the final decade of his life at his parental home in Lancaster, Pennsylvania, where he converted a room overlooking the garden into a studio. At times, the gregarious and widely travelled Demuth, who was homosexual and diabetic, felt trapped in Lancaster; although he had a deep affection for his home town, he was used to New York's artistic and liberal circles. It is within this context of illness and 'captivity' that *My Egypt* should be assessed.

In 1927, Demuth began a series of paintings of modern industrial buildings near his home; *My Egypt* depicts the grain elevators of the Eshleman Company. Demuth compares their simple rounded structure with the monuments of ancient Egypt—as Tutankhamun's tomb had only been discovered in 1922, the allusion would have been particularly topical. He suggests a link between Pennsylvania's rich harvests and ancient Egypt's role as the granary of the Roman Empire. There is, however, a subtext. Egypt was a place of captivity for the Jews seeking to return to the Land of Canaan; Demuth sought relief from the 'captivity' of his sickroom/studio and *My Egypt* has been described as the artist's memorial to himself, painted at a time when he felt the nearness of death. He may also have known that in Jewish literature 'Egypt' signifies the imprisonment of the spirit by the body, which only death can end. 'It is,' he wrote to the director of the Whitney Museum of American Art, who purchased the piece in 1931, 'one of my best things, I think.' **LM**

FOCAL POINTS

1 SKYLINE

From the top left of the picture, two rays of light beam down directly from the heavens and shine on the grain silos. Demuth uses the effect, commonly employed to indicate the presence of God, to imply that ordinary secular buildings can possess a quasi-religious significance.

2 GREY PLUME OF STEAM

A small plume of grey steam ascends from the chimney's rim, adding a curved line to this mostly angular picture. At times, Demuth's paintings recall those of Lyonel Feininger, who was painting in Germany at the same time and who painted towers and spires bisected by diagonals.

3 RED BUILDING

Demuth has placed a dark red patch (a rooftop) to the right of the grain elevators, together with a deep orange block (a chimneybreast) to the left of them. Compositionally, these two coloured areas emphasize the soaring whiteness of the edifice.

4 DIAGONAL LINES

The long diagonal and horizontal lines in *My Egypt* contrast with the strong vertical structure and serve to unite the image, adding spatial dynamism as well as depth and bulk. Demuth was influenced by Cubism's (see p.388) fractured planes and Futurism's (see p.396) 'lines of force'.

ARTIST PROFILE

1899–1914

After completing his studies in Philadelphia, Demuth made two extended trips to Paris, enrolling at the Académies Julian, Colarossi and Moderne. He was particularly influenced by new artistic trends during his stay from 1912 to 1914.

1915–20

During these five years, Demuth entered New York's art milieu and won recognition with a solo show at the city's Daniel Gallery. He also travelled to Bermuda and painted there.

1921–26

Demuth's paintings of flowers and fruit proved very popular. He also began to paint aspects of his home town, including *Lancaster* (1921). During the early 1920s, Demuth moved away from watercolour to paint his major works in oil.

1927–35

Increasingly debilitated by diabetes, Demuth spent longer periods in Lancaster painting, among other subjects, the industrial buildings series of which *My Egypt* is the most famous work. He also painted one of America's Modernist icons, *I Saw the Figure 5 in Gold* (1928).

Nighthawks 1942
EDWARD HOPPER 1882 – 1967

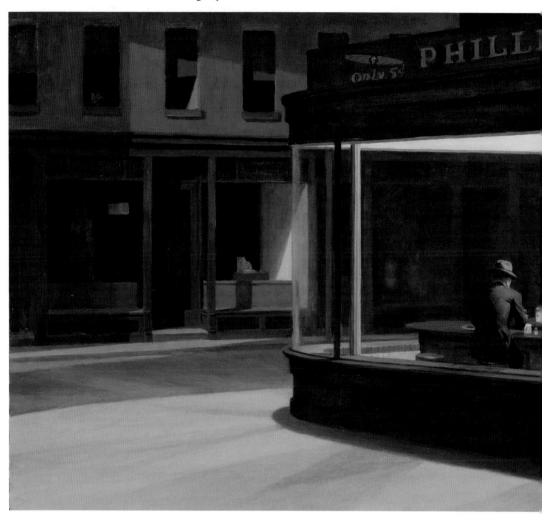

oil on canvas
33 ¹/₈ x 60 in. / 84 x 152 cm
Art Institute of Chicago, USA

⬡ **NAVIGATOR**

From 1913 to 1923 Edward Hopper worked as a magazine illustrator; he did not enjoy the work but it sharpened his compositional skill and taught him that less can be more. In this spare, impassive, realist painting Hopper evokes a powerful sense of urban alienation, highlighting what American sociologist Richard Sennett called 'the paradox of isolation in the midst of visibility'. The bright fluorescent light in the all-night diner contrasts strongly with the surrounding gloom outside. It is the only light source in the painting and throws out sharply defined shadows, echoing the stark lighting effects of film noir and giving the painting a cinematic quality. The curved facade of the diner contains no door—imprisoning the figures within and shutting out the viewer—while the overhead light draws the viewer's eye to the tableau of figures, lending them a theatrical air. In particular, the eye is drawn to the bright red dress and auburn hair of the only woman in the painting. Although her hand is almost touching that of the man beside her, she engages with no one. The solitary nature of the grey-suited man is accentuated by his distance from the other figures and by the presentation of his back to the viewer. **LM**

FOCAL POINTS

1 DARK SHOPFRONT

The only distinguishable object in the eerily empty shop is the solitary cash register. Hopper was as fascinated by the obscuring effects of night as by the illumination of daylight. Many of his works involve night-time scenes, including *Night in the Park* (1921) and *Night Windows* (1928).

2 TWO CUSTOMERS

The man and woman sitting next to each other are brought closer together by the vast space around them. In fact, they might be strangers. They have a certain hawkish resemblance—a 'nighthawk' is both a nocturnal bird and a night prowler—and both seem trapped in private thoughts.

3 BALANCE

The two metallic coffee urns behind and to the right of the server act as an inanimate male/female counterweight to the couple seated at the bar. Their bright lustre makes them stand out—indeed, they seem to assume as much importance as the figures, almost as if they are customers themselves.

4 TOUCHES OF DETAIL

Small touches—the salt and pepper cellars, the napkin, the cups and the morsel of sandwich in the woman's hand—are delineated in realistic detail. Against the sparse, predominantly dark background of the rest of the piece, the viewer's eye is drawn to these objects.

5 THE THIRD CUSTOMER

With his back to the viewer and staring straight ahead, the man is half in shadow and hardly noticeable at first. He is an important element in the painting's composition, though: his anonymity heightens the sense of the picture's self-contained and somewhat impenetrable reality.

⟁ ARTIST PROFILE

1900–12

Hopper studied at the New York Institute of Art and Design. He also made three visits to Europe, in 1906, 1909 and 1910.

1913–23

Despite selling his first painting at the Armory Show in 1913, Hopper enjoyed little success and briefly abandoned oil painting.

1924–44

Hopper's first mature painting, *The House by the Railroad* (1925), ushered in a productive period, when he produced major works such as *Nighthawks*, *Gas* (1940) and *Morning in a City* (1944). His classic works embrace both urban American life and rural scenes, often conveying solitude, isolation or tension.

1945–67

Abstract Expressionism (see p.452) left him isolated, but his work later influenced Pop art (see p.484). Despite his ill-health, Hopper continued to produce major works such as *Intermission* (1963).

FAUVISM

1 *Bridge over the Riou* (1906)
André Derain • oil on canvas
32 ¹/₂ x 40 in. / 82.5 x 101.5 cm
Museum of Modern Art, New York, USA

2 *A Dancer at the Rat Mort* (1906)
Maurice de Vlaminck • oil on canvas
28 ³/₄ x 21 ¹/₄ in. / 73 x 54 cm
Private collection

3 *La Rue pavoisée* (1906)
Raoul Dufy • oil on canvas
31 ⁷/₈ x 25 ⁵/₈ in. / 81 x 65 cm
Musée National d'Art Moderne,
Centre Pompidou, Paris, France

Fauvism was the earliest and among the briefest of the European avant-garde art movements of the 20th century, peaking between 1905 and 1907. The start of the century was a period of societal and technological change. Inventions such as the motor car and radio, and the wider availability of electricity, were transforming people's everyday lives. It was in this context that Fauvism burst on to the art scene. The Fauves' group identity, like that of the Impressionists (see p.316), came from a critical review. When artists Henri Matisse (1869–1954), André Derain (1880–1954) and Maurice de Vlaminck (1876–1958) exhibited together at the Salon d'Automne in 1905, critic Louis Vauxcelles (1870–1945) described them as the 'Fauves'—the 'Wild Beasts'—in a dismissal of their aggressive brushwork, lack of nuance and strident, non-naturalistic use of colour. French painter Matisse was the unofficial leader of this group of artists who, by liberating colour from its conventional descriptive role and radically distorting pictorial space, paved the way for other artistic movements, such as Cubism (see p.388) and Expressionism (see p.378).

The experiments with colour and pictorial space that characterize Fauve paintings evolved from the Post-Impressionist (see p.328) art of Vincent van Gogh, Paul Gauguin and Paul Cézanne, and from the Neo-Impressionist paintings of Georges Seurat and Paul Signac. It was while working with Signac in St Tropez, in the South of France, that Matisse painted his idyllic scene *Luxury, Calm and Pleasure* (1904–05); it inspired artist Raoul Dufy (1877–1953) to write: 'In front of this picture…Impressionist realism lost all its charm for me a

KEY EVENTS

1900	1901	1905	1905	1905	1905–08
The Exposition Universelle opens in Paris. Vlaminck sees that many cannot afford to attend and he begins to write novels about social division.	Derain and Vlaminck paint together for a short period at Derain's home town of Chatou.	Derain and Matisse experiment with a new primitive style using bright colours and thick brushstrokes, a style later derided as 'unnatural'.	A group of artists exhibit at the Salon d'Automne in Paris. Critic Louis Vauxcelles describes them as 'Les Fauves'.	Matisse creates the exquisitely Fauvist painting *Open Window, Collioure*.	Othon Friesz (1879–1949) and Dufy rent a studio together; they choose one that located very close to that used by Matisse.

looked at this miracle of creative imagination at work in colour and line'. During the summer of 1905, Fauvism blossomed as Matisse and Derain painted side by side in the French village of Collioure. The pair flouted existing rules of painting and Matisse likened the experience to painting 'like children in the face of nature'. As the Fauve style evolved, the semi-regular dots and dashes of colour, which created the shimmering surface of *Luxury, Calm and Pleasure* for example, were replaced by bold, sketchy brushstrokes and patches of pure colour.

Matisse and Derain did not use colour to imitate nature; they used it imaginatively to create both harmonies and disharmonies. Rejecting the convention of painting a realistic illusion of space, they instead emphasized the flat surface of the canvas. This way of painting was applied to both portraits, such as Matisse's picture of his wife Amélie, *Madame Matisse (The Green Stripe)* (1905), and landscapes, such as Derain's *Bridge over the Riou* (opposite). This work has a complex composition, in which the space has been flattened and compressed. Derain uses an unnatural colour palette, for example in the pink and blue hues on the tree trunk on the right, to convey the intense light of the South of France.

Other artists developed similar ways of exploring colour, including Vlaminck, whom Derain met by chance on a train in 1900. The two men immediately began painting together at Chatou on the outskirts of Paris. Vlaminck was an anarchist sympathizer and mainly self-taught artist who brought a revolutionary zeal to his art. 'What I could have done in real life only by throwing a bomb,' he once wrote, 'I tried to achieve in painting using colour of maximum purity ... to re-create a liberated world.' In *A Dancer at the Rat Mort* (right), his technique is characteristically direct and energetic—sometimes achieved by squeezing paint straight from the tube on to the canvas.

Georges Rouault (1871–1958), Albert Marquet (1875–1947), Raoul Dufy, Kees van Dongen (1877–1968) and, briefly, Georges Braque (1882–1963) exhibited as Fauves, although they did not follow any shared doctrine. For them, as for many artists, Fauvism was influential but only as a passing phase. Braque, for example, soon went on to develop what became known as the Cubist style. Dufy's painting *La Rue pavoisée* (right, below), which shows a French street decked with large tricolore flags, demonstrates his adoption of the bright colours and bold contours of the Fauves. From 1908, however, after working with Braque at L'Estaque, near Marseille, Dufy developed a more subtle technique, which showed the influence of Cézanne.

The Fauves enjoyed their most successful period between the Salon d'Automne of 1905 and the Salon des Indépendants of 1906. A year or so later, the group had begun to drift apart, although Matisse continued to develop the possibilities suggested by Fauvism for several more years. In 1917 he moved to the French Riviera and his use of Fauvist colour is especially marked in the series of portraits of women as odalisques that he painted in the 1920s. He used a similar palette of Fauvist colours in his landscapes of the coastal environment, to capture the vibrant effects of the warm southern light. **JW**

1906	1906	1907	1908	1908	1910
Derain is sent to London by his dealer and paints thirty pictures of the city, including *Charing Cross Bridge*, using bold primary colours.	Braque has a brief period of intense Fauvism, displayed in such paintings as *The House Behind the Trees* and *The Yellow Seacoast*.	Colour is first used in the photographic process when Auguste and Louis Lumière launch the Autochrome Lumière.	Vauxcelles uses the term 'Cubism' in reference to works of art by Picasso and Braque.	A number of Fauve painters, most notably Braque, begin to move towards Cubism.	Matisse paints *The Dance* (see p.372) a rhythmic painting of intense colours.

The Dance 1910
HENRI MATISSE 1869 – 1954

oil on canvas
102 3/8 x 153 7/8 in. / 260 x 391 cm
State Hermitage Museum,
St Petersburg, Russia

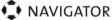 NAVIGATOR

This monumental painting was commissioned, along with a companion piece entitled *Music* (1910), by Henri Matisse's patron, the Russian textile baron Sergei Shchukin, for the stairwell of his Moscow mansion, Trubetskoy Palace. Initially Shchukin was averse to the idea of having a painting containing nudes on public display, and requested that the dancers wear dresses. Matisse demurred and sent the Russian a watercolour sketch of nude dancers that persuaded him to change his mind. However, when Matisse showed the developing work at the Salon d'Automne in Paris in 1910, he was subjected to savage criticism—one critic suggesting he was mentally ill—and Shchukin cancelled the commission. This was a devastating blow to the artist. Fortunately, after some days of reflection, Shchukin asked Matisse to continue his work.

It is thought that Matisse got the idea for his composition in 1905 while watching some fishermen and peasants performing the circular *sardana* dance on a beach in the South of France. The dancers' simplified forms stretch across the canvas in a rhythmic pattern of expressive movement. Matisse restricted his palette to three colours: blue for the sky, an orange-pink for the bodies and green for the hill. In an earlier study, the dancers are painted in pale, realistic flesh tones, but in this version Matisse intensified the colour to a deep terracotta in order to create a vibrant contrast with the vast areas of blue and green. The simplicity of Matisse's design, with its three basic elements—dancers, an empty expanse of green and an empty expanse of blue—creates an image in which the abstract relationships between shape and colour are of paramount importance and the brilliantly coloured empty space plays its part. **JW**

FOCAL POINTS

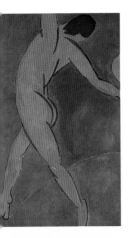

1 DISTORTED FIGURES

In this work five figures join hands to form a circle as part of a wild, whirling dance. Matisse creates a sense of contained energy amid the action by distorting the sinuous contours of the leg and foot of the figure on the far left of the frame. In addition, by compressing the figure's legs and feet to fit within the corner of the rectangular canvas, Matisse produces a sense that the dancer is bracing his body against the edge.

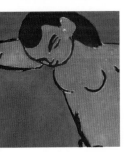

2 RHYTHMIC CURVES

Set against the plain blue background, the dancers' sienna-coloured arms form an undulating rhythm across the canvas. Matisse simplifies the dancers' anatomy to increase the impact of his design. As the middle dancer bends her head forward, the curve of her shoulder blades becomes part of the rising and falling patterns of the linked arms. Mirroring the curves of the arms are the undulations of the stylized green hill upon which the dancers perform.

3 CROPPED ELEMENTS

At the top right, the curve of a dancer's head is cropped by the canvas edge, adding to the sense of movement. At other points around the perimeter of the canvas, figures burst out from or touch the edge. This close containment focuses the eye on Matisse's simple but deliberate composition.

4 DYNAMIC TENSION

The hands of two of the figures have slipped apart during the whirling dance. The gap between their hands (echoing that between the fingers of God and Adam in Michelangelo's *The Creation of Adam*, 1510) shows tension. The diagonal formed by their reaching arms sustains the sense of movement.

ARTIST PROFILE

1869–98

Matisse was born in Le Cateau-Cambrésis in northern France. He studied law, and took up painting in 1889 while convalescing after an attack of appendicitis. He abandoned his legal studies and enrolled at Paris's Académie Julian. From 1895 to 1898 he studied at the Ecole des Beaux-Arts.

1899–1905

Matisse flirted with Impressionism (see p.316) but after making friends with André Derain and Maurice de Vlaminck he played with the expressive potential of colour. The three artists were dubbed the 'Fauves' (Wild Beasts) after their works were shown, along with a few others, in October 1905.

1906–17

Matisse's reputation grew and in 1908 he opened a school in Paris. His rivalry with his friend Pablo Picasso for the leadership of the artistic avant-garde led him to publish his *Notes d'un peintre* (Notes of a Painter) in the same year. He travelled in Europe and Africa and painted figures, still lifes, interiors and portraits on an increasingly large scale.

1918–54

Matisse travelled in Europe and North Africa making murals and etchings. During World War II he devised his cut-out paper technique and created his book *Jazz* (1947), in defiance of the Nazis. In 1954 he died of a heart attack at his home in Nice.

DEVELOPING THE THEME

Matisse (below) used the image of the circle dance in many of his works. He had included a similar circle of dancers in the background of *The Joy of Life* (1905–06) and he went on to depict sections of dance in a number of subsequent canvases. However, it was a commission from a wealthy patron, American inventor Albert C. Barnes, that led him to develop the motif on an ambitious scale in *The Dance* (1930–33). Barnes wanted Matisse to create a huge mural to decorate three arched spaces in the picture gallery of the Barnes Foundation in Philadelphia. For this work, in which the lines of the figures are more simplified and stylized than in the 1910 version, Matisse first used the paper cut-out technique as a way of adjusting the forms of his compositions and seeing how alterations might look.

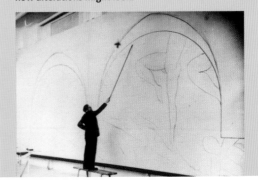

ECOLE DE PARIS

1 *Reclining Nude* (1917)
Amedeo Modigliani • oil on canvas
23 ⁵/₈ x 36 ¹/₄ in. / 60 x 92 cm
Private collection

2 *The Violinist* (1912)
Marc Chagall • oil on canvas
74 x 62 ¹/₄ in. / 188 x 158 cm
Stedelijk Museum, Amsterdam,
Netherlands

3 *Andromeda* (1927–29)
Tamara de Lempicka • oil on canvas
38 ³/₈ x 25 ⁵/₈ in. / 100 x 65 cm
Private collection

From 1904 to 1940 the history of art is dominated by a sequence of overlapping and interrelated art movements. However, many artists also worked independently during this period. The term 'Ecole de Paris' (School of Paris) does not refer to an artistic movement as such; rather it serves to group together the many unaligned artists who settled in Paris in the years leading up to and just after World War I. The term was first used by writer André Warnod (1885–1960) in an article published in 1925. He intended the phrase to encompass all artists who had flocked to the city over the previous two decades, including Pablo Picasso (1881–1973) and Henri Matisse (1869–1954), but it has since come to be linked with about eighty artists who settled in Paris from abroad—primarily from Europe but also from as far afield as Japan.

The Ecole de Paris was a social and cultural phenomenon because the artists associated with it shared neither a unified socio-political objective nor an aesthetic approach; their art is representational, with notable exceptions in sculpture, and focuses on the human figure. The artists shared a belief that working in the French capital gave them the chance to study great art, take part in a community of like-minded artists and benefit from the interest of numerous private dealers and collectors. In Montparnasse artists mixed with writers and musicians. In the years before 1914, intellectuals with socialist political leanings, such as Warnod and poet Guillaume Apollinaire (1880–1918), befriended foreign artists because they believed that supporting an international cultural agenda could stem the oncoming tide of xenophobia and militarism.

KEY EVENTS

1903	1904	1905	1906	1910	1912
French sculptor Alfred Boucher (1850–1934) opens the live-in studio complex La Ruche (The Beehive) in Paris as a home for aspiring young artists.	Picasso and Brâncuși settle in Paris. The city has become an artistic centre after the innovations of Impressionism (see p.316).	The Fauves (see p.370) exhibit at the Salon d'Automne in Paris. Jewish painter Jules Pascin (1885–1930) leaves his native Bulgaria to live in Paris.	Modigliani arrives in Paris and first lives at Le Bateau-Lavoir (The Laundry Boat) studios in Montmartre, then home to Picasso and other émigré artists.	Jewish-Polish painter Moïse Kisling (1891–1953) moves to Paris and becomes Modigliani's neighbour at La Ruche studios in Montparnasse.	Chagall rents a studio at La Ruche; by then it is home to 140 immigrants. He meets Apollinaire, Picasso and French painter Robert Delaunay (1885–1941).

A significant number of the incoming artists were Jews from Eastern Europe who were fleeing tsarist restrictions on education, the threat of pogroms and the strictures of life in the shtetls—village communities run in strict Orthodox lines. One such émigré was Russian-born Chaïm Soutine (1893–1943), whose work typifies the independent spirit of an Ecole de Paris artist with its decorative, almost passionate use of colour and often disquieting subject matter that reveals his sense of alienation. Fellow Russian Marc Chagall (1887–1985) arrived in Paris in 1910. His art was influenced by the broken planes of Cubism (see p.388) and the translucent coloration of what Apollinaire called Orphism (see p.396), which he combined with a distinctive narrative line. In *The Violinist* (right), the painter reflects his former home life in a traditional Hasidic Jewish community near Vitebsk. The violinist depicted against the backdrop of a rustic village is a reference to the fiddlers who played at ceremonies and festivals. This reveals Chagall's nostalgia for his cultural and religious roots. The combination of floating houses, biblical or Jewish folkloric references and bright palette became the cornerstone of Chagall's art.

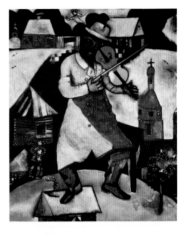

Romanian-born Constantin Brâncuşi (1876–1957) arrived in Paris in 1904. He developed a highly simplified sculptural style in which all surplus detail, such as clothing, defined facial features and limbs, was removed. For Brâncuşi, who refused to call his work abstract, what mattered was 'not the outer form but the idea, the essence of things'. His sculpted portraits, which he often made in many versions, were not expressive psychological studies but a synthesis of all the individual's characteristics in one overriding form.

Italian Amedeo Modigliani (1884–1920) came from a family of Sephardic Jews and moved to Paris in 1906. Initially embarking on a career as a painter, Modigliani renewed his interest in sculpture in 1909 when he met Brâncuşi. But because of a lack of sales and a lung complaint aggravated by stone dust, he returned to painting in 1914. His series of nudes was undertaken between 1916 and 1919. Their open sensuality caused a scandal when he exhibited some in 1917; the classic poses of works such as *Reclining Nude* (opposite) reference the Old Masters and fly in the face of the Futurist (see p.396) notion that the era of the nude had been surpassed by the machine. Like Modigliani, Polish refugee Tamara de Lempicka (1898–1980) referred to Renaissance motifs but also the Neoclassicism (see p.260) of Jean-Auguste-Dominique Ingres. In *Andromeda* (right), she paints her subject with a brooding sexuality. Her work is heavily stylized in an Art Deco manner and captures the social style of wealthy and hedonistic socialites.

From 1930 the Musée du Jeu de Paume in Paris began to acquire the works of Ecole de Paris artists, and this sparked a debate about the differences between the work of French and foreign artists. The 1930s saw the gradual demise of the Ecole de Paris, as leading artists died or left the city. After World War II, New York replaced Paris as the capital of avant-garde art. **LM**

1913	1917	1916	1918	1925–26	1930
Soutine arrives in Paris and lives at La Ruche; he befriends Modigliani. Japanese painter Tsuguharu Foujita (1886–1968) moves to Paris.	The Russian Revolution causes the upper-class de Lempicka to flee St Petersburg where she lived with her husband. She later moves to Paris.	Modigliani meets Polish art collector Léopold Zborowski (1889–1932), who becomes his dealer and that of many Ecole de Paris artists.	Apollinaire dies and a vital lynchpin in Paris's artistic life is lost. He organized art shows and wrote critiques of his friends' work.	Soutine paints *The Groom* or *The Bellboy* (see p.376). He often chose hotel or bar workers as subjects for his portraits.	Pascin kills himself. The Ecole de Paris goes into decline during the 1930s as Soutine, Chagall and Foujita all leave Paris, and the art critics follow.

The Groom *or* The Bellboy 1925 – 26
CHAÏM SOUTINE 1893 – 1943

oil on canvas
38 ⅝ x 31 ½ in. / 98 x 80 cm
Musée National d'Art Moderne,
Centre Pompidou, Paris, France

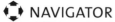

◆ NAVIGATOR

C haïm Soutine made numerous portraits of Paris's low-paid workers. He portrayed hotel porters, bellboys and maids without any desire to flatter but always with care for his subject's individuality. In *The Groom*, also known as *The Bellboy*, he makes it clear that his subject has a hard life: the young man's emaciated face makes him appear older than his years and his expression is that of one who is subsumed by his position of servitude.

Like many of Soutine's works, the painting is infused with restless energy and the figure's angular frame adds to this. The swirling brushstrokes reveal more about the artist's state of mind—he was prone to depression—than about his sitter. This may suggest an affinity with the expressive brushwork of Vincent van Gogh, but Soutine downplayed the influence, declaring more of an affinity with Old Masters such as Rembrandt.

Soutine characteristically chose a limited range of colours to delineate his subjects. In his palette, each colour—particularly his white and red, as seen in this masterpiece—possesses apparently innumerable subtle hues. The vivid colour of the bellboy's uniform provides a reference to the Fauves (see p.370) but Soutine's work is also seen as a forerunner of Abstract Expressionism (see p.452) because of its expressive brushwork. In this work, the purposeful strokes give the portrait a psychological edge and a penetrating resonance. **CK**

FOCAL POINTS

1 REBELLIOUS POSE

With his legs carelessly open and his hands resting defiantly on his hips, the bellboy has a bold air of insouciance. The figure looms out of a murky, flattened background in an arresting manner that demands attention. His head is barely connected to his body but floats spectrally as if haunting the canvas. The striking image demands that the viewer focuses on a person who would not normally be addressed as an individual by society.

2 PSYCHOLOGICAL PORTRAIT

This is an intense portrait that challenges the viewer to engage emotionally with the sitter's state of mind and predicament in life. The bellboy does not look directly at the viewer: the gaze is indirect, with eyes cast down and lips pursed in an expression of insolent servitude.

3 LIMITED PALETTE

The black of the background and the bright scarlet of the worker's uniform dominate the painting. Soutine's colour palette is limited, consisting only of red, black and white, but his agitated brushwork and flecks of bright white add texture and tone. The result is a canvas that is packed with rich colour and resonant movement. The viewer sees a mournful but impudent figure, motionless at this particular moment but ever busy in his daily routine.

4 BRUSHWORK

Soutine creates movement with circular brushstrokes and counter-directional scratches into the paint with the end of his brush. Such emotionally charged brushwork enables him to convey how the sitter is feeling despite the tranquillity of the pose; it also reveals his own disturbed mental state.

ARTIST PROFILE

1907–13

Soutine resists pressure from his Orthodox Jewish community to abandon a career as a painter and takes a design course in Minsk before enrolling at the Vilnius School of Fine Arts.

1914–19

He settles in Paris and acquires a room in La Ruche—The Beehive—where he meets many fellow artists. He suffers a period of intense poverty and feelings of alienation, but is helped by Amedeo Modigliani, who recommends him to his dealer Léopold Zborowski as 'a man of genius'.

1920–22

Aided by Zborowski, Soutine paints almost 200 pictures at Céret in the Pyrenees—many of which he later methodically destroys. He establishes his distinctive brushwork and palette.

1923–30

After achieving recognition and financial stability, he focuses on portraiture, concentrating on Paris's serving class as well as choir boys, altar servers and first communicants. He also follows Rembrandt by painting sides of beef.

1931–43

Soutine's painting is impeded by severe bouts of illness caused by stomach ulcers. His compositions become more ordered, the palette grows darker and his portrait subjects turn their stare away from the viewer and become introspective.

THE BEEHIVE COMMUNITY

When artists arrived in Paris and needed somewhere to stay, they headed to La Ruche (The Beehive) in Montparnasse. They paid a tiny rent to live and work in the small wedge-shaped studios, which they called 'coffins'. The building was also used as an exhibition space and was a vital meeting place for artists because it provided the opportunity for them to meet other Ecole de Paris painters, sculptors and writers. At various times Soutine, Amedeo Modigliani, Robert Delaunay, Marc Chagall, Diego Rivera, Marie 'Marevna' Vorobieff and Fernand Léger lived in the complex.

Marevna was the first female Cubist painter and Rivera's lover. When their relationship ended, she had an affair with Soutine. She immortalized her time in Paris in *Homage to Friends from Montparnasse* (1962; below), which shows (left to right) Rivera, Marevna and her daughter, writer Ilya Ehrenburg, Soutine, Modigliani and his wife, Max Jacob, painter Moïse Kisling and art dealer Léopold Zborowski.

GERMAN EXPRESSIONISM

1 *Two Men at a Table* (1912)
Erich Heckel • oil on canvas
38 1/8 x 47 1/4 in. / 97 x 120 cm
Hamburger Kunsthalle, Hamburg,
Germany

2 *Self-portrait* (1914)
Karl Schmidt-Rottluff • woodcut
14 1/4 x 11 5/8 in. / 36 x 29.5 cm
Private collection

3 *Nude Boy and Girl on the Shore* (1913)
Ernst Ludwig Kirchner • oil on canvas
41 x 30 in. / 104 x 76 cm
R & H Batliner Art Foundation,
Salzburg, Austria

The term 'Expressionism' was first used in the way we understand it today in 1912 by Herwath Walden (1879–1941), owner of *Der Sturm* (The Storm), a German progressive art magazine. Expressionist artists, many of whom worked in Germany where the movement originated, wanted to create art that confronted the viewer with an intense, direct and personal depiction of the artist's state of mind. Expressionist art was a form of representational art that comprised certain core elements: linear distortion, a reappraisal of the concept of beauty, radical simplification of detail and bold coloration.

Expressionist artists achieved a heightened sense of urgency through the use of non-naturalistic colour and exaggerated, elongated forms. The painting *Two Men at a Table* (above) by Erich Heckel (1883–1970) was inspired by Fyodor Dostoyevsky's novel *The Idiot,* and Heckel combines lurid colour with angular draughtsmanship to create a nightmarish scene. Opposing the rigidity and constraints of modern industrial society, artists such as Heckel were determined to question established notions of the wider function of art. If there was evil in the world, the Expressionists felt that it should be portrayed.

The Expressionist movement was associated with two groups of artists, one based in Dresden and the other in Munich, who had many goals and influences in common. The artists wanted to distinguish themselves from the bourgeois urban society in which most of them grew up. Some of the artists lived communally in rural areas, where they developed a fascination

KEY EVENTS

1905	1907	1909	1910	1911	1912
Four students set up Die Brücke in Dresden. Around the same time, the avant-garde group the Fauves appears in France, led by Matisse.	Marianne von Werefkin (1860–1938) creates her first Expressionist work. Later she becomes a member of NKVM/Der Blaue Reiter.	Kandinsky founds the New Artists' Association of Munich (NKVM). Influenced by Fauvism (see p.370), it holds three shows from 1909 to 1911.	Nolde brings a mystical dimension to the movement with works inspired by biblical themes, such as *Dance Around the Golden Calf.*	Der Blaue Reiter, a splinter group of NKVM, forms led by Marc and Kandinsky. Its first show opens on the same day as the NKVM's last.	*Der Sturm* uses the term 'Expressionism', although it has been used loosely prior to this. Der Blaue Reiter publishes its almanac in May.

for 'primitive' societies and collected and imitated German folk art in an effort to rekindle art's vital force, which they believed had been smothered. They discovered and were influenced by the work of Paul Gauguin (1848–1903) who, working first in Brittany and later in the Pacific islands in the late 1800s, had abandoned the use of realistic colours and rendered his often imaginary scenes in the simple, flattened forms that later characterized Expressionist painting.

Expressionist artists were also looking back to the art of the German Renaissance, to Albrecht Dürer (1471–1528) and Mathis Grünewald (c. 1475–1528). Their studies convinced them of the expressive power of black on white and they worked to invigorate the medieval technique of printing from wooden blocks. Karl Schmidt-Rottluff (1884–1976) drew not only on wood-cut printing but also on his researches into African tribal art to produce the forbidding *Self-portrait* (right). The work of Vincent van Gogh (1853–90) and Edvard Munch (1863–1944) also influenced the Expressionists. In a search for something deeper, a world philosopher Friedrich Nietzsche described as 'abundant in beauty, strangeness, doubt, horror and divinity', these painters had stepped outside conventional society and rejected conscientious imitation of nature.

In the early 1900s, Ernst Ludwig Kirchner (1880–1938), an architecture student from Dresden who was taking an art course in Munich, visited an exhibition of contemporary German painting. Deeply disappointed, he described what he saw as 'anaemic, bloodless and lifeless daubs', adding that 'it was quite evident that the public was bored'. It helped convince him to take action, and back in Dresden in 1905 he formed an artists' group with three fellow students who shared his love of painting: Erich Heckel, Karl Schmidt-Rottluff and Fritz Bleyl (1880–1966). On Schmidt-Rottluff's suggestion, they called themselves 'Die Brücke' (The Bridge), echoing Nietszche's notion that life for humankind was not an end in itself but a bridge to a better future. Only Kirchner had received any formal art training, but the group were convinced that the 'new art' they would create could not be learnt in any case because it first had to be invented.

It was Heckel who managed the artists' affairs and found them studio space in a disued cobbler's workshop. He also organized exhibitions of the artists' work and arranged painting expeditions to Dangast and the Moritzburg lakes outside Dresden. These locations were to prove important to the group because it was during these trips that the artists painted the landscapes and nudes that became the hallmark of the early years of northern German Expressionism. Kirchner's *Nude Boy and Girl on the Shore* (right) is typical of these works in its depiction of unashamed youth in an arcadian setting; the figures' exaggerated and elongated forms and mask-like faces suggest drama and otherworldliness. To help the group's finances and develop a support network, the artists created a network of 'passive' members who, for a yearly subscription costing twelve marks, received a portfolio of Die Brücke prints.

1913	1914	1915	1916	1918	1920
As individual styles in Die Brücke emerge, the artists lose their group identity. Personal rifts, present since the group's birth, cause the group to dissolve.	Der Blaue Reiter disbands with the outbreak of World War I. Kandinsky returns to Russia. Co-founder August Macke dies in action.	Nathalia Goncharova (1881–1962), an original member of Der Blaue Reiter, designs ballet costumes and sets for Sergei Diaghilev's *Liturgy*.	Franz Marc dies in combat at the Battle of Verdun.	The first manifesto of Dada (see p.410) is published, attacking the sentimentality and fundamental principles of Expressionism.	Max Beckmann (1884–1950) paints *Carnival*. His work has many affinities with German Expressionism, but he does not join any movement.

4 *Horse in a Landscape* (1910)
Franz Marc • oil on canvas
33 ¹/₂ x 44 ¹/₈ in. / 85 x 112 cm
Museum Folkwang, Essen, Germany

5 *Church at Murnau* (1909)
Wassily Kandinsky • oil on canvas
19 ¹/₈ x 27 ¹/₂ in. / 49 x 70 cm
Museum of Modern Art, New York, USA

6 *Kandinsky* (c. 1910)
Gabriele Münter • oil on canvas
35 ³/₈ x 17 ¹/₈ in. / 90 x 43.5 cm
Private collection

While the early work of Die Brücke artists drew on the influences of Gauguin, Van Gogh and Post-Impressionism (see p.328) in general, in the years 1905 to 1908 it also moved towards a distinctive 'Expressionist' style. Adopting a dazzlingly bright palette, the artists painted in thick impasto with short, sculpting strokes to create a shimmering effect, exemplified by Kirchner's *Two Women in the Street* (1914; see p.386). Frequently working alongside each other, they criticized and made copies of each other's work, developing a collective style that they believed would gain them attention. In spite of often working in the open air, they used limited perspective and gradually ceased to imitate nature. From 1908 they diluted their paint with petrol and applied it in larger and thinner monochrome swathes; this speeded up the drying process.

Emil Nolde (1867–1956) worked with Die Brücke between 1906 and 1907. This deeply religious artist gained a reputation for brooding seascapes but was also inspired by biblical themes. The group taught him the art of the woodcut, and in turn he introduced them to acid etching. Max Pechstein (1881–1955), who joined in 1906, had gained a reputation for decorative and naturalistic portraits in the Post-Impressionist style. The academy-trained artist was loath to abandon the precept that a painting's structure is governed by its forms and not by the distribution of colour, yet he too succumbed to Expressionism's dramatic atmosphere and angular draughtsmanship. Pechstein moved from Dresden to Berlin in 1908, and by 1911 all the group's members had done so. Convinced that their group identity would serve them well in the capital, they found instead that to achieve success they had to function as individuals. Gradually they worked together less often, and the group dissolved in 1913.

In southern Germany a different group of painters had gathered around Wassily Kandinsky (1866–1944), a Russian lawyer-turned-painter who had moved to Munich in 1896. After a period of formal training at the Akademie der Bildenden Künste München, Kandinsky decided that the best way to learn about art was to teach it. In 1901 he co-founded the Phalanx art group and school in Munich. Gabriele Münter (1877–1962), a student at the school, became his lover and artistic collaborator in 1902. In her portrait *Kandinsky* (left), she used simplified detail and romantic imagery, such as the sunlit tea service for two on the table, to express her feelings for the artist. On their return to Munich in 1908, the couple spent the summer in the little town of Murnau in Upper Bavaria and the following year Münter bought a house there.

The Murnau years of 1908 to 1910 were important because Kandinsky, Münter and their friend the artist Alexei von Jawlensky (1864–1941) developed a distinctive strand of Expressionism during this time. In their bright, colourful landscapes and street scenes, influenced by von Jawlensky's contact with Fauvism (see p.370), they pared down descriptive detail to the bare essence, executing their subjects with an increasingly strong compositional sense. Kandinsky's *Church at Murnau* (below) relies far more on shape and colour than on the detail of his earlier works to convey the scene. In December 1909 Kandinsky formed the Neue Künstlervereinigung München (New Artists' Association of Munich), or NKVM. The group mounted just three shows before splitting at the end of 1911, and none was well received. However, the press notices prompted Munich artist Franz Marc (1880–1916) to make contact with Kandinsky. Marc's maturer work, such as *Horse in a Landscape* (opposite, above), is known for its portrayal of animals and unconventional use of primary colours.

From July 1911 Kandinsky and Marc collaborated on an almanac of arts called *Der Blaue Reiter* (The Blue Rider) and also mounted two Blaue Reiter touring exhibitions. Kandinsky and Marc daringly placed reproductions of works by some of Europe's leading modern artists next to works by children and the mentally handicapped. Significantly, the journal's cover was a bold, black and white woodcut of a horse and rider; like Die Brücke, the Blaue Reiter group recognized the expressive power of the medium. German Expressionism reached its peak with Der Blaue Reiter and, although the group disintegrated at the onset of World War I, Expressionist art became widespread in Germany after the conflict ended. When the Nazis came to power in 1933, they suppressed Expressionist art along with other avant-garde art they considered 'degenerate'. From the mid 1930s Expressionism was to influence many young American artists with the exodus of numerous European artists to the United States. **LM**

Improvisation III 1909
WASSILY KANDINSKY 1866 – 1944

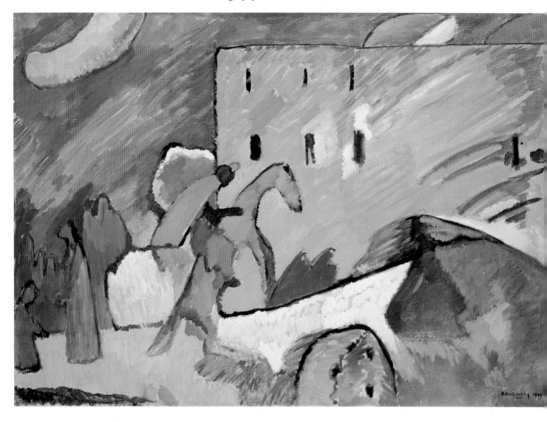

oil on canvas
37 x 51 ¼ in. / 94 x 130 cm
Musée National d'Art Moderne,
Centre Pompidou, Paris, France

Wassily Kandinsky's *Improvisation III* was painted in a period during which the artist alternated between painting the small town of Murnau in Germany and its surroundings, and depicting landscape drawn from his imagination. These imagined scenes often contained references to folklore or fairy tales. Painting in this way, Kandinsky gave an increasingly free rein to his use of intense colour, bold outline and crude shapes. He often worked alongside Alexei von Jawlensky, and the strong, diagonal brushstrokes in *Improvisation III* exemplify the influence of Fauvism (see p.370). In this painting, and others in the series, Kandinsky veiled his subject matter to allow colour to achieve its expressive potential. In each work, he retained a representational core by including certain motifs, such as simplified topographical features: church towers, mountains or, as here, a horse and rider. The horse and rider are familiar figures in Kandinsky's work, and the blue horseman became a symbol of the artist's quest for spiritual renewal in art as in society. As such it gave its name to the Blaue Reiter group of Expressionist artists, spearheaded by Kandinsky.

Between 1909 and 1914 Kandinsky painted thirty-five numbered *Improvisations* and some that remained unnumbered. For many of these he also produced preparatory sketches and variations. In his theoretical treatise *Concerning the Spiritual in Art* (1911–12), Kandinsky defined the improvisation as 'chiefly unconscious, for the most part suddenly arising expressions of events of an inner character, hence impressions of "internal nature"'. Kandinsky was equally fascinated by the expressive potential of improvised music. **LM**

⬢ NAVIGATOR

👁 FOCAL POINTS

1 MEANING OF COLOUR

All colours hold a psycho-spiritual meaning for Kandinsky: for example, depending on its hue, red can relate to a flame or to blood and pain. According to Kandinsky, colour, like musical sounds, is a gateway to the soul: light blue suggested to him the sound of a flute, and dark blue a cello.

2 HORSE AND RIDER

The horse and rider hold special significance among the motifs employed here. The knight, in the form of St George, who vanquished the dragon, features prominently as a figure of worship in Russian Orthodox icons, and would have resonated with Kandinsky from an early age.

3 FAUVIST BRUSHSTROKES

Von Jawlensky's painting style introduced Kandinsky to Fauvism's broader brushstrokes of bright colour. Kandinsky added dark outlines to these areas of colour, which gave his pictures a distinctive solidity. As Kandinsky moved towards abstraction, he changed the way in which he employed the outline: rather than being a device used to define objects, by containing an area of colour, it became a means of drawing abstract shapes within an area of colour.

4 GREEN FIGURES

The identity of the two green figures conversing remains one of Kandinsky's secrets, but they represent some aspect of the world of men. In many of Kandinsky's *Improvisations*, there is a divide between the left-hand side of the picture, which represents the material world, and the right-hand side, which represents the spiritual one. Kandinsky commented 'Movement to the right ... gives the impression of a homeward journey, to the left—out into the world.'

🕐 ARTIST PROFILE

1896–10

At the age of thirty, Kandinsky abandoned his career as a teacher of law and economics to enrol at art school in Munich. He met fellow artist Gabriele Münter in 1902 and they became lovers. His early works were influenced by Pointillism and Fauvism and were inspired by time spent in Murnau, Germany.

1911–21

Kandinsky formed the artist's group Der Blaue Reiter (The Blue Rider) in 1911 with Franz Marc and August Macke, among others. He continued to produce works influenced by music and painted his most complex work, *Composition VII*, in 1913; it exemplifies the increasingly abstract nature of the artist's style.

1922–32

After spending a few years in Russia, Kandinsky returned to Germany to teach at the Bauhaus. He continued to work with bold coloration but introduced geometric elements, such as circles, triangles, arrow shapes and straight lines, into his painting. This was his most intense period of production.

1933–44

When the Bauhaus was closed by the Nazis, Kandinsky moved to France, and became a French citizen in 1939. His paintings from this period feature new elements of fantasy and non-geometric forms, as seen in *Sky Blue* (1940). His late works demonstrate a Surrealist (see p.426) influence.

MURNAU

In the clear light of the Bavarian Alps, the various buildings of the German town of Murnau and its surrounding hills, fields and forests, as seen in *Murnau with Church II* (1910; below), were a major source of inspiration to Kandinsky. In this small market town near Munich, Kandinsky found an ideal environment for making the advances in style that took him from Post-Impressionism (see p.328), through Fauvism and on to his unique form of Expressionist abstraction. As a student Kandinsky had immersed himself in peasant customs and beliefs, and it was at Murnau that Kandinsky learnt—in the company of his lover, Gabriele Münter—the Bavarian folk art of painting simple, brightly coloured landscapes and religious scenes on glass. This technique, together with the woodcut, was important in the development of

Kandinsky's Expressionist style. He always maintained that his intense colours were not from his imagination but from direct experience of the Murnau landscape.

Fate of the Animals 1913

FRANZ MARC 1880 – 1916

oil on canvas
77 ⅛ x 104 ¾ in. / 196 x 266 cm
Kunstmuseum, Basel, Switzerland

⚙ NAVIGATOR

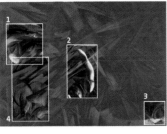

From 1910, Franz Marc turned to the depiction of animals as his sole artistic motif, as he was disillusioned with the materialism that he believed beset humankind. He explained that animals, 'with their virginal sense of life, awakened all that was good in me'. In this large-format picture, nearly 9 feet (2.7 m) wide, Marc depicts the destruction of the world that he cherishes and, in artistic terms, a world he had also created. In earlier paintings, he had portrayed horses both singly and in groups and shown them in a heroic, even contemplative style, evoking a sense of the animals' magnificence. In *Fate of the Animals*, deer, horses and foxes—animals that he had repeatedly depicted living harmoniously—are besieged by an apocalyptic catastrophe as nature turns against itself. On the reverse of the painting, Marc wrote, 'And All Being Is Flaming Suffering'. He had wanted to be a priest before studying art and the phrase evoked the biblical Book of Revelation. Also evocative of this book is the line, 'The trees showed their rings and the animals their veins', which was the painting's original title before it was changed, on Paul Klee's suggestion, to the chillingly simple present title. While serving at the front line in 1915, Marc received a picture postcard of the painting; it astonished him: 'It is like a premonition of this war, horrible and stirring; I can hardly conceive that I painted this!' The painting was severely damaged in a fire during World War I, as can be seen on the picture's right-hand side. In 1918, two years after the artist's death at the Battle of Verdun, it was painstakingly restored by his friend and fellow participant in Der Blaue Reiter (The Blue Rider) group, Paul Klee. **LM**

FOCAL POINTS

1 GREEN HORSES

Unlike horses in some of Marc's other paintings, in which they are shown as heroic, the green horses are depicted as helpless. A mother whinnies for her panic-stricken foal that is running blindly towards a reddish falling tree—Marc's symbol of material domination and doom.

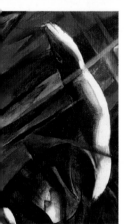

2 BLUE DEER

At the heart of the picture stands a solitary blue deer. For Marc, the deer represents gentleness. His colours possess certain psychological properties: he associates blue with 'masculinity, austere ruggedness and intellect', yellow with cheerful femininity, and red with the material world and domination. As the blue deer arches its neck back, it receives the final death blow, represented by the shaft of orange light cutting across the picture.

3 RESTORATION

When Paul Klee repainted the damaged right-hand section of *Fate of the Animals* in 1918, he purposely did not attempt to replicate the unique 'translucence' of Marc's original coloration, concentrating instead on maintaining the picture's compositional integrity.

4 BALANCE

Abstract and animal forms interpenetrate and overlap each other as hard, arrow-like diagonals. Marc has consciously evolved a style in which it would be impossible 'to take away, add or shift the slightest line' without fundamentally upsetting the balance and inner tension of the work. In *Fate of the Animals*, these cross-cutting shards of vegetation and shafts of light suggest that there is a complete balance between life and the destructive force.

ARTIST PROFILE

1900–02

Having studied theology and philosophy, Franz Marc turned his attention to art in 1900. He enrolled at the Akademie der Bildenden Künste in Munich, where he remained for two years, and focused his studies on traditional landscape painting.

1903–09

Marc visited Paris in 1903 and 1907 and drew great inspiration from the work of Vincent van Gogh and the Post-Impressionists (see p.328). He moved to the countryside in 1909 where he joined a colony of artists. He concentrated his painting on animal subjects, believing their inherent beauty and spirituality to be superior to that of humankind.

1910–13

In 1910 Marc befriended the artist August Macke. He began to simplify his style and use colour in a non-naturalistic way. He assigned special significance to the colours he used: for example, he described 'red' as 'brutal and heavy and always to be opposed', as seen in *The Red Bull* (1913). In 1911 he formed the artist group Der Blaue Reiter, which included Kandinsky. He exhibited with the group across Germany from 1911 to 1913.

1914–16

By 1914 Marc's paintings had become abstract in style, notably influenced by the Futurist style of Robert Delaunay. Marc was killed in action in 1916.

THE ALLURE OF ANIMALS

Franz Marc's focus on the realm of animals—to the exclusion of any reference to humankind—was unique in modern art at the time. This deeply religious painter explained his fascination as follows: 'Is there any more mysterious idea for an artist than the conception of how nature is mirrored in the eyes of an animal? How does a horse see the world, or an eagle, or a doe, or a dog?' In 1909 Marc moved to Sindelsdorf in Upper Bavaria, where he lived with his cats, two tame deer and his Siberian sheepdog Russi, featured in *Dog Lying in the Snow* (1910–11; below). The artist had studied animal anatomy and supplemented his income by teaching the subject. His mission was to do more than simply record animal behaviour; he wanted to promote a system of moral values—which he felt was lacking in humankind—by depicting the 'virtues' he perceived in different species.

Two Women in the Street 1914
ERNST LUDWIG KIRCHNER 1880 – 1938

oil on canvas
47 ¹/₂ x 35 ³/₄ in. / 120.5 x 91 cm
Kunstsammlung Nordrhein-Westfalen,
Düsseldorf, Germany

rnst Ludwig Kirchner created a series of paintings of Berlin street scenes that hum with the tension of life in the big city. In *Two Women in the Street*, he focuses on the women who, dressed in their furs and plumed hats, display a newfound spirit of independence and a certain icy sensuality. The angularity of the drawing and the vigorous cross-hatching heighten the sense of movement conveyed by the picture. This is increased even further by the triangular, streamlined shape that he has given the women's faces. The jagged edges and mask-like forms reveal Kirchner's admiration for Primitivism (see p.342). As is typical of the artist, the subject of the painting extends from the top to the bottom of the canvas without any reference to a horizon and with very limited perspective. There is nowhere for the viewer's eye to roam but back to the women's deep v-neck collars and their theatrically embellished heads.

Kirchner's move from Dresden to Berlin in October 1911 greatly affected his painting. He enjoyed the anonymity of living in the city of Berlin, which enabled him to witness the activities of the people living there at close quarters. He used bold, non-naturalistic colour and short aggressive brushstrokes to depict the city's affluent hedonists and middle-class couples as they promenaded along fashionable Friedrichstrasse. Kirchner also portrayed Berlin's prostitutes, standing in groups or singly, not always distinguishable in dress or style from the middle-class women, but surrounded by watching men. **LM**

FOCAL POINTS

1 BOLD COLOUR
Kirchner's bright acid colours are emphasized by his extremely expressive style of drawing and visible brushstrokes. The use of a palette limited to shades of green, yellow, pink and black is typical of this period and of the work of Expressionist artists.

2 ANGULAR WOMEN
The artist depicts the women with angular, elongated faces and chiselled features. Kirchner explained that this style reflected the woman in his life, Erna Schilling. Her 'beautiful, shapely, architectonically structured' body was for Kirchner the archetype of female Berlin.

3 PINK ARCH
The pink arch is essential to the picture's balanced composition. It is a reminder of place and represents a facet of Berlin's grand buildings. Kirchner qualified as an architect, and in this painting he delineates the women's clothing in a sculpted, almost architectural style.

4 KEY FEATURES
Kirchner emphasizes the hands and lips of the women because these features are intrinsic to the heightened sense of the street's nocturnal sexual charge. He also invests his subjects with individual facial characteristics that go beyond the sallow skin and mask-like forms.

ARTIST PROFILE

1901–05
Kirchner moved to Dresden in 1901 to study architecture at the university there. He met and befriended Fritz Bleyl, with whom he formed the artists group Die Brücke (The Bridge) in 1905, with Karl Schmidt-Rottluff and Erich Heckel.

1906–10
Die Brücke held its first exhibition in 1906 in Dresden. Kirchner spent time at the Moritzburg lakes between 1907 and 1910 in order to paint nudes in natural surroundings. These works are characterized by harsh lines and discordant colour.

1911–14
Kirchner moved to Berlin and produced a series of paintings that is regarded as the highlight of Expressionism. These works fall into two categories: those that present Berlin's architectural forms and those that present its people.

1915–38
Kirchner joined the army in 1915 and had a car accident in 1916; he never recovered from either experience. He continued to paint and his style became more abstract. Overcome by mental and physical pain, he committed suicide in 1938.

CUBISM

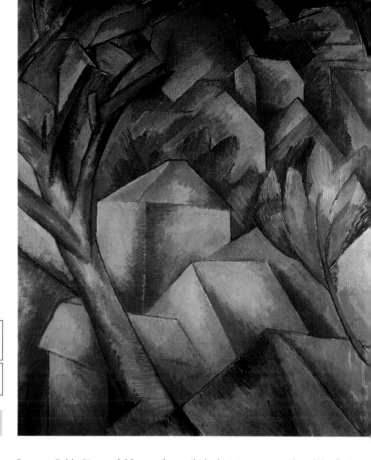

1 *Houses at L'Estaque* (1908)
Georges Braque • oil on canvas
28 ¾ x 23 ½ in. / 73 x 60 cm
Kunstmuseum, Basel, Switzerland

2 *'Ma Jolie'* (1911–12)
Pablo Picasso • oil on canvas
39 ⅜ x 25 ¾ in. / 100 x 64.5 cm
Museum of Modern Art, New York, USA

3 *Portrait of Picasso* (1912)
Juan Gris • oil on canvas
36 ¾ x 29 ¼ in. / 93.5 x 74 cm
Art Institute of Chicago, USA

In 1907 Pablo Picasso (1881–1973) unveiled what is now considered the first Cubist painting, *Les Demoiselles d'Avignon* (1907; see p.392). Based on his memory of a brothel located in Calle Avinyó in Barcelona, the subject was as unconventional as the style of painting was radical. Poet and art critic Guillaume Apollinaire (1880–1918), André Derain (1880–1954), Georges Braque (1882–1963) and Henri Matisse (1869–1954) all came to see it and every one of them initially rejected Picasso's painting, writing it off as 'some kind of joke'. It took more than thirty years for the art world to come to terms with the painting that set the agenda for Cubism, prefigured collage and influenced almost every other important movement in 20th-century art.

Cubism was developed in Paris during the first two decades of the 20th century, chiefly led by Picasso and Braque (who had quickly become interested in and engaged with the style). Both painters were very interested in the later

KEY EVENTS

1906	1907	1907	1909	1910	1911–12
Works by Cézanne present scenes from two simultaneous visual perspectives. The innovation is an important stimulus for Cubism.	Picasso completes *Les Demoiselles d'Avignon* (see p.392). Originally entitled *Le Bordel d'Avignon*, the subject matter is shocking and the style revolutionary.	Braque and Picasso begin to define the Analytic Cubist style of painting. Together, they continue to develop the style until 1912.	Picasso and Braque work in their respective studios in the district of Montmartre, Paris.	Picasso praises art dealer Daniel-Henry Kahnweiler. He asks: 'What would have become of us if Kahnweiler hadn't had a business sense?'	Braque paints *Man with a Guitar* (see p.394), signalling a move in Cubist style towards a greater degree of realism.

work of French Post-Impressionist Paul Cézanne (1839–1906), whose flat, abstract approach they found most appealing. Cézanne saw basic geometric forms, such as the sphere, cone and cylinder in nature, and a memorial exhibition of his work at the Salon d'Automne in 1907 proved a catalyst for Cubism. Like Cézanne, the Cubists insisted that art was not a copy of nature but a parallel to it, although the Cubists developed this concept much further. Another influence on Cubism was African art, as seen in the mask-like faces of Picasso's *Les Demoiselles d'Avignon* and in the limited palette of natural earth tones and colours that dominated much of the early Cubist work.

Picasso and Braque were seen as joint leaders of the fledgling movement, not by agreement, but purely because both artists were heading in a similar direction at the same time. The close collaboration between the two painters led Braque to liken their relationship to that of two mountain climbers roped together, pulling each other up. Between 1907 and 1912, both men made what are now considered to be the first early or 'Analytic' Cubist paintings; these were experiments that attempted to understand not simply how the camera or eye might capture an image, but also how they believed the mind processed it. The artists intellectually 'broke down' structures in order to analyze and re-create them. The result was a group of paintings that pictured the world as it had never been seen before. Painting tonally, using grey, black, blue, green and ochre, they constructed austere images, presenting complex, multiple views of an object, which was reduced to overlapping opaque and transparent planes. In these cold, flattened images, natural forms were reduced to geometric shapes, in particular cylinders, spheres and cones.

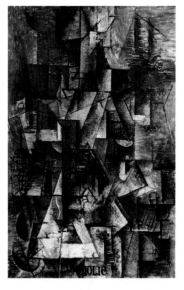

In the summer of 1908, Braque went to L'Estaque, in southern France, where he painted a group of landscapes with buildings created in the Analytic Cubist style. Art dealer Daniel-Henri Kahnweiler was intrigued by these paintings and agreed to promote Picasso's and Braque's work. To bring the art to a wider audience, and in order to cause a ripple of publicity, Kahnweiler held an exhibition at his own gallery, the Galerie Kahnweiler in Paris, in November 1908. It included one of Braque's summer paintings, *Houses at L'Estaque* (left). Art critic Louis Vauxcelles came to the exhibition and inadvertently came up with the name 'Cubism' when he unfavourably reviewed Braque's work in the influential magazine *Gil Blas*. In the article, he accused the artist of making paintings that reduced everything to 'geometric outlines, to cubes'.

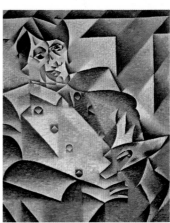

Although Cubism was initially despised by the majority of critics and the public was certainly not yet ready for it, the revolutionary new style was taken up by many artists in Paris, the most prominent of whom was the Spanish-born French painter Juan Gris (1887–1927), whose first Cubist paintings appeared in 1912. Excited by the new movement, artists began constructing images of people, places and domestic objects using a network of illusory planes. By simultaneously embracing a medieval flatness of field and Renaissance illusions of volume, the Cubists developed a shallow space where they could mix surface pattern and spatial ambiguities with static objects observed from shifting viewpoints.

1912	1913	1914	1915	1915	1917
Picasso and Braque create their first works of Synthetic Cubism, in which the planes are arranged decoratively and subjects become more recognizable.	Duchamp's Cubist-Futurist *Nude Descending a Staircase, No. 2* (see p.391) is exhibited at New York's Armory Show.	World War I begins and Germany invades France. Braque enlists in the French army and is twice decorated for bravery.	On 11 May, Braque is wounded in the head and temporarily blinded at Clarency. This war wound affects his health for the rest of his life.	Picasso is devastated by the death from illness of his mistress, Marcelle Humbert (whom he called Eva Gouel) at the age of thirty.	While convalescing in Villepinte, France, after a mustard gas attack, Léger paints *The Card Players*, imbuing geometric shapes with movement and colour.

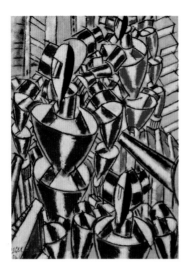

By 1911 a little warmth had begun to appear in some Analytic Cubist paintings. Picasso's *'Ma Jolie'* (see p.389), for example, was both the name of the refrain of a French popular song and Picasso's pet name (meaning 'my pretty girl') for his lover Marcelle Humbert. By including the words in the painting, Picasso was not simply making a dedication or employing a device; he was using the words to personalize and humanize a barely discernible image of a woman playing a guitar. Less contrived and more traditional in the devices it used to restore warmth to its canvas is Juan Gris's *Portrait of Picasso* (see p.389). Here Gris achieved his goal by putting his subject through a less savage experience of dissection and by adding more sunlight and colour to his palette. The Cubists were learning to create a more audience-friendly product.

Fernand Léger (1881–1955) injected a real sense of pleasure and optimism into Cubism by painting a series of small, sharply delineated compositions in bright primary colours, quite different from the sombre, more academic works of Picasso and Braque. More like drawings than paintings, they were made quickly using one-stroke brushstrokes that replaced the carefully constructed planes of earlier Cubist paintings. With these images, Léger introduced a new aesthetic to painting, an aesthetic that broke firmly with the ideas of the 18th and 19th centuries—the rules about perspective, foreshortening, texture and the use of chiaroscuro—and launched the Cubist movement into an optimistic, technologically driven, Modernist world. One of the most remarkable of these paintings is *La Sortie des Ballets Russes* (left), which was the first in what has become known as Léger's 'disc' series (the name derives from the method of 'disc geometry' with which Léger experimented when creating the shapes of the objects and figures in his paintings). In this series, he used a vibrant palette of bright yellows, reds, blues and black.

Between 1912 and 1914, Léger's chromatic moves, coupled with Picasso's and Braque's development of collage, helped to precipitate change and accelerate interest in the movement. This second 'Synthetic' phase of Cubism, as it became known, focused less on a way of seeing and more on a process of structuring and designing. Colour assumes a stronger role in these works, and shapes, while remaining fragmented and flat, are larger and more decorative. Often, other materials, such as newspaper fragments and pieces of cloth, are pasted on to the canvas, prefiguring collage. Different textures are explored and there is a greater emphasis than before on using a combination or 'synthesis' of different styles within one piece of work. Georges Braque's *Still Life on a Table: 'Gillette'* (opposite, above) clearly illustrates the difference between the early and later stages of Cubism. Constructed from drawn, painted and pasted paper elements, it is a perfect example of the alchemy of collage and the ability of artists at this time to turn the contents of a rubbish bin into beautiful and revolutionary images. A discarded paper wrapper from a safety razor blade, a *trompe l'oeil* sample of oak skirting board and some freely drawn charcoal lines are organized on a clean white surface to produce an image that is built from the familiar but that is as abstract as music.

Driven by an expanded group of artists that included Robert Delaunay (1885–1941), Francis Picabia (1879–1953), Jean Metzinger (1883–1956), Fernand Léger and Marcel Duchamp (1887–1968), the Synthetic phase began in 1912 and lasted throughout the 1920s. Duchamp's *Nude Descending a Staircase, No. 2* (opposite, below) aroused huge controversy at New York's Armory Show in 1913; the work showed the fragmentary style of Cubism and the dynamic movement of Futurism (see p.396). As the relationship between Cubism and collage grew, so collage, based on a cutting, sticking and folding of the 'found' process, began to influence everyone's method. Artists fell so in love with the medium that they even began painting pictures that looked as

4 *La Sortie des Ballets Russes* (1914)
 Fernand Léger • oil on canvas
 53 ¼ x 39 ½ in. / 136.5 x 100.5 cm
 Museum of Modern Art, New York, USA

5 *Still Life on a Table: 'Gillette'* (1914)
 Georges Braque • charcoal, pasted paper
 and gouache • 18 ⅞ x 24 ¾ in. / 48 x 62 cm
 Musée National d'Art Moderne, Centre
 Pompidou, Paris, France

6 *Nude Descending a Staircase, No. 2* (1912)
 Marcel Duchamp • oil on canvas
 57 ⅞ x 35 ⅛ in. / 147 x 89 cm
 Philadelphia Museum of Art, USA

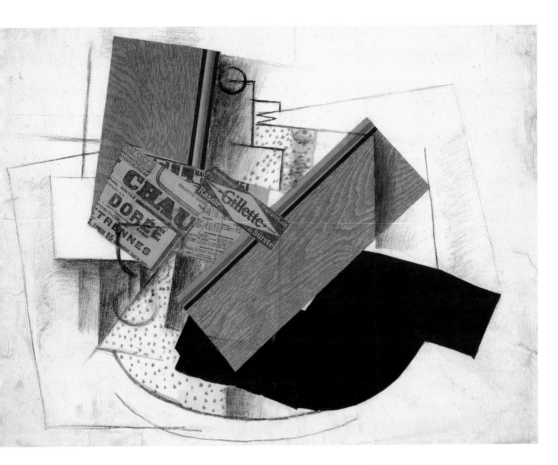

though they were collages. This more decorative view of art made Synthetic Cubism more popular with the public than earlier Cubist styles. The technique reached its zenith in the work of Matisse and continued into later 20th-century movements, especially Pop art (see p.484). As increasingly robust materials were used, the influence of collage spread into three dimensional work, at which point Cubism 'opened up' sculpture. Voids and solids were viewed as being of equal artistic value and, with Picasso in the vanguard, others, including Jacques Lipchitz and Russian sculptor Alexander Archipenko, followed.

Cubism was deeply affected by war: from World War I, in which many artists fought, through the Spanish Civil War and into World War II. The horrors of what the artists had seen and heard began to permeate into their works and many, especially Léger and Braque, changed their styles dramatically after 1918. The outbreak of war also marked the end of Braque's association with Picasso. Braque, who served with distinction as an infantry sergeant, was seriously wounded in 1915. He underwent a lengthy convalescence in Sorgues, in France during which he became close to Juan Gris. Braque's painting moved away from geometric forms to softer, freer brushwork, notable in works such as *Still Life with Playing Cards* (1919).

Back in 1907, *Les Demoiselles d'Avignon* had set the agenda not just for Cubism but for the whole of modern art. Through its fragmentation of an image, the Cubist movement enabled Orphism, Rayonism (see p.396) and Futurism; in pushing geometry to the foreground, it informed Suprematist and Constructivist art (see p.400); with its use of collage, it anticipated Dada (see p.410), Surrealism (see p.426) and Pop art; and finally, through the use of flat planes, it pointed the way to Abstract Expressionism (see p.452). **SF**

Les Demoiselles d'Avignon 1907

PABLO PICASSO 1881 – 1973

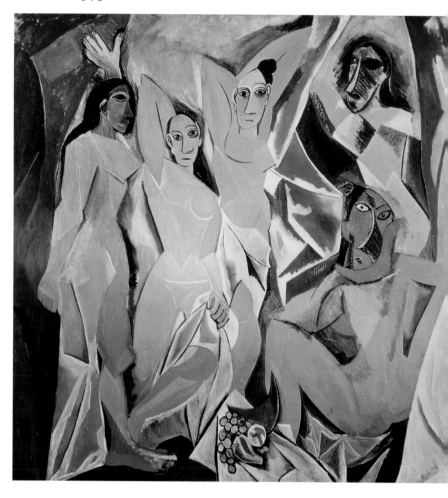

oil on canvas
96 x 92 in. / 244 x 234 cm
Museum of Modern Art, New York, USA

✪ NAVIGATOR

When it was shown privately in 1907 to critics, poets and artists including Georges Braque and Henri Matisse, Pablo Picasso's radical work—depicting prostitutes in a brothel in Barcelona—had a hostile reception. It was the style of art, not the subject matter, that most shocked these early viewers. The work's startling modernity results from a series of audacious artistic strategies. Bodies and background are reduced to geometric forms. There is little sense of spatial depth and the disjointed perspective is unsettling, forcing the eye to dart about the canvas to find meaning. The influence of African masks is central in this painting and shows in the mask-like faces, which also reflect Picasso's interest in Iberian sculpture. The angular figures are barely connected, save in their nakedness. Picasso has created a resolutely flat plane, emphasized by a narrow palette of colours and by his use of line drawing to define forms rather than manipulating colour and light as the Impressionists did. This work has a sexual undercurrent, reinforced by the energetic brushstrokes. The painting broke with Picasso's previous work and with the history of art, anticipating the fragmentary nature of much 20th-century art and new techniques such as collage. He later dubbed it his 'first exorcism painting', referring perhaps in part to this discarding of tradition. **FP**

⊙ FOCAL POINTS

1 FIGURE IN PROFILE

This muscular standing figure wears a less frightening mask than those on the far right of the composition. She is holding back a red curtain to reveal the group of women and stands impassively, like a guard, at the edge of the scene. The figure opposite her also draws back curtains.

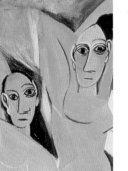

2 TWO CENTRAL FIGURES

These women form the heart of the composition. With their arms raised up above them, they revel in their nakedness and sexuality. They stare directly and provocatively out of the frame, locking the viewer in their gaze. These figures contrast with the 'primitivism' of the other *demoiselles*—their faces are softer and more realistic. Their prominent ears and wide, staring eyes point to the influence of ancient Iberian sculpture.

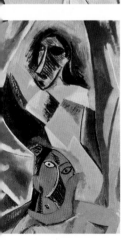

3 FIGURES IN MASKS

Both these figures wear what seem like African masks, which gives them a rather inhuman appearance. The squatting figure has the most Cubist head of the group. Although she is seated with her back to the viewer, her head peers out of the canvas. This shifting of parts of the human anatomy—so that they are seen from the front and back at the same time—is a Cubist trait. The obviously Cubist style of these two makes them stand out in the group.

4 TABLE

The table jutting out in the foreground is the only remaining element of an earlier version of this work that included two male figures (a sailor and a medical student), both of whom Picasso erased from the canvas. The cut fruit is on sensual display, rather like the nude women.

⊙ ARTIST PROFILE

1901–04
In his Blue Period Picasso produced works in subdued, blueish tones. Subjects included alcoholics, beggars and prostitutes.

1905–06
The Rose Period was lighter in tone, notable for its pink and orange palette, and featured harlequins and circus performers.

1907–12
Picasso developed Analytic Cubism with Georges Braque. Objects were reduced to their basic geometric shapes and the subject was depicted from several viewpoints.

1912–18
Picasso developed Synthetic Cubism with Braque and Juan Gris. Fragments of newspaper, sheet music and cloth were incorporated in the paintings to create collages.

1919–29
The work of Picasso's Neoclassical phase (see p.260) frequently recalled the painting of Jean-Auguste-Dominique Ingres.

1930–48
The use of symbolic forms, such as the Minotaur, characterized Picasso's work and identified him as a Surrealist (see p.426).

1949–71
Picasso's work became more colourful and reinterpreted the work of masters such as Edouard Manet and Rembrandt.

AFRICAN INFLUENCE

African art was an important inspiration for Picasso, and in *Les Demoiselles d'Avignon* he drew on the abstracted forms and imagery seen in the ceremonial masks of the Dogon tribe (below). The Dogon are an ethnic group from Mali who are known for their mask dances and sculpture. The 'primitivism' of the masks represented vitality to Picasso. The influence of African art on Picasso lasted from 1907 to 1909, the period during which Cubism was born. France was colonizing Africa and the media was packed with exotic stories. Paul Gauguin had sparked an interest in tribal art and many Fauve artists collected African masks and statues. In the summer of 1907, before he finished *Les Demoiselles d'Avignon*, Picasso visited the Musée d'Ethnographie du Trocadero in Paris, where he saw masks in the African and Oceanic collections that may have led him to alter the depictions on his canvas. The visit had a profound effect on the artist: '[The masks] were magic things. . . . They were against everything—against unknown threatening spirits. . . . I too am against everything.'

Man with a Guitar 1911 – 12
GEORGES BRAQUE 1882 – 1963

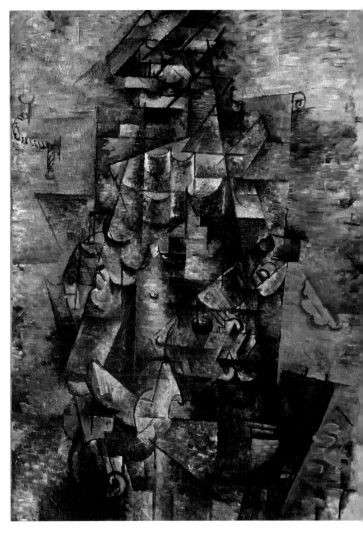

oil on canvas
45 ¾ x 31 ⅞ in. / 116 x 81 cm
Museum of Modern Art, New York, USA

✧ NAVIGATOR

Georges Braque's *Man with a Guitar* is an almost perfect example of Analytic Cubism, the name given to the early phase of Cubist work, in which the appearance of a subject is represented as interlinking flat planes, usually painted with a muted colour palette.

As his starting point, Braque took the theme of a single figure playing a stringed instrument, as realized the previous year by Pablo Picasso in a relatively representational painting entitled *Girl with a Mandolin (Fanny Tellier)* (see panel opposite). Braque demonstrated how an image could be reduced to a form of abstraction never previously imagined. He replaced the painter's traditional single perspective with multiple perspectives on a largely flat plane, with two- and three-dimensional forms coexisting in different ways. The composition may initially appear bewildering, but Braque provides clues for orientation. Elements of the guitar—strings and body—emerge, and a strong diagonal running from the centre down to the left indicates the figure's arm. The result is a dense but suggestive canvas that invites investigation. **SF**

1 DENIAL OF DEPTH

By painting a tassel and thumb tack on the picture plane, Braque intentionally destroys any illusion of depth. He emphasizes that this is, like all Cubist paintings, an experiment and a work in progress: it is closer to being a page from a notebook than a fully realized 'art treasure'.

2 LAYERING OF PLANES

Braque creates volume using a succession of planes. He paints in layers that progressively abstract the final image. Parallel diagonal brushstrokes, painted as deletion marks on the surface of the picture, further obscure the features of the guitarist's head, preventing the viewer from humanizing it.

3 BACKGROUND TO THE FORE

In the top-right corner of the painting Braque uses a self-consciously painterly approach. He painted wet on wet and left visible brushstrokes. He used a monochromatic colour scheme and the opaque planes help to unify the composition. But Braque is also playing with the viewer. When the eye travels across the canvas, the background leaps to the fore, rather than receding, thus allowing Braque to create multiple views of his subject.

4 *TROMPE L'ŒIL*

Braque revolutionized painting but worked with painterly tradition. The guitarist's nipple is near the centre of the image. Braque looks back to Renaissance *trompe l'œil* and chooses to draw the viewer's eye to it by using tones: the nipple is painted in a mid-tone lit from the top right and is given depth by a dark-toned shadow on the bottom left. He echoes the nipple shape by using similar tones to represent the soundhole of the guitar, which appears below it.

1882–99

Braque grew up in Le Havre, in France. He trained to become a painter and decorator and studied fine art in the evenings.

1900–07

Braque's early influence was Impressionism (see p.316), but this was replaced by Fauvism (see p.370) after he attended a Fauvist exhibition in 1905. His art was further transformed by seeing a retrospective exhibition in Paris of the works of Paul Cézanne in 1907. Braque met Picasso, who also lived in Montmartre, Paris, in the same year.

1908–13

Braque and Picasso worked closely together, forging the tenets of Cubism and, in 1911, painting together in Céret in the French Pyrenees. Collage became part of their work in 1912. It was during this period that Braque turned from landscapes to still lifes, with their greater scope for multiple perspectives.

1914–17

Braque enlisted in the French Army and fought in World War I. He was severely wounded in 1915 and later discharged.

1918–63

Leaving Paris, Braque moved to Normandy, where he took up his art once more. Working prolifically and alone, his style remained Cubist but with a strongly meditative character.

THE ROAD TO ABSTRACTION

Created in Paris just over a year before fellow leader of the Cubist movement Georges Braque painted *Man with a Guitar*, Picasso's painting *Girl with a Mandolin (Fanny Tellier)* (1910; below) is a reminder of how difficult it can be, even in revolutionary times, not to hark back to the past. In the spring of 1910, as Cubist paintings became more abstract, Picasso evidently still felt the need to portray recognizable subjects with illusions of volume. His palette was virtually monochromatic so as not to detract from the structure of form itself. A transitional piece anticipating Analytic Cubism, this work is painted in *trompe l'oeil* bas-relief, as if the central figure were trapped part way through the process of being

released from a slab of stone. Sculptural, concrete and full of illusion in some areas, such as the mandolin, which is partly abstracted and partly flat, the painting illustrates the struggle Picasso was experiencing in breaking with the past to enable a truly modern art.

FUTURISM, ORPHISM AND RAYONISM

1 *Speeding Automobile* (1912)
Giacomo Balla • oil on wood
21 7/8 x 27 1/8 in. / 55.5 x 69 cm
Museum of Modern Art, New York, USA

2 *La Tour Eiffel* (1910–11)
Robert Delaunay • oil on canvas
Kunstmuseum, Basel, Switzerland

3 *Rayonism, Blue-Green Forest* (1913)
Natalia Goncharova • oil on canvas
21 1/2 x 19 1/2 in. / 54.5 x 49.5 cm
Museum of Modern Art, New York, USA

The years leading up to World War I saw notions of distance, and the time taken to traverse it, change dramatically with the advent of the aeroplane, motor car and wireless communications. A number of interrelated art movements arose that sought to reflect the extraordinary pace of technology and its implications for society. The mainspring of this new consciousness was the Italian avant-garde art movement, Futurism. Although it reflected the particular circumstances relating to its country of origin, it impacted on the artistic vanguard from Moscow to New York.

The movement was started by Italian poet Filippo Tommaso Marinetti (1876–1944). In February 1909 Italian newspaper *La gazzetta dell'Emilia* published Marinetti's *Futurist Manifesto*, in which he declared: 'We shall sing the love of danger, the habit of energy and fearlessness.' He called for the rejection of traditional values and the glorification of new technology. Soon his love of speed and mechanization were shared by architects, composers, writers, designers, film-makers and artists. By March 1910 the Italian painters Umberto Boccioni (1882–1916), Carlo Carrà (1881–1966), Giacomo Balla (1871–1958), Gino Severini (1883–1966) and Luigi Russolo (1885–1947) had aligned themselves with the movement and issued the *Manifesto of Futurist Painters*. Besides calling art critics 'complacent pimps', it demanded that Italy stop looking back nostalgically to its past, celebrate modern life, embrace change and develop a culture fit to reflect its recent industrialization. A month later, as Futurism

KEY EVENTS

1909	1910	1911	1912	1913	1914
On 5 February Marinetti publishes the *Futurist Manifesto* in Bologna's *La gazzetta dell'Emilia*; two weeks later it appears in *Le Figaro*.	The *Manifesto of Futurist Painters* and the *Technical Manifesto of Futurist Painting* are published.	Futurist works are exhibited for the first time in Milan's 'La Mostra d'Arte Libera' (Exhibition of Free Art), alongside work by children and amateurs.	Painter Boccioni begins to create sculptures for the first time. He exhibits in London at the Sackville Gallery, influencing nascent Vorticist artists.	Balla paints *Abstract Speed*, a triptych of a car passing along a once-peaceful road. Boccioni paints *Dynamism of a Cyclist* (see p.398).	Russian painter Lyubov Popova (1889–1924) begins *Portrait*; she uses the word 'Futurism' to form an integral part of the composition.

egan to take shape as a recognized artistic movement, the group issued the
echnical Manifesto of Futurist Painting, which stressed the need for artists to
xpress the dynamic nature of movement in their work.

Influenced by Neo-Impressionist Paul Signac's (1863–1935) Divisionist style
f separating colours into individual dots or patches, the Futurist painters
ttempted to create the illusion of speed by using small dabs of colour that the
ewer combines optically, rather than physically mixing pigments. Boccioni's
he City Rises (1910) uses such techniques, but he added a new dynamism
sing diagonals to create a swirling maelstrom. However, it was not until
ne Futurists encountered Cubism (see p.388) in 1911 that they were able to
chieve a systematic method of depicting mechanized movement. They took
ubism's broken planes, multiple angles and staggered repetition of the same
mage and applied it to the depiction of shifting time and space. They used
righter more vibrant colours than the Cubists and chose machines, such as
utomobiles, trains and bicycles, for subject matter. They also added 'force lines'
hereby diagonals served to place viewers in the picture's centre, drawing
nem in, as in Balla's *Speeding Automobile* (opposite).

The Futurists' influence spread quickly across Europe. Their philosophy,
vith its focus on speed and fast-paced contemporary living, was particularly
mbraced by Russian avant-garde artists. In France, Boccioni accused Robert
)elaunay (1885–1941) of imitating the Futurists with his *La Tour Eiffel* (right,
bove), although Delaunay strongly denied it. French poet and art critic
uillaume Apollinaire (1880–1918) later coined the term 'Orphism' to describe
)elaunay and his wife Sonia's near-abstract kaleidoscopic and translucent
aintings. Delaunay's theory of 'simultaneous contrasts' placed colours in
uch a way that they appear to both separate and unite at the same time.
he development of Italian Futurism was hindered by internal rifts in 1914 and
ne death of Boccioni, its most energetic and articulate spokesperson, in 1916.

In Russia, Futurism had a huge impact on art and literature. Mikhail
arionov (1881–1964) and his wife Natalia Goncharova (1881–1962) combined
uturism's emphasis on movement with the broken forms of Cubism and rich
olour of Orphism to create Rayonism. From 1911 to 1920 both artists worked on
he theoretical and plastic aspects of Rayonist painting, with Larionov tending
owards analytical studies and Goncharova towards their implementation.
hey devised a method of applying intersecting diagonal lines to represent
he 'rays' that they believed occur when light reflects both off an object's
urface and between objects, so a moving object creates an almost infinite
umber of reflecting rays. The painters depicted the rays using diagonal lines
f paint (often applied to the canvas with a palette knife) that striate the
vhole of the picture's surface, as seen in Goncharova's *Rayonism, Blue-Green
orest* (right, below), and the results sometimes veer towards total abstraction.
ike the Italian Futurists, Goncharova suggested movement by the rhythmic
epetition of shapes and lines. In England, the only painter to ally with the
uturist movement was C. R. W. Nevinson (1889–1946), who co-authored
Futurist Manifesto: Vital English Art (1914) with Marinetti. **LM**

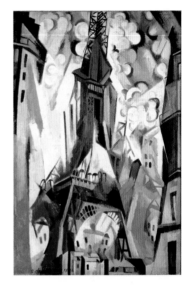

1916	1917	c. 1919	1928	1931	1934
occioni dies after eing thrown from his orse during a cavalry raining exercise and he Futurist movement s deprived of its key heorist.	Carrà is conscripted into the army. He meets Giorgio de Chirico (1888–1978) and makes a dramatic change in style moving away from Futurism.	Virgilio Marchi's (1895–1960) architectural study *Search for Volumes in an Isolated Building* typifies the ideal of a Futurist building.	Painter and composer Russolo moves to Paris and takes his 'Noisemakers' and 'Russolophone' instruments into avant-garde cinema.	Guglielmo Sansoni (1896–1974), known as 'Tato', organizes Italy's first exhibition of 'aeropaintings'; declaring aircraft as Futurist subject matter.	Construction begins on Angiolo Mazzoni's (1894–1979) design for a Futurist railway station in Trento, Italy. It takes two years to complete.

Dynamism of a Cyclist 1913
UMBERTO BOCCIONI 1882 – 1916

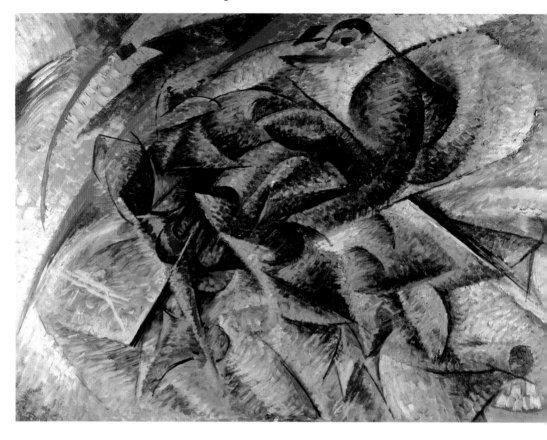

oil on canvas
27 ¹/₂ x 37 ³/₈ in. / 70 x 95 cm
Private collection

I ssued on 11 April 1910, the *Technical Manifesto of Futurist Painting* outlined the signatories' intention to capture movement—and the notion of speed in particular—in an innovative way. Umberto Boccioni spent the years from 1910 to 1912 trying to fulfil this ambition. He applied a Divisionist technique to Milanese cityscapes, creating an ever-increasing sense of movement and flux in his work. He introduced 'force lines'—parallel and intersecting streaks of paint suggesting 'calm or frenzy, sadness or gaiety'—that help give objects a sense of directional movement. However, it was not until he visited Paris in 1911, and saw the fragmented planes of the Analytic Cubism (see p.388) of Pablo Picasso and Georges Braque, that Boccioni succeeded in imparting a powerful dynamism to his painting. *Dynamism of a Cyclist* is one of a series of 'dynamism' works, executed in 1913, that included studies of a human body and a soccer player. The form initially appears abstract; the shape of the man and the bicycle are discernible and Boccioni manages to capture not only speed, but also the process of a constant physical reaction.

The *Technical Manifesto* states, 'To paint a human figure you must not paint it, you must render the whole of its surrounding atmosphere.... Painters have shown us the objects and people placed before us. We shall henceforward put the spectator at the centre of the picture.' The painting's energetic but highly controlled cross-hatching within the subdivided planes and the shifts of tone and colour, suggesting depth and three-dimensionality contribute to a seamless unity between space and matter. **LM**

❖ NAVIGATOR

👁 FOCAL POINTS

1 FUSION OF LANDSCAPE

Although the painting is an abstract depiction of a state of flux, once the cyclist and bicycle are identified it is possible to assign other abstract shapes an objective status. This is the case with the swathe of green and the curved streak of pink at the top of the picture. Nowhere do bicycles go faster than on a mountain road, and these forms, suggesting a mountainous landscape, provide a topographical setting, albeit fused with the figure.

2 COMPLEMENTARY COLOURS

Boccioni believed that 'innate complementariness' was essential in painting and he juxtaposes purple, blue, red, yellow, orange and green to make his point. Using such vivid complementary colours gives the painting a modern feel and creates a sense of brilliant artificial light.

3 DEPICTING SPEED

The elongated conical shape in orange and the thinner dark line at right angles to it are the frame of the bicycle. Similar lines, drawn more loosely, project behind the cyclist as well. The circular, short streaks of white mixed with grey and indigo represent the rapidly spinning wheels and spokes. This rendering confirms Boccioni's aim to portray the 'dynamic sensation' of speed using sharp, diagonal lines to create a rhythm through the use of pattern and repetition.

4 A SENSE OF ENERGY

The cyclist's head, in the form of a conical black curve, is the meeting point of all the forces of energy described in the picture. The cyclist's bulk and the schematized landscape surrounding it together form a leftward-pointing chevron that provides a clear sense of direction to the viewer.

🕐 ARTIST PROFILE

1882–1905

Boccioni was born in Reggio Calabria in Italy. His family moved around Italy and he completed his schooling in Catania, Sicily. In 1901 he moved to Rome, where he learnt the rudiments of painting and worked as a sign painter. There he met Gino Severini and studied with him under Divisionist painter Giacomo Balla. Boccioni completed his first painting in 1903.

1906–11

Boccioni travelled to Paris and Russia; on his return in 1907 he joined the Scuola Libera del Nudo dell'Accademia di Belle Arti in Venice, where he took drawing classes. He then moved to Milan, where he met Filippo Tommaso Marinetti and other founder members of the Futurist movement. Boccioni became the main theorist of the group.

1912–14

Boccioni travelled to Paris and London, where he exhibited work that influenced the emerging British Vorticist movement. He was exposed to Cubist sculpture while in Paris and began to sculpt as well as paint, preferring to make work in wood, iron and glass rather than marble or bronze.

1915–16

When Italy entered World War I in 1915, Boccioni volunteered for military service. He died in Verona a year later, after being thrown from his horse during a cavalry training exercise.

BERGSONIAN PHILOSOPHY

Futurist ideology was greatly influenced by French philosopher Henri Bergson (1859–1941). In the early 20th century his writings achieved near cult status. In *Matter and Memory* (1896), he wrote, 'True change can only be explained by true duration; it involves an interpenetration of past and present, not a mathematical succession of static states.' The notion of the multiplicity of facets within a single movement enabled the Futurists to construct the concept of simultaneity and led to their depiction of movement using repetition of the same image. In *Creative Evolution* (1907) Bergson formulated the idea of the *élan vital* or 'vital impetus'. He drew attention to the paradox that consciousness is in an almost constant state of flux while being surrounded by a seemingly inert world of objects. This influenced Futurist ideas about memory.

SUPREMATISM AND CONSTRUCTIVISM

1 *Beat the Whites with the Red Wedge*
(1919)
El Lissitzky • lithograph
19 3/8 x 27 1/4 in. / 49.5 x 69 cm
Lenin Library, Moscow, Russia

2 *Monument to the Third International*
(1920)
Vladimir Tatlin • letterpress illustration
11 x 8 5/8 in. / 28 x 22 cm
Museum of Modern Art, New York, USA

3 *Head of a Woman* (c. 1917–20)
Naum Gabo • celluloid and metal
24 1/2 x 19 1/4 x 14 in. / 62 x 49 x 35.5 cm
Museum of Modern Art, New York, USA

The Russian revolutionary period is associated with a creative dynamism in which pioneers of non-objective, abstract art increasingly placed their labour at the service of the revolution. The Bolsheviks came into power in 1917 with the intention of changing society for ever, and many young artists, sympathetic to their cause, saw a way to escape the domination of market forces and give art a more concrete social role.

Yet the Russian Revolution did not create the Russian avant-garde. Artists such as Kasimir Malevich (1878–1935), Liubov Popova (1889–1924), Vladimir Tatlin (1885–1953) and Alexander Rodchenko (1891–1956) were aware of the latest cultural and artistic trends in Paris and Berlin, and had exhibited in Russia and abroad prior to 1917. Malevich's art had been influenced by Impressionism (see p.316) and Futurism (see p.396) before arriving at what was an artistic seismic wave: Suprematism, which he defined as 'the supremacy of pure feeling in creative art'. His monochromatic, geometric forms set floating over a white ground influenced other artists such as Popova, Ivan Kliun (1873–1943) and El Lissitzky (1890–1941). But the revolution required a less spiritual kind of art than Suprematism to help accomplish its aims. It was in answer to this need that Constructivism developed, applying aspects of Suprematism's uncluttered dynamism to the wider context of graphic art, theatrical and industrial design, and architecture.

KEY EVENTS

1913	1914	1915	1916	1917	1918
Malevich places a black square against the sun in his stage design for *Victory Over the Sun*, a Futurist opera. *Black Square* is the first Suprematist work.	After visiting Picasso's studio in Paris, Tatlin is influenced by his Cubist constructions and makes abstract sculptures from industrial materials.	Malevich publishes his essay *From Cubism and Futurism to Suprematism* and shows Suprematist works at '0.10: The Last Futurist Exhibition'.	Popova, Kliun and other artists join the Supremus group led by Malevich to develop Suprematist philosophy and discuss its applications.	The February and October Revolutions lead to the creation of the Soviet Union. The new order adopts Suprematism as its artistic voice.	Constructivism starts to replace Suprematism as its supporters work in art establishments and advocate a utilitarian artistic culture.

The seeds of Constructivism were sown as early as the spring of 1914, when the artist and merchant seaman Tatlin went to visit Picasso's studio in Paris. Tatlin was determined to transform the painted planes he saw in Picasso's Cubist works into 'real materials in real space'. It is also possible that he saw Picasso's *Guitar* (c. 1914)—a radical, three-dimensional construct made of sheet metal and wire. Tatlin's wall-mounted reliefs were followed by free-hanging sculptures constructed out of everyday materials such as string, wood, metal and plastic, which he picked for their inherent qualities of texture, colour and shape. Later Tatlin designed and modelled an extraordinary spiral structure known as *Monument to the Third International* (right), although prohibitive costs prevented it from being built.

With the formation of the workers' state, the emphasis on using everyday materials in art took on fresh significance. In doing this, artists were identifying with the workers who used these materials in industrial production. Even non-objective painting could take on a Constructivist guise. It was argued that the canvas, metal tacks, wood and pigments that went into making a picture made it a constructed object, one that El Lissitzky described as 'a construction and, like a house, you have to walk round it'. Single lines, flat areas of colour and geometric shapes were applied so that they appeared as non-painterly 'constructions' positioned in the canvas's surface.

El Lissitzky's Russian Civil War poster *Beat the Whites with the Red Wedge* (opposite) combined Suprematist shapes and Dada-influenced (see p.410) typography to convey its political message. He described his technical designs, or Prouns (Project for the Affirmation of the New), as 'an interchange station between painting and architecture'. Popova experimented in a similar area but called her works 'Architectonics'.

By 1918 Constructivism had secured the official backing of the ruling Communist Party. Artists such as Tatlin and Rodchenko began to seek ways of aiding the economy by devoting their skills to the design of practical objects, such as workers' clothing and domestic heaters, and product marketing. To this end, Rodchenko adapted the photomontage techniques that he had developed under the influence of Dada to designing book covers, film posters and even advertisements for biscuits.

Naum Gabo (1890–1977) and his brother Antoine Pevsner (1886–1962) laid out the tenets of Constructivism in the *Realistic Manifesto* (1920). Gabo experimented with ways to construct space without depicting mass, using sheet materials such as cardboard, plywood and galvanized iron, resulting in works such as *Head of a Woman* (right). But the brothers were wary of subordinating art to political and social requirements and left Russia for the West in the early 1920s. Their sculptures helped to diffuse Constructivist ideas throughout Europe. **LM**

1919	1920	1921	1922	1923	1924
The 'Non-objective Creation and Suprematism' show is held in Moscow. Malevich declares the Suprematist experiment is over.	Gabo and Pevsner publish the *Realistic Manifesto* and coin the term 'Constructivism'. The Vkhutemas school of art and design is founded in Moscow.	Moscow hosts the 'First Constructivist Art Exhibition'. Vladimir Lenin (1870–1924) introduces the New Economic Policy, a shift to state capitalism.	Malevich and his followers move to Inkhuk in St Petersburg, where he works on his three-dimensional 'arkhitektony' works.	Rodchenko produces a series of illustrations for Vladimir Mayakovsky's poem 'Pro eto' (About This) (see p.404).	Lenin dies: the rise of Stalinism sees Socialist Realism imposed and the decline of the Russian avant-garde in art, literature, film, music and architecture.

Suprematist Composition: Airplane Flying 1915
KASIMIR MALEVICH 1878 – 1935

oil on canvas
22 ⁷/₈ x 19 in. / 58 x 49 cm
Museum of Modern Art, New York, USA

⚽ NAVIGATOR

When Kasimir Malevich arrived at the concept of Suprematism, he was determined to negate all references to the physical presence of objects in the material world. Instead, he presented the viewer with a new pictorial language, which he felt contained 'the entire system of world-building'. Malevich's Suprematist works were first shown at '0.10: The Last Futurist Exhibition' (1915) in St Petersburg. His painting *Suprematist Composition: Airplane Flying* was one of the thirty-nine canvases he displayed at the show. Thirteen squares, rectangles and lines in red, yellow, black and blu are carefully positioned against a white background. The shapes seem to fall and rise, momentarily steady themselves, only to rise and fall again, implying a state of flux. Malevich noted, 'My new painting does not belong solely to the earth. The earth has been abandoned like a house, it has been decimated.' It is this challenge to the most elemental physical force—gravity—that places Malevich's abstraction on a spiritual plane.

Malevich often returned to the theme of flight, even comparing his journe into abstraction with an aeroplane taking off: 'The familiar recedes ever furthe and further into the background.' For the artist, however, manned flight was driven not so much by practical aims as by emotion—the thrill of speed itself. He even envisaged a blending of human and machine as a natural extension of the unification of humanity, which he was confident would come about. **LM**

1 WHITE BACKGROUND

Malevich leaves the background spatially ambiguous. He shows movement within a void of white, which he declared to be 'the true real colour of infinity'. Neutral backgrounds were common in early art forms, such as wall painting, and came back into popular use in 20th-century modern art.

2 LIMITED PALETTE

Malevich reduces his palette to the three primary colours plus black and white. These colours offer dark, light and mid tones. He uses black and white to establish the core image, then adds red, yellow and blue to accent it and bend it in space. The mid tones make the contrasts less stark, while the chromatic value of the red pushes the yellow back into the picture. The use of white allows the artist to emphasize the colours and edges of the geometric shapes.

3 USE OF FORM

This detail shows how colour and form can be used to orchestrate relationships. It illustrates the degree to which the picture asks the viewer to consider a world made from pure colour and geometry. The artist dispenses with realism in order to force the viewer to concentrate on the bigger picture. He chooses geometric shapes because he believes that depicting the sensation of flight using pure form is more realistic than painting a representation of an aeroplane.

4 PORTRAYAL OF MOVEMENT

Although this image is composed within a grid, there is a sense of movement that is achieved by flipping the angles between the component parts. Malevich portrays movement through the proximity and irregularity of shapes in pictorial space. He places them on a diagonal axis to create a sense of tension.

1878–1903

Malevich was born in the Ukraine but in 1896 his family moved to Kursk in Russia, where he worked for the local railway company. He started painting at the age of twelve and from 1895 to 1896 he attended the Kiev School of Art.

1904–14

He studied in Moscow, first at the Stroganov School and later at the Moscow School of Painting, Sculpture and Architecture. He was influenced by Natalia Goncharova and Mikhail Larionov. Through contact with Cubist (see p.388) and Futurist (see p.396) art, his work moved towards total non-representation.

1915–16

Malevich exhibited his first Suprematist works and published his essay *From Cubism and Futurism to Separatism*. He joined a cooperative and worked with other Suprematist artists.

1917–26

In the first days of the Russian Revolution, Malevich was appointed Commissar for the Preservation of Monuments and Antiquities. In 1919 he exhibited his *White on White* series at Moscow's 'Non-objective Creation and Suprematism'. He gave up painting for three-dimensional architectural studies.

1927–35

Malevich returned to representational painting, producing portraits, landscapes and figurative works, often of peasants.

BLACK SQUARE: ZERO FORM

Painted in a uniform black tone, *Black Square* (1915; below) was the first of Malevich's four variations on this theme. It revolutionized art by taking abstraction to its ultimate geometric simplification and demonstrated that a painting could exist unaided by any reference to a specific external reality. The artist's choice of a dense black gives the picture a quasi-mystical aura; when it was first exhibited at '0.10: The Last Futurist Exhibition' it was positioned tilting downwards in the corner opposite the entrance to the show, exactly where a Russian religious icon would be placed in a home or inn. Such a display was not by chance: Malevich said, 'The corner symbolizes that there is no other path to perfection except for the path into the corner.' Malevich died of cancer in 1935 and, fittingly, a black square was exhibited above his deathbed. It

was one of the few paintings that was retained by his heirs. In true Suprematist style, Malevich designed his own coffin, and a stone cube with a black square marked the spot where his ashes were buried.

Illustration for 'Pro eto' (About This) 1923
ALEXANDER RODCHENKO 1891 – 1956

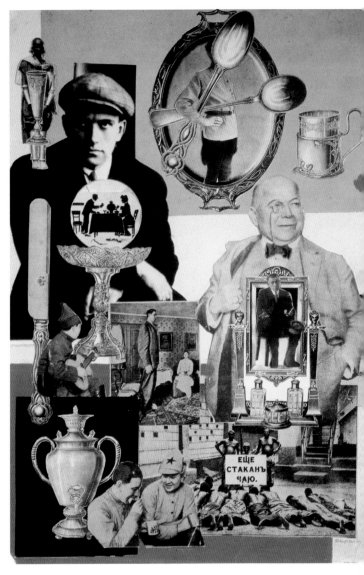

photocollage on cardboard
16 ³/₄ x 12 ³/₄ in. / 42.5 x 32.5 cm
State Mayakovsky Museum,
Moscow, Russia

⬖ NAVIGATOR

Alexander Rodchenko was a foremost practitioner of both Constructivism and Productivism, in which art was applied to utilitarian design. He was a pioneer of photomontage, which he used to produce Communist propaganda in the form of posters, books and journals, often with the aid of his friend, poet and playwright Vladimir Mayakovsky. The work (above) is unusual in that it is not a piece of propaganda but one of a series of photomontages he produced to accompany a poem written in 1923 by Mayakovsky. Entitled 'Pro eto: Ei i mne' (About This: To Her and To Me), the poem concerned the poet's relationship with his lover—a married woman, Lilya Brik—from whom he had been separated for a few months. Rodchenko's witty use of imagery refers to the unusual nature of the couple's affair, Mayakovsky's yearning for Brik and the poet's hopes for the future of the Communist state. **LM**

◉ FOCAL POINTS

1 PHOTOMONTAGE AND TEXT

Underneath each page of illustration there is a line of verse. Rodchenko selected images of the home to go with the line, 'And the century stands/as it was/Unwhipped/ domesticity's mare won't move'. Mayakovsky's work was the first ever to be illustrated with photomontage.

2 THE CAPITALIST

The plump capitalist with a monocle and bow tie has an air of self-importance. The image contrasts with that of the Red Army soldier playing a guitar. Mayakovsky and Brik supported the Bolsheviks, and Rodchenko is emphasizing that their relationship cannot be separated from their politics.

3 DOCUMENTARY PORTRAIT

In a groundbreaking move, all eleven photomontages in the book include photographs of Mayakovsky and Brik in various settings—encircled by zoo animals, perched on buildings and, as in this case, surrounded by the trappings of a wealthy bourgeois home. All of these add a sense of documentary.

4 FOUND IMAGE

The artist cut most of his images from magazines. Here a group of semi-naked men lie flat in front of a placard to which Rodchenko has added the words 'one more cup of tea' to suggest they are not part of a Communist utopia, in which work is seen as the highest good.

5 VISUAL SATIRE

The lovers were in a *ménage à trois* with Brik's husband, and the photomontage hints at the imbalances Rodchenko witnessed within their unconventional relationship. The amusing image of a very tall man dwarfing a petite woman acts as a visual commentary on the love poem.

⏱ ARTIST PROFILE

1891–1910

Rodchenko was born in St Petersburg to a working-class family and moved to Kazan in 1909 after his father died.

1911–16

He attended the Kazan School of Art and after graduating went to Moscow to study architecture and sculpture. In 1914 he was conscripted into the army as a medical orderly. In 1916 he became an assistant to artist Vladimir Tatlin.

1917–21

He started experimenting with abstraction and produced a series of stark paintings of lines and circles utilizing a compass and ruler. He also made 'Spatial Constructions'—free-hanging, geometric sculptures cut out of card or plywood.

1922–29

Rodchenko began to do illustrative work for books, magazines, product packaging and posters, and experimented with photomontage. He also designed furniture and theatrical scenery and costumes. He became involved in the Soviet film industry and from 1924 studied photography at the Moscow Institute for the Graphic Arts.

1930–56

He switched to concentrate on photography, pioneering unconventional camera angles. Rodchenko returned to painting in the 1930s and gave up photography in 1942.

A REVOLUTIONARY MUSE

Brik was Mayakovsky's lover but she became a muse for both him and Rodchenko. Her good looks and revolutionary spirit led Rodchenko to use her image in his photomontages for posters, pamphlets and publications, creating some of the most memorable images in Soviet art. His most famous portrait of her appears in a poster he designed in 1924, which shows Brik cupping her hand to her mouth and shouting, 'BOOKS' (below). The poster has become one of the most imitated images of the era, and was adapted by the pop group Franz Ferdinand for the cover of their album *You Could Have It So Much Better* (2005). The group's appropriation of the image is indicative of Rodchenko's huge and enduring influence on graphic design, illustration and typography.

DE STIJL

1 *Tableau 1, with Red, Black, Blue and Yellow,* 1921
Piet Mondrian • oil on canvas
40 ¹/₂ x 39 ³/₈ in. / 103 x 100 cm
Gemeentemuseum den Haag, Netherlands
© 2010 Mondrian/Holtzman Trust
c/o HCR International Virginia

2 *Composition* (1918)
Bart van der Leck • oil on canvas
29 ¹/₈ x 24 ³/₄ in. / 74 x 63 cm
Tate Collection, London, UK

3 *Interrelation of Volumes* (1919)
Georges Vantongerloo • sandstone
8 ⁷/₈ x 5 ¹/₂ x 5 ¹/₂ in. / 22.5 x 14 x 14 cm
Tate Collection, London, UK

The group De Stijl (The Style) formed with the publication of *De Stijl* journal in the Netherlands in 1917. The journal expressed the theories of multi-faceted artist and poet Theo van Doesburg (1883–1931) and painter Piet Mondrian (1872–1944) who were seeking to create a forum for architects, designers and painters sharing an abstract aesthetic. This common sensibility derived from a number of sources, including the Modernist architecture of Frank Lloyd Wright (1867–1959), whose designs were shown in a touring exhibition in 1910, and the flat, coloured planes and thin black lines of decorative stained glass. De Stijl also incorporated ideas from philosophical and utopian socialist writings and the contemporary trend towards non-representational painting. It was a very loose grouping of artists; Mondrian and Dutch architect and furniture designer Gerrit Rietveld (1888–1964) never met.

The term 'Neo-Plasticism' is inseparable from De Stijl. It defined the group's approach, in which the palette was confined to the three primary colours plus black, white and grey, and compositional elements were restricted to horizontal and vertical lines and rectangular planes. Furthermore, balance and harmony—the essence of De Stijl design—should not have recourse to symmetry. These

KEY EVENTS

1917	c. 1917	1917	1918	1919	1919
Van Doesburg and Mondrian publish the first issue of *De Stijl* in the Netherlands. The journal publicizes their theories of Neo-Plasticism.	Van Doesburg paints *Composition (The Cow)* in gouache, oil and charcoal on paper, reducing its form to pure abstraction.	Rietveld designs his *Red and Blue Chair,* one of the first three-dimensional applications of De Stijl principles; he joins the group in 1919.	Van der Leck leaves De Stijl group. He is supported by private commissions and seldom exhibits; he goes on to work as an interior designer.	Mondrian, who had been forced to remain in the Netherlands by the outbreak of World War I, returns to Paris, to which he had first moved in 1911.	Van Doesburg and Rietveld decorate and furnish a room in De Stijl manner for their Dutch patron Bartholomeus de Ligt (1883–1938).

ules were not always strictly adhered to, but the compositional elements
defined a style that continued after Mondrian's secession from the group
in 1923. Neo-Plasticism was also promoted by the 'Cercle et carré' (Circle
and Square) association of artists, which was founded in France in 1929
and organized an exhibition of artists in 1930 at Galerie 23 in Paris.
Represented there were Mondrian, Wassily Kandinsky (1866–1944), the
architect Le Corbusier (1887–1965), members of the Bauhaus (see p.414)
and many other artists.

The three major painters in De Stijl—van Doesburg, Mondrian and Bart
van der Leck (1876–1958)—arrived at their collective abstract style having spent
several years depicting the natural world under the influence of Impressionism
(see p.316) and Fauvism (see p.370). De Stijl path to abstraction began with
the natural form, which artists then reduced. For example, van Doesburg
simplified the form of a cow through a series of sketches to achieve an abstract
image of a cow made up of various geometric shapes. Van Doesburg
introduced the use of diagonal lines for their dynamic effect, as in *Counter-
Composition of Dissonances, XVI* (1925; see p.408), and quarrelled with
Mondrian, who preferred to use only vertical and horizontal lines. After van
der Leck met van Doesburg and Mondrian, his paintings, such as *Composition*
(right, above), became completely abstract, although he soon returned to the
inclusion of figurative elements.

De Stijl paintings between 1917 and 1919 are often so similar that it can
be difficult to distinguish an individual artist's hand. However, it is Mondrian's
precise, sometimes austere, but harmonious canvases, such as *Tableau 1, with
Red, Black, Blue and Yellow* (opposite) that typify De Stijl, and he continued to
pursue the style after the group disbanded. The profundity in his work is
achieved with a deceptive sparsity: by intersecting vertical and horizontal lines,
and areas of a single colour, he invites the viewer to explore.

The tendency to incorporate the viewer is seen in De Stijl architecture
and interior design, for the group had the expressed intention of removing
the mystique from art. De Stijl applied the same design rules to the inside and
outside of a building. This coincided with the group's desire to create a society
in which the individual (or home interior) harmonized with the communal
(or building exterior). As early as 1917 Rietveld applied these design tenets
to making furniture and children's toys and many of his pieces have a
contemporary feel almost a century later. His crate furniture dating from 1934
is considered to be the earliest example of a product designed for assembly
by the purchaser.

Painter, sculptor and architect Georges Vantongerloo (1886–1965) joined
the group at its inception and once stated: 'There is no need to express art in
terms of nature. It can perfectly well be expressed in terms of geometry and
the exact sciences.' His sandstone sculpture *Interrelation of Volumes* (right) has
an architectural feel, as if he had stepped forward in time and realized a three-
dimensional version of Neo-Plasticism, while simultaneously constructing
forms reminiscent of a much earlier civilization. **LM**

1920–21	1922	1923	1925	1931	1932
Van Doesburg works with Dutch architect Cornelis de Boer (1881–1966), producing colour schemes for housing in Drachten in the Netherlands.	At his studio in Weimar, Germany, van Doesburg delivers a course on De Stijl architecture to Bauhaus (see p.414) school students.	The influential 'Les Architectes du groupe De Stijl' (The Architects of De Stijl Group) exhibition is held at the Galerie de l'Effort Moderne in Paris.	De Stijl is denied its own pavilion at the 'Exposition Internationale des Arts Décoratifs et Industriels Moderne' in Paris.	Van Doesburg dies in Switzerland. With their principal organizer deceased, the remaining members of the group disband.	The journal *De Stijl* ceases publication after architect and furniture designer Robert van 't Hoff (1887–1979) finances the final issue.

Counter-Composition of Dissonances, XVI 1925

THEO VAN DOESBURG 1883 – 1931

oil on canvas
39 ³/₈ x 70 ⁷/₈ in. / 100 x 180 cm
Gemeentemuseum, The Hague,
Netherlands

 NAVIGATOR

Painter, writer, typographer, designer and architect Theo van Doesburg was the organizer and leading theorist behind De Stijl movement and edited its magazine. Eager to embrace a wide range of activities, he was well known among Europe's avant-garde and was also involved with the Dada (see p.410), Bauhaus (see p.414), Concrete art and Abstraction-Création movements.

He and Piet Mondrian influenced each other, creating abstract paintings using a limited colour palette in blocks crossed by vertical and horizontal lines. However, from 1924, van Doesburg began using diagonal lines in his work, maintaining that a diagonal grid pattern creates a dynamic tension between the rectilinear format of a canvas and its composition. *Counter-Composition of Dissonances, XVI* is one of a series of works painted in this style. For him, this innovation freed him from the earth-bound verticals and horizontals used by De Stijl. He called this new phase of De Stijl 'Elementarism', publishing its manifesto in 1926. Van Doesburg's change in approach caused a temporary rift with Mondrian, who felt his colleague was not adhering to the tenets of Neo-Plasticism. Mondrian left De Stijl as a result. **CK**

1 CUT-OFF EDGES

Many of the square and rectangular shapes appear incomplete; the forms appear to be cut off by the boundaries of the canvas. This lack of visual cohesion is deliberate as the artist wants the viewer to participate and resolve the tension created by the visual anomaly, which seems contrary to expectations of space. The viewer's eye naturally travels past the edge of the canvas to complete the image, arriving in the real world, thus extending the work's spatial area.

2 BLACK LINES

Van Doesburg received his first commission to create a stained glass window in 1916. He used the same technique of combining heavy black outlines and coloured planes in both his paintings and stained glass projects. They combined his interests in abstraction, colour theory and architecture.

3 DIAGONAL AXIS

De Stijl artists used geometry and mathematical formulae to create cohesion in their work. A black line sweeps across the canvas from the top right to bottom left to form a diagonal axis and bisect the painting. Van Doesburg believed that diagonal lines and inclined forms created dynamic tension.

4 YELLOW RECTANGLE

The single yellow rectangle appears out of place in the context of the restricted colour palette used by the artist. De Stijl artists, influenced by contemporary classical music and jazz, used colour contrasts to create visual equivalents of the dissonant notes or chords that they had heard. They were also inspired by geometric shapes and sought to create works that spurned the use of symbolism and the representation of natural, organic forms.

⏱ ARTIST PROFILE

1883–1916

Van Doesburg was born Christian Emil Marie Küpper in Utrecht. He had his first exhibition in 1908 at The Hague. Van Doesburg went on to write poetry and art criticism. From 1914 to 1916 he served in the Dutch army, after which he began a collaboration with a number of architects.

1917–25

He co-founded De Stijl group and periodical. From 1922 he taught at the Weimar Bauhaus and was involved with the Dadaists. He had a solo show at Weimar's Landesmuseum in 1924; the same year he published *Principles of Neo-Plastic Art*.

1926–31

His manifesto promoting the diagonal, *Elementarism*, was released. In 1929 he published the first issue of *Concrete Art* for the Paris-based group of the same name and began to focus on architecture. He died in Davos, Switzerland.

DADA

1 *L'Oeil Cacodylate* (1921)
Francis Picabia • oil and photocollage
on cloth
58 ¹/₂ x 46 ¹/₂ in. / 148.5 x 117.5 cm
Musée National d'Art Moderne,
Centre Pompidou, Paris, France

2 Photograph of Hugo Ball performing
the sound poem 'Elephant Caravan'
at the Cabaret Voltaire in 1916

3 Replica of Marcel Duchamp's
Fountain (1951)

There is a dualism at the core of Dada, the cultural phenomenon that
erupted between 1916 and 1922, because it encompassed both a deeply
destructive urge and a seemingly limitless, playful inventiveness. Dada
artists vigorously challenged previously held notions of artistic merit: they
belittled the traditional emphasis placed on painterly aesthetics, expressiveness
and the sanctity of the work of art itself. Instead, they promoted the non-
aesthetic, the illogical, the self-contradictory and the throwaway. The Dadaist
ideal originated in Zurich and New York almost simultaneously, thus developing
two closely related but distinctive strands before spreading to other artistic
centres across Europe. Among those cities where it was most enthusiastically
embraced were Berlin, Hanover, Cologne and Paris.

KEY EVENTS

1914	1915	1916	1917	1918	1919
World War I breaks out. It drives pacifist artists such as Picabia and Duchamp to go to the United States.	Romanian author and performer Tristan Tzara (1896–1963) edits the journal *Chemarea* (The Call). Its content prefigures that of the Dada aesthetic.	Ball, Tzara, Jean Arp (1886–1966) and Marcel Janco (1895–1984) open Cabaret Voltaire in Zurich and stage the first Dada performance.	Picabia founds the Dadaist magazine *391* in Barcelona. Huelsenbeck founds Super-Dada in Berlin.	Tzara writes his *Dada Manifesto*. Hausmann experiments making photomontages and assemblages. World War I ends; Germany becomes a republic.	Picabia launches Dada in Paris. Max Ernst (1891–1976), Johannes Baargeld (1892–1927) and Arp co-found a Dada group in Cologne.

Although Dada borrowed from previous art movements by developing Cubist (see p.388) collage techniques and adopting Futurism's (see p.396) flair for self-publicity, it was critical of the role that art had played in the run-up to World War I. It pilloried the notion of the spiritual rebirth that some Expressionist artists hoped war would bring and the Futurists' excitement at the prospect of mechanized warfare. Dadaists felt art had betrayed humanity, and it was this essentially anti-art stance that made Dada so dynamic.

World War I saw many artists go into exile. German writer and performer Hugo Ball (1886–1927) went to Switzerland and in May 1916 he and a group of other expatriate artists opened the Cabaret Voltaire nightclub in Zurich. This club became the stage for the first Dada performance. Ball was joined by his friend German poet Richard Huelsenbeck (1892–1974) and it was while trying to find a name for one of their cabaret acts that they stumbled on the word dada—French for 'hobby horse'—and used it to name the movement. They became known for their loud, provocative performances: in 1916 Ball appeared on stage wearing a shiny metallic suit and a conical hat (right) to announce a new poetic genre, 'sound poems', which consisted of syllables and sounds. His 'Elephant Caravan' comprised a stream of sounds recited to an African drumbeat. The promotion of nonsense over sense was the Dadaist way of undermining the belief that society could use logic and science to resolve any problem.

In 1917, Huelsenbeck moved to Berlin and founded a more aggressive form of Dada, Super-Dada. Within a year, insurrectionary Berlin had become the centre of Dada and developed its own distinctive style. Artists such as Hannah Höch (1889–1978), Raoul Hausmann (1886–1971) and George Grosz (1893–1959) pioneered photomontage, cutting up magazine and newspaper photographs to create absurd, satirical collages such as Höch's *Cut with the Kitchen Knife through the Last Weimar Beer-Belly Cultural Epoch in Germany* (1919–20). The artists aimed to create a new reality, socially and artistically; some created assemblages using found objects which were fixed to boards or canvas and sometimes painted. The prime exponent of this kind of assemblage was Kurt Schwitters (1887–1948), a Dada pioneer working in Hanover from 1919. He called his assemblages 'Merz', after one of his collages titled *Das Merzbild* to which he fixed a paper strip upon which was written 'Kommerz und Privatbank'.

Dada spread to New York through Frenchmen Marcel Duchamp (1887–1968) and Francis Picabia (1879–1953), who moved there in 1915. They met Man Ray (1890–1976) and together began to make work that questioned attitudes to the artistic process, such as Picabia's *L'Oeil Cacodylate* (opposite), made from greetings and friends' signatures. Duchamp pushed the iconoclasm of Dada to its extreme with his 'ready-mades'—industrially manufactured functional objects that he displayed with little or no alteration. The most famous is *Fountain* (replica, right), an upturned urinal on a plinth signed 'R. Mutt', a firm of sanitary engineers. He entered it for a show held by the Society of Independent Artists in New York, where it was placed behind a screen. European Dada questioned the purpose and cultural value of art; Duchamp questioned what constituted an artwork and—in a materialistic society—undermined notions of material value. **LM**

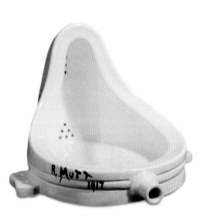

c. 1919	1920	1921	1922	1923	1924
Hausmann creates his photomontage *The Art Critic* (see p.412), in which he implies that journalists' opinions can be swayed by cash.	Berlin hosts 'Erste Internationale Dada-Messe' (The First International Dada Fair).	French poet André Breton (1896–1966) abandons Dada after disagreeing with Tzara. Man Ray makes his readymade, *Gift*, out of an iron and nails.	Tzara delivers his *Lecture on Dada*: 'Like everything in life, Dada is useless.'	Schwitters publishes his periodical *Merz*. Grosz's *Ecce Homo* is published; he is charged with defaming public morals and fined.	Breton launches *The Surrealist Manifesto*; both non-conformist and absurd, Surrealism (see p.426) is considered the natural successor to Dada.

The Art Critic *c.* 1919
RAOUL HAUSMANN 1886 – 1971

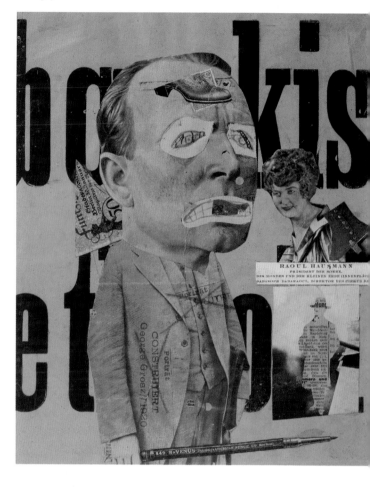

lithograph and photocollage on paper
12 ¹/₂ x 10 in. / 32 x 25.5 cm
Tate Collection, London, UK

✴ NAVIGATOR

Dada in Berlin associated itself with the workers' movement and its political struggles. Painter Raoul Hausmann was a core member of the group and was known in Dada circles as the 'Dadasopher' because of his theoretical writings. He also edited the Dadaist journal *Der Dada* (1919–20), which adopted a left-wing political agenda. Unconventional in both its design and typography, *Der Dada* was filled with articles, poems, photomontages, satirical cartoons, faked photographs and nonsense words scattered at random. Hausmann began to create satirical photomontages in 1918 as a protest against the conventions and values of a bourgeois society. He used everyday materials, such as photographs and newspaper cuttings, and radical typography to create works that addressed contemporary political events and at the same time challenged the more traditional representational style of the Expressionists (see p.378). In *The Art Critic*, Hausmann lampoons journalists whose opinions about art could be purchased—or at least influenced—with cash, as evidenced by the positioning of a fragment of a German banknote behind the neck of the critic. By scrawling several black lines over the critic's eyes, symbolically obscuring his vision, Hausmann also indicates that the judgement of the art critic—like that of all establishment figures—is in any case impaired. **LM**

👁 FOCAL POINTS

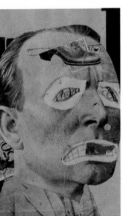

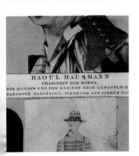

1 ANTI-ESTABLISHMENT CRITIQUE

A neatly folded German fifty-mark note is tucked into the critic's collar, implying that the critic's opinion, even if it cannot be bought directly, can certainly be swayed or influenced by contact with money. The critic's natty three-piece suit also implies that he is more interested in capitalist materialism than art. Hausmann's photomontage is a blistering critique of the art establishment, which was frequently attacked by the Dadaists.

2 IRONIC PORTRAITURE

The art critic is identified by a rubber stamp as being German artist George Grosz, although the image is likely to be of an anonymous figure cut from a magazine. The mouth and eyes are covered in child-like drawings, the eyes are blinded, the tongue curls towards a society lady on the right, and the cheeks are reddened to suggest the critic's judgement may be impaired by drink, ironically implying that the critic is still a German chauvinist at heart.

3 SELF-REFERENTIAL

Kaiser Wilhelm II's abdication in 1918 saw the political classes jockey for power, and Dadaists ridiculed their ambition. The often self-referential Hausmann included his visiting card, which described him as 'President of the Sun, the Moon, and the Little Earth (inner surface)'.

4 USE OF TYPOGRAPHY

The silhouette of a man filled with newsprint contains the word 'Merz' in bold. It alludes to Kurt Schwitters and his 'Merz' collages, and to the fact that his membership of Berlin's Club Dada was rejected because he also painted landscapes and was therefore deemed to be bourgeois.

🕐 ARTIST PROFILE

1886–1913

Hausmann was born in Vienna, but moved to Berlin in 1901 with his family. From 1905 to 1911 he studied at a private art school. From 1912 he started to produce Expressionist paintings and write articles against the art establishment.

1914–18

When war broke out, as an Austrian in Germany Hausmann avoided the draft. He met Höch in 1915 and, although he was married, they had an affair for seven years. In 1918 he founded Berlin's Dada Club with architect and artist Johannes Baader (1875–1955) and writer Richard Huelsenbeck. He began to experiment making photomontages and assemblages, and also writing sound poems.

1919–32

Hausmann contributed to the group's first show in 1919. The same year he edited the first edition of *Der Dada* magazine. He helped organize the 'Erste Internationale Dada-Messe' (1920). When Dada fell out of favour in the 1920s, he took up photography, producing portraits, nudes and landscapes.

1933–71

He moved to Ibiza in Spain and then Czechoslovakia to escape Nazi persecution. During World War II he lived in France. When there was a revival of interest in Dada in the 1950s, he corresponded with contemporary artists about its relevance.

BERLIN'S DADA ART FAIR

In 1920 the Dadaists organized the 'Erste Internationale Dada-Messe' (First International Dada Fair) as a parody of commercial art fairs. It took place in the gallery of Berlin art dealer Dr Otto Burchard (1892–1965) and its catalogue cover (below) was designed by John Heartfield (1891–1968). In all, some 174 pieces of work were displayed in two rooms. Suspended from the centre of one of the rooms was Rudolf Schlichter (1890–1955) and John Heartfield's *Prussian Archangel* (1920), a tailor's dummy dressed in a German officer's uniform with a papier-mâché pig's head. It was a scathing attack on the militarism of the German authorities, which the artists believed led to World War I, and it caused offence. The next year the artists were charged with slandering the military, but the judge accepted that the work was a practical joke and they escaped being sent to prison.

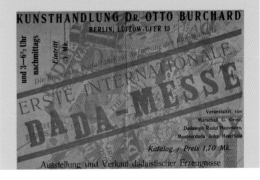

BAUHAUS

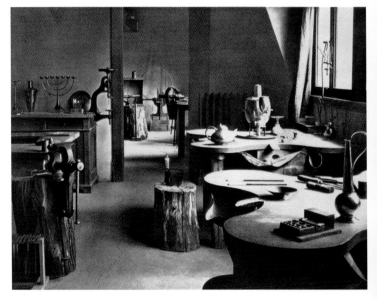

1 **The Bauhaus metal workshop (1923)**
Photograph taken while the Bauhaus
school was still in its original location
in Weimar, Germany.

2 **Folding armchair model no. B4 (1927)**
Marcel Breuer • chrome-plated tubular
steel and Eisengarn fabric
27 ⁷/₈ x 30 ⁷/₈ x 25 in. / 71 x 78.5 x 63.5 cm
Museum of Modern Art, New York, USA

3 **Bauhaus exhibition poster (1923)**
Joost Schmidt • oil on canvas
30 x 18 ³/₄ in. / 76 x 47.5 cm
Bauhaus Archive, Berlin, Germany

The Bauhaus ('build the house') crafts and design school was founded
by the architect Walter Gropius (1883–1969) at Weimar in 1919. Gropius
was a Modernist, believing that the modern world in all its complexity
required a fresh, functional, streamlined aesthetic. Furthermore, in his
manifesto he declared his intention 'to create a new guild of craftsmen without
the class distinctions that raise an arrogant barrier between craftsman and
artist'. During the Bauhaus's fourteen-year history, in which the school survived
political and economic upheavals as well as bouts of internal factionalism,
the school produced some 500 graduates. The staff also created a teaching
programme that permanently revolutionized design training and eventually
led to a host of products being put into manufacture.

Initially Bauhaus teaching reflected a utopian vision of a community
of artisans and artists producing simple, well-made craft products. A leading
teacher was the mystic Johannes Itten (1888–1967), who ran the compulsory
preparatory course. His lessons included 'Analyses of the Paintings of the Old
Masters', 'Drawing after the Nude' and 'Studies of Materials'. Taught in parallel
with these classes were those of Wassily Kandinsky (1866–1944) and Paul Klee
(1879–1940), who had arrived at the school by 1921 to teach colour theory and
analytical drawing. After Itten's course, pupils would enrol in workshops, in
metalwork (above), weaving, theatre/stage, pottery, wall painting, typography
or print. Gropius's first Bauhaus appointment was the painter and engraver
Lyonel Feininger (1871–1956), who taught in the print workshop.

From 1921 to 1922 Theo van Doesburg (1883–1931)—a leading member
of the Dutch De Stijl group (see p.406)—gave a series of guest lectures at the

KEY EVENTS

1919	1920	1921	1922	1923	1923
Gropius produces the Bauhaus manifesto. His work, always Modernist in character, begins to be influenced by Expressionism (see p.378).	Gunta Stölzl (1897–1983) joins the Bauhaus as a student; she is appointed as leader of the school's new women's class in the same year.	Van Doesburg gives his first Bauhaus lecture in a bid to increase the influence of the Dutch De Stijl group (see p.406), of which he is the founder.	Klee arrives as a permanent lecturer at the school and is given two studios where he teaches form in mural painting, stained glass and bookbinding.	Bauhaus adopts the slogan 'Art into Industry', inspired by William Morris's 19th-century Arts and Crafts Movement.	Inspired by the Russian avant-garde, Moholy-Nagy and his wife Lucia introduce experimental photography to the Bauhaus canon.

Bauhaus. Influenced by contemporary Constructivist ideas (see p.400), he criticized the school's emphasis on craft rather than industrial production and his remarks served as a catalyst for change. László Moholy-Nagy (1895–1946) was brought in to replace Itten and the course was divided in two, with Moholy-Nagy emphasizing the technical and theoretical aspects of how materials function, and the artist Josef Albers (1888–1976) involved in practical applications. The stated theme of the school's first exhibition (right, below)—'Art and Technology: A New Unity'—reflected its gradual abandonment of its earlier craft ethos. Moholy-Nagy insisted that his pupils study balance in their design, focusing on the distribution of weight and space as well as colour and texture. This natural balance became a key facet of Bauhaus style.

From 1925 an influential stage workshop was set up, led by the artist and sculptor Oskar Schlemmer (1888–1943), who described it as 'the flower in the buttonhole of Bauhaus'. He had worked on *The Triadic Ballet*, his plotless theatrical production, from 1916 to 1922, and it was finally premiered in 1923. It featured fantastical Bauhaus-made costumes and masks and the music of avant-garde composer Paul Hindemith. Another interdisciplinary production involving several workshops was Kandinsky's production of Modest Mussorgsky's visually suggestive symphonic work, *Pictures at an Exhibition*.

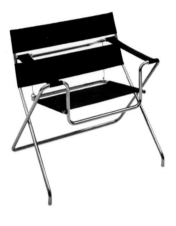

In 1925, after a conservative regional government was elected, pressure grew for the progressive design school to close. The 'Circle of Friends of Bauhaus' was formed to drum up moral and financial support, and both Albert Einstein and Marc Chagall joined it. Within a year the school had moved to an iconic glass and metal school and residential complex in Dessau, designed by Walter Gropius, with Bauhaus workshops providing the lighting and furniture. The Bauhaus was also granted official 'School of Design' status; this meant that it could award diplomas equivalent to those granted by universities. With the move to Dessau came a new focus on the design of modern housing and the appliances and furniture within it.

From 1925 to 1930 the Bauhaus instigated many significant design projects, signing agreements with private companies such as Standard Möbel furniture. Such projects included the Wagenfeld lamp, chairs made of chrome-plated tubular steel and fabric (right, above) by Marcel Breuer (1902–81) and Bauhaus wallpaper, which was used in large public housing projects and became the school's most successful product. In the move towards design for manufacture, the school set up its own trading company—Bauhaus Co. Ltd—in November 1925, turning the typography workshop into a professional graphic design studio under the leadership of Herbert Bayer and Moholy-Nagy.

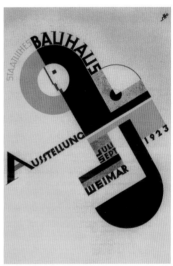

In 1928 Gropius left the school and was replaced by Hannes Meyer who, although popular with the pupils and a successful administrator, was obliged to resign in 1930 because of his left-leaning views. The school was forced to move again and spent its last years in Berlin under the leadership of architect Ludwig Mies van der Rohe (1886–1969), who went on to design the Seagram Building in New York. However, the impossibility for the Bauhaus of conforming to Nazi aesthetics led to its closure in 1933. **LM**

1924	1925	1927	1928	1930	1933
The fall of the Social Democrat-controlled government in Thuringia, Germany, results in reduced funding for the Bauhaus school.	Klee paints his masterpiece *Fish Magic* (see p.416), one of a series of artworks with an underwater theme.	Swiss architect Hannes Meyer (1889–1954) becomes head of the school's architectural programme. He is a Marxist and impatient with aesthetic issues.	Gropius leaves the Bauhaus; Meyer replaces him. His more pragmatic methods lead to the school's first profitable year in 1929.	Meyer resigns. As new director of the Bauhaus, Mies van der Rohe takes its architectural programme in a new direction.	The Nazi Party comes to power in Germany. The Bauhaus is accused of subversion and is closed. Gropius moves to England and others go to the USA.

Fish Magic 1925
PAUL KLEE 1879 – 1940

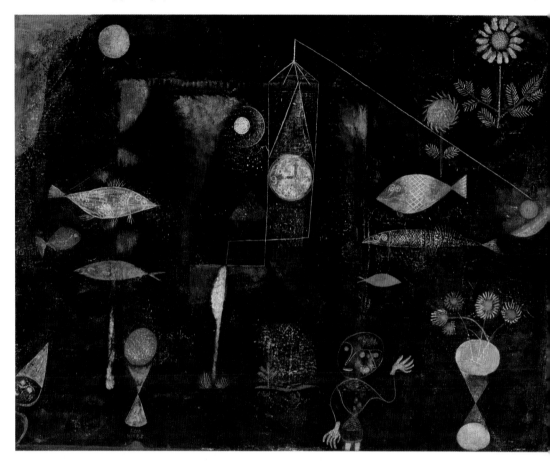

oil on canvas
30 ³/₈ x 38 ³/₄ in. / 77 x 98.5 cm
Philadelphia Museum of Art, USA

☼ NAVIGATOR

Paul Klee had already established a reputation as a highly distinctive and innovative artist when architect Walter Gropius invited him to join the Bauhaus school in 1921. Throughout his career Klee explored the effects of using unconventional combinations of pigments, waxes and varnishes painted over a compound of chalk, beeswax and plaster. He kept extensive notes about his work and his almost 10,000 drawings and paintings can be precisely dated. During the ten years he spent at the Bauhaus school, his lectures and experimental studies amounted to some 3,000 pages. Such regard for detail is combined in Klee with the most extraordinary visual imagination, mastery of colour and perfectly weighted graphic touch. His art conjures fantastical worlds that defy everyday logic but charm and convince the viewer into an amused acceptance of the unreal.

Fish Magic is one of a series of drawings and watercolours in which Klee depicted the world under water. The other paintings of the series portray only fish and other common marine creatures, but here the fish are cohabiting with human figures and artefacts. The picture is partly a meditation on time, with the clock face representing human time and the sun and moon representing the vastly greater celestial time. Pasted into the centre of the painting is an extra square of canvas, individually painted; it has a strong theatrical quality, enhanced by its suggestion of an opened stage curtain. **LM**

👁 FOCAL POINTS

1 PICTURE IN A PICTURE

On close inspection, the viewer can see a square section within the rectangular painting. This appears like a stage within a stage because it too has its own red curtain. However, the inner and outer worlds present no problem for the fish, and they are able to swim between the two without difficulty.

2 THE SUN AND THE MOON

Echoing the shape of the clock face near by, a sun nestles in a crescent moon. Here there is a dual logic: without the light of the sun everything under the waves would be lost in darkness. At the same time, the movements of the sea are strongly influenced by the phases of the moon.

3 CLOCK

At the centre of the picture is a clock whose hands and highlighted numbers read 1925, the year of the painting's execution. Thin white lines surround the dial and describe a simple belfry, but they also stretch up and suggest the form of a fisherman's net—one in which only time is caught.

4 AMBIGUOUS FISH

Klee's golden-red fish has its eyes on one side of its head like a plaice, although it swims in the manner of a goldfish. As a young man, the artist had been transfixed by a visit to an aquarium in Naples and the experience remained with him. Another fish picture, *Golden Fish*, dates from the same year.

5 MAIDEN

Here is a young woman with two faces, suggesting Janus, the Roman god who guarded doorways. She is serious with thin lips and at the same time sensual with full, red lips. In view of Klee's 'stage within a stage' effect within the canvas, the woman may be an actress or performer.

🕐 ARTIST PROFILE

1901–10

In his formative years Klee studied art at the Munich Academy, met and married the pianist Lily Stumpf and had a son, Felix. The artist travelled to Italy to study Renaissance art (see p.150) and the Baroque (see p.212) but felt overwhelmed by the art of the past. In 1910 he secured the first of many solo shows.

1911–20

Klee attended the first Blaue Reiter (Blue Rider) exhibition in Munich and joined the group. He met Robert Delaunay in Paris and translated his influential treatise, 'Light', into German in 1913. His sense of colour was awakened by a trip to Tunisia the following year. He was achieving growing recognition.

1921–30

He joined the Bauhaus school and gave classes on composition and colour theory. In 1923 Klee met the artists Kurt Schwitters and El Lissitzky. He exhibited two paintings alongside the Surrealists (see p.426) in a show in Paris in 1925.

1931–40

Klee joined the prestigious Düsseldorf Academy but, with the ascendancy of the Nazis, was dismissed as a 'degenerate artist'. He moved to Switzerland. In 1936 Klee was diagnosed with scleroderma, an incurable disease. He continued to paint, despite his illness, and produced many significant works until his death in 1940.

KLEE AND KANDINSKY

Klee enjoyed a long friendship with fellow Bauhaus teacher Wassily Kandinsky. Both had taken unconventional routes to become artists—Klee was a skilled musician capable of playing violin with Bern's City Orchestra, and Kandinsky was a trained academic lawyer. The pair first met in 1911 in Berlin, where Klee was soon to join and exhibit with the Blaue Reiter group. After World War I (as a foreign national Kandinsky had returned to Russia) their paths crossed again at the Bauhaus, where both artists developed theoretical evaluations of form and colour. In 1924 they formed Die Blauen Vier (The Blue Four) with Lyonel Feininger and Alexei von Jawlensky. When the Bauhaus school moved to Dessau, the Klees shared a Bauhaus-designed house (below) with Kandinsky and his wife Nina.

Composition–assemblage–photogram 1926
LÁSZLÓ MOHOLY-NAGY 1895 – 1946

photomontage
39 ³/₈ x 28 ¹/₂ in. / 100 x 72.5 cm
Stichting Gemeentemuseum, The Hague,
Netherlands

⚙ NAVIGATOR

In 1920, László Moholy-Nagy moved from Vienna to Berlin, where he discovered Dada's (see p.410) virulent photomontages, Suprematism's (see p.400) solid forms and Constructivism's architectural approach to composition. Inspired, Moholy-Nagy began experimenting with photography in 1921, creating extraordinary ghost-like images by placing objects on light-sensitive paper or photographic plates, then exposing them to a light source. He described his discovery—the 'photogram'—as 'photography without camera'. A Bauhaus professor, Moholy-Nagy made photographic studies that mirrored his earlier Constructivist paintings, in which translucent geometric forms are superimposed on each other to create an intense illusion of depth.

The Constructivist-inspired work seen here reflects his aim to make 'light paintings' with photograms. In 1926, when the Bauhaus moved to Dessau, he set up his first real darkroom studio, where he could manipulate light effects and so increase pictorial complexity. He sought to create a new visual literature, declaring 'The illiterate of the future will be ignorant of the pen and the camera alike.' **LM**

FOCAL POINTS

1 PICTURE WITHIN A PICTURE

The thin wooden picture frame provides an illusory effect and creates a picture within a picture, which Moholy-Nagy uses to emphasize the fact that all art is artifice. He also seeks to replicate the visual complexity and multiple viewpoints in contemporary urban life: 'One travels in a tramcar, looks out of the window, behind drives a car, likewise the windows of this car are transparent. Through them one sees a shop, which in turn has a transparent window.'

2 LINE OF LIGHT

Moholy-Nagy plays with the spatial, painterly and sculptural potential of light in his photograms. Here, the thin white diagonal line he makes using light connects and frames the elements within the composition. He employs it as a device to construct a three-dimensional space on a flat plane in a technique he called 'glass architecture'. This was a reference to the use of glass in contemporary buildings, representing greater openness and democracy.

3 USE OF COLOUR

The work is predominantly grey, broken only by the brown of the frame and the red of the crayoned circle. By introducing a bright-coloured circle, the artist stresses the constructed nature of the image and the material elements that comprised it, including a strip of metal, wood and perspex.

4 SPECIAL EFFECTS

The artist was fascinated by the seemingly infinite shades of grey he was able to capture. He also experimented with special effects by passing light through fluids such as water, acids and oil, or reflecting light off metal, glass or crystals. Here the reflections create a shimmering shadow effect.

ARTIST PROFILE

1895–1919

Moholy-Nagy was born in Borsod, Hungary and studied law. He served as an artillery officer in World War I and sketched scenes of the trenches; his interest in art deepened after he was injured and hospitalized. After the war, he abandoned his legal studies and attended a free art school in Budapest, where he developed a fluid style of monochrome portraiture.

1920–23

The artist moved to Berlin, where he came into contact with leading avant-garde art movements. He began to depict machines and urban architecture in an increasingly abstract way and became interested in photographic processes.

1924–27

Moholy-Nagy taught at the Bauhaus and took over as head of the preparatory course. He made significant contributions in the fields of metalwork, photography and theatre.

1928–33

He resigned from the Bauhaus and worked as a typographer, curator, film-maker and theatrical designer, producing his influential book *From Material to Architecture* in 1929.

1934–46

Moholy-Nagy left Nazi Germany for Britain, then the USA, where he opened a design school in Chicago, the New Bauhaus, later known as the Institute of Design. He died of leukaemia.

TOTAL THEATRE

Moholy-Nagy devised the concept of the Theatre of Totality, in which the traditional barrier between the stage and audience is removed. Rather than staging conventional works, he aimed to surround the spectators with constantly changing sound and light effects that would give them a sense of participating in the action. In order to help create this experience, he invented the Light–Space Modulator (1922–30; replica below), a mechanically driven rotating kaleidoscope that projected an array of patterns made up of colour, light and shadow. As well as fulfilling the function of a stage-lighting device, it is also a free-standing kinetic sculpture and a seminal example of the machine aesthetic in art. Moholy-Nagy used it to make his short film *Light Play: Black-White-Grey* in 1930.

NEUE SACHLICHKEIT

The term 'Neue Sachlichkeit' (New Objectivity) represents the desire of a growing number of German artists in the early 1920s to take a hard look at the society they lived in, and to depict the reality they saw in an objective and dispassionate way. It was a trend or tendency rather than a coherent movement. Artists, many of whom had been involved in Expressionism (see p.378) and Dada (see p.410), moved away from the idea of a collective creative purpose to rely on their individual analysis and depiction. The term was first used by art historian and director of the Stadtlische Kunsthalle museum in Mannheim, Gustav F. Hartlaub (1884–1963). He used it to describe those artists who had turned away from Modernist trends and towards traditional painterly values that were more associated with the high art of the Northern Renaissance (see p.182). They espoused naturalism in colour, precise contours for objects, intense characterization and non-expressive brushwork, and placed the human figure at the centre of their objective lens.

Neue Sachlichkeit was a reaction to the spiritual utopianism of Expressionism with its belief that the human condition could be bettered from within, and to Dada's political iconoclasm. Both movements were out of step with a Germany that was tired of upheaval and wanting to shed its cares in the Roaring Twenties. Dada had also acquired a fashionable chic and was no longer radical

In 1925 Hartlaub's museum held a major exhibition called 'Die Neue Sachlichkeit: Deutsche Malerei seit dem Expressionismus' (The New Objectivity German Painting Since Expressionism) in which he assembled the work of

KEY EVENTS

1918	1919	1920	1922	1923	1924
Armistice ends World War I, Kaiser Wilhelm II (1859–1941) abdicates and Germany becomes a republic. The war changes many artists' attitude to their work.	The Weimar Republic is founded, based on a new democratic constitution; it marks the beginning of years of dissatisfaction and social discontent.	Right-wingers attempt to overthrow the government in Berlin's Kapp Putsch. The working classes rally and the Weimar Republic survives.	A survey by the art journal *Das Kunstblatt* uncovers an aesthetic shift and describes it as 'a new naturalism'.	Hartlaub solicits contributions for a New Objectivity show. The National Socialists attempt to seize power at the abortive Beer Hall Putsch in Munich.	The government subdues Communist and Nazi insurrection and manages to halt the dangerous cycle of hyperinflation that had damaged the econom

rtists who had 'remained unswervingly faithful or have returned to positive, palpable reality'. It brought together more than 120 paintings from across ermany, representing the work of thirty-two artists. There were two distinct trands to the new art: a 'Verist' (depicting actual reality) left-leaning and ocially critical wing, represented by George Grosz (1893–1959), Otto Dix 891–1969), Rudolf Schlichter (1890–1955) and Georg Scholz (1890–1945); and politically neutral wing, which included Georg Schrimpf (1889–1938), whose ortraits display a melancholia influenced by his study of High Renaissance rt (see p.172), and the precise, chilly eroticism of Christian Schad (1894–1982). nd yet, such divisions were not stringent: Max Beckmann (1884–1950) avoided eing placed in a group, but most of the pictures in Hartlaub's show were his. eckmann moved from the claustrophobic nightmare world that he described n his paintings in the years immediately after World War I towards a gentle nd melancholic symbolism that drew heavily on Greek mythology. He often ainted self-portraits and placed himself at the centre of his haunting painting *efore the Masked Ball* (opposite). He is the only figure in the room who is vearing a mask, one that frames and obscures his eyes like a blindfold, and is ne only figure prepared to look confidently towards the viewer.

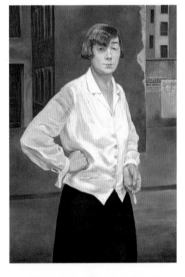

Schlichter's work from 1921 onwards was realistic and he frequently ortrayed the outcasts of society. His *Portrait of Margot* (right) depicts a rostitute, who often modelled for him, standing on a deserted street. The efiant expression on her face and her nonchalant pose, holding a cigarette, re in marked contrast to her seedy surroundings and her professional role, onstituting a challenge from the artist to the prevailing bourgeois mentality. chad had been both an Expressionist and Dada artist, but by 1927 he was ainting friends and acquaintances from Berlin's decadent cabarets and ightclubs with extreme and analytical realism. Schad's precise portraits have o overt political subtext, are self-contained and are removed from any defined ocial context. Yet his work displays a ruthlessly clinical approach to his ersonally experienced reality, as in his *Self-portrait with Model* (right).

The cornerstone of Neue Sachlichkeit, however, is formed by the work of)ix and Grosz. Both artists were accomplished draughtsmen and technical nasters of paint; they made visceral social commentaries on their times by uxtaposing social extremes in the same frame. The characters shown within heir canvases represent the explosive mix of unresolved social contradictions hat was Germany during the Weimar Republic. Works such as Grosz's *The Pillars f Society* (1926; see p.422) and Dix's *Metropolis* (1928; see p.424) hold a mirror o society: they depict prostitutes and their wealthy clients, the elegant doyennes f Berlin society drifting past begging or hobbling war cripples: the winners nd the losers. Grosz's primary motivation for painting was to show his disgust vith the extremes of social division, whereas the driving force behind Dix's vork was his revulsion at the depths to which human beings could sink. **LM**

1925	1926	1928	1929	1930	1933
Aannheim hosts 'The New Objectivity: Serman Painting Since xpressionism'. Adolf Hitler's (1889–1945) Mein Kampf (My truggle) is published.	Grosz produces *The Pillars of Society* (see p.422), which attacks the ruling classes as amoral and responsible for Germany's renewed warmongering spirit.	Dix paints *Metropolis* (see p.424), a vicious critique of his country's treatment of wounded soldiers when they returned home after fighting in World War I.	The Wall Street Crash in October leads to a world economic crisis that causes mass unemployment; the German electorate becomes disillusioned.	The September elections see Hitler's Nationalist Socialist movement gain ground to become the second largest party in the Reichstag.	Hitler comes to power. The new regime condemns avant-garde art and removes a number of paintings from galleries; many artists leave Germany.

The Pillars of Society 1926
GEORGE GROSZ 1893 – 1959

oil on canvas
78 3/4 x 42 1/2 in. / 200 x 108 cm
Staatliche Museen zu Berlin,
Germany

W hen Hitler was made chancellor in Germany in 1933 and George Grosz immediately left to go into exile, the summation of all that he loathed in the psyche of many of his fellow countrymen—militarism, xenophobia and a lust for overbearing might—had finally triumphed: the Nazis had come to power. The Nazis, for their part, had branded Grosz 'Cultural Bolshevist Number One', partly because, after joining the German Communist Party at its inception in 1918, he had been politically militant under the pseudonym 'Propagandada' in the Berlin Dada (see p.410), but mostly because his art had consistently stripped away their mask of legitimacy.

The Pillars of Society is one of Grosz's most persuasive and overtly political paintings. Previously he had focused on the war profiteers and their political allies, as well as those crippled in the fighting. Here, the 'pillars of society' are the deluded and corrupt German opinion-formers who were energetically steering the country into war and civil conflict. Grosz habitually made rapid sketches of the faces and mannerisms of people who interested him, and these provided rich material for his satirical portraits. Behind the 'pillars' he depicts a burning building, with shovel-bearing workers marching to the political left and Nazi soldiers marching to the political right. By the time of this painting, Grosz had achieved a graphic style that had surpassed mere caricature to become satirical portraiture in the tradition of William Hogarth and Francisco de Goya. **LM**

◉ FOCAL POINTS

1 CHURCHMAN

A priest wearing a clown-like and unctuous grin delivers a sermon to his congregation, in which he appears to be giving his blessing to what the 'pillars of society' are about to unleash on Germany. Grosz was appalled that churchmen endorsed a regime that flouted every principle of Christianity.

2 POLITICAL LEADER

Grosz lampoons the Social Democrat leadership, whom he sees as the betrayers and gravediggers of the German social democratic revolution of 1918. He gives the bloated, drunk-looking politician a head full of steaming manure where his brains should be.

3 NATIONALIST

A monocled ultra-nationalist wearing a swastika on his tie stands holding a sabre in one hand and a beer mug in the other. On his face he 'sports' fraternity duelling scars—an emblem of his Prussian youth. A horseman emerges from his head bearing the nationalist flag on his lance.

4 NEWSPAPER MAN

A journalist with the pince-nez of an intellectual carries a bloody palm frond, a pen and newspapers. The viewer is left in no doubt as to Grosz's low opinion of establishment journalists—Grosz gives him an upturned chamber pot, redolent also of a military helmet, for a hat.

◔ ARTIST PROFILE

1909–17
Having studied drawing in Dresden and Berlin, Grosz gained attention for his anti-war satirical work. He famously depicted an army doctor passing a skeleton as 'fit for action'.

1918–24
In the turmoil following World War I, Grosz worked alongside John Heartfield making Dada propaganda posters. A pioneer of photomontage, he adapted the technique to his painting. Grosz used watercolour and pen and ink to savagely attack postwar society. Particularly infamous are his drawings of 1921 titled The Face of the Ruling Class.

1925–32
Grosz took up oil painting and contributed to the Neue Sachlichkeit tendency. His subject matter thus reflected the fierce political polarization in German society.

1933–59
Grosz left Germany in 1933, settled in the USA and taught at the Art Students League of New York. He returned to Germany in 1959, the year of his death, feeling that his American dream had been 'a bubble'.

Metropolis 1928
OTTO DIX 1891 – 1969

tempera on wood
71 ¹/₄ x 158 ⁵/₈ in. / 181 x 403 cm
Kunstmuseum, Stuttgart, Germany

Otto Dix trained at Dresden's Hochschule für Bildende Künste (Academy of Fine Arts) where he developed a natural compositional talent and acquired a thorough knowledge of paint and graphic technique. In the mid 1920s, he began to paint in tempera (pigment mixed with egg yolk), which he would then cover with layers of semi-transparent mastic glaze. Dix used this method to create the shimmering textures and translucent colours that give the triptych *Metropolis* its disturbing, burlesque atmosphere.

In this work, Dix depicts the extreme social divisions within Weimar society. In three separate but interconnected tableaux, the artist vividly illustrates the contrast between the pleasure-seeking and affluent Bright Young Things of the jazz age and those caught up in harsher aspects of the times—impoverishment, prostitution and exclusion. The triptych has a strong theatrical tone—the beggar on the left panel seems to be staring at a brightly lit stage and the strangely sculpted features on the far right resemble fanciful theatrical scenery. This heightens the sense of unreality in the city scenes. Dix also addresses the themes of sexual appetite and physical decay. His women are lascivious, carnal, innocent and repellent all at the same time, and it is this fusion of contradictory qualities that makes *Metropolis* both a political statement and a symbol of the exclusive pursuit of pleasure for its own sake. **LM**

✦ NAVIGATOR

1 BEGGING EX-SOLDIER

An embittered legless beggar in the doorway, perhaps reminded of his better days when he was whole and in uniform, angrily surveys a quasi-military procession of prostitutes as it sashays past. The figure of the beggar is based on Dix himself.

2 JAZZ BAND

An American jazz band plays to a sophisticated, privileged clientele in a Berlin nightspot. Dix modelled the musicians' faces on well-known figures in Dresden society: the tenor saxophonist is Dr Alfred Schulze, a director of the Dresden Academy.

3 LUXURIOUS DETAIL

Dix displays technique and artistry in a rich array of fabrics and textures, such as the redhead's green dress. Another well-realized feature in the central panel is the pink feather fan, which Dix uses to halo the head of the transvestite carrying it.

4 STARK CONTRAST

Prominent in the foreground of the right panel are the modern shoes of a prostitute as she parades in one of Berlin's fashionable streets. Echoing those of the woman dancing drunkenly in the central panel, the shoes jar with the stumps of the war cripple beside her.

SURREALISM

1 A group of Surrealist artists pose
in a photographic set at a fair in
Montmartre, Paris (undated). On the
bicycle in the foreground is Louis Aragon,
and André Breton is at the far right.

2 *Monument to the Birds* (1927)
Max Ernst • oil on canvas
63 ³/₄ x 51 ¹/₈ in. / 162 x 130 cm
Musée Cantini de Marseille,
France

3 *The Soothsayer's Recompense* (1913)
Giorgio de Chirico • oil on canvas
53 ³/₈ x 70 ⁷/₈ in. / 136 x 180 cm
Philadelphia Museum of Art, USA

The Surrealist movement originated in Paris in the early 1920s and
became one of the most significant artistic influences of the century.
Originally a literary style created by a group of French avant-garde poets,
Surrealism has become part of the European cultural mindset, and the word
'surreal' is in common usage. The French word *sur-réalisme*—hence 'surrealism'
(super-reality)—was first used in 1917 by the poet and critic Guillaume
Apollinaire, but it was not until the poets André Breton (1896–1966) and Louis
Aragon (1897–1982) adopted the phrase and gave it a theoretical and practical
meaning that the Surrealist epoch came into being. Breton and his colleagues
(above) believed that the purpose of creativity was to unlock the unconscious
mind. They considered the human race to be naturally preoccupied with three
fundamentals—sex, violence and death—and held that it was impossible for
anyone to act instinctively in Western 'ordered' society.

Breton and his circle published their views in the journal *Littérature*,
alongside articles discussing the significance of Dada (see p.410). From
1920 Dadaists such as Max Ernst (1891–1976) made the French capital their
home. Breton appreciated Dada's spontaneity and iconoclasm but was critical
of its nihilistic, anti-art tendencies. However, he saw collage, a central Dada
technique, as the ideal visual tool for his 'poetic' purposes. He understood
that Dada art also juxtaposed contradictory aspects of reality to make a

KEY EVENTS

1924	1925	1925	1925	1926	1929
Breton launches the Surrealist movement by publishing its first manifesto and the inaugural issue of *The Surrealist Revolution*.	Breton extends the scope of Surrealism from its literary origins by reproducing works from Surrealist artists in issues of *The Surrealist Revolution*.	'La Peinture Surréaliste' (Surrealist Painting) becomes the movement's first exhibition, with works by Miró and Man Ray, among others.	The Paris Surrealist group demonstrates its politics by joining the French Communist Party in support of the Rif uprising against French rule in Morocco.	A new group of Surrealist artists forms in Brussels, including Magritte and Camille Goemans (1900–60), both of whom move to Paris in 1927.	Dalí and Luis Buñuel (1900–83) add to the growing canon of Surrealist cinema with their jointly directed sixteen-minute silent film *Un Chien andalou*.

426 1900 TO 1945

'super-reality'. Ernst produced many collages after he moved to Paris. He also developed the graphic art techniques of *frottage*—using pencil rubbings of objects to create images—and *grattage*—scraping semi-dried paint across canvas to reveal the imprints of objects beneath. He invented extraordinary forms of life in his canvases, which also reflected his fascination with birds, as shown in paintings such as *Monument to the Birds* (right).

In their desire to access new mental states, the Surrealists experimented with hypnosis, drugs and alcohol, séances and trance. They also played rapid-fire word games to reveal hidden associations, and in their 'automatic writing' sessions wrote poems with as little premeditated thought as possible. They also recounted their dreams and collectively analyzed them as they discussed the psychoanalytic writings of Sigmund Freud. André Masson (1896–1987) aligned himself with the Surrealists from 1924 and began to draw in the same 'automatic' way in which the group made poetry. He experimented by randomly throwing glue and then sand on to canvas to make shapes that he would then draw and paint.

The Spanish Catalan artist Joan Miró (1893–1983), who was introduced to the Surrealists by Masson, also incorporated chance elements into his painting. Miró's art is more hallucinatory than 'oneiric' (dream-like). In the early 1920s, he was so poor that he nearly starved, and he experienced visions, which populated his work of that period. His complex landscapes are alive with strange, amoebic or stick-like beings and the bold colours and fantastical forms

1931	1936	1937	1937	1940	1945
Dalí paints *The Persistence of Memory* (see p.430), one of a series of what the artist called his 'hand-painted dream photographs'.	The British Surrealist Group is formed and stages the London International Surrealist Exhibition. Roland Penrose (1900–84) heads its committee.	Picasso paints *Guernica* (see p.434), combining a Cubist structure with Surrealist imagery to depict the bombing.	Magritte paints *On the Threshold of Liberty* (see p.432). It is his second version of the painting; the first smaller version was painted in 1929.	Breton organizes an International Surrealist Exhibition in Mexico City that includes the Mexicans Frida Kahlo (1907–1954) and Diego Rivera (1886–1957).	By the end of World War II, the organized Surrealist movement no longer exists, and the artists are dispersed worldwide by political events.

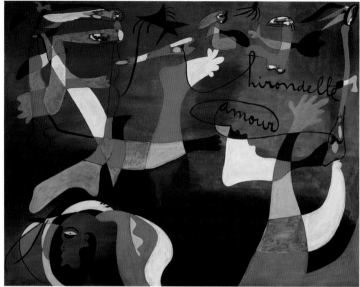

4 *Hirondelle Amour* (1933–34)
Joan Miró • oil on canvas
78 3/8 x 97 5/8 in. / 199 x 248 cm
Museum of Modern Art, New York, USA

5 *You Must Stay* (c. 1927)
Yves Tanguy • oil on canvas
8 7/8 x 6 1/4 in. / 22 x 16 cm
Private collection

6 *Being With* (1946)
Roberto Matta • oil on canvas
87 x 180 in. / 221 x 447 cm
Metropolitan Museum of Art,
New York, USA

of *Hirondelle Amour* (above) are also typical of Miró's style. The work was one of four tapestry cartoons—preparatory paintings or drawings for tapestry—and was produced during a period that marked a return to painting for Miró, who had previously concentrated on collage and works based on Dutch masterpieces. From the early 1920s, Miró's compatriot Pablo Picasso (1881–1973) was drawn to the curved, organic shapes and saturated colours of painters such as Masson and Miró. In his black and white painting *Guernica* (1937; see p.434), Picasso depicts the ugliness and chaos of war in a Surrealist style.

In 1928 Breton published the artistic manifesto *Surrealism and Painting*. In it he argued that, in the present epoch, Surrealism was the only relevant and progressive style; he advised all artists to 'either seek a purely interior model or cease to exist'. Then, in 1930, the journal *The Surrealist Revolution* changed its name to *Surrealism at the Service of the Revolution*, implying that the political agenda would now take precedence over the psychological one. Miró, Masson and Ernst all worked on designs for Sergei Diaghilev's Ballets Russes, an enterprise that drew protest from the Surrealist leadership who questioned artistic engagement with the commercial world. A leaflet handed out at the premiere of Diaghilev's *Romeo and Juliet* in Paris in 1926 stated: 'It is inadmissible that ideas should be at the behest of money'. At about this time Miró and Masson parted company from the Surrealist group.

The new change of emphasis was reflected in the arrival of 'oneiric surrealism', in which artists returned to traditional painting and drawing techniques to depict their dream-like or nightmarish visions. The principal oneiric painters of this period were Salvador Dalí (1904–89), René Magritte (1898–1967) and Yves Tanguy (1900–55), who had all been influenced by the Metaphysical art of Giorgio de Chirico (1888–1978), pioneered between 1913 and 1920. De Chirico's paintings, such as *The Soothsayer's Recompense* (see p.427), contained nostalgia for classical Renaissance sculpture and architecture, but his eerily silent city squares were empty save for a few incongruous and crudely painted objects and faceless, inanimate statues. It was on seeing de Chirico's art in 1922 that Tanguy decided to become a painter, despite his lack of formal training. Tanguy came from Brittany's rocky Finistère peninsula and throughout his career he was fascinated by strange geological

formations. His Surrealist landscapes, such as *You Must Stay* (right), frequently included fantastic anthropomorphic stone structures. Belgian artist Magritte first encountered de Chirico's work in 1923; over several years he evolved a painting style full of pictorial riddles. His painting *The Treachery of Images* (1928–29) showed an ordinary smoker's pipe with the painted caption 'Ceci n'est pas une pipe' (This is not a pipe). It challenged viewers to question their acceptance of realistic images. Magritte believed that the audience should look hard at the reality he depicted in order to unravel some of the hidden riddles they contained.

The Catalan painter Dalí was as enigmatic as the self-contained Magritte but much more flamboyant. Dalí announced his arrival on the art scene with a sensational first solo show in Paris in 1929. His declared aim was 'to systematize confusion and thus help to discredit completely the world of reality'. Dalí was a technically brilliant draughtsman and painter who brought Surrealism to a wider public through his often shocking vision and flagrant courting of publicity. In his paintings Dalí explored both his phobias and his perversities and desires. In 1931 Dalí discussed the idea of Surrealist 'sculpture' in an article for *Surrealism at the Service of the Revolution*. His sculptures were like three-dimensional collages; he took Marcel Duchamp's concept of 'ready-mades', in which ordinary manufactured objects were slightly modified and labelled as art, but then combined two or more unrelated objects. Dalí described his sculptures, such as *Lobster Telephone* (1936), as being 'absolutely useless from the practical and rational point of view' but engendering fantasies 'of a delirious character'. Other artists followed Dalí's example, producing objects that were often strongly sexual and fetishistic.

Surrealism attracted followers throughout Europe and the Americas. The Chilean-born architect Roberto Matta Echaurren (1911–2002), known as Roberto Matta, took up painting when he joined the Surrealists in Paris in 1937. Matta painted 'psychological morphologies'—imaginary landscapes derived from his subjective psychological state. At the onset of World War II, Matta was one of many other European artists who moved to the United States, where their avant-garde ideas influenced young American artists. His huge, mural-like canvas *Being With* (below), a complex composition of architectural structures and human-like figures with limbs at odd angles, marked a shift in his work to what he called 'social morphologies' and reflected the horrors of the times. **LM**

The Persistence of Memory 1931
SALVADOR DALÍ 1904 – 89

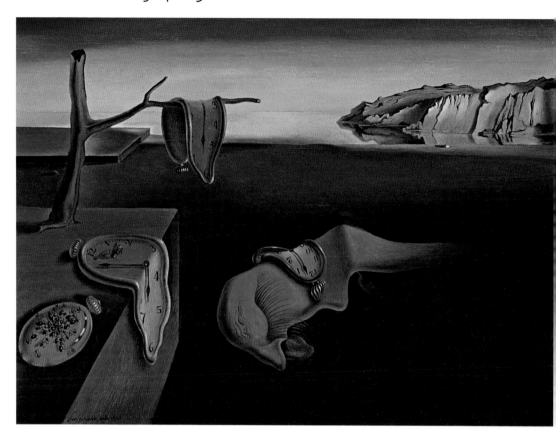

oil on canvas
9 ¹/₂ x 13 in. / 24 x 33 cm
Museum of Modern Art, New York, USA

S alvador Dalí once commented: 'My whole ambition in the pictorial domain is to materialize the images of concrete irrationality with the most imperialist fury of precision.' Essential to his practice, Dalí manufactured in himself states of extreme anxiety and distress—often by scaring himself with the dead bodies of insects and hedgehogs—in which he would try to blur the distinction between his imaginings and reality. This enhanced, paranoid state would unleash his imaginative capacity and he would create images open to multiple interpretations, based on real objects.

In *The Persistence of Memory* he created a self-contained and convincing irrational world—dream-like and still—that is rendered yet more intense by the tiny canvas. The viewer's first impression of this gem-like painting is of a vast and empty scene, but then the eye focuses on the arrangement of objects in the foreground, most notably a number of fob watches in various states of transformation. By suggesting that metal watches and their delicate internal mechanisms can stretch and melt, Dalí challenges our rational understanding of the physical world. He also comments on the nature of time itself. Dalí had been fascinated by Einstein's *General Theory of Relativity*, published in 1920, which describes how time bends under the impact of gravity. It was for him a logical step to ask: 'If time itself bends, why not watches?' Dalí's painting also suggests an older and more familiar theme, the inevitability of death, for although all the watches have stopped at different moments, they all point to the approaching hour; death awaits each of us individually. **LM**

◆ NAVIGATOR

1 MELTING WATCH

The soft watches of Dalí's painting were suggested to him one warm evening after a headache persuaded him not to accompany his wife Gala to the cinema. Sitting with the remains of their meal and contemplating a landscape he was working on, he noticed that a Camembert cheese had melted and begun to spread over the rim of the dish. It was the sight of this cheese that gave Dalí the idea for the melting watches, and within hours the work was completed.

2 BIZARRE CREATURE

The strange figure in the foreground, over which a melting watch is draped like a saddle or blanket, is a caricature of Dalí himself. An almost identical 'portrait' is central to his painting *The Great Masturbator* (1929). The eyelashes suggest an enormous eye closed in a state of contemplation, sleep or death. Dalí is proposing that only by overcoming the limitations imposed by 'earthly' time can consciousness be given free rein.

3 EMPTY COASTLINE

The landscape is the rugged coastline near Dalí's home at Port Lligat, north of Barcelona. Frequently Dalí's brush transformed natural geological features into bizarre animal or human forms, but here the cliffs are represented simply and in 'a transparent and melancholy light'.

4 CRAWLING ANTS

The only living creatures depicted in the composition are the ants crawling over the back of the orange watch and a solitary fly on the 'soft' watch to the right of it. Dalí hated being in the presence of ants and frequently included them in his paintings as a symbol of putrefaction.

1922–26

Dalí attended the Academia de San Fernando in Madrid. His work included experiments with Cubism (see p.388) and Dada (see p.410). In 1926 he was introduced to Pablo Picasso in Paris. Already gaining attention for his bizarre dress sense, he grew his moustache, inspired by that of Diego Velázquez.

1927–34

Dalí began to live with Elena Ivanovna Diakonova, known as Gala, in 1929 and married her in 1934. Also in 1929 he officially joined the Surrealists in Paris. In 1930 he and Gala moved into a small house at Port Lligat. In 1934 the artist was criticized by the Surrealists for his refusal to support left-wing politics. Although he denied that he was a fascist, he was expelled.

1935–48

In 1936 Dalí took part in the London International Surrealist Exhibition. He and Gala moved to the USA in 1940. He quarrelled with Luis Buñuel, blaming his former fellow student's communism and atheism. He left the USA in 1948.

1949–89

Dalí and Gala returned to Catalonia for good, despite the fascist regime of General Franco. His interest in science and mathematics manifested itself increasingly in his paintings. His Catholicism also became more pronounced. Gala died in 1982. Dalí's death in 1989 was due to heart failure.

DALÍ'S FILM PROJECTS

The impact of the 'Surrealist Revolution' went far beyond painting, touching all the arts and cinema in particular. With his compatriot, the avant-garde film director Luis Buñuel, Dalí worked on a number of projects that became the first Surrealist films. Sequences such as the graphic depiction of a young woman's eye being sliced open with a razor in *Un Chien andalou* (1929; below), and the passionate fellation of the toe of a religious statue in *L'Age d'or* (1930), shocked audiences with their overt breaking of taboos and virulent anti-clericalism, and many cinemas banned the films. In the 1940s, when Dalí was living in the USA, he also worked alongside Alfred Hitchcock, creating and designing a nightmarish dream sequence, at times highly reminiscent of his paintings, for the influential film *Spellbound* (1945). Such incongruous juxtapositions have since become common practice.

On the Threshold of Liberty 1937

RENÉ MAGRITTE 1898 – 1967

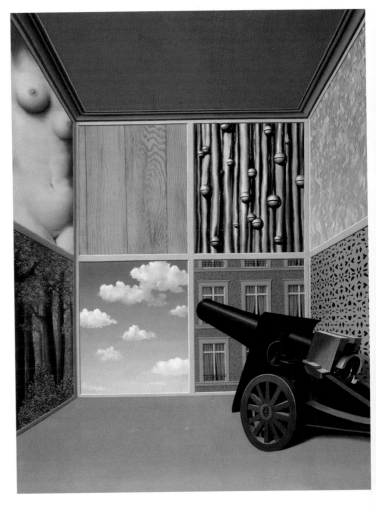

oil on canvas
94 x 73 in. / 239 x 185.5 cm
Museum Boijmans van Beuningen,
Rotterdam, Netherlands

⬡ **NAVIGATOR**

U nlike those of other Surrealist artists, René Magritte's quixotic and naturalistically painted images are not a product of dreams or self-induced psychological states. They spring from his contemplation of the phenomena of everyday life. Magritte believed that conscious thought leads to the idea and the idea is what matters in painting. If a picture's underlying concept is viable, he said, then a reproduction of a picture can serve just as well as the original. This is particularly relevant in the case of *On the Threshold of Liberty* because Magritte produced two versions: a smaller picture from 1929, without the grey ceiling, and this larger version from 1937, which was made to fit the London stairwell of Magritte's patron, the poet and Surrealist collector Edward James. The painting contains a number of motifs essential to the artist's work: the empty spaces and sense of dead calm; the paintings within a painting; and the positioning of objects out of their normal contexts so that they assume a 'super-real' importance. There are eight equally sized wall panels depicting a forest, sky with clouds, house facade, filigree paper cut-out, female torso, wood grain, jingle-bells and fire. All are subjects or designs that Magritte took from his pre-1929 works. **LM**

FOCAL POINTS

1 FEMALE TORSO

Magritte paints this female torso with the suggestive curves, natural flesh tones and contrasts typical of a Renaissance figure. Reduced to a torso, the woman remains anonymous—totally female but totally without a character. The theme of woman as sex object recurs in numerous 20th-century works, including the film *That Obscure Object of Desire* (1977) by Luis Buñuel, himself an early exponent of the cinema of Surrealism.

2 WOOD PANEL

The simulated wood on the back wall is a major motif in his paintings from 1927 to 1930; it echoes the importance of wood grain in the work of fellow Surrealist Max Ernst, whose *frottages* were known to Magritte. Magritte was easily capable of such technical artistry.

3 ARTILLERY WEAPON

The room would be empty but for one object—the heavy artillery piece. The gun is aimed at the torso, emphasizing its own phallic associations. Its presence suggests that, for Magritte, the possibility of crossing the threshold of liberty may be endangered by a powerful intruder.

4 SKY PANEL

Sky is conventionally painted above the horizon, but here Magritte has placed his 'sky panel' on the lower of two tiers, in a sense naturally enough between the house and the woods. Magritte's summery skies are always quite uniform as he explained: 'I used light blue where sky had to be represented but never represented the sky, as artists do, to have an excuse for showing one of my favourite blues next to one of my favourite greys.'

ARTIST PROFILE

1916–18

Magritte studied painting at the Académie Royale des Beaux-Arts in Brussels from 1916 to 1918, acquiring specialized technical skills that were later used in many of his paintings.

1919–25

Magritte served in the Belgian infantry from 1921 to 1922, after which he married Georgette Berger in 1922 and worked as a draughtsman in a wallpaper factory.

1926–29

Sponsored by the Galerie la Centaure in Brussels, Magritte began to paint full time, producing his first surreal painting, *The Lost Jockey*, in 1926. His first Brussels exhibition, in 1927, was abused by critics. He left for Paris, where he met André Breton, the founder of Surrealism.

1930–45

Returning to Brussels in 1930, Magritte formed an advertising agency with his brother Paul. He remained there during the German occupation of Belgium in World War II.

1946–67

With other Belgian artists, in 1946 Magritte signed the manifesto *Surrealism in Full Sunlight*. In the lean post-war years he lived by making forgeries. He returned to his art in 1948, taking up the Surrealist themes of his earlier work.

THE MEANING OF WORDS

Influenced by the German philosopher Ludwig Wittgenstein (1889–1951), Magritte became fascinated by the relationship between a thing and the word used to represent it. For Magritte, everyday reality was full of paradoxes and open to multiple interpretations. The painter took up this theme in a series of paintings called *Key to Dreams* (1927; below) in which he depicted unambiguous objects on a canvas. Under each image he painted a word that incorrectly described the object—for example, the leaf is labelled 'the table' and the bag is labelled 'the sky'—except for the fourth and final image, which is correctly labelled as 'the sponge'. It is this last image that stands out, highlighting the role played by a name in how visual reality is understood.

Guernica 1937

PABLO PICASSO 1881 – 1973

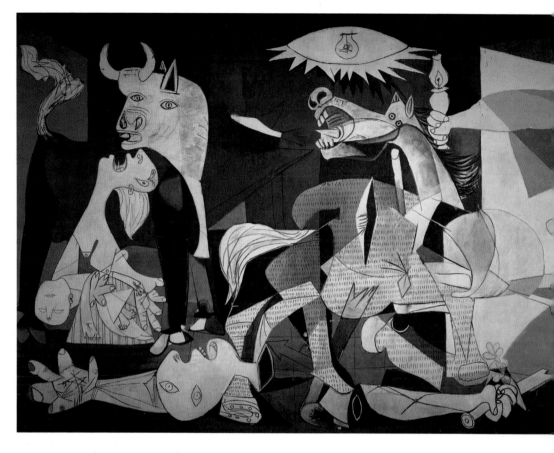

oil on canvas
137 ³/₈ x 305 ¹/₂ in. / 349 x 776 cm
Museo Reina Sofía, Madrid, Spain

P ablo Picasso painted *Guernica* as a passionate attack on Spain's fascist government, despite the fact that the work had been commissioned by the Spanish Republic for exhibition in the Paris World's Fair. A portrayal of the German carpet-bombing in 1937 of Guernica, the Basque capital in northern Spain, during the Spanish Civil War, the painting has become a universal symbol of the atrocity of war. The painting's power lies partly in its mixture of epic elements and abstract forms, and Picasso's decision to deny the canvas any colour conveys a powerful sense of journalistic credibility.

The artist expresses his outrage through the use of violent imagery. Some of the disturbing images in *Guernica*, such as the Minotaur, Spanish bulls and women in the throes of suffering, recur in his work. *Guernica* is heavily infused with narrative symbols, but Picasso never committed himself to interpretations of them, commenting, 'What ideas and conclusions you have got, I obtained too, but instinctively, unconsciously.' The figure of a horse trampling a woman suggests that Europe's dictators of the time—Franco, Hitler and Mussolini— were out of control. Although Picasso was never officially part of the Surrealist movement, the painting offers much evidence of its influence on the artist. The figures it contains are nightmarish and distorted, notably the extended necks of the suffering women, the long arm (centre, top) and the apparently severed head in the foreground. Picasso combined these Surrealist elements with his own Cubist (see p.388) innovations to produce a shattering evocation of suffering. **SE**

✦ NAVIGATOR

FOCAL POINTS

1 BULL OR MINOTAUR

Picasso uses the motif of the bull or the Minotaur—half-man and half-bull—to signify the struggle between the human and the bestial. This static figure of a bull, with two widely spaced human eyes, stands over a distraught woman as she grieves for the dead child held in her arms.

2 LIGHT BULB

Painted within the almond shape of an angry-looking eye, a solitary light bulb blazes out over the figure of a horse in pain. The light bulb is symbolic both of the blinding Spanish sun and of the pitiless environment of a wartime torturer's cell, harshly lit by a shadeless bulb.

3 TERRIFIED FIGURE

To the extreme right of the painting is a person, probably a woman, who is falling or trapped in a building with flames raging above and below. The helpless figure's contorted face makes a direct emotional appeal and draws the viewer into his or her pain and bewilderment.

4 SWORD AND FLOWER

A dead warrior's arm, possibly that of a statue, lies at the bottom centre of the painting; the figure has been crushed under debris or the arm may be severed. The hand continues to grasp a shattered sword. A ghostly flower growing close to the hand is a faint symbol of the renewal of life.

5 HORSE

The central and dominant image of the horse represents death, here inflicted on the Spanish people by their dictator and the bombers of Nazi Germany. Picasso subliminally suggests death to the viewer by rendering the horse's nostrils and teeth like a human skull.

PICASSO AND THE MINOTAUR

The image of the Minotaur—the half-man, half-bull monster of Greek mythology—was used by Picasso long before he painted *Guernica*. For the first issue of the Surrealist magazine *Le Minotaure*, which was published between 1933 and 1939, Picasso produced a maquette

design (below), commissioned by editors André Breton and Pierre Mabille (1904–52). The Minotaur also appears in his etching *Minotauromachy* (1935), as a monstrous creature in a psychosexual struggle, related to Picasso's feelings about his wife and pregnant mistress.

MEXICAN ART

1 *La Calavera de la Catrina* (1913)
José Guadalupe Posada • zinc etching
4 ³/₈ x 6 ¹/₈ in. / 11 x 15.5 cm
Private collection

2 *The Dancers* (1942)
Rufino Tamayo • oil on canvas
46 x 36 in. / 117 x 92 cm
Private collection

3 Section from *The Epic of American Civilization* (1932–34) showing the *Hispano-America* panel (centre), including detail from *Anglo-America* (left) and *Gods of the Modern World* (right)
José Orozco • mural
118 x 160 ¹/₄ in. / 300 x 407 cm
Baker Memorial Library, Dartmouth College, Hanover, USA

In the years leading up to Mexico's popular revolution (1910–20), an anti-government movement arose that combined satirical art and illustration to dramatic and controversial effect. It is seen at its best in the lively political satires of José Guadalupe Posada (1851–1913), whose *calaveras* (caricatures in skul form) are now intimately associated with Mexico's Day of the Dead celebrations in November, although they also serve as a macabre metaphor for corruption in society. Posada's artistic heyday came during the dictatorship of Porfirio Díaz, lasting from 1884 to 1911. This regime afforded Posada rich material for satire and inspired a stream of illustrations, book jackets and cartoons for popular periodicals. In *La Calavera de la Catrina* (above), he presents a skeletal society belle in an ostentatious hat; this jarring but iconic image is often featured in Day of the Dead festivities.

The work of another, very different Mexican artist, Rufino Tamayo (1899–1991), grew out of his background as a Zapotec Indian. Tamayo eschewed realism in favour of a more abstract, experimental style. An expert in Mayan and Aztec sculpture, he drew on native folk and Pre-Columbian art (see p.112), fusing these traditions with a vibrant palette and a compositional approach that incorporated the flat planes and limited depth characteristic of Cubism (see p.388). *The Dancers* (opposite, above) is an example of Tamayo's poetic, spiritual work. There is a sense of balance in the painting, between vibrant reds and oranges and cooler blues, but also between movement and stasis; the two female figures have a Modernist, mask-like anonymity. Tamayo's apolitical stance attracted criticism from many of his peers, however, and he left Mexico for New York in 1926, not returning until 1959.

KEY EVENTS

1910	1917	1920	1920–21	1921	1927
The Mexican Revolution begins and the Mexican people demand 'land and liberty'. Emiliano Zapata emerges as a leading revolutionary.	Orozco travels to the USA for the first time. He eventually moves there in 1927, producing murals in California, New York and New Hampshire.	Alvaro Obregón is elected president of Mexico and a revolutionary nationalist regime is installed to popular acclaim.	Rivera and Siqueiros see Renaissance frescoes in Italy and are inspired to paint directly on to wet or dry plaster in the same manner.	Mexico's education minister, José Vasconcelos, commissions the first educative public murals.	Rivera creates his fresco *Man Masters the Elements* for the Escuela Nacional de Agricultura at Chapingo, central Mexico.

Prior to the revolution, muralism had long been established as an art form in Mexico. Wall paintings were part of Mayan culture, had later decorated Spanish Baroque churches and were often found as folk art in Mexican inns and hostelries. The term 'Mexican Muralism' refers to the revival of this style of large-scale painting that was provoked by the revolution in 1910 and fostered by the arrival of the national revolutionary government of Alvaro Obregón in 1920. The movement was at its peak during the 1920s and 1930s, when large numbers of politically charged murals were commissioned for public places. This period became known as the Mexican Mural Renaissance. Although Tamayo produced a number of murals in Mexico, the artists who are predominantly associated with Mexican Muralism are José Orozco (1883–1949), David Siqueiros (1896–1974) and Diego Rivera (1886–1957), collectively known as 'Los Tres Grandes', or The Big Three. They embarked upon the most extensive programme of state-sponsored mural painting since the Italian Renaissance and reflected their commitment to left-wing politics in their work. Siqueiros, Orozco and Rivera reinvigorated mural art by focusing on the lives of the oppressed and stressing the importance to the new Mexico of the formerly colonized indigenous peoples.

Orozco had first-hand experience of the revolutionary wars that raged in Mexico from 1910 to 1920. Much of his art has a melancholic air and focuses on the suffering of the Mexican people. His most ambitious mural, *The Epic of American Civilization*, has twenty-four panels painted as 'a representation of a continent characterized by the duality of indigenous and European historical experiences'. In the panel, *Hispano-America* (below), the figure of Mexican rebel

4 *The Flower Seller* (1942)
Diego Rivera • oil on masonite
48 x 48 in. / 122 x 122 cm
Private collection

5 Injured worker, detail from
*For the Complete Safety of All Mexicans
at Work* (1952–54)
David Siqueiros • pyroxylin on masonite
Centro Médico La Raza, Mexico
City, Mexico

6 *Self-portrait with Velvet Dress* (1926)
Frida Kahlo • oil on canvas
12 ⅛ x 9 in. / 31 x 23 cm
Private collection

Emiliano Zapata stands alone among corrupt politicians as an army general prepares to stab him in the back. This work is particularly powerful in context, as it is preceded by the panel *Anglo-America*, in which expressionless white schoolchildren line up in regimented fashion beside their stern teacher. The panel that follows, *Gods of the Modern World*, is a savage attack on institutionalized education and shows skeletons in academic gowns. Not surprisingly, Orozco greatly admired Posada's unsettling illustrations, which he had seen being produced when he was growing up in Mexico City.

Rivera lived in Europe from 1907 to 1921 and spent most of that time in Paris, where he developed a bold and colourful form of Synthetic Cubism. By the mid 1920s, he had become recognized as the leading figure of Mexican Muralism. At times, this created conflict—particularly with Siqueiros, who thought that Rivera was not sufficiently militant and too keen on self-promotion. Rivera's first major mural project was executed for Mexico's Ministry of Education between 1922 and 1928; it presented the life, struggles and achievements of the Mexican people. This was followed by the epic mural cycle *History of Mexico: From the Conquest to the Future* (1929–30) in the Palacio Nacional, Mexico City. Rivera's extraordinary draughtsmanship and mastery of classic and modern techniques make his murals the most varied, complex and technically ambitious of those of The Big Three. In *The Flower Seller* (above), a subject to which the artist returned several times, the vendor's calla lilies radiate from her basket, their brilliance heightened by the dark background. They seem to weigh her down, but this painting is a tribute to Mexico's indigenous people, whom Rivera applauds here for their industrious nature and for working in harmony with the land. In a comic touch, the hands, feet and balding pate of the flower seller's husband are visible behind the basket.

Most Mexican Muralism is realist in style to ensure that the paintings can be comprehended by as wide an audience as possible. Siqueiros and Rivera were particularly impressed by the simple, clear narratives of Italian

Renaissance frescoes. In 1921, Siqueiros launched *American Life* magazine; it had only one edition but was significant because it called for a new type of Mexican monumental art that would be neither too nostalgic nor picturesque. The following year, the fervently Marxist Siqueiros formalized Mexico's ambitions for a programme of public art in his 'Declaration of Social, Political and Aesthetic Principles', in which he proclaimed: 'Our fundamental aesthetic goal must be to socialize artistic expression and wipe out bourgeois individualism.'

Siqueiros's murals are distinguished by their great dynamism, strongly contrasting colours and dramatic chiaroscuro. His signature technique was the use of pyroxylin paint applied with a spray gun, which he first employed in 1933. Many of Siqueiros's works, such as the series of murals titled *For the Complete Safety of All Mexicans at Work* in Mexico City's Centro Médico La Raza, directly reflect the artist's close alliance with Mexico's industrial workers. The detail of the injured worker (right, above) reveals Siqueiros's debt to two quite different artistic predecessors. Influenced by the work of Michelangelo, which he had studied during a trip to Europe in 1919 to 1922, he began to employ dramatic perspective in his work, often foreshortening figures in his paintings; the Futurist Umberto Boccioni, meanwhile, helped foster his enthusiasm for the machine age. From 1952 to 1956 Siqueiros created an outdoor mural at the campus of the Universidad Nacional Autónoma de México in Mexico City; he also gained a commission for the artist and architect Juan O'Gorman (1905–82), who covered the entire facade of the library building in a vast mosaic mural.

The Big Three wanted to create original art that was both Mexican and universal. Their work mixed classical and Modernist influences with their own Pre-Columbian and indigenous heritage. While satisfying the needs of the educational and political mural programme, their mural art also enabled them to develop their own individual styles and techniques. Orozco's style leaned towards Surrealism (see p.426) whereas Siqueiros's tended towards Expressionism (see p.378). All of The Big Three adapted their styles to make paintings with oil on canvas; these smaller works were vital in supplementing the artists' incomes as state-employed artists and also represented some of their most enduring images. Their private commissions in the United States helped to bring wider attention to their public work.

Although politics and the question of Mexican national identity found its way into her work, Frida Kahlo (1907–54)—Rivera's wife and lifelong muse—more often took her personal reality as her subject matter. Severely injured in a road accident as a young girl, Kahlo taught herself to paint while recuperating. *Self-portrait with Velvet Dress* (right, below) was the first of numerous self-portraits, and she painted it for Alejandro Gómez Arias, her lover at the time. Kahlo imbued later works with complex symbolism, referencing both herself and her country in paintings such as *Self-portrait with Thorn Necklace and Hummingbird* (1940; see p.442). *Self-portrait with Velvet Dress* is a simpler piece, in the style of 19th-century Mexican portrait painters who, in turn, were influenced by Renaissance portraiture. Kahlo's self-portrait draws partly on *The Birth of Venus* (*c.* 1482–86) by Sandro Botticelli: in both works, the subject extends her right hand across her body; both also have water as a background, although in Kahlo's painting the waves are dark and swirling passionately, more reminiscent of the intense brushwork of Vincent van Gogh.

Kahlo's careful style, integration of strange juxtapositions and her ability to make the extraordinary seem commonplace saw her branded a Surrealist by many critics. The artist herself rejected the title, however, wryly commenting that she had not known she was a Surrealist until the movement's leading proponent, André Breton, arrived in Mexico in 1938 and told her that she was one. **LM**

Detroit Industry (south wall) 1932–33
DIEGO RIVERA 1886–1957

fresco
211 x 540 in. / 536 x 1372 cm
(lowest panel)
Detroit Institute of Arts, USA

✵ NAVIGATOR

From the early 1930s onwards, Diego Rivera received seven highly prestigious public art commissions in the United States. The most important of these was a commission to decorate the 'garden court' of the Detroit Institute of Arts with scenes of Detroit industry. Rivera was hugely enthusiastic about the project, and so the initial idea of using only the two main panels on the south and north walls extended to include all twenty-seven panels surrounding the court. Rivera toured Detroit and spent two months at Ford's River Rouge plant, where the new V8 model had just been launched.

On the south wall (above), the top central panel depicts the white, red, black and yellow races that shape North American culture and comprise its workforce. The wall's main panel depicts the manufacture of the V8's exterior, with a completed red automobile in the far distance. To the left and right of the top central panel, and in corresponding positions elsewhere in the court, are scenes of other Detroit industries, completing Rivera's portrait of the city. **LM**

👁 FOCAL POINTS

1 PHARMACEUTICALS

In this panel Rivera depicts the pharmaceutical industry, which he links to enlightenment and human progress. In a panel on the north wall opposite, he contrasts this beneficial use of chemicals with harmful products, also made in Detroit, in a portrait of workers in gas masks making poison gas.

2 COMMERCIAL CHEMICALS

This right-hand panel complements the depiction of the pharmaceutical industry to its left. Like its companion, it celebrates chemical manufacture as one of the great kingpins of Detroit's industry. Its two central pairs of workers combine in a strongly symmetrical composition.

3 STAMPING PRESS

Rivera's representation of the gigantic fender stamping press was influenced by his studies in 1921 of indigenous art and culture in the Tehuantepec and Yucatán regions. The press is an anthropomorphized figure, similar in form to Coatlicue, the earth goddess in monumental Aztec sculpture.

4 COMPANY MANAGEMENT

The two figures observing the plant in operation are Rivera's patron, Edsel B. Ford, president of the company, and Dr William R. Valentiner (in profile), who oversaw the commissioning of the murals. The men are placed in a corner, just as patrons were in Renaissance paintings.

5 WORKERS

Unlike Charles Sheeler, who in 1927 photographed the River Rouge plant denuded of its workforce, Rivera displays his communist sympathies by placing the workers at the centre of his composition. Dominated by machines, their frenetic activity appears like a choreographed dance.

🕐 ARTIST PROFILE

1898–1921

Rivera enrolled at the San Carlos Academy, Mexico City, and exhibited for the first time in 1906, with twenty-six works. The artist then travelled in Europe and lived in Paris. He became aware of the revolutionary hero Emiliano Zapata; now a revolutionary himself, he returned to Mexico in 1921.

1922–57

Rivera began to paint revolutionary murals and joined the Communist Party, visiting the Soviet Union in 1927. He married artist Frida Kahlo in 1929. He spent the years 1930 to 1934 painting murals in the United States, and returned in 1940 for the last time to paint a ten-panel mural for the Golden Gate International Exposition, San Francisco. He died in Mexico City.

Self-portrait with Thorn Necklace and Hummingbird 1940

FRIDA KAHLO 1907 – 54

oil on canvas
24 ⅛ x 18 ½ in. / 61 x 47 cm
Harry Ransom Center, Austin, USA

 NAVIGATOR

Frida Kahlo's paintings are often labelled Surrealist (see p.426) because they are packed with symbolism. Yet Kahlo denied being a true Surrealist, stating that she painted her personal reality rather than her dreams. That reality was a painful one, because she suffered from ill health for most of her life. Neither was she a stranger to emotional pain: she had several love affairs, including one with Russian revolutionary leader Leon Trotsky. Her passionate relationship with her husband, Mexican artist Diego Rivera proved to be turbulent (both had affairs) and was punctuated by periods of separation. This work was painted the year after she and Rivera divorced, only to remarry months later, and in the same year that Trotsky was assassinated. Her omnipresent physical suffering and psychological torment are apparent in the symbolism she uses. Despite her tortured existence, Kahlo was an inspiring figure and was politically active in helping post-revolution Mexico to forge its identity. She portrays herself as a proud *mestiza*, a Mexican of mixed European and Amerindian ancestry. Kahlo draws on Pre-Columbian and Christian imagery to depict herself as a combination of a Christ-like figure and an Aztec goddess. She portrays herself as a martyred but all-powerful deity in the Mexican folkloric tradition. **SH**

👁 FOCAL POINTS

1 IDENTITY

Centrally placed as in religious icons, the face is the focal point of the painting. Kahlo's unwavering gaze suggests both her suffering and her resilience. Her hair is dressed in a traditional Mexican style, revealing her strong sense of Mexican identity and her pride in her *mestiza* origins.

2 COLOUR AND NATURE

The excessively bright colours and exaggerated textures of the succulent leaves reflect Kahlo's interest in native Mexican art, and the yellow leaf resembles a halo. The dragonflies and butterflies around her head are Christian symbols of resurrection, representing hope and rebirth.

3 BLACK CAT

A black cat appears over Kahlo's left shoulder. Traditionally an omen of bad luck, the cat menacingly watches the hummingbird below the artist's throat as if waiting to pounce. Kahlo loved animals and kept many pets, especially after she realized that she would never bear children.

4 NECKLACE

Kahlo's thorn necklace reveals her roots and patriotism. A hummingbird hangs from its centre and is a Mexican symbol of luck in love—but hers is dead. The thorns digging into her neck draw drops of blood, reminding the viewer of Christ's suffering and also alluding to her own pain.

5 MONKEY

Monkeys are symbolic of the devil or lust, but to Kahlo, her pet monkey signifies the love she was not receiving from Rivera, both just after their divorce and often during their marriage. With its playful nature, the monkey also represents the child she could not have because of ill health.

🕐 ARTIST PROFILE

1907–17

Kahlo was born in Coyoacán; her father was a German photographer and her mother a *mestiza*. At the age of six, she contracted polio, which damaged her right leg permanently.

1918–28

She sustained serious injuries to her uterus, spine, ribs, pelvis, collarbone and right leg after a bus crash. This led to more than thirty operations during her life. While recovering she began to paint and completed her first self-portrait in 1926.

1929–35

Rivera and Kahlo married and a year later they moved to the USA. She had a miscarriage and the first of three abortions, and began an affair with Hungarian photographer Nickolas Muray, who purchased some of her work (including *Self-portrait with Thorn Necklace and Hummingbird*) to help her in a time of financial difficulty. She and Rivera separated in 1935.

1936–40

Kahlo had a relationship with Trotsky. French writer André Breton helped her stage a solo exhibition in New York in 1938 and she was regarded as a Surrealist. In 1939 she divorced the womanizing Rivera but remarried him a year later.

1941–54

She showed work in Mexico, the USA and Europe. Her right leg was amputated in 1953. She died of cancer in her home town.

AUTOBIOGRAPHICAL ART

Of Kahlo's 143 paintings, more than fifty are self-portraits and even those that are not strictly self-portraits are autobiographical. Self-portraits are the most personal form of expression and reflection in art. Kahlo (below; photographed in 1944) used the genre as a way of exposing her physical and mental state and her circumstances. She also realized that painting self-portraits was convenient. Kahlo taught herself to paint after a serious bus accident in 1926; her chronic health problems often left her bedridden and painting herself was the easiest option. The self-portraits resemble Mexican retablos and Kahlo drew on folkloric and religious traditions. The addition of symbols emblematic of her psychological state packs her work with intense emotions and hidden significance.

MODERNIST SCULPTURE

1 *Sleeping Muse* (1910)
Constantin Brâncuşi • bronze
6 ¼ x 9 ⅞ x 7 ⅛ in. / 16 x 25 x 18 cm
Musée National d'Art Moderne,
Centre Pompidou, Paris, France

2 *Guitar* (1912–13)
Pablo Picasso • sheet metal and wire
30 ½ x 13 ¾ x 7 ⅝ in. / 77.5 x 35 x 19 cm
Museum of Modern Art, New York, USA

3 *Head No 2* (1916; enlarged version 1964)
Naum Gabo • COR-TEN steel
69 ⅛ x 52 ¾ x 48 ¼ in. / 175.5 x 134 x
122.5 cm
Tate Britain, London, UK

The seeds of Modernism were sown at the turn of the 20th century when the values of the century that preceded it were threatened by far-reaching cultural and political changes in Western society. These included such diverse factors as the spread of Marxism, the growth of psychoanalysis, the expansion of mass media and technological advances, such as the development of the automobile. Painters, writers and sculptors rejected 'traditional' forms of art and literature and sought new ways of representing the fragmented, fast-moving, industrialized world around them. They were often motivated by a belief in progress and the possibility of social utopias.

There is no single defining characteristic of Modernist sculpture: rather it represents a turning point as sculptors re-examined what their art constituted. Artists began to reassess notions of representation, space, form, volume and mass; their choice of materials; and even their construction methods. The early 20th-century works of Paris-based sculptor Constantin Brâncuşi (1876–1957) contain simple lines and geometric shapes. They represent a move away from realism towards the abstract in an effort to capture the essence of a subject. Brâncuşi's *Sleeping Muse* (above) was inspired by the folk artists of his native Romania and reflected the interest of several contemporary artists in Primitivism (see p.342). Brâncuşi used part of the body to represent the whole and focused on the head as the most expressive component of the human form. The features of the ovoid-shaped face are simplified; elegant curves represent the nose and eyebrows while grooves mark the closed eyelids. Its bronze surface is highly polished to emulate the finish of man-made industrial products.

KEY EVENTS

1912	1913	1914	1915	1920	1922
Printmaker Eric Gill turns to sculpture and carves *Mother and Child*. Like Brâncuşi he cuts directly into the stone.	Brâncuşi sculpts the first of five versions of *Mlle Pogany*, a spare and streamlined bronze bust of a young woman that inspires great debate.	Epstein creates *Torso in Metal from 'The Rock Drill'*. He describes it as 'the armed sinister figure of today and tomorrow'.	Henri Gaudier-Brzeska (1891–1915) is killed in his native France, fighting in World War I. A memorial exhibition is held in his adopted home, London, in 1918.	Gabo writes the *Realistic Manifesto*, a key Constructivist text; it focuses on divorcing art from conventions such as line, colour, volume and mass.	James Joyce's radically Modernist text *Ulysses* and T. S. Eliot's epic poem *The Wasteland* are published.

Brâncuşi's commitment to the true nature of the material used for a sculpture also characterized his construction method. He employed direct carving, cutting straight into a block of material. This was innovative for the period because most sculpture was constructed using indirect carving, whereby a model was made that was then cast in plaster; often this plaster version was then sent out to be carved by a craftsman. Brâncuşi's direct carving method provoked a revolution in sculpture as contemporaries began to carve simple forms from marble, stone and wood, respecting the shape of the original block. Direct carving allowed sculptors to interact directly with their material; surfaces became uncluttered to reveal the material itself, and were polished to reveal colour and markings, often with abstract results. Truth to material, Primitivist influence and direct carving all became integral to 20th-century sculptural practice and Brâncuşi's legacy can be seen in works such as *Jacob and the Angel* (1940–41; see p.448) by Sir Jacob Epstein (1880–1959). The translucence and marbling of the alabaster used in this sculpture suggest the skin tones, muscles and veins of the figures carved.

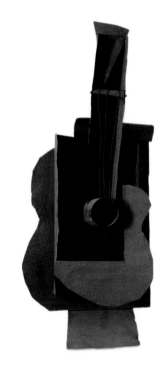

Together with Brâncuşi, the most influential Modernist sculptor was Pablo Picasso (1881–1973). His innovative work *Guitar* (right) was made from everyday materials, in the form of sheet metal and wire, rather than the traditional stone or bronze. However, it is not only the materials Picasso chose that make it a revolutionary piece of sculpture: he also applied Cubist (see p.388) principles to a three-dimensional object by breaking it down and rearranging it into fragmented planes. The hole in the soundboard of the instrument is represented by a cylinder that sticks out rather than a void or space.

A few years later Russian sculptor Naum Gabo (1890–1977) developed a 'stereometric' method of sculpting that was influenced by scientific theory and the Constructivist (see p.400) love of industrial materials. He experimented with various materials, including cardboard, plywood, celluloid, sheet metal, glass, wire and plastic. Gabo aimed to create form by describing space rather than using mass, so that the interior of an object was open to reveal three dimensions. This represented a departure from the notion that sculpture should consist of a closed volume of mass. From 1915 to 1920 Gabo used planes to construct busts and figurative works, reinventing methods of treatment for traditional sculptural subjects. His *Head No 2* (right) is a subsequent enlargement of one of these pieces.

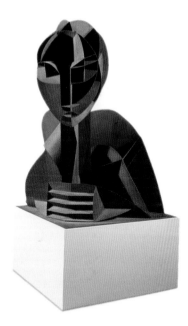

By the 1930s and 1940s, sculpture had become more abstract and stylized. It was a particularly rich and innovative period in British sculpture, and is represented by direct carvers such as Sir Henry Moore (1898–1986) and Dame Barbara Hepworth (1903–75). Moore, Hepworth and their friends and fellow artists Gabo and Eric Gill (1882–1940) influenced one another as they embraced artistic change. Visits to Europe enabled British sculptors to study and assimilate the skills and ideas of European avant-garde artists such as Picasso and Jean Arp (1886–1966). Moore spurned Victorian representational

1924	1928	1932	1939–40	1940–41	1943
Japanese-American sculptor Isamu Noguchi (1904–88) exhibits his first works in plaster and terracotta.	Moore gains his first public commission for the headquarters of London Underground; Hepworth has her first solo exhibition in the British capital.	Duchamp coins the term 'mobile' to describe American sculptor Calder's new suspended art form.	Spanish sculptor and metalworker Julio Gonzalez (1876–1942) makes his mark with the avant-garde piece *Cactus Man No 1*.	Epstein creates *Jacob and the Angel* (see p.448).	The Museum of Modern Art in New York hosts a retrospective of Calder's work, co-curated by Duchamp.

sculpture and flirted with Cubism before moving on to create Modernist works of an increasingly abstract nature. His experiments with materials, space and form saw him lead the way for a new kind of figurative sculpture in the United Kingdom that referenced the nation's rolling landscape, in which his organic works were often placed.

Moore's *Reclining Figure* (above) is one of many of his works that share this title. It was made at a time when the artist was starting to create sculptures on themes—the mother and child, the reclining figure—that were to intrigue him for the rest of his life. His interest in the reclining figure was deeply influenced by the Mexican Chac-mool—a Pre-Columbian stone statue that shows a reclining human figure with the head up and turned to one side and holding a tray over the stomach. The British sculptor first saw a plaster cast of a Chac-mool in an exhibition at the Louvre in Paris in the early 1920s. In this *Reclining Figure* the head is disproportionately tiny. Moore habitually made the heads of his figures small in an effort to add a sense of monumentality to the torso and limbs, and shift the viewer's focus to the form of this monumental body. Like Gabo, Moore employed space to create form, here making the woman's curvaceous shapes into an organic structure that blends easily into a natural environment.

Hepworth met Moore while she was studying at the Leeds School of Art. Like Moore, she was excited by direct carving, although she concentrated on abstract forms rather than representational work. Carved from lagos wood, *Hollow Form (Penwith)* (opposite, above) is typical of Hepworth's adoption of the ethos of truth to material; she carved wooden pieces in a way that was sympathetic to the rings of the tree, celebrating its organic form. From the late 1930s she focused on the interplay between space and mass in sculpture. The concept of the void is central to many of her pieces; by piercing material to create a hollow core, Hepworth uses the light created by the space to make her works 'vital'. The play of shadow and light through the work and across its surface forms new abstract shapes. These shapes change over time depending on the light cast on the sculpture, repeating its curvaceous form. In this way, the sculpture constantly has new life breathed into it so that it becomes vital.

The steady refinement of form to its essence that was so characteristic of Brâncuși's work also came to define the sculptures of Swiss sculptor and painter Alberto Giacometti (1901–66), who once stated that he sought to portray not a human figure, but rather the shadow that it casts. After aligning himself with the Surrealists (see p.426), Giacometti began in the late 1940s to create isolated, knife-thin, elongated figures, such as *Standing Woman* (left),

that became his trademark. His early sculptures were tiny, but as he created larger ones, they also became thinner. Although he worked with live models, creating clay maquettes before casting in bronze, his figures are wraith-like. With no musculature, his haunting sculptures reflect the existentialist pain that followed World War II. Whereas Giacometti's female figures are shown standing and immobile, his attenuated male figures are shown walking or gesturing, for example *Man Pointing* (1947).

In Paris, inspired by the abstract works of Piet Mondrian (1872–1944), Alexander Calder (1898–1976) devised his coloured kinetic standing and suspended sculptures made from geometric shapes of metal, wire and rods. Calder visited Mondrian's studio on a trip to Paris in 1930 and was so impressed by the environment—white walls decorated with coloured rectangles of paper—that Calder decided 'it would be fun to make these rectangles oscillate.' Kinetic sculpture was not new and, like sculptors before him, Calder initially used motors to provide movement (leading Marcel Duchamp [1887–1968] to be the first to call them 'mobiles' in 1931), but he pioneered sculptures that are suspended on wires and move in response to wind and air currents.

Pieces such as *Scarlet Digitals* (below) embody Calder's attempt to make a 'moving Mondrian'. Its use of a restricted number of bold colours and abstract shapes is similar to that employed by Mondrian to create Neo-Plastic canvases such as his *Composition with Yellow, Blue and Red* (1937–42). Whereas Mondrian painted interacting lines and white space punctuated by colour to create a sense of visual rhythm, Calder uses space, light and movement to create both visual and spatial rhythms. By allowing his mobiles to move with the air, he added a sense of unpredictability as to how and when a sculpture moves. His mobiles helped reinvent what had been largely a static art form. **CK**

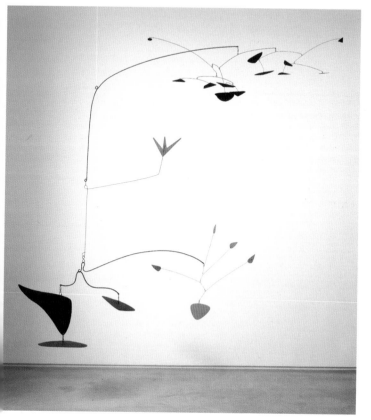

4 *Reclining Figure* (1938)
Henry Moore • cast lead
5 3/4 x 13 in. / 14.5 x 33 cm
Museum of Modern Art, New York, USA

5 *Hollow Form (Penwith)* (1955–56)
Barbara Hepworth • lagos wood,
part painted
35 3/8 x 25 7/8 x 25 5/8 in. / 90 x 66 x 65 cm
Museum of Modern Art, New York, USA

6 *Scarlet Digitals* (1945)
Alexander Calder • sheet metal, wire
and paint
85 x 95 x 41 in. / 216 x 241 x 104 cm
Calder Foundation, New York, USA

7 *Standing Woman* (1948)
Alberto Giacometti • painted bronze
65 3/8 x 6 1/2 x 13 1/2 in. / 166 x 16.5 x 34 cm
Museum of Modern Art, New York, USA

Jacob and the Angel 1940 – 41
JACOB EPSTEIN 1880 – 1959

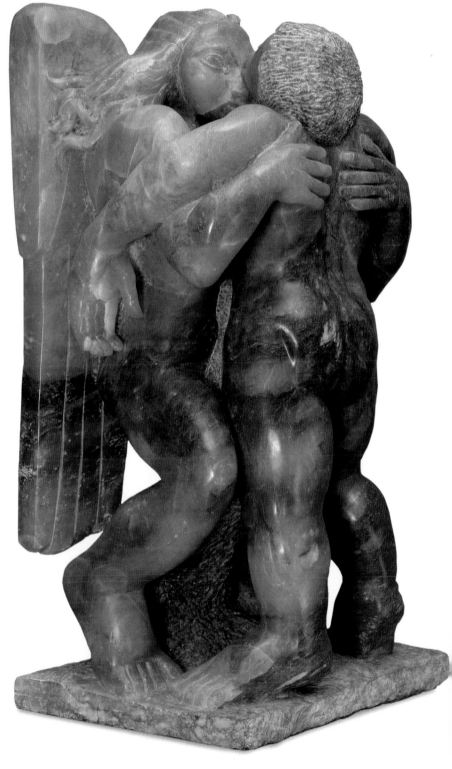

alabaster
84 ¹/₄ x 43 ¹/₄ x 36 ¹/₄ in.
214 x 110 x 92 cm
Tate Liverpool, UK

This sculpture by Sir Jacob Epstein depicts a story from the Book of Genesis. Having tricked his father, Isaac, into giving him the blessing that was his brother Esau's birthright, Jacob becomes fearful for his life. He prays to God, whereupon a mysterious figure appears before him. Jacob takes hold of the stranger and pleads with him for salvation; the stranger pulls away and the struggle lasts all night. In most versions, at daybreak Jacob's opponent reveals himself as an angel, blesses Jacob for not giving in and renames him 'Israel'. Jacob realizes that he has been struggling with God.

Epstein's sculpture depicts Jacob at a point when he is close to giving up the struggle. The artist believed that the nature of a material was mainly what dictated the form of an artwork, and he carved directly into a block of alabaster to create this piece. The brown and pink mottle running through the translucent alabaster easily suggests veins and blood vessels. The piece is open to multiple readings. There are homoerotic overtones in the combatants' clasp and the angel could be embracing Jacob, supporting him or overpowering him. The sculpture also represents Epstein's struggle as an artist to create and to be accepted by contemporary society—early on in his career, his nudes were vilified as obscene. Epstein was the son of a Polish Jew who emigrated to the United States; given that he carved *Jacob and the Angel* during World War II, it is likely that the artist was also alluding to the terrible struggles of the Jews at that time. **CK**

◉ NAVIGATOR

◉ FOCAL POINTS

1 SEXUAL OVERTONES

There are definite sexual aspects to the piece, and the suggestion of a kiss. Entrepreneur Charles Stafford bought the work and toured with it in Britain, America and South Africa as an 'adults-only' exhibit. Stafford offered visitors their money back if they did not find it shocking.

2 JACOB

In contrast to previous artists' interpretations of the theme, Epstein renders Jacob as a diminutive figure, and this is emphasized by the angel's pose. His arms droop, revealing his exhaustion, and he seems to be a humble rather than a heroic figure, who truly has to be saved by God's grace.

3 ANGEL'S WING

The sculpture is carved from one block of alabaster, a side of which is visible in the length of the angel's wings. Epstein advocated direct carving from stone without using a maquette (small model). This often created a textured surface and imperfections that became part of the final sculpture.

4 THIGHS AND HANDS

The massive thighs, hefty hands and stocky shape of the figures owe more to Primitivism (see p.342) than to the graceful rhythms of classical and Renaissance sculpture, in which the body was idealized. Along with artists such as Pablo Picasso, Epstein was inspired by African art.

◔ ARTIST PROFILE

1880–1912
Epstein studied first in New York and then in Paris, where visits to the Louvre inspired his interest in ancient art. Early works—a facade for the British Medical Association building in London (1908) and Oscar Wilde's tomb in Paris's Père Lachaise Cemetery (1912)—were mutilated or censored.

1913–25
Anxiety about the threat of war inspired Epstein to create *The Rock Drill* (1913–15), reflecting 'the terrible Frankenstein's monster we have made ourselves into'. His sculpture *Rima* (1923–25), in London's Hyde Park, was daubed with paint by one outraged visitor.

1926–41
Epstein devoted himself increasingly to bronze portrait busts from the 1920s; in contrast to his larger works, these were warmly received. Owing to its controversial nature, *Jacob and the Angel* was taken on tour as a provocative attraction.

1942–59
Epstein produced his last major work, *St Michael and the Devil*, for Coventry Cathedral between 1956 and 1958.

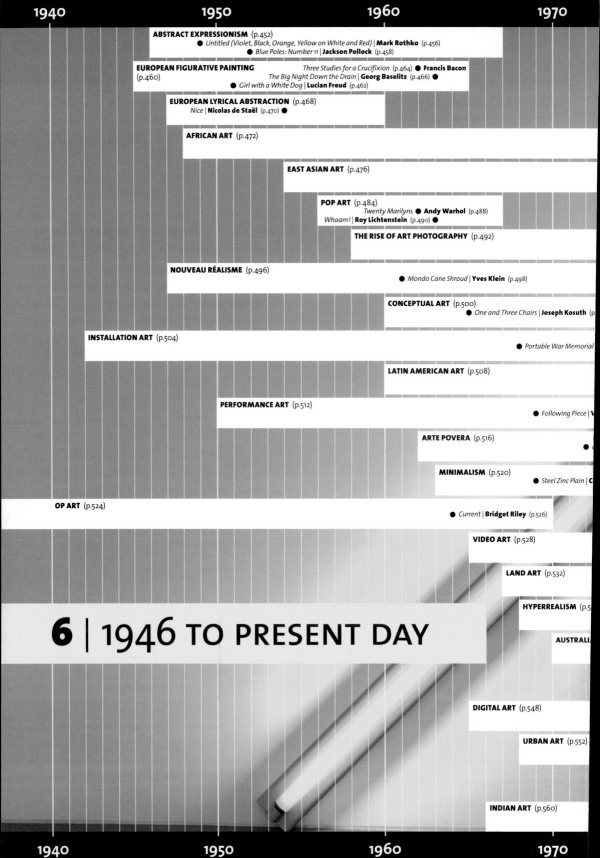

6 | 1946 TO PRESENT DAY

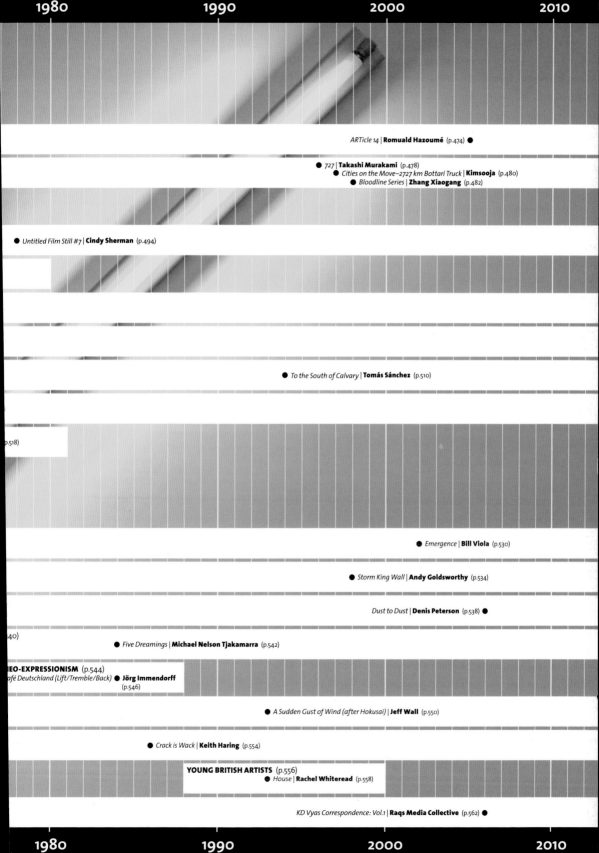

ABSTRACT EXPRESSIONISM

T he term 'Abstract Expressionism' was first coined in 1919 by the German magazine *Der Sturm* to describe the non-representational abstract works of the German Expressionists (see p.378). In 1946 American art critic Robert Coates (1897–1973), writing for *The New Yorker*, used it to describe the abstract works of a group of American artists active between the 1940s and 1960s. Although differing in style, these works sought to achieve an emotional or expressive effect. The artists worked mainly in New York and for this reason they came to be known as the New York School. Paris had been at the heart of the art world in the early 20th century, but the exodus of artists from Europe as a result of World War II had ended the French capital's predominance. New York rapidly came to the fore to take its place as the centre of avant-garde art. The 1951 exhibition 'Abstract Painting and Sculpture in America' at the Museum of Modern Art cemented the reputation of the movement as a major artistic force.

Many of the artists associated with Abstract Expressionism had established their careers in the 1930s. This was partly because of the Federal Art Project, a state-sponsored programme that promoted the role of the artist within society. The programme often required artists to produce murals, and Abstract Expressionists continued to produce large-scale works for decades afterwards. The artists sought international recognition and those who worked under the auspices of the programme tended to rebel against its somewhat prescriptive agenda—artists were often required to execute works in a Social Realist style. The artists also rejected the national style of painting that prevailed at the time—Precisionism and Realism (see p.364)—in which American urban and rural scenes were depicted, usually in a romantic and

1 *Vir Heroicus Sublimis* (1950–51)
Barnett Newman • oil on canvas
95 ³⁄₈ x 213 ¼ in. / 242 x 542 cm
Museum of Modern Art, New York, USA

2 *Woman I* (1950–52)
Willem de Kooning • oil on canvas
75 ⅞ x 58 in. / 193 x 147 cm
Museum of Modern Art, New York, USA

3 *The Bridge* (c. 1955)
Franz Kline • oil on canvas
82 x 54 ½ in. / 208.5 x 138.5 cm
Munson-Williams-Proctor Arts Institute,
Utica, New York, USA

KEY EVENTS

1946	1947	1948	1948	1948	1950
The art critic Robert Coates uses the term 'abstract Expressionist' in an article published in *The New Yorker* magazine.	Pollock produces his first drip paintings by placing the support directly on to the studio floor and pouring, dripping and flinging paint on to its surface.	Rothko, Newman and Motherwell help co-found The Subjects of the Artist School in New York, devoted to promoting meaning in abstract art.	Newman's essay *The Sublime Is Now* is published in *The Tiger's Eye*, a periodical written by and for artists.	Newman begins his series of 'zip' paintings, in which areas of colour are separated by thin, vertical lines.	De Kooning begins his *Woman* series. It marks a shift to representational imagery, which many Abstract Expressionists tried to avoid.

nationalistic manner. The new generation of artists wanted to develop a more abstract pictorial language based partly upon European precedent. This ambition is evident even in early paintings by Jackson Pollock (1912–56) such as *Bird* (c. 1938–41), which employs the same flattening of pictorial space and faux-naive handling of paint that was prevalent within European art movements such as Fauvism (see p.370), Cubism (see p.388) and Futurism (see p.396).

The Abstract Expressionists also looked towards Surrealism (see p.426) for inspiration and attempted to assimilate into their paintings the psychoanalytic ideas of Carl Jung (1875–1961) and Sigmund Freud (1856–1939) regarding myth, memory and the unconscious mind. Surrealist artists had arrived in the United States after the outbreak of World War II and a number of galleries and museums had staged exhibitions of their work. The American artists were formulating responses to, and drawing upon, an artistic movement that placed great importance upon social and technical forms of radicalism.

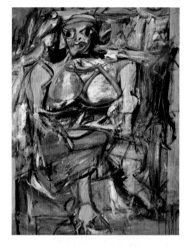

As Abstract Expressionism gained momentum during the second half of the 1940s, two broad pictorial styles emerged..The first style emphasized the expressive capacity of the brushmark itself, as exemplified in *Woman I* (right) by Dutch émigré Willem de Kooning (1904–97). It is one of a series of six figurative paintings of women that he produced from 1950 to 1955, all notable for their ferocious-looking figures enmeshed within an urgent, staccato-like configuration of brushmarks. 'Action' painters such as de Kooning took their cue from the spontaneous, psychic automatism of Surrealism and sought to uncover fundamental truths that resided within the artist's unconscious mind; these were unmediated by conscious decision-making processes and found expression in sweeping, gestural brushstrokes. Pollock experimented with this approach but increasingly moved to exploring line itself. He tested out the limits of this ambition in the 'all-over' canvases that he produced between 1947 and 1952. Having placed large, unprimed and unstretched sections of canvas on to the studio floor, he then moved slowly around, and occasionally across, the canvas, dripping, dribbling and flinging paint on to its surface. The result of this method of working is exemplified by *Blue Poles: Number 11* (1952; see p.458). Franz Kline (1910–62) was also interested in line, but paintings such as *The Bridge* (right) appear more calligraphic than Pollock's artwork because his improvised, sweeping brushwork merges negative and positive space.

The second Abstract Expressionist pictorial style provided a counter-strategy to action painting. Rather than producing canvases replete with a configuration of variegated painterly marks that supposedly indexed the artist's psyche, painters such as Barnett Newman (1905–70) sought to purge their canvases entirely of extraneous detail so that the viewer could be made aware of 'being alive in the sensation of complete space'. The Latin title of Newman's painting *Vir Heroicus Sublimis* (opposite) translates as 'Man, heroic and sublime'. Newman and his peers drew upon the idea of the sublime,

1953	1959	1961	1965	1966	1967
The Museum of Modern Art in New York purchases de Kooning's *Woman I*, a move that brings the work to wider public attention.	Pollock's style of action painting greatly influences Allan Kaprow (1927–2006), who choreographs the first public 'happening' in New York.	Abstract Expressionist sculptor David Smith (1906–65) begins *Cubi*—a series of large-scale, geometric steel structures.	'The Decisive Years, 1943 to 1953' exhibition features notable Abstract Expressionist works by de Kooning, Newman, Pollock and others.	Motherwell completes a mural for the John F. Kennedy Federal Building in Boston. To end speculation, he explains, 'The painting is totally abstract'.	One of Newman's three *Broken Obelisk* sculptures is installed in front of the Rothko Chapel in Houston.

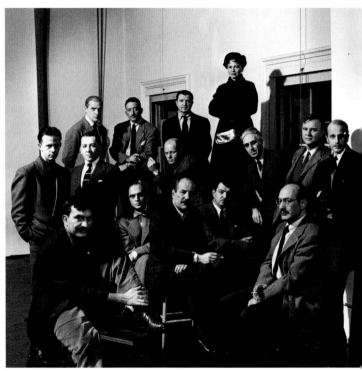

4 *The Irascibles,* a photograph of American abstract artists taken for *Life* magazine in 1950 by Nina Leen. It includes Willem de Kooning (back row, left), Jackson Pollock (middle row, third from left), Robert Motherwell (middle row, second from right), Barnett Newman (front row, centre) and Mark Rothko (front row, right).

5 *Pompeii* (1959)
Hans Hofmann • oil on canvas
84 ¼ x 52 ¼ in. / 214 x 133 cm
Tate Collection, London, UK

6 *Elegy to the Spanish Republic, 108*
(1965–67)
Robert Motherwell • oil on canvas
82 x 138 ¼ in. / 208 x 351 cm
Museum of Modern Art, New York, USA

as described in the writings of the 18th-century philosopher Edmund Burke (1729–97), as a way of thematically framing their endeavours. Newman sought to create art that instilled in the viewer a sense of experiencing a metaphysical encounter. *Vir Heroicus Sublimis* was the largest canvas up to this point in his career and functions as a chromatic expanse, offering a saturated visual field of colour within which the viewer is immersed. This second pictorial style was called 'colour field painting' by art critic Clement Greenberg (1909–94) and includes the work *Untitled (Violet, Black, Orange, Yellow on White and Red)* painted by Latvian-born artist Mark Rothko (1903–70) in 1949 (see p.456).

One of the first colour field painting theorists was the German teacher and painter Hans Hofmann (1880–1966). He had worked in Paris with avant-garde artists such as Robert Delaunay (1885–1941) and emigrated to the United States in 1932. His painting *Pompeii* (opposite, above) is typical of his later works, which are characterized by the juxtaposition of brightly coloured rectangles that the viewer interprets as being set back at varying distances; this deployment of form and colour is calculated to evoke a sense of tranquillity and space.

Some Abstract Expressionist artists experimented with both the expressive brushwork of action painting and the scale and saturated colour of colour field painting, as can be seen in works by Robert Motherwell (1915–91) such as *Elegy to the Spanish Republic, 108* (opposite, below). This is one of a series of more than 140 canvases, started in 1948, that typically consist of blot-like black ovals and white vertical rectangles. In the series Motherwell attempts to convey the sense of loss experienced by the world in the aftermath of the Spanish Civil War; he likened the blots to the display of a dead bull's testicles following a bullfight.

The idea that Abstract Expressionist paintings had no meaning and were concerned only with their technical radicalism and novelty gave the art establishment cause not to take the works seriously. In 1950 twenty-eight artists signed a letter to the president of the Metropolitan Museum of Art in New York protesting against a juried exhibition that aimed to enlarge the

museum's collection of contemporary art. The missive accused museum staff of favouring a jury that consisted of critics who were hostile to 'advanced art', and Abstract Expressionism in particular. Photographer Nina Leen (c. 1909–95) assembled fourteen of the protesters to take a photograph that later came to be known as *The Irascibles* (opposite). Ironically, the misunderstanding regarding Abstract Expressionism originated partly with Greenberg, the art critic most closely associated with it, who had championed the style and become its unofficial spokesperson. Greenberg's art criticism tended to emphasize the formal properties of a work of art and downplay or refuse to interpret its underlying meaning. Conservative critics tend to insist that meaning in art requires literal representation of recognizable subjects, so Greenberg's formal critical approach narrowed the Abstract Expressionists' audience.

However, other critics offered contrasting responses to Abstract Expressionism. Harold Rosenberg (1906–78) claimed that the artist's canvas, in the context of Abstract Expressionism, became 'an arena within which the artist could act'. By interpreting the act of painting as a psychological drama, Rosenberg promoted the idea of the 'artist as individual' that had already found expression in existentialist philosophy. Many Abstract Expressionists had grown up at a time when the United States was politically isolated in the world, and the archetypal Abstract Expressionist sought to rethink the terms upon which the role of an artist had been understood. It was unfortunate for the credibility of the movement that its drive towards artistic liberty became associated with right-wing individualism and reactionism. Abstract Expressionism's freedom was used as propaganda against Communism, which had found its own artistic expression in Social Realist painting.

The momentum of Abstract Expressionism, the breadth of its aesthetic and intellectual ambition, and the momentum of Modernism proved counter-productive for the movement. The demise of Abstract Expressionism arose out of the group's set of competing artistic values and temperaments, and from the fact that the next generation of artists was impatient to dismantle its perceived rhetoric and engage with different issues and contexts. **CS**

Untitled (Violet, Black, Orange, Yellow on White and Red) 1949
MARK ROTHKO 1903 – 70

oil on canvas
81 ¹/₂ x 66 in. / 207 x 167.5 cm
Solomon R. Guggenheim Museum,
New York, USA

When Mark Rothko painted *Untitled (Violet, Black, Orange, Yellow on White and Red)* he was arriving at a point of maturity in what was a highly nuanced and distinct visual style. He had abandoned any remaining references to recognizable imagery and consequently the painting owes its expressive force to its juxtaposition of a series of luminous rectangles of colour. The canvas, like many that Rothko executed in the late 1940s, is slightly larger than human in scale and this charges the relationship between the work and the viewer. The dimensions play a part in making the colours appear to hover slightly in front of the canvas, their literal support. Rothko was fully aware of the dramatic potential of his canvases of this time, saying in 1951 that he chose to paint large pictures '…precisely because I want to be very intimate and human. To paint a small picture is to place yourself outside your experience….However you paint the larger picture, you are in it.' Rothko achieves this immersion entirely by means of his highly sensitive, if not almost preternatural, command of colour. **CS**

◈ NAVIGATOR

◉ FOCAL POINTS

1 ORANGE PAINT

The area of orange paint weaves the two main parts of the central image together. By allowing the opaque red at the top of the painting to flow into the luminous yellow at the bottom, Rothko has made a semi-translucent bond between the two halves both physically and optically.

2 BLACK PAINT

The horizontal black bar divides the painting in half. The bar's function is to separate the red of the upper half from what appears to be partly a reflection of the red in the lower half. The bar also divides the smooth colour of the upper half from the more emphatic brushstrokes beneath. Rothko's art drew on form, line and, most importantly, colour as fundamental properties to be used in and of themselves, rather than be made to serve representational ends.

3 WHITE AND RED PAINT

White paint around the edge of the painting serves to frame and intensify the chromatic values of the central colours. At the same time, flowing red brushstrokes to the left and right frame and intensify part of the white border. As a result, the entire image seems to float or hover on a neutral ground.

4 YELLOW PAINT

The luminous yellow paint combines with the red to form the central image. When Rothko applied the colours his intention was not to produce a 'skin' of paint but to arrive at a stain of intense, pure colour. This would allow the weave of the canvas to glisten, rather than reflect or absorb incident light.

⏱ ARTIST PROFILE

1903–35

Born in Russia, Marcus Rothkowitz emigrated to the United States in 1913. He had his first one-person exhibition in New York in 1933 at the Contemporary Arts Gallery. In 1935, with other members of the Gallery Secession, he formed The Ten, a loose and progressive artists' collective.

1936–45

In 1936 Rothko was employed by the Works Progress Administration to produce paintings for federal buildings. He was naturalized as a US citizen in 1938. In 1945 he held a show at the Art of This Century Gallery, an exhibition space run by Peggy Guggenheim from 1942 to 1947.

1946–52

In 1948, along with Barnett Newman, William Baziotes (1912–63), David Hare (1917–92) and Robert Motherwell, Rothko founded The Subjects of the Artist School in New York to determine what should be the proper subject matter for the contemporary artist. He exhibited with other Abstract Expressionists in the show 'Fifteen Americans' at the Museum of Modern Art in New York in 1952.

1953–70

In 1958 Rothko showed at the Venice Biennale; he also began a series of paintings for New York's Four Seasons restaurant. In 1961 the one-person exhibition 'Mark Rothko' opened at the Museum of Modern Art. In 1964 he was commissioned to paint a series of murals for a chapel in Houston, Texas.

Blue Poles: Number 11 1952

JACKSON POLLOCK 1912 – 56

oil, enamel and aluminium paint
with glass fragments on canvas
83 7/8 x 192 1/2 in. / 213 x 489 cm
National Gallery of Australia,
Canberra, Australia

This transitional work by Jackson Pollock represents a development from his works that were created exclusively by dripping paint on to a medium—a style that peaked around 1950—towards a style incorporating figurative elements. Pollock's 'drip' method entailed placing the support, in this case a section of unstretched canvas, on the floor of the studio and then dripping, pouring and at times throwing paint over its surface. To the onlooker, this performance almost resembled a dance. In Pollock's earlier work he had tended to utilize a limited range of pastel colours in natural shades; for example, *Autumn Rhythm (Number 30)* of 1950 comprises black, brown, white and turquoise-grey. In *Blue Poles: Number 11*, the palette embraces harsher, more electric colours such as the blue of the eight 'poles' themselves.

Although Pollock's technique appeared to favour chance, the artist stressed that everything in his paintings was fully intended and stated, 'There is no accident.' Pollock believed that contemplation of his paintings gave the viewer access to personal and unconscious responses to the modern world. But whereas Pollock's earlier works invited open-ended interpretation, here the superimposition of 'poles' suggests schematic figures on a background, an innovation that elicits more specific associations from the viewer—swaying trees or masts being only two of them. As Pollock advised, the viewer should look passively and 'try to receive what the painting has to offer'. **FR**

 NAVIGATOR

1 INTERWOVEN COLOURS

Pollock made one pass after another across the canvas, using enamels of different colours and approaching from different angles. Like a spider weaving a web, he built up a carefully wrought, multi-layered and densely textured network of interrelated colours and lines.

2 VERTICAL ELEMENTS

On top of the web he had built up from rapidly applied lines of paint, Pollock finally added the more deliberate, traditionally painted, structural elements of the 'blue poles'. The blue streaks do not run into the background because the canvas was allowed to dry before they were painted.

3 DRAUGHTSMANSHIP

US poet Frank O'Hara once wrote about Pollock's painting: 'There has never been enough said about Pollock's draughtsmanship, that amazing ability to quicken a line by thinning it, to slow it by flooding.' This skill is evident even in Pollock's seemingly haphazard application of paint.

4 ARBITRARY EDGE

Pollock started painting with his canvas laid flat on the floor—there was no defined edge until the picture was framed. What we see in the painting is only the central action, and the corners and edges are arbitrary—they could have been closer to or further from the centre.

EUROPEAN FIGURATIVE PAINTING

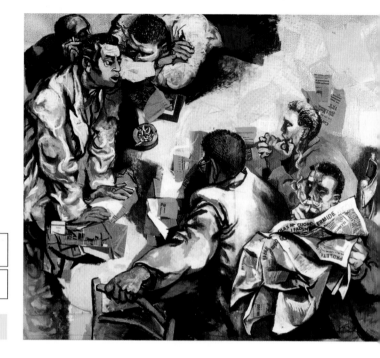

1 *The Discussion* (1959–60)
Renato Guttuso • tempera, oil
and mixed media on canvas
92 ½ x 99 ⅝ in. / 235 x 253 cm
Tate Collection, London, UK

2 *Portrait of Diego Seated* (1957)
Alberto Giacometti • oil on canvas
Fondation Maeght, Paris, France

3 *Head of J. Y. M.* (1973)
Frank Auerbach • oil on canvas
Sheffield Galleries and Museums Trust, UK

Although the years after World War II saw the widespread acceptance of abstract art in Europe, figurative artists generally preferred to portray figures and objects in a recognizable way. They painted challenging images of contemporary figures and their surroundings that were often unsentimental, sometimes poetic and occasionally brutal in their treatment of their subjects. Artists most closely associated with figurative painting include Francis Bacon (1909–92), Lucian Freud (b.1922) and Frank Auerbach (b.1931). Much of their work was as experimental as the work of the abstract artists: it embraced not only different styles of painting but also different theories of what should be represented and how. Bacon's representation of subject matter was the most controversial because his work featured unsettling, sometimes violent, figures in various states of grief, despair, isolation and oppression. In *Three Studies for a Crucifixion* (1962; see p.464) he represents his subject as a hunk of raw meat.

For some artists, figurative painting was the only artistic style that could make sense of social and political realities. Italian Communist painter Renato Guttuso (1911–87) combined painting and collage in *The Discussion* (above) to convey the heated debates about art and politics that marked the period. He frequently attracted controversy because of the subject matter of his work and

KEY EVENTS

1944	1947	1948	1950	1951	1951
Bacon finishes *Three Studies for Figures at the Base of a Crucifixion*. In later years he comments that he perceives this work as the start of his career.	Giacometti exhibits for the first time in twelve years. This is also the year in which he begins making his characteristic tall, skinny sculptures.	Sartre writes about the work of Giacometti in an essay titled *La recherche de l'absolu* (The Quest for the Absolute).	Kossoff begins attending art classes taught by Bomberg. Auerbach is a fellow student and both are influenced profoundly by Bomberg's style.	Taslitzky's *Riposte* is exhibited in Paris and causes widespread fury. It is removed from the exhibition, despite Taslitzky's protests.	Freud finishes two pivotal figurative works, *Interior in Paddington* and *Girl with a White Dog* (see p.462); they make him famous.

Crucifixion (1940–41), which denounced the horrors of war and depicted Christ as a symbol of human suffering, was fiercely attacked by the Vatican. Guttuso was a friend of Picasso (1881–1973), whose *Guernica* (1937; see p.434) influenced *Crucifixion*; indeed Guttuso drew on Cubism (see p.388) to give added force to his imagery. In France other Communist painters, such as André Fougeron (1913–98) and Boris Taslitzky (1911–2005), also aroused controversy: Taslitzky's *Riposte* (1951), depicting armed police attacking striking dockers, was forcibly removed from exhibition when first seen in Paris in 1951; Fougeron's *Atlantic Civilisation* (1953) attacked American influence on European politics and culture. German artist Georg Baselitz (b.1938) made paintings such as *The Big Night Down the Drain* (1962–63; see p.466) that were a response to Germany's role in World War II. His work helped keep German figurative painting alive in the 1960s and was a great influence on the younger generation of German Neo-Expressionists (see p.544) in the 1980s, who became known as the 'Neue Wilden' (Wild Youth).

In Britain, figurative painters such as John Bratby (1928–92) and Jack Smith (b.1928) were known for their 'kitchen sink realism', a derogatory term for a school of painting that depicted the daily toil of the working classes. Alberto Giacometti (1901–66), a Swiss-born painter and sculptor working in Paris and once a member of the Surrealist group (see p.426), had a very different vision of humanity. His portraits present the figure as fundamentally alone and isolated from society: an idea that had strong affinities with the existentialist philosophy espoused by Jean-Paul Sartre (1905–80), who was an eloquent commentator on the artist's work. Giacometti generally painted portraits of a select circle of family and friends, including his brother Diego, seen in *Portrait of Diego Seated* (right, above). These works were built up from a multitude of expressive brushstrokes that revealed the artist's own insecurities. Freud also preferred to paint people he knew, including his first wife Kitty in *Girl with the White Dog* (1950–51; see p.462). He concentrated his sensitivities on the depiction of flesh tones and his portraits of naked figures convey an intensity that is found rarely in 20th-century nude painting.

The British painter David Bomberg (1890–1957) inspired a number of figurative painters through his teaching. He shared with Giacometti the belief that a painting can never be completely finished and taught his pupils that an artist's perception of the world was not just a matter of the accumulation of visual detail: other senses have a part to play and an artist must depict the whole experience rather than the sum of its parts. Bomberg's best-known disciples are Leon Kossoff (b.1926) and Auerbach. Both artists became known for their use of impasto: thick paint and agitated surfaces that reflect their intense energy. Like Giacometti and Freud, Auerbach usually painted portraits of friends. He did not work from sketches or under paintings; instead he relied upon his sitters to replicate their pose from session to session. The pose, with head tilted back, seen in *Head of J. Y. M.* (right) was one he used frequently. **JGS**

1953	1954	1956	1957	1958	1965
Smith's *Mother Bathing Child* depicts an impoverished woman washing her child in a kitchen sink, leading to the term 'kitchen sink realism'.	Bratby wins an artistic bursary to travel to Italy. Unimpressed, he returns to England determined that all he needs for inspiration is already around him.	Auerbach has his first solo show. It is held at the Beaux-Arts Gallery in London.	Bomberg dies, unaware of the enormous impact his work is having on the figurative movement.	The French government is outraged by the suggestion, in Fougeron's *Massacre at Sakiet III*, that it was involved in the deaths of sixty-eight civilians.	Kossoff paints *Woman Ill in Bed, Surrounded by Family*. It draws on the artist's own experience but the composition is based on an engraving by Albrecht Dürer.

Girl with a White Dog 1950 – 51
LUCIAN FREUD b.1922

oil on canvas
30 x 40 in. / 76 x 101.5 cm
Tate Britain, London, UK

Lucian Freud was a good friend of Francis Bacon and shared that artist's bleak view of the human condition as being one of anxiety, isolation and loneliness. Nonetheless, Freud's early paintings, such as *Girl with a White Dog*, were hard-edged, tight and linear, and could hardly be more different technically from Bacon's loose and painterly works. Freud's early work owed much to Surrealism (see p.426) in its cold, disconcerting, intense atmosphere. Later his style became more figurative and his handling of paint more fluid; he was especially lauded for his ability to simulate flesh.

This is the last of the portraits that Freud made of his first wife, Kitty Garman, daughter of the celebrated sculptor Jacob Epstein (1880–1959). Their marriage broke up shortly after the painting was finished. The wide, subtly asymmetric eyes are typical of Freud's early painting. To prevent any intermingling of paint, Freud would use different brushes for each colour and would clean his brush after each application. The austere setting—a depiction of Freud's studio—is a regular feature of his work, regardless of who is sitting.

Freud was primarily concerned with capturing the psychological state of the sitter. The artist wrote that his object in painting pictures was to 'try and move the senses by giving an intensification of reality'. He also held that 'the subject must be kept under close observation' and that this must be 'day and night' so that every facet of the sitter's life would be revealed. Such observation enabled the artist to select the details that he needed to make his paintings stand independently, without reference to their original subjects. **JGS**

◉ NAVIGATOR

FOCAL POINTS

1 EYES

The popular saying that 'the eyes are the mirror of the soul' is nowhere more true than in Freud's early paintings. As here, the eyes tend to be large, widely spaced, glistening and somewhat staring. Vulnerable in themselves, they give expression to the anxiety and apprehensiveness of the sitter.

2 BREAST

Kitty Freud was pregnant at the time of the painting, and the suckling of a baby is suggested by her single, exposed breast. The pose may have been inspired by *The Virgin of Melun* (c. 1450–53), a depiction of the Madonna and child by the French painter Jean Fouquet (c. 1420–81).

3 DOG

The dog resting its head on the sitter's knee was a wedding present to the couple. Freud's placement of the dog's head, combined with its watchful look, qualifies the erotic connotations of the sitter's exposed breast and the bed with a message of sexual inaccessibility.

4 FOOT

The convincing depiction of feet is one of the supreme challenges in drawing. In all his portraits, Freud attempts to express the soul of his sitter through careful observation of the body. Here, he devotes as much attention to the sitter's foot as to her hands and face.

5 MATTRESS

The distortion of the stripes beneath the sitter and her dog communicates their weight. By placing his partly unclothed sitter on an unsheeted mattress, Freud suggests that this is an intimate scene and thus emphasizes the sexual connotations of the encounter between portrait and viewer.

ARTIST PROFILE

1922–44
Lucian Freud was born in Berlin, the son of an architect and the grandson of the psychoanalyst Sigmund Freud. He moved to Britain in 1933. His first solo exhibition was in 1944.

1945–58
His large painting *Interior near Paddington* (1951) depicted photographer and friend Harry Diamond. Freud was chosen for the British Pavilion of the 1954 Venice Biennale. *Woman Smiling* (1959) was an early example of a more painterly style.

1959–83
Freud had a major retrospective in 1974 at the Hayward Gallery, London. It included detailed views of plants and waste ground as well as the portraits familiar to his admirers. He declined a CBE in 1977 but in 1983 was made a CH.

1984–88
Freud had an international exhibition of his work in Paris in 1987 to 1988. He painted *Leigh Bowery Seated* (1990), one of a series of nude paintings of the performance artist who was notorious for his extravagant costumes.

1989–present
He completed a controversial portrait of Queen Elizabeth II (2001). A nude portrait of Sue Tilley, *Benefits Supervisor Sleeping* (1995), was sold in 2008 for $33.6 million, an auction record for a work by a living artist.

FREUD AND HIS SITTERS

Freud's sitters have generally been close friends or members of his large family, such as his daughter Annie, portrayed in *Annie Reading* (1969; below). The sittings can take many months: in one case a woman was depicted with a child with whom she became pregnant in the early months of the painting. By the time the picture was finished, she was almost ready to give birth again.

In Freud's portraits there is rarely any precise indication of the sitter's social role or status; the artist prefers instead to concentrate on psychological tension and the physical relation of the sitter's body to its setting. He is also drawn to draw unusual bodies, most famously in the series of nude portraits of Sue Tilley (known as Big Sue); he found beauty in the luxuriant folds of his subject's flesh.

Three Studies for a Crucifixion 1962

FRANCIS BACON 1909 – 92

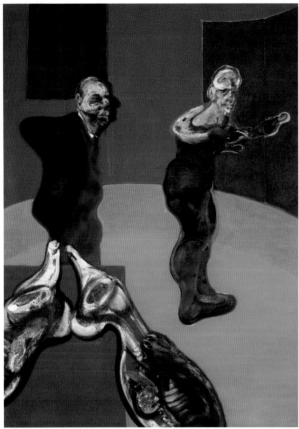

oil with sand on canvas
78 x 57 in. / 198 x 145 cm (each panel)
Solomon R. Guggenheim Museum,
New York, USA

This work was painted over two weeks, with the intention of providing a suitable climax for Francis Bacon's retrospective at London's Tate Gallery in 1962. Its acquisition by one of the leading museums of modern art in the United States helped to seal Bacon's international reputation as a figurative painter. The frankness with which Bacon treats themes of violence, sexuality and mortality was extreme for a British painter of his day. By Bacon's own admission he produced this painting during a period of drunkenness and hangovers. Far from viewing his intake of alcohol as a disadvantage when working, the artist maintained that it gave him greater artistic freedom.

Although Bacon was an avowed atheist, this was not the first work in which he adopted the traditional triptych form used for altarpieces—his *Three Studies for Figures at the Base of a Crucifixion* (1944) was also a triptych. Bacon had also previously produced several paintings relating to the Crucifixion theme, the first in 1933. The Crucifixion of Christ has long been a central subject in European art and Bacon realized that he could exploit its connotations of ritual sacrifice by placing it in secular contexts. Bacon saw the Crucifixion as an established symbol of the brutality and violence of human behaviour; this is underlined by his representation of the victim as butchered meat. He emphasized human mortality by displacing the Crucifixion from its usual central position; there is no Christian sense of hope or resurrection, only one of anxiety and fear. **JGS**

⬙ NAVIGATOR

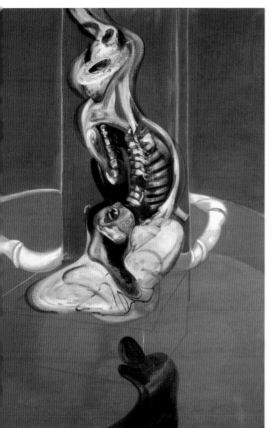

⏱ ARTIST PROFILE

1909–26
Bacon was born in Dublin to English parents. He and his family moved to London in 1914 when World War I started.

1927–44
Bacon went to live in Berlin, then Paris, and began to draw and paint in watercolour. In 1928 he returned to London and worked as an interior and furniture designer. Bacon started to paint oils in a style that was influenced by Pablo Picasso and Surrealism (see p.426), but destroyed many of his works.

1945–56
The artist created a sensation when he exhibited his oil and pastel triptych *Three Studies for Figures at the Base of a Crucifixion* (1944). His first major solo exhibition in 1951 included the first of a series of paintings based on Diego Velázquez's (1599–1660) *Portrait of Pope Innocent X* (1650).

1957–92
Bacon exhibited a series of paintings inspired by Vincent van Gogh's (1853–90) *The Painter on the Road to Tarascon* (1888). In 1962 the Tate Gallery organized a retrospective of his work and Bacon resumed his use of the triptych, which had become his characteristic format. He died of pneumonia in Madrid.

👁 FOCAL POINTS

1 MAN IN AWKWARD POSE
Bacon hated narrative readings of his work, but some critics have suggested that this figure represents his father, an army officer and racehorse trainer, casting out his son whose homosexuality had been discovered. The awkward pose and distortion add to the impression of malevolence.

2 MANGLED BODY
Bacon is known for the visceral quality of his paintings. Here the exposed rib cage of the mangled, crucified figure sliding down the cross resembles a butchered carcass of meat. Bacon stated that images of slaughterhouses were an inspiration: a reminder that humans are made of flesh.

3 SHADOWY FORM
The voyeuristic presence of an observer is suggested by this disturbing figure. Bacon's work is always enigmatic: the image is reminiscent of the saints present in traditional representations of the Crucifixion; it may even suggest death or a soul departing from the dead body.

4 ABSTRACT EFFECT
Although Bacon is one of Britain's foremost figurative painters, his paintings can appear abstract when closely examined. A gambler in art as well as in life, he exploited the effects of accident and left splashes of paint if they added to the emotions he was trying to evoke in a work.

5 CENTRAL FIGURE
The bloody image of a bulbous man lying in a foetal position on the divan in the central panel embodies human vulnerability. The figure is writhing in anguish. Whether his pain is existential or physical is unclear, and it may refer to Bacon's taste for sadomasochistic activity.

The Big Night Down the Drain 1962 – 63

GEORG BASELITZ b. 1938

oil on canvas
98 ³/₈ x 70 ⁷/₈ in. / 250 x 180 cm
Museum Ludwig, Cologne, Germany

⬢ **NAVIGATOR**

Georg Baselitz began his career in an era dominated in art by abstraction and Minimalism (see p.520), yet turned instead to German Expressionism (see p.378) for inspiration. He produced deliberately crude and sometimes obscene figurative paintings that addressed the trauma and confusion he encountered within a divided and politically fractious Berlin. Baselitz came from a generation of German artists who were taking as subject matter their country's responses to its terrible legacies from recent decades. Baselitz and Eugen Schönebeck (b.1936) made their challenge to the prevailing mores and values explicit in 1961 with their *Pandämonische Manifest 1* (*Pandemonium Manifesto 1*).

In what is probably a self-portrait, *The Big Night Down the Drain* depicts a boy or man wearing shorts and apparently masturbating. The act may be connected to the supine figure in the background, or it may be unconnected—Baselitz was aware of similar erotic images produced by the mentally ill. Imbued with a psychological and poetic complexity, *The Big Night Down the Drain* seems far removed from the contemporary artistic debates taking place elsewhere in the world. The work is replete with references to other artists, primarily late canvases featuring crudely rendered figures by the American artist Philip Guston (1913–80). Baselitz casts his disturbing, ageless, anti-heroic protagonist—with its blank stare and roughly drawn limbs—as a tragic figure whose role appears to be to confront the many unpalatable truths facing post-war Germany. **CS**

👁 FOCAL POINTS

1 BLOOD-RED PAINT
Red paint in the background on the left suggests recent violence and echoes the blood-red treatment of the figure's ear. The masturbator's complicity in the violence is suggested by the red, which seems to bleed from the figure into the background and vice versa, one affecting the other.

2 FACE
The face of the masturbator, conveys Baselitz's feelings about the dwarf-like subject. With tiny eyes and a barely suggested nose, mouth and moustache, the face and hair resemble the physiognomy of Adolf Hitler, suggesting a representation of a traumatized Germany.

3 FIGURE ON FLOOR
There is no explicit clue to explain the fate or *raison d'être* of the slumped figure behind the masturbator. Apparently naked and smeared with red, it appears to have suffered violence. It may represent the German nation, brought down by the ambitions of Hitler and National Socialism.

4 PENIS
Baselitz deliberately gave his figure a grotesque penis as an aggressive act aimed at the German viewer, who typically insisted on art that disguised or concealed the reality of post-war Germany. The painting's visual link between sexual gratification and violence speaks of national violation.

🕐 ARTIST PROFILE

1956–62
Born Hans-Georg Kern, the artist studied painting at the Hochschule für Bildende Künste in East Berlin but was expelled for 'socio-political immaturity'. He moved to West Berlin and renamed himself Georg Baselitz, the new surname drawn from his place of birth: Deutschbaselitz, Saxony.

1963–68
The Big Night Down the Drain and another canvas from his inaugural one-person exhibition at the Galerie Werner & Katz in Berlin in 1963 were confiscated by the authorities on the grounds of obscenity. In 1965 he won a scholarship for a year's residential study at the Villa Romana in Florence.

1969–78
In 1969, Baselitz made his first painting in which the figures are upside down, a motif that appears throughout his oeuvre. In 1972 Baselitz exhibited work in Berlin's documenta 5.

1979–present
Baselitz began to make monumental sculptures in wood. After the reunification of Germany in 1990, a calmer, more pastoral element entered his paintings.

EUROPEAN LYRICAL ABSTRACTION

1 *Capetians Everywhere* (1954)
Georges Mathieu • oil on canvas
116 ⅛ x 236 ¼ in. / 295 x 600 cm
Musée National d'Art Moderne,
Centre Pompidou, Paris, France

2 *Phoenix II* (1951)
Wols • oil on canvas
36 ¼ x 28 ¾ in. / 92 x 73 cm
Private collection

3 *Untitled* (1956)
Hans Hartung • India ink on paper
10 ¾ x 8 ⅛ in. / 27.5 x 21 cm
Private collection

L yrical Abstraction originated in Europe as a reaction to the attempts of
numerous painters influenced by Geometric Abstraction to treat pictorial
form in a systematic and entirely rational way. Although elements of
Lyrical Abstraction are discernible within the so-called 'improvisations' of
Wassily Kandinsky (1866–1944), it was in 1947 that the French painter Georges
Mathieu (b.1921) coined the phrase *abstraction lyrique* to describe paintings
that emphasized the unique personal expressiveness of the artist. European
Lyrical Abstraction is a development of particular aspects of both Surrealism
(see p.426) and Abstract Expressionism (see p.452), combining Surrealism's
fascination with the freely expressed psychic state of the artist with Abstract
Expressionism's emphasis on the artistic 'gesture'.

Mathieu attempted to extend and refine his ideas by developing an
expressive and quasi-calligraphic vocabulary. He gained a degree of notoriety
by 'creating' large-scale paintings in front of an invited audience, assuming the role
of showman and making explicit the idea of artistic performance that had always
been tacitly present when Jackson Pollock (1912–56) made his 'all-over' canvases.
On one occasion, Mathieu painted a 40-foot-long (12 m) canvas, *Homage to the
Poets of the Whole World*, at the Théâtre Sarah Bernhardt as part of Paris's
Festival International d'Art Dramatique in 1956. In works such as *Capetians
Everywhere* (above), Mathieu sought to elevate the painter's expressive mark
to the point where his psychic energies seem to be fully manifested in the form
of a lyrical, painterly, yet for the most part monochromatic, line. In contrast, the

KEY EVENTS

1947	1948	1949	1950	1951	1951
The exhibition 'L'Imaginaire' is organized by Mathieu at the Palais du Luxembourg, with works by Wols, Riopelle, Hartung and Picasso.	The 'HWPSMTB' exhibition is named after seven artists: Hartung, Wols, Francis Picabia, François Stahly, Mathieu, Tapié and Camille Bryen.	Artists including Wols, Mathieu, Jean Fautrier (1898–1964) and Jean Dubuffet (1901–85) exhibit in 'Huit œuvres nouvelles' at the Galerie Drouin, Paris.	Estienne questions the role of academic painting in his pamphlet *L'art abstrait est-il académisme?*	Michel Ragon publishes *Expression et non-figuration*, further promoting what is by now an established movement.	The show 'Véhémences confrontées' in the Galerie Nina Dausset, Paris, compares works by European and American Lyrical Abstractionists.

work of Jean-Paul Riopelle (1923–2002) did not exploit any single pictorial device or strategy; instead, his *Painting* (1951–52) and other works recalled the all-over appearance of canvases made by Pollock between 1947 and 1952.

Although the artists associated with Lyrical Abstraction placed great emphasis on the material aspects rather than the content of their works, many of the paintings express a sense of disquiet that reflects the social context in which they were produced. During World War II an entire generation of artists had been faced with the question of what kind of art could or should be made in response to the horrors of war. For the Lyrical Abstractionists the question affected their work in a very subtle, yet palpable way. For example, the German artist Wols (Otto Wolfgang Schulze; 1913–51) was interned by the French for a period of fourteen months at the start of the war; in his work *Phoenix II* (right, above), Lyrical Abstractionist spontaneity of gesture is supplemented by stains of colour and fine tracery that together suggest blood and physical injury.

Mathieu was the progenitor of two exhibitions in Paris that were important in the crystallization of Lyrical Abstraction: 'L' Imaginaire' in 1947 at the Palais du Luxembourg, and 'HWPSMTB' at the Galerie Colette Allendy in 1948. The earlier exhibition included an eclectic mix of painters, ranging from Riopelle and Mathieu to Picasso (1881–1973) and Hans Hartung (1904–89), whose later work *Untitled* (right, below) is a powerful example of monochromatic gestural art. It was the eclecticism of Mathieu's selected artists that led to the coining of the term 'Lyrical Abstraction', referring to a type of painting that privileged both the subjectivity of the artist and the primacy of the mark itself. However, the spontaneous and expressive painterly styles of these artists quickly fell under the rubrics of other, often interrelated, categories of painting that were being mooted at that time. For example, critic Charles Estienne introduced the term 'Tachisme' in 1954 (from the French word *tache*, meaning 'stain') in relation to another related term, *Art Informel* (art without form), which had been introduced in 1952 by the artist Michel Tapié (1909–87).

Lyrical Abstractionism attempted to build on key aspects of Modernist painting—gesture and a focus on materials—and its decline was signalled by the beginnings of a Post-modernist sensibility. The physical gesture ceased to be the prime concern of artists; increasingly paintings became meditations, less immediate and less reverential than before, upon the role of the objects being depicted. This new emphasis had its roots in the legacy of Dada (see p.410) artist Marcel Duchamp (1887–1968), taken up by Jasper Johns (b.1930) and Robert Rauschenberg (1925–2008). In particular, the artistic potential of the *objet trouvé* (found object) or 'ready-made' made artists realize that Modernism did not imply abstraction. Artists such as Pierre Restany (1930–2003), Yves Klein (1928–62) and Piero Manzoni (1933–63) all sought to extend the parameters of avant-garde art in Europe through a critique of artistic gesture rather than a celebration of it. **CS**

1952	1953	1954	1954	1956	1960
Tapié coins the term *Art Informel* in his book *Un Art Autre* to describe gestural and improvisatory works that completely break with tradition.	Gallery owner Jean-Robert Arnaud founds the art and architecture magazine *Cimaise*, gaining publicity for the Lyrical Abstractionist artists.	Nicolas de Staël (1914–55) paints *Nice* (see p.470), in which the French city is suggested solely by juxtaposed broad areas and bands of colour.	Estienne introduces Tachisme, which features gestural brushwork, dribbled paint and suggestions of scribbled writing.	As part of the Festival International d'Art Dramatique, Mathieu paints *Homage to the Poets of the Whole World*, at the Théâtre Sarah Bernhardt.	The introduction in Milan of Nouveau Réalisme by Restany and Klein ends the vogue for Lyrical Abstraction.

Nice 1954
NICOLAS DE STAËL 1914 – 55

oil on linen
28 ⁷/₈ x 36 ³/₄ in. / 73.5 x 93.5 cm
Hirshhorn Museum and Sculpture
Garden, Washington, DC, USA

I n 1955, one year after Nicolas de Staël produced this painting, the artist committed suicide at the age of forty-one, exhausted, depressed and discouraged by adverse criticism of his attempts to reconcile abstract and figurative art. *Nice* was painted at a time when the Russian-born artist had become increasingly restless and peripatetic. He had spent two years of his life in the French city of Nice after his demobilization from the French Foreign Legion in 1941 and it was here that he had met other artists who were also determined to explore the potential of abstraction within painting.

On one level this work—painted years after de Staël's wartime stay in Nice—can be appraised as an attempt to depict a remembered past. The painting's economy of form, line and colour, along with the flattening of space that underpins its composition, may be construed as suggesting the vicissitudes of memory as well as its tendency to simplify and distort the past. De Staël included no identifiable detail and avoided any hint of nostalgia, presenting instead a schematic yet solidly rendered approximation of the coastal city. Applying the paint with a palette knife in a thick impasto, he counterbalanced perfectly the three contiguous and discrete blocks of pale grey, red and black with the three horizontal bands of green. The painting's serenity, rather than deriving from faithfully represented qualities of its subject matter, is achieved solely through de Staël's mastery of compositional effects and his sophisticated understanding of highly nuanced colour harmonies. **CS**

 NAVIGATOR

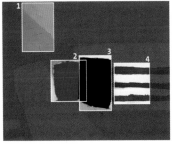

◉ FOCAL POINTS

1 DIAGONAL

The diagonal set up by the meeting of the grey and green areas of paint helps to create a soft, perspectival landscape. If the diagonals of the painting were extended, they would meet at a vanishing point beyond the top left corner of the painting, as might occur in a representational painting. This detail demonstrates the degree to which European, as opposed to American, abstract painters were at this time still committed to representational or 'reminiscent' abstraction.

2 SLAB OF RED

Set in a field of tertiary colour, this slab of pure red was a 'high note' applied quite late in the process of making the painting. De Staël applied it with one sweep of the palette knife and then modified it to make the central area more smooth, reflective and dominating.

3 BLACK RECTANGLE

This near-rectangle of thick black paint performs two functions. The first is to adjust the flatness of the painting and gradually bend it into the perspectival framework set up to its left; this is achieved by tapering the top and bottom edges towards the top left. The second function is to interact with the red as an active foreground protagonist. It is as if the black rectangle bounces off the red one to give the painting its energy.

4 GREEN STRIPES

Within the half-abstract, half-representational world of this painting, the green stripes drag the energy of the red–black collision off to the right, while suggesting a three-dimensional structure. Probably the artist's final gesture within the painting, the green stripes are in effect his closing remarks.

◔ ARTIST PROFILE

1914–39

Born in St Petersburg, de Staël moved with his sisters to Brussels in 1922, and in 1932 he commenced his formal education at the Académie Royale des Beaux-Arts. He travelled to Morocco in 1936 and met the painter Jeannine Guillou (1909–46). In 1939 he returned with Guillou to Paris; he enlisted with the Foreign Legion at the outbreak of World War II.

1940–46

De Staël was demobilized in 1941 and joined Guillou in Nice, along with other artists. He returned to Paris in 1943. In 1944 the art dealer Jeanne Bucher exhibited works by the artist in her Paris gallery. Guillou died in 1946.

1947–52

De Staël married Françoise Chapouton in 1947. During the same year he moved into a studio on Rue Gauguet in Paris. In 1950 he was represented by the dealer Jacques Duborg. In 1951 he had his first exhibition in New York and he was also invited by René Char to illustrate a book of his poetry. In 1952 de Staël had his first London exhibition, at the Matthiesen Gallery.

1953–55

In 1953 de Staël moved to Lagnes, near Avignon, where he established a studio. In 1954 his work was exhibited at the Paul Rosenberg Gallery in New York, and he settled in Antibes. In 1955 he committed suicide by jumping from a building.

PATH TO ABSTRACTION

The two years that Nicolas de Staël (below, in his Rue Gauguet studio) spent in the city of Nice after his demobilization in 1941 had a profound impact on his artistic ambitions. He spent much time in the company of artists including Robert (1885–1941) and Sonia Delaunay (1885–1979), Alberto Magnelli (1888–1971) and Jean (aka Hans) Arp (1886–1966), who were all developing different ways of abstraction to liberate form from traditional figuration. In the post-war years, de Staël quickly became known as one of the leading abstract painters associated with the Ecole de Paris. His abstract work was influenced by his close friendship with

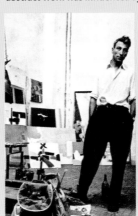

Georges Braque (1882–1963), whom he came to know in Paris in 1947. Another influential friendship was that of German artist Johnny Friedlaender (1912–92), who said abstract artists could mediate understanding of the world by animating forms with a 'soul'; the process of abstraction helped the artist to reveal the essence of the entity depicted.

AFRICAN ART

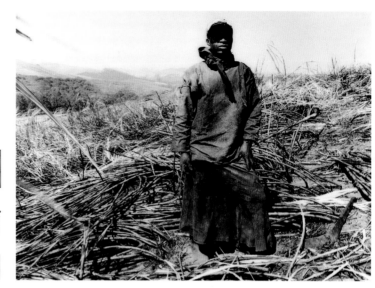

1 *Untitled,* from the series 'Sugar Cane Workers' (*c.* 2003)
Zwelethu Mthethwa • colour photograph
5 ³/₄ x 7 ¹/₂ in / 14.9 x 19.3 cm
Musée National d'Art Moderne, Centre Pompidou, Paris, France

2 *Flowers in a Vase* (1962)
Uche Okeke • gouache on paper
22 x 15 in. / 56 x 38 cm
Collection Skoto Gallery, New York, USA

3 *Jackson's Throne* (1989)
Jackson Hlungwani • iron and wood
47 ¹/₄ x 27 ⁵/₈ x 31 ¹/₂ in. / 120 x 70 x 80 cm
Gallery 181, Randburg, Gauteng, South Africa

In the 19th century transatlantic slavery was abolished, only to be replaced by the gradual imposition of colonial rule. This rule was contested from the outset by local intellectuals, whose research and political action led to the development of modern ethnic and national identities. Out of this period of rapid and far-reaching political, technological and religious change, the three most surprising elements in the African visual arts have been the development of photography; the resilience of local traditions of ceremony, masquerade, healing cults and textile and dress production; and the emergence of new art forms in painting, printmaking, sculpture, public art and installation. A new tradition of African-print cloth arose from the Dutch attempt to undercut Indonesian batik, alongside local resist-dyeing. All these art forms have flourished in ways that now define a series of local African visual modernities.

Photography arrived in the cities of coastal West Africa from the 1840s, brought by African, African-American and European photographers. African traditions of portraiture and documentation avoided the exotic and 'primitive' imagery to which European photographers were prone. Photography became a popular means of self-representation, and today most African homes display photographs articulating the realities and choices of fashion, status, modernity and tradition. One of the many outstanding portraitists was the Malian Seydou Keita (1921–2001), who was active in Bamako in the 1950s.

The first sub-Saharan African painter using easel, canvas and oils was Aina Onabolu (1882–1963) of Lagos, Nigeria. He was self-taught but wanted

KEY EVENTS

1948	1951	1952	1958	1960	1960
Keita sets up his first photographic studio at Bamako-Koura in the Malian capital.	*Drum* magazine is published in South Africa. Soon to become Africa's foremost black family magazine, it showcases the work of black photographers.	Artist Cecil Skotnes (1926–2009) joins Johannesburg's Polly Street Recreational Centre and transfoms it into an art school.	The Zaria Art Society is organized at the Nigerian College of Arts, Science and Technology by Okeke, Onobrakpeya and other students.	Nigeria becomes a state independent of Britain; Ivory Coast and Togo gain their independence from French rule.	Okeke is instrumental in producing 'Natural Synthesis', a manifesto calling for a synthesis of African traditional art and the principles of modernism.

to establish art education within the colonial education system. Following in Onabolu's footsteps was Ben Enwonwu (1921–94), the first sub-Saharan artist to gain an international reputation. The publicity given to developments in Nigeria stimulated similar events in Uganda. By the late 1950s, in Zaria, Nigeria, at the very first university fine art department, a group of students led by Uche Okeke (b.1933) and Bruce Onobrakpeya (b.1932) set about reforming the teaching syllabus to emphasize indigenous artistic traditions. Under the rubric of 'Natural Synthesis', they sought a focus on myth, folktale, textile design and body arts, believing that these traditions could enrich a modern Nigerian art. Okeke's *Flowers in a Vase* (right, above) is an example of his work from this time. Nigeria has since seen the growth of a secure local, state and individual patronage and several universities with fine art and graphic design departments that offer improved prospects for upcoming generations of artists.

However, while art colleges emerged in almost every country, they were not the only context for the appearance of new art forms. Apprenticeship continued to be a means of entry to visual practice, as in the signpainting of Congolese Chéri Samba (b.1956) and Ghanaian Kwame Akoto (b.1950; aka Almighty God). Very occasionally a genuine visionary has appeared, free of either the art college or the studio master. One such is Frédéric Bruly Bouabré (b.1923) of the Ivory Coast, a former civil servant who, after a vision of cosmic activity, took to drawing as a way of understanding the world. Romuald Hazoumé (b.1962) began making art by seeing faces in the discarded plastic rubbish of Porto Novo. His work (see p.474) represents a younger generation of artists outside the usual educational trajectories.

In 19th-century South Africa the traditions of its black population were concerned with gender, initiation to maturity, warfare and internal hierarchy. An interest in painting, sculpture, graphics and installation developed within rural areas and black townships, and by the mid 20th century, photographers, especially through *Drum* magazine, had published evidence of the brutalities of apartheid. Artists such as Gerard Sekoto (1913–33) were forced to live and work in Europe. Under apartheid, art was not deemed an appropriate subject in the education of black South Africans, although with white patronage there were successful projects, such as Johannesburg's Polly Street Centre in the 1950s, and the Rorke's Drift Art and Craft Centre in Natal in the 1960s. After Polly Street was closed, white artists such as Bill Ainslie (1934–89) opened their studios to black South Africans, including David Koloane (b.1938). These artists and many others, including Penny Siopis (b.1953) and Jane Alexander (b.1959), exposed the traumas of apartheid, while the photographs of Zwelethu Mthethwa (b.1960; opposite) reveal the continuing legacy of inequality. Meanwhile, in rural Transvaal, sculptor Jackson Hlungwani (1923–2010) continued his work of healing the world through constructing his own New Jerusalem. *Jackson's Throne* (right, below) is typical of his powerful, rough-hewn sculpture. **JP**

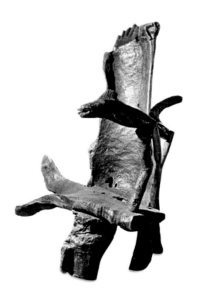

1966	1967	1982	1991	2006	2007
The first World Festival of Black and African Arts and Culture (FESTAC) is held in Senegal; a second festival is held in Nigeria in 1977.	On the outbreak of civil war in Nigeria, Okeke and Onobrakpeya are among artists forced to return to their Igbo homeland. Igbo art influences their work.	Bouabré produces his book *Ouest African Alphabet*, a blend of handwriting and illustrations designed to help Africans learn to read more quickly.	Koloane founds The Bag Factory studios, an important facility for both black and white artists in Johannesburg.	Akoto—whose studio of painters in Kumasi, Ghana is named the Almighty God Artworks—has a large solo show of his paintings in Accra.	Former advertising billboard painter Samba exhibits at the Venice Biennale. His theme is Sodom and Gomorrha in everyday street life.

ARTicle 14 2005
ROMUALD HAZOUMÉ b. 1962

mixed media installation
October Gallery, London, UK

Romuald Hazoumé was born in Porto-Novo, Benin Republic. Porto-Novo had once been the Atlantic port of the empire of Oyo, the great rival to Edo-Benin after the demise of Ife, the ancient Yoruba city in Nigeria. Porto-Novo had long been a cosmopolitan, multi-ethnic centre, a town of crooks, traders, priests and slaves, marketing all manner of goods, as well as people, from all around the Atlantic. This coastal region—now part of an almost continuous metropolis stretching from Lagos to Accra—is Hazoumé's subject.

ARTicle 14 takes its name from the hypothetical 14th article in African constitutions—'débrouilles-toi, toi même'—suggesting 'get by as best as you can on your own'. Hazoumé's market stall references the street traders who are struggling to survive in urban West Africa. The installation also critiques consumerism and globalization; many of the objects on the stall—football shirts, mobile phones, plastic toys and DVDs—are imported from outside Africa. Hazoumé points to the unequal trade relationship that has long existed between Africa and Europe: 'Today Europeans have taken away all our masks, in return they have left us waste which we do not even manufacture ourselves'. This waste is found littering every African town or city. The use of found objects points to the resourcefulness of Africans but also, the artist believes, traces the relationship between objects and people: 'Everything we use says something about us…It is in these materials that we can read about the lives of people'. **JP**

✦ NAVIGATOR

1 PLASTIC JERRY CAN

The jerry can is a good example of how Africans get by in the best way they can. The jerry cans are heated and stretched to increase their capacity for carrying black market petrol from Nigeria. Young men carry the fragile plastic cans on the back of motorcycles, which often results in fatal accidents.

2 PHOTOGRAPH OF STALL

Behind the market vendor's stall is one of Hazoumé's panoramic photographs of an African street market. Here the actual stalls that inspired him to make his installation can be seen. The hectic vibrancy of the scene in the photograph contrasts with the static nature of his stall in the gallery.

PLASTIC MASKS

Romuald Hazoumé first came to international attention through the witty and inventive masks he created from plastic jerry cans. The French curator and collector André Magnin bought a series of the Beninese artist's masks and later included them in the 'Out of Africa' show in 1992. The masks were not intended for wear or performance, but rather focused on the anthropomorphic possibilities of discarded plastic containers, while at the same time drawing attention to the vast quantities of dumped rubbish that litters almost every African town or city. Hazoumé uses the curves of the jerry cans to suggest facial features, with the spout becoming a mouth and the handle a nose. He then adds other items to transform the can into one of his 'characters'. For *Sénégauloise* (2009; below), for example, he added a piece of patterned fabric to make a traditional headwrap. 'You can see the character and personality in each one', Hazoumé says.

The artist may have been inspired by the masks traditionally worn by men at secret initiation ceremonies but his mask-making, like his other assemblages, are also connected to his view of contemporary African society and its problems.

⧗ ARTIST PROFILE

1962–92

Before turning to art, Hazoumé considered a career in medicine or sport. It is unclear whether he had any formal art training, although his work based on recycling found materials soon found an international resonance. In the mid 1980s he began sculpting masks using plastic jerry cans, which appeared in 'Out of Africa' at the Saatchi Gallery, London, in 1992.

1993–2006

His early mask-making led to more monumental forms and installations. In 1996 he won the George Maciunas Prize. From 1997 to 2005 he created *La Bouche du Roi*, his re-creation of a slave ship made from a combination of plastic petrol cans, spices and audio visual elements. The artwork was exhibited internationally and is now in the British Museum, London.

2007–present

In 2007 Hazoumé won the Arnold Bode Prize at documenta 12 in Kassel, Germany. In 2009 his solo exhibition 'Made in Porto-Novo' opened at the October Gallery, London. The artist continues to work in Porto-Novo while living in Cotonou in the Benin Republic.

EAST ASIAN ART

W hen *Execution* (above) by Yue Minjun (b.1962) sold for $5.9 million at London's Sotheby's auction house in 2007, it became the most expensive work of Chinese contemporary art. The price confirms the appeal of East Asian contemporary art to Western collectors; the work's similarity to *The Third of May, 1808* (1814; see p.270) by Francisco de Goya (1746–1828) illustrates the influence of Western iconography on East Asian art. The face frozen in laughter with closed eyes (a self-portrait) is a recurring motif in Yue Minjun's work, suggesting a concealment of underlying emotions.

Although Chinese contemporary art is in its infancy, it has gone through several stages. The liberalizing policies of the late 1970s led to a period of vibrant activity. Artists drew inspiration from performances and exhibitions that made contemporary Western art accessible for the first time and experimented with different styles and media. However, after the brutally suppressed Tiananmen Square protests in 1989, they began to question the notion of cultural identity. This led to the emergence of 'Political Pop art', which draws on Pop art (see p.484), and 'Cynical Realism', which focuses on socio-political issues. Artists such as Zhang Xiaogang (b.1958) started to grapple with their country's past in works such as *Bloodline Series* (1997; see p.482). The government began to view contemporary art as potentially subversive and prohibited artists from exhibiting their work publicly. In consequence, artists such as Zhang Huan (b.1965) left for the West. There he began to engage in a

KEY EVENTS

1954	1956	1959	c. 1960	1968	1979
Jiro Yoshihara (1905–72) founds Japan's 'Gutai Bijutsu Kyokai' (Gutai Art Association); the group's works anticipate Performance art (see p.512).	Japan becomes the first Asian country to open its own pavilion at the Venice Biennale.	Seoul's 'Contemporary Artist Invitational' show has paintings by South Korean *Informel* (Informal) artists inspired by *Art Informel* abstraction.	South Korean artist Suh Se-ok (b.1929) founds the Mungnimhoe group, which seeks to reinvigorate ink painting.	A group of Japanese artists form the 'Mono-ha' (School of Things) movement; it creates installations from natural and manmade materials.	China's leader Deng Xiaoping (1904–97) travels to the United States to meet the US president as relations with the West begin to thaw.

series of performances, including *Family Tree* (right), in which he invited three calligraphers to write Chinese texts on his face until it was completely black. During the run-up to the Beijing Olympics in 2008, restrictions—at least on apolitical art—were relaxed, and the 21st century has seen many artists return to China, bringing new influences and ideas with them. Artists are finding ways to interface with traditional Chinese ink painting and calligraphy, engage in performance art and work with new technologies in order to explore diverse themes, including globalization and issues of identity.

In Japan, fine art suffered from being viewed negatively by the West for a long time. Although Western concepts provided great stimulation for Japanese artists, they also destroyed the integrity of Japanese art. To comprehend the nature of Japanese art in modern times, it is necessary to understand this split identity. Japan's defeat in World War II and the subsequent dominance of US political and cultural forces significantly influenced the development of post-war Japanese art. The opening of Japan's pavilion at the Venice Biennale in 1956 symbolized Japan's return to the international art world. A number of Japanese artists absorbed Western avant-garde movements and made them their own, resulting in pieces such as the installation *Mirror Room (Pumpkin)* (opposite, below) by Yayoi Kusama (b.1929). The artist's psychedelic works reference abstract art, and the mirrors in her pumpkin-coloured room make the dots appear to continue to infinity, surrounding viewers when they enter the space. From the 1980s, Japanese art became an object of curiosity and was seen as the hybrid product of a highly technologically developed society that is a unique mix of the old and new. When the economic bubble burst in the 1990s, Japanese society faced unprecedented challenges and emerging artists began to question the nature of Japanese identity. The result was work such as *727* (1996; see p.478) by Takashi Murakami (b.1962), which references subcultures and has broadened the reach of contemporary Japanese art.

In South Korea, the context from which movements emerged after the Korean War was local, as were the artistic sources that artists referenced: from ink painting and white porcelain to *buncheong* (powder green) stoneware. Most South Korean artists first encountered Western art at home and then later when they studied abroad. Their sojourns affect their art practice. Themes of identity, movement and communication are explored in the 1990s by artists whose work has begun to be recognized, as exemplified in the performance piece *Cities on the Move–2727 km Bottari Truck* (1997; see p.480) by Kimsooja (b.1957). But Korean traditions still matter. The 'Mungnimhoe' (Ink Forest Group) of the 1950s and 1960s experimented with new visual languages using the traditional means of ink, brush and paper. The everyday is also a significant subject for artists. Reacting to contemporary political circumstances, 'Minjung Misul' (People's Art) of the 1980s reflected social realities through popular visual idioms such as *minhwa* (folk painting). **IY/EB/KM**

1 *Execution* (1995)
Yue Minjun • oil on canvas
59 x 118 ⅛ in. / 150 x 300 cm
Private collection

2 Performance stills from Zhang Huan's *Family Tree* performed in New York, USA in 2000.

3 *Mirror Room (Pumpkin)* (1991)
Yayoi Kusama • mirrors, iron, wood, plaster, styrofoam and acrylic paint
78 ¾ x 78 ¾ x 78 ¾ in. / 200 x 200 x 200 cm
Hara Museum of Contemporary Art, Tokyo, Japan

1985	1985	1986	1989	1999	2002
The first 'Asian International Art Exhibition' is held in Seoul, South Korea.	Robert Rauschenberg's (1925–2008) 'Overseas Cultural Interchange' opens at Beijing's China Art Gallery; it is the first time Pop art (see p.484) is shown in China.	South Korea first attends the Venice Biennale, using a small space within the Italian hall. The South Korean pavilion is built nine years later.	The massacre in Beijing's Tiananmen Square leaves hundreds of civilians dead. It triggers the rise of the Cynical Realism style.	The Italian pavilion at the Venice Biennale hosts ten Chinese artists. The first official Chinese pavilion is built in 2005.	The Today Art Museum is founded in Beijing. It promotes Chinese contemporary art and is the first privately run art museum in China.

727 1996
TAKASHI MURAKAMI b. 1962

acrylic on canvas mounted on board
118 x 177 in. / 300 x 450 cm
Museum of Modern Art, New York, USA
Courtesy of Blum & Poe, Los Angeles
© 1996 Takashi Murakami/
Kaikai Kiki Co., Ltd. All Rights Reserved

This early work by Japanese artist Takashi Murakami illustrates his artistic vision and technique. It comprises both Western and Japanese artistic elements and the title refers to a Japanese cosmetic company and references commercial jet airliners; it is said that Murakami found the diverse significance of the numerals both quirky and amusing.

The central image is one of the early versions of his signature character, 'Mr. DOB', which he created in 1993. An amalgamation of Doraemon (a robotic cat from a popular manga series in Japan) and video game character Sonic the Hedgehog, the ambiguous entity of Mr. DOB epitomizes the complex development of manga comic books and anime animated films in Japan after World War II. Observers may also detect a resemblance in Mr. DOB to the cartoon character Mickey Mouse. For Murakami, the influence of American subculture on post-war Japan symbolizes the impotence of Japanese politics, society and culture. Often changing its appearance and becoming a form of self-portrait, the Mr. DOB character appears in many of Murakami's works and has permeated Japanese society sufficiently to become a ubiquitous commodity.

The painting is multilayered in its meaning and its complexity is symptomatic of Murakami's art. For example, the DOB name is inscribed in the image, with 'D' represented on the left ear, 'O' as the circle outline of the face and 'B' on the right ear. The word 'DOB' is an abbreviation of the Japanese phrase 'dobojite, dobojite, oshamanbe'. *Dobojite* comes from the 1972 anime *Inakappe Taisho* (*General Taisho*) and is slang for 'why'. *Oshamanbe* was a catchphrase used by comedic actor Toru Yuri (1921–99) and is the name of a town in Hokkaido. **KM**

◆ NAVIGATOR

FOCAL POINTS

1 SURFACE

The triptych composition of the painting invites comparison with the format of traditional Japanese folding screens; it also emphasizes the image's flatness. Sometimes the artist uses a monochromatic background to produce a very smooth surface, but here the surface patina shows the traces of many layers of paint; Murakami applied and then scraped away the paint to create an effect reminiscent of those in *nihonga* paintings of the late 19th century.

2 EARS

Murakami gives his Mr. DOB character big, round ears like Mickey Mouse's, conjuring the essence of the cheerful cartoon character. However, the artist depicts Mr. DOB as a menacing creature and the round letter shapes on the ears emphasize the grotesque figure's multiple eyes.

3 WAVE

The elegant wave unites the composition. It brings to mind the waves depicted in Katsushika Hokusai's (1760–1849) woodblock print *Under the Wave, off Kanagawa* (c. 1829–33; see p.292). Hokusai was a *ukiyo-e* (pictures of the floating world) painter and printmaker and, by referencing such an iconic image, Murakami conflates a traditional style with the fluid and speedy movement found in contemporary anime and manga imagery.

4 MOUTH

Mr. DOB's sharp-toothed grin is a motif that also appears in other characters in Murakami's later works. The figure's gaping, open mouth suggests a guffaw, scream or growl and dramatizes the emptiness of meaning across the surface of the painting, conveying absurdity, fear and aggression.

ARTIST PROFILE

1962–93

Murakami was born in Tokyo. He studied painting at the Tokyo National University of Fine Arts and Music, and his doctorate thesis was titled 'The Meaning of the Nonsense of the Meaning'. He held his first solo show, 'Exhibition L'Espoir: Takashi Murakami', at Tokyo's Gallery Ginza Surugadai in 1989. He created his alter ego, Mr. DOB, in 1993.

1994–97

Murakami won a fellowship to study at New York's P.S.1 Contemporary Art Center. In 1996, he founded the Hiropon Factory in Saitama, a workspace for art projects; *hiropon* is Japanese slang for 'heroin'.

1998–2001

The artist set up the Hiropon Factory New York Studio in Brooklyn, New York. He curated the 'Superflat' exhibition at the Parco Department Store Gallery in Shibuya, which explored the effect of mass-produced entertainment on contemporary Japanese aesthetics; it opened in the Museum of Contemporary Art, Los Angeles, the following year. In 2001 Murakami also founded the Kaikai Kiki artists' collective.

2002–present

Murakami exhibited in Japan, Italy, Great Britain, France, Germany and the United States. The Guggenheim Museum Bilbao in Spain held a retrospective of his work in 2009.

SUPERFLAT THEORY

With a strong awareness of the flatness of *nihonga* paintings and a great interest in subcultural works, such as *Galaxy Express 999* (1979; below) by animator Yoshinori Kanada (1952–2009), Murakami notes that Japanese art is characterized by its flatness. This aesthetic observation has led him to see contemporary Japanese culture as being 'Superflat', in that it merges traditional Japanese and Western cultural influences with the modern *otaku* obsession with manga, anime and video games. He uses aspects of the Japanese *otaku* aesthetics as a critical tool to invade Western artistic values and create art that both amuses and unsettles. His Superflat theory legitimizes his use of Japanese 'low art' to produce works that appeal to 'high art' viewers both in Japan and the West, and successfully bridges the gap between the traditional and the contemporary.

Cities on the Move–2727 km Bottari Truck 1997
KIMSOOJA b. 1957

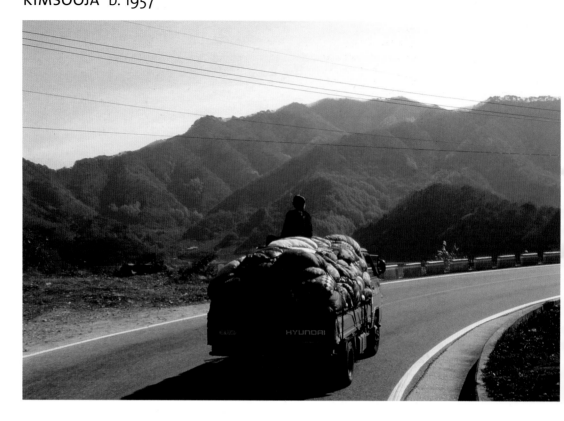

performance still
from a short film

⬡ NAVIGATOR

South Korean artist Kimsooja works across a range of media, including video, installation, performance and photography. Her work explores nomadism, the role of women in society and the relationship of the individual to society and the self. She references Christianity, Zen Buddhism, Confucianism, shamanism and Tao philosophy in an attempt to highlight the similarities and differences between various cultures and their spiritual beliefs.

In *Cities on the Move–2727 km Bottari Truck*, Kimsooja sat on a mound of multicoloured *bottari* (Korean for 'bundles') tied to the back of a blue pick-up truck. *Bottari* are used by ordinary people to store items when in transit, but in Korean 'bundle up one's *bottari*' signifies that a woman has to pack her things, having been forced from her home. Quiet, still and solitary, Kimsooja travelled 1,694 miles (2,727 km) across South Korea for eleven days in November 1997. Constantly in transit from one city or village to another, the artist relived her childhood nomadic lifestyle as part of a military family and acted out her itinerant existence as an artist travelling the globe, reliving memories and collecting new experiences. She shuttled through sights and sounds, weaving together a thick fabric of observations and contemplations.

In the videos documenting her journey, she appears as an anonymous silhouette against the shifting landscape: her body clad in black, hair pulled back in a ponytail, face turned away from the camera. She could be anyone: a refugee fleeing a war zone, a woman returning home and reconnecting with her past, an immigrant adapting to her adopted country, a seeker of alternate ways of living, a voyager navigating through a foreign culture, a drifting vagabond or a daring runaway. **IY**

⊙ FOCAL POINTS

1 BOTTARI TRUCK

The *Bottari Truck* is an ongoing project. Kimsooja installed it with a mirror structure as *D'Apertutto, or Bottari Truck in Exile* at the Venice Biennale in 1999, dedicating it to Kosovo War refugees. In 2005, it was installed with video projections in Cologne at a gallery adjacent to a former Nazi-run prison.

2 THE BODY

According to Kimsooja, her body was one of the *bottari* on the truck. Its contents—her inner self—altered in response to the physical environment and passing landscape. The relationship between the self and its surroundings oscillated between withdrawal and engagement.

3 THE LANDSCAPE

Rural and urban sceneries formed the backdrop of Kimsooja's performance as she revisited all the places she had lived, travelling up and down mountains, along winding coasts, across shores and through city traffic, and crossing natural and artificial borders. In one video of her journey, the viewer hears the artist identifying the locations she passes through; she claims the territories as she names them, but possesses each for just a fleeting moment.

4 BOTTARI BUNDLES

A *bottari* is a bundle wrapped in fabric, often containing a traveller's belongings. It signifies departure but not destination, and can be an emotionally charged artefact in the personal history of someone who had to flee because of war, hardship or ostracism. For her performance, Kimsooja reworked bed covers into *bottari* because they are colourful, intimate, everyday objects associated with dreams, tears, sickness, birth, lovemaking and death.

⊙ ARTIST PROFILE

1957–87

After studying painting at Hongik University in Seoul, South Korea in 1984 Kimsooja won a scholarship to study lithography at the Ecole Nationale Supérieure des Beaux-Arts in Paris. Inspired by her mother and grandmother, she started to use sewing as her main form of artistic expression.

1988–98

Kimsooja had her first solo show 'Kim Soo-Ja' at the Gallery Hyundai, Seoul in 1988. In 1992 she moved to live in New York and became the artist-in-residence for a year at the city's P.S.1 Contemporary Art Center. *Bottari* began to appear as a recurrent motif in her oeuvre.

1999–2005

She began her global performance and video project *A Needle Woman* (1999–2004). In 2003, the artist launched a website, inspiring her to use a 'one word name', which 'refuses gender identity, marital status, socio-political or cultural and geographical identity by not separating the family name and the first name'.

2006–present

The artist commenced her ongoing video projects *Mumbai: A Laundry Field* and *A Mirror Woman: The Sun & The Moon*, which are filmed in Mumbai and Goa in India. She continues to work on site-specific architectural projects in Europe.

LOTUS: ZONE OF ZERO

Shadows cast by the 2,000 hanging lotus-shaped lanterns and sounds of Tibetan, Gregorian and Islamic chants enveloped the audience in Kimsooja's *Lotus: Zone of Zero* (2008; below) at the Galerie Ravenstein in Brussels. Religious beliefs and cultural meanings are conflated in this piece. The lotus flower signifies the Buddhist concepts of purity, cause and effect. Set against the glass dome of a rotunda, the structure forms concentric circles like a rose window in a church. The circle is also the basis for patterns in Islamic art, as well as the Hindu and Buddhist mandala.

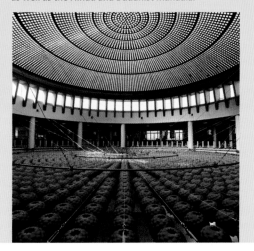

Bloodline Series 1997

ZHANG XIAOGANG b. 1958

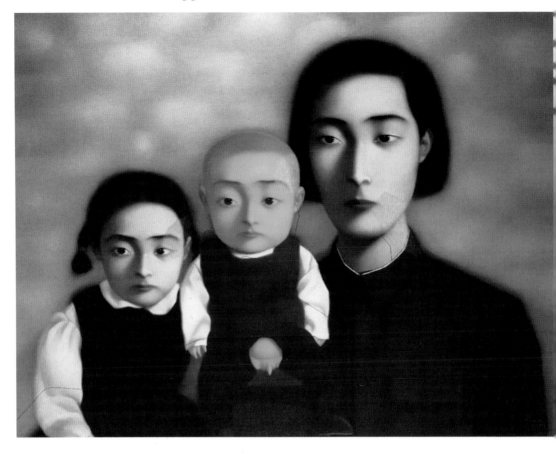

oil on canvas
58 ¼ x 74 in. / 148 x 188 cm
Private collection

◆ NAVIGATOR

The Chinese have traditionally regarded society as one large family with the family unit as its cornerstone. Proponents of this model argue that if individuals are taught assigned roles and responsibilities in relationship to one another within their family, they will then apply what they have learnt outside the nuclear family. This will benefit humankind at large and lead to peace and harmony in society. Yet in this portrait from the series *Bloodline*, Zhang Xiaogang asks what happens to individuality in a culture that puts the needs of society first.

Zhang was inspired to create his series by the studio family portraits taken during China's period of social and political upheaval known as the Cultural Revolution (1966–76). These photographs were characterized by a strict uniformity. Here Zhang depicts a family mostly in black and white against a grey background as if they were a faded memory or in an old photograph. The family members are virtually interchangeable because of their stylized, archetypal features set in sombre mask-like faces with detached expressions. The calm formality of the image, however, is shockingly disturbed by the exposed genitalia of the baby figure. The artist also strikes a jarring note with his use of small areas of bright, incongruous colour. This family portrait arouses a sense of unease in the viewer, hinting that the uniformity demanded by a conformist society comes at a price: individuals suppress their emotions and deny their needs. This, Zhang intimates, is perhaps too big a price to pay. **EB**

1 YOUNG GIRL

Zhang often uses patches of yellow or red colour in his predominantly monochromatic portraits. Here the young girl has a patch of yellow on her face. These colour patches are open to interpretation; some observers have compared them to birthmarks or the spots on an ageing photograph.

2 BABY

The figure of the baby is at the heart of the portrait. The viewer's eyes are drawn to him by his yellow face, in contrast to the white faces of the other figures. His genitals, like the rest of his body, are also rendered in yellow. Naked male genitalia recurs through the *Bloodlines* series, identifying the sex of Zhang's often androgynous figures. This glimpse of genitalia also disrupts the portraits' sense of conformity and points to the vulnerability of the individual.

3 MOTHER

The mother figure in Zhang's family portrait appears outwardly serene except for a hint of apprehension in her fixed glassy eyes. It is said that Zhang's schizophrenic mother was the model for all the mother figures in the *Bloodline* series. For him, she exemplifies the painful tensions that inevitably arise when someone tries to acknowledge their personal needs and to satisfy the demands of a conformist society at the same time.

4 THIN RED LINE

The thin red line meandering across the painting connects one member of the family to another and represents the genealogical bloodline that unites the group. The wayward line also suggests the complex historical and cultural ties that connect individuals to each other as a family, and to society.

1966–81

Born in Kunming, Yunnan province, the son of government officials, Zhang grew up in Chengdu in Sichuan province during the Cultural Revolution, a time of political and social upheaval. His parents were sent to work in the countryside; he stayed behind with his three brothers and an aunt. In 1976 he was sent to a farm to be re-educated.

1982–84

After studying oil painting at the Sichuan Academy of Fine Arts in Chongqing, Zhang designed sets and costumes for a dance troupe. In 1984 he was hospitalized for depression-related alcoholism, which led to the series of drawings the following year titled *Dialogue with Death*. He then became part of the Surrealist-influenced 'New Imagist' group.

1985–91

Zhang co-founded the 'Current of Life' movement that explored the nature of individuality within the Chinese culture of collectivism. He had his first solo show in 1989 at the Sichuan Academy of Fine Arts.

1992–present

After a trip to Europe, in 1993 Zhang began the *Bloodline* series of paintings inspired by family photographs. He won the Bronze Prize at the São Paulo Biennial in 1994. Zhang lives in Beijing and exhibits internationally.

ANCESTRAL PORTRAITS

Zhang models his family portraits on the traditional ancestral painted family portraits that were designed to capture for posterity the individual or family unit. In ancestral portraits, such as the example shown below, individuals are shown in stiff frontal and symmetrical poses, their shape and status suggested by their garments. Portraits are formalized and their subjects, who are often seated, appear dignified, sombre and removed. Although there was no systematic attempt

to idealize the subject, there was little or no reference made to individual characteristics or personality traits, except those that were considered auspicious. By rooting his portraits in these visual traditions, Zhang raises issues about culture, tradition, identity and continuity. His subjects' alienated gaze challenges the viewer to search for the truth.

POP ART

1 *Just What Is It That Makes Today's Homes
So Different, So Appealing?* (1956)
Richard Hamilton • collage
10 ¼ x 9 ¾ in. / 26 x 25 cm
Kunsthalle Tübingen, Germany

2 *Campbell's Soup Can* (1964)
Andy Warhol • silk screen on canvas
35 x 24 in. / 91 x 61 cm
Leo Castelli Gallery, New York, USA

3 *Floor Burger* (1962)
Claes Oldenburg • acrylic on canvas filled
with foam rubber and cardboard boxes
52 in. / 132 cm high
84 ¼ in. / 214 cm diameter
Art Gallery of Ontario, Toronto, Canada

The word 'pop' was first used publicly in a visual arts context in a
work exhibited at London's Whitechapel Gallery in 1956. It appeared
emblazoned on an outsize red lollipop, held by a half-naked body builder
at the level of his genitals, in a collage titled *Just What Is It That Makes Today's
Homes So Different, So Appealing?* (above). The images for the collage were
taken predominantly from US magazines. The artist responsible for this witty
collage—Richard Hamilton (b.1922)—was a member of an informal association
of British critics, painters, architects, sculptors and academics known as The
Independent Group. They first met in 1952 at the Institute of Contemporary
Arts in London to explore a shared fascination with contemporary North
American mass culture, from advertising and packaging to popular music,
magazines and comics.

The Whitechapel exhibition 'This Is Tomorrow' both celebrated this popular
commercial culture itself—using gimmicks such as having a jukebox playing
throughout—and displayed works by artists who, like Hamilton, were
embedded in the fine art tradition but inspired by imagery and techniques
from mass culture. Hamilton listed the characteristics of the art he liked as:

'Popular (designed for a mass audience); transient (short-term solution); expendable (easily forgotten); low cost; mass-produced; young (aimed at youth); witty; sexy; gimmicky; glamorous; big business.'

In 1956, Pop art was a tendency whose time—and, indeed, whose name— had not yet come. Although the British art critic Lawrence Alloway (later to become a major influence on Pop art in the United States) was already using the term by 1958, the international art world remained indifferent and slow to catch on. The art world was dominated at the time by North American Abstract Expressionism (see p.452) and it was noticing little else, particularly not an obscure form of new British art. In the United States, however, separate but parallel developments began to challenge the Abstract Expressionist hegemony during the decade and works with Pop art overtones began to appear. Ironically, in later years, the movement would often, erroneously, be described as a North American invention. The works of Jasper Johns (b.1930)—including his famous paintings of the Stars and Stripes, included in his *Flag* series from the 1950s—and of Robert Rauschenberg (1925–2008) —whose collages and three-dimensional 'combines' incorporated magazine illustrations and other symbols of mass consumerism, such as Coca-Cola bottles—were bringing a new kind of imagery into North American art.

The sudden efflorescence of Pop art as a ubiquitous artistic and media phenomenon on both sides of the Atlantic came in the early 1960s. In the United Kingdom, the pivotal moment was the 'Young Contemporaries' exhibition of 1961, which introduced artists such as David Hockney (b.1937), Peter Blake (b.1932), Patrick Caulfield (1936–2005) and Derek Boshier (b.1937) to public notice. In the United States, 1962 was a key year because some of Pop art's most famous practitioners, including Roy Lichtenstein (1923–97), Tom Wesselman (1931–2004) and Andy Warhol (1928–87), held their first exhibitions. Lichtenstein's massive, painted, cartoon-strip images, such as *Whaam!* (1963; see p.490), and Warhol's silk-screened reproductions, such as *Campbell's Soup Can* (right) were greeted initially with incomprehension. At the same time, Swedish-born US sculptor Claes Oldenburg (b.1929) was exhibiting massive, hyperrealist, canvas and foam-rubber versions of everyday objects—for example, *Floor Burger* (right, below)—that were also identified as Pop art.

Whether left-wingers critical of capitalism or aesthetes at odds with the vulgarity of modern society, the traditional consumers of fine art were initially wrong-footed by Pop art's embrace of what Lichtenstein called 'the most brazen characteristics' of contemporary mass commercial culture. The venality of popular culture was precisely what true artists were supposed to oppose. Yoko Ono (b.1933) later described the attitude to popular culture prevalent among avant-garde artists (of whom she was one) before the Pop art revolution: 'We consciously and determinedly rejected Elvis and rock and roll.... We were interested in art.' Alloway expressed the contrary view held in Pop art circles: 'We felt none of the dislike of commercial culture standard among most intellectuals, but accepted it as fact, discussed it in detail and consumed it enthusiastically.'

4 *A Bigger Splash* (1967)
David Hockney • acrylic on canvas
95 ⁵/₈ x 96 in. / 243 x 244 cm
Tate Britain, London, UK

5 *Sgt. Pepper's Lonely Hearts
Club Band* album cover (1967)
Peter Blake and Jann Haworth (design)
Michael Cooper (photography)

6 *Standard Station* (1966)
Ed Ruscha • oil on canvas
20 ¹/₂ x 39 in. / 52 x 99 cm
Private collection

Sometimes Pop artists produced work that could be interpreted as a critique of modern consumer society rather than an endorsement. British artist Boshier's *First Toothpaste* (1962) painting, one of a series of works inspired by a TV commercial for a striped toothpaste, seemed critical of advertising and the consumer society. When Warhol produced silk-screen prints of an electric chair or car crashes, instead of soup cans and pop culture idols such as Elvis Presley and Marilyn Monroe, he was evidently drawing attention to a darker side of the modern US experience. Such gestures, however, were the exception within Pop art. Most of the artists were in revolt not against consumer society itself but the artificial distinction between 'high' and 'low' culture made by critics and the elitist refinement of traditional 'good taste'.

The artists' relation to the imagery that they plundered—itself the work of commercial artists, illustrators and photographers—was mostly one of respect, even admiration. Lichtenstein, for example, vigorously rejected the notion that his overblown cartoons were parodies of the originals, while accepting that there could be a certain irony in his way of treating the comic illustration genre. Indeed, some key figures in Pop art had a background in commercial art, including Warhol, who had previously worked as an illustrator in magazines, and James Rosenquist (b.1933)—creator of *F-111* (1965) one of the most effective Pop art works—who was a billboard artist before moving into fine art.

Despite the ambition to break down distinctions between elite and mass culture, Pop artists remained predominantly producers of works that were exhibited in galleries and collected by the wealthy, the high value of which depended upon their uniqueness and authenticity. Only an occasional crossover into popular culture was achieved, most notably in the design of pop music album covers: Peter Blake and his artist wife Jann Haworth (b.1942) produced the vivid collage for The Beatles' *Sgt. Pepper's Lonely Hearts Club Band* (opposite, above) in 1967, Hamilton masterminded the stark design for The Beatles' *White Album* cover in 1968 and Warhol conceived the artwork for The Rolling Stones' *Sticky Fingers* album sleeve in 1971.

Pop art was never a coherent movement. Individual Pop artists had different agendas and developed along different trajectories. Hockney, for example, earned his classification as a Pop artist with his 'tea paintings' of 1960 and 1961, in which the marketing graphics of Typhoo tea packaging is represented. Many of Hockney's early nudes and even his first 'swimming pool' painting were based on magazine images. His best-known painting with this theme, *A Bigger Splash* (opposite), is an icon of modern art, but by the end of the 1960s, Hockney was showing an aesthetic conservatism and attachment to traditional values, such as the importance of figure drawing. Caulfield was originally seen as a Pop artist because of his use of flat areas of colour enclosed by black outlines and his depiction of consumer goods, as seen in *Interior Night* (1971). It became apparent, after all, that he had the traditional painterly concerns of colour and form. Ed Ruscha (b.1937) rejected the spontaneity of Abstract Expressionism, which he felt did not allow him to express his ideas, in favour of carefully planned images of everyday objects and scenes that combined abstraction with typography, such as *Standard Station* (below).

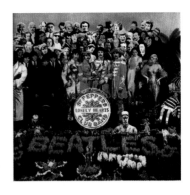

By contrast, Warhol pursued with dedication the task of expunging traditional artistic value from his work. Provocatively naming his New York studio 'The Factory', Warhol set out to manufacture images by impersonal processes (for example silk-screening), laconically proclaiming their lack of any value save for their monetary value on the inflated art market. As Warhol said, he had learnt 'to see commercial art as real art and real art as commercial art.' Writing in 1967, critic Morse Peckham articulated Warhol's own public pose when he stated that the work 'leaves nothing for the critic to do, and nothing for the public to do, except to buy it, if they are silly enough to do so, as they most assuredly are'.

By the end of the 1960s, Pop art's vigour as a brand name was rapidly fading, though many artists continued to produce good work in the same or a similar style in subsequent decades. Some Pop art works remain so tied to their period that their main value now is as a focus for nostalgia—as in Hamilton's *Swingeing London* (1967), representing Mick Jagger and gallery owner Robert Fraser handcuffed after a drugs bust. Yet Pop art was one of the first Postmodern art movements, and also the first serious attempt to face up to the problem of where the fine artist and his product—the unique, authored work of art—fit in the modern, media-saturated, consumerist world. **RG**

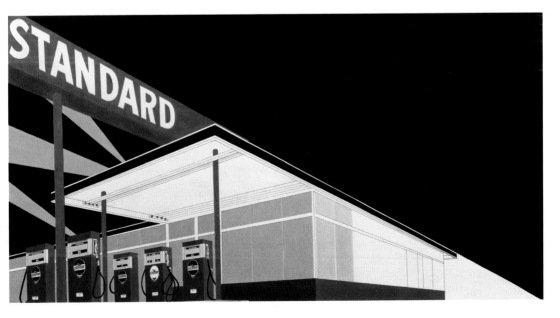

Twenty Marilyns 1962
ANDY WARHOL 1928 – 87

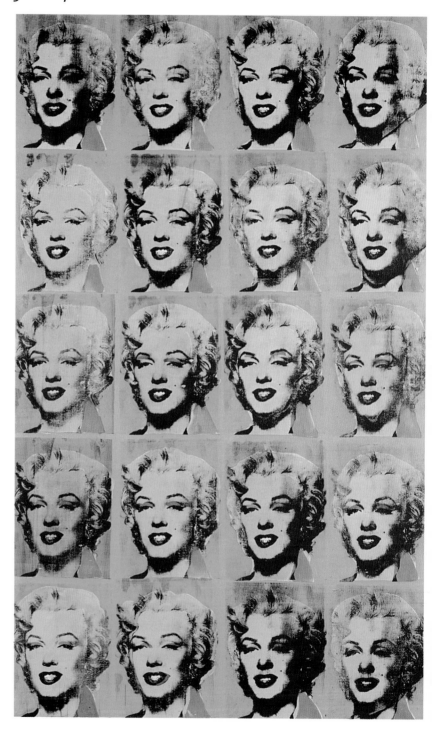

silk screen
77 ¹/₂ x 45 ⁵/₈ in. / 197 x 116 cm
Private collection

NAVIGATOR

A ndy Warhol started making paintings of film star Marilyn Monroe (1926–62) soon after her death. He used a black and white publicity photograph taken by Gene Korman for the 1953 movie *Niagara* to create a stencil for silk-screen printing, a technique he had adopted for transferring a photographic image to canvas. Over a period of four months Warhol created more than twenty works based on the Korman photograph. What Warhol called the 'assembly line effect' of the repeated image reflects critically upon the supposed uniqueness of the work of art in a world of mass reproduction and mass media. The choice of a celebrity pin-up shot as a basis for a gallery painting queries the traditional distinction between high and popular art. But Warhol had an ambivalent relationship to such issues. He was entranced by the glamour of celebrity, found beauty in the face of a Hollywood sex symbol and sought to abolish both the craftsmanship and genius of the individual artist through embracing mechanical reproduction. Yet the repetitive *Marilyns* are full of small variations, the paint is applied by hand and the effect is remote from the surface gloss and perfection of fanzine photography. Art critics have related the *Marilyns* to Byzantine icon painting, an art tradition that Warhol was exposed to through his Byzantine Catholic faith. Originally iconoclastic, the *Marilyns* have come to be seen as icons. Intended to undermine the notion of the masterpiece, they have been assimilated into the Western art tradition. **RG**

👁 FOCAL POINTS

1 SAME BUT DIFFERENT

Warhol said he liked the silk-screen process because 'you get the same image, slightly different each time'. The variations occur through the clogging of ink or the screen slipping off register. A pre-existent image was transformed via a process over which he had partial control.

2 INK SHADOWS

The photographic image is applied on top of the painted image by rolling black ink over the screen with a squeegee. The rough handling of the silk-screen inking creates grainy shadows and stains, besmirching the glamour of the original shot and hinting at anxiety and mortality.

3 LURID COLOURS

The coloured areas—hair, lipstick, skin, eye shadow, dress collar and background—were painted in by hand on top of a coat of white paint, which shows through in the teeth. The choice of colours is lurid and the effect artificial, although the painting remains broadly naturalistic.

⏱ ARTIST PROFILE

1928–48
Born Andrew Warhola to a working-class immigrant family in Pittsburgh, Pennsylvania, Warhol trained as a commercial artist at the Carnegie Institute of Technology.

1949–62
He moved to New York and became a successful illustrator, known for his shoe advertisements. In May 1962 Warhol held his first fine art exhibition, showing thirty-two canvases of Campbell's soup cans in Los Angeles. He was identified with Pop art, the critical sensation of that year, and adopted silk-screen printing. His first *Marilyn* paintings were exhibited in November 1962.

1963–67
Warhol established a studio in Manhattan at 231 East 47th Street. He called it 'The Factory' and it became the focus of an underground circle of artists, actors, musicians, drug addicts and misfits. He produced large numbers of series paintings, mostly manufactured by his assistants. In 1963 he began making experimental films using his friends as actors. He also promoted the rock band The Velvet Underground.

1968–69
In June 1968 Warhol was shot and almost killed by Valerie Solanas (1936–88), a feminist extremist whom he had offended. He suffered physical effects for the remainder of his life and never fully recovered from the ordeal. From the end of the radical 1960s Warhol lost his perhaps spurious association with a counterculture opposed to American capitalism.

1970–87
He shamelessly touted for portrait commissions from the rich and emphasized his commitment to art as business. Opinions about his later work differ, but some critics feel its celebration of the ascendant money culture constitutes satire, both on the state of modern art and on modern society. He died from a cardiac arrhythmia after a gall bladder operation.

Whaam! 1963
ROY LICHTENSTEIN 1923 – 97

acrylic and oil on two canvases
68 ³/₄ x 80 ³/₈ in. / 175 x 204 cm
(each canvas)
Tate Modern, London, UK

Roy Lichtenstein based this painting on a comic book panel by illustrator Jerry Grandenetti (b.1927) that appeared on the cover of issue 89 of *All-American Men of War*, published by DC Comics in February 1962. Grandenetti was known for his 'wash-tone' covers in which he used ink washes of black and white to create an image that was photostatted by the printer. *Whaam!* is Lichtenstein's witty and irreverent reaction to the contemporary popularity of Abstract Expressionism (see p.452), particularly its large swathes of pure colour and the dripping canvases of its 'action painters'. Lichtenstein was attempting to deflate that movement's pomposity by presenting pictorial subject matter based on what was regarded as crass commercial art. He was also commenting on the inanity of society by focusing attention on stories, often aimed at children, that glorified war and destruction. Presenting a misleading view of war that was pure fantasy, the stories made heroes of two-dimensional characters for their aggressive actions.

The painting established Lichtenstein in the public eye as the American master of Pop art. He said of his decision to plunder penny-book romances and war comics for inspiration: 'It was hard to get a painting that was despicable enough so that no one would hang it. Everyone was hanging everything. It was almost acceptable to hang a dripping paint rag…the one thing everyone hated was commercial art. Apparently they didn't hate that enough either.' **CK**

⚙ NAVIGATOR

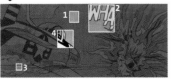

1 BENDAY DOTS

This area of stencilled dots reproduces the dots that were once the mechanism by which tone and mixed colour were achieved in a printed image. Named after American illustrator and printer Benjamin Day (1810–89), they are most commonly seen in comic books of the 1950s and 1960s.

2 TEXT

The inclusion of text in painting was not a new idea. Words appeared in Egyptian tombs, featured through the medieval and Elizabethan period and flourished as an integral part of Cubism (see p.388) and Conceptual art (see p.500). The text is used to endorse rather than create meaning.

3 COLOUR

Within most cultures colour is understood to add value; drawings can be made in black and white but paintings demand colour. The colour in this painting is drawn from two sources: a basic Modernist aesthetic and the range of primary colours used to print cheap comic books.

4 BLACK OUTLINE

Lichtenstein uses the most basic language available to a painter: a black outline surrounding areas of white or colour. Lead performs this function in stained glass windows, as do the black lines prominent in paintings by Modernist artists such as Fernand Léger (1881–1955) and Piet Mondrian (1872–1944).

THE RISE OF ART PHOTOGRAPHY

1 *Memphis (Tricycle)* (c. 1969)
William Eggleston • dye transfer print
11 ¾ x 18 in. / 30 x 46 cm
Museum of Modern Art, New York, USA

2 *Ajitto* (1981)
Robert Mapplethorpe • silver gelatin print
Dallas Museum of Art, Dallas, USA

3 Seagulls eating chips, from the *West Bay*
series (1996)
Martin Parr • colour photograph

Photography was firmly established as an artistic medium by the end of
World War II. Reportage had reached new heights because of the war, and
afterwards photographers sought to document candidly the effects of
poverty and disaster. Don McCullin (b.1935) is typical of photographers whose
work reflected an increasing social conscience. He began his career photographing
gang life, with images such as *Street Gang, Finsbury Park* (1958), and his later
shots of conflicts in Northern Ireland and Vietnam were so disturbing that the
British government banned him from covering the Falklands War in 1982.

Photographers reflected the politics of the time and a shift towards
liberalism in the late 1950s. Robert Frank (b.1924) catalogued his journey across
the United States by highlighting race and class differences in his book of
photographs *The Americans* (1958). His work influenced successors such as
Diane Arbus (1923–71), who captured the emerging anti-war feeling with *Child
with Toy Hand Grenade* (1962). Her work tackled social issues and she is well
known for documenting the lives of marginalized Americans. Nan Goldin
(b.1953) continued the documentary trend by taking photographs with an
autobiographical edge in *The Ballad of Sexual Dependency* (1979–86) series,
which explores obsession, addiction, love and sexuality in punk-era New York.
Printed on Cibachrome, these images are exceptionally clear with vivid colour.

Landscape photography was equally affected by socially progressive ideas
and gave way to images that show space, often of an urban nature, and explore
notions of culture and identity. Hiroh Kikai (b.1945) took black and white shots
of Tokyo shop fronts and residential areas that depict the city's modernity and
architectural detail but have an eerie quality because they lack human presence.

KEY EVENTS

1958	1960	1965	1970	1972	1977
Frank publishes a book of photographs, titled *The Americans*.	Arbus has her photographs published for the first time in *Esquire* magazine.	Eggleston begins to experiment with colour negative film.	Mapplethorpe starts using a Polaroid camera.	A year after the death of Arbus, the Museum of Modern Art in New York holds a retrospective of her work.	Sherman starts taking photographs of herself, usually dressed up in elaborate costumes.

William Eggleston (b.1939) focuses on small-town America and subject matter of little intrinsic aesthetic beauty. He has created images striking in their colour, shape and sense of pattern, for example *Memphis (Tricycle)* (opposite).

Artists began to mix photography with other media as early as the 1960s and Andy Warhol and Robert Rauschenberg silk-screened photographs on to canvases. Barbara Kruger (b.1945) mixed photography, found photographic images and type to make a series of agit-prop pieces critiquing corporate greed, right-wing politics, and sexual and racial stereotypes. Cindy Sherman (b.1954) drew on contemporary imagery from magazines and films to create her *Untitled Film Stills* series (1977–80; see p.494), in which she staged various scenes to create a new form of portraiture.

Sensibilities change according to culture and time and the late 20th century saw art become ever more transgressive. Robert Mapplethorpe (1946–89) took black and white photographs with homoerotic themes that touched a nerve. His classical nudes such as *Ajitto* (right) were respected, but photographic art is contentious because of its capacity to capture 'true' images and Mapplethorpe was keen to push the boundaries. His sadomasochistic images, such as *Self-portrait* (1978) showing the artist's anus penetrated with a bull-whip, were censored in Washington DC and San Francisco.

Martin Parr (b.1952) uses gaudy colours and exaggerated close-ups to critique contemporary life. His work has addressed mass tourism, consumerism and globalization. The photograph below is from the *West Bay* series; it seems innocently humorous, yet the irony of its fluttering Union Jack flag suggests the demise of the British empire, the seaside resort and even its national dish. **CK**

1982	1987	1988	1991	1995–99	2010
McCullin is banned by the British government from covering the Falklands War.	Warhol dies; among the works he leaves are more than 60,000 photographs.	The Whitney Museum in New York holds the first retrospective of Mapplethorpe's work; he dies the following year.	Kruger makes the controversial decision to use the American flag in her work *Untitled (Questions)*.	Parr uses vibrant colours and dark humour to explore the excesses of global capitalism in his series *Common Sense*.	Eggleston's exhibition '21st Century' opens in London and New York. Typically it focuses on mundane life, but uses more muted colours.

Untitled Film Still #7 1978

CINDY SHERMAN b. 1954

black and white photograph
9 ¹/₂ x 7 ¹/₂ in. / 24 x 19 cm
Museum of Modern Art, New York, USA

This image by American photographer Cindy Sherman is one of the sixty-nine photographs from her series *Untitled Film Stills* (1977–80). She began the series when she was twenty-three years old and it catapulted her to success as a pioneering feminist artist. The series featured only images of women and took as its inspiration the depiction of femininity in post-war American film and fanzines, yet Sherman distanced herself from the feminist tag. The artist claimed that she started the series with the idea of documenting the life of an actress 'at various points in her career', from 'ingénue' to 'more haggard' as success took its toll. The series outgrew this initial concept when Sherman went on to show women in a multiplicity of roles, such as office worker, housewife and sex kitten. Influenced by racy, glossy images of female stereotypes used to illustrate photo-novellas, she highlighted the objectification of women and celebration of youth at a time when feminism was on the rise; her work therefore challenged ideas of gender in post-war America. Sherman used make-up, costumes and wigs to transform herself into the protagonist in her photographs, mimicking and at the same time subverting notions of portraiture and celebrity. Although not a Pop artist, Sherman drew on popular culture for her work, following in the tradition of 1960s artists such as Andy Warhol. As the series title and contents suggest, Sherman was influenced by cinema in the way she shot her photographs and in her recreation of the idea of the female starlet. **CK**

⏱ ARTIST PROFILE

1976–80
Sherman graduated from State University College at Buffalo, New York in 1976. She studied painting but then switched to photography. Together with friends she set up an avant-garde art gallery that later became the Hallwalls Contemporary Arts Center. In 1977 she moved to New York City and began her series *Untitled Film Stills*.

1981–84
In 1981 at New York's Skarstedt Gallery she exhibited *Centerfolds*, a series of colour photographs, based on men's magazine centrefolds, that explored ideas of voyeurism and fantasy. In 1983 to 1984 she produced several series of fashion photographs for *Harper's Bazaar* and the French edition of *Vogue* that portrayed her as a battered mannequin.

1985–present
Sherman showed *Fairy Tales and Disasters* (1985–89), a series of photographs exploring the grotesque aspect of fairy tales. In 1997 the Museum of Modern Art showed 'Cindy Sherman: The Complete Untitled Film Stills'. The artist also directed the comedy horror movie *Office Killer*. In 2006 Sherman created a series of fashion advertisements for designer Marc Jacobs.

👁 OTHER STILLS FROM THE SERIES

UNTITLED FILM STILL #11 (1978)
Sherman involves the viewer in constructing a narrative around her images. The artist appears in gender-typical roles, as seen in classic Hollywood films. Here she plays the disappointed lover.

UNTITLED FILM STILL #54 (1980)
Some of the stills seem like press shots. This one depicts a vulnerable-looking starlet. She spends her life courting attention yet tries to shield herself from the intrusions of photographers.

UNTITLED FILM STILL #48 (1979)
Sherman uses cinematic devices, such as framing, scenery and costume. Here she portrays a young hitchhiker. Her dress suggests she is unsophisticated; perhaps she is fleeing to a new life in the city.

NOUVEAU RÉALISME

1 **Home Sweet Home** (1960)
Arman • gas masks and wooden box
63 x 55 ¹/₈ x 7 ⁷/₈ in. / 160 x 140 x 20 cm
Musée National d'Art Moderne, Centre
Pompidou, Paris, France

2 Photograph of Niki de Saint Phalle
holding a rifle in front of one of her
shooting paintings, taken at her 'Feu à
volonté' show at Galerie J., Paris in 1961.

3 **Compression 'Ricard'** (1962)
César Baldaccini • painted metal
60 ¹/₄ x 28 ³/₄ x 25 ¹/₂ in. / 153 x 73 x 65 cm
Musée National d'Art Moderne, Centre
Pompidou, Paris, France

The Nouveaux Réalistes (New Realists) were a group of European
artists who were gathered together by French art critic Pierre Restany
(1930–2003). Restany officially founded the group on 26 October 1960
at the Parisian home of Yves Klein (1928–62). Swiss artists Daniel Spoerri
(b.1930) and Jean Tinguely (1925–91) and several French artists, including
Arman (Armand Pierre Fernandez; 1928–2005) and Martial Raysse (b.1936),
joined them in signing a declaration the following day: 'New realism = new
perceptive approaches to the real.' This broad definition created a collective
identity that encompassed the wide range of work that these artists produced,
as well as that of those who joined them later: Niki de Saint Phalle (1930–2002),
César Baldaccini (1921–98) and Bulgarian-born Christo (Christo Vladimirov
Javacheff; b.1935), among others.

KEY EVENTS

1947	1958	1960	1961	1961	1961
Armand Fernandez rejects his surname and names himself 'Armand'. In 1958 he drops the 'd' to correspond to a printing error.	Klein instructs a painted nude model to press her body against a canvas to make his first anthropometry.	The Nouveau Réalisme movement is founded by Restany and Klein at the home of Klein in Paris, France.	Klein begins *Mondo Cane Shroud* (see p.498), his anthropometry for Italian film director Gualtiero Jacopetti.	Christo and Jeanne-Claude (Jeanne-Claude Denat de Guillebon; 1935–2009) collaborate for the first time. They work under the name 'Christo' until 1994.	Domenico 'Mimmo' Rotella (1918–2006) develops his décollage technique, in which he fixes torn advertising posters to canvas.

Nouveau Réalisme was a major departure from the mainstream abstract painting of the late 1950s. The backdrop of deprivation and destruction against which this first generation of post-war artists worked had changed. A new society was emerging—one of increasing affluence, technological advances and rapid political change—and it was this 'new' world that the Nouveaux Réalistes explored. They aimed to describe everyday reality without idealization, and for inspiration they looked to the Dadaists (see p.410) and Marcel Duchamp's (1887–1968) ready-mades, Fernand Léger's (1881–1955) Cubist machine aesthetic (see p.388) and the Surrealists' (see p.426) appreciation of the 'marvellous' in the 'ordinary'. They rejected all that was linked with the abstract painters and looked at the world, creating work that engaged directly with contemporary society.

It was common for the Nouveaux Réalistes to incorporate objects from the everyday world into their work and Restany referred to this as the 'poetic recycling of urban, industrial and advertising reality'. Raysse was fascinated by the properties of plastic and created assemblages out of household objects; Spoerri's assemblages were known as 'trap' or 'snare' pictures, in which he fixed leftover objects (often from a meal) into a permanent display. This 'poetic recycling' gave discarded or overlooked objects new life as art. It also resulted in works that can be read as direct critiques of the commodity culture and consumer waste or those that address historical and contemporary themes. Arman is best known for his 'accumulations' project, in which he arranged large quantities of identical objects, often melted down, in plexiglas or wooden cases or set them in concrete. *Home Sweet Home* (opposite) is an accumulation of gas masks that brings home the horrors of the Holocaust and provided a particularly intense viewing experience when exhibited in New York during the war crimes trial of Adolf Eichmann in 1961.

Many works by Nouveaux Réalistes embrace 'creative destruction' and are the results of actions or performances. Klein's 'anthropometries' (see p.498), in which the bodies of nude women are used as 'living brushes' to make paintings, are perhaps the best known. Other examples include Arman's *colères* (fits of rage), collections of smashed objects displayed in boxes; Saint Phalle's *tirs* (shooting paintings), which were made by firing a rifle at an assemblage embedded with paint-filled sacks (right, above); and César's 'compressions' (right), which were created by loading objects, such as cars, motorcycles and jewellery, on to a hydraulic scrap metal press and crushing them.

The Nouveaux Réalistes took great pleasure in exploring different processes of making art and shared their artistic inspirations and motivations with a number of American artists, including Robert Rauschenberg (1925–2008), Jasper Johns (b.1930) and Larry Rivers (1923–2002), with whom they formed strong ties of friendship. Restany noticed these growing friendships and in 1961 he organized an exhibition in Paris titled 'Le Nouveau Réalisme à Paris et à New York,' which featured work by the Nouveaux Réalistes and the Americans. **AD**

1962	1963	1965	1970	1970	1980
Klein dies of a heart attack. He is just thirty-four years old.	Spoerri, a founder member of Nouveau Réalisme, becomes involved with the international Fluxus movement.	César begins to experiment with different types of plastics as artistic media.	The last Festival of Nouveau Réalisme is held in Milan and the group is officially dissolved.	Tinguely celebrates Nouveau Réalisme by building a gigantic phallus outside the cathedral in Milan in order to explode it.	Christo begins the *Surrounded Islands* project in Miami, Florida. The eleven islands of Biscayne Bay are 'wrapped' in pink polypropylene fabric.

Mondo Cane Shroud 1961

YVES KLEIN 1928 – 62

pigment, synthetic resin on gauze
108 x 118 ½ in. / 274 x 301 cm
Walker Art Center, Minneapolis,
Minnesota, USA

The *Mondo Cane Shroud* was commissioned in 1961 for Italian film
director Gualtiero Jacopetti's (b.1919) documentary *Women in the World*
(1962). The intention was to show Yves Klein painting at an easel with
a brush, then follow his progression through painting with rollers, sponges
and finally using nude models as 'living brushes'—work he called
'anthropometry' (body painting). Klein was pleased with the original cut of
the film; however, it was dramatically altered and the soundtrack changed
without his consent. He next saw it at the Cannes Film Festival in 1962, where
it premiered as *A Dog's World*, and was horrified to find his artwork
sensationalized and sexualized and himself mocked in what amounted to
a 'shockumentary', showing bizarre practices from around the world. This
anthropometry was made on a large piece of glass in the centre of a room filled
with the artist's work. The audience's reaction to Klein's painting performance
ranged from fascination to shock and amusement. The theatricality of the
event makes *Mondo Cane Shroud* an important early example of both body art
and performance art. **AD**

◉ PERFORMANCE STILLS

MODELS AS LIVING BRUSHES
In his anthropometries Klein used models as living brushes. They smeared themselves with blue paint and pressed against a canvas or piece of paper to make an imprint, according to his instructions.

ANTHROPOMETRY IN ACTION
Klein (right) choreographed the models without touching them or the paint. He wanted the results to resemble the shadowy images created by the indentations left on white mats by judo contestants.

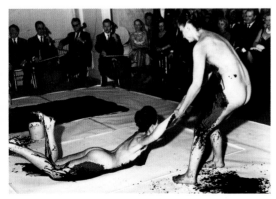

LIVE PERFORMANCE
The first live presentation of anthropometries took place on 9 March 1960. The room was covered in white paper and Klein conducted the women to the accompaniment of his *Monotone Symphony* (1949).

◷ ARTIST PROFILE

1947–54
Klein began studying judo, mysticism, spiritualism and philosophy. These subjects were to become life-long passions and sources of inspiration for his artwork. In 1954 he published a book of his monochromes, *Yves: Peintures*.

1955–57
He settled in Paris and met Pierre Restany, who would champion his work. After exhibiting his monochromes in Paris, he stopped painting in other colours and began to use only blue. He exhibited seemingly identical blue monochromes in Milan, where they were a critical and commercial success, followed by shows in Paris, Düsseldorf and London.

1958–59
Klein won a commission to decorate the Gelsenkirchen opera house in Germany with murals and sponge reliefs. He held his infamous exhibition 'Le Vide' (The Void), in which he exhibited a plain white gallery containing only an empty cabinet.

1960–62
In 1960 he founded Nouveau Réalisme with Restany, and published his photomontage *Leap into the Void*, which showed him leaping from a house. As well as anthropometries (1960–61), Klein produced *peintures de feu* (fire paintings; 1961–62), which were made using flames as a brush. He died of heart failure in 1962 at the age of thirty-four.

INTERNATIONAL KLEIN BLUE

Early in his career, Yves Klein was drawn to the power of colour, especially that emitted by pure pigment. He was concerned that the brilliance of powdered pigment was 'killed' by the oil or glue that it was usually mixed with, so searched for an alternative that would allow him to fix the pigment to the canvas without changing the colour. With the assistance of a Parisian paint dealer, Edouard Adam, he discovered a colourless, synthetic resin, Rhodopas M, that provided the desired effect. At his first exhibitions of differently coloured monochrome paintings, many people had viewed the abstract works as part of a decorative whole, instead of experiencing the colour and presence of each individual painting. This troubled Klein and he decided that using only one

colour might guide the viewer to the desired experience. He chose a deep ultramarine blue, which to him conveyed the essence of space. He adopted the colour as his personal stamp, and on 19 May 1960 he received a patent for International Klein Blue (IKB).

CONCEPTUAL ART

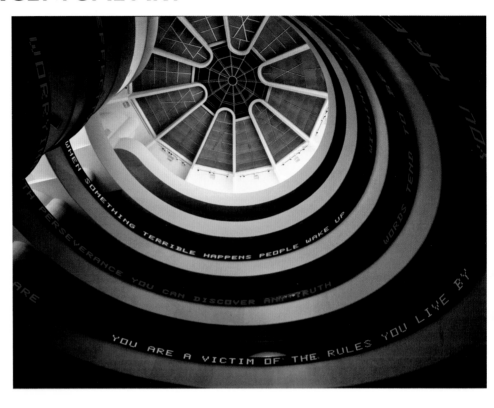

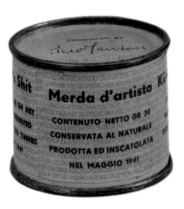

C onceptual art emerged in the 1960s as a challenge to the categories imposed on art by museums and galleries. The latter provided audiences with the clear statement: 'This is art.' Conceptual art, on the other hand, sought to challenge art's very nature, asking: 'What is art?' The philosopher and anti-art activist Henry Flynt (b.1940) first referred to 'concept art' in 1961, although the term 'Conceptual art' was not used until later in the decade. In 1967 artist Sol LeWitt (1928–2007) wrote an article for the journal *Artforum* titled 'Paragraphs on Conceptual Art'. In it he contended that this new art was an inversion of earlier practices, bringing the concept to the foreground and making the actual production of the artwork secondary. In fact, the roots of Conceptual art reach back to Dada (see p.410) and Marcel Duchamp's (1887–1968) ready-made *Fountain* (1917), a urinal set on a pedestal and signed with the fictitious name 'R. Mutt'. Transporting a mass-produced urinal into a museum, Duchamp asked viewers to reflect on their preconceived notions of what art was and how museums lend authenticity to art objects.

KEY EVENTS

1963	1965	1967	1968	1969	1970
Beuys starts to give public 'action' performances. *The Chief* (1964) features the artist being wrapped in a blanket of felt.	Kosuth's *One and Three Chairs* (see p.502) is composed of a real chair, a picture of a chair and a definition of the word 'chair'.	LeWitt coins the term 'Conceptual art' in a journal article; it marks the progression from Minimalism (see p.520) to Conceptual art.	Belgian Marcel Broodthaers (1924–76) comments on art institutions with his installation *Museum of Modern Art* at his Brussels home.	American Robert Barry (b.1936) creates *Telepathic Piece*—a spoken statement about communicating telepathically with a piece of art.	The first dedicated Conceptual art exhibition, 'Conceptual Art and Conceptual Aspects', opens at the New York Cultural Center.

Conceptual art was also a reaction to art being regarded as a commodity. Italian artist Piero Manzoni (1933–63) questioned the nature of the art object while critiquing mass production and consumerism in a particularly provocative manner. In 1961 he produced ninety small cans labelled *Merda d'artista* (Artist's Shit) (opposite, below). Each can purported to contain the artist's faeces and was priced by weight based on the current value of gold. As opening the cans was said to destroy the value of the work, for a long time it remained uncertain what the cans actually contained. In 2007, after cans reportedly sold for at least $80,000, Manzoni's collaborator Agostino Bonalumi (b.1935) claimed in an Italian newspaper that the tins contained plaster.

In the 1960s, Conceptual art challenged the status quo both politically and culturally. Joseph Beuys (1921–86) worked to make authority visible and, at times, to challenge it directly. In his performance *How to Explain Pictures to a Dead Hare* (right), Beuys walked around an art gallery for three hours while cradling a dead hare in his arms. Covering his face and body in honey and gold paint, Beuys transformed himself into a shamanistic figure. He moved his lips quietly during this time, as though lecturing the deceased animal about the images around them. This act was intended to convey to the audience the need to understand art spiritually, as well as intellectually. For Beuys, this concept extended beyond the gallery and into the classroom. He was an instructor at the Kunstakademie Düsseldorf and believed the discussions that took place in his classroom to be of equal importance to artistic production.

Conceptual art has often employed written words or statements. Joseph Kosuth (b.1945) has used language to convey his message in works such as *One and Three Chairs* (1965; see p.502). In 1971 John Baldessari (b.1931) staged an exhibition at the Nova Scotia College of Art and Design. Unable to travel to the venue himself, he instructed the students to write 'I will not make any more boring art' on the walls of the gallery. In a parody of school punishment, the students took the proposal one step further and wrote the line over and over again, until the walls were completely covered. The artist's proposal, the students' actions and the scribbled walls became inseparable components of an artwork that used satire to provoke debate on what constitutes art.

Conceptual art has been most significant for creating such debates and it paved the way for Installation (see p.504) and Performance (see p.512) art. Although Conceptual art's heyday was past by the mid 1970s, it has been hugely influential since that time on younger generations, including the Young British Artists (see p.556). American artist Jenny Holzer (b.1950) works with texts, often in the form of LED signs, that are placed in public spaces. In *Untitled* (opposite, above) these texts can take the form of aphorisms, such as 'You are a victim of the rules you live by'. In projecting numerous, often contradictory, one-liners on to the facades of buildings and galleries, she questions the meaning of language through her art. **CV**

1 *Untitled (Selections from Truisms, Inflammatory Essays, The Living Series, The Survival Series, Under a Rock, Laments and Child Text)* (1989)
Jenny Holzer • mixed media
Solomon R. Guggenheim Museum, New York, USA

2 Joseph Beuys during the performance of *How to Explain Pictures to a Dead Hare* on 1 January 1965 at Alten Galerie Schmela, Düsseldorf, Germany.

3 *Merda d'artista, No. 014* (1961)
Piero Manzoni • metal, paper, excrement
1 7/8 x 2 1/2 in. / 4.8 x 6.5 cm diameter
Museum of Modern Art, New York, USA

1971	1973	1974	1977	1991	2001
British artists Gilbert & George (b.1943 and 1942) make their first 'photo-pieces', some of which relate to their heavy drinking bouts.	American art critic Lucy Lippard (b.1937) publishes the book *Six Years*, which documents the ideas behind Conceptual art.	Artist Michael Craig-Martin (b.1941) begins teaching at London's Goldsmiths College; he influences many of the Young British Artists (see p.556).	Walter De Maria (b.1935) creates *Vertical Earth Kilometer*, a work that 'exists' in people's minds because only a few centimetres of the piece is visible.	British art collector and gallery owner Charles Saatchi (b.1943) funds and exhibits Damien Hirst's (b.1965) shark in formaldehyde.	Martin Creed (b.1968) wins the Turner Prize for *The Lights Going On and Off*, an empty room in which the lights go on and off.

One and Three Chairs 1965

JOSEPH KOSUTH b. 1945

wood and silver gelatine photograph
32 ³/₈ x 15 x 21 in. / 82 x 38 x 53 cm (chair)
Photograph enlarged to size of chair
and text panel aligned to top edge of
photograph (artist's instructions)
Museum of Modern Art, New York, USA

✪ NAVIGATOR

In 1970, at the Museum of Modern Art in New York, Joseph Kosuth curated 'Information', a Conceptual art exhibition that posited art as a source of information and ideas, rather than aesthetics. *One and Three Chairs* was Kosuth's contribution to 'Information' and he explained the concept as follows: 'The expression was in the idea, not the form—the forms were only a device in the service of the idea.' The work includes three forms of a chair: a generic folding chair, a silver gelatine photograph of a chair and a photographic enlargement of the dictionary definition of the word 'chair', and it engages viewers with the idea of a chair physically, representationally and verbally. Where Conceptual art broadly asks, 'What is art?', this artwork asks, 'What is a chair?' and 'How have we come to recognize it as such?' Kosuth is questioning how representations or accounts of an object relate to the object itself, how these relations are processed and whether one form has more value than another. He asks viewers to consider how art and culture are constituted through language and meaning, rather than through beauty and style. **CV**

ir (chār), n. [OF. *chaiere* (F. *chaire*), < L. *cathedra*: cathedra.] A seat with a back, and often arms, usually one person; a seat of office or authority, or the office elf; the person occupying the seat or office, esp. the chair- n of a meeting; a sedan-chair; a chaise†; a metal block clutch to support and secure a rail in a railroad.

1945–63

Joseph Kosuth was born in Toledo, Ohio in 1945. He attended the Toledo Museum School of Design and studied privately with the Belgian painter Line Bloom Draper from 1955 to 1962.

1964–66

In 1964, the artist moved to New York to study at the School of Visual Arts. He soon began making his first Conceptual works and enquiries into art, language and meaning.

1967–70

Kosuth first showed his Conceptual works at the Museum of Normal Art, an exhibition space he helped found in 1967. Two years later he held his first solo exhibition and became the American editor of the journal *Art and Language*.

1971–present

Between 1971 and 1972, Kosuth studied anthropology and philosophy at the New School for Social Research in New York, and was influenced by the philosophy of Ludwig Wittgenstein. Since the 1970s, Kosuth has continued exploring language and meaning in art.

👁 FOCAL POINTS

1 PHOTOGRAPH OF CHAIR

This black and white photograph raises important questions regarding truth and imitation in a museum space. It is a photograph of the actual chair in the artwork and therefore changes each time the piece is installed in a new venue. The photograph also reflects a new approach to photography in the 1960s, whereby fewer artists were taking photographs themselves, preferring to outsource their production and printing.

2 DEFINITION OF 'CHAIR'

Kosuth was one of the first artists to investigate the linguistic nature of art propositions. Words create knowledge and understanding, particularly the way they are presented. When reading this dictionary definition of the word 'chair', we may associate the words directly with the physical wooden chair or the photograph of the chair provided by the artist. Read alone, the definition might evoke personal experiences with other chairs.

3 CHAIR

Kosuth's wooden chair is an example of a ready-made, an ordinary chair taken out of its usual context and reframed within a gallery setting. In this way, the chair is stripped of its useful functions and is given a new meaning as an art object for contemplation. The physical appearance of the chair is unimportant and a different chair is used and photographed in each venue where the piece is shown. Kosuth wrote instructions as to how the three forms should be installed.

INSTALLATION ART

1

2

3

1 *Wrapped Reichstag, Berlin* (1971–95)
Christo and Jeanne-Claude
polypropylene fabric with aluminium
surface and rope
Berlin, Germany

2 *The Weather Project* (2003–04)
Olafur Eliasson
Turbine Hall, Tate Modern, London, UK

3 *The Man Who Flew Into Space
From His Apartment* (1968–96)
Ilya Kabakov • mixed media installation,
six poster panels with collage and text
37 ³/₄ x 37 ¹/₂ x 57 ⁷/₈ in. / 96 x 95 x 147 cm
Musée National d'Art Moderne, Centre
Pompidou, Paris, France

The term 'Installation art' came into common usage in the late 1960s but its roots can be traced back to the ready-mades of Marcel Duchamp (1887–1968), and pieces such as his *1,200 Bags of Coal* (1938) in which he heaped bags of coal on to a floor, and the 'Merz' assemblages by German artist Kurt Schwitters (1887–1948). Initially, Installation art was viewed as site-specific work, often created for a particular gallery space or exhibition. Schwitters spent a decade transforming the rooms of his house in Hanover, Germany into works of art, starting in c. 1923. His assemblages anticipated the emergence of Installation art, as did the empty room, *The Void* (1958), that Yves Klein (1928–62) created for a show in Paris, 'The Specialisation of Sensibility in the Raw Material State into Stabilised Pictorial Sensibility'. The Frenchman emptied the space of all its contents except a large cabinet, painted the room white and hung a blue curtain across the entrance. Viewers were forced to queue on the opening night to see what he called 'an invisible painting'.

Such creations flouted the idea that art was collectable and marketable and embraced art for art's sake. The ephemeral nature of Installation art is exemplified by *Break Down* (2001), created by Young British Artist (see p.556) Michael Landy (b.1963), in which he systematically destroyed all of his possessions. Landy's work was installed in an old department store in London's Oxford Street and visitors were able to watch 7,227 items being demolished in a production line process. The items ranged from articles of clothing to cars, from pots and pans to artworks. A comment on materialism,

KEY EVENTS

1942	1956	1961	1967	1967	1968
Duchamp installs *Mile of String* for the 'First Papers of Surrealism' exhibition in New York.	Kaprow makes *Penny Arcade*, one of the artist's first 'environments.'	Claes Oldenburg (b.1929) converts his studio in Manhattan into The Store, a hybrid space that functions as a gallery, studio and shop.	In 'Art and Objecthood', Michael Fried (b.1939) criticizes the tendency of artistic practices to 'theatricalize' their relationship with the viewer.	Sony introduces a portable video recording device, Portapak, and video installations begin to become popular.	Ed Kienholz (1927–94) constructs his triptych *Portable War Memorial* (see p.506).

the piece was a one-off in terms of location and time, and only the catalogues detailing the items serve as a reminder of its existence.

Installation art has evolved into a three-dimensional art form that transforms the exhibition space into an immersive environment. American performance artist Allan Kaprow (1927–2006) created multimedia works that he called 'environments'; his best-known work is *Yard* (1961) in which he filled an entire courtyard with used car tyres. The work of Ilya Kabakov (b.1933) placed unprecedented emphasis on the role of the viewer. In *The Man Who Flew Into Space From His Apartment* (right, below), for example, the installation resembles a theatre or film set and the viewer is embroiled in the narrative of the piece. Installation art may be created for a certain space, but can also be recreated in the same or similar form elsewhere. American feminist Judy Chicago (b.1939) produced *The Dinner Party* (1974–79), which consists of a triangular table with thirty-nine place settings, each commemorating a female figure in history. It was first installed at the San Francisco Museum of Modern Art and was then taken on tour before finding its permanent home at the Brooklyn Museum.

Increasingly, installations have a sensory as well as visual appeal. In 1987 British artist Richard Wilson (b.1953) created *20/50*, an installation of a room filled with sump oil, in Matt's Gallery in East London. The bizarre but beautiful work, renowned for its odour and mirrored surface, was bought by art collector Charles Saatchi in 1991 and is now displayed at the Saatchi Gallery in London. Museums and galleries have warmed to the idea of installations and it is common practice to commission artists. London's Tate Modern has commissioned numerous artworks for its vast Turbine Hall. They have ranged from a series of sculptural pieces and environments, such as *Double Bind* (2001) by Spanish artist Juan Muñoz (1953–2001), to *The Weather Project* (right, above) by Danish artist Olafur Eliasson (b.1967). Eliasson used humidifiers emitting sugar and water to create a fine mist and lamps to create a yellow light; the piece was crowned by a large mirror on the ceiling and viewers often lay on the floor to look up to what resembled a large sun on a hazy day.

Installations have also been created outside of galleries and museums, most spectacularly with the work of Christo (b.1935) and Jeanne-Claude (1935–2009). The American couple have made artworks out of land and cityscapes around the world, most famously with *Wrapped Reichstag, Berlin* (opposite), in which they wrapped the German parliament building with aluminized polypropylene and rope. Although such works cannot be sold in an art market, the artists sell Christo's preparatory drawings and collages to pay all the expenses of their projects. *One & Other* (2009) by British sculptor Antony Gormley (b.1950) reveals just how far the concept of Installation art has developed. The work involved members of the public each spending an hour on an empty plinth of London's Trafalgar Square in what was a blend of sculpture, installation and performance art. **CK**

1974	1974–79	1993	1993	1997	2007
Conflating Performance art (see p.512) with Installation art for *I like America and America Likes Me*, Joseph Beuys (1921–86) spends three days with a coyote.	Chicago installs *The Dinner Party*; each place setting celebrates the achievements of a particular woman.	For *Germania*, his contribution to the Venice Biennale, Hans Haacke (b.1936) breaks up the marble floor of the German Pavilion with a jackhammer.	Ann Hamilton (b.1956) creates *Tropos*, an installation that covers a factory floor with horse hair and includes a person sitting at a desk burning books.	Christine Hill (b.1968) makes *Volksboutique*, a fully functioning second-hand clothes shop, for documenta X, held in Kassel, Germany.	Doris Salcedo (b.1958) creates *Shibboleth* in Tate Modern's Turbine Hall. It entails creating a 'crack' in the floor, echoing Haacke's *Germania*.

Portable War Memorial 1968

ED KIENHOLZ 1927–94

plaster casts, tombstone, blackboard, flag,
poster, restaurant furniture, photographs,
Coca-Cola machine, stuffed dog, wood,
metal, fibreglass
114 x 384 x 96 in. / 289.5 x 975.5 x 244 cm
Museum Ludwig, Cologne, Germany

Although *Portable War Memorial* is associated with American Pop art (see p.484), Ed Kienholz's work defies easy categorization and sits awkwardly within that genre. Familiar American icons are juxtaposed with everyday forms in a three-dimensional, hybridized tableau that displays an ambivalent attitude to the nation's military past. The assemblage, with its consciousness of political reality and appearance of having an underlying message to impart, repudiates the throwaway rationale of Pop art.

Portable War Memorial was constructed as a triptych and is intended to be read from left to right. On the left are readily identifiable examples of military imagery from the two World Wars together with the figure of the singer Kate Smith concealed in a barrel, from which the song 'God Bless America' can be heard. In the central section to the left a peacetime cafe table sits in front of a black memorial wall inscribed with the names of 475 cities that no longer exist; ominously, an area is left blank to accommodate the names of those cities that might be destroyed in the future. In the central section to the right a couple converse, oblivious, at a snack bar. In the right section stands a Coke dispenser positioned behind an inviting table with parasol and chairs and next to a blank memorial wall. Although the work's strong anti-war message cannot be denied, Kienholz never intended to cause offence to his fellow Americans. Rather, he sought to create a 'memorial' that was pensive rather than hubristic. **CS**

 NAVIGATOR

1 UNCLE SAM

The iconic image of Uncle Sam, originally designed in 1917 by James Montgomery Flagg, played a pivotal role in the American recruitment drive during World War I. The poster is what the artist termed a 'propaganda device' that brings awareness of war into the lives of ordinary people.

2 MARINES AT IWO JIMA

The memorial features a copy of the Iwo Jima Memorial that stands near Arlington National Cemetery (itself based on a photograph of US Marines on Mount Suribachi in 1945). They appear to be placing the flag on to a cafe table, in an ironic parallel to the sunshade shown on the table on the right.

3 TOMBSTONE

The black memorial carries a cautionary message; the inverted military cross is constructed in such a way that the details of future conflicts can easily be entered. Kienholz suggests that the futile loss of life due to war might continue indefinitely unless other ways of resolving conflicts can be found.

4 ALL-AMERICAN COUPLE

The central section contains a photograph of two people sitting at a bar. They are surrounded by American iconic imagery of a very different nature, including an actual Coke dispenser. But while war looms in the background of their lives, there is nothing here to remind them of that fact.

LATIN AMERICAN ART

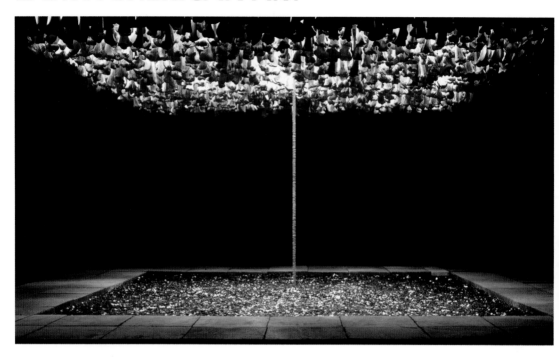

M uch of the art produced during the 20th century throughout Latin America has expressed the region's colonial history in such a way as to create an identity that is independent of European influence. Latin American artists have set out to reinterpret the region's origins in a nostalgic manner. Local or native elements have been represented in an eclectic way, and indigenous symbols and images have been questioned. For example, *Abaporu* (1928) by Tarsila Do Amaral (1886–1973) inspired the Anthropophagic movement, which aimed to replace elements of European culture with something 'more Brazilian'. More recently, the work of artists such as Vladimir Cybil (b.1967) and Andre Juste (b.1956) from Haiti, and Betsabee Romero (b.1963) from Mexico has re-established the importance of national symbols.

Brazilian Cildo Meireles (b.1948) developed an interest in political art after the military coup in 1964. His work recalls political and religious oppression and his best-known piece is *Mission/Missions (How to Build Cathedrals)* (above), an installation that explores the Jesuit missions to Paraguay, Argentina and Brazil that began in 1610. In this work a carpet of 600,000 coins lies beneath a canopy of bones and the two elements are joined by a column of Communion

KEY EVENTS

1960	1970	1972	1973	1976	1986
After the Revolution (1959), Mendieta is exiled from her native Cuba. Her work explores her Cuban roots and interest in ancient cultures.	Meireles begins to explore ideas of space and circulation in his art. He becomes particularly noted for his installations.	Mendieta begins to use ritualistic performances in her art and uses her body as a medium for nature works.	In a US-backed coup in Chile, General Pinochet (1915–2006) ousts elected Socialist leader Salvador Allende (1908–73), who commits suicide.	Ferrari is forced into exile in São Paulo, Brazil after threats from the Argentine military dictatorship. He finally returns to Buenos Aires in 1991.	Cybil settles in the United States after spending most of her childhood in Haiti, where she hid from the authorities during her family's persecution.

wafers that symbolizes the attempt of the missionaries to save the indigenous populations from cannibalism by converting them to Catholicism.

Many Latin American artists have moved away from their home countries and the effects of such migration have resulted in a cultural hybridization in their work. In a great many cases, marginalization, unemployment and political turbulence have contributed to the artists' decision to leave. Cuban artist Ana Mendieta (1948–85) was a victim of the Peter Pan Operation (a US government programme in the early 1960s intended to give refuge to the children of Cubans who opposed the revolutionary government) in that the move cost her a great portion of her cultural identity; she frequently addressed this experience in her sculpture, photography and Performance art (see p.512). The term 'Chicano art' refers to a cultural hybrid and is used to describe the art created in the border region between the United States and Mexico, which presents a mixture of two cultures to create a new one. The majority of this art is public art, or rather, created in the streets.

Many Latin American countries suffer from economic, political and social underdevelopment. Peruvian artist Fernando Bryce (b.1965) developed a critique of problems in Latin America using a series of twenty-nine pen and ink drawings about US Defense Department propaganda from the 1950s. These brochures promoted tourism in Latin America and the series *South of the Border* (2002) questions cultural stereotypes and the credibility of printed documents. Argentine artist León Ferrari (b.1920) is well known for his works on political and religious subjects. His *Western and Christian Civilization* (opposite, below), in which the figure of Jesus Christ is crucified on the fuselage of a US fighter plane, is a protest against the Vietnam War.

Insecurity and social violence in Latin America have at times reached great proportions, particularly in Venezuela, Mexico, Ecuador and Brazil. Inspired by the work of David Siqueiros (1896–1974), one of 'Los Tres Grandes' (The Big Three) muralists of Mexican art (see p.436), Rafael Cauduro (b.1950) addresses some of these problems in his mural *The History of Justice in Mexico* (2009), which was commissioned for the Supreme Court Building in Mexico City. His realist style infuses the work with a crude and unmistakable sense of violence; ironically the location of the mural will prevent it from being seen by the masses.

Brazilian-born multimedia artist Vik Muniz (b.1961) lives and works in New York. He does not believe that political art serves any real purpose; instead he prefers to make donations from his various exhibitions to charitable organizations that support poor children in Brazil. His work often appropriates European images, which he reinterprets by assembling objects (often food) and then photographing the result. In *Medusa Marinara* (right) he arranged spaghetti and sauce on a plate, shaped into a likeness of Caravaggio's *Medusa* shield (1597). **AP**

1 *Mission/Missions (How to Build Cathedrals)* (1987)
Cildo Meireles • mixed media
93 x 20 x 20 in. / 236 x 51 x 51 cm
Collection Daros-Latinamerica, Zurich, Switzerland

2 *Medusa Marinara* (1997)
Vik Muniz • instant colour print
3 1/2 x 4 1/2 in. / 9 x 11 cm
Metropolitan Museum of Art, New York, USA

3 *La Civilizacion Occidental y Cristiana (Western and Christian Civilization)* (1965)
León Ferrari • polyester, wood, cardboard
78 3/4 x 47 1/4 x 23 5/8 in. / 200 x 120 x 60 cm
Colección Fundación Augusto y León Ferrari Arte y Acervo

1992	1994	2002	2007	2008	2009
Hugo Chávez (b.1954) leads a failed coup in Venezuela. He will become the country's president in 1999.	Tomás Sánchez (b.1948) produces the Hyperrealist work *To the South of Calvary* (see p.510).	Bryce creates his iconic series *South of the Border*, highlighting the gulf between Latin America and the United States.	Ferrari is awarded the Golden Lion at the Venice Biennale.	Meireles is the first Brazilian artist to be given a full retrospective at the Tate Modern, London.	Cauduro continues in a long tradition of Mexican muralism when he produces *The History of Justice in Mexico*.

To the South of Calvary 1994

TOMÁS SÁNCHEZ b. 1948

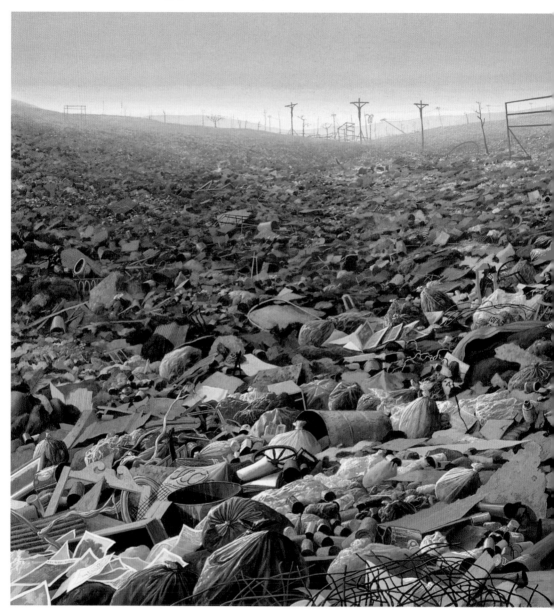

1 CRUCIFIXES

As the rubbish blurs into the background, the horizon is punctuated by a series of cross-like structures, the foremost three of which resemble the crosses in Christ's crucifixion. This religious reference amid the waste brings the notion of redemption into juxtaposition with that of waste.

2 LITTER

The contrasting colours used to depict the litter in the foreground are unusually vivid, reminding the viewer that the litter will remain in existence for some time. Although the various objects have been abandoned in the landfill site, they remain as evidence of consumerism.

◆ NAVIGATOR

T he original title of this work by Cuban artist Tomás Sánchez is *Al Sur del Calvario* and the piece represents the degradation that material consumerism brings to contemporary societies. The artist is one of the masters of Hyperrealism (see p.536) in Latin American landscape painting and has focused on representing the beauty of detail in all of his paintings. This work depicts details of everyday objects that human societies push aside, abandon and turn into litter, even if they are not yet useless.

The composition of the painting, and the V-shape created by the hill slopes in particular, directs the viewer's attention from the brightly coloured rubbish in the foreground towards the hills in the background (most probably made of litter, too), where the air sustains a hazy and polluted atmosphere. This smoggy context takes the colours away gradually as the viewer is drawn further into the painting; the technique imitates the natural blur that the human eye experiences when confronted with landscape in real life. The piles of litter soften in colour and definition in the distance, as do the figures that are located so far away that they are barely discernible.

Sánchez is a master of naturalistic landscape painting, but most of his compositions depict nature, sky and water in imaginary scenes. Throughout his career—especially during the 1980s—he has frequently returned to reflect upon the subject of waste and has visited many large cities, such as Mexico City, to research scenes such as this. In *To the South of Calvary* the artist suggests that even in the most impure places, such as rubbish dumps, there is redemption and there is still a god. He transmits a spiritual ethos in this way in many of his paintings, and this aspect of his work has inspired comparison with the German Romantic painter Caspar David Friedrich (1774–1840). The two artists share the same transcendental values in contemplating nature; some of Friedrich's landscapes also feature crucifixes at the far distance. **AP**

acrylic on canvas
36 x 48 in. / 91.5 x 122 cm
Private collection

3 LADDER

Sánchez composed this painting using a meticulous sense of perspective. The angle of the ladder points towards the crosses and helps the viewer to perceive the depth of field. The various clusters of litter bags also highlight the way in which the vast landfill site recedes into the horizon.

4 BARBED WIRE

The presence of the barbed wire appears as a menace to the viewer. Its foreground position gives the sense that the viewer might trip over the wire, become entangled or get cut. The mesh of thorny spines also references Christ's crown of thorns.

PERFORMANCE ART

Performance art has its origins in the theatrical events staged by Futurist (see p.396), Dadaist (see p.410) and Surrealist (see p.426) artists in the early 20th century. It adopts their notions of eroding the boundary between artist and audience through interaction. By the 1950s such interactions developed into what were known as 'happenings', staged by artists such as Allan Kaprow (1927–2006) in New York. In the 1960s, the term 'Performance art' came to be used to describe artworks in which artists use their body as a medium in performing actions, which may incorporate music, song and dance, fluctuate in length and be repeated in different locations. At this time, the medium was spearheaded by an international group of artists, composers and designers including John Cage (1912–92), George Maciunas (1931–78), Yoko Ono (b.1933), Nam June Paik (1932–2006) and Carolee Schneemann (b.1939), who formed the Fluxus collective in 1960. The group expanded to include a host of other artists, most notably German artist Joseph Beuys (1921–86).

Fluxus—meaning 'flow' in Latin—wanted the everyday to be brought into art. Fluxus artists drew upon Marcel Duchamp's (1887–1968) concerns regarding the viewer's relationship to an artwork. Duchamp considered that the deciphering process that spectators went through in order to understand an artwork was permeated by their own desires and creativity, and that this was an integral aspect of the artwork. Fluxus artists wanted to close the gap

KEY EVENTS

1950	1952	1961	1963	1964	1965
Photographer Hans Namuth (1915–90) photographs Jackson Pollock (1912–56) creating his 'action' paintings.	Cage instigates the first 'happening' at Black Mountain College in North Carolina.	Fluxus is given its name by Maciunas.	Beuys gives his first 'action' performances, *Composition for 2 Musicians* and *Siberian Symphony, 1st Movement*, in Düsseldorf.	Ono performs *Cut Piece* at the Sogetsu Art Centre in Tokyo, inviting the audience to cut off pieces of her garment until she is naked.	Nauman gives up painting. Afterwards much of his work is filmed performances and installations including audience participation.

between modern art and daily life. Instead of an art of self-expression, which they believed overvalued the individual artist, they championed a political art that was engaged with the physical world and social issues within it.

Fluxus artists adopted strategies from the Dada movement, such as chance and improvisation, in their works. Beuys's *I Like America and America Likes Me* (opposite, below) is a typical example. He flew to New York, where he was wrapped in a blanket and taken by ambulance to the René Block Gallery. There he shared a room with a wild coyote for three days. Beuys interacted with the coyote by sleeping on a bed of straw, walking with a shepherd's crook, and throwing leather gloves at the coyote. The performance ended when Beuys hugged the coyote, after which he left the gallery and returned to the airport. The coyote was regarded as a god by Native Americans and Beuys's shamanistic performance illustrated the debasement of an indigenous culture in what was a critique of American imperialism and the Vietnam War.

By the late 1960s Performance art had become increasingly accepted and its proponents more numerous. Artists such as Vito Acconci (b.1940; see p.514) and Bruce Nauman (b.1941) began to make performance pieces. Serbian artist Marina Abramovic (b.1946) produced *Lips of Thomas* (opposite, above), which was first performed in 1973 at the Galerie Krinzinger in Innsbruck, Austria. In 2005, she re-enacted the performance at New York's Solomon R. Guggenheim Museum. She arrived on stage naked and after eating honey and drinking wine, she traced the drawn outline of a star on her stomach with a razor. Abramovic next donned an army cap and boots and picked up a stick, weeping while a Russian song played from a speaker. When the song ended, she lay down on a cross-shaped bed of ice and began to whip herself. She repeated the performance for a number of hours, before attaching a bloodied white handkerchief to the stick; the performance was dedicated to the resilience of subjugated Slav peoples.

By the 1970s, artists began to use Performance art to address issues specific to the type of bodies being represented. Ana Mendieta's (1948–85) performances addressed gender and cultural identity relating to her Cuban heritage. She melded Performance and Land art (see p.532) in a series of pieces that included *Tree of Life* (right), in which she covered her body with grass and mud, and stood against an oak tree in a goddess-like pose. In doing so, she explored the relationship of the female body to landscape and expressed her pain regarding her life as a Cuban in exile in the United States.

In the 1980s, artists looked to video and popular entertainment as sources of material. Laurie Anderson (b.1947) became known for work that combined the visual aspect of performance with multimedia. Recordings of songs such as 'O Superman (For Massenet)' (1981) became popular outside the art world and she began to perform in music venues as well as art spaces. Matthew Barney (b.1967) and Mariko Mori (b.1967) continue to draw on popular culture to create works fusing performance, video, photography and installation. **OM**

1 Performance still from Marina Abramovic's re-enactment of *Lips of Thomas* at the Solomon R. Guggenheim Museum, New York, USA on 14 November 2005 in the *Seven Easy Pieces* series.

2 Performance still from Ana Mendieta's *Tree of Life* performed near Old Man's Creek, Iowa, USA in 1976.

3 Performance still from Joseph Beuys's *I Like America and America Likes Me* at the René Block Gallery, New York, USA in May 1974.

1970	1971	1972	1988	1994	2008
Italian-British artists Gilbert & George (b.1943 and 1942) perform *The Singing Sculpture* at the Nigel Greenwood Gallery in London.	Acconci performs *Seedbed* at New York's Sonnabend Gallery. Hidden under a ramp, he masturbates while talking about his sexual fantasies.	Beuys is sacked from his teaching position at the Düsseldorf Academy; this prompts a widespread student strike and protest movement.	Barney begins *Drawing Restraint*, an ongoing performance-based project on the idea that form emerges through struggle against resistance.	Mori stands in a Tokyo subway car dressed as an alien for *Subway*, a piece on constructed identity.	Anderson takes her performance *Homeland*, which tackles American fears about security, on an international tour.

Following Piece 1969
VITO ACCONCI b. 1940

performance still
short film

This early performance piece by New York-based artist Vito Acconci was executed in 1969. It involved the artist following the first passer-by he saw after exiting his Manhattan apartment building each day. The act of following was documented in photographs and typewritten accounts. *Following Piece* comprised twenty-one acts of following that took place on twenty-one different, non-consecutive days. The individual acts of following lasted from five minutes to five and a half hours. Acconci created specific guidelines beforehand; a note written before the execution of the piece outlines its form: 'Each day I pick out, at random, a person walking in the street. I follow a different person everyday; I keep following until that person enters a private place (home, office, etc) where I can't get in.'

All of Acconci's performance works scrutinize routine bodily actions, demonstrating their broader social implications. By acting out *Following Piece*, Acconci submits himself completely to the intentions of the person he is trailing. In this way he engages directly with other people and their lived experiences. Instead of odd or eccentric performances, the audience discovers concise explorations of the body's relation to space and others. **OM**

👁 DOCUMENTING THE WORK

1 PUBLIC AND PRIVATE SPACE
The piece takes place in an urban setting. Although Acconci moves within a public space, when he follows a stranger he subjects himself to their will and enters their private sphere.

2 THE ARTIST'S BODY
Acconci uses his own body as a medium and a vehicle in the work. He also assigns an important role to the participation of outsiders who were unaware that they were being used.

🕐 ARTIST PROFILE

1940–62
Born in New York to parents of Italian descent, Acconci studied English literature, before becoming an art teacher and a poet.

1963–74
For several years Acconci co-edited the journal *0 to 9* with author and poet Bernadette Mayer (b.1945). In 1969 he became a performance and video artist. He had his first solo show at the Rhode Island School of Design in 1969.

1975–87
From the mid 1970s Acconci used audiovisual installations in his practice. In 1987 a major retrospective of his work travelled throughout the United States.

1988–present
Since the 1980s, Acconci's work has been mainly architectural. For *Island in the Mur* (2003) he created an artificial island in the river to integrate it into the life of the Austrian city of Graz.

▲ In *Remote Control* (1971), Acconci coaxes a woman to tie herself up. The work points to the pervasive role of technology in modern life.

REPETITION IN ART

Acconci studied poetry before becoming a visual artist and his artistic practice has been strongly motivated by writing. Among the figures that have shaped his career as an artist is the Irish dramatist and poet Samuel Beckett (1906–89). Beckett's experiments in literature, such as his novel *Watt* (1953), use repetition to alter the audience's expectations. Similarly, Acconci employs repetition in artworks such as *Step Piece* (1970; below) where he stepped on and off a stool at the rate of thirty steps a minute for as long as he could, each day over a four-month period. By emphasizing the everyday but then abstracting it through repetition, Acconci is artistically related to Bruce Nauman and works such as *Walking in an Exaggerated Manner Around the Perimeter of a Square* (1968). Both artists applied techniques from Beckett's writing into visual

art. Acconci's Video art relies largely on repetition— and on being controversial. Works such as *Seedbed* (1972)—which involved Acconci lying under a ramp at New York's Sonnabend Gallery while he masturbated and vocalized his fantasies about the visitors walking above him—rely on repetitive actions.

ARTE POVERA

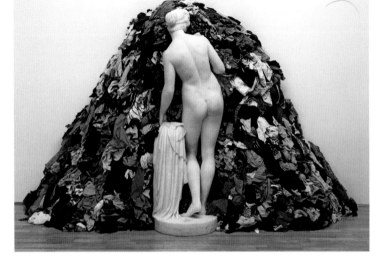

1 *Venus of the Rags* (1967, 1974)
Michelangelo Pistoletto • marble
and textiles
83 ¹/₂ x 133 ⁷/₈ x 43 ¹/₄ in. / 212 x 340
x 110 cm
Tate Modern, London, UK

2 *Untitled* (1968)
Jannis Kounellis • steel and wood trolley
with rubber tyres and charcoal
11 ³/₄ x 47 ¹/₄ x 47 ¹/₄ in. / 30 x 120 x 120 cm
Hamburger Kunsthalle, Germany

3 *Object, Conceal Yourself* (1968)
Mario Merz • iron rods, wire mesh, linen
sacks filled with wool, and neon
82 ⁵/₈ x 43 ¹/₄ in. / 210 x 110 cm
Ileana and Michael Sonnabend
Collection, New York, USA

The critic Germano Celant (b.1940) coined the label for this Italian movement in 1967, drawing on the concept of 'Poor Theatre' introduced by Polish director Jerzy Grotowski (1933–99). Celant described it as a movement that called attention to facts and action, and explained that 'Arte Povera', meaning 'Poor Art', referred to the humble materials used by practitioners of the time to make anti-elitist art.

The artists at the core of the group were all Italian: Mario Merz (1925–2003), Michelangelo Pistoletto (b.1933), Giovanni Anselmo (b.1934), Luciano Fabro (1936–2007), Pino Pascali (1935–68), Alighiero Boetti (1940–94), Giulio Paolini (b.1940), Piero Gilardi (b.1942), Emilio Prini (b.1943), Gilberto Zorio (b.1944) and Giuseppe Penone (b.1947), with the exception of the Greek-born, Italian-trained Jannis Kounellis (b.1936). Their preoccupations were Italian and the movement appeared at a time of huge social change and political disruption. The 1950s and 1960s saw a financial boom in Italy, owing to rapid industrialization, yet an economic division remained between the north and south. There was opposition over the Vietnam War, which led to nationwide protests, and there were workers' strikes and the beginnings of terrorism.

In the art world, Pop art (see p.484) dominated. Although both Pop art and Arte Povera used banal materials, Arte Povera rejected Pop art's empty reflections of consumerism and mass production. Arte Povera artists attempted a re-engagement with the world, underpinned by intellectual influences such as writing on semiotics by Italian author Umberto Eco (b.1932) and works on

KEY EVENTS

1962	1964	1965	1966	1967	1967
Eco publishes *The Open Work*, a semiotic study of art and film. It has a powerful influence on the philosophy of Arte Povera.	The Italian press is hostile when Pop art (see p.484) dominates the Venice Biennale and Robert Rauschenberg (1925–2008) wins the Grand Prize.	Merleau-Ponty's work on consciousness, *Phenomenology of Perception* (1945), is published in Italy.	'Arte abitabile' (Habitable Art) at Galleria Sperone, Turin, shows works by artists such as Pistoletto and Boetti that announce Arte Povera's aesthetic.	In October Celant curates 'Arte Povera—Im spazio' (Poor Art in Space) at Galleria La Bertesca, Genoa.	In November *Flash Art* magazine publishes Celant's article 'Arte Povera: Notes for a Guerrilla War'.

phenomenology by French philosopher Maurice Merleau-Ponty (1908–61). Like Minimalism (see p.520), Arte Povera pointed to the intrinsic quality of materials, but for different reasons. For Arte Povera artists it was a way to challenge tradition, order and structure. Their juxtaposition of objects sometimes evoked Surrealism (see p.426), but the works were never absurd for the sake of it and often had radical intent. For example, Merz's *Object, Conceal Yourself* (right, below) is one of a series of igloo-shaped works, made from natural and artificial materials, that explores nomadic peoples and how nature connects with daily life. Its neon lettering 'Objet cache-toi' echoes the slogan of French student protesters who took to the streets of Paris in 1968. Boetti's *Mappa* (1971–72; see p.518) is the first in a series of embroidered maps that examine the shifting nature of geopolitics and the relationship of art to craft.

When Arte Povera arrived, Italy had relatively recently emerged from the devastating effects of World War II and Arte Povera artists grappled with the country's past as much as had their Futurist (see p.396) forerunners, but without denying it. Instead, Italian artistic history, from ancient Rome to the Renaissance (see p.150) and Baroque (see p.212), was reconsidered. They opted for installations often made from found materials, such as in Pistoletto's *Venus of the Rags* (opposite). It presents an iconic image from antiquity juxtaposed against the detritus of modern society by depicting a garden statue of the Roman goddess appearing to peer into a pile of second-hand clothes.

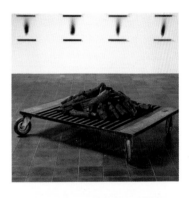

The theme of nature is common in Arte Povera work. Penone used photographs to record his interventions in the growth of trees, as he attempted to relocate beauty within nature rather than within the object of art. Paradoxically, artists took nature to the gallery, most dramatically in 1969 when Kounellis tethered twelve horses in Rome's Galleria L'Attico. He wanted the gallery to become a theatre where life and fiction are one, and the horses evoked heroic equine statues. Kounellis abandoned painting and opted to make installations, such as *Untitled* (right, above), from unorthodox and everyday materials, which he described as 'painting the shadows'. The soot marks on the wall behind the trolley are typical of his work at that time, which explored the deterioration of things and the traces they left. He wanted to illustrate the difficulties of painting's trying to reflect a concrete reality that is, in fact, illusive. An interest in the passing of time was a constant in Arte Povera, most notably in a work by Anselmo of a head of lettuce held by a copper wire between two unequal pieces of granite. When the lettuce wilts, the smaller block of granite falls: it is a sculpture that is both fragile and alive.

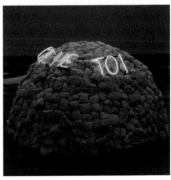

Arte Povera dissipated in the 1970s in the wake of political assassinations and the growth of the Brigate Rosse (Red Brigades) terrorist organization, which lessened the appeal of Arte Povera's revolutionary stance. In the following decades, a shift to painting in Italian art somewhat overshadowed Arte Povera, but its influence remained far-reaching. **WO**

1968	1968	1969	1969	1971	1981
Grotowski writes *Towards a Poor Theatre*, which advocates eliminating the superfluous, such as make-up, and reducing theatre to its essence.	From June to September the Venice Biennale is besieged by student demonstrations and there are clashes with the police.	Celant's book *Arte Povera* is published.	'Live in Your Head: When Attitudes Become Form' opens at the Kunsthalle Bern. It includes an Arte Povera piece and goes on to Germany and the UK.	The last show for more than a decade to use the term 'Arte Povera' opens in Munich, 'Arte Povera: 13 italienische Kunstler' (Arte Povera: 13 Italian Artists).	Arte Povera dominates 'Identité Italienne, l'art en Italie depuis 1959' (Italian Identity, art in Italy since 1959) at Paris's Centre Pompidou.

Mappa 1971–72

ALIGHIERO BOETTI 1940–94

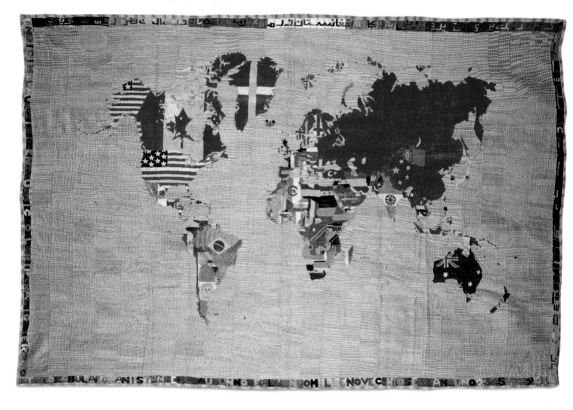

embroidery on cloth
57 ⁷/₈ x 89 ³/₄ in. / 147 x 228 cm
Private collection

◆ NAVIGATOR

A lighiero Boetti was a member of Arte Povera for several years and subscribed to the movement's ethos of rejecting high art by using ordinary materials and adopting an open attitude to the artistic process. Both are exemplified in his series of large-scale embroidered maps. Although the maps recall medieval *mappae mundi*, they are examples of 'low' art because they are made from inexpensive materials by a group of Afghan women commissioned by Boetti. He handed over the creative process to the weavers, subscribing to the Arte Povera idea of breaking down the barrier between artist and audience via participation, saying: '…I did absolutely nothing; when the basic idea, the concept, emerges everything else requires no choosing.'

This is the first of his hand-embroidered maps; the last was made in 1992. Each country is represented on the map by the colours and pattern of its flag. As the world's borders change, so the appearance of the maps alters over the series, showing the collapse of the Soviet Union, the reunification of Germany and disputes over territories in the Middle East. The constant flux in geopolitics is reflected in the maps' making, too: initially they were created in Kabul, Afghanistan, but after the weavers' families were forced to flee during the Soviet invasion in 1979, production was halted for three years. The maps were then made by women in refugee camps in Peshawar, Pakistan, and the maps' framing borders changed to include texts of statements on jihad and the status of Afghan refugees. The series demonstrates many of the themes of Boetti's work: the passing of time, seriality, the use of commonplace materials, chance versus order, systems of classification and non-Western cultural production. His use of chance in art with map-making as the subject matter was original. **WO**

👁 FOCAL POINTS

1 BORDER

Each map has a border along its edges containing text written in Italian, Farsi or Dari. The multi-coloured writing frames the map and contains information about the date and place of execution, highlighting Boetti's fascination with temporality. Some text reads from left to right, but some has to be read from top to bottom or upside down, as the artist challenges the concept of order and meaning of the signs used in conventional writing.

2 POLITICAL FLUX

This map was made before the break-up of the Soviet Union. It shows that the idea of a nation is just that—an idea—because its borders can change or the nation can disappear entirely over time. Embroidering a map takes years, so finished maps may reflect a state of the world that is no longer accurate.

3 FLAG COLOURS

The concentrations of colours on the countries shown on the map is in accordance with the colours that these countries use on their flags. The predominance of red, yellow and green that appears on the African continent is because many of the countries there adopted flags whose colours are based on the Pan-African colours of the 1798 tricolour flag of Ethiopia: red, gold and green. Red represents power, gold peace and green hope.

4 MATERIALS

The map is embroidered on cotton, in keeping with the Arte Povera idea of using everyday materials. The designs were executed by female weavers and Boetti stipulated that they use all available colours in equal quantities, leaving the decision regarding final colour composition to the women.

🕐 ARTIST PROFILE

1940–66
Boetti was born in Turin. He abandoned his studies at Turin University's faculty of engineering to become an artist. He began experimenting with chance in art with *Annual Lamp* (1966), a lamp that lights up once a year for eleven seconds.

1967–69
Although untrained, Boetti joined the Arte Povera movement in January 1967 and had his first solo show at the Galleria Christian Stein in Turin the same year. In 1969 he began a project sending letters to fictitious addressees.

1970–88
He began his systematic 'exercises' using pencil on squared paper, based on musical and mathematical rhythms. In 1971 Boetti made his first trip to Afghanistan, where he worked in collaboration with artisan textile workers. From 1973 he signed his works 'Alighiero e Boetti'; the 'e' means 'and', reflecting the artist's interest in duplication. As the decade progressed he disassociated himself from the Arte Povera movement.

1989–94
Boetti exhibited fifty-one tapestries with texts in Italian and Farsi at the 'Les Magiciens de la Terre' (The Magicians of the Earth) exhibition in Paris. In 1990 he won the Special Jury Prize at the Venice Biennale. He showed fifty kilims at the Magasin in Grenoble, his last exhibition, in 1993.

ORDER AND CHANCE

Boetti was fascinated by order and chance. In 1993 he created a series of fifty kilims—*Alternando da uno a cento e viceversa*—in collaboration with fifty individuals or groups who each created a design based on a ten by ten grid of alternating black and white squares; the grids transformed numbers into patterns, ranging from simple 'L' shapes to a pixellated face. These were then translated on to kilims woven by Afghani refugees in Pakistan. The preparatory drawing of the kelim below was designed by Ecole Régionale des Beaux-Arts de Saint-Etienne.

MINIMALISM

1 *Diagonal of May 25, 1963
(to Constantin Brâncuși)* (1963)
Dan Flavin • yellow fluorescent tube
96 in. / 244 cm (length of tube)
Dia Art Foundation, New York, USA

2 *Open Cube* (1968)
Sol LeWitt • lacquer on aluminium
41 3/8 x 41 3/8 x 41 3/8 in. / 105 x 105 x 105 cm
Nationalgalerie, Staatliche Museen
zu Berlin, Germany

3 *Untitled (Stack)* (1967)
Donald Judd • lacquer on galvanized iron
9 x 40 x 31 in. / 23 x 101.5 x 79 cm
(each unit)
Museum of Modern Art, New York, USA

The term 'Minimalist' was derived from the title of an essay written in 1965 by the British philosopher Richard Wollheim (1923–2003), who was reflecting on the minimal manual effort exerted by the artists around him. Although he was commenting particularly on works such as the colour field paintings of Ad Reinhardt (1913–67) and the ready-made sculptures of Marcel Duchamp (1887–1968), the Minimalist tag came to be applied to a group of American sculptors practising in New York in the 1960s: Carl Andre (b.1935), Dan Flavin (1933–96), Donald Judd (1928–94), Sol LeWitt (1928–2007) and Robert Morris (b.1931). These Minimalist artists created pared-down objects in which there was no attempt at representation or illusion.

The painting practices of Reinhardt and Frank Stella (b.1936) laid a foundation for the Minimalist sculptors. Stella's 'black paintings'—total abstractions consisting of black stripes separated by thin strips of unpainted canvas—were shown in New York in 1959 as part of the 'Sixteen Americans' exhibition at the Museum of Modern Art. The canvases denied hierarchy of composition and revealed no hidden meanings, symbols or references. It was these factors that the sculptors translated into three dimensions. They showed a preference for the materials and methods of mass production—plexiglas, aluminium, wooden beams, fluorescent lights, galvanized steel and magnesium tiles—and commissioned factory workmen to produce the sculptures according to their specifications. Judd's sculpture *Untitled (Stack)* (opposite, below), consisting of twelve identical iron boxes affixed to a wall,

KEY EVENTS

1962	1963	c. 1964	1965	1965	1966
Morris begins a two-year course in art history at Hunter College in New York. It is four years since he held his first solo exhibition.	Flavin begins to use fluorescent lighting as his main artistic medium.	Judd begins to experiment with a new medium: coloured perspex. It becomes one of his trademarks.	Judd publishes an essay titled 'Specific Objects' in *Arts Yearbook 8*, proposing a new theory of Minimalist aesthetics.	The term 'Minimalist' is coined by writer and philosopher Richard Wollheim.	Morris publishes 'Notes on Sculpture 1–3' in *Artforum* magazine. He attempts to define a conceptual framework for Minimalism.

demonstrated an interest in geometry as an organizational system: each box is of identical size and they are spaced precisely 9 inches (23 cm) apart. Because of the serial repetition of elements, Judd contended that there was no hierarchy in the composition and that it elicits no emotional response. The object stands alone in real space and does not depend on a viewer for completion.

The non-relational nature of Judd's iron boxes cannot be applied to all Minimalist sculpture of the 1960s. During this period, a debate arose around what was perceived to be the inherent theatricality of some of the installations. In 1967 art critic Clement Greenberg (1909–94) suggested that Minimalist art was too 'far-out' and intellectual, and no more readable than 'a door, a table, a sheet of paper'. Two months later, critic Michael Fried (b.1939) published his seminal essay 'Art and Objecthood', which also chastised Minimalist sculptures for being little more than mere objects. However, Fried went further, to argue that the works altered the relationship between viewers and traditional art objects. He suggested that the Minimalist works existed in gallery spaces in a manner akin to theatre stage settings, and individual interaction with them was a necessary component of the art experience. These were objects intended to be encountered and negotiated personally by the viewer, rather than merely contemplated from a distance. Fried feared that Minimalism would lead to the demise of the art object altogether.

Fried may have been referring to an installation by Morris at the Green Gallery, New York, in 1964, in which the viewer's progress through the gallery was deliberately obstructed by seven grey-painted, geometric, plywood structures. Another artist whose work presented the viewer with alterations of the gallery environment was Flavin, who first used electric lighting as an artistic medium in 1961 and went on to use fluorescent tubes in a variety of settings. For *Diagonal of May 25, 1963 (to Constantin Brâncuși; opposite)*, Flavin installed a single yellow fluorescent tube at an angle of forty-five degrees. Works such as this were not only sculptural in their own right but also transformed the gallery experience in their play of shadow and coloured light. Flavin also created corners and corridors of light that intensified the effects.

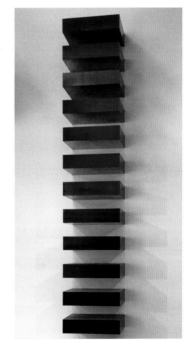

Sculptures by LeWitt further attest to both the objecthood of Minimalist forms and their reliance on viewers for completion. *Open Cube* (right, above) is a three-dimensional aluminium outline of a cube with five of the twelve edges missing. Its mathematical starkness is disrupted by the viewer's need to imagine it into wholeness. Later in 1968, LeWitt produced *Buried Cube Containing an Object of Importance But Little Value*, wherein he buried a small cube in the garden of a Dutch collector. A series of photographs document the artist digging the hole, standing next to the object and covering it with soil as an act of bidding farewell to Minimalism. LeWitt's later work helped to push the art world into the further dematerialization of the art object through Conceptual art (see p.500). **CV**

1968	1969	1969	1970	1971	1975
Morris creates *Steam*, an early piece of Land Art (see p.532), in which he uses the transparency of steam to create a sense of dematerialization.	Judd exhibits *Untitled*, which consists of ten stacked copper boxes, two fewer than he used in his iron sculpture of 1967.	Andre creates *Steel Zinc Plain* (see p.522) and other floor-level sculptures made from squares of metal in a chequerboard pattern.	Andre's work becomes the focus of a major exhibition at the Guggenheim Museum, New York.	Morris's 'Bodyspacemotion-things' exhibition at London's Tate Gallery causes a sensation but is quickly closed because of overcrowding.	To emphasize the mutability and impermanence of his work, LeWitt uses chalk to create his mural *Wall Drawing #260*.

Steel Zinc Plain 1969

CARL ANDRE b. 1935

steel and zinc
72 ¹/₂ x 72 ¹/₂ x ³/₈ in. / 184 x 184 x 0.9 cm
Tate Modern, London, UK

⬖ NAVIGATOR

Of all the Minimalist artists, none held himself more closely to the stated parameters of the movement than Carl Andre. The artist remarked: 'My work is aesthetic, materialistic and communistic. It is aesthetic because it is without transcendent form, without spiritual or intellectual quality. Materialistic because it is made out of its own materials without pretension to other materials. And communistic because its form is equally accessible to all men.' For Andre, who was influenced by his visit in 1954 to European historic and prehistoric sites such as Stonehenge, it was important that his work should be in dialogue with its environment.

Steel Zinc Plain reflects the elemental simplicity of Andre's purpose. The work consists of thirty-six plates, half of them steel and half of them zinc, placed next to one another on the gallery floor in a square, chequerboard formation. The work is one of a series of floor-based sculptures in which Andre explores the qualities of his materials, as well as those of the work's surroundings. For Andre, the negative space of the floor that remained exposed around his various formations was an integral part of the artwork. *Steel Zinc Plain* has no start or finish, no top or bottom. Spectators can walk over it, bringing to the work their own sense of direction, perspective and touch. **CV**

⊙ FOCAL POINTS

1 FLOOR-LEVEL SCULPTURE

By creating sculpture on which the viewer could walk, Andre changed the manner in which visitors to art galleries engaged with their environment. The sculpture, rather than being viewed passively and objectively from a distance, became part of the viewer's own territory and reality.

2 CONTRASTING METALS

Andre's work offers the viewer an opportunity to meditate on the modern, industrial materials he has used, in this case steel and zinc. In 1969 Andre produced other works of identical size using different combinations of metals; these included *Steel-Aluminium Plain* and *Lead-Copper Plain*.

EQUIVALENT VIII

The *Equivalents* series created by Carl Andre in 1966 consisted of eight separate works, each being a unique arrangement of 120 bricks made from sand and lime. Although the arrangements were different, in each case the constituents—bricks of equal dimensions and weight—were the same; the works were therefore 'equivalent' in the materials used. The arrangement *Equivalent VIII* (below) stopped at ankle height and was said to give viewers the sensation that they were wading through a sea of bricks.

The purchase of *Equivalent VIII* in 1972 by the Tate Gallery in London provoked an uproar. The original work had gone unsold and Andre had returned the bricks to reclaim his money. He recreated the work for the Tate using firebricks. Andre's detractors believed that the Tate had wasted its money in buying a 'simple'

arrangement of bricks, while his supporters placed *Equivalent VIII* among the most important pieces of 20th-century contemporary art. The work was vandalized with paint in the year of purchase, but was returned for display in 1977.

⏱ ARTIST PROFILE

1951–57

From 1951 to 1953, Andre attended Phillips Academy in Andover, Massachusetts, where he studied art with Patrick Morgan. He travelled to England and France in 1954, then joined US Army Intelligence in North Carolina. Settled in New York in 1957, he made sculptures influenced by Constantin Brâncuși.

1958–65

Andre met Frank Stella, whose paintings deeply influenced his sculptural style. Stella and Andre came to share a studio on West Broadway, New York. Andre began drawings for his *Elements* series of sculptures.

1966–present

After showing his work *Lever* in the 1966 'Primary Structures' exhibition in New York, Andre refined his interest in using the floor not only as a stage but also as a component of his work. In 1985 he married Cuban performance artist Ana Mendieta (1948–85), who fell to her death from her apartment window later that year.

OP ART

The term 'Op art' was first used in the autumn of 1964 by *Time* magazine to describe a new style of art. The article stated: 'Preying and playing on the fallibility in vision is the new movement of "optical art" that has sprung up across the Western world...op art is made tantalizing, eye-teasing, even eye-smarting by visual researchers using all the ingredients of an optometrist's nightmare.' Later, the term was used to refer to all art that uses illusion or optical effects and has a psychophysiological effect on the viewer. Op art practitioners created images that play with the viewer's perceptual processes; the viewer sees an image that moves, alters perspective or leaves an after-image. To achieve these effects the artists employed phenomena such as line interference, reversible perspective, moiré fringes, chromatic vibration and colour contrasts. Bridget Riley (b.1931) used black and white lines and geometric patterns in works such as *Current* (1964; see p.526) to convey movement, while Victor Vasarely (1908—97) exploited the ambiguity of tessellated coloured surfaces to create the illusion of 3D shapes, exemplified by *Marsan* (above).

The Op art movement gained greater recognition in 1965 when New York's Museum of Modern Art held an exhibition on perceptual abstraction, 'The

KEY EVENTS

1917	1938	1949	1955	1960	1962
Mondrian exhibits *Composition in Lines*. Decades later it is heralded as an early example of Op art.	Vasarely paints *Zebra*, in which diagonal black and white curved stripes create the impression of a seated zebra.	Albers begins his *Homage to the Square* series. The chromatic colour shifts of squares set inside one another challenge visual reception.	The Galerie Denise René in Paris holds 'Le Mouvement' (The Movement) exhibition of Kinetic and Op art; it includes work by Vasarely.	A group of American artists form the Anonima Group; they work collectively to create artworks that investigate optical perception.	Riley holds her first solo show at Gallery One in London.

Responsive Eye'. It showed works by Riley, Vasarely, Josef Albers (1888–1976), Almir da Silva Mavignier (b.1925), Richard Anuszkiewicz (b.1930), Julian Stanczak (b.1928) and Tadasuke Kuwayama (b.1935), known as Tadasky, that draw on geometric principles and colour theory. For example, Tadasky's hypnotic *A-101* (opposite, below) was created using Japanese brushes and a rotating device, resulting in a composition of concentric rings of varying colours and width. The combination of positive and negative space produces a fluctuating effect. Not all Op art destabilizes the viewer with flashing or vibrating images. Works such as Mavignier's *Shifting and Colour Alternation 3* (right) play on permutations of colour that warp to create a deceptively swollen topography, so that a flat surface seems curved.

For centuries artists have employed devices, such as *trompe l'œil*, to create visual effects that confuse the eye. Early Modernists paved the way for Op art by pairing pure colour with abstraction, and instead of being presented with specific constructions, viewers were confronted with shapes of colour and lines. *Composition in Lines* (1917) by Piet Mondrian (1872–1944) has been retroactively identified as Op art. From the 1950s artists began experimenting with kinetics. This first found expression in three dimensions in Kinetic art sculptures that move and therefore disrupt the stable viewpoint of the viewer, a goal also adopted by Op art painters working in two dimensions.

The arrival of European refugee artists, such as Albers, in the United States proved to be important. Albers explored the idea that what the viewer sees is determined by how the brain processes the information contained in an image; he created works that explore perceptual ambiguity in terms of colour, plane and line. His teaching and writing on colour theory in *Interaction of Color* (1963), illustrating how colours interact to change a composition and hence the viewer's perception of an image, influenced a generation of American artists.

Socio-politically the 1960s saw science presented as the key to the fulfilment of a new and progressive social vision, and Op artists aimed to create a visual and often disturbing embodiment of the proposed new reality. While government and industry romanticized technological advancements and the notion of the space age, Op art critiqued it. While Pop art (see p.484) was a self-conscious product of society, drawing motifs and themes from commercial sources, Op art sought to avoid commercial inferences by taking a scientific approach, employing technical skill and mathematical principles.

However, Op art rapidly became part of consumer culture. Fashion designers and graphic artists adopted its visual devices, and soon Op art images graced advertising boards, album sleeves and interior decor. When 'The Responsive Eye' show opened, Manhattan boutiques were displaying clothing whose textile designs copied exhibitors' paintings. This assimilation into popular culture discredited Op art, as it came to be seen as an ephemeral phenomenon that appealed to the masses rather than as high art. **EWI**

1 *Marsan* (1966)
Victor Vasarely
Private collection

2 *Shifting and Colour Alternation 3* (1968)
Almir da Silva Mavignier • oil on canvas
55 ¹/₂ x 39 ³/₈ in. / 141 x 100 cm
Hamburger Kunsthalle, Germany

3 *A-101* (1964)
Tadasky • synthetic polymer paint
on canvas
52 x 52 in. / 132 x 132 cm
Museum of Modern Art, New York, USA

1964	1965	1965	1965	1966	1970
The phrase 'Op art' is used for the first time in an article in the 23 October issue of *Time* magazine titled: 'Op Art: Pictures that Attack the Eye.'	The Museum of Modern Art in New York holds a major exhibition of Op art, titled 'The Responsive Eye'.	Fashion designer Larry Aldrich (1906–2001) produces a dress collection inspired by Op art. Riley later sues for copyright infringement.	Vasarely receives the Grand Prize at the São Paolo Biennale in Brazil.	In late March, the Scott Paper Company launches the Op art Paper Caper dress to promote its paper towels and tissues.	Vasarely opens the Vasarely Foundation research centre and museum to show his work at the Château de Gordes in France.

Current 1964

BRIDGET RILEY b. 1931

synthetic polymer paint
on composition board
58 ³/₈ x 58 ⁷/₈ in. / 148 x 149.5 cm
Museum of Modern Art,
New York, USA

Bridget Riley developed her distinctive style in the late 1950s and she was inspired by the optical and often illusionary effects of the paintings of Post-Impressionist (see p.328) Georges-Pierre Seurat (1859–91). During the early 1960s her black and white geometric canvases echoed the work of Victor Vasarely, an earlier pioneer of Op art. In 1964, when *Current* appeared on the cover of a New York exhibition catalogue, Riley found herself at the centre of the Op art movement, presenting geometric constructions and colour combinations calculated to evoke sensations of movement and instability. When viewing a painting the eye naturally flits from the foreground to the background and back again; with *Current* the eye finds the shift of attention swift and at times aggressive. Instinctive attempts by the eye and brain to find stability prevent the viewer from focusing on any one area of the painting. Riley's rigorous investigation of the optical potential of vertical parallel lines chimed with alternative culture's burgeoning preoccupation with the effects of hallucinogenic drugs. **EWI**

👁 FOCAL POINTS

1 UNDULATING LINES

The long sweeps of parallel lines at the top and bottom of the work create the impression of furrows. The surface appears to move and the eye finds it difficult to rest. However, after the eye experiences the 'vibrations' of the central area of shorter waves, the long curves seem relatively restful.

2 VIBRATING LINES

The three rows of short, parallel curves appear to vibrate. As the viewer stares at the central area, shades of yellow begin to appear and seem to float above the image. The ability of certain black and white patterns to generate the impression of colour in the brain intrigued Riley during this period.

🕐 ARTIST PROFILE

1931–59
Riley was born in London and spent her childhood in Cornwall and Lincolnshire. She studied art, first at London's Goldsmiths College and later at the Royal College of Art. She painted figure subjects in a semi-Impressionistic manner, before moving on to Pointillism and landscapes.

1960–64
In the early 1960s she began to paint black and white works that explored optical phenomena. She had her first solo show in 1962 at London's Gallery One.

1965–66
Riley exhibited at the 'The Responsive Eye' show at New York's Museum of Modern Art. Her painting *Current* was used as the image on the cover of the show catalogue, which helped bring her art to global attention. Towards the end of this period, Riley introduced greys and tonal progression into her work.

1967–70
The artist began investigating colour and produced her first stripe painting. In 1968 she represented Great Britain in the Venice Biennale and became the first female British painter to be awarded the prestigious International Painting Prize.

1974–present
The use of the curve became the basis of her painting. After a trip to Egypt in the winter of 1979 her palette became more intensely colourful. Patterning was increasingly significant in her compositions as she continued to explore visual effects.

WORKING METHOD

Riley (below) has never studied optics. Creating effects of light, movement and space in her distinctive Op art paintings requires meticulous precision, but she calculates how an image should be made intuitively, rather than by employing complex mathematics. She makes sketches akin to technical drawings, often on finely ruled graph paper, and paints and cuts pieces of paper that she then uses to make collages and painted cartoons. Sometimes an image becomes part of a final work, or occasionally she may return to it later. She uses

assistants to execute the final canvases, which are painted using acrylics and have immaculate surfaces. By using assistants to complete her works, Riley avoids the issue of the painter's signature—she believes the artistry of her work lies in a combination of its content and her choices when conceiving an image, plus any subsequent alterations or revisions.

VIDEO ART

Since its invention, celluloid has attracted the attention of artists, from Salvador Dalí (1904–89) to Andy Warhol (1928–87) to German artist Joseph Beuys (1921–86). Video art, however, began in the mid 1960s when portable video technology first made it possible to play back footage instantly. With moving images and sound, Video artists referred to and played with cinematic form, often critiquing mainstream film, video and TV culture. Video art was unconstrained; it could be without actors, audio and plot, and be of unspecified length. Works could also form part of an installation.

Relatively cheap, ubiquitous and easily mastered, video technology became a valuable tool for artists. Among the pioneers of Video art was South Korean Nam June Paik (1932–2006). His *Distorted TV* (1963) consists of thirteen television sets showing the same programme electromagnetically deformed in thirteen ways. This piece is not strictly Video art, but Paik's later work, such as *Charlotte Moorman with TV Cello and TV Glasses, New York, 1971* (opposite, above), has led some to define his earlier work as such. The work was a video installation comprising three televisions, one showing a direct feed of a live performance by cellist Charlotte Moorman, the second a video collage of other cellists and the third an intercepted broadcast television feed. As Moorman played Paik's one-stringed 'cello' with a bow, she transformed the assemblage into a musical instrument that produced electronic sounds.

In the early 1970s American Conceptual artists (see p.500) began to practise Video art; among them were Bill Viola (b.1951), Dan Graham (b.1942),

1 *Cremaster Cycle I* (1994)
Matthew Barney · production still
of feature-length film
Film rights owned by Matthew Barney

2 *Charlotte Moorman with TV Cello
and TV Glasses, New York, 1971* (1971)
Nam June Paik · video still

3 Untitled (*Rapture* series), (1999)
Shirin Neshat · gelatin silver print
42 ½ x 67 ½ in. / 107.95 x 171.45 cm
Gladstone Gallery, New York, USA

KEY EVENTS

1965	1969	1972	1972	1974	1976
Nauman gives up painting, enabling him to concentrate on Video art, Performance art (see p.512) and sculpture.	Frank Gillette (b.1941) and Ira Schneider (b.1939) use nine television screens to create *Wipe Cycle*, the world's first multi-channel Video art.	Graham exhibits *Past Future Split Attention*, a video installation that lasts just over seventeen minutes.	Gilbert & George produce Video art, which they call 'sculptures on video tape'.	The Museum of Modern Art in New York establishes the world's first gallery devoted to Video art.	Viola is appointed artist-in-residence at the WNET Channel 13 Television Laboratory in New York. Some of his works are premiered on television.

Vito Acconci (b.1940) and Bruce Nauman (b.1941). Graham's *Past Future Split Attention* (1972), for example, documents his project of psychologically restructuring space and time. It shows two people who know each other in the same space. One predicts the other's behaviour, while the second recounts the first person's past behaviour by memory. British performance artists, sculptors and photographers Gilbert & George (b.1943 and 1942) recognized the potential of video with pieces such as *Gordon's Makes Us Drunk* (1972). The two men, seen drinking at a table as music plays, repeatedly say, 'Gordon's makes us drunk.'

As Video art became mainstream, artists toyed with different ways of having their works viewed, including multiple-screen installations and projections on a cinematic scale. Iranian Shirin Neshat (b.1957) projected *Rapture* (below) on two opposing walls. Iranian men and women appear on separate screens, separated from one another; the work highlights the inequalities between the sexes in that country. Standing between the two projections, which run simultaneously, the viewer is constantly turning round and thus finds passive viewing impossible. *Rapture* was shot on 35-mm film that was then transferred to video. Artists have blurred the definition of Video art—the format of a work has become less important than the conception of a Video artist as someone who works with moving images and sound.

The *Cremaster Cycle* (1994–2002; opposite) by American Matthew Barney (b.1967) is a series of feature-length films in which Barney plays with cinematic genres, including the musical, Western and zombie horror. What distinguishes the cycle from Hollywood fare are the photographs, sculptures and installations that Barney made to go with each part of the cycle. These explore the creation process and are an essential part of the work. **CK**

1978	1994	1997	1999	2002	2008
In Düsseldorf, Germany, Paik becomes the first lecturer in Video art to be appointed in Europe.	Barney begins his controversial *Cremaster Cycle* series of feature films and associated artworks.	Gillian Wearing (b.1963) wins the Turner Prize for *60 Minutes Silence*, a 'living photograph' of twenty-six 'police officers' keeping still as they faced the camera.	Neshat makes the dual-screen Video art work *Soliloquy* to comment on the crossover between Middle Eastern and Western cultures.	Viola makes *Emergence* (see p.530), inspired by the fresco *Pietà* by Italian painter Masolino da Panicale (c. 1383–c. 1435/40).	Tracey Emin (b.1963) curates a room at London's Summer Exhibition. Among the pieces is the video *Barbed Hula* by Sigalit Landau (b.1969).

Emergence 2002
BILL VIOLA b. 1951

colour high-definition video
rear projection on screen mounted on
wall in a dark room
12 minutes running time
78 x 78 in. / 200 x 200 cm (projected
image size); room dimensions variable
photo: Kira Perov
J. Paul Getty Museum, Los Angeles, USA

Bill Viola has been a pioneering video artist since the 1970s and his work is known for its stylish finish and painterly feel. His videos progress so slowly at times that it is difficult to perceive any movement. They demand intense concentration from the viewer, who is invited to experience the work directly and interpret it in their own way. *Emergence* is part of the series begun by Viola in 2000 titled *The Passions*, inspired by devotional art from the late medieval and early Renaissance period. The piece was shot in one take on 35-mm film at seven times normal speed. In post-production Viola transferred the film to high-definition video and slowed it down considerably. The result was a video with astonishing visual and emotional clarity in which each video frame is an artwork in itself. The scene is a courtyard in which two women sit in silence beside a marble cistern. The purpose of their presence is unknown and time appears suspended. A sudden gush of water breaks the silence and a pale man emerges; Viola described the moment thus: 'To our contemporary eye, it's a drowning; in my inner eye, midwifery.' **CK**

1 CISTERN

Emergence features a white marble cistern marked with a cross against a deep blue backdrop. The bold use of colour and the simple setting call to mind paintings of the Renaissance; the size of the projection and the video's composition are reminiscent of a church altarpiece.

2 BIRTH

The women's vigil is interrupted by a premonition. The young woman anticipates the emergence of a man's head from the cistern. In Christian iconography the video could depict the resurrected Christ, although Viola chose instead to represent the cycle of life from birth to death.

3 EMERGENCE

The women watch in disbelief as the body emerges and the water overflows. The distortion of time creates a feeling that the video is like a fresco cycle, and the narrative unfolds slowly. Viola's videos are frequently shown in ultra-slow motion; the sense of stillness adds to their painterly quality.

4 DRYING

Viewed in isolation this still echoes depictions in painting of covering Christ's body in a winding sheet for burial. In the video sequence, the women could simply be drying the man. Showing a man emerging from water has connotations of cleansing, purification, birth and spiritual rebirth.

5 EMBRACE

Viola is known for depicting extreme states of emotion and his use of slow motion means that the viewer is able to observe the emotional state of the actors in great detail. Here the women go from a state of grief and expectation to an outpouring of love in a final tender embrace.

1973–80

Viola graduated with a fine arts degree from New York's Syracuse University in 1973. In 1980 he moved to Japan to take up a cultural exchange fellowship. There he studied Zen Buddhism under the priest and painter Daien Tanaka and became the first artist-in-residence at Sony Corporation's Atsugi Laboratories.

1981–86

He returned to the United States to live in Long Beach, California and created works based on medical-imaging technologies of the human body at a local hospital, animal consciousness at the San Diego Zoo and fire-walking rituals among the Hindu communities in Fiji. In 1983 he took up a teaching post on the advanced video course at the California Institute of the Arts in Valencia, California.

1987–present

In the late 1980s Viola travelled extensively in the American Southwest photographing Native American rock art sites and videoing desert landscapes. His installations and videotapes were exhibited at the Museum of Modern Art in New York. In 1995 he represented the United States at the 46th Venice Biennale in Italy with five installations titled *Buried Secrets*. His show titled 'Bill Viola: The Passions' was exhibited at the J. Paul Getty Museum in Los Angeles, California in 2003 and 2007–08.

RENAISSANCE ROOTS

Emergence has the quality of an Old Master by Rubens or Titian. Although Viola professes that he is not interested in restaging historical paintings, he has admitted that the piece was inspired by the fresco *Pietà* (1424; below) by Italian artist Masolino da Panicale at Empoli's Museo della Collegiata in Tuscany. A major painter in Florence during the early Renaissance, Masolino is best known for his collaboration with Masaccio (1401–28) on a cycle of frescoes in Florence's Capella dei Brancacci that are famed for their innovative depiction of three-dimensional space. Masolino's *Pietà* depicts the Virgin Mary and Saint John mourning and venerating Christ's corpse, which is shown standing upright in a marble tomb. The composition of *Emergence* mirrors *Pietà*; however, its narrative is very different. Rather than being a work that shows an outpouring of grief, Viola's video celebrates the cycle of life.

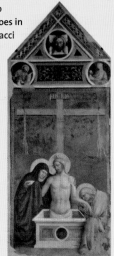

LAND ART

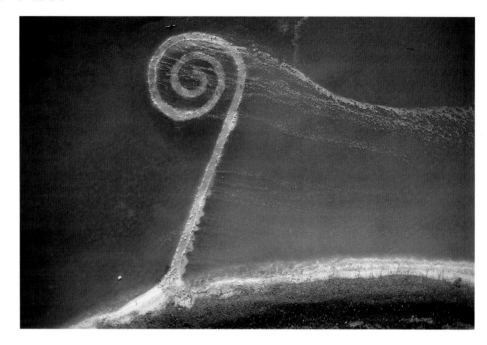

I n the late 1960s Land art—also known as Earth art—emerged as one of many artistic trends for finding new materials, disciplines and locations for the practice and exhibition of art. Land artists explore the potential of landscape and the environment for both their materials and their sites. Rather than representing nature, they utilize it directly in their work.

The first practitioners of Land art were Americans, including Walter De Maria (b.1935), Nancy Holt (b.1938), Sol LeWitt (1928–2007), Richard Serra (b.1939), Robert Smithson (1938–73) and James Turrell (b.1943). Later came the British artists Andy Goldsworthy (b.1956) and Richard Long (b.1945), Dutch artist Jan Dibbets (b.1941) and Israeli Dani Karavan (b.1930).

Land art includes monumental sculptures made from nature itself; examples are excavations by Turrell and environmental installations by De Maria and Karavan. In 1970 Smithson transformed an area of industrial wasteland into one of the most famous pieces of Land art, *Spiral Jetty* (above). The work consists of a spiral road of black basalt stones and earth projecting into the waters of Utah's Great Salt Lake, which had been reddened by algae, bacteria and brine shrimp. At the time Smithson was unaware that water levels were low and soon the work was inundated. In 2002, after years of drought, *Spiral Jetty* made a dramatic reappearance. In the interim the rocks had become

KEY EVENTS

1967	1967	1970	1971	1976	1977
Long produces his first work made by walking. It is a photographed track in an English grass field titled *A Line Made by Walking*.	Dibbets gives up painting in favour of Land art and photography.	Smithson transforms an industrial wasteland into a work of art with *Spiral Jetty*.	Alice Aycock (b.1946) creates *Sand/Fans*; her four industrial fans around a giant mound of sand suggest a man-made interaction of natural elements.	Karavan represents Israel in the Venice Biennale with the work *Environment for Peace*.	De Maria creates *The Lightning Field* in New Mexico; it is a grid of 400 erect steel poles tipped with needles to attract lightning.

encrusted with white salt crystals. Smithson was fascinated with the physical concept of entropy, or 'evolution in reverse'—nature not only self-regenerates, it also self-destroys—and this interest is apparent in *Spiral Jetty*. While Smithson appropriated nature for an artistic purpose, nature was able to reclaim the artwork by means of salt encrustation and erosion.

Land art also includes immense sculptures in the landscape. Holt's astronomical constructions include *Sun Tunnels*, which consists of four large pipes arranged in a cross formation in the Great Basin Desert, Utah. The tunnels (two are shown, right) are aligned with the positions of the sun on the horizon at sunrise and sunset during the solstices. Another example of Land sculpture is Serra's monumental, rusting work *Slab for the Ruhr* (below), a commemoration of the declining coal and steel industries of Germany's Ruhr Valley. The steel slab stands in the centre of a vast, levelled slag heap that is kept bare of vegetation as an authentic reminder of the Ruhr's industrial past.

The work of Land artists embraces photography, diagrams and texts, such as those of Dibbets, Goldsworthy, LeWitt and Long, that record excursions and temporary interventions in the landscape, or capture and frame natural phenomena and the passage of time. Long explores remote landscapes, but his primary medium is walking. Throughout his career his solitary walks have taken him to Alaska, Mongolia, Bolivia and the Sahara as well as the British countryside. He exhibits photographs of his interventions in the landscape and creates sculptural installations of mud, stones and other materials he has collected on his travels. His works have the feel of souvenirs, echoing his actions and encouraging the viewer to follow in his footsteps. **AD**

1 *Spiral Jetty* (1970)
Robert Smithson • earthwork
1500 x 15 ft / 457 x 4.5 m
Great Salt Lake, Utah, USA

2 *Sun Tunnels* (1973–76)
Nancy Holt • concrete
216 in. / 549 cm long; 108 in. / 275 cm
outside diameter (each tube)
Great Basin Desert, Utah, USA

3 *Slab for the Ruhr* (1998)
Richard Serra • steel
570 x 165 x 5 ³/₈ in. / 1450 x 420 x 13. 5 cm
Schurenbach slag heap, IBA Emscher
Park, Essen, Germany

1978	1984	1994	1998	2000	2006
Holt, who married fellow Land artist Smithson in 1963, is awarded a Guggenheim Fellowship.	Mary Miss (b.1944) begins work on South Cove, a public project at Battery Park in New York. It takes three years to reach completion.	Goldsworthy publishes *Stone*, documenting his belief that the locations of his artworks are as essential to his art as the works themselves.	Goldsworthy completes *Storm King Wall* at Storm King Art Center in New York State (see p.534).	Long holds eleven one-man exhibitions in a single year, including a large wall work made of mud at London's Tate Modern.	Chris Drury (b.1948) visits Antarctica and sees it as a benchmark against which he can 'compare and contrast' other landscapes.

Storm King Wall 1997 – 98
ANDY GOLDSWORTHY b. 1956

field stone
5 x 2278 ft / 1.5 x 695 m
Storm King Art Center, Mountainville,
New York, USA

⛑ NAVIGATOR

For Andy Goldsworthy, a wall 'is a line that is in sympathy with the place through which it travels'. He explored this idea in *Wall that Went for a Walk* (1990), his first permanent commission, in the Grizedale Forest, Cumbria, England. The wall, 492 feet (150 m) long, weaves around trees and rocks and follows the landscape, rather than making the landscape conform to it. In 1995 Goldsworthy was invited to make a work for the Storm King Art Center, a park for modern sculpture in New York State's Lower Hudson Valley.

After exploring the grounds a number of times, Goldsworthy settled on a wooded area where he had found a derelict farm wall. He used this as a point of departure and the artist and his team of professional British 'wallers' created a serpentine, drystone wall, 2,278 feet (695 m) long and made of 1,579 tons of field stones found on the site. Incorporating the remains of the original farm wall, it emerges out of the earth, snakes through a line of trees, dips into a pond, comes out on the far side and heads straight up a treeless hill to the edge of the park, where it encounters a highway. Art and nature are literally entwined, making Goldsworthy's piece a fitting symbol of the Storm King venture. **AD**

FOCAL POINTS

1 TREES AND WALL

Storm King Wall explores the dynamic between wood and stone, between the trees and the wall. The trees grew up around the original wall, which was toppled by their spreading roots. For Goldsworthy, walls are structures that settle and change their form with time as external forces act upon them.

2 WATER

At one point the wall descends into a pond, only to reappear on the other side of the water. Rather than functioning as a boundary or border, the wall transforms the viewer's perception of the park. The artist's intervention emphasizes the beauty and transience of nature.

LAND ART AND PHOTOGRAPHY

Photography is an integral part of Goldsworthy's Land art. His ephemeral works, such as the snow pyramids of his *Arctic Circle* (c. 1980; below), are usually created at private or remote locations, making photography essential. The artwork is photographed as soon as it is made and the photograph becomes, in a sense, the work, or at least the part of it that can be shared with, and collected by, others. Goldsworthy has said that 'photographs are not the purpose but the result of my art'. Goldsworthy also photographs his permanent works, documenting how they are made as well as the ways in which the works change during the day and in different weathers and seasons. He produces books that record and accompany most of his projects, making both his public and private works available to a wider audience. His images serve as documents or 'traces' of the events or artworks, and also as a means of communication. In the words of the artist, 'Photography is my way of talking, writing and thinking about my art.'

⏱ ARTIST PROFILE

1974–78
Andy Goldsworthy studied at Bradford College of Art and then at Preston Polytechnic, England. Earlier experience as a farm labourer led him to see farming as a sculptural activity.

1979–85
Goldsworthy began to make ephemeral sculptures in the landscape, experimenting with materials such as sand, snow, stones, leaves, twigs and ice, and creating forms such as arches, cairns, cones, holes and spires. In 1985 he moved to Scotland.

1986–present
The artist received his first outdoor residencies (Yorkshire Sculpture Park, England), permanent commissions (Grizedale Forest, England) and international projects in the United States, Netherlands and Germany. Later he worked on larger scale, environmental projects. Thomas Riedelsheimer (b.1963) made a documentary about him in 2001, *Rivers and Tides*.

HYPERREALISM

1 **D Train** (1988)
Richard Estes • serigraph on paper
35 ³/₄ x 60 ³/₄ in. / 91 x 177 cm
Smithsonian American Art Museum,
Washington, DC, USA

2 **Queenie II** (1988)
Duane Hanson • polychromed bronze
with accessories • life-size
Saatchi Gallery, London, UK

3 **Epiphany I (Adoration of the Magi)** (1996)
Gottfried Helnwein • mixed media on canvas
82 ⁵/₈ x 131 ¹/₈ in. / 210 x 333 cm
Denver Art Museum, USA

The highly detailed works of Hyperrealist painting and sculpture have their roots in Photorealism, a movement that emerged in the late 1960s in the United States. The term is used to describe art that seems as realistic as a photograph and that often uses photographs as its primary source. American painter Denis Peterson (b.1944) distinguished Hyperrealism from Photorealism by pointing out that in the former visual imagery is used to recreate a photorealistic image that is almost more realistic than its photographic source, whereas Photorealism simply emulates the photograph. Hyperrealist artists make meticulous changes to a work's depth of field, colour and composition in order to emphasize a socially conscious message about aspects of contemporary culture and politics.

The first artists to create Hyperrealistic works were American and included painters Peterson, Richard Estes (b.1936), Audrey Flack (b.1931) and Chuck Close (b.1940). The creation of their virtuoso pieces involved months of painstaking effort. Estes's work *D Train* (above) is typical of his depictions of the city as an eerie, geometric landscape characterized by highly reflective glass and steel surfaces. In Europe, Hyperrealist painters included Austrian Gottfried Helnwein (b.1948). He first used a Hyperrealistic technique to portray extremes of suffering. His later works tackle the theme of Nazism and the Holocaust, most famously in his *Epiphany* series (1996–98). In *Epiphany I (Adoration of the Magi)* (opposite, below) SS officers with a mother and child represent the Magi and the Virgin Mary and Jesus, with the child being admired as an example of Aryan perfection.

KEY EVENTS

1965	1968	1973	1973	1976	1979
Spanish painter Antonio López-García (b.1936) begins to produce highly detailed paintings and drawings of interiors and mundane objects.	Estes holds his first one-man show in New York.	Belgian art gallery owner Isy Brachot III uses the phrase 'Hyperréalisme' as a French translation for 'Photorealism'.	Isy Brachot III puts on a show of American and European Photorealists' work at his gallery in Brussels.	Gober moves from Vermont to New York City.	Close finishes his work *Mark*, a facial portrait, on which he has been working for fourteen months.

Hyperrealism is not confined to painting. American sculptors such as Duane Hanson (1925–96) also made Hyperrealistic life-size sculptures. Hanson focused on figurative works, usually representing ordinary people of middle America. *Queenie II* (right) depicts an overweight African American woman dressed as a cleaner and pushing her cleaning trolley. The sculpture has a strong physical presence that reminds the viewer that low-paid workers are often 'invisible' in society. Hanson makes casts from models and then creates his sculptures using fibreglass resin or bronze, decorating his figures with clothes and accessories. Viewed in situ, at first glance the sculptures often appear to be real people. American sculptor Robert Gober (b.1954) began to make Hyperrealist sculptures in the early 1980s and his handmade works also seem realistic. Unlike Hanson's human figures, however, Gober's sculptures are of everyday domestic items, such as urinals and sinks, that focus the viewer's attention on the intimacies of personal hygiene and the notion of waste.

Australian sculptor Ron Mueck (b.1958) is probably the best-known Hyperrealist sculptor of the 21st century. He came to prominence with *Dead Dad* (1996–97), a diminutive representation of his dead father, naked and lying on his back, which was exhibited at London's Royal Academy in 1997. Mueck creates figurative sculptures from fibreglass, resin and silicone. His works are often nude with remarkable fine detail—ragged yellow toenails, facial stubble and body hair. Mueck plays with the idea of scale; in contrast to *Dead Dad*'s smallness, *Pregnant Woman* (2002) is a huge sculpture of a naked pregnant woman with her hands above her head. Mueck takes the classical idea of the perfection of the human body and instead shows the fragility of the human form. **CK**

1988	1988	1997	2004	2006	2007
Hanson constructs the life-size sculpture *Queenie II* using mainly polychromed bronze.	Close suffers a blood clot on his spinal cord that leaves him paralyzed and requiring a wheelchair.	Mueck's *Dead Dad* causes a sensation at London's Royal Academy. It is cast in silicone and acrylic.	Flack is awarded an honorary doctorate by the Lyme Academy College of Fine Arts in Connecticut.	Peterson paints *Dust to Dust* (see p.538), a portrait of a homeless man slumped against a wall.	Helnwein's one-man show, 'The Disasters of War', is dedicated to the memory of Francisco de Goya.

Dust to Dust 2006

DENIS PETERSON b. 1944

acrylic and oil on canvas
40 x 40 in. / 101.5 x 101.5 cm
Artist's collection

 NAVIGATOR

American Hyperrealist painter Denis Peterson chose a man living on the street as the subject of *Dust to Dust*. The title of the painting is a religious reference. 'Ashes to ashes, dust to dust' is part of a passage in the Bible (Genesis 3:19) that is quoted in the *Book of Common Prayer* and is often spoken at funerals. The implication of the painting is that the man is near to death, or may already be dead. He is lying in public view but no one would know or care about his passing, such is society's disregard for the homeless.

In this work Peterson asserts that a man of negligible social status who inhabits the lowest stratum of society is just as worthy of having his portrait painted as any titled individual or famous person, and, more importantly, is just as deserving of having his humanity recognized. However, this is no crass attempt to enlist sympathy. The lighting is low key, almost neutral, and the scene occurs in an atmosphere as sterile as that of a hospital. In contrast to the precise detail with which the painting itself is rendered, there is a striking emptiness to the composition and the upper half of the canvas depicts a blank white wall, underscoring the man's lowly position. Peterson is asking viewers to acknowledge the less fortunate members of society. **CK**

👁 FOCAL POINTS

1 FEATURES OF CHRIST

The subject's beard and long, straggly hair recall numerous depictions of Christ in art throughout history. Much of the face is hidden from view, but the man is clearly gaunt from hunger. Peterson's colour palette is muted and his choice of blue—traditionally the colour used to represent the divine in religious works—is deliberate. Like Christ, the homeless man has had to endure hostility or indifference for much of his later life on earth.

2 VULNERABLE POSE

Cropped like a photograph captured by a passer-by, the composition has an intimacy and absence of emotion that was deliberate, as the artist explained: '[It] was a new means of bringing the viewer directly into a scene in a physical sense…I would continually hear people saying that they felt they could touch him (and then physically would) which I found perplexing, particularly where in actual reality no one would ever do that.'

3 TRAINERS

The subject of Peterson's painting is a homeless man who lives on the street, but the trainers he is wearing carry the instantly recognizable Nike logo. Peterson's work often alludes to advertising and the pressure that it exerts on individuals to conform and participate in consumerism.

4 NEWSPAPER

The Star is a tabloid daily newspaper. Here, its front page juxtaposes an image of a semi-clad woman with the shocking headline 'I'm killing our 4 kids', about a father who murdered his family. The tragedy takes on an even more chilling irony as this man lies friendless, without a family of his own.

🕐 ARTIST PROFILE

1944–67

Peterson was born in New York City. His grandfather, a painter and protégé of Claude Monet (1840–1926), was a restorer of Rembrandt paintings. He taught his grandson the drawing and painting techniques of the Old Masters.

1968–79

Peterson received a BA from New York's Hofstra University; he had already restored numerous 16th- and 17th-century paintings for museums. He went on to work as an illustrator for studios and advertising agencies while maintaining his own studio. In 1973 he was among the first Photorealist painters to emerge in New York.

1980–2000

In around 1980 he closed his studio and stopped exhibiting to help raise his family. He returned to painting full time in 2000.

2001–06

Peterson distinguished Hyperrealism from Photorealism as being based on a philosophy of iconic visual symbolism. He produced four major thematic series: *Don't Shed No Tears*, *The Wall*, *Walkin' New York* and *Carnival of Light*. *Dust to Dust* was the first painting of his hallmark series *The Wall*, which he began after he was attracted to a scene shot by photographer Hugh Hill (b.1964). Inspired by Hill's dedication to the disenfranchised, he worked for two years on the series.

PORTRAYING CONFLICT

Don't Shed No Tears (2006; below) is one of a series of paintings by Peterson that focuses on genocide, pain and survival. It portrays a refugee from Darfur in the Sudan. Peterson's interest in portraying the suffering caused by conflict perhaps stems from the fact that his great-grandmother was an Armenian who fled to America to escape the Armenian genocide that took place in the Ottoman Empire in the early 20th century.

Peterson's hyperrealistic technique, inspired by the work of photojournalists, enables him to show even more detail than his source photographs can. He alters the composition of each photograph by adding or taking away parts of the image, adding and accentuating fine details and changing the colour scheme. In *Don't Shed No Tears* he carefully twisted the hair of his subject and even added more wrinkles to her face in his attempt to universalize her pain.

AUSTRALIAN INDIGENOUS ART

1 *Bush Fire Dreaming* (1982)
Clifford Possum Tjapaltjarri • synthetic
polymer paint on canvas
32 1/4 x 40 3/8 in. / 82 x 102.5 cm
Art Gallery of South Australia,
Adelaide, Australia

2 *Water Dreaming* (1974)
Johnny Warangkula Tjupurrula
synthetic polymer paint on canvas
27 1/2 x 21 7/8 in. / 70 x 55.5 cm
Art Gallery of South Australia,
Adelaide, Australia

3 *Bugaltji—Lissadell Country* (1986)
Rover Thomas Joolama • natural earth
pigments and bush gum on canvas
35 3/8 x 70 7/8 in. / 90 x 180 cm
Private collection

Iconographic and stylistic elements dating back to Ice Age art continue to be used in Australian indigenous contemporary art, making it the longest continuous art tradition in the world. From the beginning of the European invasion, art was a primary means by which indigenous people communicated with, and became part of, the modern world. By the mid 20th century, two significant modern art movements had emerged in remote Australia, one comprising several schools in Arnhem Land and the other located at the Central Australian Lutheran mission of Hermannsburg. The latter's watercolour landscapes were exhibited as contemporary fine art, but Aboriginal art was only fully accepted as an integral part of contemporary art in the late 1980s. This was largely owing to the impact of a new acrylic painting movement in Papunya, Central Australia.

Papunya is the centre of Australia's most successful late 20th-century art movement. It comprised mainly Pintupi tribesmen whose vision, skills and energy enthused the movement. Equally important was the knowledge of the artists who had grown up at the nearby Hermannsburg mission. The men began painting in 1971 after an art teacher, Geoffrey Bardon (1940–2003), introduced them to acrylic paints and encouraged them to paint in their own traditions. Papunya Tula Artists Pty Ltd was formed in 1972. At this time it numbered about twenty-five painters. They rapidly worked through a series of stylistic innovations, motivated mainly by the formal problems of transposing ceremonial ground

KEY EVENTS

1960	1971	1972	1976	1979	1981
Papunya is established as an administrative settlement and over the next several years Pintupi and other tribal groups are moved there.	Bardon is posted to Papunya. He encourages Aboriginal artists to paint in their traditional styles and successfully sells the work in Alice Springs.	Papunya Tula Artists Pty Ltd is formed.	The Governor-General signs the Aboriginal Land Rights (Northern Territory) Act. A collective of Australia's indigenous people now owns half the land.	Aboriginal art, in the form of bark paintings from Arnhem Land, is included in the Biennale of Sydney for the first time.	Three large Papunya Tula acrylic canvases are included in the inaugural Perspecta, the biennale of Australian contemporary art.

and body designs on to canvas, and bringing restricted knowledge into the public arena. Johnny Warangkula Tjupurrula (*c.* 1925–2001) developed a poetic and layered dotting technique, as seen in *Water Dreaming* (right), which was particularly influential, as were the large cartographic designs by the Tjapaltjarri brothers Tim Leura (*c.* 1929–84) and Clifford Possum (1932–2002). *Bush Fire Dreaming* (opposite) features Clifford Possum's refined and precise dotting technique.

Although commercial success was limited in the 1970s, this changed in the 1980s. Non-indigenous artists, collectors and curators, excited by affinities between contemporary post-conceptual art and the Papunya Tula paintings, began buying Aboriginal art. At the same time many Pintupi painters resettled deep in the desert and spread their aesthetic ideas to relatives in other communities. Inspired by the success of Papunya Tula, the Desert communities established their own art centres. The unprecedented demand for Desert paintings raised the profile of Aboriginal artists: several works by the Kimberley painter Rover Thomas (*c.* 1926–98) and Anmatyerre artist Emily Kame Kngwarreye (*c.* 1910-1996) have since fetched high prices at auction, including Thomas's *Bugaltji—Lissadell Country* (below), which depicts the devastation caused by a cyclone in Darwin. Arnhem Land artists such as John Mawurndjul (b.1952) and Gulumbu Yunupingu (b.1945) also began to garner significant attention within the contemporary art world. Women also became important artists and, most significantly, the success of the Desert art movement inspired urban-based artists. In the 1990s it became a movement in its own right, and its artists are now among the most successful in Australia.

The competition between the numerous art centres, along with the artists' increasing exposure to contemporary Western art and the demand to develop individual careers, has inspired great innovation. Papunya Tula remains the most powerful Aboriginal art centre and since the 1990s it has produced some of the most compelling abstract art in the world. **IM**

Five Dreamings 1984
MICHAEL NELSON TJAKAMARRA b. c. 1949

acrylic on canvas
48 x 71 5/8 in. / 122 x 182 cm
Gabriella Pizzi Collection,
Melbourne, Australia

Michael Nelson Tjakamarra is the incarnation of the White Cockatoo Dreaming associated with Pikilyi, a major rock hole west of Yuendumu in Central Australia, where Tjakamarra was born. *Five Dreamings* references a number of other Dreamings that pass near Pikilyi. These Dreaming tracks were created by ancestral beings during their travels when the world was created. The stories associated with them explain the features of the place and people born there. Aborigines believe that these ancestral beings are incarnated in their creations, animating all things to this day. The modern painting movement derives its designs from those used in ceremonies directed at invoking the ancestral beings. Thus the paintings are a record of the place and people, their creation and life force.

Tjakamarra painted *Five Dreamings* in the second year of his professional career with the artists' cooperative Papunya Tula, when he was developing an individual yet recognizable Western Desert style. Choosing a distinctive range of colours, he adopted innovations of earlier Papunya Tula artists, combining the poetic formalism and much-admired dappled dotting techniques of Johnny Tjupurrula Warangkula with the ambitious spatial arrangements and tonality of the Tjapaltjarri brothers, Tim Leura and Clifford Possum. Those artists produced large acrylic paintings that, in the manner of ceremonial ground designs, arranged several Dreaming stories in accurate topographical relationships. Tjakamarra abandoned this topographical aspect and organized his Dreaming stories for their formal clarity and sense of placement on the canvas. He subsequently painted two other versions of the painting, in 1986 and 1991. **IM**

✪ NAVIGATOR

FOCAL POINTS

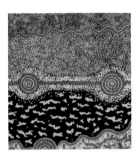

1 INTERCONNECTED ROUNDELS

The work is bisected by five roundels joined by a line. These represent geographical sites associated with the Dreaming of a spirit-being named Flying Ant. An important Aboriginal food source, flying ants build large anthills in the area of the Northern Territory represented schematically by Tjakamarra.

2 SINUOUS TRACKS

These two roundels represent Mawarriji and Jangakurlangu, each an important site of the Dreaming of a spirit-being named Possum. The Possum Dreaming myth tells of the love and elopement of Possum beings, a pair of lovers who were chased to the site of Kunajarrayi and killed. The long, sinuous lines represent the tracks of the Possum beings. Tjakamarra witnessed major ceremonies associated with this particular Dreaming when he was a young man.

3 ANIMAL PRINTS

These three roundels relate to Miruwarri, a site associated with the Rain Dreaming. The roundels may also refer to initiation ceremonies that took place at Kunajarrayi. In the area of these roundels are the paw prints of animals, which may refer to a spirit-being called Rock Wallaby, or to two other spirit-beings, the Two Kangaroo Men, or indeed to both. The Dreaming path of the Two Kangaroo Men spirit-beings is one of the most extensive in the Western Desert.

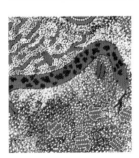

4 SERPENT

The Rainbow Serpent Warnayarra is associated with a waterhole at Yirlkirdi. In this Dreaming, two Rainbow Serpents rose up in the form of a huge whirlwind and entered the ground at Yirlkirdi. This area is also associated with the Dreamings of the Rock Wallaby, Flying Ant and Water.

ARTIST PROFILE

c. 1949–82

The son of a powerful Warlpiri leader and medicine man, Tjakamarra was brought up in the bush and instructed in Warlpiri ceremonial life and painting traditions. He married and moved to Papunya in 1976.

1983–87

In 1983 the artists' cooperative Papunya Tula accepted Tjakamarra as a painter. In 1984 his *Three Dreamings* won the inaugural National Aboriginal Art Award. *Five Dreamings* and two other paintings by the artist became the first Western Desert works to be shown at the Sydney Biennale in 1986. In 1987 *Five Dreamings* was reproduced on the cover of the catalogue for the large 'Dreamings' exhibition in New York.

1988–present

Tjakamarra's mural-sized work *Possum Dreaming* was permanently installed in the Sydney Opera House in 1988, and at the opening of the new Parliament House in Canberra his mosaic forecourt received wide publicity. In 1989 Tjakamarra joined a long list of prominent artists—including Andy Warhol, Robert Rauschenberg, Frank Stella and Roy Lichtenstein—who were invited to contribute to BMW's Art Car Project. Tjakamarra was awarded the Order of Australia in 1993 for services to the arts. In 2001 he began to make several collaborative paintings with Imants Tillers (see below).

APPROPRIATION ART

The fine balance between Aboriginality and the look of contemporary art achieved in *Five Dreamings* led to its being frequently reproduced and exhibited in the 1980s. The painting caught the world's attention when Australia's most celebrated postmodernist artist, Imants Tillers (b.1950), appropriated it for *The Nine Shots* (1985; below). The juxtaposition of the two paintings at the 1986 Sydney Biennale created enormous controversy and fed growing anxiety about the status of Aboriginal art in the art world. While the debate focused on the validity of Tillers' appropriation, it helped Aboriginal art to be accepted as contemporary art, which assisted Tjakamarra's career as a contemporary artist.

Instrumental in this outcome was *The State of the Art* (1987), an internationally distributed British film and book that singled out *Five Dreamings* and *The Nine Shots* for extended analysis in the context of the emerging globalization of contemporary art.

NEO-EXPRESSIONISM

A fter the demise of abstraction in the 1960s, painting fell out of favour as a raft of other artistic strategies vied for attention in an increasingly eclectic artistic milieu. However, during the late 1970s, painting re-emerged with the Neo-Expressionist movement, which was characterized by artworks featuring intense, often violent, subject matter. Typically the canvases were large and artists applied paint at speed in a deliberately crude manner. They also often embedded other materials in the surface of their work, which made it difficult to decipher the painted image. These techniques prompted critics to dub some Neo-Expressionist painting 'Bad Painting'; the term was used not only to describe works that were deliberately created 'bad' to increase their emotional value but also to attack paintings that were simply a mess.

American painter Julian Schnabel (b.1951) sought to express himself in an exaggerated, gestural and flamboyant style with large-scale figurative canvases bedecked with fragments of broken crockery, such as *The Student of Prague* (above). The painting's composition is akin to that of a traditional triptych and Schnabel uses religious imagery in the form of crucifixes. Yet he disrupts the two-dimensional plane of the canvas with a raw, jagged surface, refusing to provide spiritual peace in a postmodern world, and so illustrating that painting is still a meaningful art form. Georg Baselitz (b.1938) made provocative paintings such as *Three-legged Nude* (opposite, above). He began painting portraits, landscapes and figures upside down in 1969, saying

KEY EVENTS

1977	1978	1979	1980	1980	1981
A group of German artists found the Galerie am Moritzplatz in Berlin, out of which grows the Neue Wilden group.	'Transavantgarde' is used to define the work of a group of Italian Neo-Expressionists, including Sandro Chia (b.1946) and Francesco Clemente (b.1952).	Schnabel produces *Circumnavigating the Sea of Shit*, one of a series of paintings that incorporates broken crockery.	Kiefer and Baselitz exhibit at 'Les nouveaux Fauves—Die neuen Wilden' at the Neue Galerie-Sammlung Ludwig in Aachen.	Baselitz and Kiefer cause controversy at the Venice Biennale with their ironic works that include Nazi motifs.	'A New Spirit in Painting' opens at the Royal Academy, London. It promotes the international scope and continued relevance of painting.

it was 'the best way to liberate representation from content'. He adopted the traditionally low-status linocut for this disorientating work, overpainting it to create an invigorating rough surface. His work influenced younger German Neo-Expressionists in the 1980s, who became known as the 'Neuen Wilden' (Wild Youth). Among them was Jörg Immendorff (1945–2007), who is best known for his *Café Deutschland* series of paintings (1977–1984; see p.546), symbolizing the tension between East and West Germany.

Neo-Expressionism also traded in a spurious sense of national identity. Whereas the work of the American Schnabel was thought brash, his European counterparts were considered to make work of a more introspective and brooding character. Despite such stereotypical views, artists associated with the movement felt at liberty to draw on a range of personal, historical and mythological sources, and Scottish artist Steven Campbell (1953–2007) referenced a wide range of sources in his exuberant and often baroque canvases. German painter Anselm Kiefer (b.1945) explored Germanic culture in his early work, but from the 1980s his subject matter widened to take on biblical subjects inspired by the tradition of history painting, as seen in *The Red Sea* (below). Artists associated with Neo-Expressionism did not suppress the personal, autobiographical or emotive aspects of their vision. For example, Paula Rego (b.1935) drew upon her childhood memories in works such as *Snow White Playing with her Father's Trophies* (1995) and frequently populated her canvases with morbid and psychologically perturbing characters.

By the mid 1980s the momentum that carried the movement had waned, although the artists associated with it continued to pursue their ideas with the same vigour that placed figurative painting back into critical focus. **CS**

1 *The Student of Prague* (1983)
Julian Schnabel • oil, plates, horns and Bondo on wood
116 x 228 in. / 294.5 x 579 cm
Solomon R. Guggenheim Museum, New York, USA

2 *Three-legged Nude* (1977)
Georg Baselitz • overpainted linocut
79 1/2 x 59 1/2 in. / 202 x 151 cm
Hamburger Kunsthalle, Germany

3 *The Red Sea* (1984–85)
Anselm Kiefer • oil, lead, woodcut, photograph and shellac on canvas
109 3/4 x 167 3/8 / 279 x 425 cm
Museum of Modern Art, New York, USA

1981	1981–82	1982	1982	1983	1988
The French Neo-Expressionist group Figuration Libre is formed by artists including Robert Combas (b.1957) and Hervé Di Rosa (b.1959).	Clemente creates his first large oils, *The Fourteen Stations*. The series of twelve paintings is shown at London's Whitechapel Art Gallery in 1983.	The 'Zeitgeist' show at Berlin's Martin-Gropius-Bau champions a return to painting with work by Schnabel, Baselitz, Chia and Clemente.	Campbell shows at the Scottish Arts Council's 'Scottish Art Now'. He leads the New Glasgow Boys' group known for large-scale, figurative paintings.	Kiefer paints *The Norns*, one of several canvases that seek to examine the architectural spaces associated with Adolf Hitler (1889–1945).	American Jean-Michel Basquiat (1960–88), one of the youngest artists associated with Neo-Expressionism, dies of a heroin overdose.

Café Deutschland (Lift/Tremble/Back) 1984
JÖRG IMMENDORFF 1945 – 2007

oil on canvas
112 1/4 x 129 7/8 in. / 285 x 330 cm
Saatchi Gallery, London, UK

⊕ NAVIGATOR

Jörg Immendorff began his career in 1963 as a Neo-Dadaist and was taught by the performance artist, sculptor and art theorist Joseph Beuys (1921–86) at the Kunstakademie in Düsseldorf, Germany. Today Immendorff is best known as a painter for his *Café Deutschland* series of paintings, begun in 1977 and continued into the 1980s, in which he expressed the chaos and paranoia of pre-reunification Germany.

The cafe was already a recurrent motif in the work of the Impressionists (see p.316), who used it as a means of depicting social mobility. Immendorff's idea of Café Deutschland was an imaginary nightclub on the border of East and West Germany. The artist was drawn to the idea of a cafe because it allowed him to interweave, within each canvas, the social commentary, autobiography, history and myth that were all integral to his vision. In *Café Deutschland (Lift/Tremble/Back)*, the artist deftly brings together imagery drawn from a range of disparate sources in order to create a swirling, kaleidoscopic tableau lacking any single focal point. In the painting Immendorff weaves together a cacophony of legible and semi-legible forms, ranging from the artist himself to the horses of the Brandenburg Gate and even a thoroughly bewildered-looking Hitler. **CS**

👁 FOCAL POINTS

1 MULTIPLE PERSPECTIVES

Conventional treatment of perspective organizes pictorial space around what is usually a single vanishing point, but here perspective is treated in an unconventional manner. Although a series of receding diagonal lines begins at the bottom right-hand corner of the picture, these are not aligned elsewhere. The often contradictory nature of the overall composition means that these lines are but one facet within an intricately designed, multi-spatial scene.

2 PORTRAIT OF HITLER

By including a provocative depiction of Adolf Hitler in his painting, Immendorff attempts to confront and disinter events of Germany's recent past that many remain reluctant to acknowledge. A number of other German artists continue to remind their country of the consequences of Nazism.

3 SELF-PORTRAIT

Unusually Immendorff depicts himself upside down and places himself at a point from which objects and people radiate centrifugally outwards. In doing so he updates a Renaissance convention and portrays himself as being complicit with the overall scene.

4 HORSES

These horses represent the horses of Victoria, Roman goddess of victory, atop the Brandenburg Gate, which remains a potent symbol of German identity. Immendorff painted them falling in a prediction of the collapse of the Berlin Wall and the reunification of Germany, which occurred five years after he produced the painting. The tumbling horses drag with them a sheet of ice, a symbol of relations between the former East and West Germany.

🕐 ARTIST PROFILE

1963–66

Immendorff studied stage design at the Kunstakademie in Düsseldorf before becoming a student of Joseph Beuys. In 1966 he produced paintings depicting babies, directly anticipating a series of agit-prop performances that fell under the rubric of 'Lidl', an onomatopoetic word made by babies.

1967–80

Immendorff taught art at a secondary school in Düsseldorf. In 1976 he met the artist A. R. Penck (b.1939), with whom he subsequently collaborated. During this period the artist commenced his *Café Deutschland* series of paintings.

1981–94

The artist worked in 1982 and 1983 as a visiting lecturer at the Kunsthochschule in Hamburg and then taught at the Werkkunstschule in Cologne. In 1989 he was appointed professor at the Städelschule in Frankfurt. In 1994 he designed the set and costumes for the production of Stravinsky's opera *The Rake's Progress* at the Salzburg Festival.

1995–2007

In 1996 Immendorff took up the post of professor at the Staatliche Kunstakademie in Düsseldorf. He was diagnosed with the wasting disease amyotrophic lateral sclerosis in 1997. In 1998 he received the Order of Merit of the Federal Republic of Germany. The artist died in Düsseldorf in 2007.

POST-WAR GERMAN PAINTING

In the early 1960s, when Immendorff was attending the Kunstakademie in Düsseldorf, he and his fellow students were preoccupied by the question of whether artists of their generation should paint. Joseph Beuys, Immendorff's teacher, supported the view held by many of his contemporaries that painting was a discredited medium. However, after their studies Immendorff and other artists returned to painting. In Immendorff's case, the use of paint became associated with a new variant form of German Expressionism. Other artists of his generation used paint to address different themes and issues. For example, photo paintings by Gerhard Richter (b.1932), such as *Seascape* (1970; below), commented directly on the fraught relationship of painting with photography. Another artist, Sigmar Polke (b.1941), assembled in his canvases imagery drawn from an

eclectic range of sources to offer a postmodern, hybridized account of the world. In 1963 Richter and Polke were to found the school of Capitalist Realism with Konrad Lueg (b.1939).

DIGITAL ART

T he term 'Digital art' was coined in the 1980s when computer engineers
began to use a paint program called Aaron, invented by pioneering
Digital artist Harold Cohen (b.1928). Cohen's program originally produced
freehand black and white drawings, such as his Miroesque *Untitled Computer
Drawing* (1982); the artist later adapted the program for colour. Today, Digital
art includes digitally edited videos and computer animations, but the term
more often refers to art created purely with a computer, photographs
manipulated using a computer and art created solely for the internet.

When digital technology became cheaper, easier to use and more available,
established artists began to make use of it. Pop artist (see p.484) Richard
Hamilton (b.1922) used the Quantel Paintbox system to rework his collage *Just
What Is It That Makes Today's Homes So Different, So Appealing?* (1956) to reflect
the contemporary era. The result, called *Just What Is It That Makes Today's
Homes So Different?* (1992), was created from scans and digital photographs.

In the 1990s German photographer Thomas Ruff (b.1958) became known
for portraits and photographs of interiors that he modified digitally to appear
painterly and in some cases blurred. In the early 2000s the artist produced
images of wild, coalescing colours such as *Substratum 15 I* (opposite), one of
a series of computer-generated prints on inkjet paper.

Artists such as Canadian Jeff Wall (b.1946) and German Andreas Gursky
(b.1955) have manipulated their photographs with digital technology to create

KEY EVENTS

1965	1971	1971	1984	1985	1985–86
The first exhibitions of computer-generated pictures are held in New York and Stuttgart, Germany.	Herbert W. Franke (b.1927) publishes his seminal book *Computer Graphics— Computer Art.*	Manfred Mohr (b.1938) holds the world's first solo exhibition of computer-generated art, in Paris.	Wall holds his first solo exhibition, at the Institute of Contemporary Arts in London.	Wilson publishes his book *Drawing With Computers.*	Andy Warhol (1928–87) uses the Amiga computer system to create a self-portrait and a portrait of Debbie Harry, lead singer of Blondie.

fantasy images that look real. Gursky's *Rhein II* (opposite, above) is typical of his bold works in which colourful, complex patterns are blown up to a monumental size. By digitally removing industrial buildings from the original photograph, the artist depicted the Rhine River as moody and romantic—but artificial.

Some artists work exclusively with digital tools. The work of American Mark Wilson (b.1943) has developed as new technology has become available. His first pieces were produced on pen-plotting machines before he moved on to laser printers and then inkjet printers. His later works are outpourings of geometric shapes and rich colour, such as *PSC31* (opposite, below).

Other artists have chosen to work on the internet. Two pioneers in this field, Dutchman Joan Heemskerk (b.1968) and Belgian Dirk Paesmans (b.1965), formed the Jodi art collective in the mid 1990s. Their works, such as 'http:// globalmove.us/' (2008) and 'http://g33con.com/' (2009), are irreverent, almost guerrilla art, packed with playful animations, witty, changing URLs and jokey images that critique anything from the software industry to capitalism.

French internet artist Christophe Bruno (b.1964) deals with questions relating to language. For 'The Google AdWords Happening' (2002), Bruno bought some key words on the Google search engine, enabling browsers to access his nonsense poetry in the form of AdWords advertisements. Although Google censored the artist within a day of the start of his poetry 'happening', he documented the event at 'http://www.iterature.com/adwords/' (2002). For artists, the internet is the most powerful and interactive tool yet. **CK**

1 *Rhein II* (1999)
Andreas Gursky • c-print / diasec
81 ⁷/₈ x 152 ³/₈ in. / 208 x 387 cm
Museum of Modern Art, New York, USA

2 *Substratum 15 I* (2003)
Thomas Ruff • chromagenic colour print
73 ¹/₄ x 97 ¹/₄ in. / 186 x 247 cm
David Zwirner Gallery, New York, USA

3 *PSC31* (2003)
Mark Wilson • inkjet on paper
46 ⁷/₈ x 35 in. / 119 x 89 cm
Victoria & Albert Museum, London, UK

1993	1993	1995	1997	2002	2007
Wall reinterprets a Japanese woodcut by Katsushika Hokusai in *A Sudden Gust of Wind (after Hokusai)* (see p.550).	The first Digital Salon is held in New York. It becomes an annual venue for Digital art.	Heemskerk and Paesmans found the Jodi collective and begin to make internet-based works.	Ruff switches from using a conventional camera to working with digital photography.	Bruno stages 'The Google AdWords Happening' to get internet users involved in an interactive Digital art event.	Gursky's *99 Cent II Diptychon* (2001) sells for £1.7 million ($3.3 million) in London, a record for a photographic image.

A Sudden Gust of Wind (after Hokusai) 1993

JEFF WALL b. 1946

photographic transparency
and illuminated display case
98 1/8 x 156 3/8 x 13 3/8 in.
229 x 377 x 34 cm
Tate Collection, London, England

⬡ NAVIGATOR

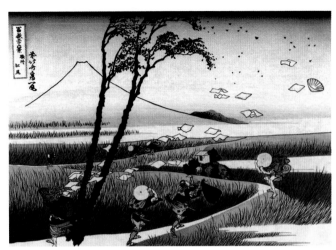

▲ *Travellers Caught in a Sudden Breeze at Ejiri* (c. 1832) is by Japanese artist Katsushika Hokusai (1760–1849), a leading *ukiyo-e* artist of the Edo period. It is part of his woodblock series *Thirty-six Views of Mount Fuji* (c. 1831), which includes *Under the Wave, off Kanagawa* (c. 1829–33; see p.292).

anadian photographer Jeff Wall uses performers, costumes and sets in order to create digital montages that appear to document a real event. His work is the opposite of street photography, which relies on capturing the moment, because Wall manipulates multiple shots to make reconstructions of scenes of contemporary daily life and reinterpretations of classical paintings. In *A Sudden Gust of Wind (after Hokusai)* he uses photography to reinterpret the subject matter of a Japanese woodcut: Katsushika Hokusai's *Travellers Caught in a Sudden Breeze at Ejiri* (above).

Unlike photographers such as Ansel Adams (1902–84) who spurned traditional fine art conventions, Wall embraces the techniques, composition, subject matter and scale used by 19th-century painters and reinterprets them for the 21st century using the latest digital technology. He converts his film exposures into digital files and then seamlessly assembles them into a final image. The process is time-consuming and the artist compares it with building up a painting over time via slow, painstaking brushwork. He spent more than a year taking, scanning and digitally processing more than one hundred photographs in order to complete this complex montage. **CK**

1 ENACTING THE SCENE

Using actors and props, Wall recreates the 19th-century Japanese scene on contemporary farmland outside Vancouver by staging a series of tableaux. Wall calls his labour-intensive technique 'cinematographic photography' because it is a process similar to shooting a film.

2 LUMINOUS QUALITY

The river running through the centre of Wall's montage has a luminous quality. This effect is achieved by printing the photograph as a transparency and displaying it in a light box, a technique that the artist adopted after observing advertisements on bus shelters in the late 1970s.

URBAN ART

T he 1980s is the decade in which graffiti, arguably the earliest form of modern Urban art, emerged as the latest product for the institutional art world. It originated in the late 1960s and early 1970s in Philadelphia, where pioneering graffiti writers Cornbread and Cool Earl worked, and first gained notoriety in New York, where writers such as Taki183 and Stan153 brought the 'New York School' of modern graffiti into existence. Graffiti focused initially on tagging (a condensed pseudonym inscribed on any available public surface); soon tags developed into 'pieces, or masterpieces—large, highly coloured and visually complex calligraphic illustrations produced using spray cans, and whose foremost, but not sole, medium was the public transportation system and the New York subway in particular. This early era of graffiti took cues from both popular culture and animation (famously the work of Vaughn Bode and Roy Lichtenstein) yet created a unique social and aesthetic culture: a visual and collective realm bent exclusively on producing ephemeral, illegal images.

By the early 1980s the New York City authorities were engaged in a so-called 'battle' against the graffiti 'vandals', yet galleries and institutions were slowly appreciating the potential of this new art form. Works by leading members of the New York scene, such as Futura 2000 (b.1955) and Dondi White (1961–98; above), made an impact on the contemporary art world and the spray can art boom started to materialize. Artists such as Jean-Michel Basquiat (1960–88) and Keith Haring (1958–90) were also a part of this alternative art community in the streets, subways and clubs of New York before they were fully embraced by the institutional gallery world under the graffiti art moniker. Haring's Urban art is characterized by bold lines, minimal graphic expression and simple animated figures. He devoted much of his career to public works that often carried strong social messages and is well known for his *Crack is Wack* (1986; see p.554) mural.

1 *Children of the Grave Again, Part 3* (1980)
Dondi White • subway graffiti
New York, USA

2 Mural created in collaboration with the 509 Cultural Centre (1998; stolen)
Sixth and Howard Streets, San Francisco, USA
Barry McGee • mural
Photograph by David M. Allen

3 Stencilled graffiti mural of a worker removing prehistoric cave paintings (2008)
Banksy • mural
Leake Street, London, UK

KEY EVENTS

1968	1971	1977	1980	1980–84	1981
Cornbread and Cool Earl start painting their tags in Philadelphia.	Taki183 is featured in the *New York Times* as the graffiti 'craze' takes hold of the city.	Basquiat begins his SAMO (Same Old Shit) project, spray painting graffiti on the walls of buildings in Manhattan.	Haring creates his signature images: the Radiant Baby and the Running Figure.	The AVANT street art guerrilla collective produces a series of wheat-paste posters and plasters them across New York.	The Washington Project for the Arts features work by Fekner and Fab Five Freddy in its exhibition 'Street Art'.

The interest of the conventional art world waned once graffiti lost its standing as 'the newest thing', although it continued to thrive and develop as an underground artistic movement. By the late 1990s, a post-graffiti and street art aesthetic came into focus. These forms had the same antagonistic status as graffiti but moved in new artistic directions and developed innovative techniques. Street art first appeared in the mid 1980s, through pioneers such as Blek le Rat (Xavier Prou; b.1952) and John Fekner (b.1940), but it came to prominence in the late 1990s. Street artists used a plethora of media such as stickers, wheat pastes and stencils. Their work occupied the same illegal public space as graffiti, but focused on images other than letter-based forms. Artists often had a 'tag' that was figurative or character-based, such as the 'OBEY GIANT' poster campaign by Shepard Fairey (b.1970) and the stencilled rats used by Banksy (b. c. 1974). Stencilling became the most common technique in street art because of the comparative ease of its production and legibility, exemplified by the volume and quality of work by Banksy (below) and others.

Many post-graffiti artists combined deep-rooted graffiti techniques with a more refined art school aesthetic. This led to a merging of graffiti with traditions such as folk art, metalwork and calligraphy. Artists such as Barry McGee (Twist; b.1966) have thus produced work (above, right) introducing philosophies of the street into the gallery setting, attempting to evoke the vigour and colour of the street within the white cube. Post-graffiti art shows the maturation of graffiti after thirty years; it embraces the key tenets of style and commitment, while being open to new avenues of creativity. The various types of Urban art differ in form and content, but their position in the heart of the public domain remains constant. **RS**

1984	1989	1998	2000	2004	2008
Blek le Rat illegally paints the Louvre with stencils of rats, tanks and human figures.	Fairey begins his sticker art campaign 'Andre the Giant Has a Posse'. The stickers were distributed by skaters and appeared across the United States.	Paris-based street artist 'Invader' begins affixing ceramic Space Invader tags to walls, bridges, monuments and subways. He goes on to tag in thirty-five cities.	Espo (Stephen Powers), Reas (Todd James) and Twist (McGee) produce the show 'Indelible Market' at the Institute of Contemporary Art, Philadelphia.	The first street art festival is held in Melbourne, Australia; it focuses on stencilled street art in particular.	Street art adorns the facade of Tate Modern in London's first exhibition of Urban art.

is Wack 1986
KEITH HARING 1958 – 90

murals
handball court, 128th Street and Second Avenue,
New York, USA

K eith Haring's death deprived the art world of a hugely talented figure. Although his 'Pop art' (see p.484) aesthetic lives on through a myriad of consumer goods, his public work is sadly missed. First and foremost, Haring's work was inherently communicative. He told a story, simply and modestly, using pared-down imagery and clean symbolic designs. In fact, he created his own visual language: a poetic vernacular and modern incarnation of hieroglyphs. For Haring Urban art was not merely a chance to put his work outside, in the 'real' world, but was also about communicating with the community at large and constituting a message of liberation and passion for life.

Crack is Wack lies alongside the FDR Highway in New York. Haring painted the original mural (opposite, above) on the side of a disused handball court wall to express his disgust at the perceived sluggishness of the government in responding to the city's growing drug epidemic. While the image was an omnipresent representation of the crack epidemic, the story was even bigger news once the public became aware of the artist's arrest. Haring was convicted, although not imprisoned, for the 'offence', and the illegal mural was painted over. However, after outcry from the local community, the city authorities gave Haring permission to redo the work, which he did, but this time he covered both sides of the wall (opposite, below; one side of the repainted version). The parks department now conserves the site and it has become a popular destination for Haring aficionados. **RS**

FOCAL POINTS

1 TEXT

Haring rarely used text in his work because it could clash with the visual language he was trying to create. Here, however, he insisted that the message could not be open to interpretation and must directly address the public. The childlike lettering rejects over-elaboration.

2 ENCROACHING DARKNESS

As the 1980s progressed, Haring's work bore a darker tinge. His use of the letter 'x' on the human body was first seen as a marker of death in his early work on HIV, and the pictorial examples of monsters were often produced with the languid, double-eyed imagery seen here.

3 HUMAN FIGURE

The human body (along with crawling babies and flying saucers) figures in almost all of Haring's designs. The simple caricatures are characteristic of his work; their almost palpable motion—conveyed by the short, surrounding lines of 'movement'—is one of his key leitmotifs.

SUBWAY ROOTS

Haring's work within the New York transportation system is a key element within his oeuvre. Unlike his associates in the classic graffiti scene, Haring worked not on the trains themselves but on the blank advertising spaces within the subway stations. He had huge respect for the graffiti artists in the city: he scrutinized the image-laden trains, eager to participate in Urban art, but did not want to reproduce their artistic style. His chalk drawings, produced between 1980 and 1985, worked perfectly on the black panels within the stations (1983; below), smooth matt surfaces much like school blackboards. The subway stations not only acted as a space for Haring to experiment with new concepts but also affected his later production; the speed at which he had to work in this illegal setting meant that he was forced to convey a narrative using a simplified, stripped-down technique.

YOUNG BRITISH ARTISTS

1		2
	3	

1 **The Physical Impossibility of Death in the Mind of Someone Living** (1991)
Damien Hirst • tiger shark, glass, steel, silicone and 5% formaldehyde solution
85 ³/₈ x 213 ³/₈ x 70 ⁷/₈ in. / 217 x 542 x 180 cm
Private collection

2 **Tragic Anatomies** (1996)
Jake and Dinos Chapman • fibreglass, resin, paint, smoke devices
Dimensions vary

3 **Everyone I Have Ever Slept With 1963–1995** (1995; destroyed by fire 2004)
Tracey Emin • appliquéd tent, mattress and light
48 x 96 ¹/₂ x 84 ⁵/₈ in. / 122 x 245 x 215 cm

This British phenomenon, which arose in the late 1980s, has no manifesto and no shared style or purpose. Its practice is diverse and ranges from the photographs and videos of Gillian Wearing (b.1963) to the highly finished paintings of Mark Wallinger (b.1959) and the dismembered carcasses of Damien Hirst (b.1965). In common with Pop artists (see p.484), the Young British Artists (YBAs) were close to contemporary fashion, culture and pop music and, like many other artistic groups, they exhibited together. Their first show, 'Freeze' in 1988, was co-curated by Hirst when he was still a student at London's Goldsmiths art school with Sarah Lucas (b.1962), Gary Hume (b.1962) and Abigail Lane (b.1967). Encouraged by tutor and artist Michael Craig-Martin (b.1941), sixteen Goldsmiths students displayed work, most of whom went on to forge careers as artists. The show focused on mixed media works: Hume showed one of his trademark painted doors; Mat Collishaw (b.1966) exhibited a Cibachrome on a light box that depicts a head being fractured by a bullet; and Hirst contributed his first spot painting, which he painted directly on to a wall.

The show was notable because it was held in an empty building in London Docklands and initiated the use of alternative exhibition spaces such as warehouses. The group expanded rapidly as other young artists joined them in group exhibitions. 'Freeze' was also the catalyst for the YBAs' relationship with collector Charles Saatchi (b.1943), who visited the show and went on to sponsor another, 'Modern Medicine', in 1990. Saatchi acted as the group's patron, collecting the artists' work and staging a series of shows beginning in 1992 in his Saatchi Gallery under the 'Young British Art' label. Their work came to prominence at the end of a recession and was made from unusual materials, such as elephant dung, blood and vegetables, reflecting the detritus of life

KEY EVENTS

1988	1990	1991	1992	1993	1993
The exhibition 'Freeze' is held in an empty London Port Authority building at Surrey Docks in London Docklands.	Hirst co-curates 'Modern Medicine' at a former biscuit factory in Bermondsey and shows *A Hundred Years*, a vitrine of maggots, flies and a cow's head.	The Serpentine Gallery's 'Broken English' is the first major exhibition by the new British artists.	The Saatchi Gallery's 'Young British Artists' includes Hirst's shark in a vitrine. He is nominated for the Turner Prize.	Lucas and Emin set up The Shop, a temporary retail outlet selling artwork multiples, including mugs and T-shirts emblazoned with slogans.	Hirst's *Mother and Child, Divided*, an installation of a bisected cow and calf, helps win him the Turner Prize.

and an atmosphere of nihilism peppered by mordant wit. Saatchi's patronage attracted criticism as his taste—which seemed shocking to some and slick to others—came to dominate the British art scene. This was also ironic, given that his M&C Saatchi advertising agency helped the ruling Conservative party in its rise to power—the party many held responsible for Britain's economic woes.

Hirst's shark in formaldehyde, *The Physical Impossibility of Death in the Mind of Someone Living* (opposite), was shown in the first 'Young British Artists' exhibition and became headline news. The trend of attracting controversy continued in 1993 when *House* (see p.558) by Rachel Whiteread (b.1963) won her the Turner Prize; in the same year she was also given the Anti-Turner Prize for being the worst artist in Britain. Tracey Emin's (b.1963) installation of a tent *Everyone I Have Ever Slept With 1963–1995* (below) and Dinos (b.1962) and Jake (b.1966) Chapman's sculptures of naked mannequins with genitalia on their faces, such as *Tragic Anatomies* (right), were attacked in the media for being in bad taste, and some visitors to the shows complained. The controversy reached its peak when the exhibits were chosen for the 'Sensation' show in 1997 at the Royal Academy. The painting of a child murderess, *Myra* (1995), by Marcus Harvey (b.1963) came in for particular criticism, leading to protests at the venue.

Despite such notoriety, the provocative nature of the YBAs' work led to a debate on the nature of what constitutes an artwork. It reinvigorated British art and helped many forms of contemporary art become more accessible. As the YBAs became successful, so they were accepted by establishment circles and known primarily as individual artists rather than as part of a movement. **WO**

House 1993

RACHEL WHITEREAD b. 1963

concrete and steel (destroyed)
193 Grove Road
London, UK

♻ **NAVIGATOR**

The first woman to win the prestigious Turner Prize, Rachel Whiteread is one of the most prominent sculptors in Britain. Materials are of great importance in her work and she uses concrete, plaster, resin and rubber. Traditional casting methods recreate an object, often in bronze, through a series of complicated procedures. Whiteread does not aim to recreate an object, but rather to solidify space by using the original object as the cast, whether it is a bath, a mattress or a house. Often, as in *House*, the casting is performed on an industrial scale. The original object is indicated by its absence, whereas in traditional casting the object is mirrored by its double.

House was a controversial work and brought the artist to public awareness. It was the cast of the interior of 193 Grove Road, the last remaining house in a Victorian terrace in the East End of London. Against the stark skyline, *House* seemed small and vulnerable, but its significance for British contemporary art is without parallel. It provoked debate in all sections of society, and became a memorial to the generations of people who had lived in Grove Road and in the surrounding area. Destroyed by Tower Hamlets London Borough Council on 11 January 1994, *House* remains only as a series of photographs. **WO**

1 TREE AND BRICK HOUSE

Viewing *House* against a backdrop of existing dwellings is a reminder that it was once a home. The building was listed for demolition, and *House* was made in situ by filling the interior of the structure with concrete before its external walls were removed. The casting process transformed a home into a blank, industrialized, dehumanized form akin to a bunker, and a building into a monument to the way of life that had existed in London's East End.

1963–92

Born in London, Whiteread lived most of her childhood in Essex. She studied at Brighton Polytechnic and then at the Slade School of Art, London. The artist held her first show at the Carlyle Gallery, London in 1988.

1993–2000

Whiteread won the Turner Prize in 1993. She represented Britain at the Venice Biennale in 1997, winning the Award for Best Young Artist, and exhibited with the Young British Artists in 'Sensation' at London's Royal Academy.

2000–present

In 2000 *Holocaust Monument* was the subject of controversy when it was unveiled in Vienna, Austria. In 2001 she installed *Untitled Monument* on the fourth plinth in London's Trafalgar Square; it was an upside-down replica of the plinth. In 2006 Whiteread was made a Commander of the British Empire.

2 BAY WINDOW

House is a sculpture made out of a void space and its volume is created by the absence of what previously existed, giving rise to spatial distortions. Where there was once an elegant bay window there appears to be an undignified stuck-on element. The detail reveals the irony of *House*. This elevation was the front face, once on show to the rest of the street and where its owners looked out on the world. Whiteread transformed it into an opaque object and sealed it like a tomb.

3 STAIRCASE AND DOOR

What at first sight appears to be a formalist object in fact provides an opportunity to consider aspects of social history. *House* contains the traces of its owners and how they lived, becoming a 20th-century time capsule. On the right, a staircase leads towards a door with a rectangular shape jutting out at its centre where there had been a letter box. The structure contains similar indentations of plug sockets and the back of a small cast-iron fireplace.

K FOUNDATION

The year Whiteread won Britain's Turner Prize for *House*, the nominees came in for intense criticism. There were objections that there was too much Conceptual art (see p.500) and that works such as *House* were made from unconventional materials. The K Foundation, formed by the two former members of British pop group The KLF, attacked the award by creating an 'Anti-Turner Prize'. This prize would be given to the artist whom the organization deemed to be the worst in Britain, selected from the Turner Prize shortlist. Whiteread won the £40,000 prize, which was twice the amount of the Turner Prize. Initially she refused to accept it, but when the K Foundation threatened to burn the cash she changed her mind. The artist gave £30,000 of her winnings to artists in financial need and £10,000 to the housing charity Shelter. On 23 August 1994, the K Foundation filmed themselves burning £1,000,000 (right) on the Scottish island of Jura.

INDIAN ART

The contemporary Indian art scene comprises a complex body of work, often departing from Modernist traditions of painting and sculpture. After India's Independence in 1947, Modernist Indian art was endorsed by the newly established state art institutions and universities and became the core of a budding national art market. However, the progressive withdrawal of government support for contemporary art led to the development of an art scene of which commercial galleries were the most vital component. The conservatism of state institutions and economic priorities of galleries accounted, in part, for a disregard for art forms other than painting and sculpture, and practices such as video, installation and performance have appeared consistently only since the 1990s. Indeed, it was in that decade that the Indian art scene started to diversify in terms of media and further confirmed an abandonment of Modernist formal preoccupations and early nationalist concerns.

The 1990s marked a crucial time for the Indian art scene in conjunction with the globalization of the Indian economy. Wider geopolitical shifts intensified art exchange worldwide and contributed to the visibility of Indian artists outside the country, particularly in biennials and triennials across the globe. At the same time, changes in communication technologies increased contacts with art institutions outside India and provided opportunities to tap into foreign funding; this facilitated the establishment of independent, not-for-profit, practice-based initiatives and venues, which gave Indian artists the chance to work with new media, installation and performance.

KEY EVENTS

1966	1970	1990	1991	1992	1997
Vivan Sundaram (b.1943) holds his first exhibition, in New Delhi.	Malani is awarded a scholarship by the French government to study in Paris.	Altaf decides to move away from painting and begins using multimedia and video.	Sundaram produces a series of works about the Gulf War.	Raqs Media Collective produces its first works. The artists are Jeebesh Bagchi (b.1965), Monica Narula (b.1969) and Shuddhabrata Sengupta (b.1968).	Jitish Kallat (b.1974) holds his first solo exhibition, at the Gallery Chemould in Mumbai.

During the 1990s established practitioners such as Nalini Malani (b.1946) and Navjot Altaf (b.1949) started to work consistently with installation and video. Towards the end of the decade younger artists such as Subodh Gupta (b.1964) and Sonia Khurana (b.1968) were also experimenting with large spatial displays, performance and new technologies. In this initial phase of diversification, the national art market maintained a conservative attitude and the international market gave only sporadic signs of interest. However, in 2005 the situation changed as the Indian economy grew. The international market started to focus on South Asia and Indian commercial galleries and increased interest from auction houses and wealthy collectors boosted the international success of a generation of artists, including Atul Dodiya (b.1959) and Rajeev Lochan (b.1956). Dodiya received critical acclaim for his Hyperrealist paintings (see p.536), installations and a series of paintings made on the metal surfaces of roller shutters. In *Mahalaxmi* (right) the painting behind the roller shutter depicts three girls who hanged themselves in order to spare their father from paying their dowries. Lochan used mixed media to shape his perception of an image and said, 'If technology helps me express my art, I will use it.' In his series *Vision of Reality* (opposite, below), for example, he began with a black and white photographic image, used chemicals to remove the elements of the image that he did not want and added to it with paint and crayon. Although the art market still revolves chiefly around painting, the recent boom has improved the status of new media and installation within India.

In times characterized by economic growth and social and political upheaval, Altaf has shown a keen interest in low-income, working-class environments in her home town Mumbai. Her video installation *Mumbai Meri Jaan* (2004), which focuses on the city through the experience of migration and the labour of three street children, offers a sensitive enquiry into neglected urban experiences. In works such as *KD Vyas Correspondence: Vol. 1* (2006; see p.562), the Raqs Media Collective explores contemporary urban spaces and experiences that upset stereotypes of localities and modalities of knowledge production and sharing. The group's installation *The Impostor in the Waiting Room* (2004) underlines how power can be exercised by controlling identity and notions of authenticity. Local references are subjected to displacement in Gupta's work. With his casts of utilitarian objects, for example stainless steel kitchen utensils (opposite, above), immigrants' bundles, plastic bags (*Potato Eaters*, 2007) and bicycles (*Cow*, 2005), Gupta has shown acute awareness of the physical presence of commodities and their circulation in everyday life in India—how they index different relationships of labour, value and power. He is one of many contemporary Indian artists who challenge common assumptions about artistic methods and aims, location and identity, and who offer powerful reflections on different ways of inhabiting the world. **EBe**

1 Installation view of *Curry* (2005)
Subodh Gupta • stainless steel
32 ¹/₄ x 40 ³/₈ in. / 82 x 102.5 cm
Adelaide, Australia

2 *Mahalaxmi* (2002)
Atul Dodiya • enamel paint on metal roller shutter (exterior); acrylic and marble dust on canvas with metal hooks (interior)
108 x 72 in. / 274.5 x 183 cm
Private collection

3 From *Vision of Reality* series (1998)
Rajeev Lochan • silver gelatin print with oil and acrylic
Private collection

1999	2002	2002	2005	2007	2008
Dodiya wins the Sotheby's Prize for Contemporary Art.	The exhibition and public art exchange Aar Paar takes place in Mumbai, India and Karachi, Pakistan. It is intended to promote peace.	Khurana begins a two-year residency at the Rijksakademie in Amsterdam.	Amar Kanwar (b.1964) is awarded the Edvard Munch Award for Contemporary Art. He receives the award from Queen Sonja of Norway.	Malani holds a one-woman show at the Walsh Gallery in Chicago.	Gupta holds three exhibitions in one year: in New York, Beijing and San Gimignano, Italy.

KD Vyas Correspondence: Vol. 1 2006

RAQS MEDIA COLLECTIVE

mixed media
Museum für Kommunikation,
Frankfurt, Germany

The *KD Vyas Correspondence: Vol. 1* was first exhibited at the Museum für Kommunikation in Frankfurt in 2006. It is a complex installation of eighteen video screens, nine soundscapes, sculpture and narrative. The piece articulates a series of eighteen 'letters' between the Raqs Media Collective and the mysterious Krishna Dwaipayana (KD) Vyasa: putative author and one of the chief characters in the Hindu epic poem the *Mahabharata*. The installation echoes the division of the *Mahabharata* into eighteen books in that it comprises eighteen visual enigmas, each referring to a specific 'correspondence' and titled accordingly. The *Mahabharata* is narrated in the form of a story being told to someone else; the main events are punctuated by a number of sub-stories to form a complex hypertext rather than a linear retelling. Similarly, the installation is immersed in the fictionality of an epistolary correspondence, which the videos do not describe but expand upon and complicate.

Raqs engages consistently with other practitioners and worked in collaboration with German architects Nikolaus Hirsch (b.1964) and Michel Müller (b.1961) to create *KD Vyas Correspondence: Vol. 1*. The architects conceived 'The Node House': a nodal steel structure for the work connecting the eighteen clusters of video screens to create an unpredictable, non-hierarchical space that is approachable from any angle. By creating a dialogue between KD Vyas and the present, the work activates and explores a different way of inhabiting time and place. With this installation and other projects Raqs has acutely reflected upon the meaning of location without falling into parochial or universalist positions. The collective's interest in mediascapes and issues of mediation also informs an ongoing reflection on the nature of time. **EBe**

1 TRAIN IN SNOW

The videos are shown to the viewer as fragments: this one is titled 'The Letter Forsaking All Claims' and shows a train travelling through an urban landscape. Each fragment communicates with the viewer, but the authenticity and subjectivity of the information are left open to question.

2 IMAGES OF WAR

In this fragment, images of war on the TV monitor capture the viewer's attention but it is not clear whether it is the present, the past or the future that is depicted. It could be the aftermath of war, because the narration of the *Mahabharata* begins after the central battle has happened.

3 INDUSTRIAL LOCATION

The installation challenges the viewer's sense of place. Although it presents mostly industrial landscapes, it is unclear where they are and when they were taken. In 'The Letter of Bitter Peacetime', gigantic, zoomorphic machines defy distinctions between natural and industrial elements. The images introduce another location, another time, to the viewer but do not answer the questions: What are these images about? Who shot them? Who are they meant for?

4 ILLUSION

The title of this video fragment is 'The Letter of Verification and Authenticity'. The viewer is presented with the illusion of a magician cutting through his own thumb, which echoes an episode that occurs in the *Mahabharata*. In the epic, Ekalavya, an aboriginal boy whose archery skills are superior to those of Prince Arjuna, is put down when the teacher orders him to cut off his right thumb as a gift in return for his unsolicited education.

1990s

Monica Narula, Jeebesh Bagchi and Shuddhabrata Sengupta are the three members of the Raqs Media Collective. They live and work in Delhi and met while studying at Mass Communications Research Centre at the Jamia Millia Islamia university. They formed the collective in 1992 and the name comes from a word in Farsi, Arabic and Urdu, and denotes the state that whirling dervishes enter into when they whirl. It is also a word used for dance. At the same time Raqs could be an acronym for 'rarely asked questions'. The members of the group refer to themselves as 'media practitioners' rather than 'artists' and their work frequently explores urban themes, ideas of knowledge and creativity, and the role and purpose of media and technology.

2001–present

In 2001 Raqs co-founded Sarai, a media initiative based at the Centre for the Study of Developing Society. The programme aims to bring together researchers, practitioners and artists in creative projects. It has enabled Raqs to engage critically and innovatively with a variety of media practices and to address complex experiences of modernity that pertain to urban spaces and Delhi in particular. Raqs has presented work at numerous exhibitions throughout the world, including documenta 11 (2002), the Venice Biennale (2003; 2005) the Sydney Biennale (2006) and Tate Britain (2009).

DECLINING TIME

The installation establishes an intriguing dialogue with the text of the *Mahabharata*, and a connection between ancient and contemporary questions, old and new media practices. Central to the *Mahabharata* is the issue of what constitutes duty (*dharma*) and appropriate conduct. This Indian miniature scroll (1750; right) is a detail from the Bhagavad Gita epos (Song of the Deity), in which Prince Arjuna doubts his ability to fight his cousins in battle until Krishna explains his warrior duties. Even after the battle has been won, the question of duty continues to haunt the protagonists. The installation explores a temporal proposition. It suggests that modalities of reproduction and the production of knowledge preserve specific ways of being in the world. By destabilizing the coordinates people use to make sense of themselves through language and images, it offers the possibility of a different way of inhabiting time and space other than hurtling towards the future. To quote Raqs, 'It explores a declining time.'

GLOSSARY

Anamorphosis
A distorted two-dimensional image that assumes normal proportions when looked at from one side or in a curved mirror.

Art Informel
A French term for a style of abstract painting popular in Europe during the 1940s and 1950s. The style was based on improvised (ie informal) techniques.

Arts and Crafts Movement
A broad movement in architecture and the decorative arts initiated by William Morris in 1861. It aimed to raise craftsmanship and design to the level of art.

Barbizon school
French landscape painters active from 1830 to 1870 and part of the Realist movement. The group took its name from the village of Barbizon, where the artists gathered.

Baroque
A style of art and architecture dominant from the early 17th to mid 18th century and characterized by extravagance, grand subject matter and rich, but sombre, colours.

Biennale
A large international exhibition held every two years. The first and most famous was the Venice Biennale held in 1895.

Blaue Reiter, Der
German Expressionist group based in Munich from 1911 to 1914 and founded by a group of avant-garde artists led by Wassily Kandinsky and Franz Marc.

Brücke, Die
German Expressionist group formed in 1905 in Dresden and dissolved in 1913. The name means 'bridge' in German and may have been chosen to convey the idea of a bridge between the artist and the rest of the world.

Chiaroscuro
Italian term (meaning light-dark) referring to the balance of light and shade in painting.

Classical
Term that came into use in the 17th century to describe the art and architecture of ancient Greece and Rome. It describes art that is created rationally rather than intuitively.

Cloisonnism
A technique used by Post-Impressionist artists whereby flat colours are surrounded by strong dark outlines.

Constructivism
A branch of abstract art that emerged in Russia in c. 1915. Constructivists believed art should reflect the modern industrial world.

Contrapposto
Italian term to describe the way in which a human figure is shown standing with most of its weight on one foot so the shoulders and arms twist away from the hips and legs.

Fluxus
A loosely organized international avant-garde group founded in 1960 by artist George Maciunas. The work recalled the anti-art sensibility of Dada and centred around 'happenings' and street art.

Genre painting
Painting that shows scenes from daily life. The style was popular in the Netherlands during the 17th century.

Grand Tour
An educational tour of Italy undertaken by the European aristocracy to view the classical and Renaissance art and architecture from the 16th to 19th centuries.

Grand manner
Grandiose style of painting that flourished in the 18th century and was influenced by academia, ancient history and mythology, painted in an idealized and formulaic style.

Impasto
Thick textured brushwork technique in which paint is applied with a brush or knife.

Japonisme
The craze for Japanese art that emerged after trade with Japan picked up in the 1850s. Impressionism was particularly influenced by Japanese woodcut prints.

Kinetic art
Art that incorporates movement or gives the illusion of movement.

Minimalism
A form of abstract art that developed in the United States in the latter half of the 1960s. It celebrated simplistic forms: painted works used mainly monochrome and primary colours and three-dimensional works used modern, industrial materials.

Modernism
Emerged in the second half of the 19th century under the premise that art should reflect modern times. Used as an umbrella term to encompass other modern artistic movements that have since flourished.

Nabis
From the Hebrew word for 'prophet', the Nabis was a group of Post-Impressionist painters active from 1888 to 1900. The style is characterized by flat patches of colour, bold contours and simplified drawing.

Neo-Expressionism
Term used from about 1980 to denote the revival of painting in an Expressionist manner. Neo-Expressionists created dramatic figurative paintings often with distorted subject matter.

Neo-Impressionism
Characterized by a divisionist technique whereby colours were placed separately on the canvas (rather than mixed in the palette) in small dabs so they would become optically mixed in the viewer's eye.

Neo-Plasticism
Term coined by Piet Mondrian to denote his geometrical abstract painting style.

Neue Sachlichkeit (New Objectivity)
Style of painting that developed in Germany in the 1920s as a reaction to Expressionism; subject matter was treated in matter-of-fact detail.

Nouveau Réalisme
French movement established in 1960 by critic Pierre Restany that aimed to bring life and art closer together. As well as painting, Nouveau Réalistes made use of collage, assemblage, happenings and installation.

Orphism
Term used to denote the Cubist-influenced work of Robert Delaunay and his wife Sonia. Their abstract work featured overlapping planes of colour.

Precisionism
School of art that developed in the USA in the 1920s. Industrial and architectural scenes in the American landscape were depicted in a simple, precise and sharply defined manner.

Primitivism
Art inspired by the so-called 'primitive' art that fascinated many early modern European artists. It included tribal art from Africa and the South Pacific, as well as European folk art.

Rayonism
An early form of abstract art that was influenced by Cubism, Futurism and Orphism. It emerged as a Russian avant-garde art movement from 1910 to 1920.

Regionalism
American realist modern art style that was at its height during the 1930s. Regionalists shunned the advance of technology and urban life and focused on rural scenes.

Romanesque
A style of European art and architecture that dominated the 10th and 11th centuries. It took its inspiration from the ancient Roman Empire.

Social Realism
Artwork painted in a realistic fashion that includes a clear social or political reference.

Suprematism
An expression coined by Kasimir Malevich in 1913 to denote Russian abstract art that encompassed elements of Cubism. The style used geometric shapes and treated the empty spaces on a canvas as an artistic medium in their own right.

Symbolism
Late 19th-century movement in which artists focused on subjective, personal representations of the world. It was fuelled by new psychological subject matter that was often mystical and erotic.

Synthetism
Term used by Paul Gauguin, Emile Bernard and their circle at Pont-Aven, Brittany, in the 1880s. It denoted their philosophy that art should synthesize subject matter with the emotions of the artist rather than with observed reality.

Vorticism
British avant-garde group formed in 1914 by Percy Wyndham Lewis. Influenced by Cubism, the machine age and realism.

CONTRIBUTORS

Roda Ahluwalia (RA) is the author of *Rajput Painting: Romantic, Divine and Courtly Art from India* (2008).

Sandra April (SA) is an arts consultant. She has worked at MoMA, the Solomon R. Guggenheim Museum and the New York Academy of Art.

Dr Meri Arichi (MA) is a teaching fellow in the department of art and archaeology at the School of Oriental and African Studies (SOAS), University of London.

Elena Bernardini (EBe) is a researcher and writer on Indian contemporary art. She studied at SOAS, University of London, and wrote her PhD thesis on new media Installation art from India.

Aliki Braine (AB) is an artist and a freelance lecturer for the National Gallery, London. She exhibits her work internationally.

Dr Elaine Buck (EB) has an MA and PhD from SOAS, University of London, in Chinese art and archaeology. She has taught and lectured for the British Museum, the Victoria & Albert Museum, Birkbeck College, University of London, Reading University and Christie's.

Julie Chan (JC) has managed co-edition projects for the Royal Collection and Here + There Ltd. She is a publicity consultant at V&A Publishing.

Nika Collison (NC) belongs to the Ts'aahl clan of the Haida nation and is curator of the Haida Gwaii Museum at Kaay Llnagaay. She contributed to *Raven Travelling: Two Centuries of Haida Art* (Vancouver Art Gallery, 2006).

Dr Amy Dempsey (AD) is an independent academic and author of *Destination Art* (2010) and *Styles, Schools and Movements: The Essential Encyclopaedic Guide to Modern Art* (2010).

Bryan Doubt (BD) holds a BFA in art history, for which he won the Pinsky Medal. He currently teaches theatre at Concordia University.

Emma Doubt (ED) has an MA in art history from McGill University, Montreal.

Samantha Earl (SE) is a freelance arts documentary researcher and producer in London. Since studying Art and Urban History at Columbia University in New York, she has been involved in filmmaking at various levels.

Dr Heather Elgood (HE) is the course director of the postgraduate diploma in Asian art at SOAS, University of London. She contributed to *Art: The Definitive Visual Guide* (2008).

Stephen Farthing (SF) is a painter and the Rootstein Hopkins research professor in drawing at the University of the Arts, London.

John Glaves-Smith (JGS) is a writer and former senior lecturer in art history at Staffordshire University, England. His publications include *A Dictionary of Modern and Contemporary Art* (1998).

Reg Grant (RG) is a freelance writer who has published more than thirty books on cultural and historical subjects. He was a contributor to *Art: The Definitive Visual Guide* (2008).

Paul Gwynne (PG) received his PhD from the University of London with a thesis on the Renaissance poet Johannes Nagonius. He is assistant professor of classics and director of the honours programme and interdisciplinary studies at the American University of Rome.

Lucinda Hawksley (LH) is an art historian, lecturer and author. Her books include *Lizzie Siddal: The Tragedy of a Pre-Raphaelite Supermodel* (2008) and *Essential Pre-Raphaelites* (1999). She gives regular talks at the National Portrait Gallery in London.

Professor Steven Hooper (PSH) is a lecturer at East Anglia University, England. He specializes in Polynesian art and has written for numerous academic journals. His article 'Embodying Divinity: the Life of A'a' appeared in the *Journal of Polynesian Society* special issue (2007).

Susie Hodge (SH) is an author whose books include studies of Impressionism, Victorian art, Picasso, Monet and modern art. She writes for museums and galleries and also gives workshops and lectures at various institutions.

Christian Kaufmann (ChK) has worked among the Kwoma people of the East Sepik Province of Papua New Guinea, as well as on the islands of Ambrym and Malakula of Vanuatu. He is a founding member of the Pacific Arts Association and co-author of *Oceanic Art* (1997).

Ann Kay (AK) is a writer and editor with a degree in history of art and literature from Kent University and a PhD in graphic design from London University.

Rose Kerr (RK) is a writer and Keeper Emeritus of the Far Eastern collection of Chinese ceramics at the Victoria & Albert Museum, London.

Carol King (CK) is a writer based in London and Italy. She studied fine art at Central St Martin's and English literature at Sussex University.

Rebecca Man (ReM) studied history of art at Sussex University. She has worked at the National Art Collections Fund and the Arts Council of England and Chelsea College of Art and Design.

Owen Martin (OM) received a degree in modern and contemporary art history from McGill University, Montreal.

Larry McGinity (LM) is an artist and writer on art. He has exhibited his artwork in London and New York, and has written on art for both children and adults.

Professor Ian McLean (IM) is a lecturer at the University of Western Australia and is on the advisory council of *Third Text* art journal. He has published extensively on Australian art. His books include *The Art of Gordon Bennett* (1997) and *White Aborigines: Identity Politics in Australian Art* (1998).

Kiyoko Mitsuyama-Wdowiak (KM) has an MA in Western history from Sophia University in Tokyo and an MPhil in art history from the University of the Arts, London. She was assistant curator at the Hara Museum of Contemporary Art, and has lectured at the British Museum, SOAS and University of London.

Rodolfo Molina (RM) was the national director of arts at CONCULTURA from 1993 to 1998 and has also been president of the Museo de Arte Popular in El Salvador. As an artist, he has had eight solo exhibitions.

Wendy Osgerby (WO) is a freelance art historian, writer and curator. She has contributed to several art books.

Professor John Picton (JP) is a lecturer at SOAS, University of London. He has worked for the British Museum and the Nigerian government's department of antiquities. He has published many books on African art, including *African Textiles* (1989) and *The Art of African Textiles* (1995).

Ana Portilla (AP) studied art history at the Iberoamericana University of Mexico and Warwick University, England. She wrote her dissertation on mathematics in art.

Megan A. Smetzer (MS) received her PhD from the department of art history, visual art and theory at the University of British Columbia, Vancouver. She is currently converting her dissertation into a book titled *Painful Beauty: A History of Tlingit Beadwork*.

Dr Craig G. Staff (CS) is an artist and writer based in Northamptonshire, England. He is a senior lecturer in the history of art and course leader for the MA fine art programme at the University of Northampton.

Rafael Schacter (RS) is completing a PhD in anthropology at University College, London. As part of his field work in Madrid, Spain, he worked with artists including 3TTMan, El Tono, Nano4814, Nuria Mora, Remed, San and Spok. In 2008 he co-curated 'Street Art' at Tate Modern, London.

Caroline Vanderloo (CV) has a PhD in art history from McGill University, Montreal.

Jude Welton (JW) studied English and history of art at Nottingham University. Her numerous books on art include *Looking at Paintings* (1994) and *Henri Matisse* (2002).

Ed Webb-Ingall (EWI) is a research assistant who is currently working for Professor Stephen Farthing.

Ingrid Yuet Ting Yeung (IY) is a PhD student in art history. She has an MA in Korean art from SOAS, University of London.

Heena Youn (HY) is editor of *KoreanArtZine*, Korean Art Resources Online. She has an MA in Chinese and Korean art history from SOAS, University of London.

Iain Zaczek (IZ) studied at Wadham College, Oxford and the Courtauld Institute of Art. His previous books include *The Collins Big Book of Art* and *Masterworks*.

SOURCES OF QUOTATIONS

p.21 '...every object...our modern world.' *The treasures of time: Firsthand accounts by famous archaeologists of their work in the Near East*, Leo Deuel, Souvenir Press, 1962

p.33 'As my eyes...the glint of gold.' *Howard Carter and A. C. Mace, Tomb of Tutankhamen*, Kessinger Publishing Co., 1923

p.151 'A structure...with its shadow.' *De Pictura*, Leon Battista Alberti, 1435

p.168 'a small...and a soldier.' *Notizie d'opere del disegno*, Marcantonio Michiel, 1530

p.172 'so dilapidated...a city.' *A Journey Into Michelangelo's Rome*, Angela K. Nickerson, Roaring Forties Press, 2006

p.177 'For Francesco...Mona Lisa.' *The Lives of the Artists*, Giorgio Vasari, Oxford Paperbacks, 2008

p.177 'Leonardo used...than human.' *The Lives of the Artists*, Giorgio Vasari, Oxford Paperbacks, 2008

p.177 'Whether you...your girdle.' *Decor puellarum*, Nicolas Jenson, 1461

p.181 'In order to paint...in my imagination.' *Raphael: His Life, Works, and Times*, Eugene Muntz, Kessinger Publishing, 2007

p.181 'Two shapely...in unison.' *The Stanze of Angelo Poliziano*, Trans. David Quint, Pennsylvania State University Press, 1993

p.193 'He swallowed...and panels.' *Janson's History of Art: The Western Tradition*, Volume II, Penelope J. E. Davies, Walter B. Denny, Frima Fox Hofrichter, Joseph F. Jacobs, Ann M. Roberts, David Simon, Prentice Hall, 2007

p.221 'Go to nature for everything.' *The Annotated Mona Lisa: A Crash Course in Art History from Prehistoric to Post-Modern*, Carol Strickland and John Boswell, Andrews McMeel Publishing, 2007

p.231 'In Flanders...or art.' *Northern Renaissance Art*, Susie Nash, Oxford University Press, 2008

p.231 'the act...the pool.' *De Pictura*, Leon Battista Alberti, 1435

p.246 'ancestor...peopled.' *A Narrative of Missionary Enterprises in the South Sea Islands*, John Williams, John Snow, 1837

p.257 'I have no...superfluous.' *Italy: With Sketches of Spain and Portugal*, Volume I, William Beckford, BiblioLife, 2009

p.260 'dip their...intellect.' *Enlightenment Portraits*, Michel Vovelle, University of Chicago Press, 1997

p.262 'the greatest...Sistine Chapel.' *The World's Most Influential Painters and the Artists They Inspired: The Stories and Hidden Connections Between Great Works of Western Art*, David Gariff, Barron's Educational series, 2008

p.267 'nearest-run...your life.' *Wellington: A Personal History*, Christopher Hibbert, Da Capo Press, 1999

p.272 'I have...paint for her.' *Encyclopedia of the Romantic Era, 1760–1850*, Christopher John Murray, Routledge, 2003

p.299 'Giving...Mr Waterhouse.' *J. W. Waterhouse*, Peter Trippi, Phaidon Press, 2005

p.310 'Everyone began...grow long.' *John Bull and His Island*, Max O'Rell, Nabu Press, 2010

p.310 'art for art's sake.' *Three nineteenth-century French writer/artists and the Maghreb: The literary and artistic depictions of North Africa by Théophile Gautier, Eugène Fromentin, and Pierre Loti*, Elwood Hartman, Narr, 1994

p.313 'flinging a pot...face.' *A Pot of Paint: Aesthetics on Trial in Whistler v. Ruskin*, Linda Merrill, Smithsonian, 1993

p.315 'consummately artistic.' *Hortus inclusus: In montibus Sanctis. Coeli enarrant. Notes on various pictures. Praeterita*, John Ruskin, D. Estes, 1913

p.316 'Impression...this seascape!' *Art in Theory: 1815–1900 An Anthology of Changing Ideas*, Charles Harrison, Paul J. Wood, Jason Gaiger, Wiley-Blackwell, 1998

p.321 'They call...of dancers.' *Edgar Degas*, Pierre Cabanne, Editions Pierre Tisné, 1958

p.321 'For me...movement.' *Edgar-Hilaire-Germain Degas*, Daniel Catton Rich, Thames & Hudson, 1954

p.322 'caught perfectly...dance hall.' *Impressionism*, Belinda Thomson, BISON, 1988

p.322 'dancing on...purplish clouds.' *Renoir*, Galeries nationales du Grand Palais, Arts Council of Great Britain, 1985

p.325 'He thinks...gripping toes.' *Philadelphia's Outdoor Art: A Walking Tour*, Roslyn F. Brenner, Camino Books, 2002

p.325 'rotating my...in turn.' *Rodin*, Bernard Champigneulle, Thames & Hudson, 1995

p.326 'The essence...every moment.' *The Annotated Mona Lisa: A Crash Course in Art History from Prehistoric to Post-Modern*, Carol Strickland and John Boswell, Andrews McMeel Publishing, 2007

p.328 'killed himself by overwork.' *Impressionism and Postimpressionism: Artists, Writers and Composers*, Sarah Halliwell, Raintree Steck-Vaughn Publishers, 1997

p.330 'a deeper...photographer.' *The Letters of Vincent Van Gogh*, Ed. Ronald de Leeuw, Penguin Classics, 1998

p.332 'treat nature...the cone.' *Theories of Modern Art: A Source Book by Artists and Critics*, Herschel B. Chipp, University of California Press, 1984

p.337 'to paint...whitish light.' *Vincent Van Gogh: The Drawings*, Colta Ives, Metropolitan Museum of Art, 2005

p.337 'There you have it...and green.' *Imaginatio Creatrix: The Pivotal Force of the Genesis/Ontopoiesis of Human Life and Reality (Analecta Husserliana)*, Ed. A-T. Tymieniecka, Springer, 2004

p.340 'The landscape...the sermon.' *Critical Readings in Impressionism and Post-Impressionism: An Anthology*, Ed. Mary Tompkins Lewis, University of California Press, 2007

p.346 'sudden violent...of a whip.' *Art Noveau*, Robert Schmutzler, Harry N. Abrams, 1978

p.360 'I put...man jumped.' *City Gorged with Dreams: Surrealism and Documentary Photography in Interwar Paris*, Ian Walker, Manchester University Press, 2002

p.361 'It is...influenced me.' Media Release: 'Martin Munkacsi: Think While You Shoot!', International Centre of Photography, 2007

p.367 'It is...I think.' *Pennsylvania Modern: Charles Demuth of Lancaster*, Betsy Fahlman, University of Pennsylvania Press, 1983

p.368 'the paradox...of visibility.' *The Fall of Public Man*, Richard Sennett, Penguin, 2003

p.370–1 'In front...and line.' *Les Fauves: A Sourcebook*, Ed. Russell T. Clement, Greenwood Press, 1994

p.371 'like children...of nature.' *The Fauves*, Gaston Diehl, Harry N. Abrams, 1975

p.371 'What I...liberated world.' *Robert Motherwell: With Pen and Brush*, Mary Ann Caws, Reaktion Books, 2003

p.375 'not the...of things.' *Brancuşi: A Study of the Sculpture*, Sidney Geist, Viking Press, 2003

p.379 'anaemic...was bored.' *The Story of Modern Art*, Norbert Lynton, Phaidon Press, 1989

p.379 'abundant in...and divinity.' *Weimar, a Cultural History, 1918–1933*, Walter Laqueur, Littlehampton Book Services, 1974

p.383 'Movement to...the world.' *Kandinsky: Catalogue Raisonne of the Oil Paintings*, Hans Konrad Röthel and Jean K. Benjamin, Cornell University Press, 1984

p.384 'It is like...painted this!' *German Expressionist Painting*, Peter Howard Selz, University of California Press, 1992

p.385 'to take...line.' *Expressionism*, Dietmar Elger, Benedickt Taschen, 1992

p.385 'Is there...a dog?' *Artists on Art from the 14th to the 20th Century*, Robert John Goldwater, Kegan Paul, 1947

p.385 'masculinity…intellect.' *Expressionism*, Dietmar Elger, Benedickt Taschen, 1992

p.385 'brutal and…be opposed.' *German Expressionism: Die Brücke and Der Blaue Reiter*, Barry Herbert, Olympic Marketing Corp., 1983

p.385 'beautiful…structured.' *Expressionism*, Dietmar Elger, Benedickt Taschen, 1992

p.388 'What would…business sense.' *In Praise of Commercial Culture*, Tyler Cowen, Harvard University Press, 2000

p.392 'first exorcism painting.' *A World History of Art*, Hugh Honour and John Fleming, Laurence King, 2009

p.393 'They were…against everything.' *A Life of Picasso: 1907–1917*, J. Richardson, Pimlico, 2009

p.396 'We shall…fearlessness.' *Futurism: A Modern Focus: The Lydia and Harry Lewis Winston Collection*, Dr. and Mrs. Barnett Malbin, New York Guggenheim Museum, 1973

p.398 'calm…gaiety.' *The Oxford Companion to Twentieth Century Art*, Harold Osborne, Oxford Paperbacks, 1988

p.400 'the supremacy…creative art.' *The Non-Objective World: The Manifesto of Suprematism*, Kasimir Malevich, Dover Publications, 2003

p.401 'real materials in real space.' *Modern Sculpture: A Concise History*, Herbert Read, Thames & Hudson, 1964

p.401 'a construction…around it.' *Art of the Avant-garde in Russia: Selections from the George Costakis Collection*, Margit Rowell, University of Washington Press, 1987

p.401 'an interchange…and architecture.' *Visions of Totality: László Moholy-Nagy, Theo Van Doesburg and El Lissitzky*, Steven A. Mansbach, UMI Research Press, 1980

p.402 'My new…been decimated.' *New Finnish Architecture*, Scott Poole, Rizzoli International Publications, 1992

p.403 'The corner…the corner.' *The Last Futurist Exhibition of Painting*, Linda S. Boersma, OIO Publishers, 1994

p.407 'There is…exact sciences.' *The Quotable Artist*, Peggy Hadden, Allworth Press, 2002

p.411 'Like everything…is useless.' *Theories of Modern Art: A Source Book by Artists and Critics*, Herschel B. Chipp, University of California Press, 1984

p.414 'to create…and artist.' *Modern Architecture: A Critical History*, Kenneth Frampton, Thames & Hudson, 2007

p.415 'the flower…of Bauhaus.' *The Bauhaus: Masters & Students by Themselves*, Ed. Frank Whitford, Overlook Press, 1993

p.418 'The illiterate…camera alike.' *Art in Question*, Karen Raney, Continuum International Publishing Group, 2003

p.419 'One travels…window.' *László Moholy-Nagy*, Arts Council of Great Britain, 1980

p.421 'remained unswervingly…palpable reality.' *Neue Sachlichkeit 1918–33: Unity and Diversity of an Art Movement*, Steve Plumb, Editions Rodopi B.V., 2006

p.427 'hand-painted dream photographs.' *The Annotated Mona Lisa: A Crash Course in Art History from Prehistoric to Post-Modern*, Carol Strickland and John Boswell, Andrews McMeel Publishing, 2007

p.428 'either seek…to exist.' *A World of Art*, Henry M. Sayre, Pearson Education, 2002

p.428 'It is…of money.' *Surreal Things: Surrealism and Design*, Ghislaine Wood, V&A Publications, 2007

p.429 'absolutely useless…of view.' *The Secret Life of Salvador Dalí*, Salvador Dalí, Dover Publications Inc., 2009

p.430 'My whole…of precision.' *Postmodern Subjects, Postmodern Texts*, Jane Dowson and Steven Earnshaw (eds), Rodopi B.V. Editions, 1995

p.433 'I used…favourite greys.' *Magritte, 1898–1998*, Gisèle Ollinger-Zinque (ed.), Harry N. Abrams, 1998

p.439 'Our fundamental…individualism.' *Art in Theory: 1815–1900 An Anthology of Changing Ideas*, Charles Harrison, Paul J. Wood, Jason Gaiger, Wiley-Blackwell, 1998

p.444 'the armed…and tomorrow.' *The impact of Modernism 1900–20: Early Modernism and the Arts and Crafts Movement in Edwardian England*, S. K. Tillyard, Routledge, 1988

p447 'perhaps…oscillate.' *Calder, An Autobiography with Pictures*, Alexander Calder and Jean Davidson, Pantheon Books, 1966

p.449 'the terrible…ourselves into.' *Jacob Epstein, sculptor*, Richard Buckle, Faber, 1963

p.453 'being alive…complete space.' *Not an Illustration But the Equivalent: Cognitive Approach to Abstract Expressionism*, Claude Cernuschi, Fairleigh Dickinson University Press, 1997

p.457 'I paint…in it.' *Not an Illustration But the Equivalent: Cognitive Approach to Abstract Expressionism*, Claude Cernuschi, Fairleigh Dickinson University Press, 1997

p.458 'There is no accident.' *Jackson Pollock: Interviews, Articles and Reviews, 1943–1993*, Pepe Karmel (ed.), Museum of Modern Art, 2000

p.458 'try to…to offer.' *Jackson Pollock: Interviews, Articles and Reviews, 1943–1993*, Pepe Karmel (ed.), Museum of Modern Art, 2000

p.459 'There has…by flooding.' *Jackson Pollock: Drawing into Painting*, Jackson Pollock and Bernice Rose, Museum of Modern Art, 1979

p.462 'try and…of reality.' *Theories and Documents of Contemporary Art: A Sourcebook of Artists' Writings*, Kristine Stiles, University of California Press, 1996

p.462 'the subject…close observation.' *Andrew Wyeth: Memory and Magic*, Anne Knutson, Rizzoli International Publications, 2005

p.481 'one word…first name.' *Women, Art and Society*, Whitney Chadwick, Thames & Hudson, 2007

p.485 'Popular…big business.' *Art into Pop*, Simon Frith and Howard Horne, Methuen Young Books, 1987

p.485 'the most brazen characteristics.' *Roy Lichtenstein*, John Coplans (ed.), Allen Lane, 1974

p.485 'We consciously…in art.' *Yoko Ono: A Biography*, Jerry Hopkins, Sidgwick & Jackson, 1987

p.485 'We felt…enthusiastically.' *Routledge Companion to Postmodernism*, Stuart Sim (ed.), Routledge, 2004

p.487 'to see…commercial art.' *Art into Pop*, Simon Frith and Howard Horne, Methuen Young Books, 1987

p.487 'leaves nothing…assuredly are.' *Art into Pop*, Simon Frith and Howard Horne, Methuen Young Books, 1987

p.489 'you get…each time.' *Finding the Artist Within: Creating and Reading Visual Texts in the English Language Arts Classroom*, Peggy Albers, International Reading Association, 2007

p.490 'It was…enough either.' *Roy Lichtenstein*, John Coplans (ed.), Allen Lane, 1974

p.497 'poetic recycling…advertising reality.' *Art: The Twentieth Century*, Flamino Gualdoni, Skira Editore, 2009

p.502 'The expression…the idea.' *Gardner's Art Through the Ages: Western Perspective*, Christian J. Mamiya and Fred Kleiner, Wadsworth Publishing, 2005

p.514 'Each day…get in.' *Conceptual Art (Themes & Movements)*, Peter Osborne (ed.), Phaidon Press, 2002

p.518 'I did…no choosing.' *The Art of Alighiero E. Boetti: When 1 is 2*, Alighiero E. Boetti, Contemporary Arts Museum, 2002

p.522 'My work…all men.' *The Fate of the Object: from Modern Object to Postmodern Sign in Performance, Art, and Poetry*, Jon Erickson, University of Michigan Press, 1995

p.535 'Photography is…my art.' *Stone*, Andy Goldsworthy, Harry N. Abrams, 1998

p.544–5 'the best…from content.' *Georg Baselitz*, Diane Waldman, Guggenheim Museum, 1995

PICTURE CREDITS

The publishers would like to thank the museums, galleries, collectors, archives, artists, and photographers for their kind permission to reproduce the works featured in this book. Where no dimensions are given, none are available. Every effort has been made to trace all copyright owners but if any have been inadvertently overlooked, the publishers would be pleased to make the necessary arrangements at the first opportunity. (Key: **t** = top; **c** = centre; **b** = bottom; **l** = left; **r** = right)

Library 224 akg-images/Electa 225 t Private Collection/© John Mitchell Fine Paintings/The Bridgeman Art Library 225 b akg-images 226 akg-images 227 r © 2010. Copyright The National Gallery, London/Scala, Florence 228 Rijksmuseum, Amsterdam, The Netherlands/The Bridgeman Art Library 229 r Private Collection/The Stapleton Collection/ The Bridgeman Art Library 230 © 2010. Copyright The National Gallery, London/Scala, Florence 231 r © Samuel Courtauld Trust, The Courtauld Gallery, London, UK/The Bridgeman Art Library 232 V&A Images/Victoria and Albert Museum 233 t San Diego Museum of Art (Edwin Binney 3rd Collection). 233 b Victoria & Albert Museum, London, UK /The Bridgeman Art Library 234 © 2010. Photo Scala, Florence. 236 Museum of Fine Arts, Boston, Massachusetts, USA/Gift of Oliver W. Peabody/The Bridgeman Art Library 237 t © Brooklyn Museum/Corbis 237 b Private Collection/The Bridgeman Art Library 238 TNM Image Archives, Source:http://TNMArchives.jp/ 240 akg-images/Erich Lessing 241 © The Field Museum, #A101440C 242 V&A Images/Victoria and Albert Museum 243 © Oriental Museum, Durham University, UK/The Bridgeman Art Library 244 l © 2010. musee du quai Branly, photo Patrick Gries/Bruno Descoings/Scala, Florence 244 t Werner Forman Archive 245 © The Trustees of the British Museum 246–247 Images courtesy Prof. Steven Hooper 248 © Archives Musée Dapper et Hughes Dubois. 249 b Vb 2633. Photo: Peter Horner © Museum der Kulturen Basel, Switzerland 249 t l Ubersee Museum/Gabriele Warnke 249 t centre © The Trustees of the British Museum 249 t r © 2010. musee du quai Branly, photo Hughes Dubois/Scala, Florence 250 © Wallace Collection, London, UK/The Bridgeman Art Library 251 t Victoria & Albert Museum, London, UK/The Bridgeman Art Library 251 b © Ashmolean Museum, University of Oxford, UK/The Bridgeman Art Library 252 Louvre, Paris, France/Giraudon/The Bridgeman Art Library 253 r © White Images/Scala, Florence 254 © Wallace Collection, London, UK/The Bridgeman Art Library 256 Photo © Christie's Images/The Bridgeman Art Library 257 National Trust of Scotland, Fyvie Castle Coll., Scotland/The Bridgeman Art Library 258 Private Collection/Photo © Christie's Images/The Bridgeman Art Library 259 r Syon House, Middlesex, UK/The Bridgeman Art Library 260 Louvre, Paris, France/Giraudon/ The Bridgeman Art Library 261 t © Harris Museum and Art Gallery, Preston, Lancashire, UK/The Bridgeman Art Library 261 b © 2010. Photo Scala, Florence/HIP 262 © 2010. Image copyright The Metropolitan Museum of Art/Art Resource/Scala, Florence 263 r © White Images/Scala, Florence 264 Louvre, Paris, France/Giraudon/The Bridgeman Art Library 266 The Art Archive/Detroit Institute of Arts/Superstock 267 t akg-images 267 b akg-images/Erich Lessing 268 t © Tate, London 2010 268 b © Tate, London 2010 269 Museum of Fine Arts, Boston, Massachusetts, USA/Gift of Martha C. Karolik for the M. and M. Karolik Collection of American Paintings, 1815-65/The Bridgeman Art Library 270 © 2010. Photo Scala, Florence. 271 r Prado, Madrid, Spain/ Giraudon/ The Bridgeman Art Library 272 Louvre, Paris, France/The Bridgeman Art Library 273 r Louvre, Paris, France/Lauros/Giraudon/The Bridgeman Art Library 274 © 2010. Photo Scala, Florence. 276 © 2010. White Images/Scala, Florence 277 © 2010. Image copyr The Metropolitan Museum of Art/Art Resource/Scala, Florence 278 akg-images/Erich Lessing 280 t © 2010. Photo The Newark Museum/Art Resource/Scala, Florence 280 b Museum of Fine Arts, Boston, Massachusetts, USA/Everett Fund/The Bridgeman Art Library 281 Werner Forman Archive 282 Pitt Rivers Museum, University of Oxford, acc. # 1901.39.1 283 t r © Canadian Museum of Civilization/Corbis 283 b r © Brooklyn Museum/Corbis 284 © 2010. musee du quai Branly, photo Patrick Gries/Valérie Torre/Scala, Florence 285 t Nebraska State Historical Society 285 b The Art Archive/Museum purchase with funds provided by the Pilot Foundation/Buffalo Bill Historical Center, Cody, Wyoming/ NA.302.144 286 Louvre, Paris, France/Lauros/Giraudon/The Bridgeman Art Library 287 t Musee de la Chartreuse, Douai, France/Giraudon/The Bridgeman Art Library 287 b © Lady Lever Art Gallery, National Museums Liverpool /The Bridgeman Art Library 288 © 2010. Image copyright The Metropolitan Museum of Art/Art Resource/Scala, Florence 290 Brooklyn Museum of Art, New York, USA/Frank L. Babbott Fund/The Bridgeman Art Library 291 r Worcester Art Museum, Massachusetts, USA/The Bridgeman Art Library 291 b The Art Archive/Bibliothèque des Arts Décoratifs Paris/Gianni Dagli Orti 292 © 2010. Image copyright The Metropolitan Museum of Art/Art Resource/Scala, Florence 294 akg-images/Erich Lessing 295 t © Birmingham Museums and Art Gallery/The Bridgeman Art Library 295 b akg-images 296 Private Collection/The Bridgeman Art Library 298 ©Tate, London 2010 299 r ©Tate, London 2010 300 Musee d'Orsay, Paris, France/Giraudon/The Bridgeman Art Library 301 Musee d'Orsay, Paris, France/Giraudon/ The Bridgeman Art Library 302 State Russian Museum, St. Petersburg, Russia/Giraudon/The Bridgeman Art Library 303 r Private Collection/Photo © Lefevre Fine Art Ltd., London/The Bridgeman Art Library 303 b Neue Nationalgalerie, Berlin, Germany/The Bridgeman Art Library 304 Musee d'Orsay, Paris, France/Giraudon/The Bridgeman Art Library 305 r Musee de Grenoble, France/Lauros/Giraudon/The Bridgeman Art Library 306 © 2010. Photo Scala, Florence. 307 r © 2010. Image copyright The Metropolitan Museum of Art/Art Resource/Scala, Florence 308 © 2010. Photo Scala, Florence. 310 ©The Barber Institute of Fine Arts, University of Birmingham/The Bridgeman Art Library 311 © Russell-Cotes Art Gallery and Museum, Bournemouth, UK/The Bridgeman Art Library 312 akg-images/Erich Lessing 314 ©Tate, London 2010 316 Musee Marmottan, Paris, France/Giraudon/The Bridgeman Art Library 317 © 2010. Photo Scala, Florence 318 t Musee d'Orsay, Paris, France/Giraudon/The Bridgeman Art Library 318 b Museum of Fine Arts, Boston, Massachusetts, USA/The Hayden Collection – Charles Henry Hayden Fund/The Bridgeman Art Library 319 © 2010. Photo Scala, Florence 320 © 2010. Photo Scala, Florence. 322 © 2010. White Images/Scala, Florence 323 r Bibliotheque des Arts Decoratifs, Paris, France/Giraudon/The Bridgeman Art Library 324 Burrell Collection, Glasgow, Scotland/ © Culture and Sport Glasgow (Museums)/The Bridgeman Art Library 326 Musee de l'Orangerie, Paris, France/Lauros/Giraudon/The Bridgeman Art Library 328 National Gallery, London, UK/The Bridgeman Art Library 329 t akg-images/Erich Lessing 329 b Staatsgalerie Moderner Kunst, Munich, Germany /The Bridgeman Art Library 330 t © The Barnes Foundation, Merion, Pennsylvania, USA/The Bridgeman Art Library 330 b akg-images 331 b Philadelphia Museum of Art, Pennsylvania, PA, USA/ Peter Willi/The Bridgeman Art Library 331 t akg-images 332 © Samuel Courtauld Trust, The Courtauld Gallery, London, UK/The Bridgeman Art Library 333 r © 2010. White Images/Scala, Florence 334 Art Institute of Chicago, IL, USA/The Bridgeman Art 336 Rijksmuseum Kroller-Muller, Otterlo, Netherlands/Corbis 338 Josefowitz Collection, New York, USA/Peter Willi/The Bridgeman Art Library 339 t © 2010. Digital image, The Museum of Modern Art, New York/Scala, Florence 339 b Private Collection/ © DACS /The Bridgeman Art Library 340 © National Gallery of Scotland, Edinburgh, Scotland/The Bridgeman Art Library 341 r Private Collection/Lauros/Giraudon/The Bridgeman Art Library 342 © 2010.White Images/Scala, Florence 343 © 2010. Digital Image, The Museum of Modern Art, New York/Scala, Florence/ © ADAGP, Paris and DACS, London 2010 344 © 2010. White Images/Scala, Florence 345 r © 2010. White Images/Scala, Florence 346 Rijksmuseum Kroller-Muller, Otterlo, Netherlands/The Bridgeman Art Library 347 t Mucha Trust/The Bridgeman Art Library 347 b Private Collection/The Bridgeman Art Library 348 Fogg Art Museum, Harvard University Art Museums, USA/Bequest of Grenville L. Winthrop/The Bridgeman Art Library 350 Imagestate/Photolibrary.com 351 t © 2010. Photo Austrian Archive/Scala, Florence 351 b akg-images 352 © 2010. Photo Austrian Archive/Scala, Florence 353 r © 2010. Photo Scala, Florence. 354 Offentliche Kunstsammlung, Basel, Switzerland/The Bridgeman Art Library 356 © 2010. Digital Image, The Museum of Modern Art, New York/Scala, Florence/© Georgia O'Keeffe Museum/DACS, 2010 357 t © 2010. Image copyr The Metropolitan Museum of Art/Art Resource/ Scala, Florence 357 b Collection Center for Creative Photography. © 1981 Arizona Board of Regents 358 t Robert Capa © 2001 By Cornell Capa/Magnum Photos 358 b © Collection Centre Poimpidou, Dist. RMN/Jacques Faujour/ © Estate Brassaï – RMN 359 © Corbis/Library of Congress, Prints & Photographs Division, FSA/OWI Collection 360 Henri Cartier-Bresson/Magnum Photos 361 r Ullsteinbild/Topfoto 362 © Ansel Adams Publishing Rs Trust/Corbis 363 r The Imogen Cunningham Trust 364 The Art Institute of Chicago, IL, USA /The Bridgeman Art Library/Art © Figge Art Museum, successors to the Estate of Nan Wood Graham/ Licensed by VAGA, New York, NY 365 t Fogg Art Museum, Harvard University Art Museums, USA/Louise E. Bettens Fund/The Bridgeman Art Library 365 b Brooklyn Museum of Art, New York, USA/The Bridgeman Art Library © Georgia O'Keeffe Museum/DACS, 2010 366 Whitney Museum of American Art, New York; Purchase, with funds from Gertrude Vanderbilt Whitney 31.172 368 Photograph by Robert Hashimoto. Reproduction The Art Institute of Chicago 370 © 2010. Digital Image, The Museum of Modern Art, New York/Scala, Florence/ © ADAGP, Paris and DACS, London 2010 371 t Private Collection/Giraudon/The Bridgeman Art Library/ © ADAGP, Paris and DACS, London 2010 371 b © 2010 White Images/Scala, Florence/ © ADAGP, Paris and DACS, London 2010. 372 © Succession H Matisse/DACS, 2010. Photo: Archives Matisse 373 © Succession H Matisse/DACS, 2010. Photo: © The Barnes Foundation, Merion, Pennsylvania, USA/The Bridgeman Art Library 374 © 2010. Photo Scala, Florence. 375 t © 2010. BI, ADAGP, Paris, France/© ADAGP, Paris and DACS, London 2010. 375 b © 2010 Photo Art Resource/Scala, Florence/© ADAGP, Paris and DACS, London 2010. 376 Musee National d'Art Moderne, Centre Pompidou, Paris, France/The Bridgeman Art Library/ © ADAGP, Paris and DACS, London 2010 377 r Petit Palais, Geneva, Switzerland/The Bridgeman Art Library/ © ADAGP, Paris and DACS, London 2010 378 Hamburger Kunsthalle, Hamburg, Germany/The Bridgeman Art Library/ © DACS 2010 379 t Private Collection/© Marlena Eleini/The Bridgeman Art Library/ © DACS 2010 379 b akg-images 380 t Museum Folkwang, Essen, Germany/The Bridgeman Art Library 380 b Private Collection/The Bridgeman Art Library/ © DACS 2010 381 © 2010. Digital Image, The Museum of Modern Art, New York/Scala, Florence/ © ADAGP, Paris and DACS, London. 382 Musee National d'Art Moderne, Centre Pompidou, Paris, France/Peter Willi/The Bridgeman Art Library/ © ADAGP, Paris and DACS, London 2010 383 r Stedelijk van Abbe Museum, Eindhoven, The Netherlands/Lauros/Giraudon/ The Bridgeman Art Library/ © ADAGP, Paris and DACS, London 2010 384 Offentliche Kunstsammlung, Basel, Switzerland/The Bridgeman Art Library 385 Städel Museum, Frankfurt am Main 386 akg-images/Erich Lessing 388 Rupf Foundation, Bern, Switzerland/Giraudon/The Bridgeman Art Library/© ADAGP, Paris and DACS, London 2010. 389 t © 2010. Digital Image, The Museum of Modern Art, New York/Scala, Florence/ © Succession Picasso/DACS, London 2010 389 b The Art Institute of Chicago, IL, USA/The Bridgeman Art Library 390 © 2010. Digital Image, The Museum of Modern Art, New York/Scala, Florence/ © ADAGP, Paris and DACS, London 2010 391 t © Collection Centre Pompidou, Dist. RMN/Droits réservés/© ADAGP, Paris and DACS, London 2010 392 © 2010. Digital Image, The Museum of Modern Art, New York/Scala, Florence/ © Succession Picasso/DACS, London 2010. 391 b © Burstein Collection/Corbis/ © Succession Marcel Duchamp/ADAGP, Paris and DACS, London 2010 393 r North Carolina Museum of Art/Corbis 394 © 2010. Digital Image, The Museum of Modern Art, New York/Scala, Florence/ © ADAGP, Paris and DACS, London 2010. 395 r © 2010. Digital Image, The Museum of Modern Art, New York/Scala, Florence/ © Succession Picasso/DACS, London 2010 396 © 2010. Digital Image, The Museum of Modern Art, New York/Scala, Florence/ © DACS 2010 397 t © L & M Services B.V. The Hague 20100304 397 b © 2010. Digital Image, The Museum of Modern Art, New York/Scala, Florence/ © ADAGP, Paris and DACS, London 2010. 398 © 2010. Photo Scala, Florence. 399 r © Bettmann/Corbis 400 akg-images/ © DACS 2010. 401 t © 2010. Digital Image, The Museum of Modern Art, New York/Scala, Florence 401 b © 2010. Digital Image, The Museum of Modern Art, New York/Scala, Florence 402 © 2010. Digital Image, The Museum of Modern Art, New York/Scala, Florence 403 r State Russian Museum, St. Petersburg, Russia/RIA Novosti/The Bridgeman Art Library 404 Russian State Library, Moscow, Russia/The Bridgeman Art Library/ © Rodchenko & Stepanova Archive, DACS 2010. 405 r © 2010. Photo Scala, Florence/ © Rodchenko & Stepanova Archive, DACS 2010. 406 Haags Gemeentemuseum, The Hague, Netherlands/The Bridgeman Art Library/ © Mondrian/Holtzman Trust c/o HCR International Virginia 407 t © Tate, London 2010/ © DACS 2010. 407 t © Tate, London 2010/ © DACS 2010 408 Haags Gemeentemuseum, The Hague, Netherlands/The Bridgeman Art Library 410 Musee National d'Art Moderne, Centre Pompidou, Paris, France/ Lauros/Giraudon/The Bridgeman Art Library/ © ADAGP, Paris and DACS, London 2010 411 b © Burstein Collection/Corbis/© Succession Marcel Duchamp/ADAGP, Paris and DACS, London 2010. 411 t akg-images 412 © 2010. Photo Scala, Florence/BPK, Bildeagentur fuer Kunst, Kultur und Geschichte, Berlin/ © ADAGP, Paris and DACS, London 2010 413 r Galleria Pictogramma, Rome, Italy/Alinari/The Bridgeman Art Library/ ©The Heartfield Community of Heirs/VG Bild-Kunst, Bonn and DACS, London 2010 414 Private Collection/The Stapleton Collection/The Bridgeman Art Library 415 b Hulton Archive/Getty Images 415 t © 2010. Digital Image, The Museum of Modern Art, New York/Scala, Florence 416 © 2010. Photo The Philadelphia Museum of Art/Art Resource/Scala, Florence/© DACS 2010 417 r akg-images/Schuetze/Rodemann 418 Haags Gemeentemuseum, The Hague, Netherlands/The Bridgeman Art Library/ © Hattula Moholy-Nagy/DACS 2010 419 r © h c gilje/Van Abbe Museum / © Hattula Moholy-Nagy/DACS 2010 420 © 2010. Photo Scala, Florence/BPK, Bildeagentur fuer Kunst, Kultur und Geschichte, Berlin/ © DACS 2010 421 t Maerkisches Museum, Berlin, Germany/Lauros/Giraudon/The

Quintessence would also like to thank: Jo Walton for her determination and persistence in sourcing a huge number of images from around the world, and Sunita Sharma-Gibson, Helena Choong, and Benjamin Connor for their assistance in obtaining images from India, China, and Korea, respectively.